Φ

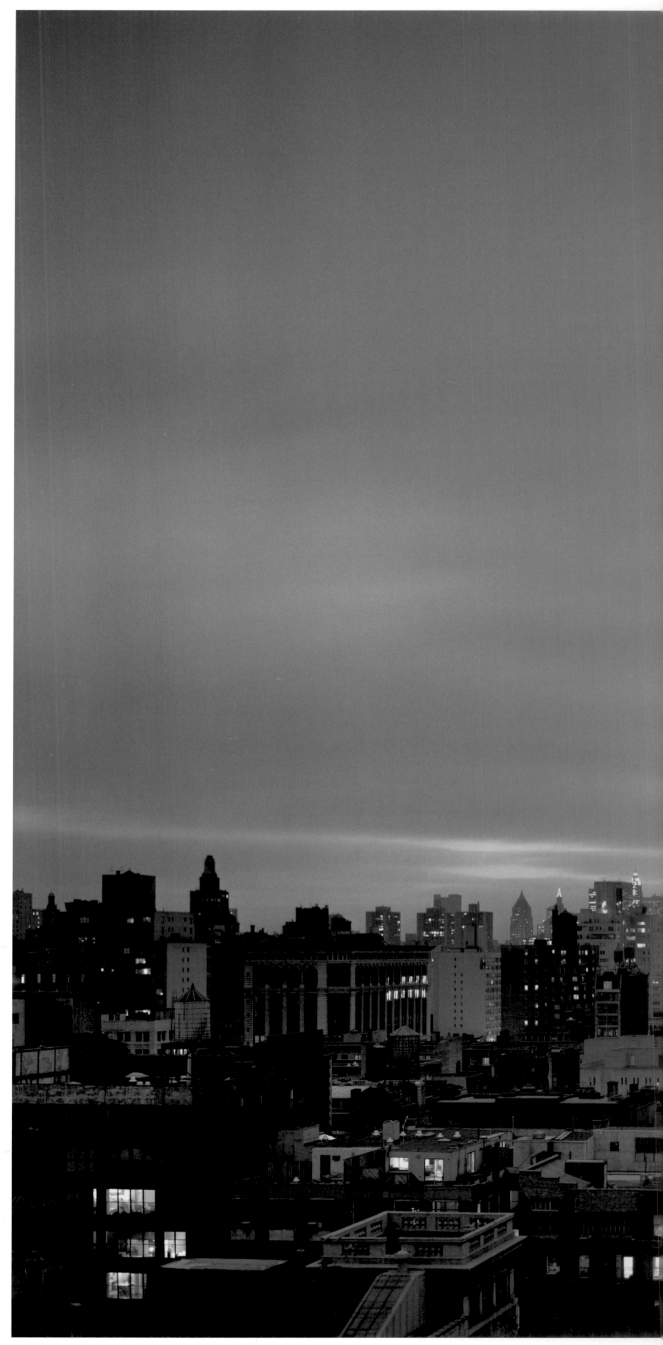

January 1st, 1983

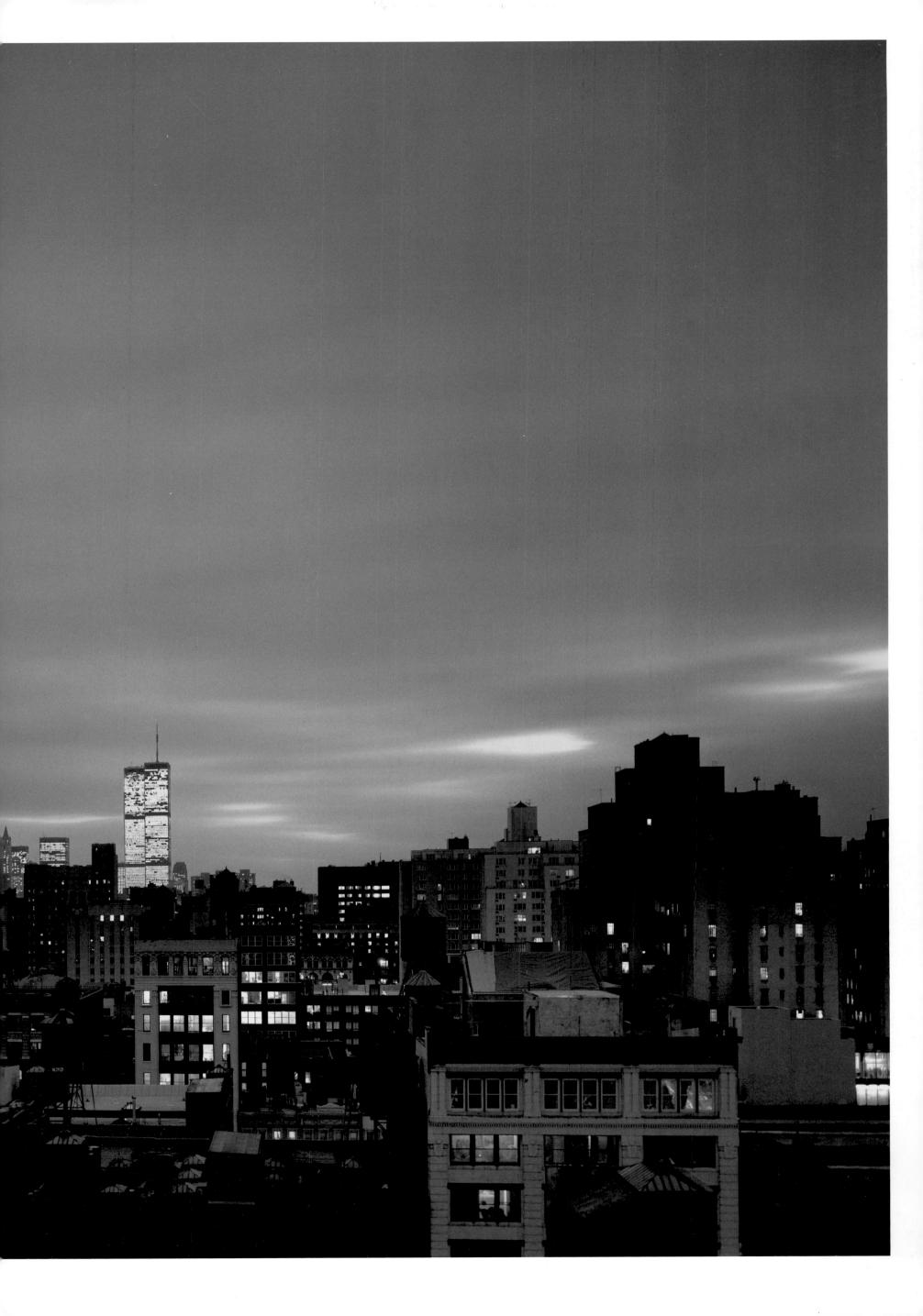

November 28th, 1988

November 30th, 1988

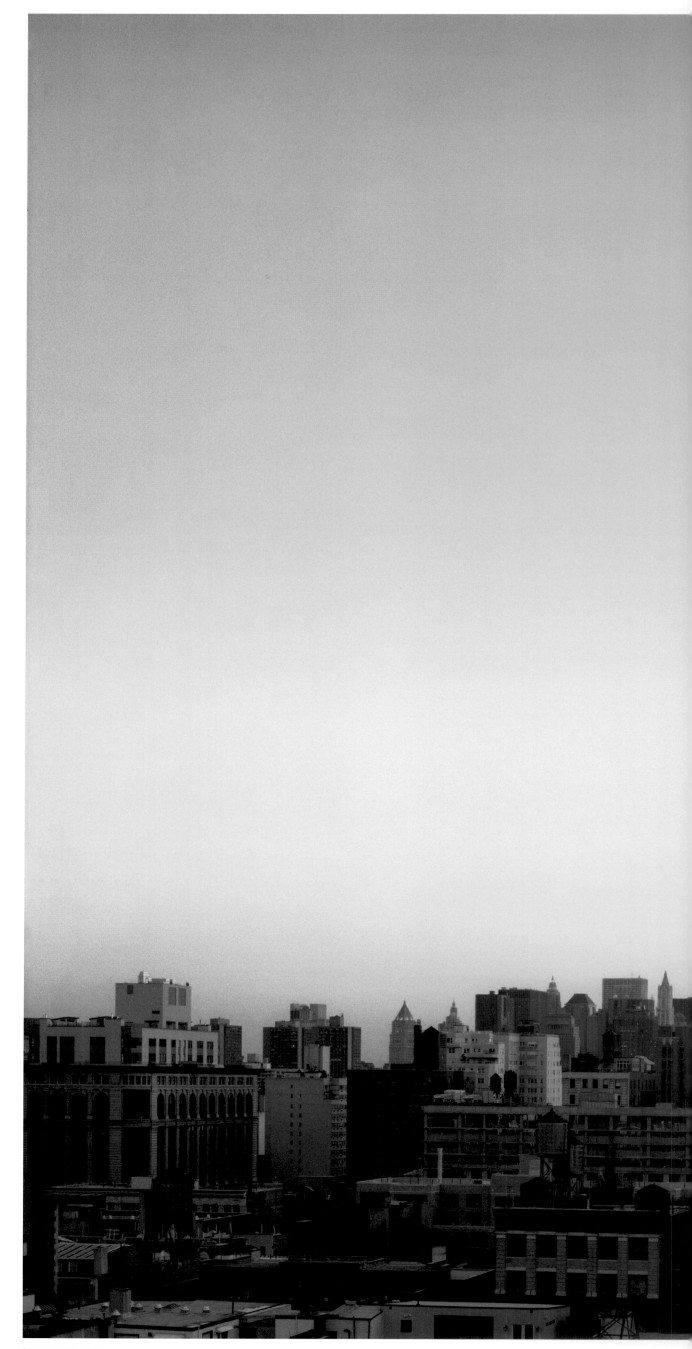

September 5th, 2001

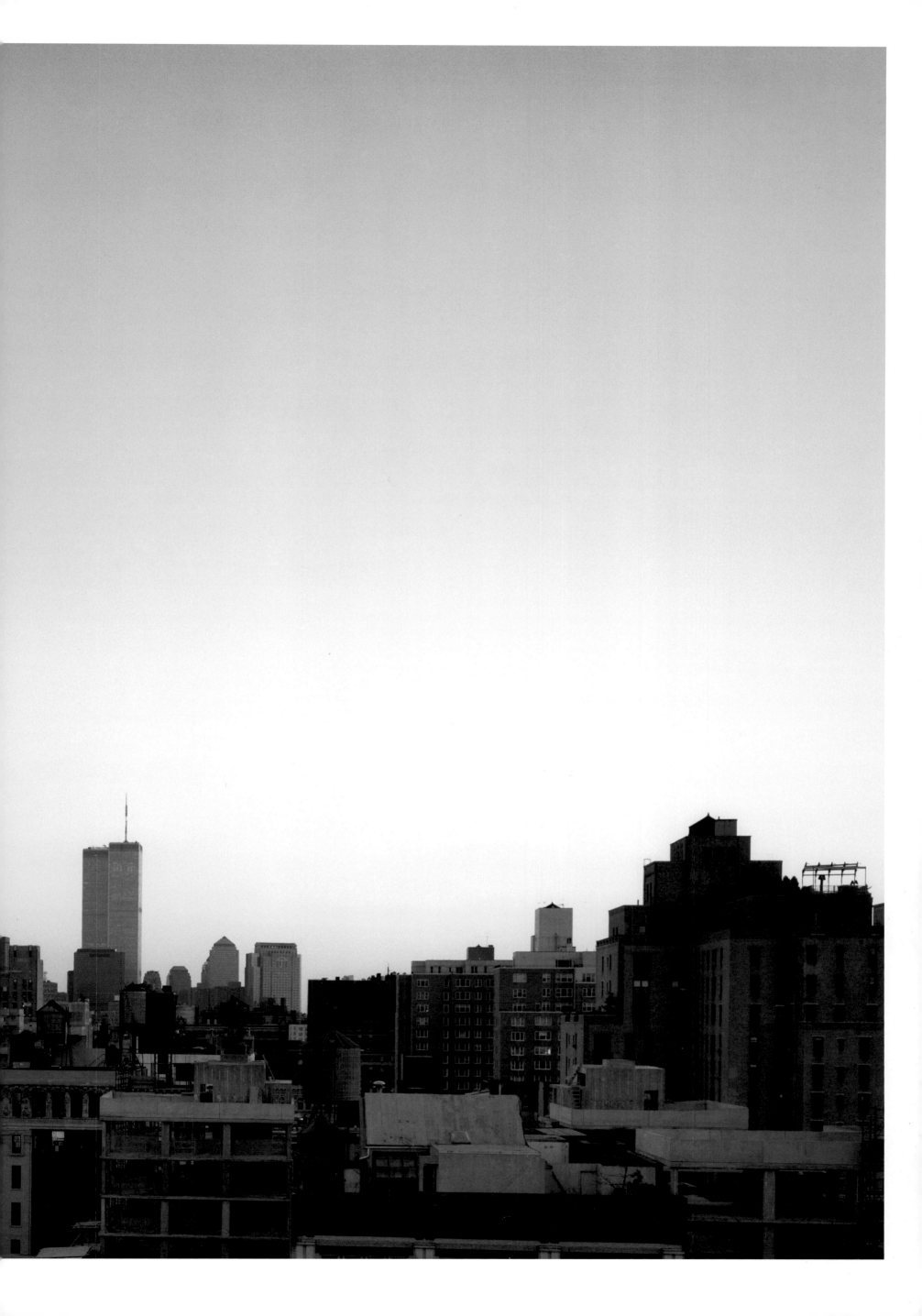

AFTERMATH JOEL MEYEROWITZ WORLD TRADE CENTER ARCHIVE

Φ

HISTORY IN THE MAKING

During the late summer of 2001, while working in Provincetown, Massachusetts, I looked at the World Trade Center every day. I was preparing for an exhibition of photographs of lower Manhattan, taken from the window of my loft on 19th Street, and so my studio walls in Cape Cod were covered with four-foot-tall work prints, creating a massive cityscape in the tiny space. The effect was overwhelming as the various seasons and weather systems chased one another around the walls of the room, and the Twin Towers punctuated every shot.

The last of these images was taken on the evening of September 5th, during a flying visit to the city. My log entry reads "WTC-7:30—Dusty blue sky, hazy yellow near horizon in east, faint pink over buildings, slightly grayer in the west. Lights on in WTC. Simple picture, no drama, empty sky, peaceful." I wasn't in love with this shot of the towers, but I wasn't worried about it, either. I remember thinking, "Oh, well, I'll come back next week. They'll always be there."

On the morning of September 11th, I was out early photographing in Chatham, a seaside town forty minutes away from Provincetown. As I stood at the water's edge, tasting the briny freshness of the air and appreciating the new quiet—tourists gone, kids back in school—I remember feeling how good the world was. I made some photographs and was thinking about breakfast when my phone rang. It was my wife, Maggie, telling me to get to a television as quickly as possible; something terrible had happened. I ran to a nearby hotel and watched as the South Tower was struck and then collapsed.

My first impulse was to get back to the city immediately. I threw my gear in the car and raced back to Provincetown as fast as I could to pack, only to find out that entering and leaving the city had been prohibited. For five days we waited. As soon as the ban on travel was lifted, Maggie and I returned to our apartment in the West Village, which was less than two miles north of the World

Trade Center. The streets were quiet, the air heavy with smoke and stench.

Early the next morning I went down to the site, only to find that the whole area had been cordoned off with cyclone fencing draped with tarpaulins, above which one could see smoke rising in the distance. There wasn't much to look at as I stood in the crowd on the corner of Chambers and Greenwich, about four blocks north of Ground Zero, but out of a lifetime of habit I raised my Leica to my eye, simply to get the feel of what was there. Whack! Someone behind me smacked me sharply on the shoulder. "No photographs, buddy, this is a crime scene!" I whipped around and found myself face to face with a female police officer. I was furious—both at being hit and at the absurdity of the command. "Listen, this is a public space," I replied. "Don't tell me I can't look through my camera!" But she came right back at me with "You give me trouble and I'll take that camera away from you!" "No you won't," I said. "Suppose I was the press?" "The press? There's the press," she said, jerking a thumb over her shoulder at about a dozen TV cameramen and reporters, roped off by yellow police tape, halfway up the block. "When are they going in?" I asked. "Never," she said. "I told you, this is a crime scene. No photography!"

Sometimes life gives you just the push you need. They can't do this to us, I thought. No photographs meant no visual record of one of the most profound things ever to happen here. We had been attacked. Now we had to bury our dead and reclaim our city. There *needed* to be a record of the aftermath. As I walked north past the press corps, penned in and waiting, my fury gave way to a sense of elation. I was going to get in there and make an archive of everything that happened at Ground Zero. This was something that I knew I could do.

Some years before, my friend Colin Westerbeck and I had written a book about the history of street photography, and in the course of our research we'd visited archives all over the world. I had seen the bounty and the failures of many of these collections and had learned from them what I thought were the requirements of a good archive. I could organize a team, with half a dozen photographers, a cinematographer, maybe an oral historian. It could be similar in approach to the work of the Farm Security Administration during the Depression—making visible for the rest of the country the consequences of a national disaster. The first thing, though, was to find a museum to partner with.

On the way home, bursting with ideas and anxious to get started, I called Robert Macdonald, then the director of the Museum of the City of New York. I told him about Mayor Giuliani's ban and how I thought it would be criminal not to have a photographic record of the "unbuilding" of Ground Zero for future generations. Macdonald was interested. He agreed to give me a letter from the museum, endorsing my presence on the site and stating that I was working on an official archive of the disaster. I picked it up that afternoon, and the following morning made my way down to Chambers Street and the West Side Highway, the place where most of the traffic entered the site. I didn't get far with my letter, however. No cop or soldier would even take the trouble to read more than a few lines. I explained, I pleaded—I even called Macdonald and asked him to speak to the officers himself. Nothing worked. As one of the cops said to me, "This place is iced!"

Clearly, I needed to appeal to a higher authority. And so I wrote a four-page proposal to Mayor Giuliani, in which I outlined my plan for forming a not-for-profit collective to raise money for, and to carry out, the documentation of the work at Ground Zero. I gave my proposal to Macdonald, who promised he'd get it to the Mayor as soon as possible. But days went by and nothing happened. Then I remembered that Adrian Benepe, the son of a friend of mine, was at that time the Manhattan Borough Commissioner for Parks and Recreation. I called Adrian, explained what I wanted, and asked if he knew anyone in the government who might help me. "We are the government," he replied, laughing. "So," I countered, "what can you do?" He reminded me that Battery Park fell within his jurisdiction. By the very next morning I had not only a worker's badge—which legitimized my presence on the site—but also a Parks employee escort to drive me through the barricades, which made my equipment far less conspicuous. September 23rd was my first day at Ground Zero. But I was still working alone, and I'd already lost precious days on the site.

Ironically, within hours of getting inside, I discovered that almost everyone who was authorized to be there was surreptitiously taking pictures—many people had small digital cameras hidden on their persons, and they were shooting away like crazy. I, on the other hand, was taking pictures for those who didn't have access to the site, and so I'd decided to work with a large-format wooden view camera. This camera was impossible to hide, but it enabled me to make images of the fullest description, with a sense of deep space. I wanted to communicate what it felt like to be in there as well as what it looked like: to show the incredible intricacy and visceral power of the site. If I could manage to stay in, I could provide a window for everyone else who wanted to know what was happening there, too—to help, or to grieve, or simply to try to understand what had happened to our city.

And what was happening inside the zone was truly amazing: the operation was being run by a pickup team of engineers, workers, bureaucrats, and civil servants that had a way of absorbing the inevitable friction and moving quickly toward solutions—solutions that were often creative and spontaneous. It was a job of unimaginable proportions that was being reimagined and approached with the can-do spirit America is famous for. My own first few days, however, were filled with frustration, as I was repeatedly ejected from the site by cops whose dispiriting answer to me was often, "I'm just following orders." Each time, however, I would circle back around with my twenty-five pounds of equipment to a less patrolled entrance,

and attempt to come back in. I kept hoping that some sort of authorization would arrive from the Mayor's office. But my biggest break came from within the site itself.

One night, down near the South Bridge, I was working my way back from the "pile"—as the heaped wreckage of the Twin Towers was called by the workers—and up a hill of debris near the World Financial Center. I was figuring out where to plant my camera when, glancing over my shoulder, I saw eight policemen sitting on a crazy collection of chairs exactly where I needed to be. My heart sank. I was going to be thrown out yet again! But then I remembered my father, who'd been in vaudeville before he became a salesman, and the way he could always make people laugh with some kind of *schtick*—whether he was making a pitch or standing on a street corner. So, without looking at the cops again, I just kept backing up toward them, pausing to frame the scene, backing up, pausing again, until I was—literally!—sitting in the captain's lap. And then, in that moment of shocked silence, I looked over my shoulder and said to him, "Hey. You're in my spot."

In an instant, the tension turned to laughter and the officers were moving their chairs, questioning me about my wooden camera, and asking me what I was up to. And when I told them, these men —detectives, it turned out, from the NYPD Arson and Explosion Squad—immediately got it. "Yeah, we need this history, for our children and our grandchildren," one of them said, and they all agreed. In fact, they started interrupting one another with pictures that they thought I should take at different points around the site. Then one of them suggested something I never could have managed alone. "Hey, do you want to see the view from the World Financial Center?"

And so, together, guided by the beams of their flashlights, we entered the blacked-out building. As we climbed through the darkened stairwells and zig-zagged through the dust-thickened offices, I began to get a sense of what panic looks like, by seeing the chaos it leaves in its wake. Finally we were outside again, nine stories above the site. The roof was a foot deep in papers, ash, and dust, and buried in this mix were chairs, Venetian blinds, wiring, curtains, and telephones; there were also huge pieces of the aluminum cladding which had flown off the face of the World Trade Center and wound up here, in ribboned masses. In the middle of it all was a bottle of mineral water standing perfectly upright. I carried my equipment to the roof's edge and took the picture that you see now on the cover of this book.

This image was the Squad's first gift to me, but it was far from the last. Before we parted that night, I told the men how grateful I was for their understanding and how exhausting it was to have to fight so hard just to stay in to do my work. In response, both Lieutenant Mark Torre and Detective Amadeo Pulley gave me their cellphone numbers. "The next time someone tries to do that to you," they said, "give us a call." And over the ensuing weeks, they did everything they could to keep me on the site.

Sometimes you have to make your own luck. It didn't take long for me to realize that I was never going to get approval for my team of photographers: I still hadn't even gotten approval for myself! And so, while my proposal bounced back and forth between various offices at City Hall, and my contract with the museum went back and forth between various lawyers, I used all my resourcefulness to stay on the pile, day after day. First, I made sure I was always "in uniform"—hard hat, goggles, respirator, gloves, heavy boots. And it wasn't simply having the gear. You also had to look the part: backwards hard hat; respirator around the neck; duct-taped pants' legs, so that jagged pieces of steel couldn't catch in them and pull you down. I also got good at forging the workers' passes (which changed color frequently) on my studio computer, and learned to display them prominently on a chain around my neck—a badge of how long I'd been on the site. When I arrived each morning, I always asked which fire chief was on duty, in case it became useful to drop his name later on. And I called on my friends in the Arson and Explosion Squad nearly every day.

I was the observer, but as I made my tours around the zone I was also being observed—especially by anyone who had a stationary post—and slowly, as the weeks passed, I could feel myself being woven into the fabric of the site. The volunteer outside the food tent would try to entice me with a granola bar; a fireman on the pile might tell me something funny that I'd missed earlier in the day. "Hey, photographer," strangers would call out to me—pointing me toward something that had just been unearthed, or tipping me off about something that was going to be demolished. And there was always the need for talk. There were small knots of men everywhere on the site—waiting for heavy machinery to pass at a crossing, or hanging around next to the raking fields, or standing by a makeshift shrine—and many of them were eager to tell you what had happened to them, or what they were thinking, or how they were feeling. Part of what I was there to do, I came to feel, was not simply to watch, but also to listen. As a result, I cried with men on the site almost every day. Often, I didn't even know their names.

The nine months I worked at Ground Zero were among the most rewarding of my life. I came in as an outsider, a witness bent on keeping the record, but over time I began to feel a part of the very project I'd been intent on recording, and I was accepted on the site as a member of the tribe. Photography is often a very solitary profession. But the intense camaraderie I experienced at Ground Zero inspired me, changing both my sense of myself and my sense of responsibility to the world around me. September 11th was a tragedy of almost unfathomable proportions. But living for nine months in the midst of those individuals who faced that tragedy head-on, day after day, and did what they could to set things right, was an immense privilege. I am deeply grateful to have worked alongside these men and women. I documented the aftermath for everyone who couldn't be there. But this book is dedicated to those who were.

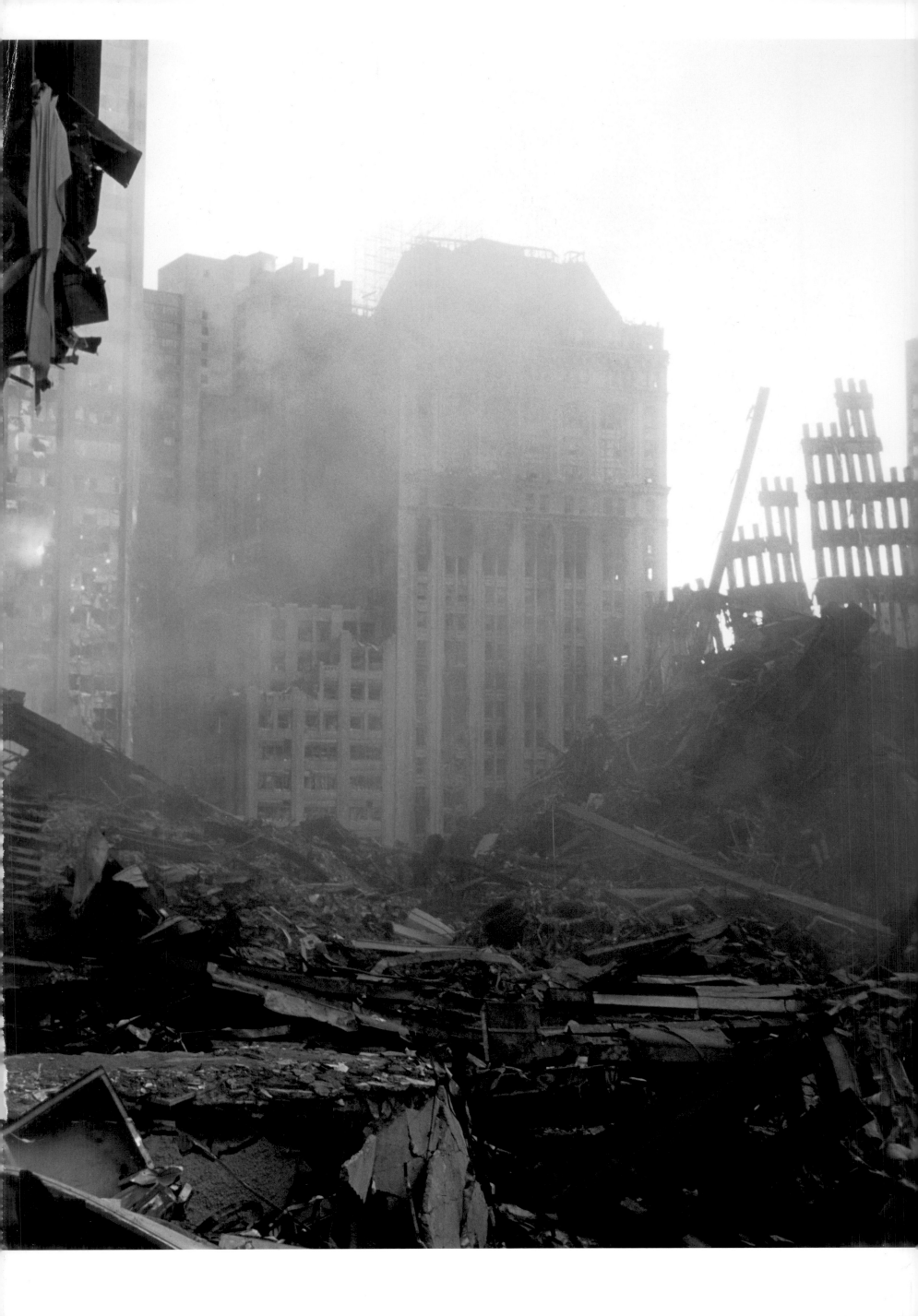

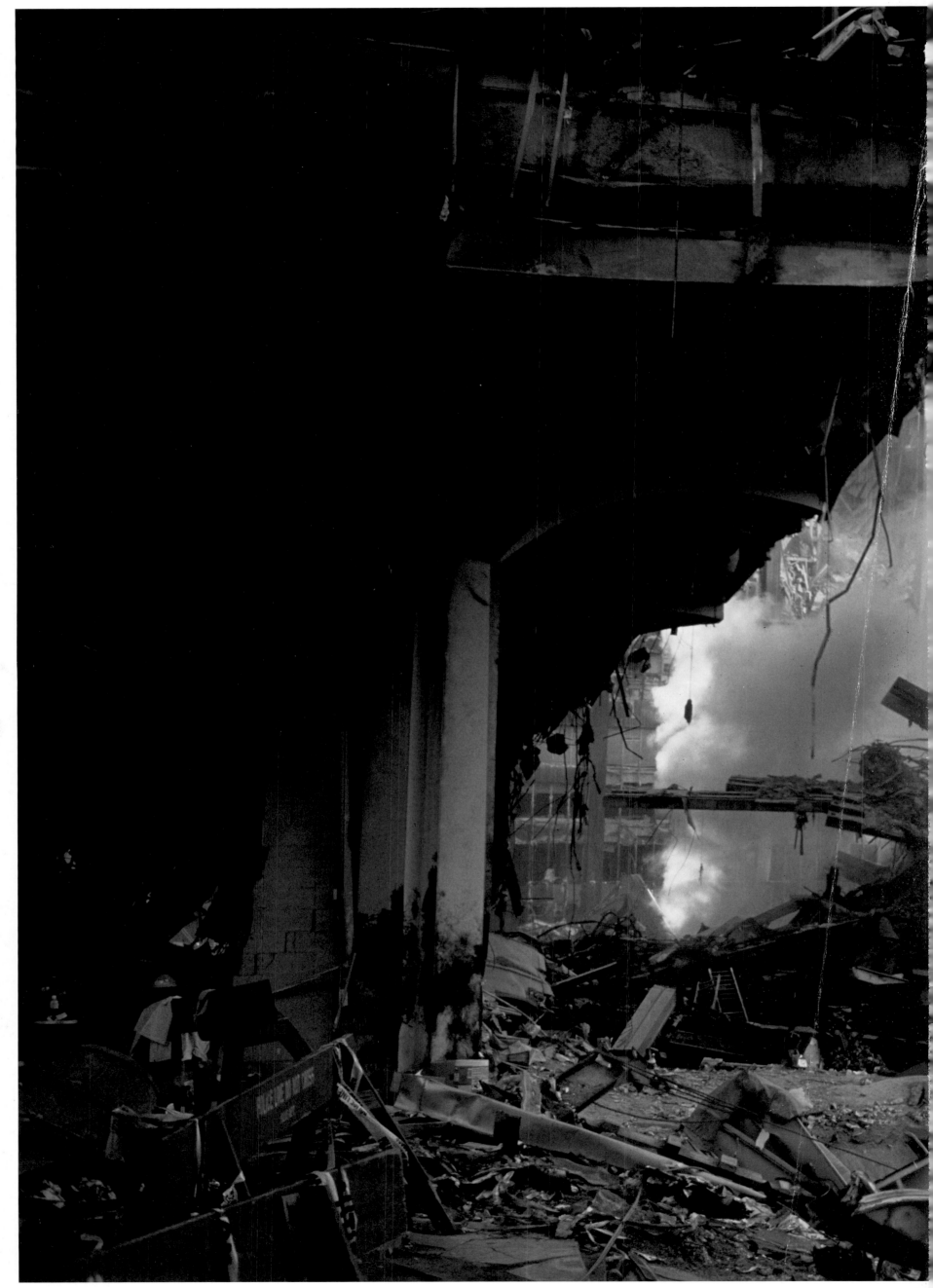

Assembled panorama of the plaza, looking south and west

FALL

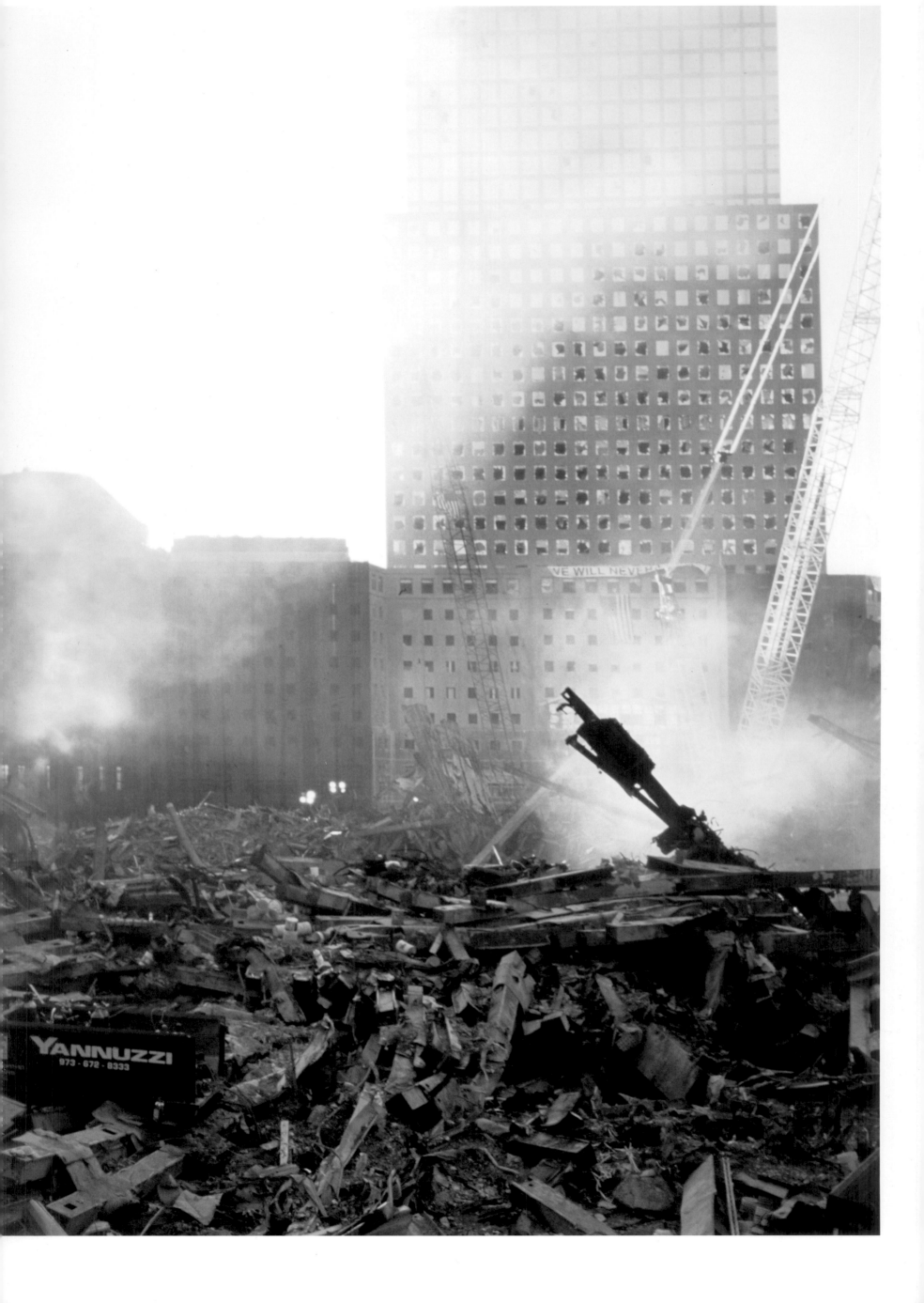

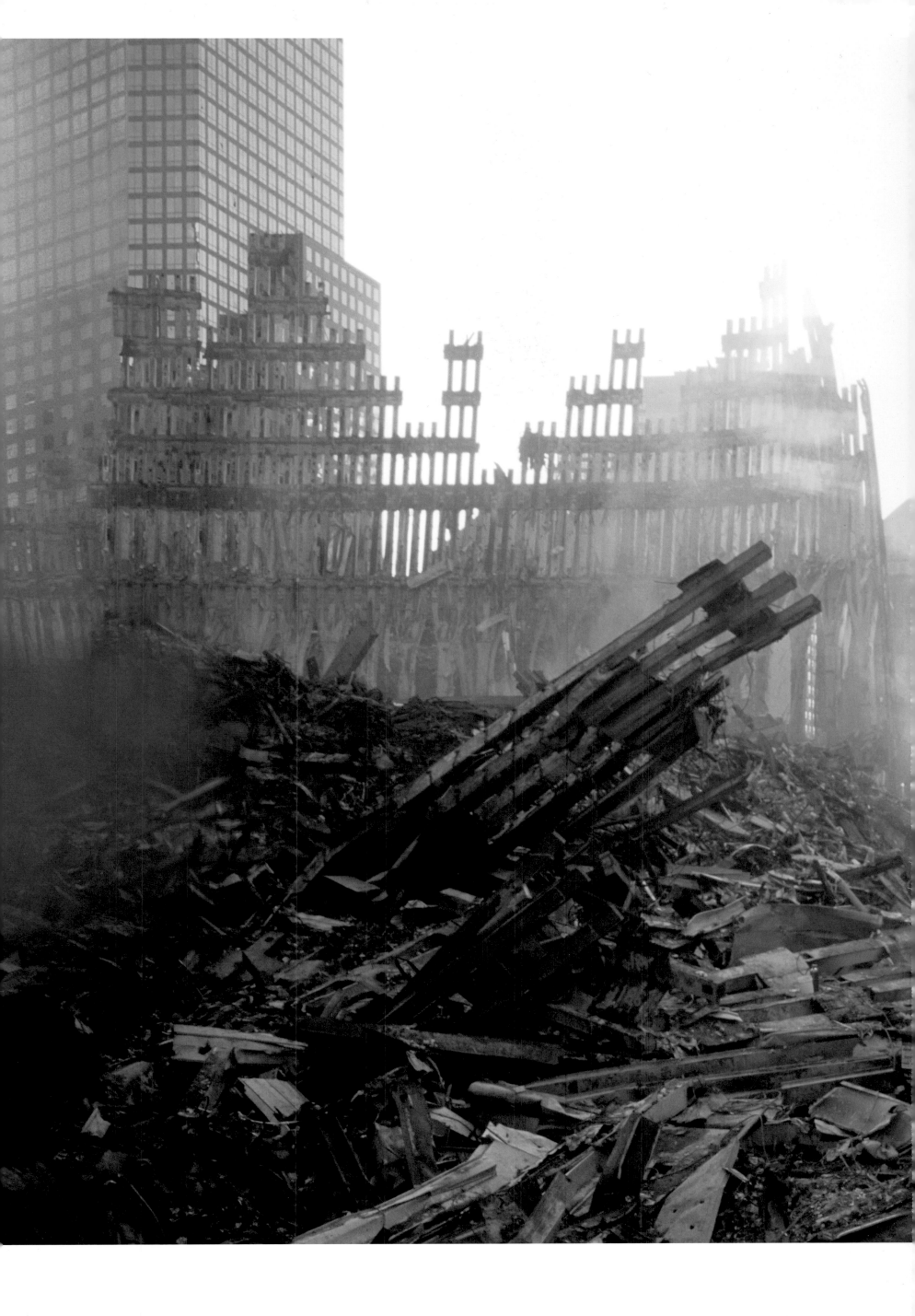

09.23

A work pass finally in hand, I climbed into a Manhattan Parks and Recreation Department cart with a "Smokey" at the wheel and rode into the site at Ground Zero, rumbling past the barriers guarded by the NYPD, the Port Authority Police Department, the National Guard, the State Troopers, and other security forces. My driver took me three blocks behind the lines, dropped me in front of the New York Telephone Building, and then took off as fast as he could, to distance himself from the trouble I was sure to get into. OK, I was inside. But where was I?

I grew up on the streets of the Bronx, and I've lived in this city all my life. But as I stood there on the West Side Highway, bare-headed in a tee shirt, jeans, and light boots, I experienced a feeling familiar to most big-city dwellers at some point or another: This is one dangerous place, and I don't look as if I belong here.

Instinctively, I glanced around for some camouflage, and there, fifteen feet away, hanging on some scaffolding, was a hard hat. I ran over and tried it on: it fit perfectly! It also came with two decals on it. One said NYPD—not a bad start. The other said AMEC, which was one of the four construction companies working the pile. Then in the back of one of the "mules"—the small vehicles used for transportation everywhere on the site—I found gloves and a mask. All I was missing was a tattoo and some muscle; otherwise, I fit right in.

Walking south, I passed the ruins of Building 6, the eight-story Customs Building. The top of the North Tower had fallen directly onto it, creating a massive atrium in the building's center that went all the way down to the parking garages below street level. This ruin was referred to as the "donut" by everyone on the site.

Next to the Customs Building, and leaning against it, was part of the north wall of the North Tower. It was here that the scale of the destruction, the enormity and complexity of the pile, and the stench from the combination of burning elements overcame me. I suddenly realized that I had been crying for several minutes and that I was shaking so hard that I had to sit down before I fell down. As I rested on a huge steel column, warm to the touch from the strong sunlight and the heat radiating from the pile, I tried to take in what I was looking at.

The tangled bird's nest of debris in front of me was what now remained of one of the tallest buildings in the world. Here it all was, crushed inside the shell of the tower, standing perhaps eight stories high and six stories below ground. One hundred and ten stories compressed into around fourteen stories of steel, aluminum, rebar, plumbing, wiring, cables, duct work, air conditioners, sheet metal, desks, filing cabinets, glass, plastic—all of it hard, and sharp. A field of swords and points and ragged edges; around it, what remained of the north and east walls of the tower rose one hundred and fifty feet or more. These, I later learned, were referred to as the "shrouds." Stripped of their coverings inside and out by the shearing effect of the collapse, they appeared flayed—rusted and bronzed in some places, bruised in others, even iridescent in certain lights.

All around me spray hissed as it hit hot metal and smoke belched from the wreckage. Every so often, the smoke would shift and the Woolworth Building, once the tallest building in Lower Manhattan, would appear above it all, glowing and white.

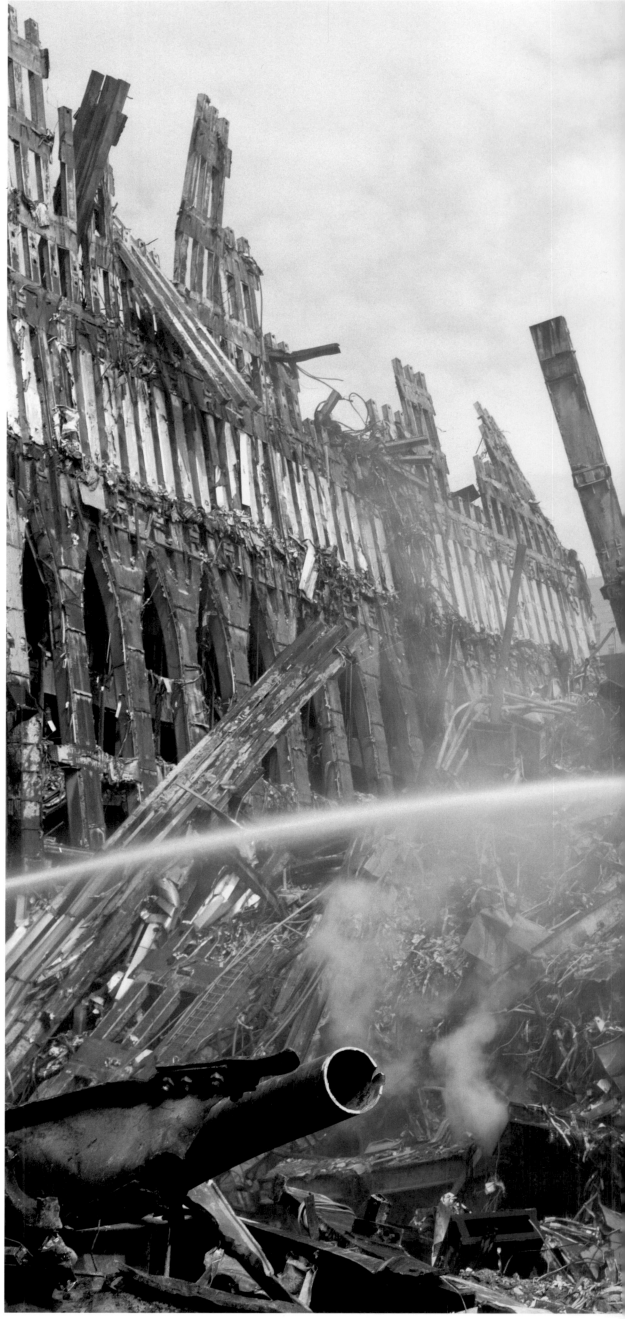

The base of the North Tower, looking east toward the Woolworth Building

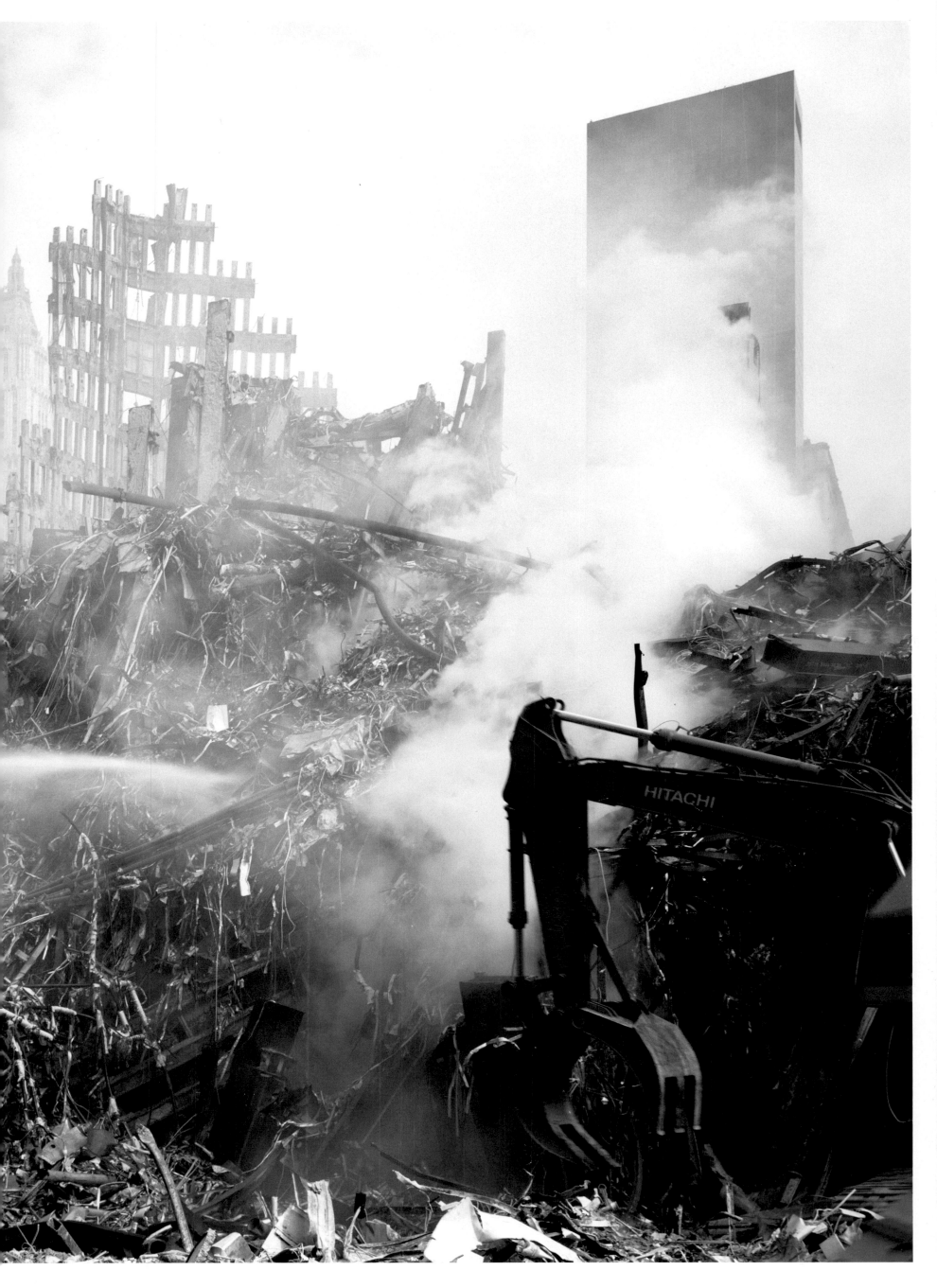

The South Tower had also been reduced to a cascade of steel, but here I could get much closer to the pile and understand the fall and its consequences in a different way. The towers had been "hull-and-core" buildings—hollow steel tubes constructed around massive central cores, without the numerous supporting beams that run through more conventional structures. This design was, in part, why the towers could be so tall—and why they fell so fast. Now, looking closely at what was left, I realized that there was no sign of concrete—which had been used primarily for flooring—except for the pall of dust over the rubble. The concrete had been pulverized by the pancaking of every story during the tower's ten-second plunge and expressed into the air in that gigantic cloud we all remember. So it was the steel, stairways, and all the hard matter of the building that churned and twisted and ground their way down into the earth.

Standing in front of the South Tower, it was impossible not to feel one's own fleshy vulnerability, and easy to understand why there had been so few survivors. Even at the end, after nine months of searching and recovery, one thousand seven hundred and ninety-six people would remain unaccounted for.

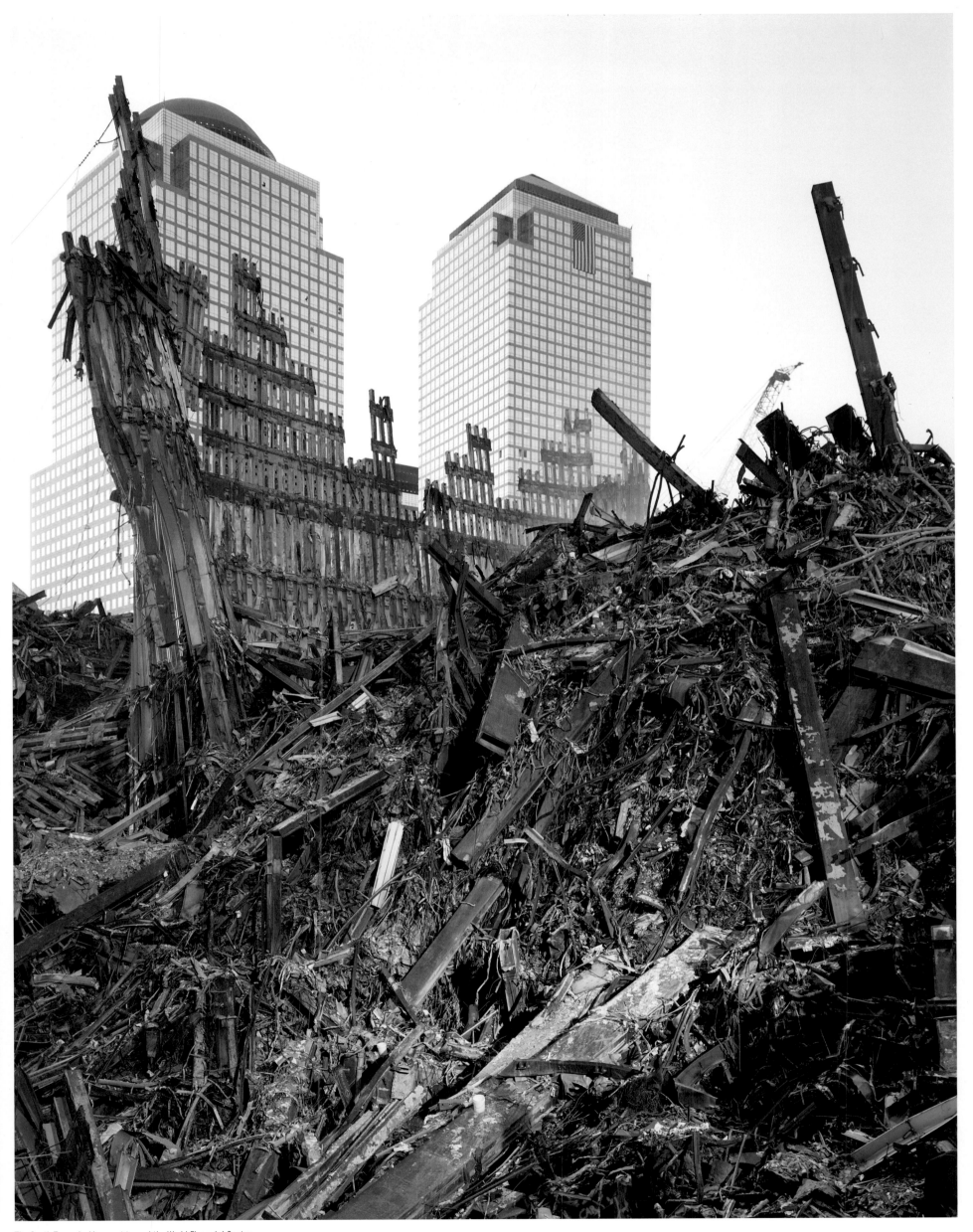

The South Tower, looking west toward the World Financial Center

When the World Trade Center was built, two hundred thousand columns were used in the design of the buildings. The exterior columns were assembled in three-story sections of three columns each, which were bound together by two spandrels, moved up the façade by "kangaroos," or climbing cranes, and bolted together by ironworkers at each level. Walking over the pile, one could see these steel tridents everywhere, strewn about like massive pick-up sticks. Some had plunged deeply into the streets, penetrating as far down as the subway tracks. Here a bundle of columns that had snapped off the North Tower during its fall flew, as effortlessly as a flicked matchstick, deep into the south flank of the American Express Building, ratcheting its way down through six floors before finally coming to rest nearly twenty stories above the street.

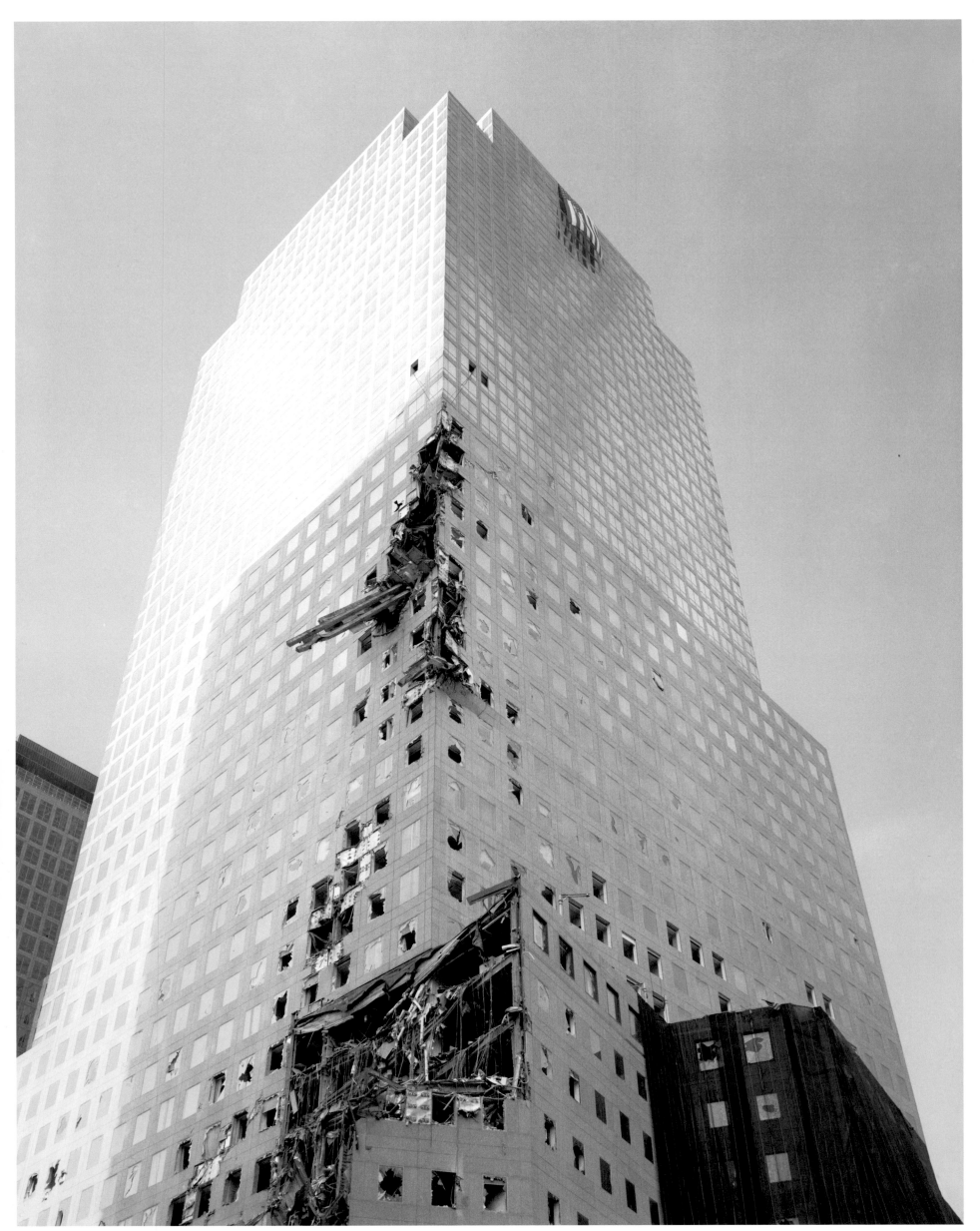

The American Express Building with a spear from the North Tower

The World Trade Center plaza sat above six levels of underground malls, pedestrian passageways, parking garages, and the PATH (Port Authority Trans-Hudson) train station. As the towers fell, the plaza itself collapsed under the weight of the debris, sinking nearly two levels below the street. In this image, rescue teams are still searching for possible survivors. Often, they had to crawl on their bellies into the voids created by the fallen beams and slabs. These were dark, dangerous, and terrifying ventures into unstable spaces, in which the only way to determine whether or not you had come across human remains was by touch and smell. The strain of these searches took its toll on many of the rescue workers. An officer from the NYPD K-9 Unit told me that even the dogs were unsettled and depressed by not being able to rescue anyone—that some of them were shying away from going in because of their sense of failure.

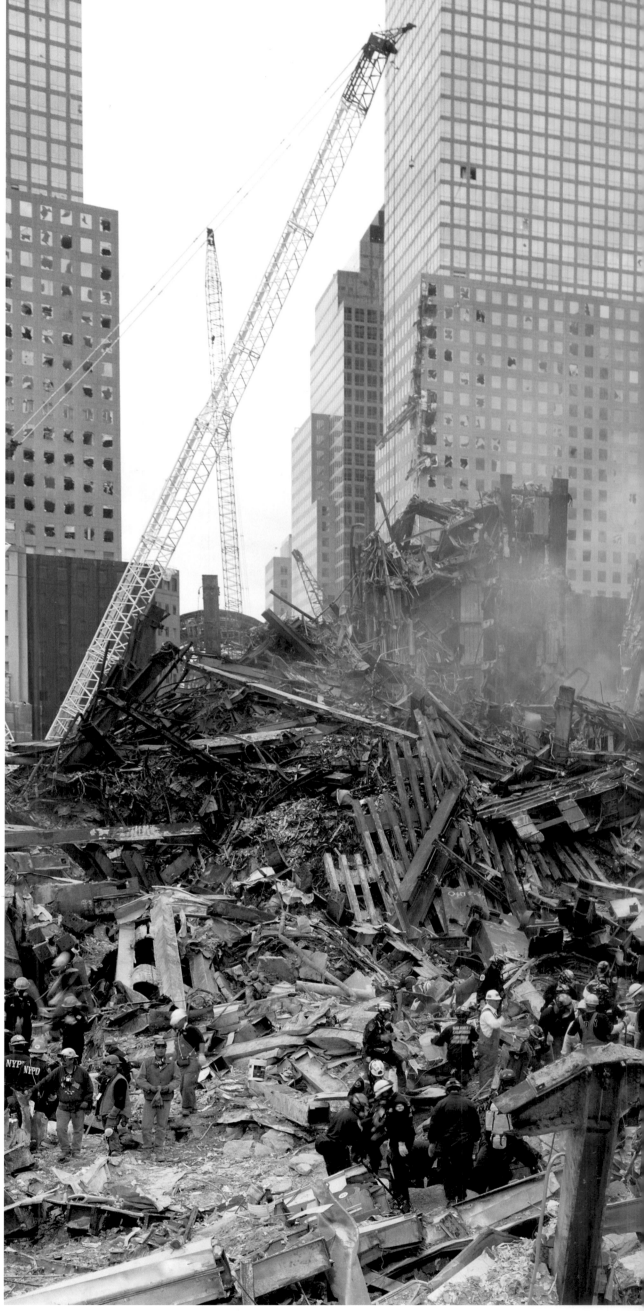

Rescue workers on the plaza

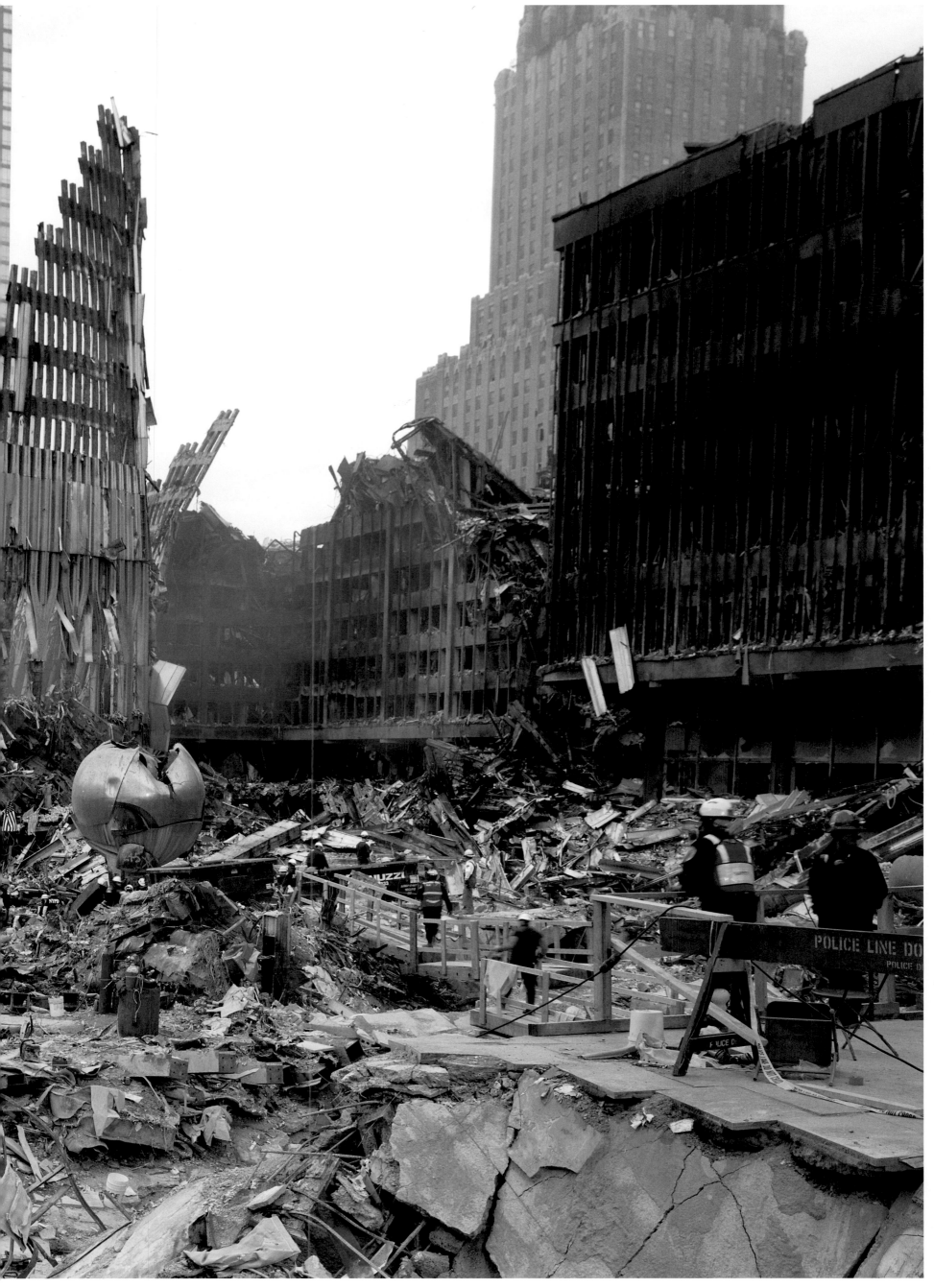

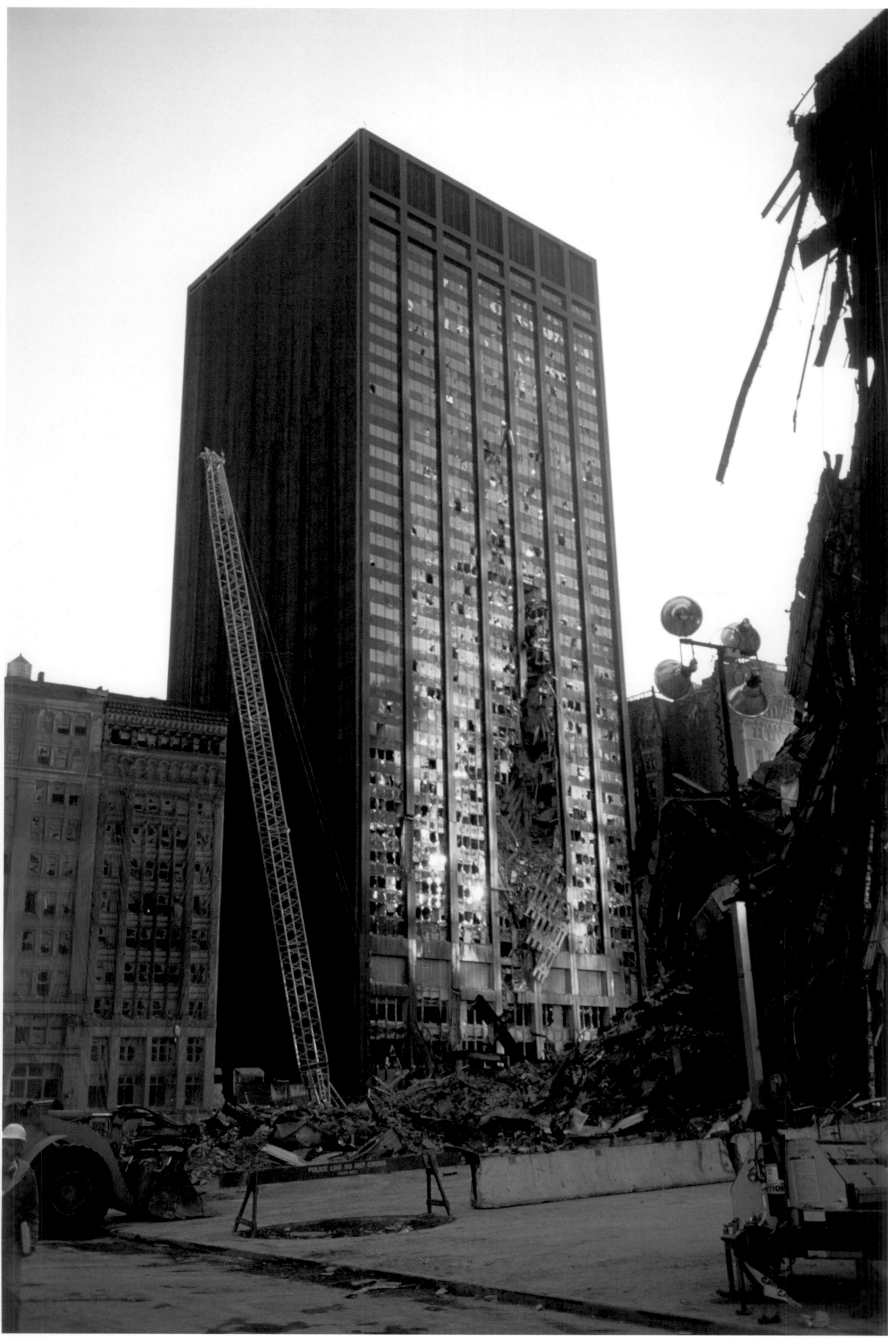

The Bankers Trust Building from Church Street

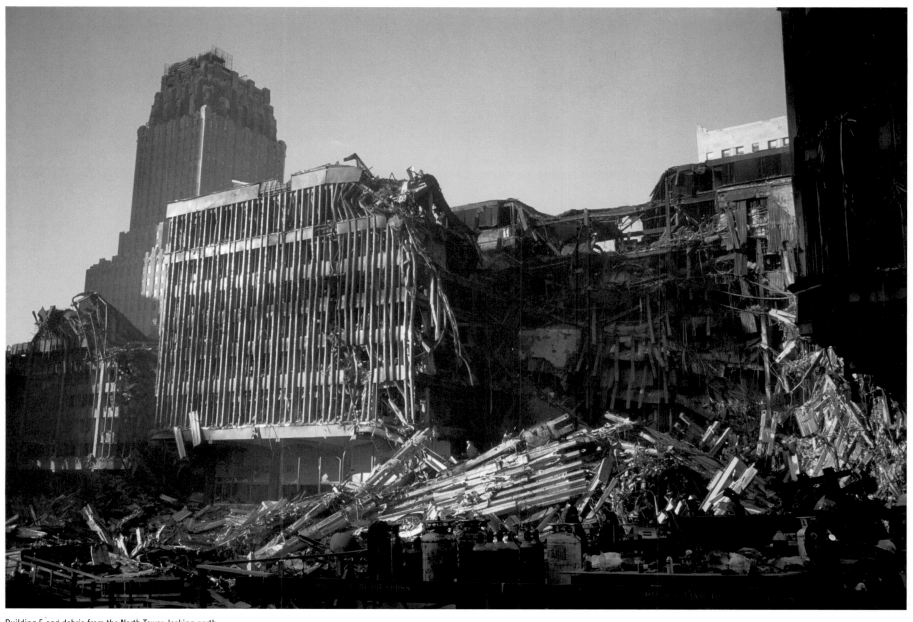

Building 5 and debris from the North Tower, looking north

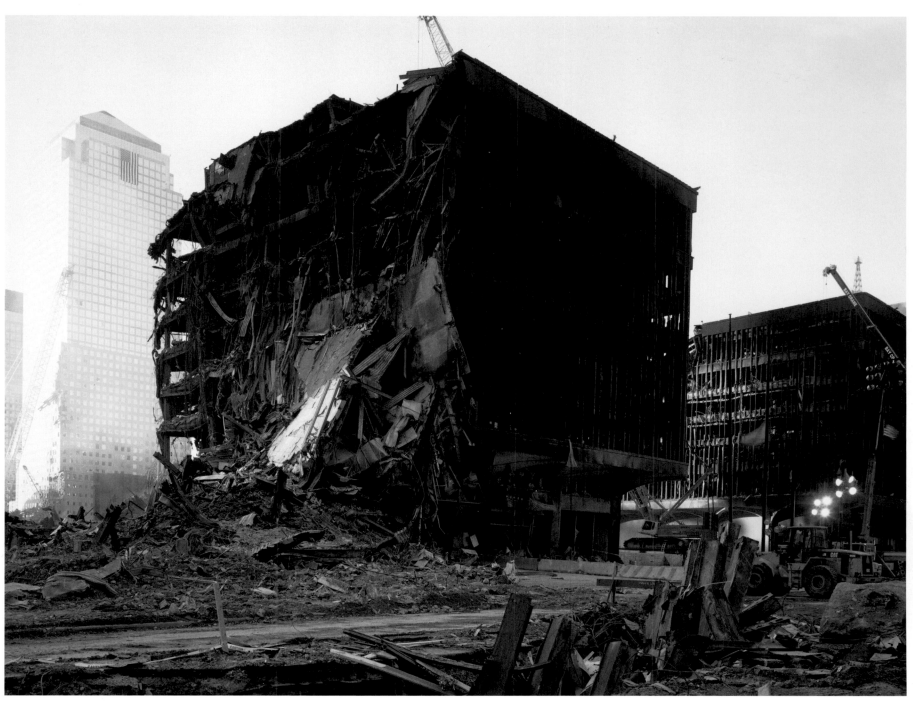

Church Street, looking west toward Building 4 and the World Financial Center

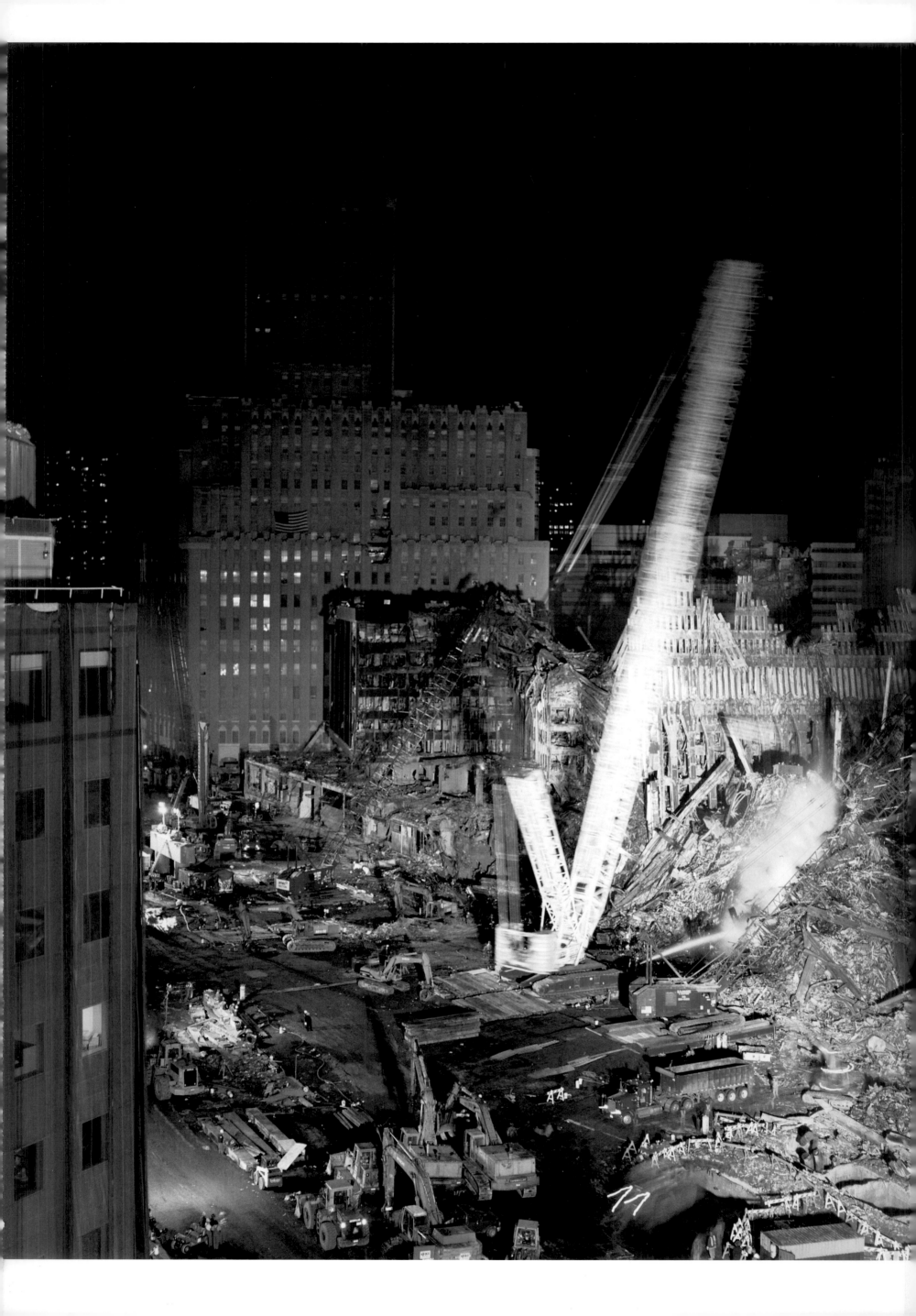

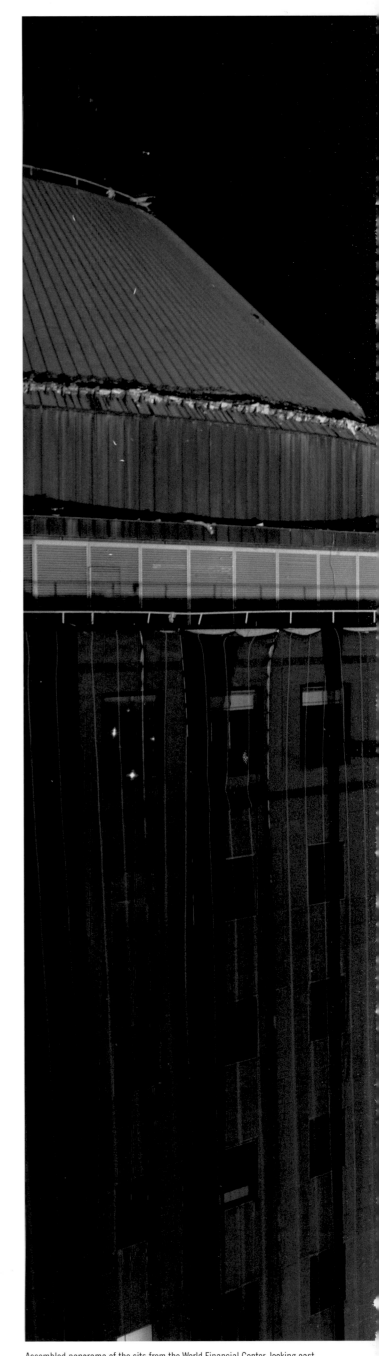

Assembled panorama of the site from the World Financial Center, looking east

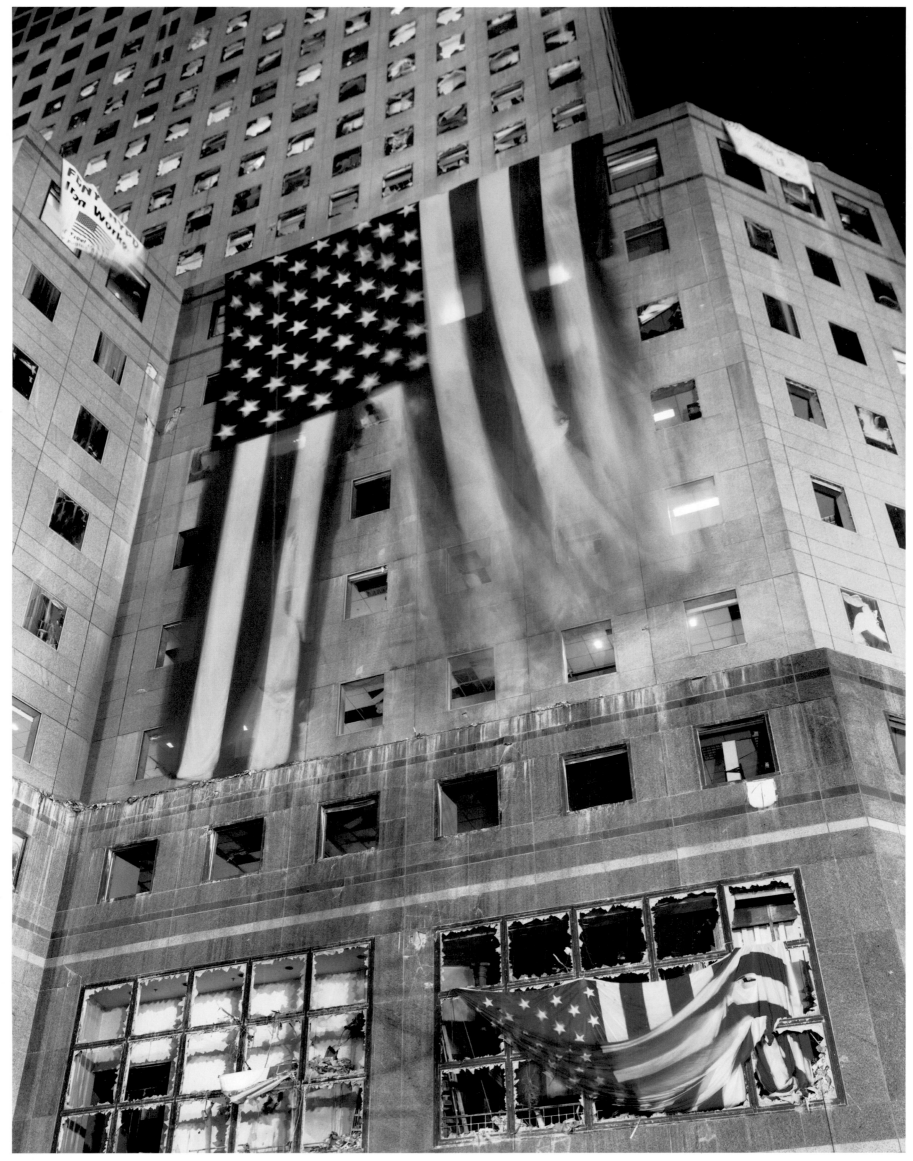

Flags on the façade of the World Financial Center

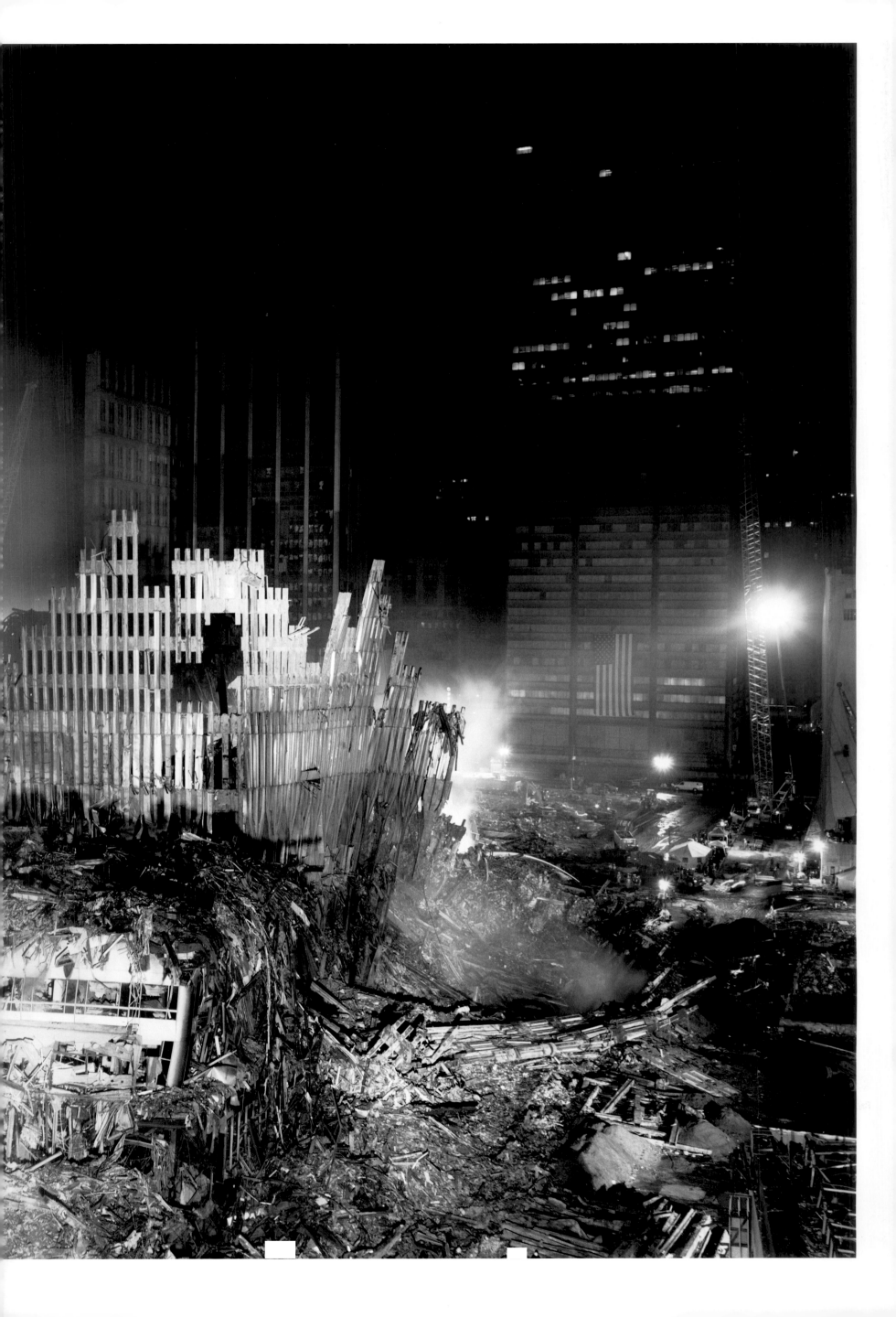

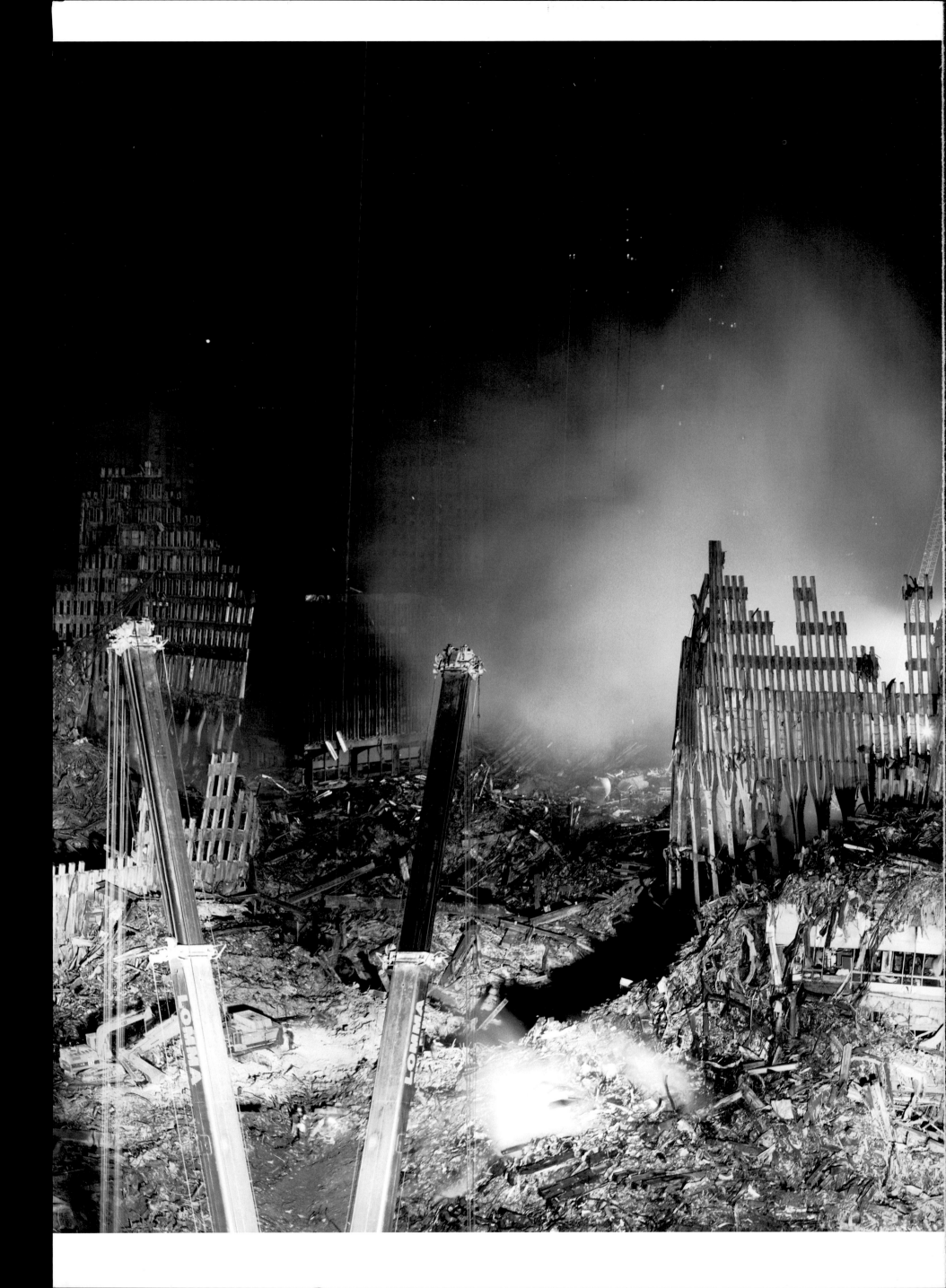

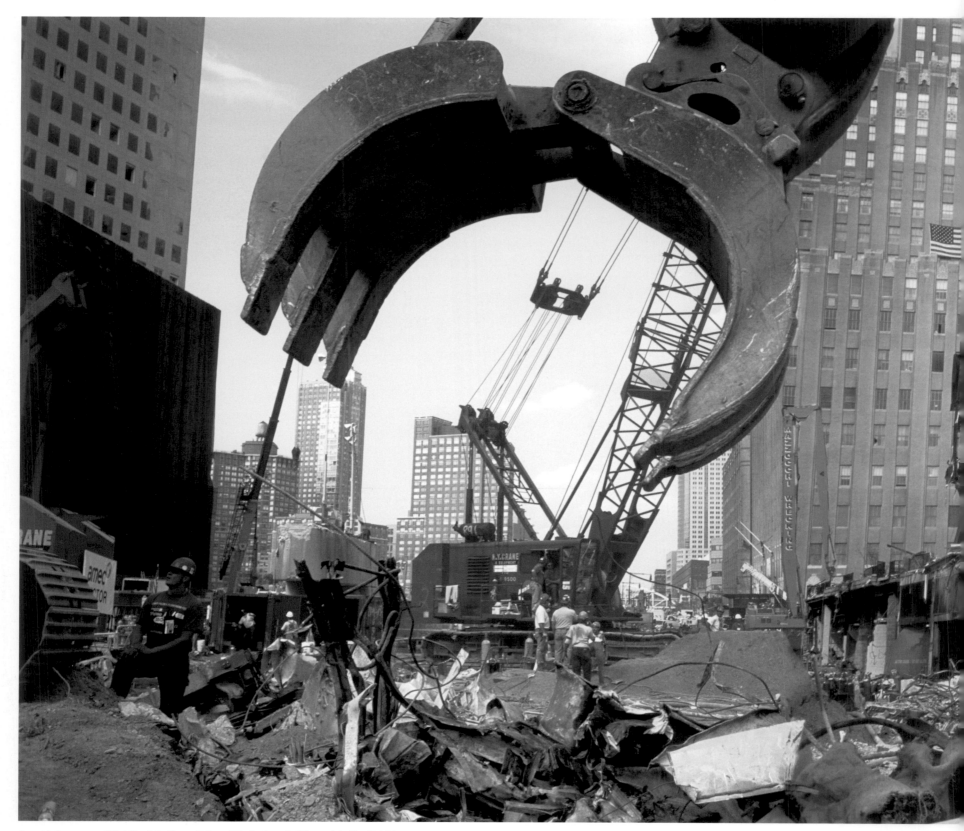

Assembled panorama of West Street, looking north toward the Customs Building and the New York Telephone Building

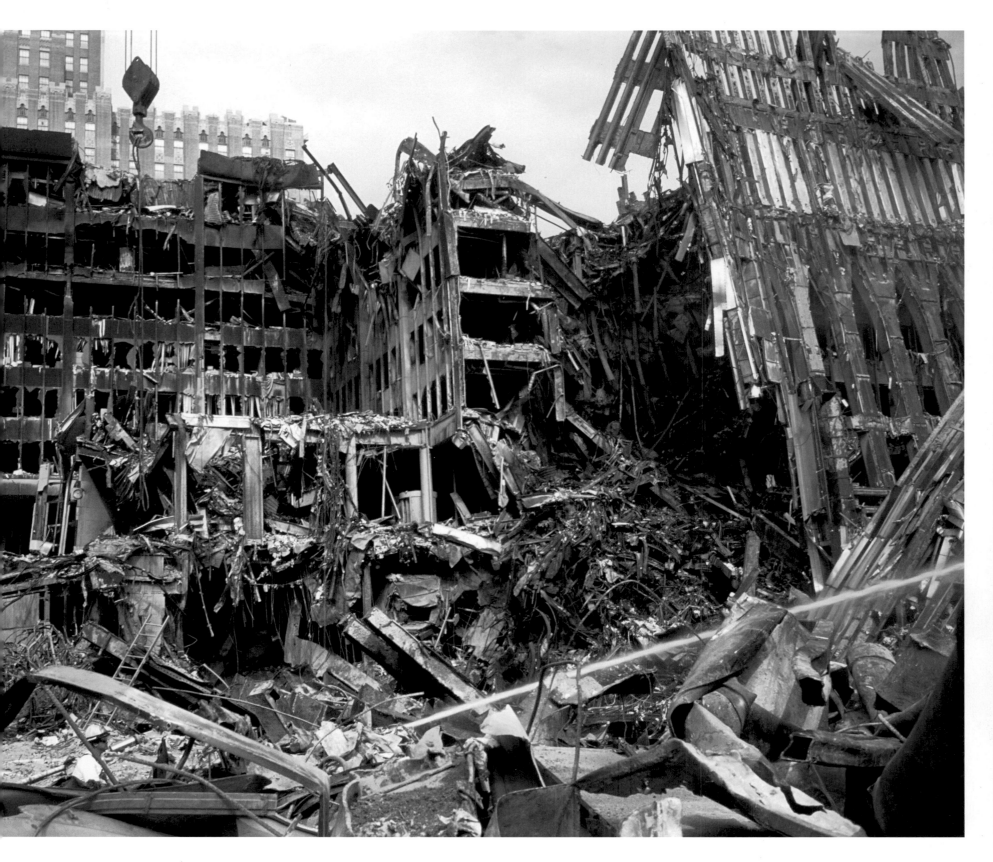

The construction workers drove the work on the pile. On September 11th thousands of them arrived from construction sites all over New York, ready to bring the skills of their trades to bear on the monumental task of deconstructing the debris fields, and many of them stayed. There were the ironworkers—welders and burners who cut the pieces of steel (or "sticks," as they called them in their offhand way) into manageable parts. There were the operating engineers, who handled the big cranes and drove the grapplers (those dinosaurs that chewed and tore at the pile and loaded the rubble onto trucks). And then there were the truck drivers, who came from all over the country in their own rigs and carried the rubble over to the Fresh Kills landfill site on Staten Island, and later to barges at loading docks set up just a few blocks north of the pile.

There were the construction superintendents, men like Charlie Vitchers, whose knowledge of all the interrelated and intricate details of making tall buildings was critical to the task at hand. There were structural engineers, and bureaucrats, and Federal Emergency Management Agency (FEMA) engineers, and corporate guys from the biggest construction companies. Finally, there were Ken Holden and Mike Burton from the Department of Design and Construction (DDC)—a city agency involved in maintaining New York's infrastructure—who, by a mixture of intuition and chance, managed to take the reins of this unruly operation and give it direction.

There were also flagmen and mechanics, demolition experts and water-truck operators, security overseers, and many more. But I always come back to the ironworkers, whose seven-thousand-degree torches sent cascades of sparks spilling everywhere over the site as they cut it down, piece by piece. Many of them were Native Americans, Mohawks from upper New York State whose agility while working on the high steel is legendary. Or guys like Willie Quinlan, who told me he'd come here as a young journeyman to build the North Tower. Now he was back, to take it all apart.

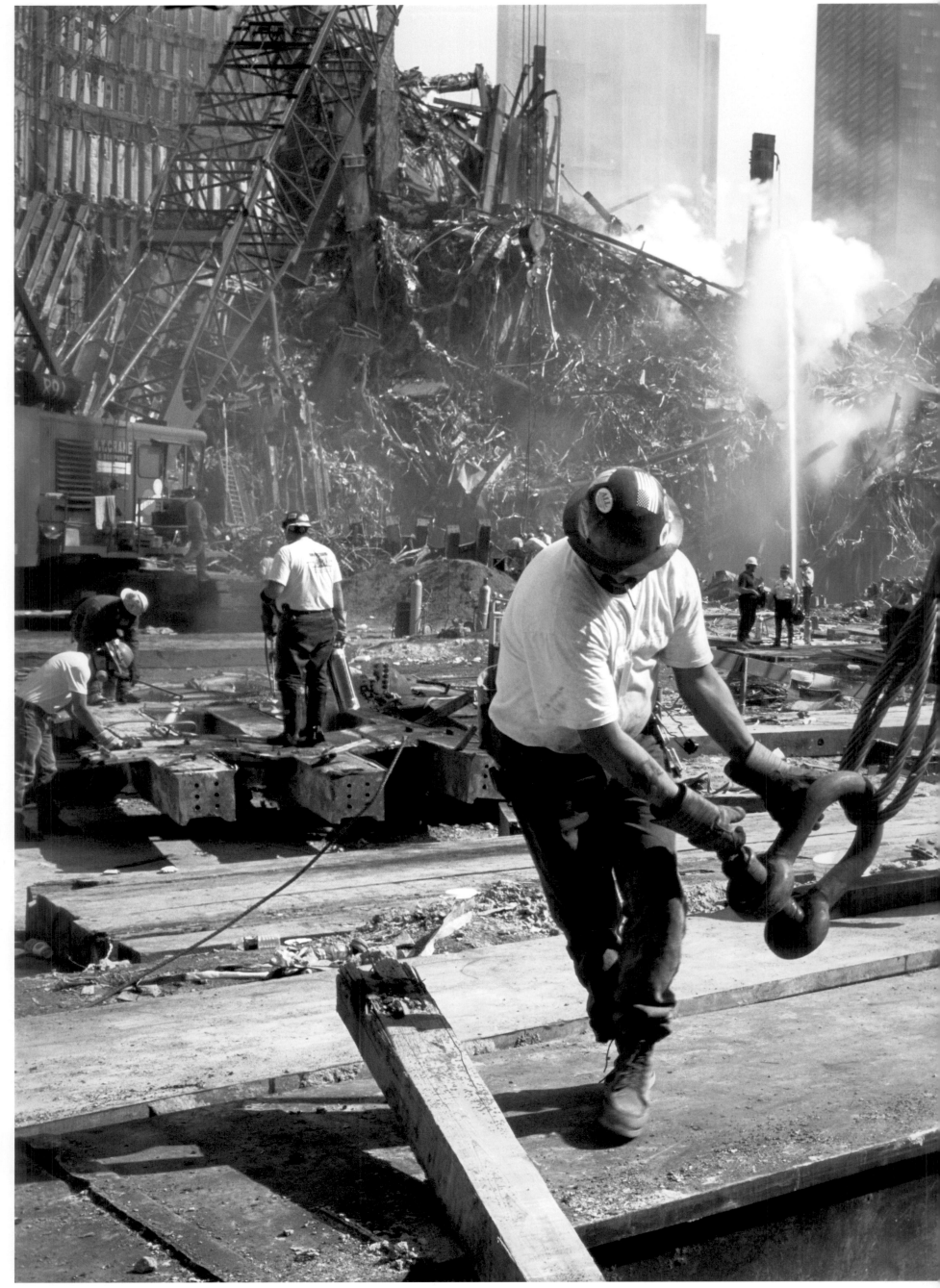

Ironworkers

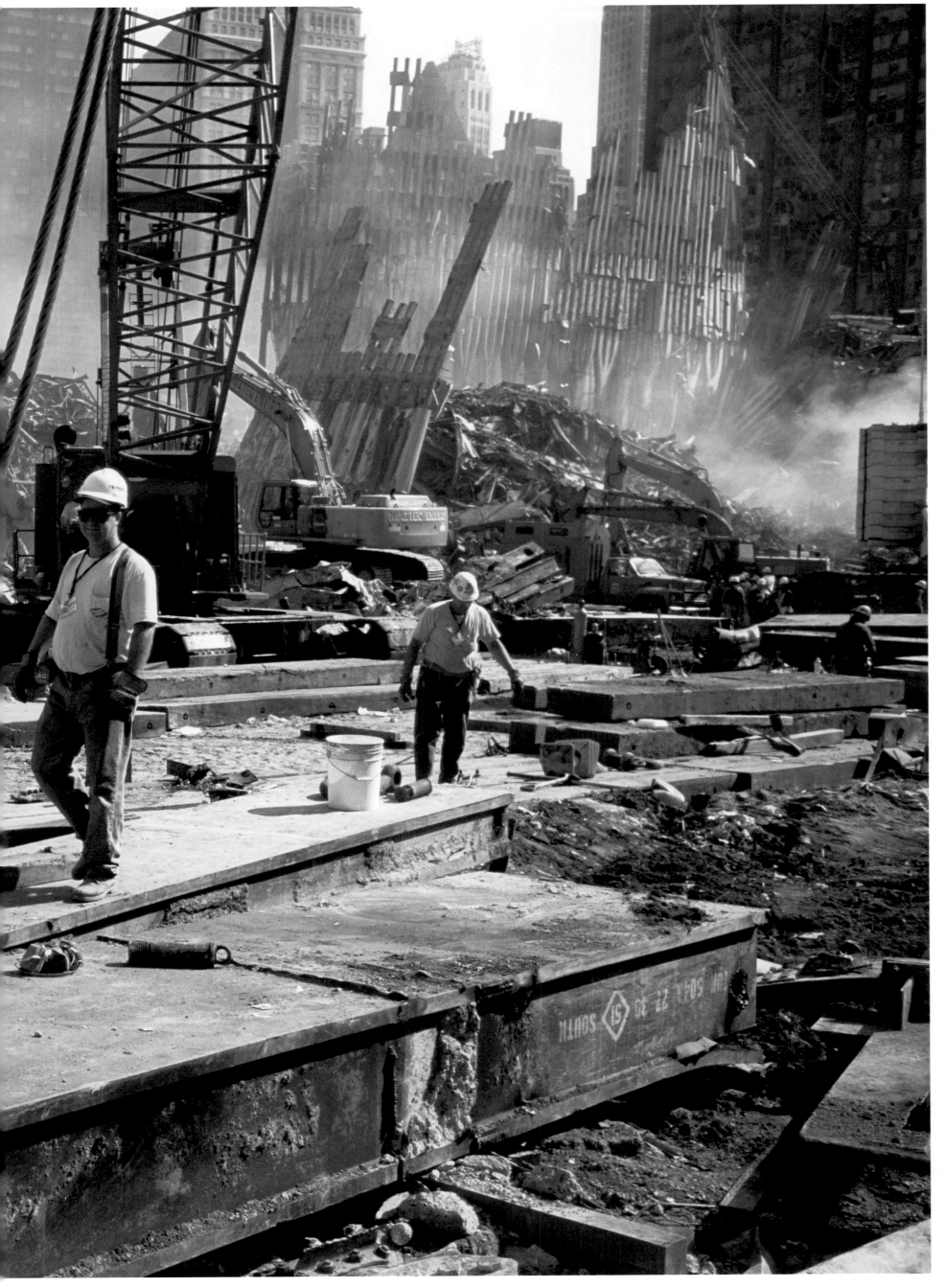

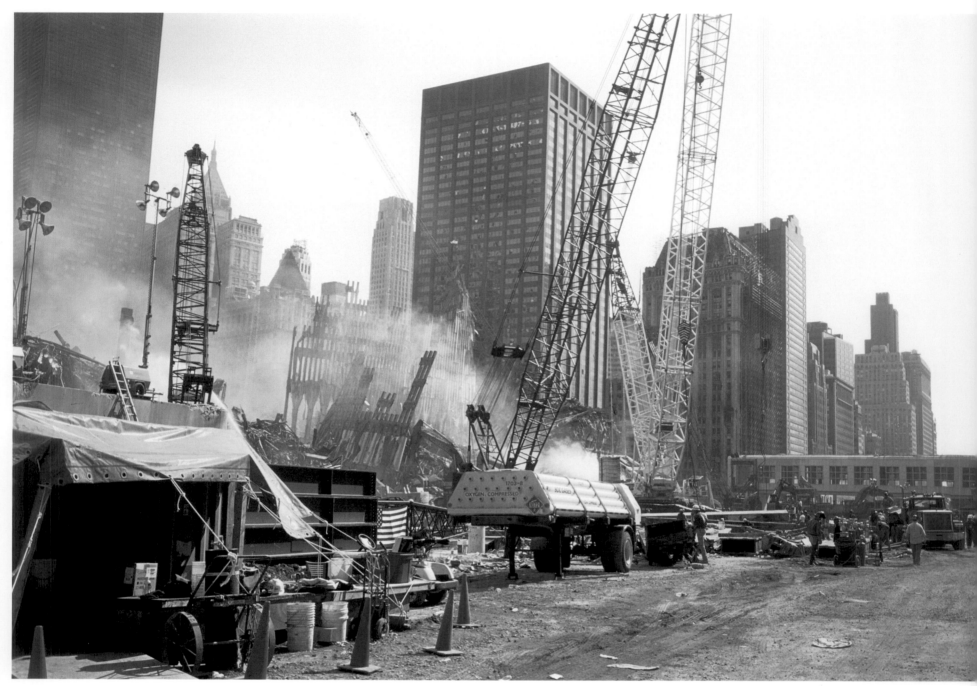

Assembled panorama on West Street, at the base of the American Express Building, looking south toward the South Bridge

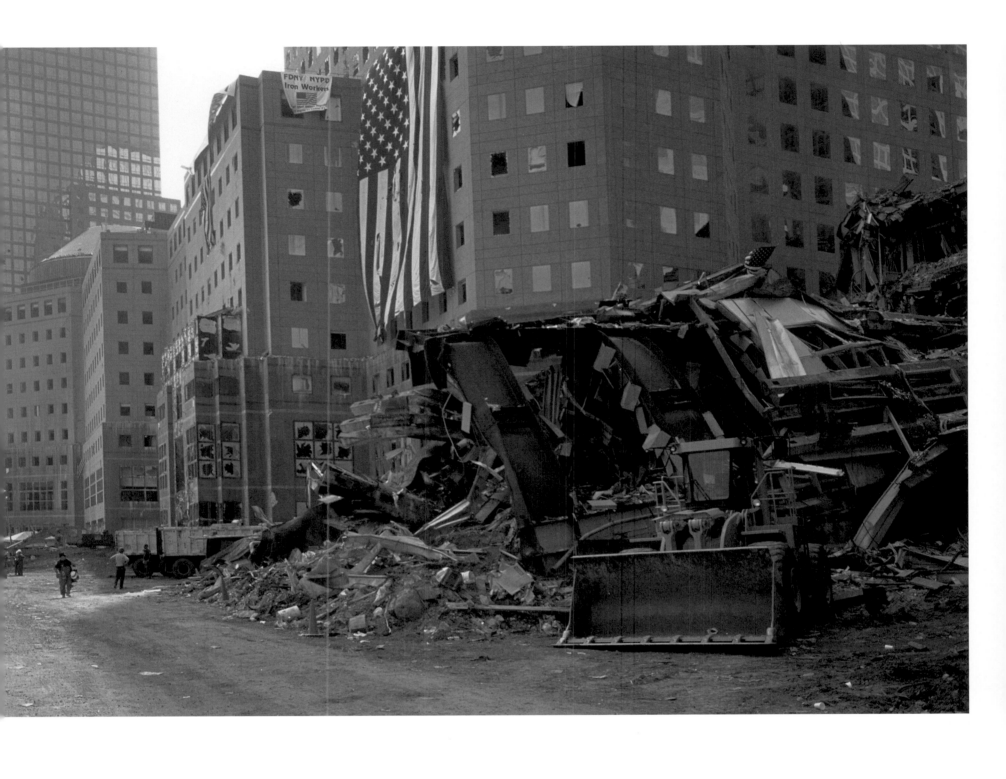

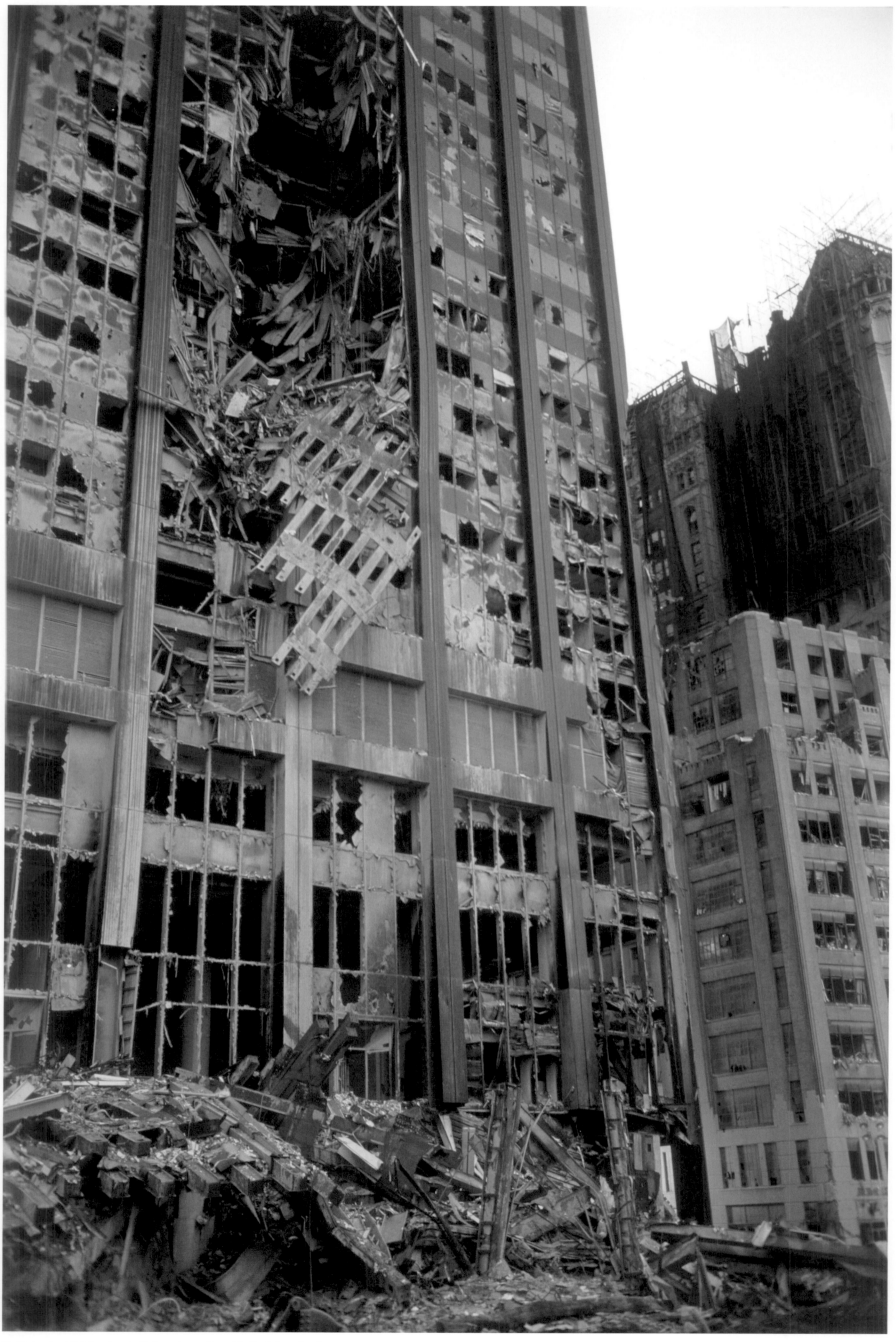

The Bankers Trust Building pierced with three-story sections of the South Tower façade

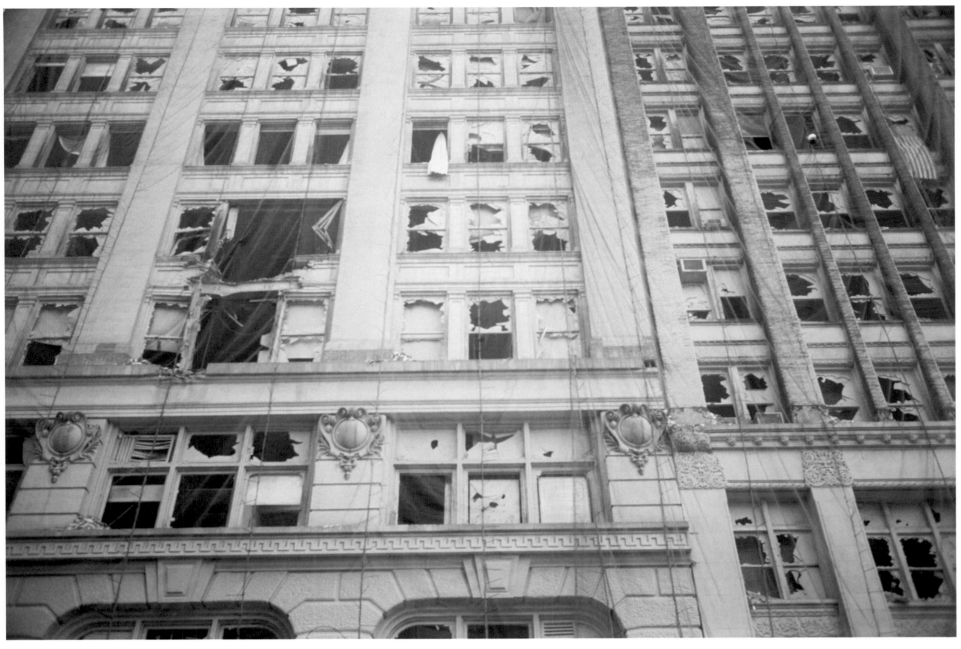

Draped buildings on Liberty Street

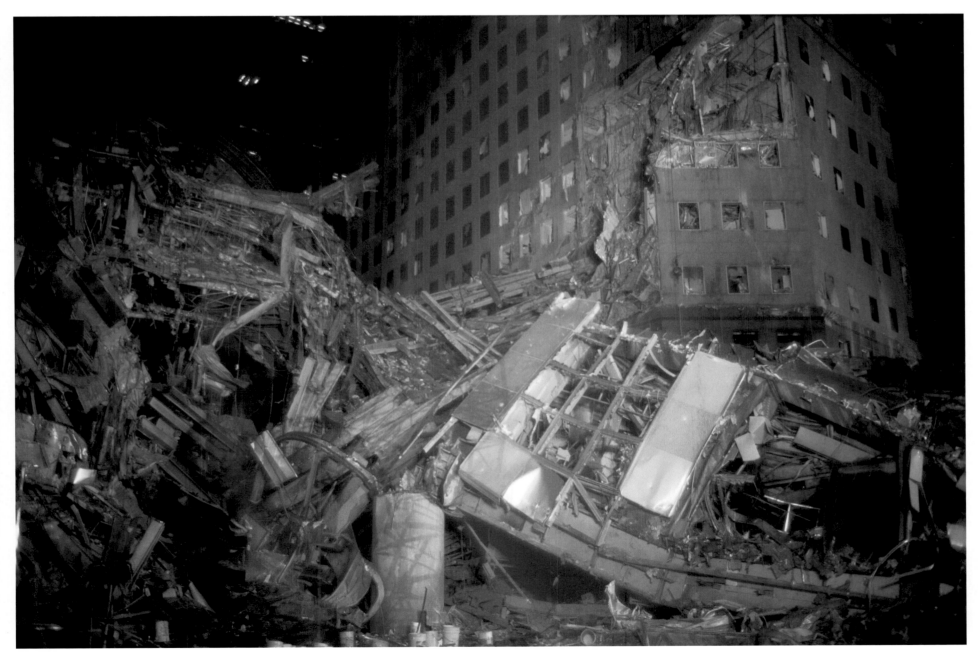

The fallen North Bridge, the Winter Garden, and the American Express Building from West Street

09.25

On my first day at the pile, I watched a bulldozer operator carefully, lovingly, grading a bed of earth in front of the North Tower, making one clean, perfect space in all the chaos, and I wondered what it was for. When I returned the next day, I had my answer.

It arrived in pieces on eighteen flatbed trucks, and then men swarmed over it, fitting the pieces together. A thousand tons! Two million pounds! The biggest crane in America. Watching the maneuvers of the operating engineers, whether it was on the cranes or the grapplers, it was amazing to see the precision, delicacy, and skilled intention at play.

On this particular evening, the crane lowered two men onto the pile. They were wearing tee shirts! Amidst all of those steel razor blades! In this image they are rigging a choker to a massive interior column—one of the heaviest pieces of steel from the core of the North Tower. This piece could weigh anywhere from twenty to sixty tons or more—light, perhaps, in relation to the crane's capacity, but the wreckage surrounding the column required the sort of strength, or "lift," of which this crane was capable. Nearby, an American flag attached to a piece of rebar is flapping in the wind.

In front of the crane, firemen poured a constant stream of water onto the pile where fires still raged below, fed by the jet fuel that had run down through the buildings before they fell. There were places on the pile where temperatures were over one thousand degrees, and the soles of the workers' boots melted.

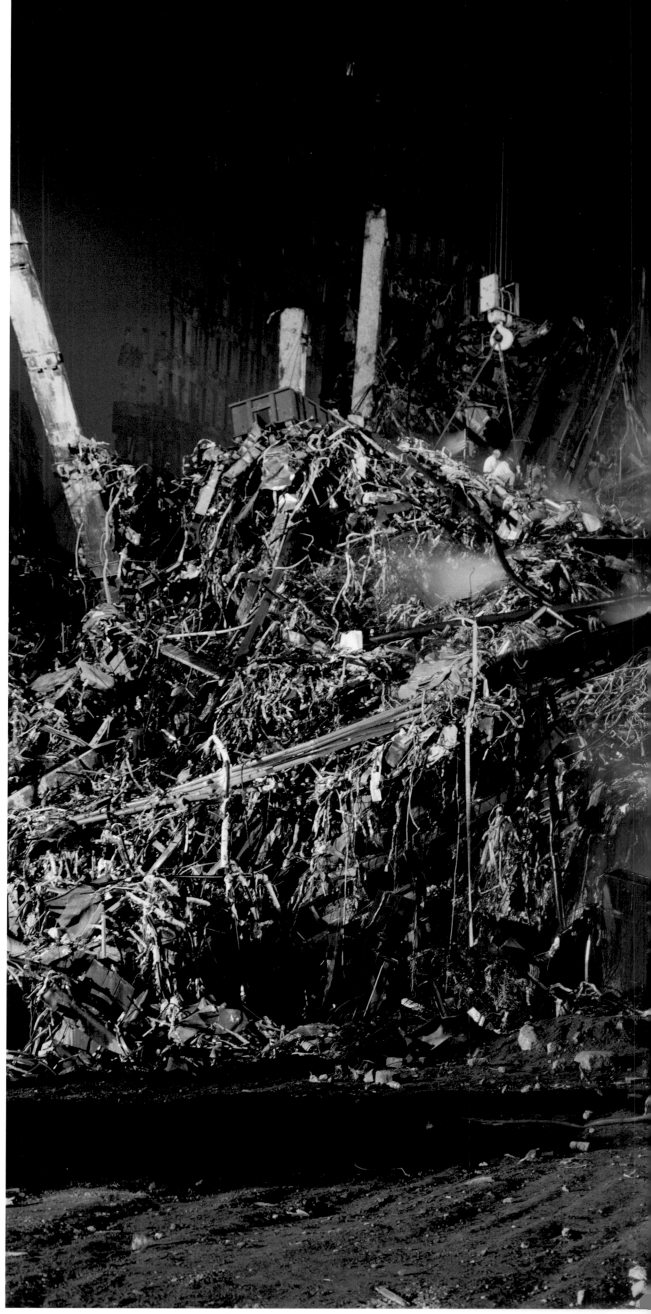

Workers with the thousand-ton crane, lifting columns on the North Tower debris pile

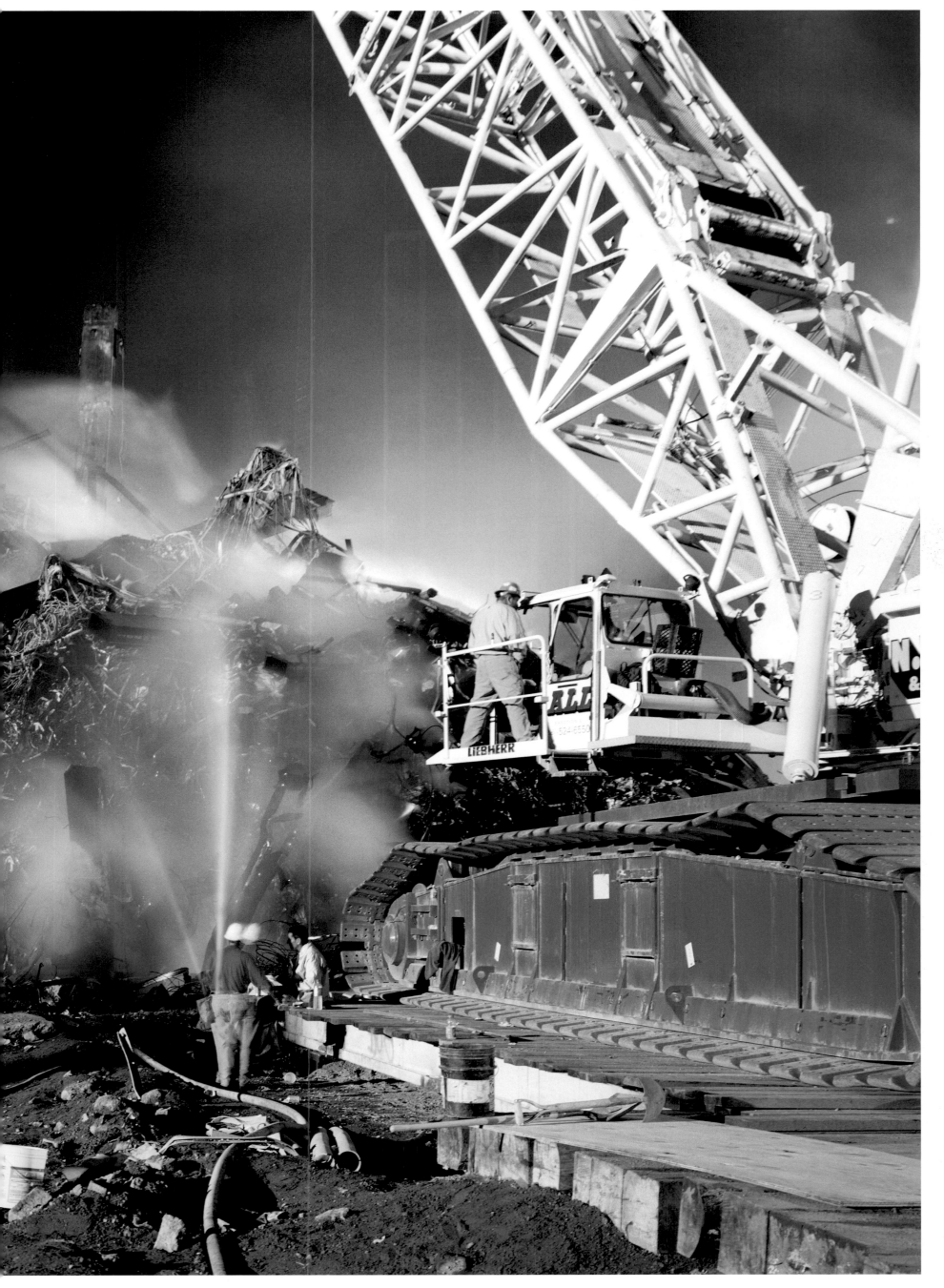

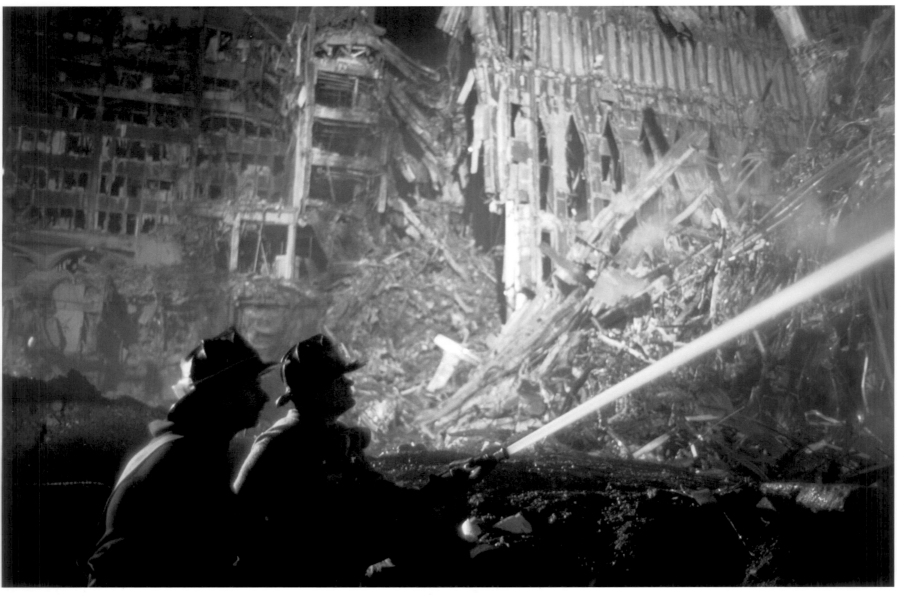

Firemen spraying the North Tower remains

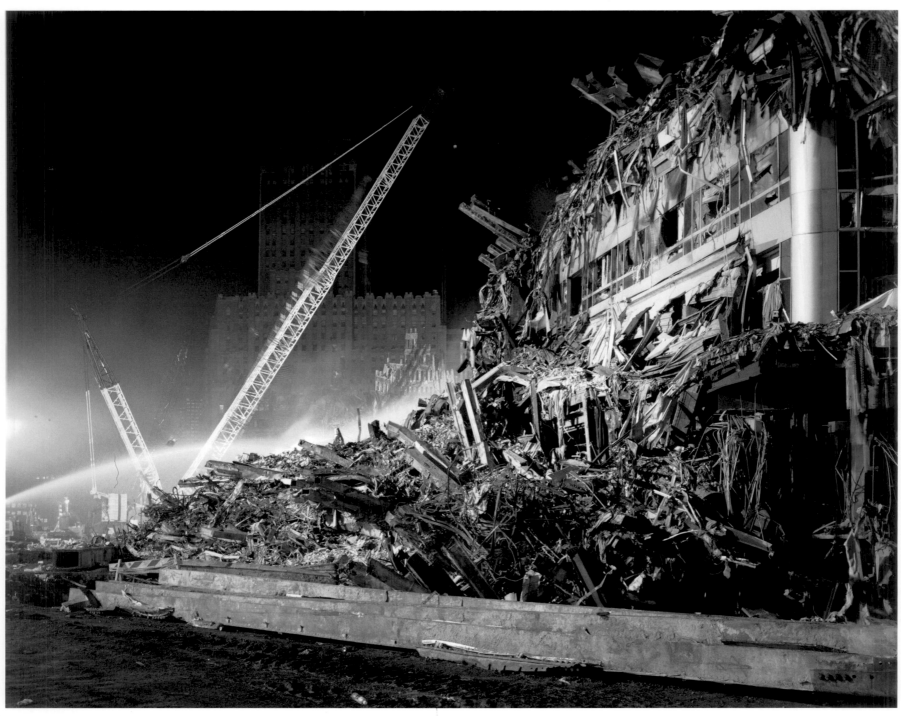

Rubble from the Marriott Hotel at the corner of West and Liberty

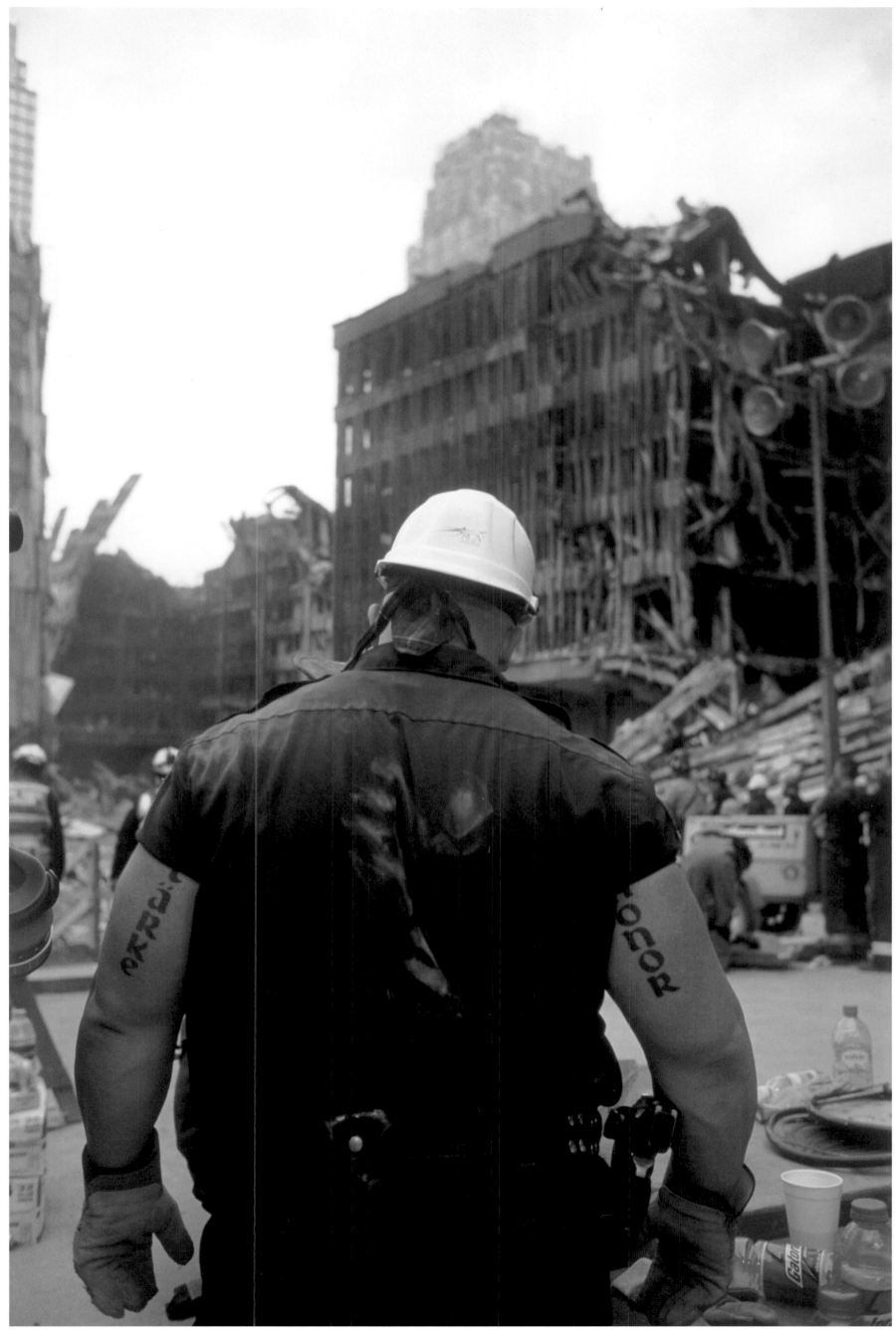

An NYPD rescue worker

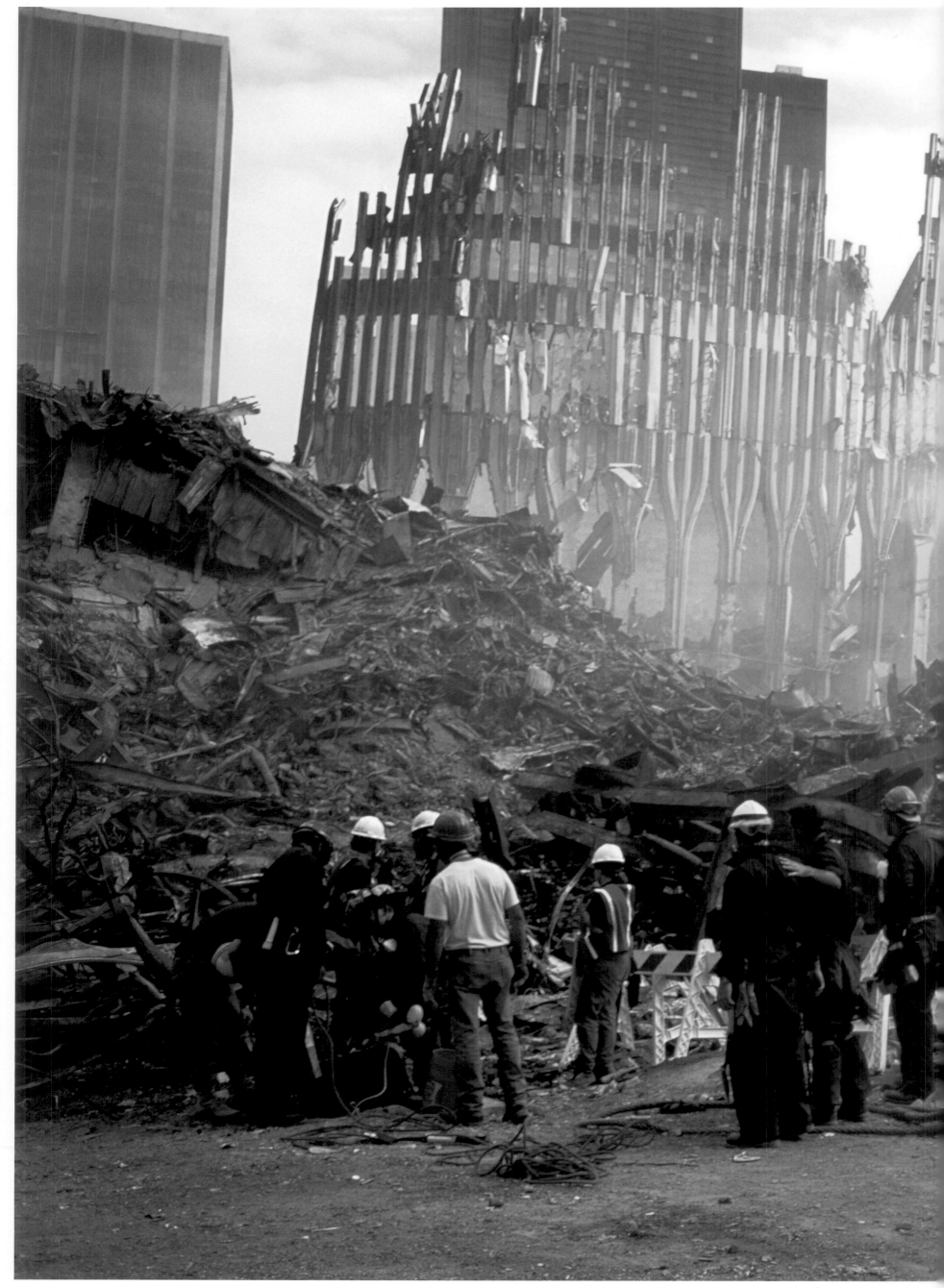

Rescue teams on West Street

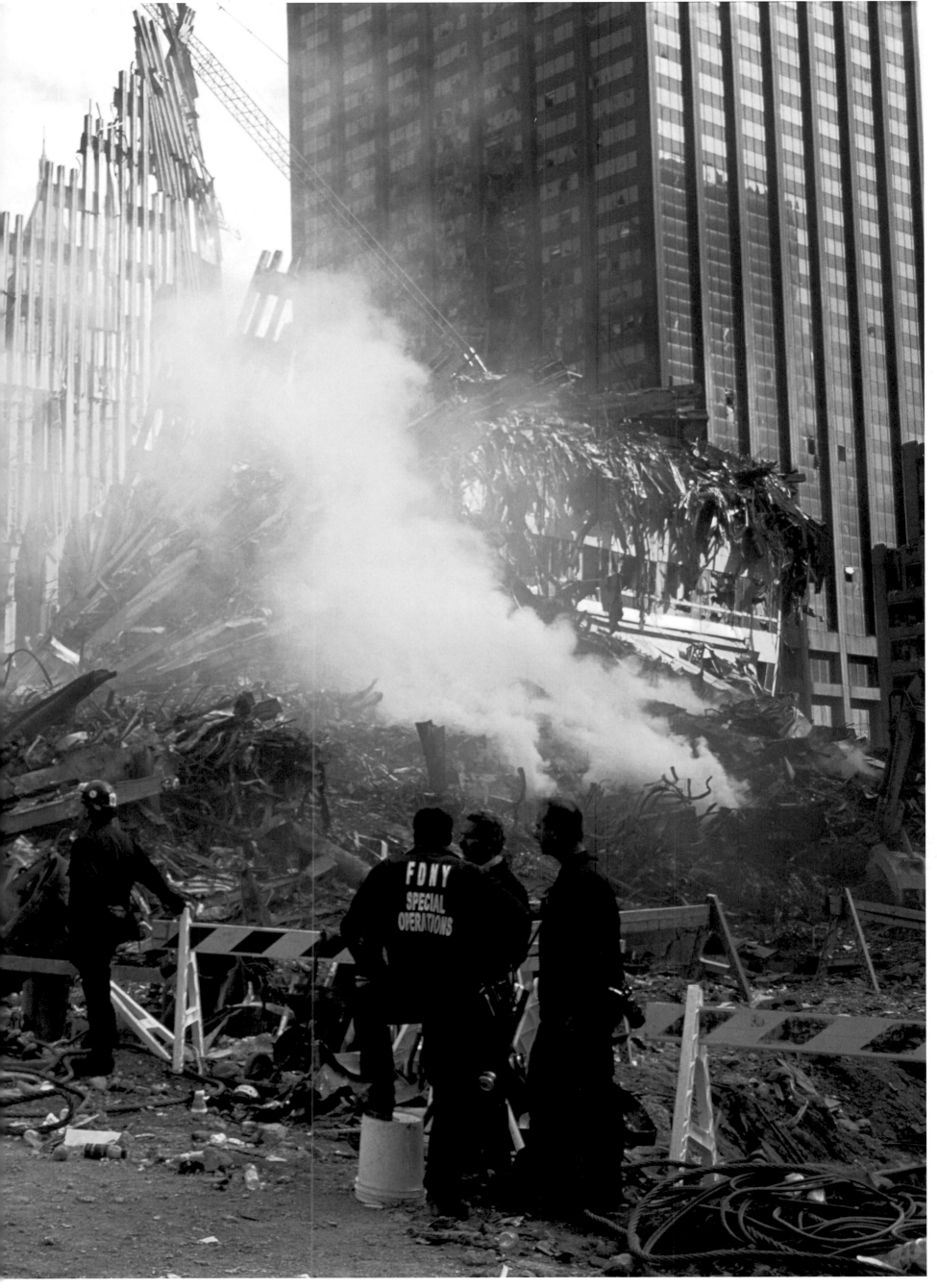

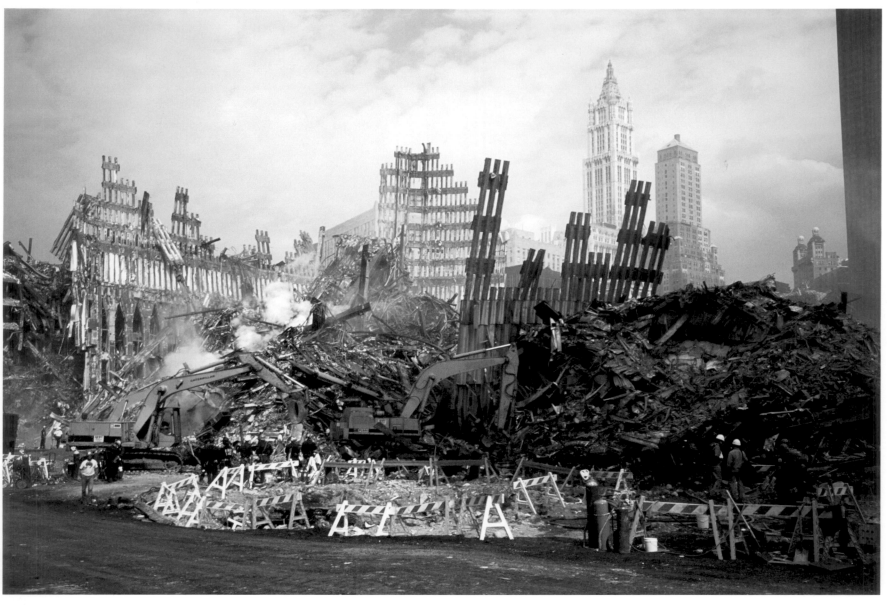

West Street, looking northeast toward the shroud of the North Tower

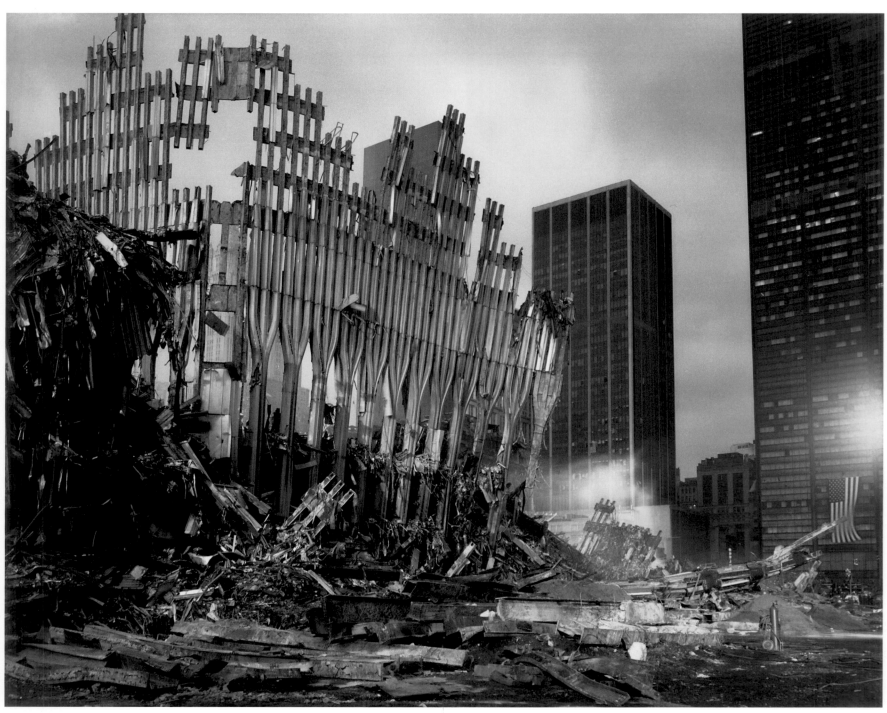

The south wall of the South Tower

On Church Street at Building 4

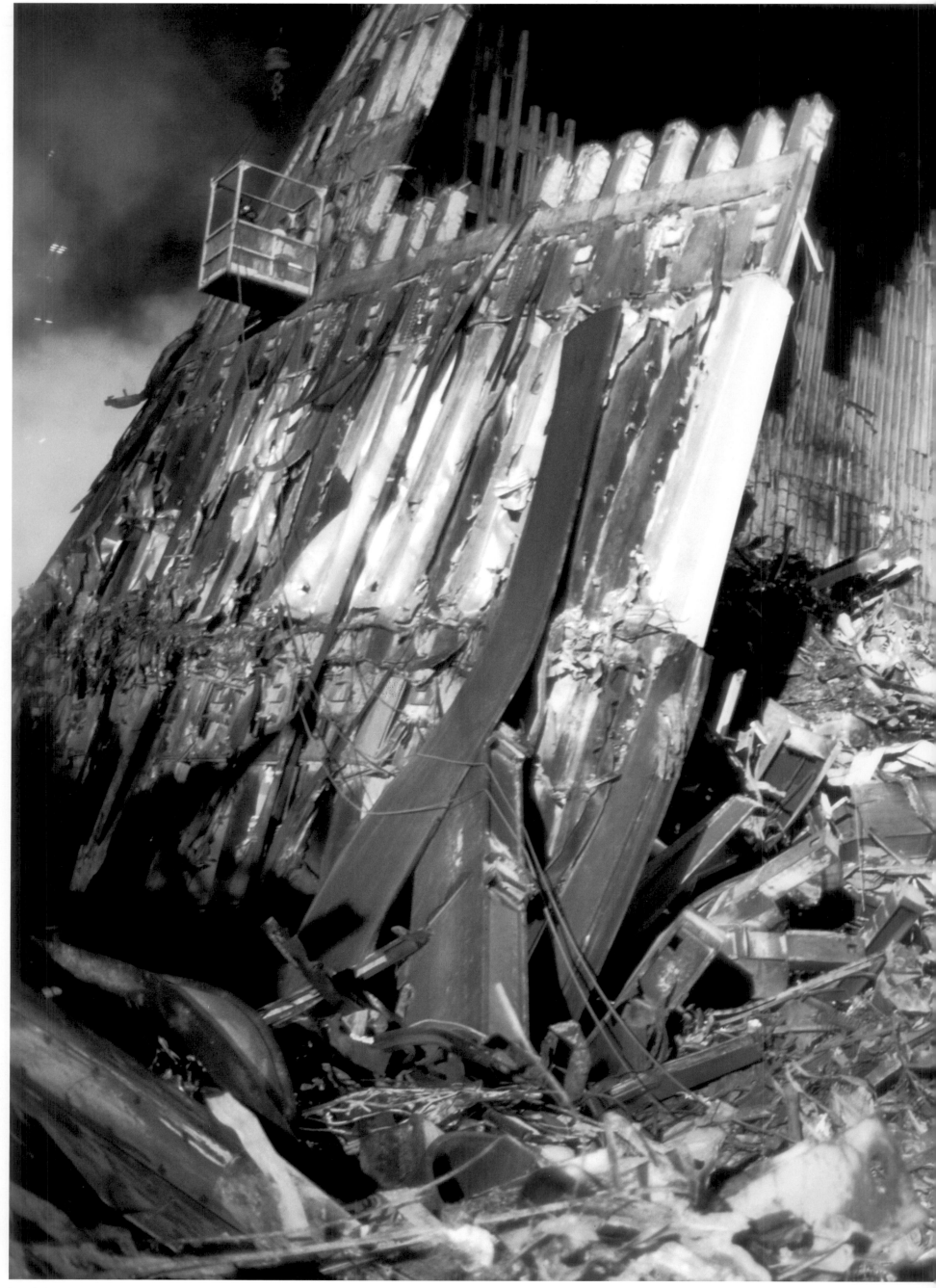

A man basket against the south wall of the North Tower. Movie-light booms were brought to the site so that the work could continue twenty-four hours a day.

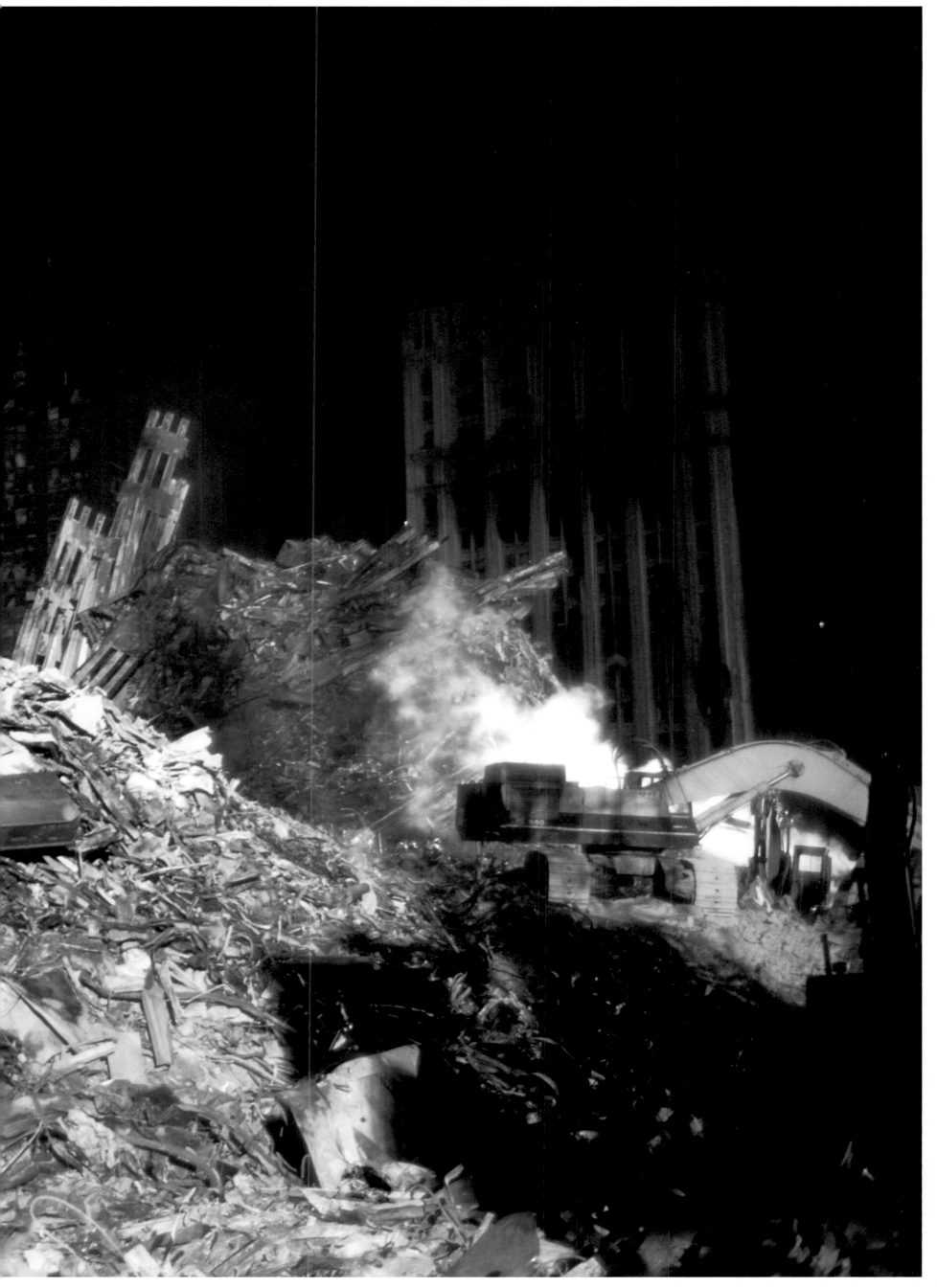

10.05

There were many places where I stopped, again and again, while making my rounds over the sixteen acres that contained the World Trade Center debris. The scale of the site had a strange accordion-like flexibility. At times it seemed merely a four-square-block area, which under normal conditions would take me twenty or so minutes to walk around. And yet everything was in flux. The hills and valleys of rubble, the machines working on and around them, and the frequently blocked passageways turned the site into an obstacle course which, because of its visual complexity and hour-by-hour changes, kept me looking at it all the more intently. Often I found myself taking eight hours to make it just once around the pile.

I stopped here, though, before the opened face of the Winter Garden, almost every day. This is where the fallen pedestrian bridge once spanned the highway between the Garden and the World Trade Center, and my gaze would drift back and forth between the two ruins. Often the North Tower looked like something from a nineteenth-century Romantic painting, while the smashed vault of the Winter Garden seemed to echo the Baths of Caracalla in Rome. Here the late afternoon light explodes into the space and slides across the south face of the American Express Building.

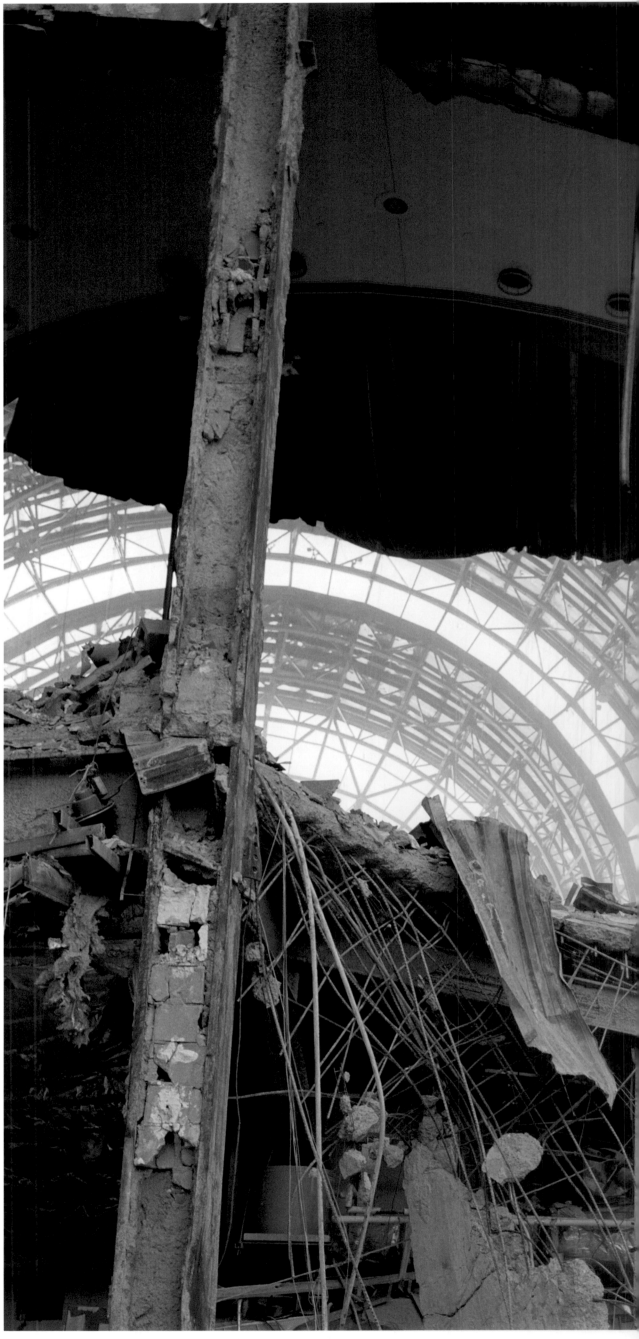

The Winter Garden, where the North Bridge used to cross West Street

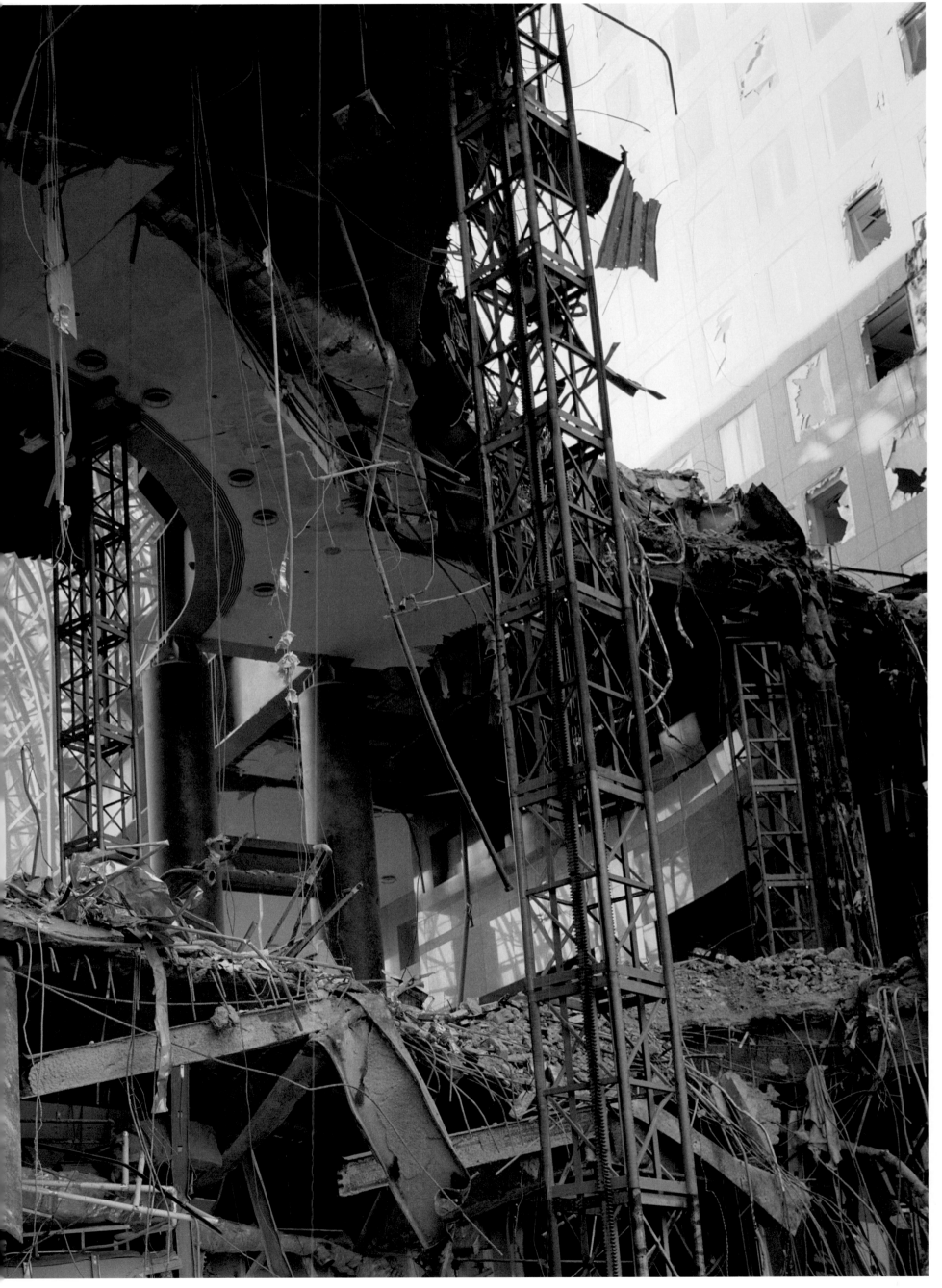

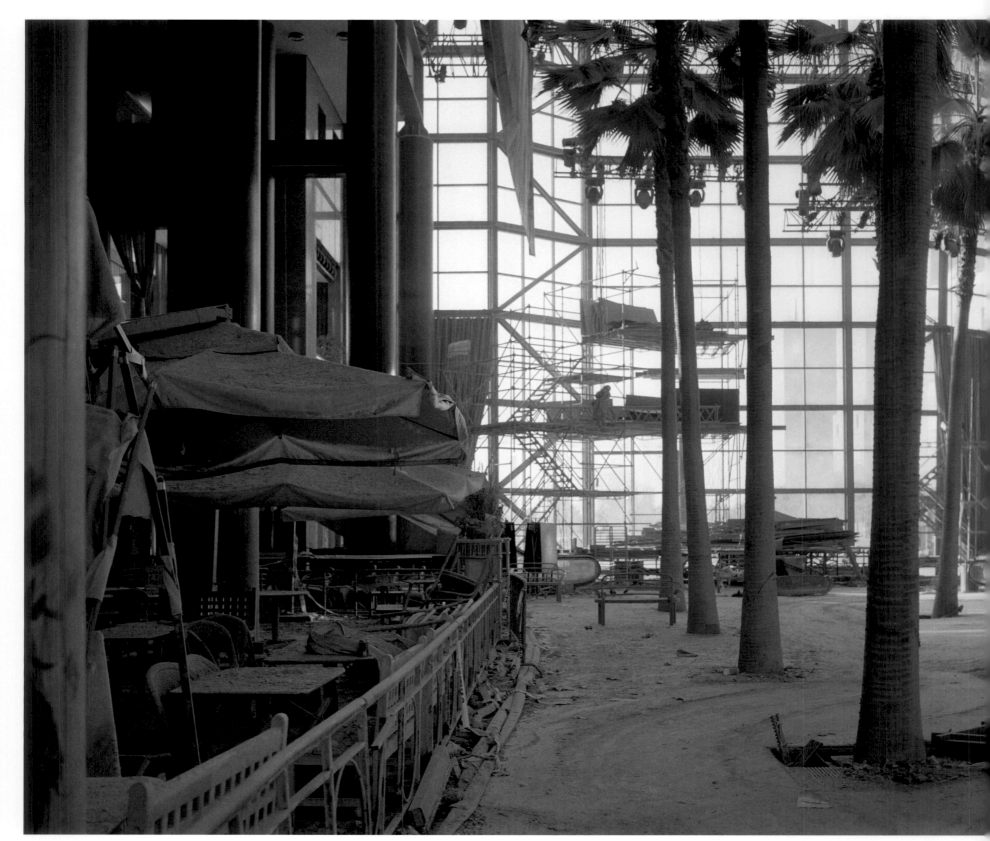

The interior of the Winter Garden

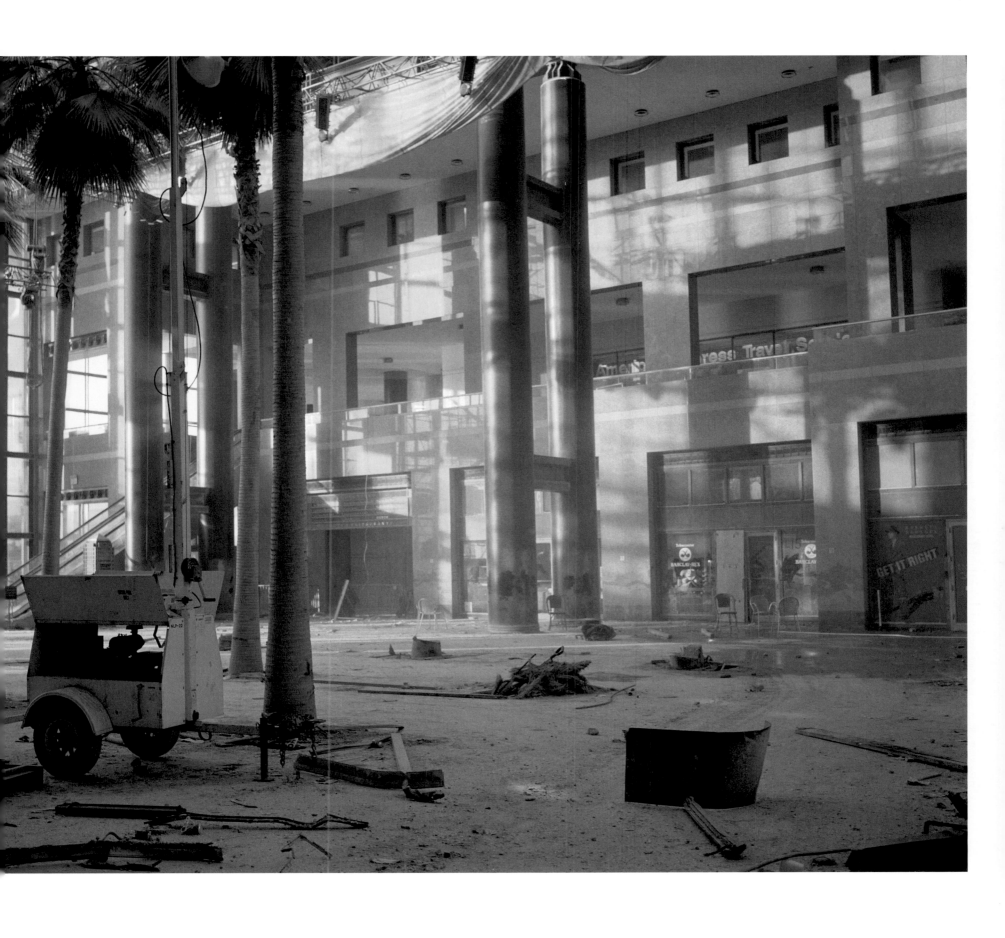

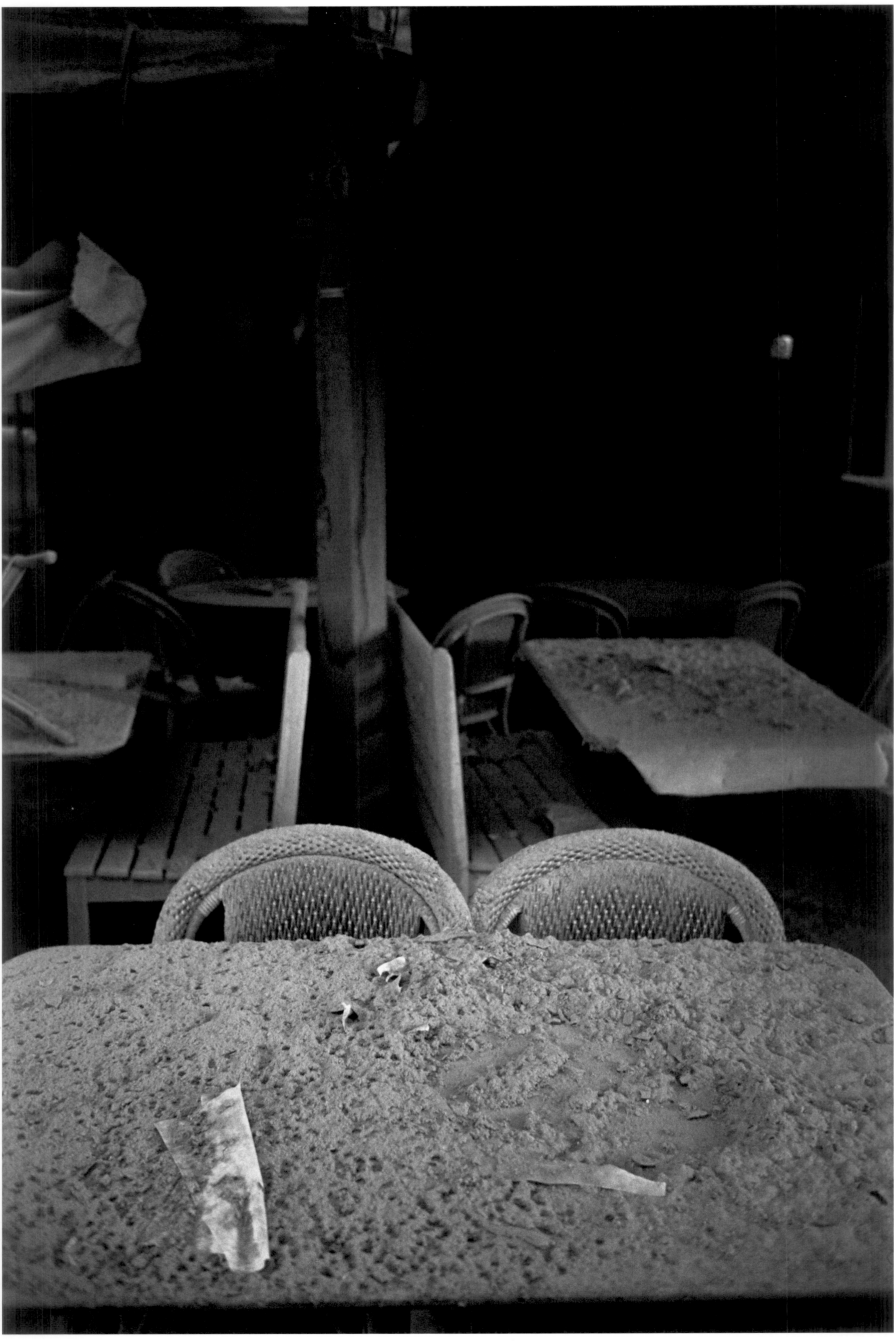

Café tables in the Winter Garden

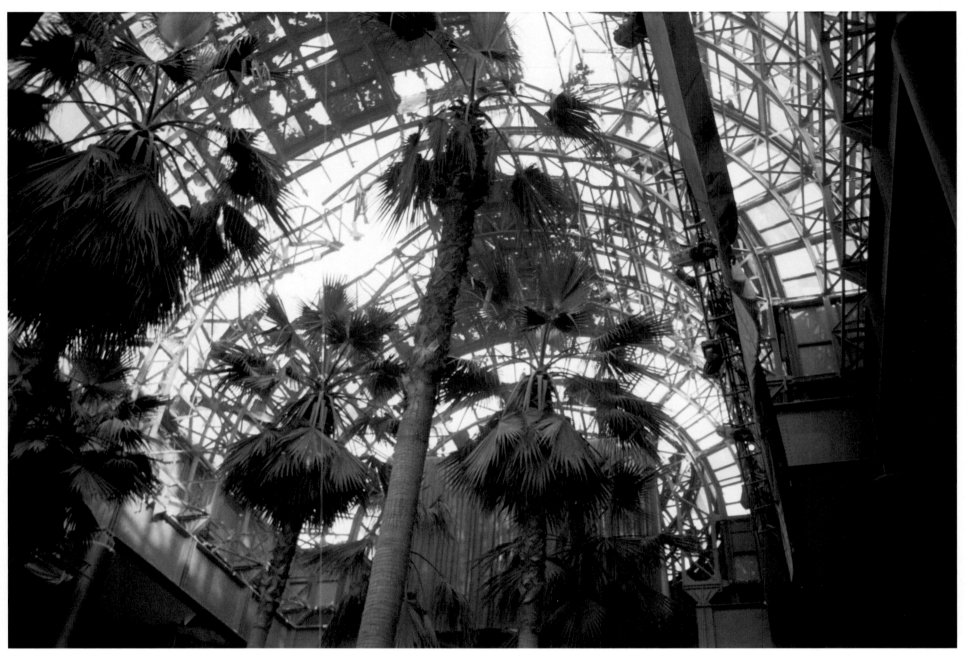

The glass roof of the Winter Garden

The interior spaces at Ground Zero were like Pompeii. A fine dust several inches deep covered everything: boardrooms, bathrooms, café tables, desks. In many cases, it sat there for months, undisturbed, absorbing moisture and solidifying into something like a cast of the object it surrounded or the space it occupied, containing both the fragile and the durable. Newspapers and napkins, pastries and ashtrays, pens and water bottles, cellphones and notebooks—the insignificant objects that describe a passing moment in a culture.

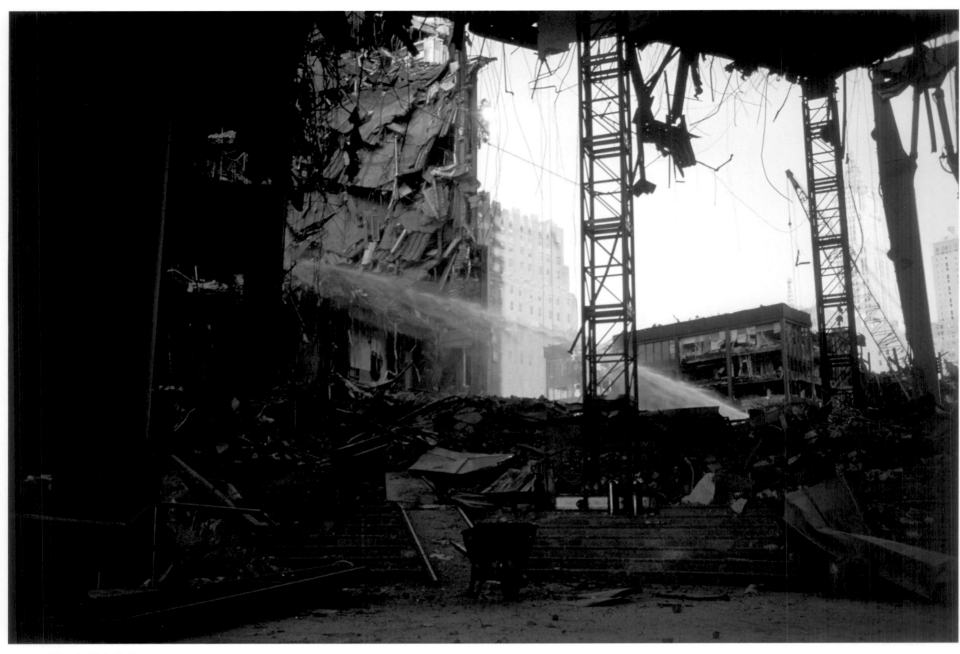

Looking east from the Winter Garden

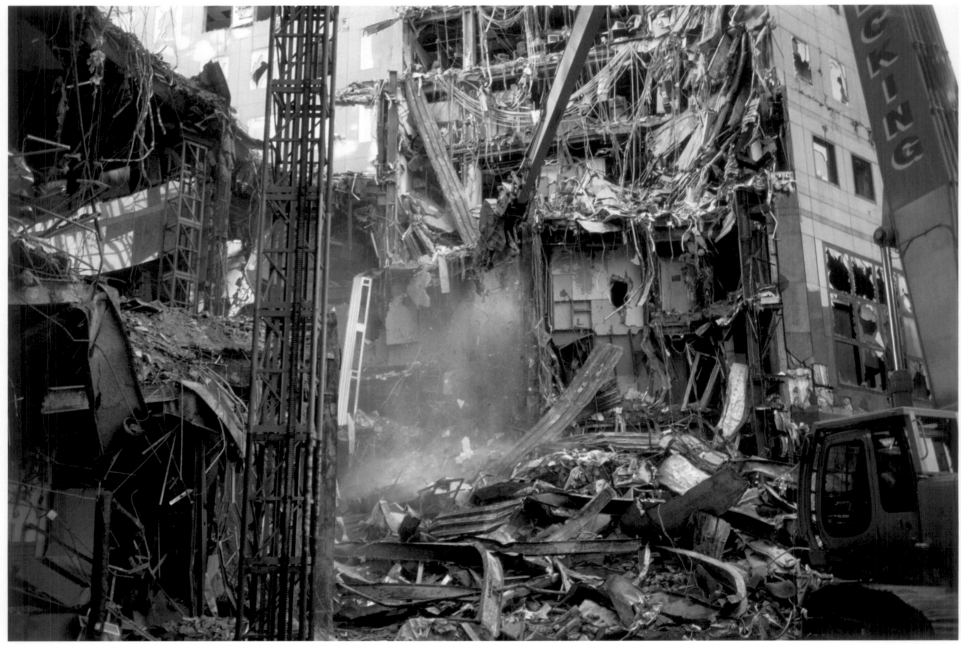

A grappler clearing debris from the American Express Building

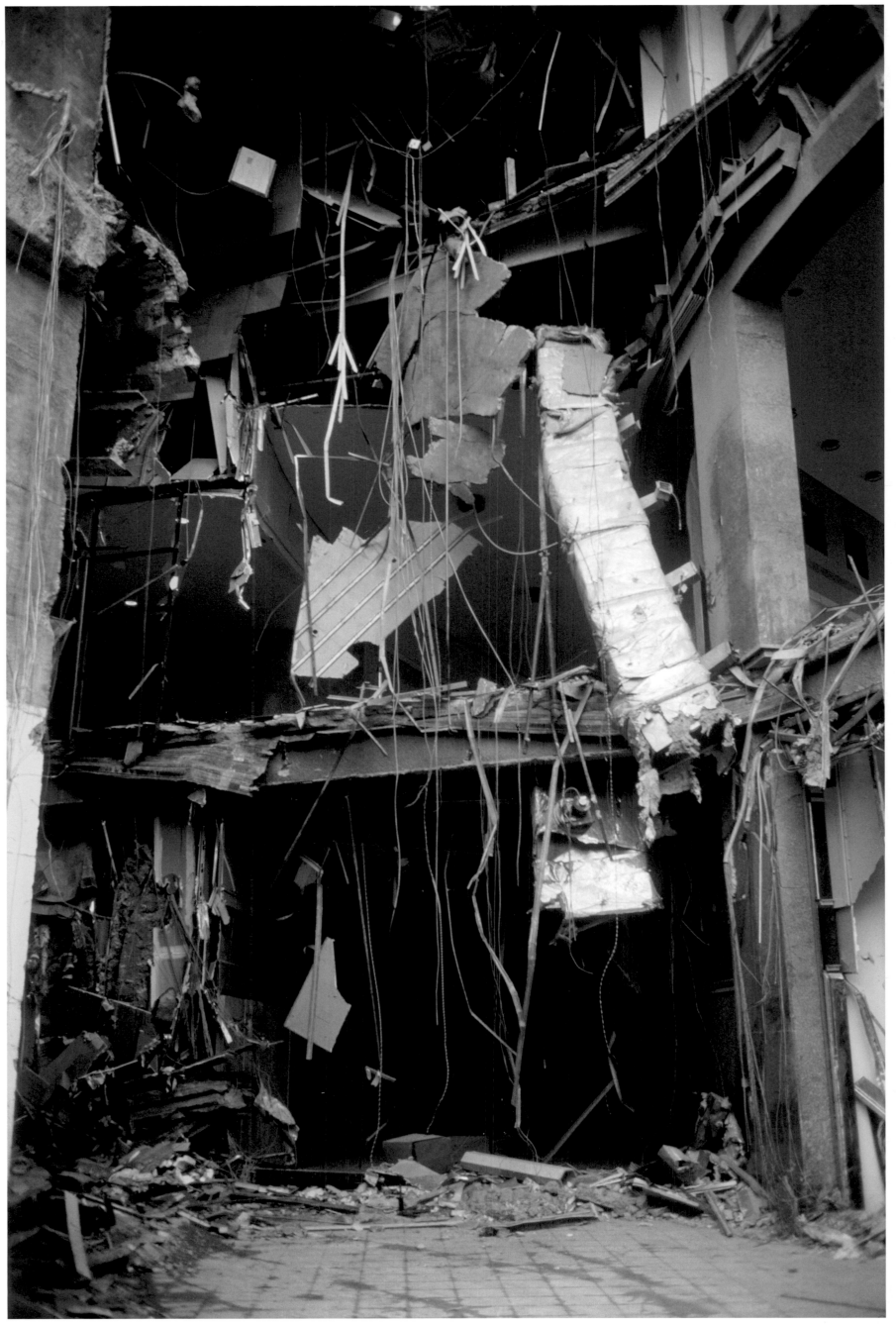

Exposed floors in 2 World Financial Center

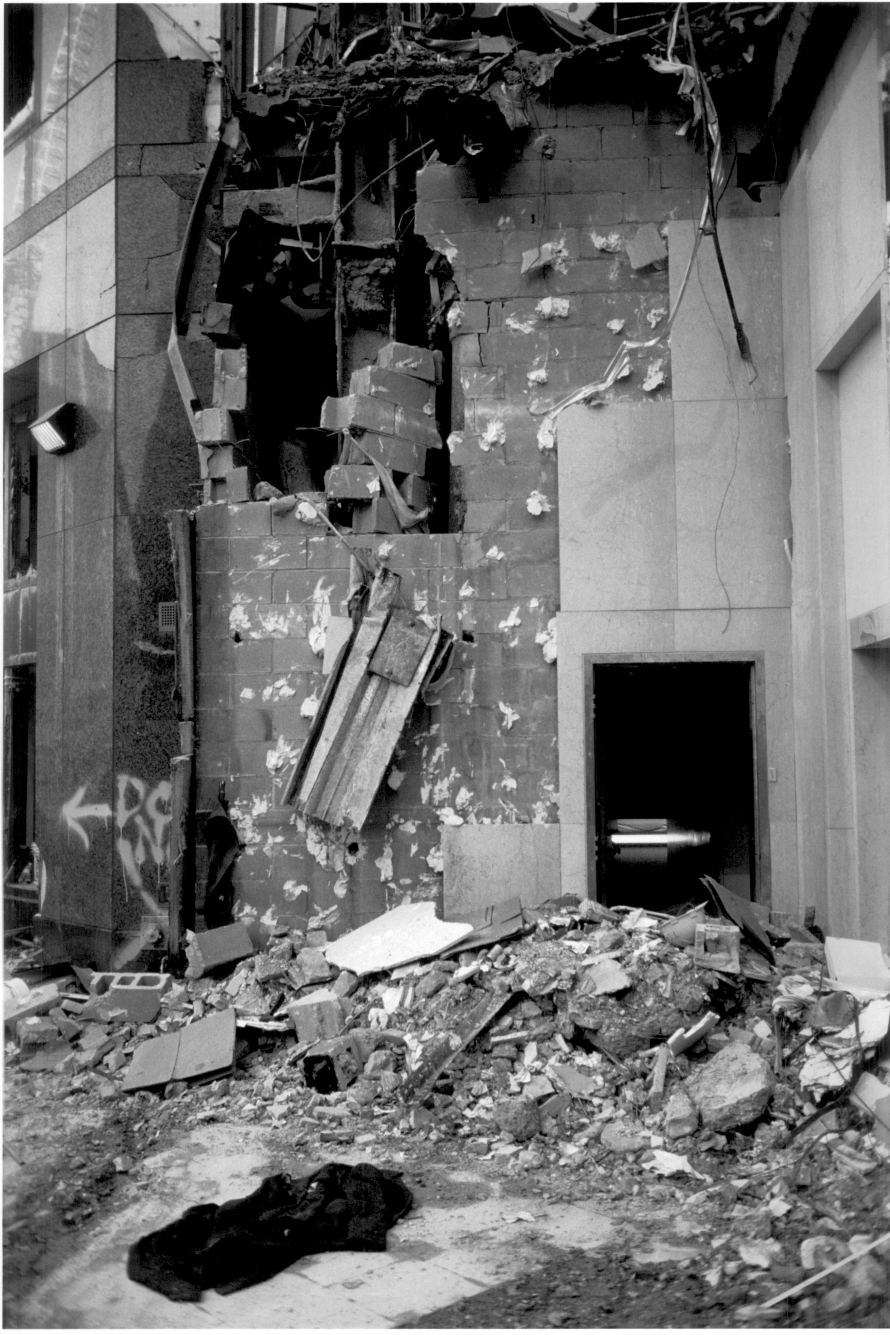

The scarred face of 2 World Financial Center

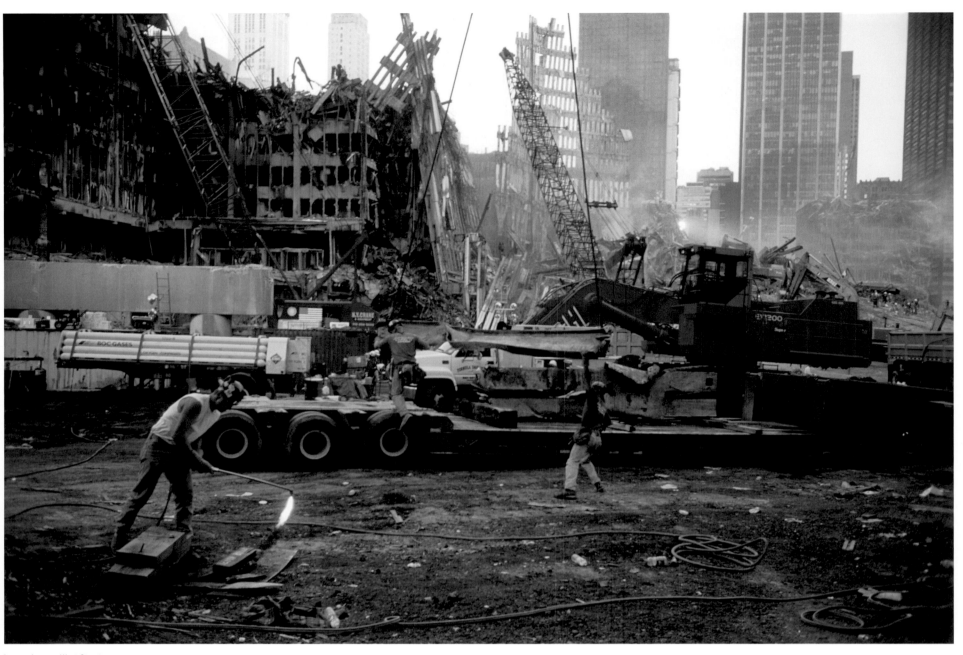

Ironworkers on West Street

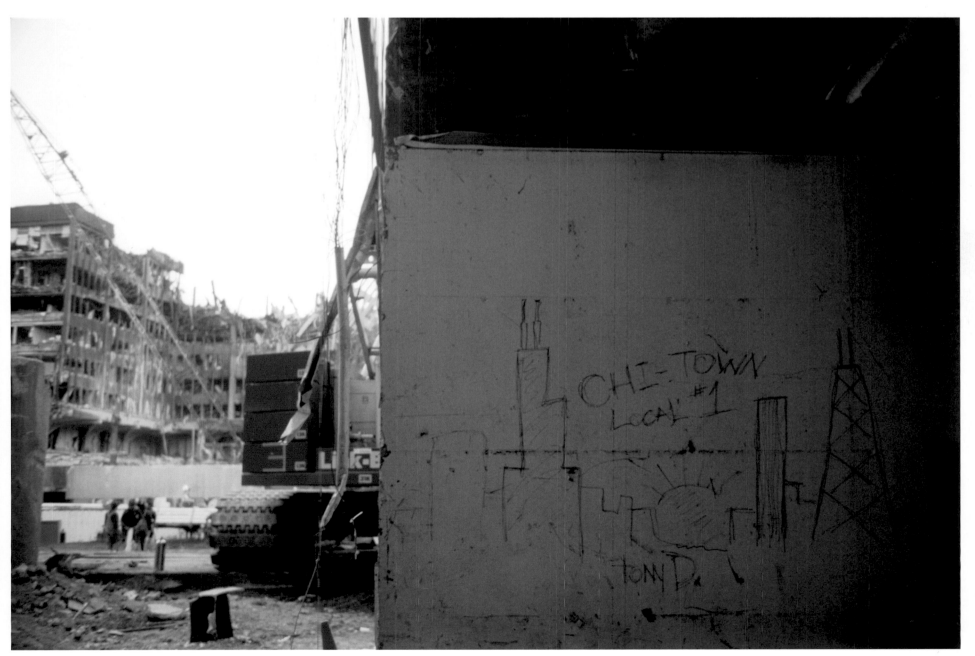

Graffiti by Chicago Local # 1 ironworkers

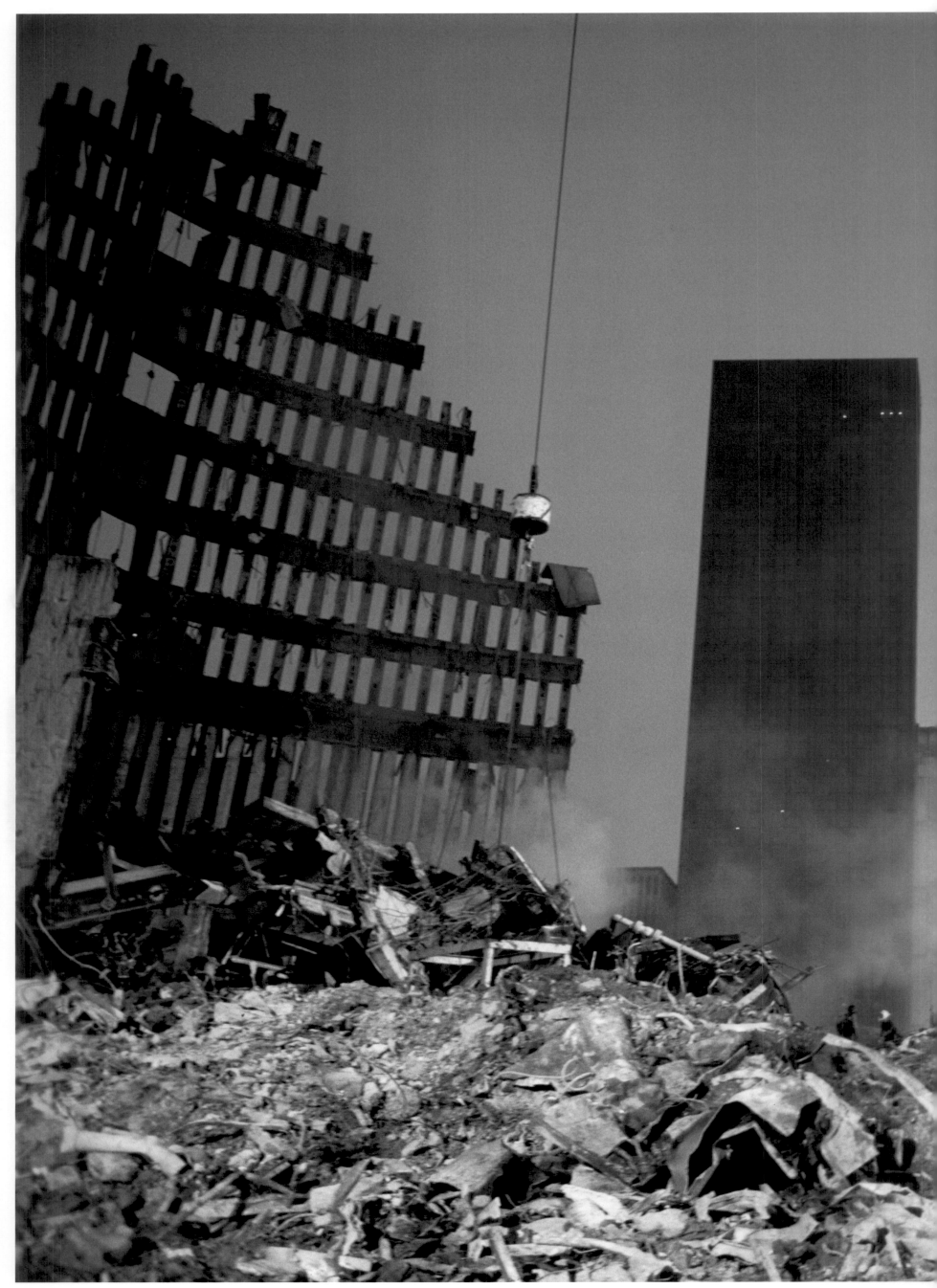

An FDNY rescue team on the pile at dusk

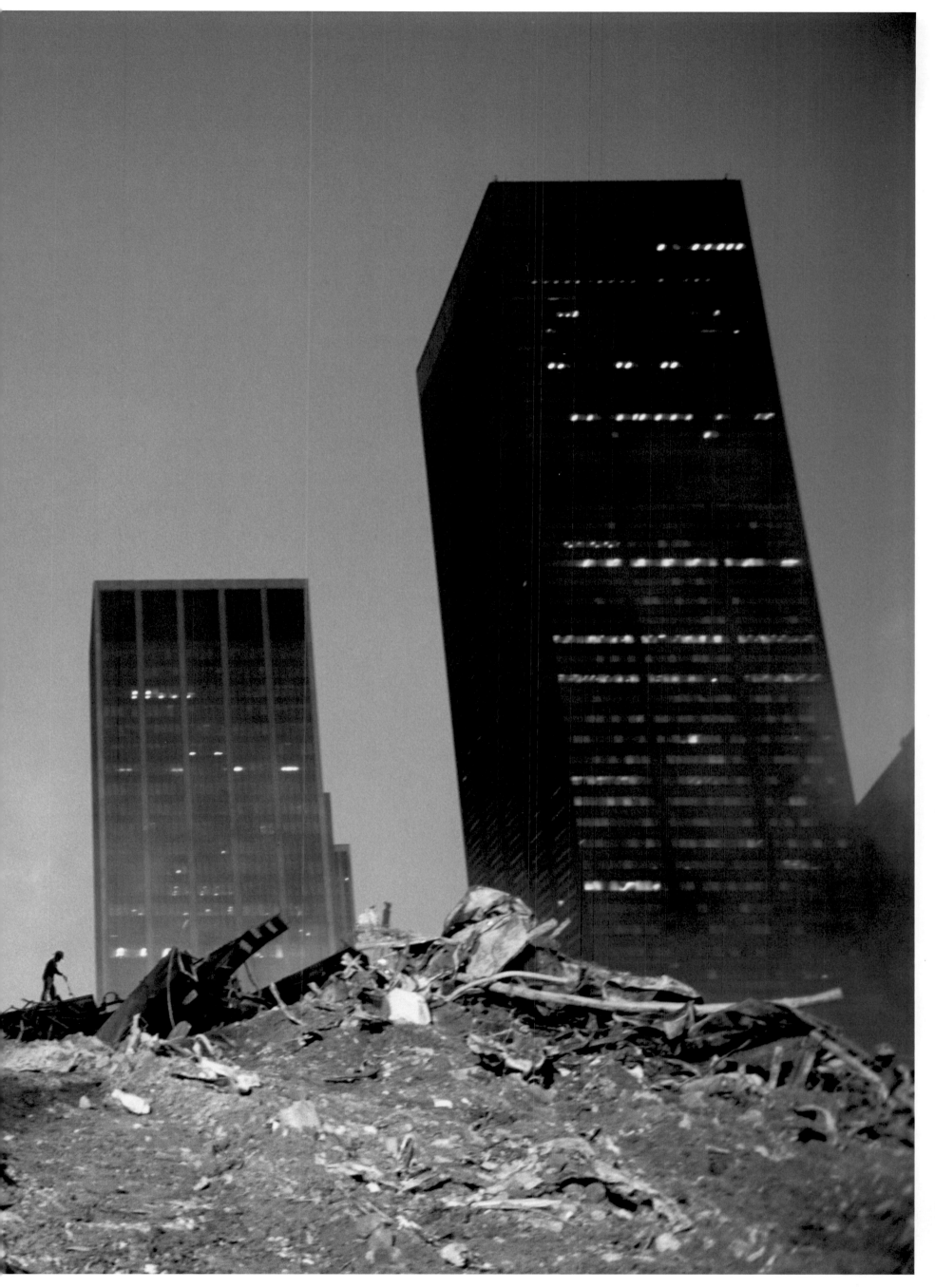

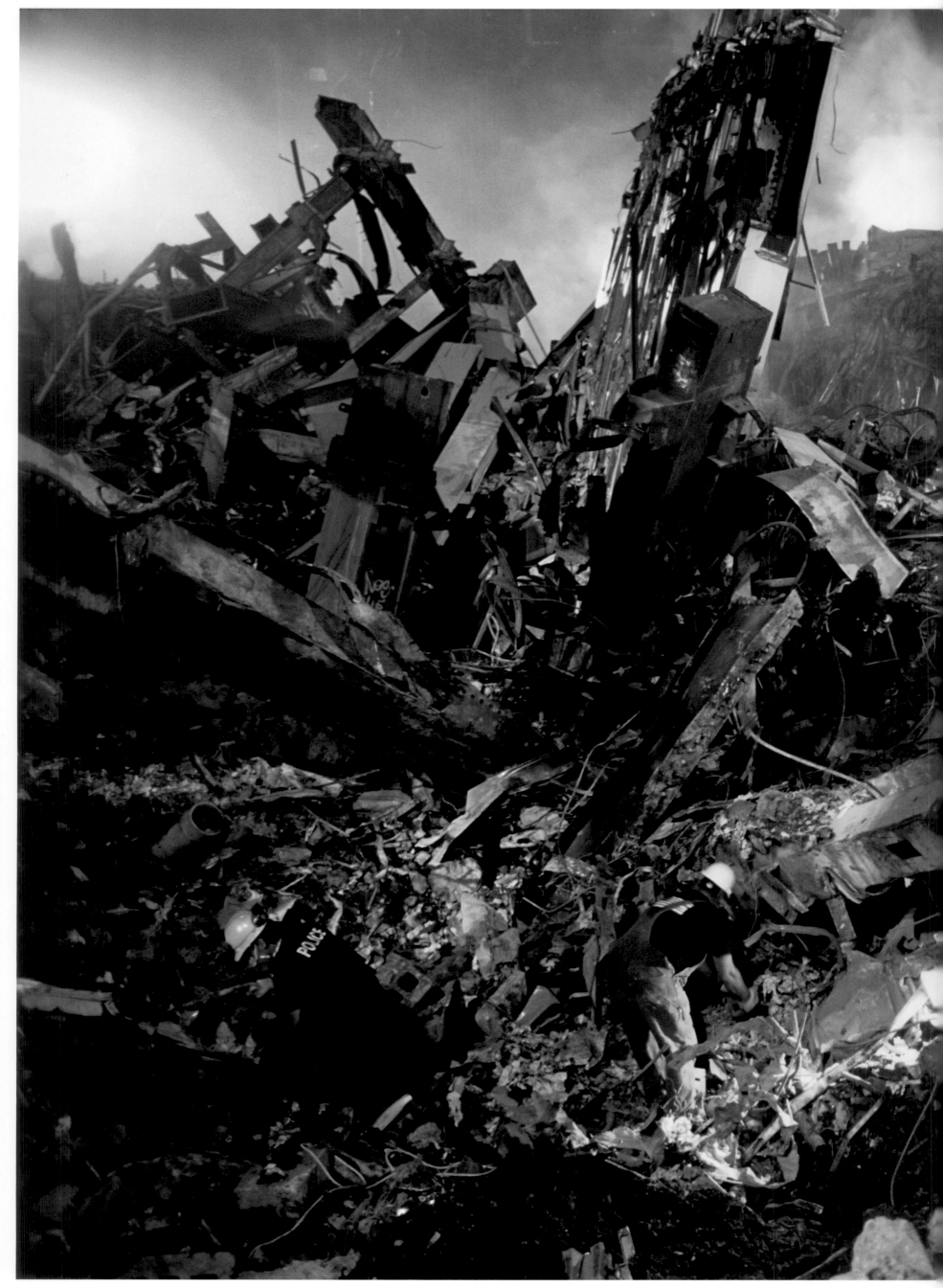

Searchers working in debris from the North Tower

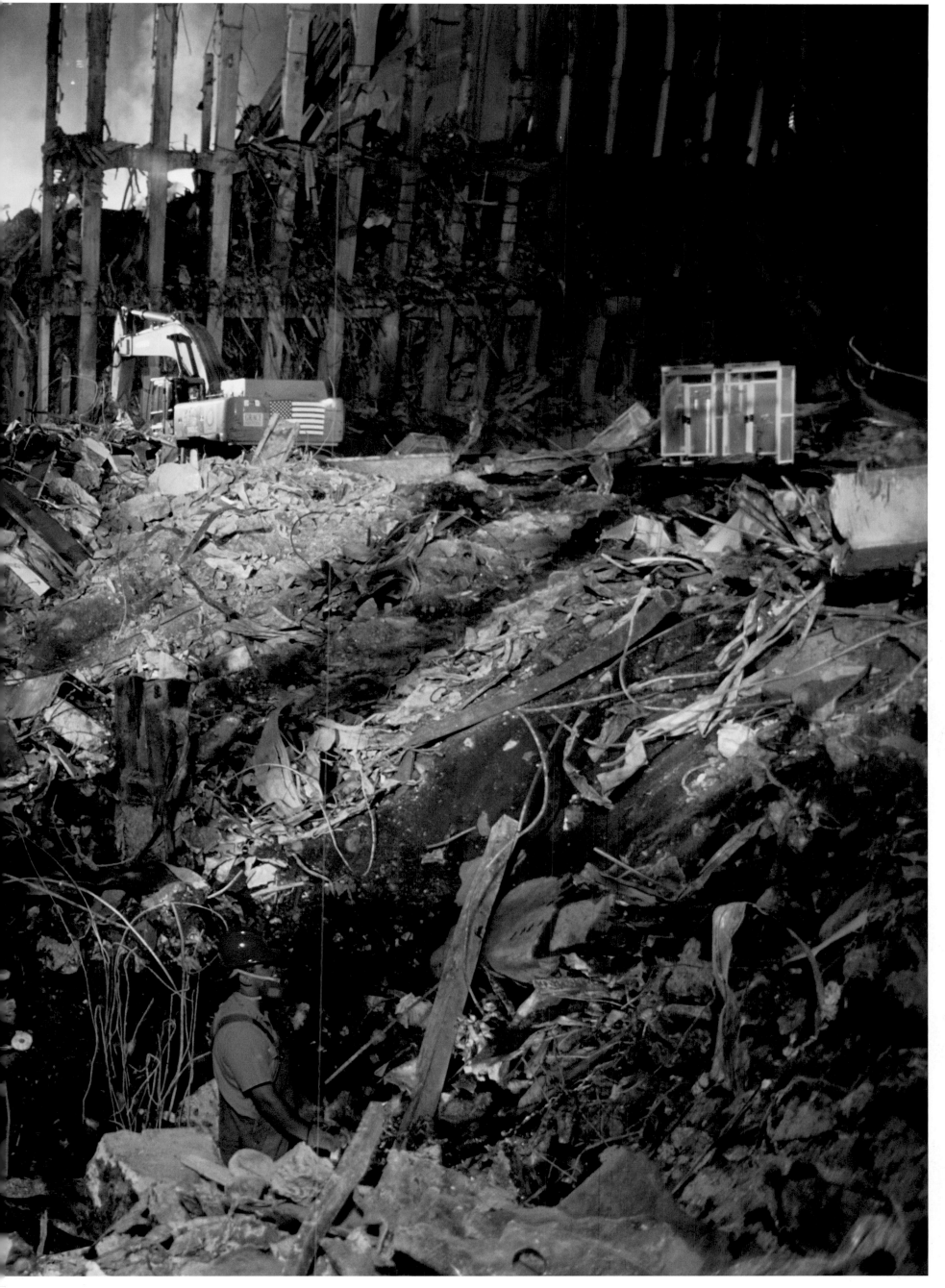

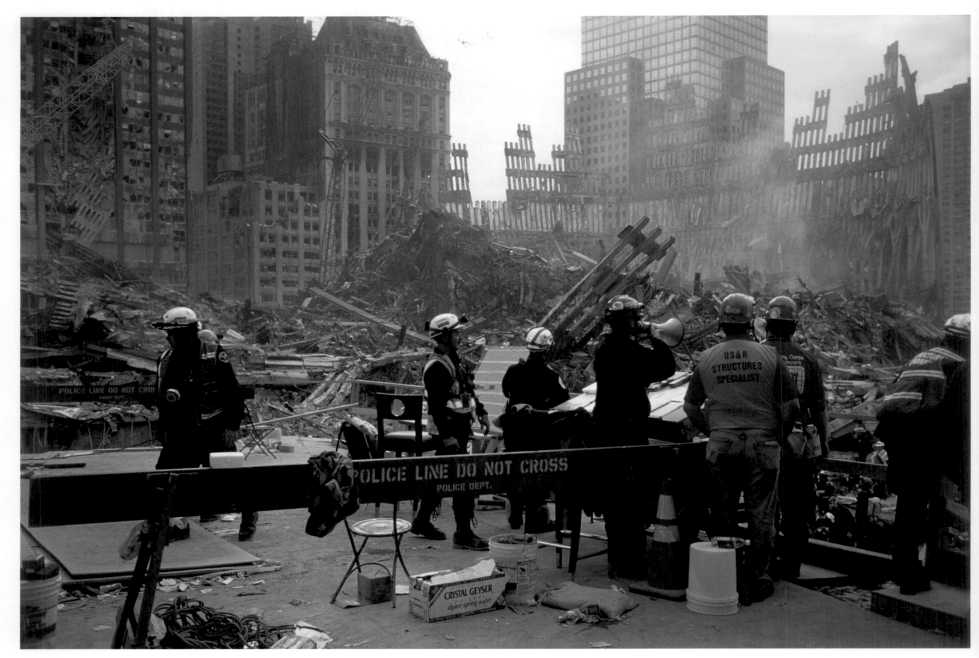

Teams of rescue workers from all over the country responded to the event. Here, some members of the California Task Force Urban Search and Rescue Team confer with the NYPD at the Command Center above the plaza.

PREVIOUS PAGE: From the very beginning, recovery of those lost on September 11th was the quest, and it continued long after there was any hope of finding survivors. The most common sight in the zone throughout the next nine months was that of workers bending over, kneeling on, or lying in the debris, scraping and sifting and picking it apart by hand or with common garden tools, looking for any evidence of the dead. The search often took on an epic quality: in the distance one might see a cluster of tiny figures on the pile carefully raking a small patch, while in the foreground a fireman scrutinized a single object.

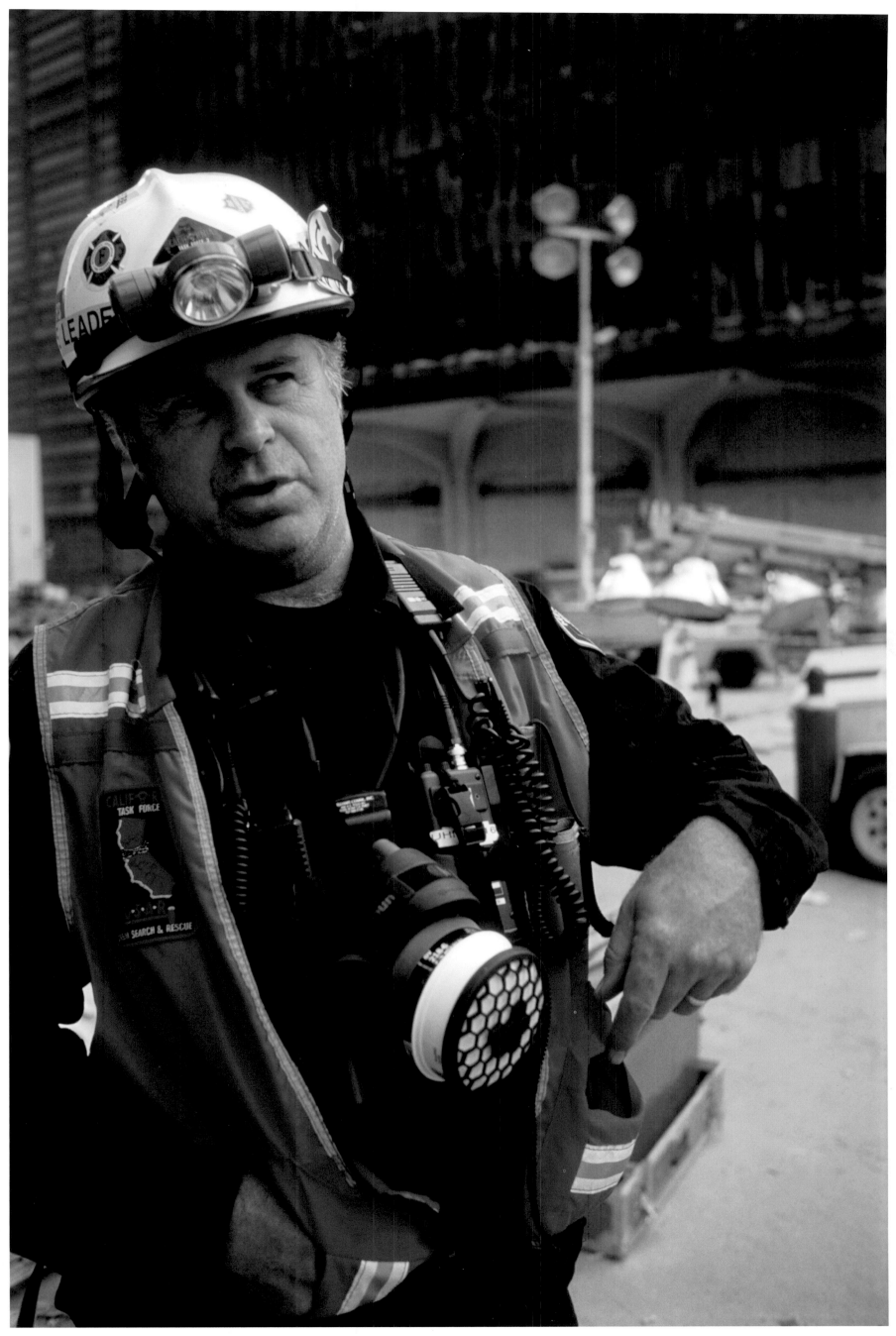

Deputy Chief Ed Greene of the California Urban Search and Rescue Team

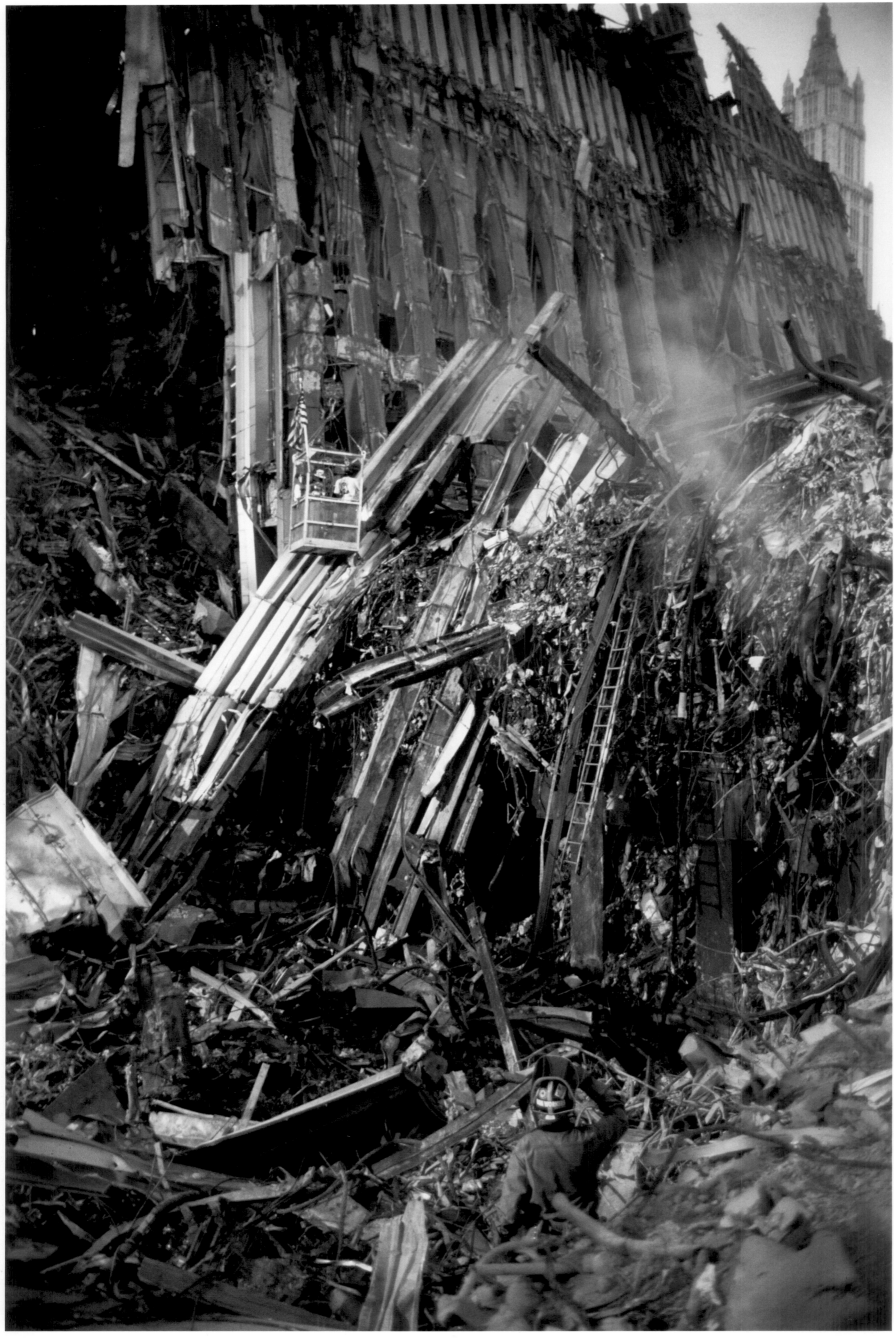

A man basket descending into the North Tower, near the north wall

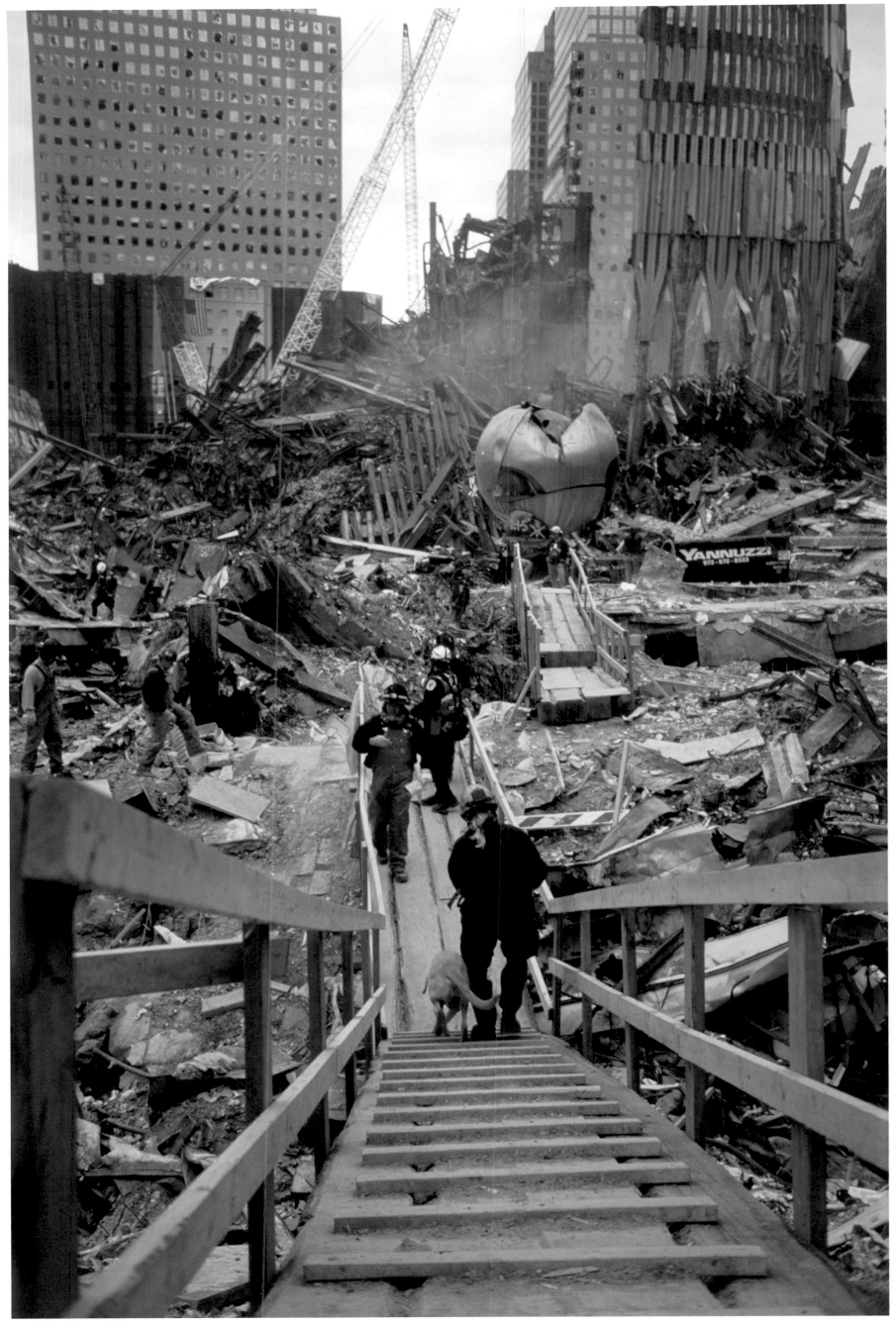

A rescue dog from the NYPD K-9 Unit being led onto the plaza

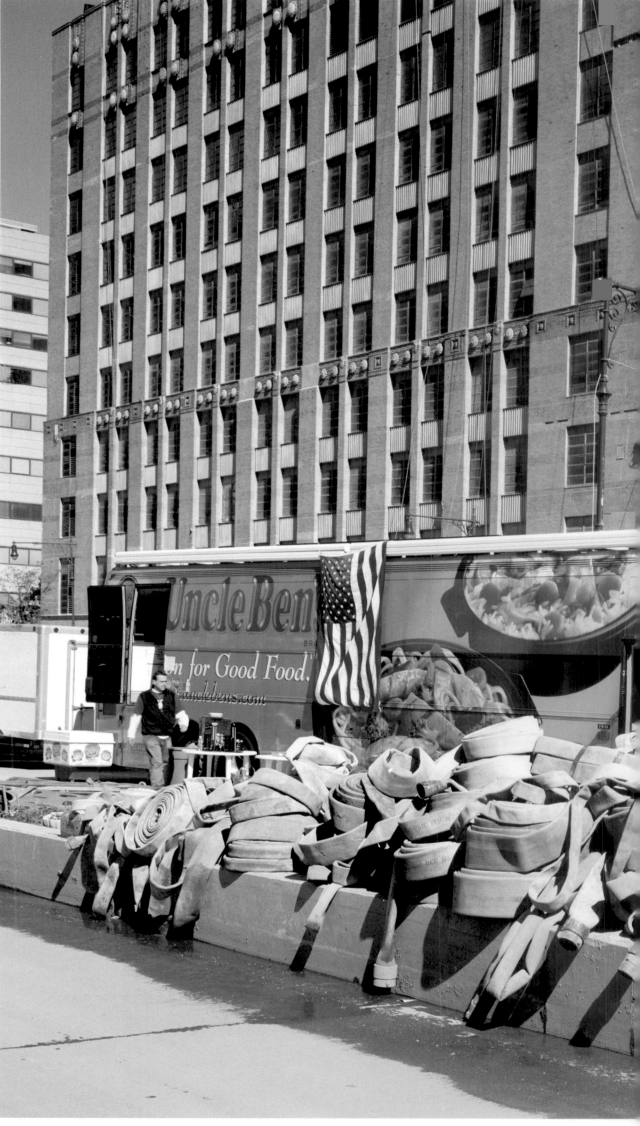

Fire hoses on West Street

10.07

Hoses were rendered useless on September 11th—first by the height of the fire itself and then, after the towers fell, by the lack of water and the destruction of the fire trucks. As a result, these coils of hose lay piled here for weeks. Fire hoses were one of the most ubiquitous items on the pile. Everywhere you looked, thousands upon thousands of feet of hose lay entwined with the debris, an intricate web of effort and loss.

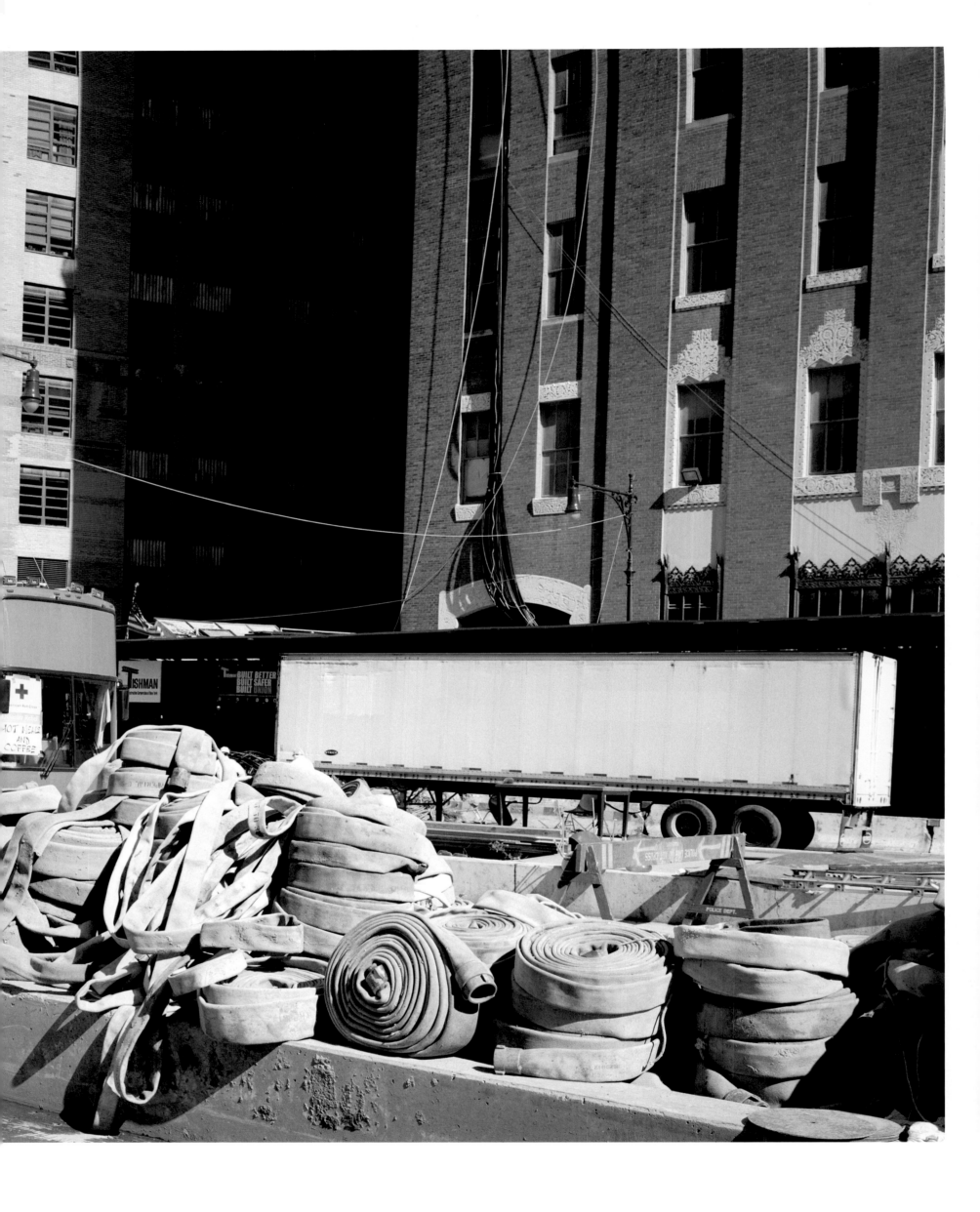

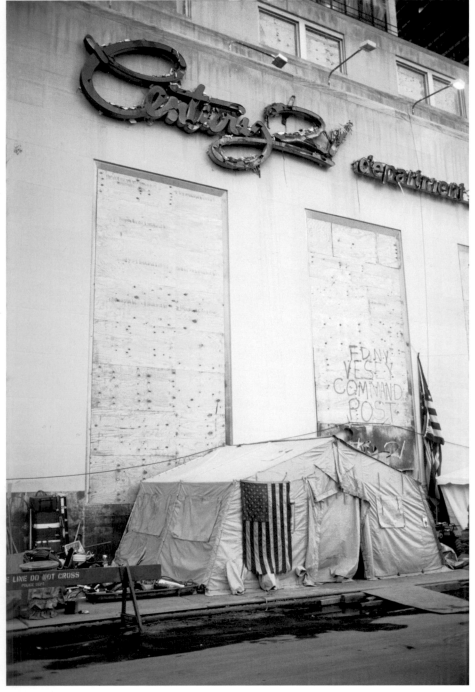

An FDNY Command Post on Church Street

Supply and service tents on West Street

The organization of services at Ground Zero was a truly remarkable feat, given the suddenness of the need, and it only seemed to become better and more comprehensive as time went by.

At first, rudimentary shelters were constructed of tarps and two-by-fours. Then informal camping and wedding tents arrived, followed by the larger Army and Red Cross tents. Later still, varieties of handmade or prefabricated buildings became part of the temporary infrastructure of the place. Although it was put together in a piecemeal, spontaneous way, the system was designed to support the workers in the most comforting manner possible.

These services dealt with almost all of our basic needs, of which one of the most important was washing. There were even facilities for cleaning vehicles of all sizes. This was particularly necessary for the big trucks leaving the site loaded with rubble; the administration didn't want any toxins or fibers traveling outside the zone. Those of us working on the site also had to wash our boots thoroughly when we left the pile for home, so as not to drag anything unwelcome with us onto the city streets. And at the dining facilities—especially the "Taj Mahal," the big, white, inflated tent on West Street—we had to vacuum our clothes before we were allowed to enter.

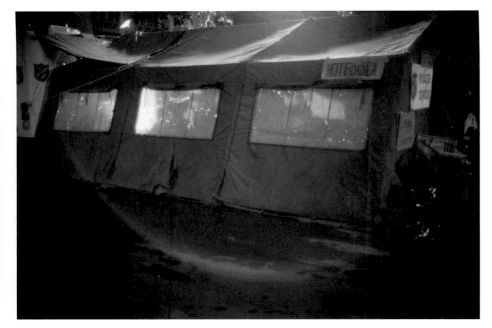

A Salvation Army tent on Church Street

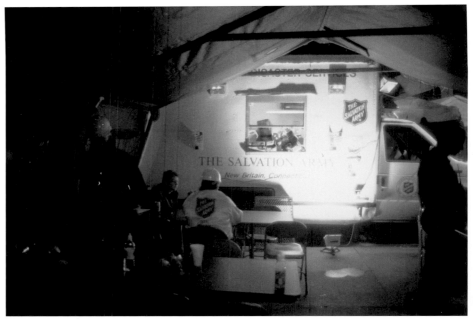

Interior of the Salvation Army tent

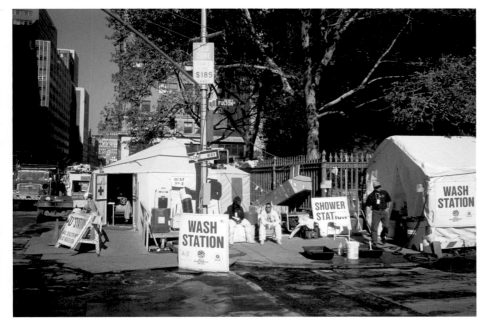

Wash stations at the corner of Fulton and Church

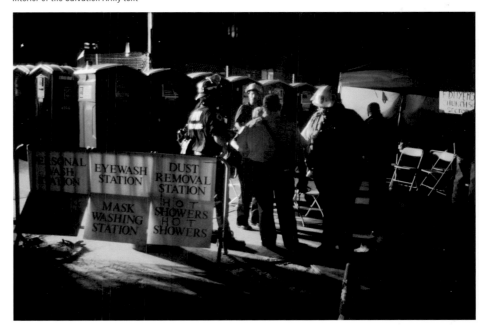

Wash stations on Church Street

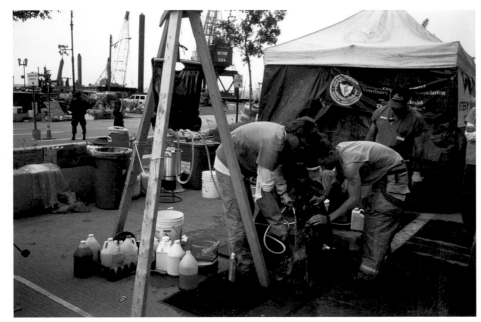

A rescue dog from the NYPD K-9 Unit being cleaned on West Street. Beyond are barges for transporting the debris.

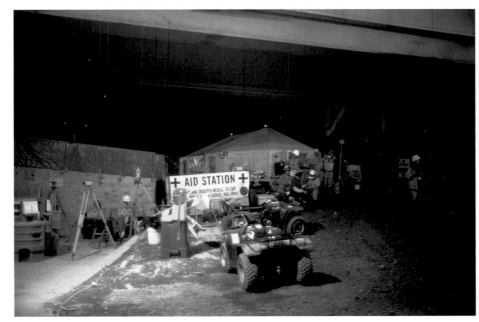

A first-aid station under the South Bridge on West Street

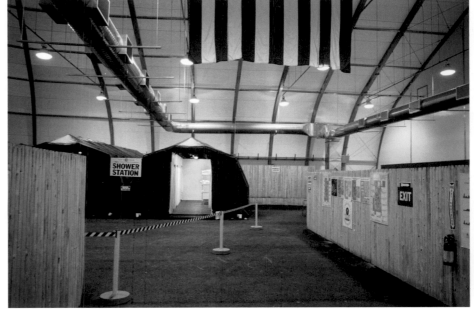

A portable building on a flatbed trailer

Interior of the shower area at the "Taj Mahal"

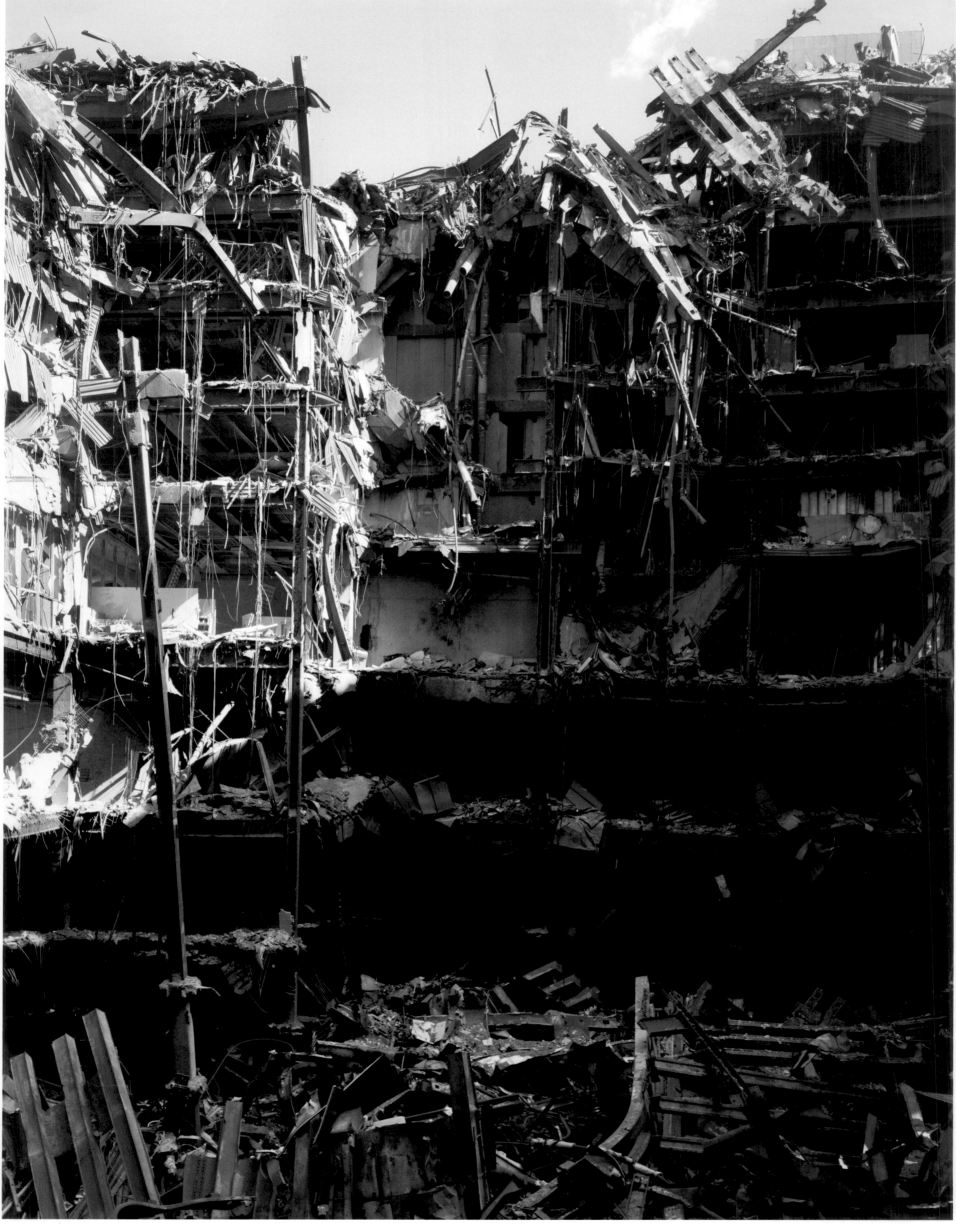

Interior of the Customs Building, known as the "donut"

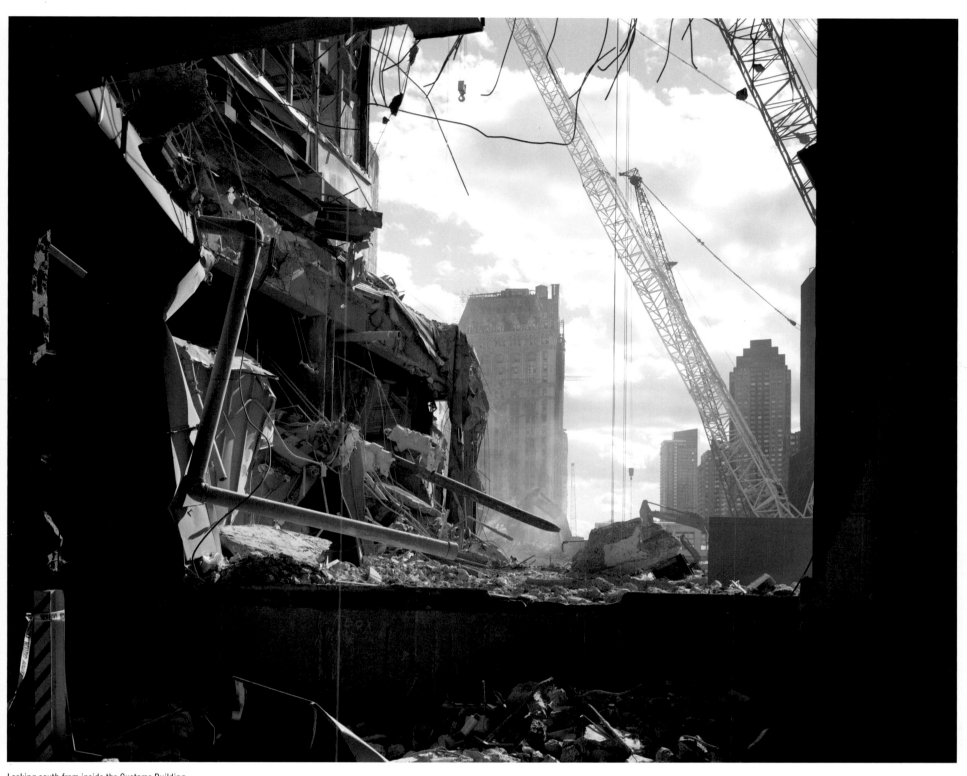

Looking south from inside the Customs Building

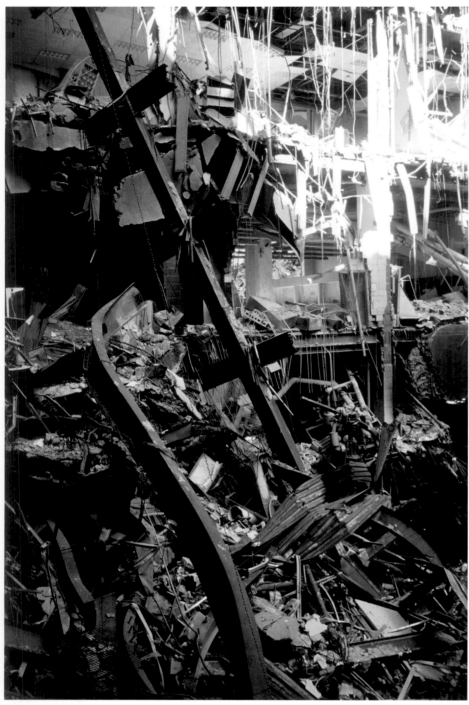

Interior of the Customs Building with sheared columns

Frank Silecchia standing in front of the cross

I stopped in front of the cross that had been mounted on the remaining support pier of the North Bridge. As I set up my camera, a burly man ambled over and told me the story of the cross and how it got there: his story. Soon after September 11th, Frank Silecchia had gone deep into the Customs Building—all the way to the hole in the donut, where falling debris from the North Tower had sheared through the building's center, slicing floor joists and columns as it fell. Standing in the midst of the chaos was the cross-shaped column. Frank said that finding the cross had affected him profoundly, convincing him that he had to make changes in the way he lived his life. For starters, he painted arrows on the ground, marking out an informal pilgrimage route—from West Street over the rubble and up to the donut—so that others could view the scene as he had. Eventually, Frank enlisted the help of some of his buddies, and they freed the cross from the pile and placed it where it stands here. When we spoke, which was frequently over the next nine months, Frank's eyes would often uncontrollably fill with tears.

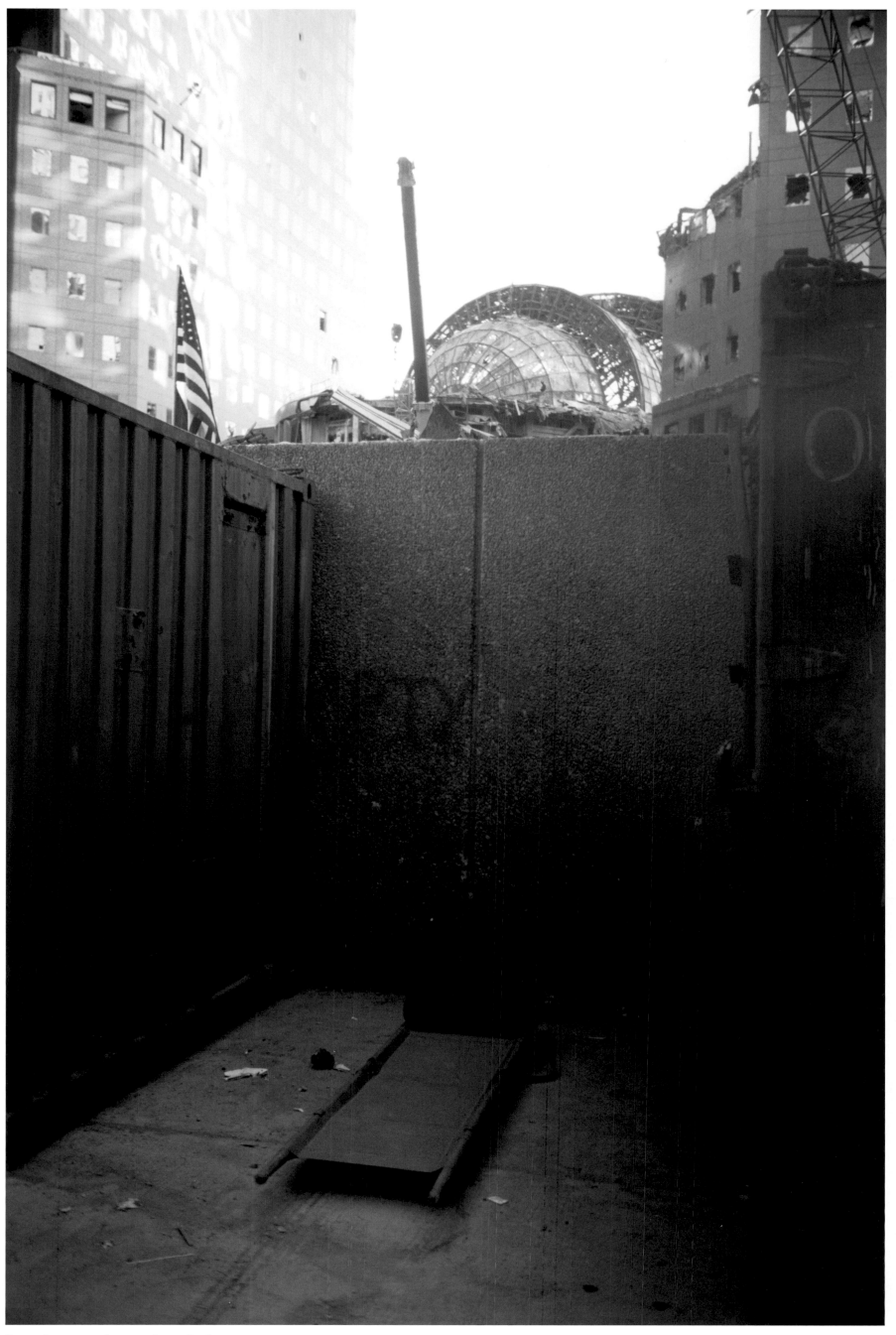

The space between two equipment containers on West Street

10.11 Easily forgotten among the monumental aspects of the disaster was the destruction of many of the trees of lower Manhattan. We New Yorkers tend to take our trees for granted, but every street has its share of them, spaced out between the parking meters and the lamp-posts, struggling to survive in deep shadow or blazing sunlight. One sees them in their cobblestone patches, or potted in concrete urns, hidden in vest-pocket parks and atrium gardens. They are part of the city's street furnishings, along with fire hydrants, parking signs, bus shelters, newsstand kiosks, and traffic lights—nearly invisible but important elements. What happened to this tree? Imagine the cyclone of debris whirling through the dust cloud, pieces of steel as big as buses, shards of glass the size of refrigerators, flying, tumbling, bouncing, sliding, and shearing apart everything standing in their way. Some policemen I came to know described running just ahead of this cloud and then throwing themselves into a building entrance from where they could hear the crash and screech of enormous things ripping through the streets.

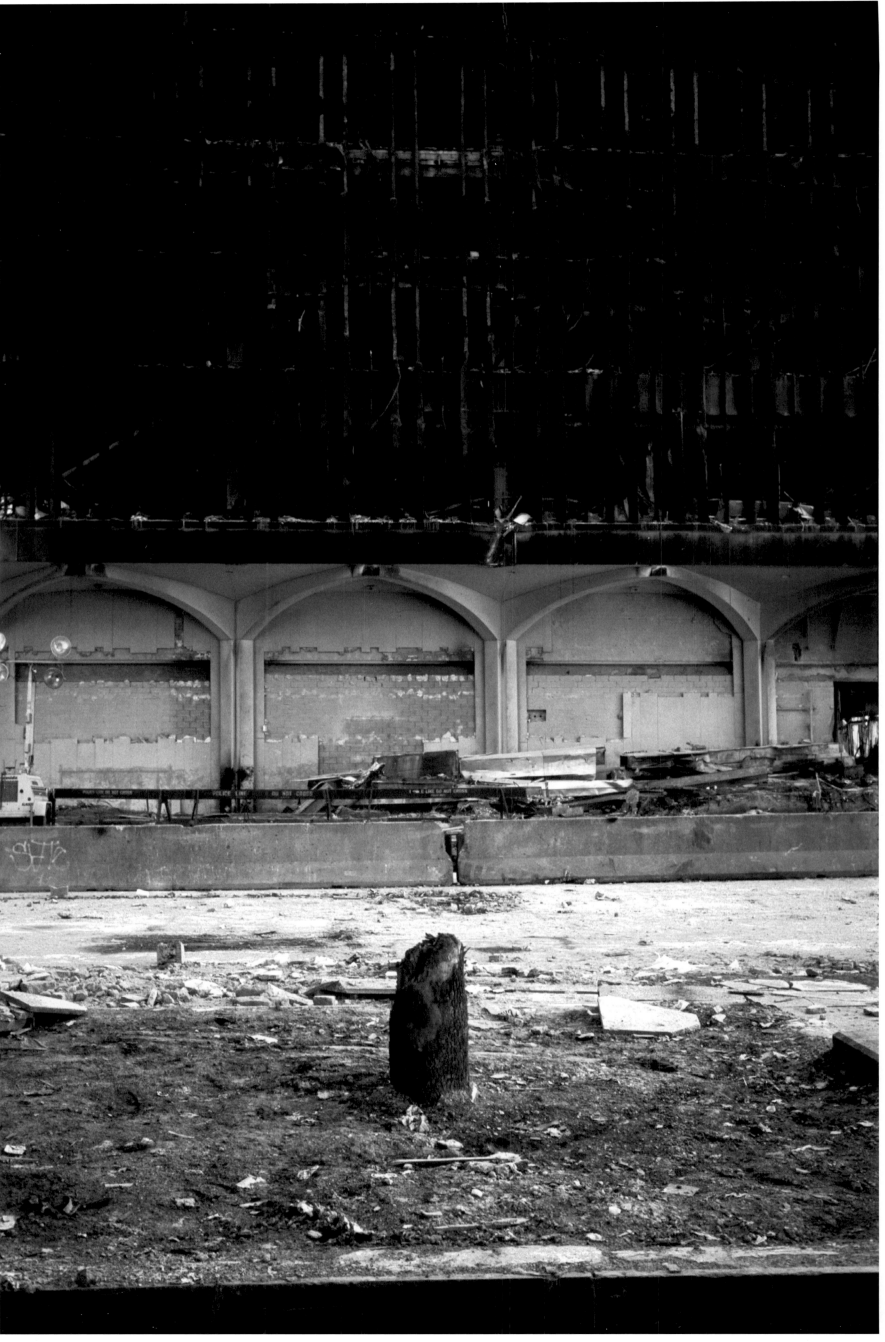

A tree stump in front of Building 5

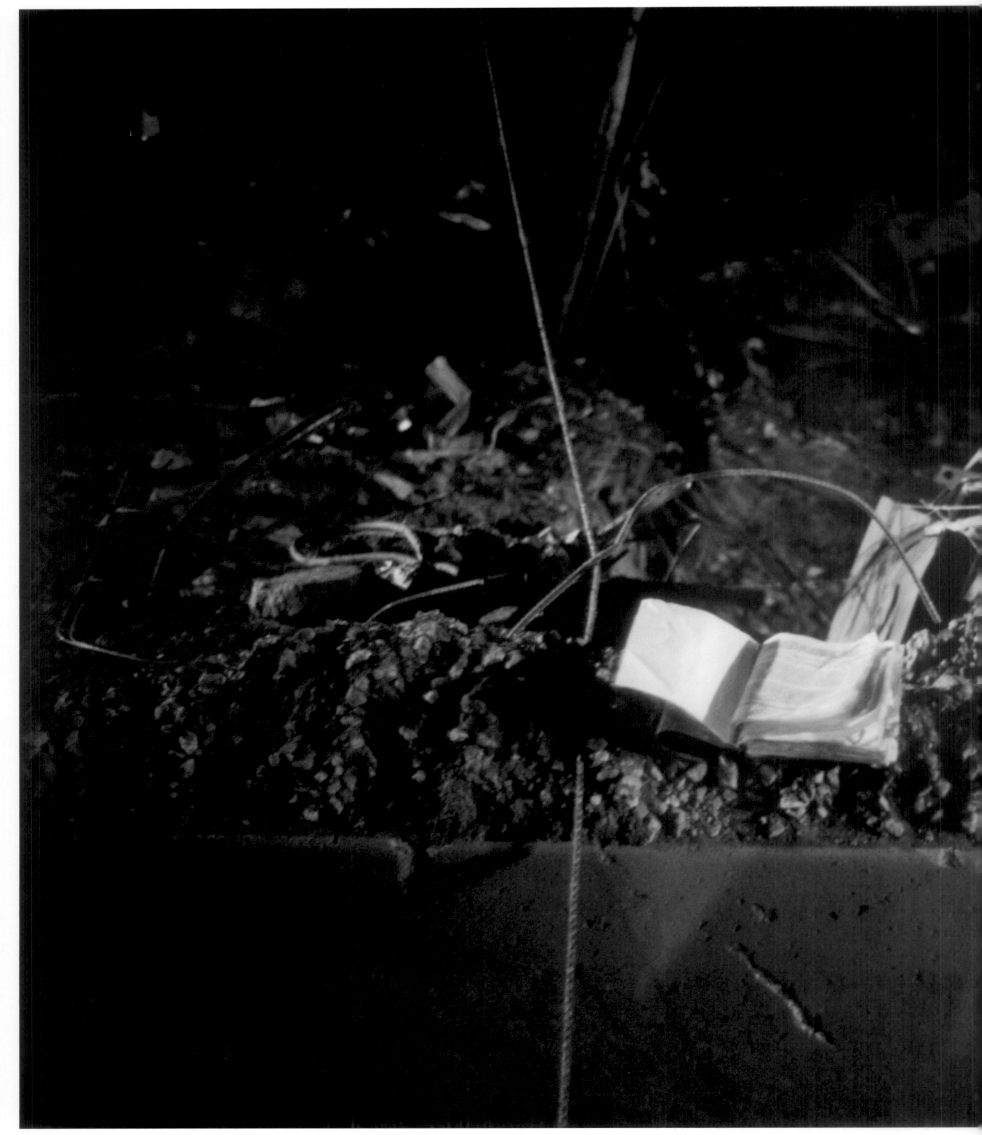

A book on the rubble near Liberty Street

One night, in a momentary lull amidst all the clatter and scraping and hissing, I heard the delicate sound of flapping pages. I turned and saw this book lying on the rubble near Liberty Street. What was so remarkable was that inside Ground Zero the heaviest and the lightest things were often what survived. Steel and paper were two of the most common elements found on the pile.

Some months later, Charlie Vitchers, who oversaw the work on the site, told me how family members would come to the perimeter of the zone and ask him or other workers to put mementos on the pile, and how one night some people gave him a book that one of the victims had been reading and left at home. Charlie placed it on the pile near Liberty Street.

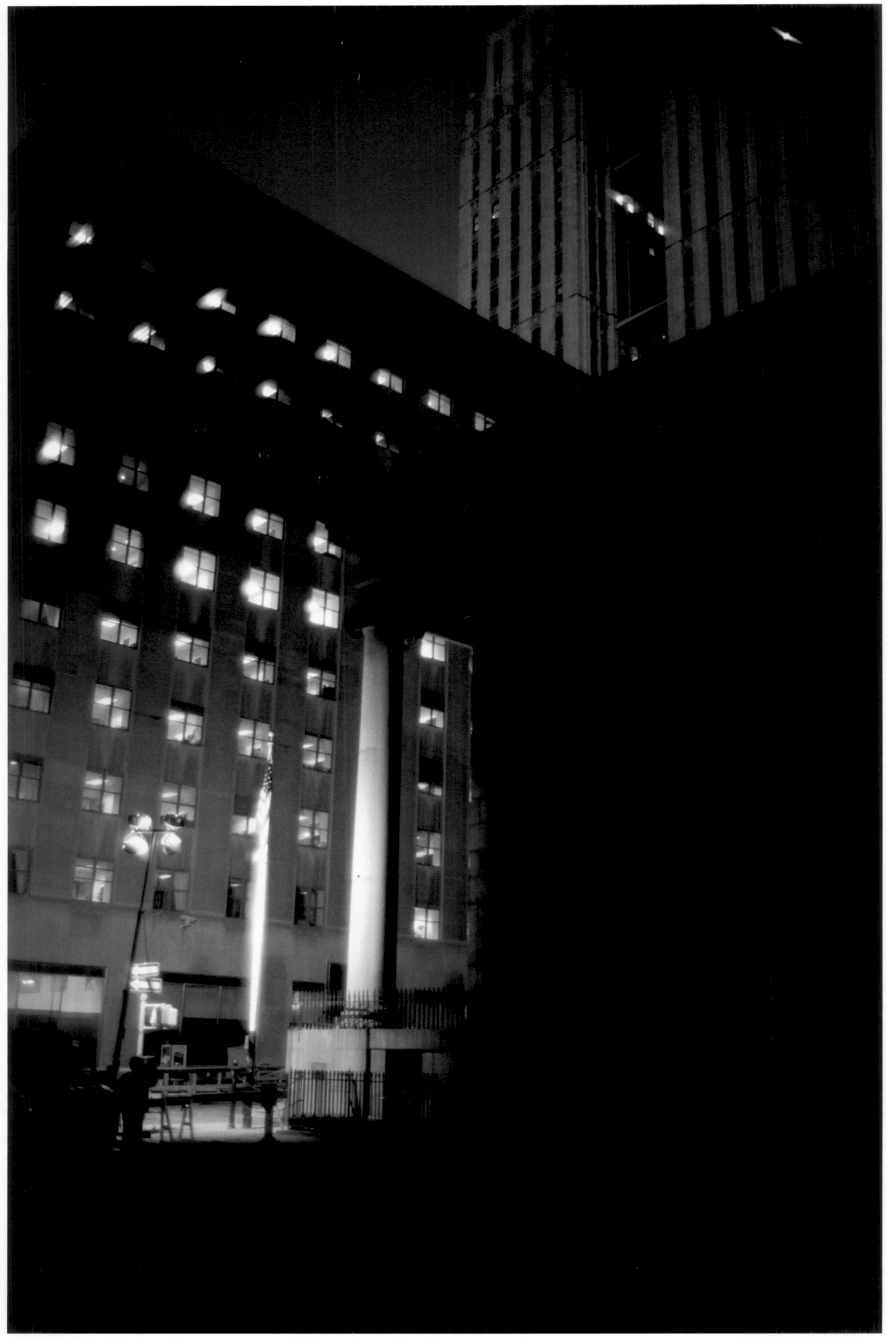

Dusk, the corner of Church and Barclay

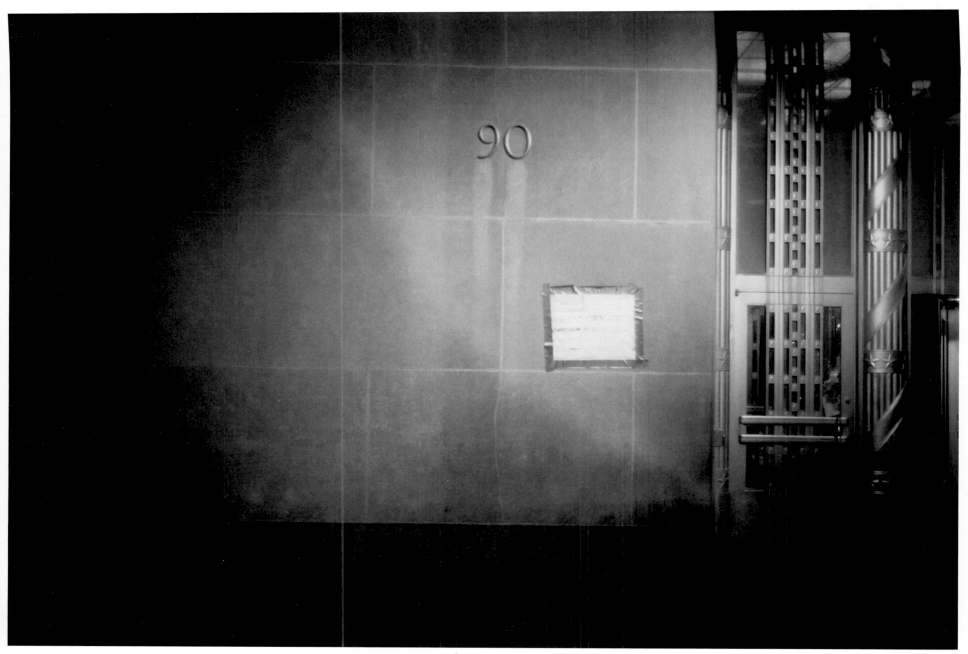

A handmade flag on 90 Church Street

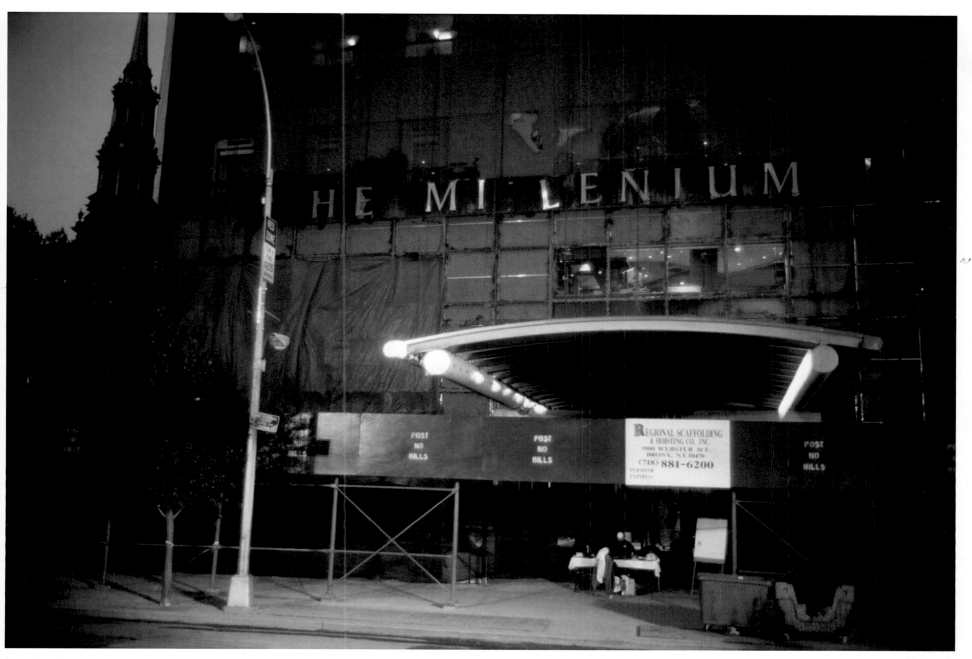

A security station at The Millenium Hotel on Church Street

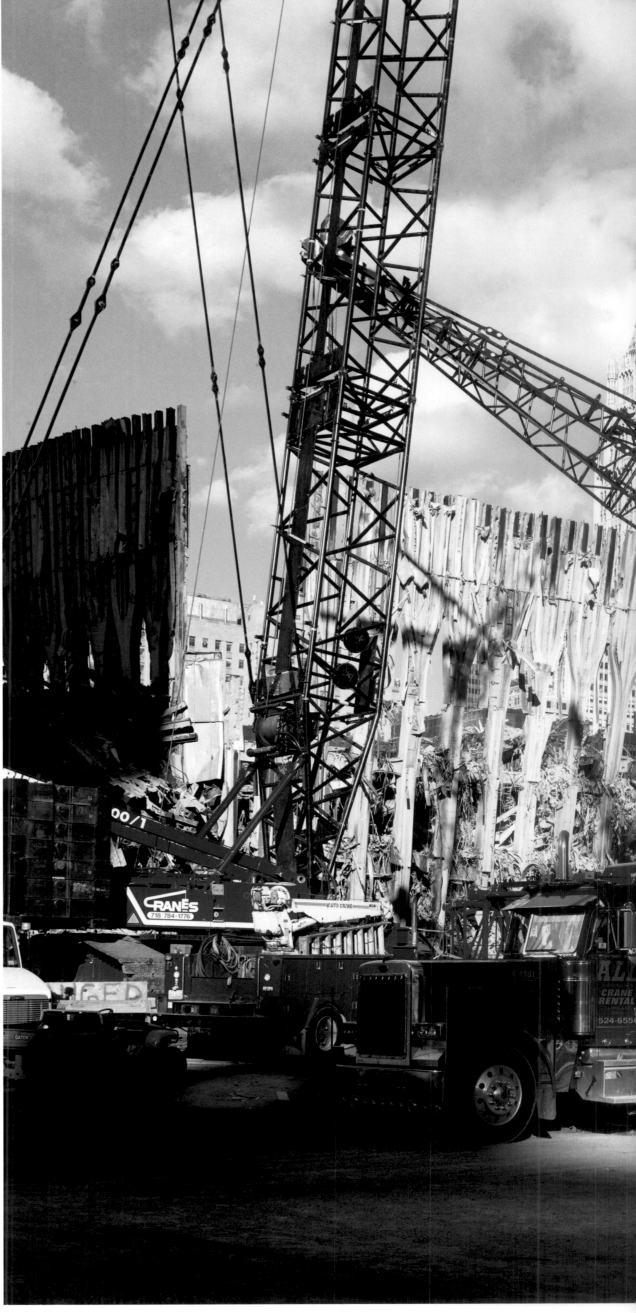

Like so many other days on the pile, this one started by my being thrown out. Two cops came over to me and said, "No photographs, you have to leave." I showed them my worker's pass and my letter from the director of the Museum of the City of New York, but they just brushed them aside, saying again, "No photographs, Chief Fellini wants you outta here." Trying to remain calm and reasonable, I answered, "Just let me explain to Chief Fellini what I'm doing here and—" "Hey, he wants you gone," one of the cops interrupted: "Now!" I realized that it was futile to talk to these guys, so I said, "Look, my car's over there," waving toward the South Tower, "so I'm heading that way." "Okay," they said, "but no more photographs!" I walked about a hundred yards and came upon this scene.

It was a stunning fall afternoon. As I stood there—the sun warm on my back, the air so clear, the colors so intense—it felt good to be alive. Instantly I felt the shame of that involuntary sensation, as I remembered that I was standing among the dead. It was a defining moment for me. Do I make a photograph of this, or should I let it go? But if I don't make a photograph, what am I doing here?

As I watched sunlight and shadow pass in waves over the site, I thought about nature's indifference to our passage on earth. Throughout history, great tragedies have happened on days like today. And yet it is often nature and time that eventually help move us away from grief, and grant us perspective and hope. I decided to set up my camera.

As I slipped under the dark cloth, I heard the sound of footsteps behind me, and a voice say, "What are you doing?" I stood up again, finding myself face-to-face with a determined-looking fireman. "No photographs allowed," he said. "Now wait a second," I replied, "I was just over with Chief Fellini" "Oh, that's a different story," he said, shrugging, and walked away. Chief Fellini came in handy several other times that afternoon. From then on, I always knew to find out who was Chief for the day and where his trailer was, so that I could drop his name and throw a gesture in the right direction.

A crane being erected on the corner of West and Liberty

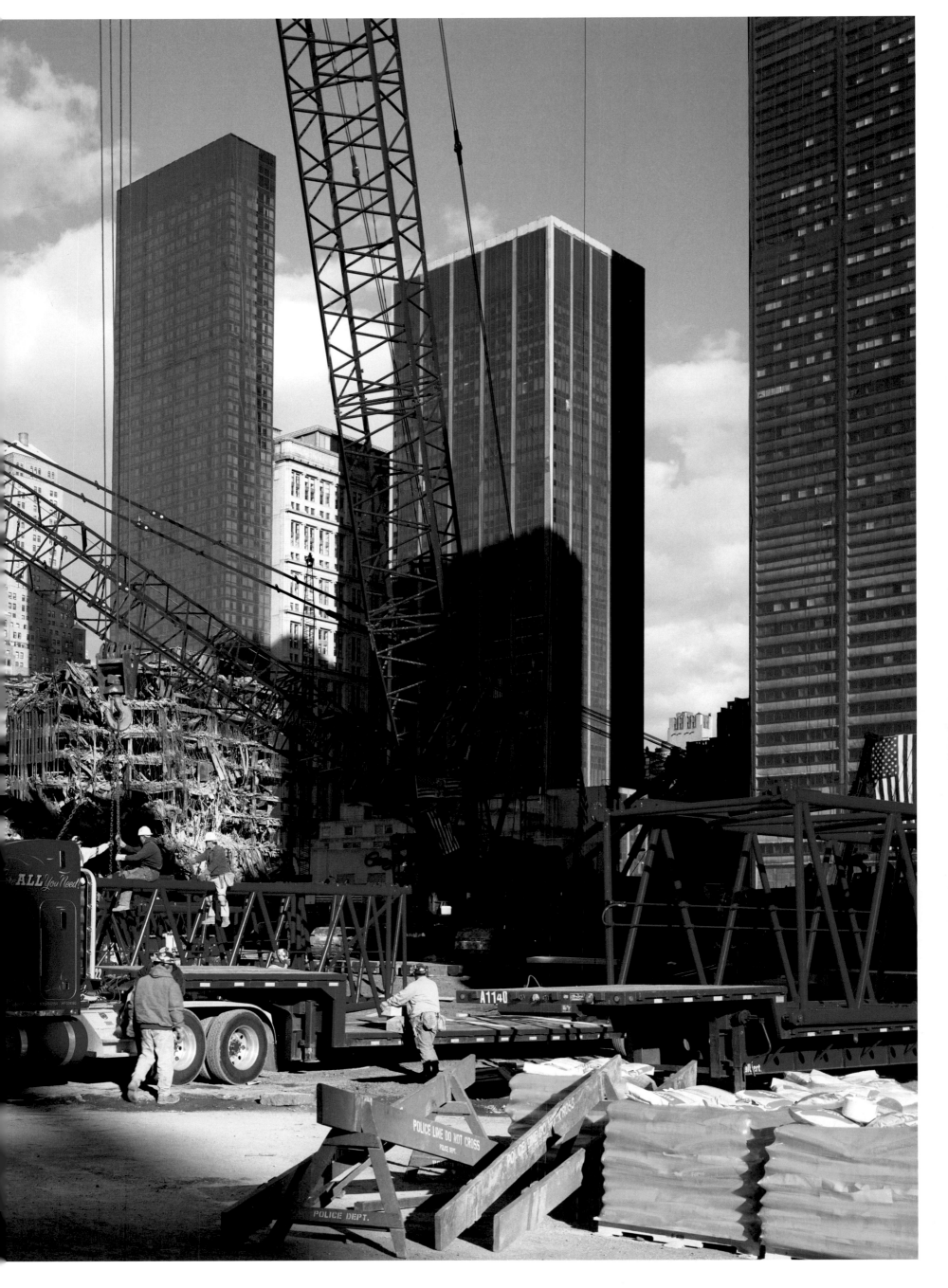

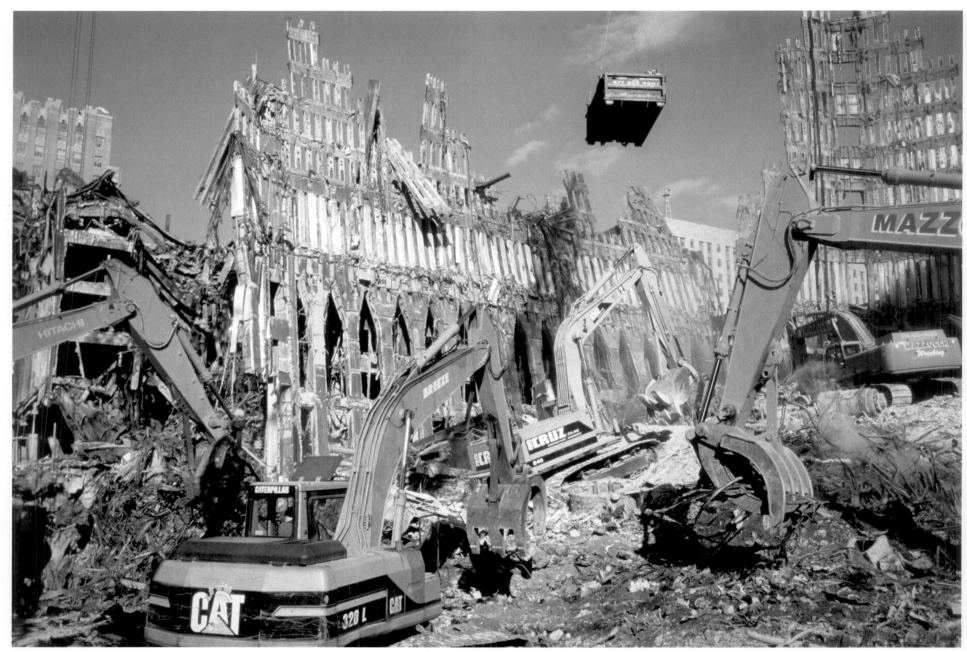
Grapplers daisy-chaining debris out of the pile at the North Tower

Exhaust tubes on Albany Street

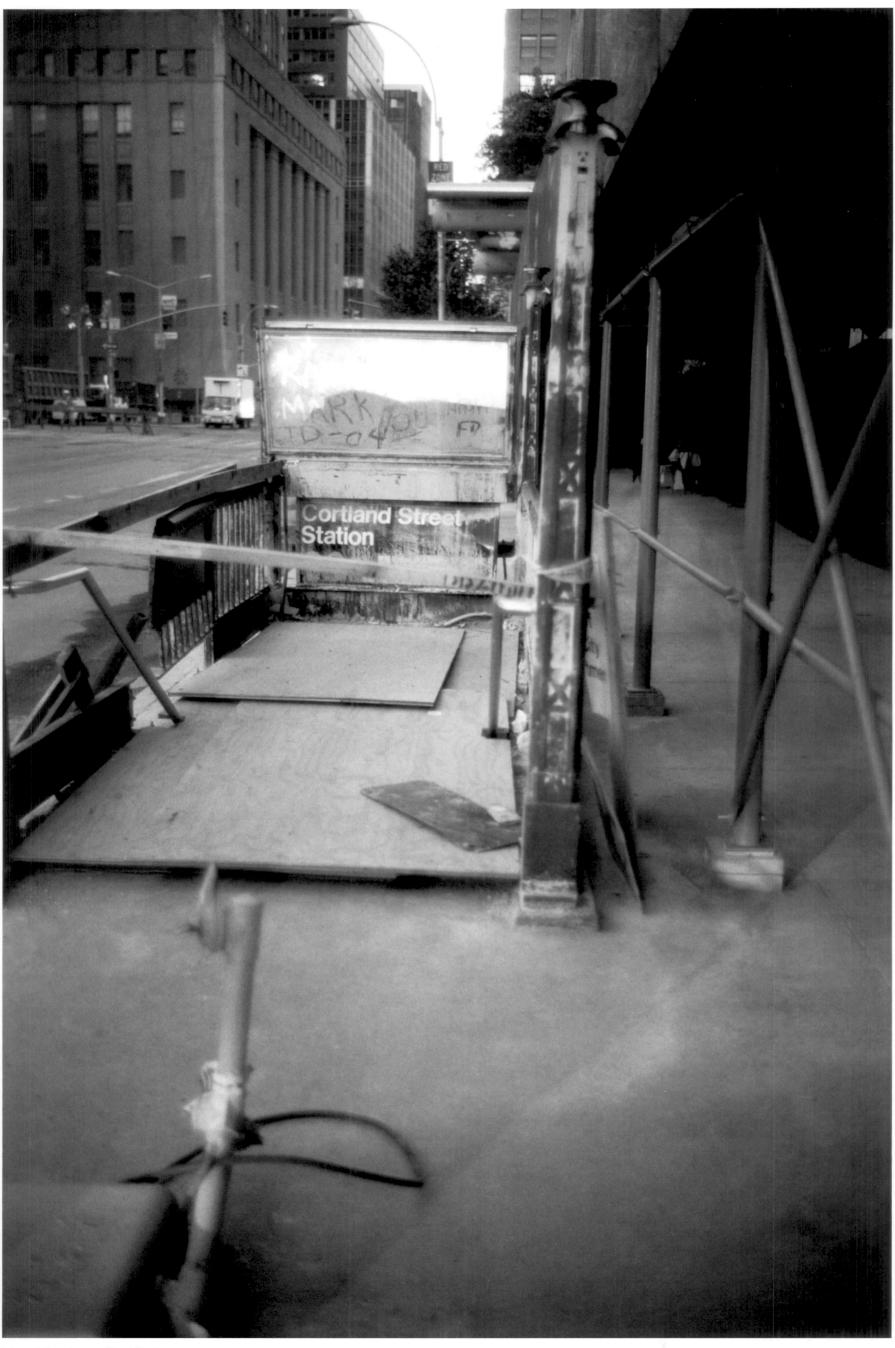

Subway station entrance on Church Street

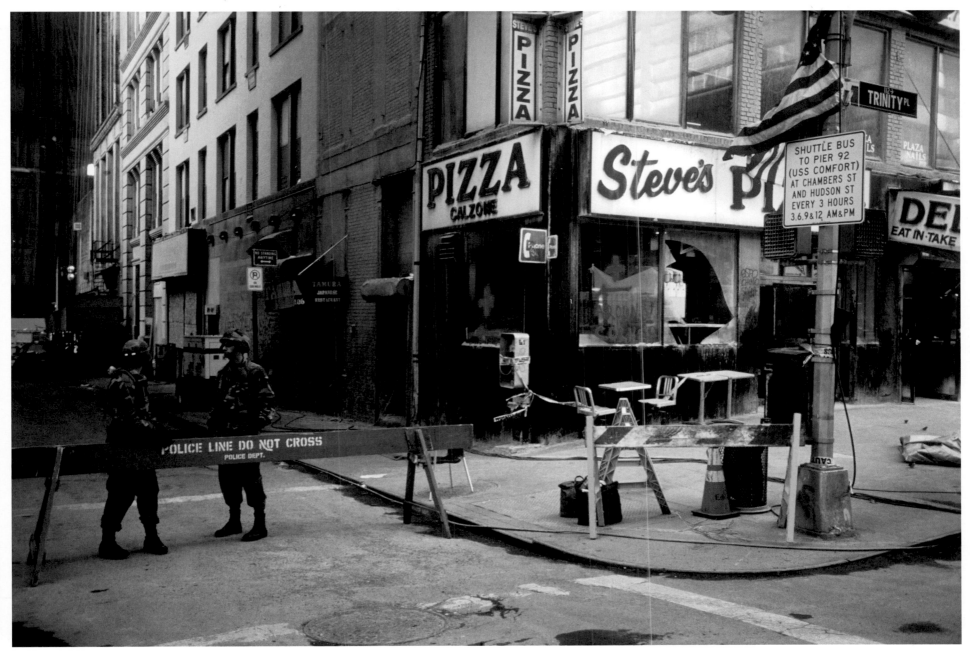

National Guardsmen on the corner of Trinity and Cedar

In the earliest days, getting into the zone required passing through many layers of security; often there would be one checkpoint right after another. It was as if each department thought of Ground Zero as its own territory. There was the NYPD, the Port Authority Police, the National Guard, the State Police, and plainclothes officials from the Federal government. The ban on photography was never lifted, but it was enforced with particular vigor in the early fall. Even many months later, though, there would always be someone—often someone newly rotated onto the site—who would feel that he was saving the pile from being photographed by throwing me out. If I sensed that my adversary was obstinate and determined to follow orders, I learned to simply leave and make my way around to the downtown perimeters, where the boundary was lightly manned and I could usually slip through. Here, at the corner of Trinity Place and Cedar Street, I was often able to take advantage of the guards' boredom and con my way in.

FOLLOWING PAGE: First you would hear the playful cries of "Room Service!" and there she'd be, one of the many volunteers who were everywhere around the pile and appreciated by everyone for the snacks, hot coffee, and cold drinks that they hauled over and around the rubble. The abundance of attractive young women doing the work provided a welcome distraction for those firemen and cops who were still grieving for their lost comrades.

A volunteer bringing food to the workers on Church Street

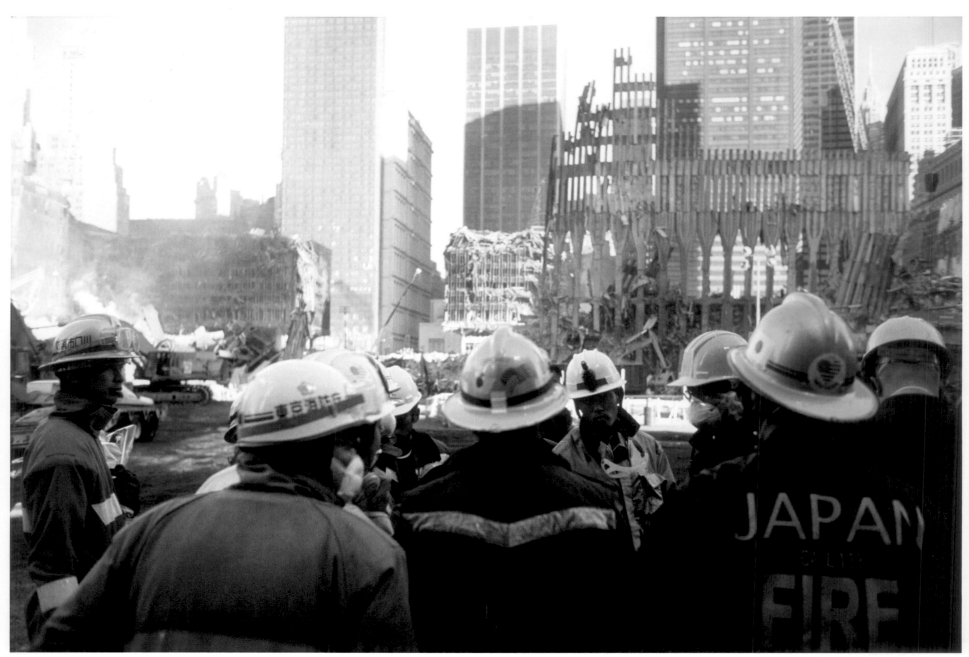

Japanese firemen visiting the pile

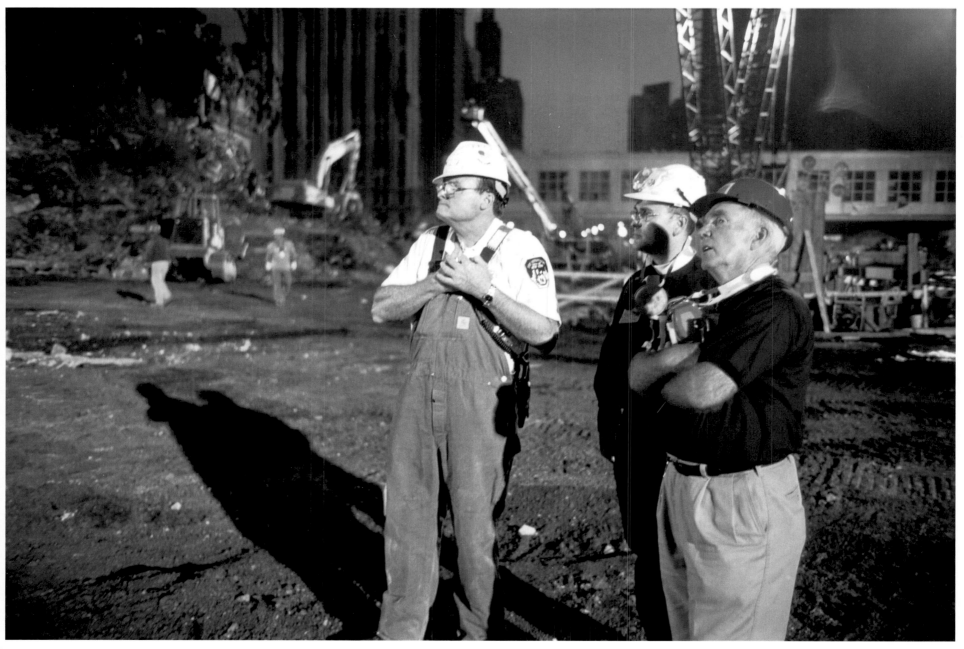

Chaplains and a fireman on West Street

A security guard at The Millenium Hotel on Church Street

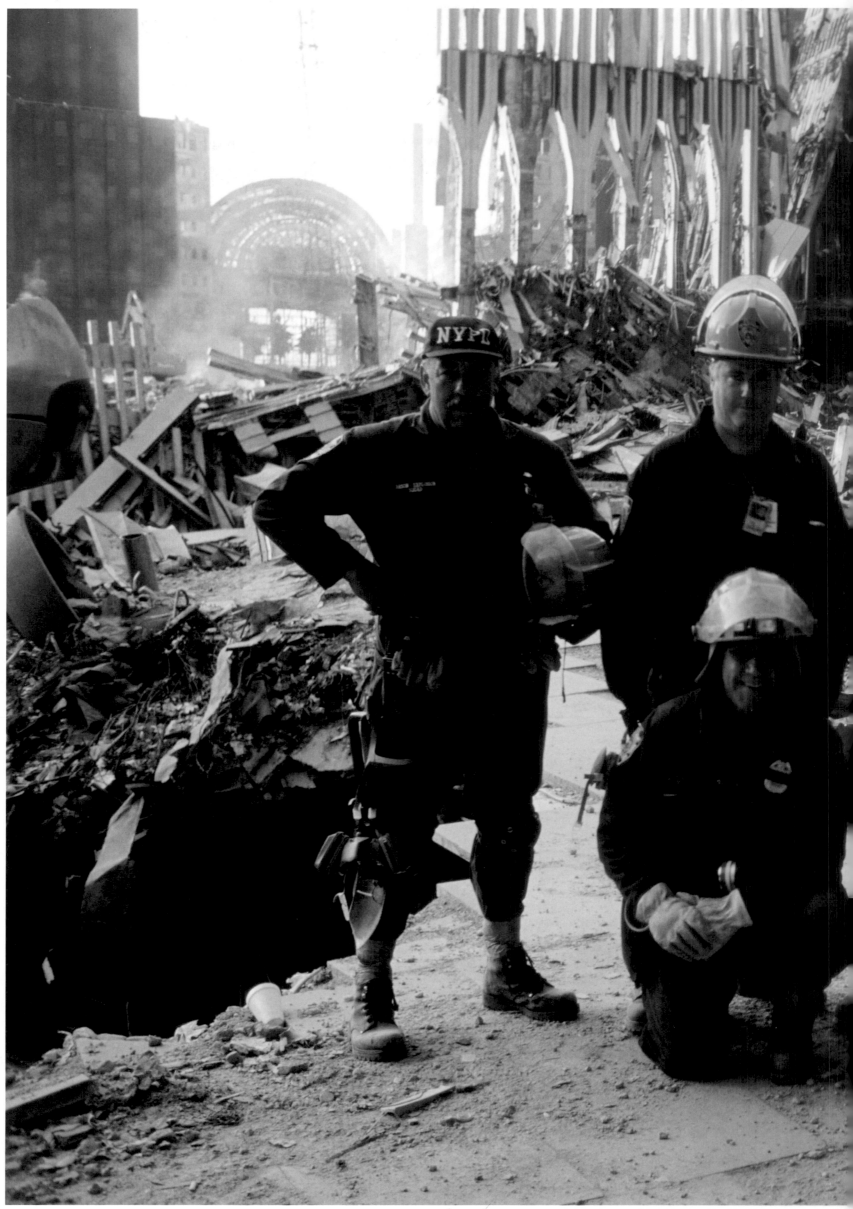

Detectives of the NYPD Arson and Explosion Squad, standing left to right: Det. William Mondore, Det. Michael Rooney, Det. John Faust, Det. Edward Scharfberg and Det. Amadeo Pulley.
Kneeling left to right: Sgt. John Santos, Commanding Officer Lt. Mark Torre and Det. John Ahearn. (Absent from picture: Sgt. Fred Manzolillo, Det. Kevin Parrett, Det. John Patane, and Det. William Ryan.)

A store window on Barclay Street

Posters and mementos on the back of a crane on West Street

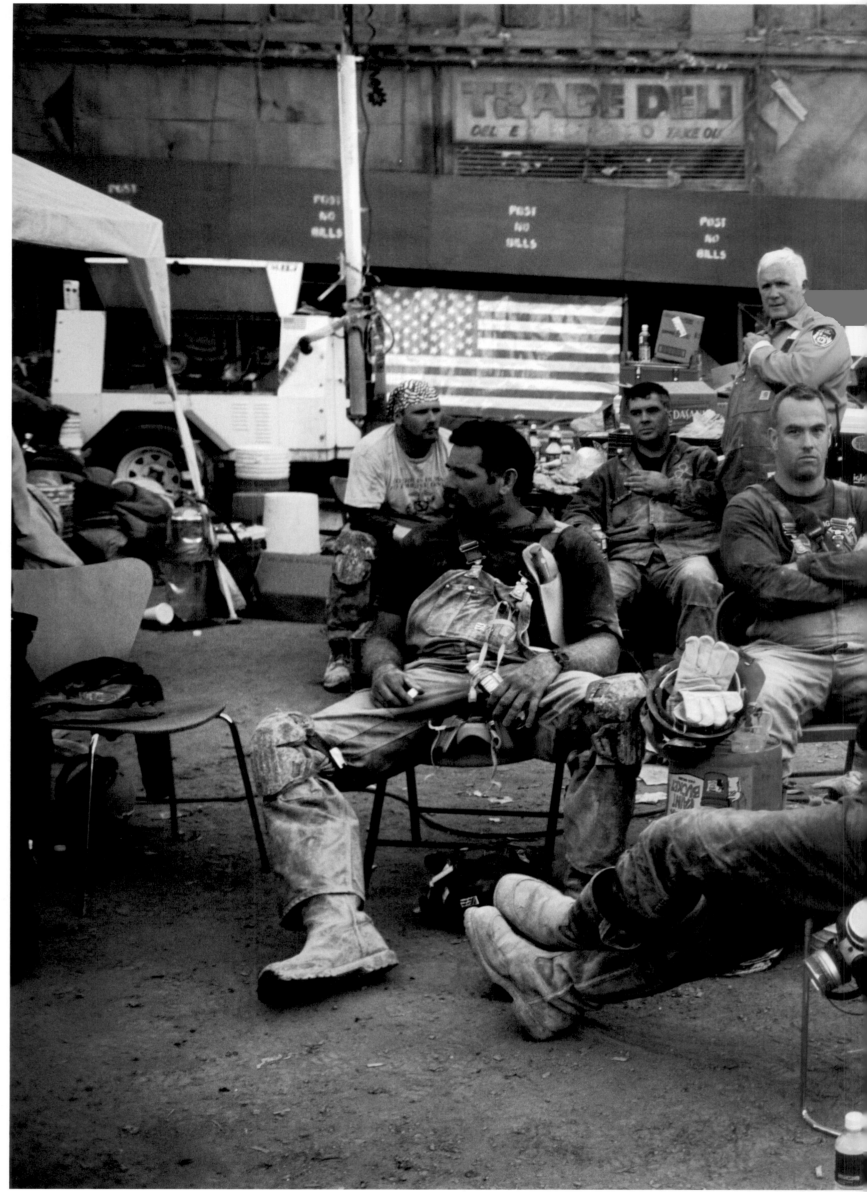

An FDNY rescue team resting on Liberty Street

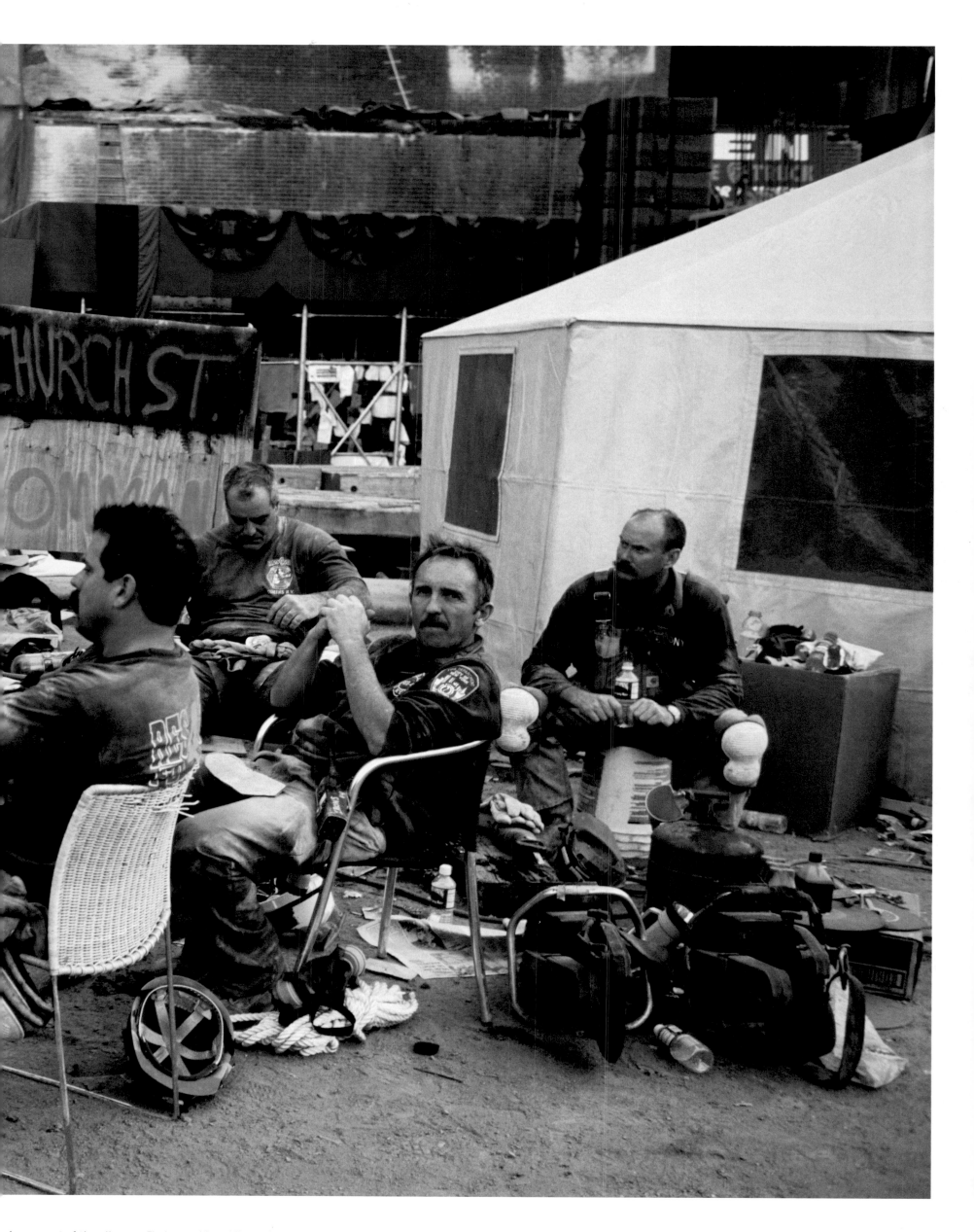

I came out of the pile near Firehouse 10 on Liberty Street and saw this team of firemen resting on one of the crazy collections of chairs gathered everywhere around the site. You'd see executive desk chairs and cafeteria chairs, bentwood and plastic, high-tech stainless and Barcaloungers, Breuer chairs and Danish modern, all rudely assembled at the perimeter of the pile but almost always facing it. In these makeshift bleachers, weary men and women had a sandwich or a smoke, and stared at the spectacle in front of them. No matter how many hours you had just put in, or how long you had been working on the pile, the fascination with what it looked like always called you back to it. The thousand or so workers who were able to enter the site daily were bound together by this experience. The outside world, where life was beginning to resemble its earlier self, was increasingly cut off from life inside the "forbidden city."

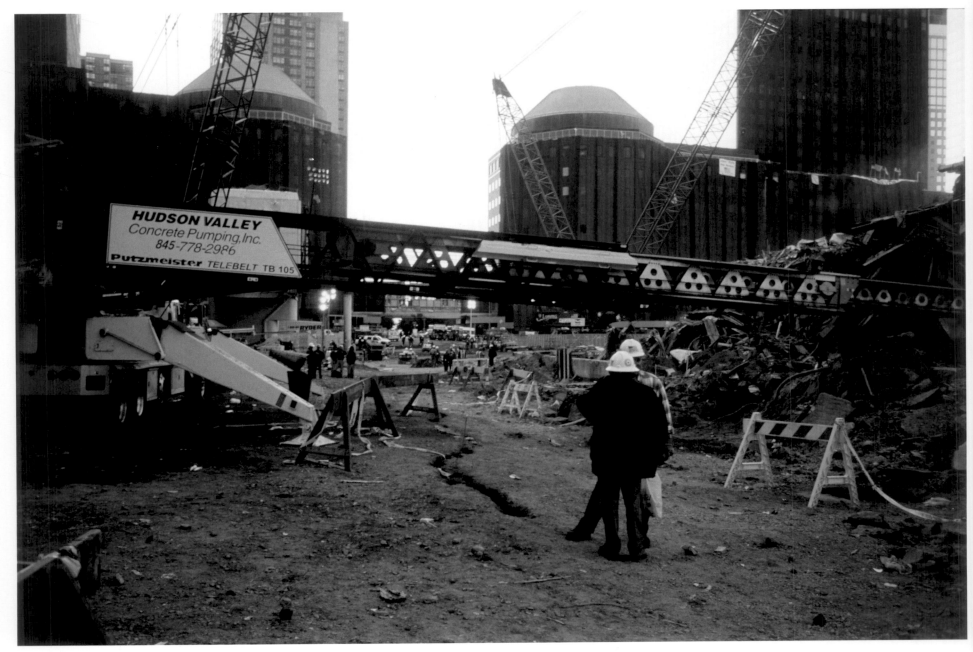

A crack opens on Liberty Street

I rounded the corner of West and Liberty and realized that something was deeply wrong. A crack nearly a foot across had opened on Liberty Street the day before, and now it was zigzagging its way east in a broken line. Certainly there were more engineers and manager-types in the vicinity than usual. What did it mean? Soon the word started spreading around the site. The slurry wall was moving.

When the World Trade Center was built, the excavated earth from the foundation site was dumped along the east bank of the Hudson River to create the landfill for Battery Park City. The hole left behind was reinforced by the slurry wall: a massive, concrete dike, or "bathtub," designed to hold back the river and gird the four sides of the eleven-acre hole in which the towers would sit. Now, because of numerous combined forces upon the wall—water seepage from the river and from all the water used on the site, the collapse of some underground levels whose outward thrust had helped to stabilize the walls, and the force of the concussion and compression of the buildings' fall—the south slurry wall was moving northward.

The great fear was that, if the slurry wall failed completely, river water would come in and flood the site—not to mention lower Manhattan, the PATH train tunnels, and the subway system. The potential for further disaster was on everyone's mind. Teams of engineers worked their way down as far as they could to inspect the situation along the west and south walls. It was decided to employ once more the tie-back system which had originally helped to hold the walls in place, until the six levels of underground structures could support them. Now, the old tie rods would be drilled out and replaced with new ones to anchor the wall more securely into the bedrock. This emergency solution was both tremendous and ongoing. As the bathtub was emptied of debris, making more of the walls accessible, the ties would be replaced, even as the other operations on the site continued at the same pace. And so, with little fanfare and considerable expertise and ingenuity, lower Manhattan was saved.

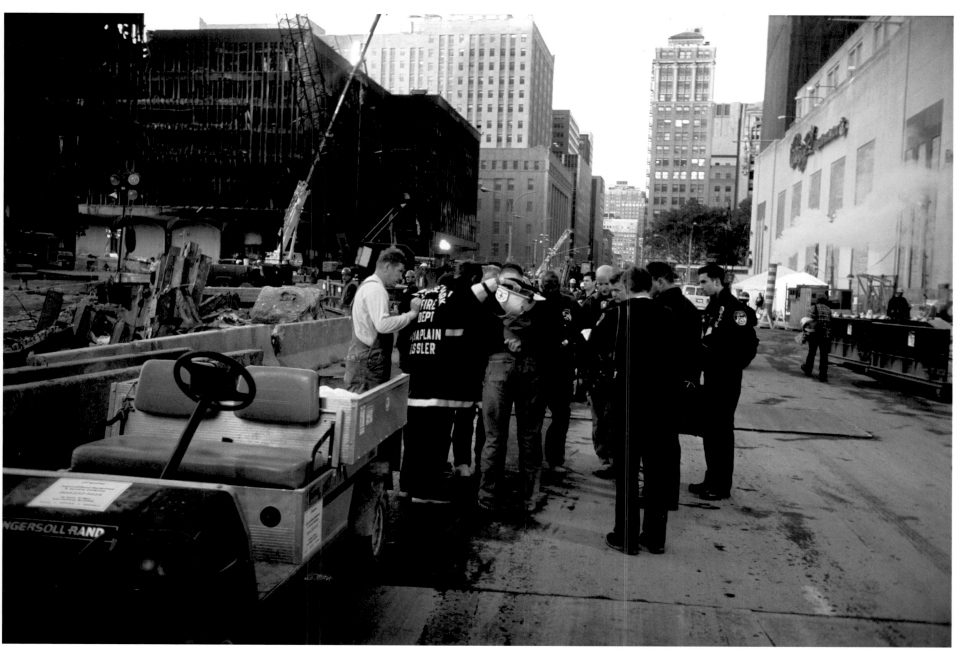

An impromptu prayer meeting on Church Street

I can't say for sure how often this happened, but I witnessed these spontaneous gatherings enough times to convince me it was a frequent occurrence. It might be that someone would come out of the pile and, overcome by what he had seen or handled, sink to his knees, or stand weeping in the street. Then, seemingly out of nowhere, a chaplain would appear with a few other workers or firemen, and form a circle around him. The grieving recovery worker would be held, or comforted, or a prayer would be shared. These brief interludes seemed to restore the resolve necessary to go back in again.

There was an abiding sense of spirituality in that place, brought about not by conventional methods but through the devotion of the one thousand workers who had committed themselves to healing the wound and recovering the remains of the dead. My signature memories of Ground Zero are gardening images—a man with a rake, or a man on his knees with a hand tool—gestures older than the Bible.

What I came to understand was that the real religion of America is individuality—that is our birthright, our offering to the world. Here you are free to be yourself, and that condition is more precious to us than anything else. This was repeatedly demonstrated by the way the workers searched for every last bit of evidence they might find—a tooth, a knucklebone, a wedding ring—anything that might identify an individual and bring solace to a family. The care they invested in this task brought to the vast physical dimensions of the site an intimate, spiritual element.

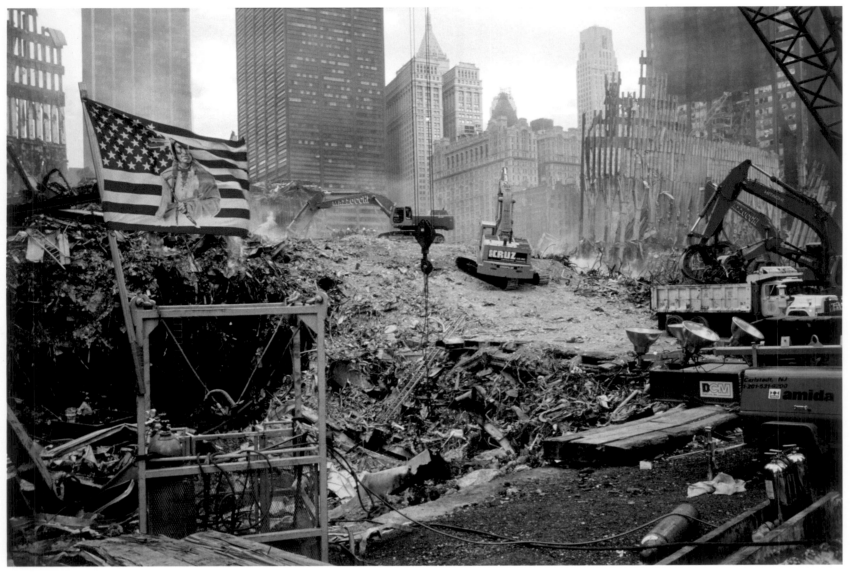
A man basket flying the Stars and Stripes with a Native American in its center

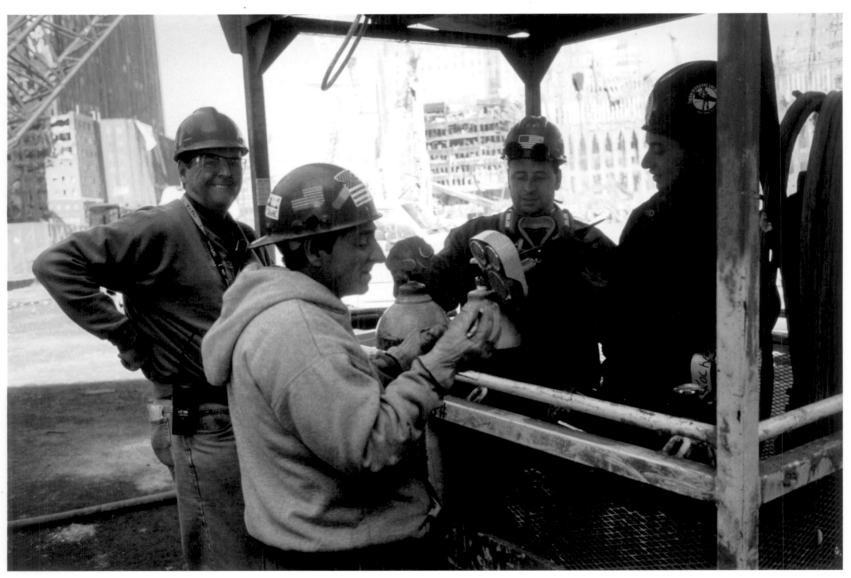
Ironworkers preparing to go up in a man basket

There was an exquisite cooperation between the crane operators and the ironworkers suspended in the man baskets. In the photograph opposite they are giving the South Tower a "haircut," as they called it. The shrouds were immense and immovable, anchored as they were in the bedrock seventy-two feet below ground. The only way to bring them down was by trimming the wall, one story at a time. A second crane would secure the pieces as the ironworkers cut them free and then place them onto the pile below. The baskets almost always flew the American flag, or sometimes a Native American variation.

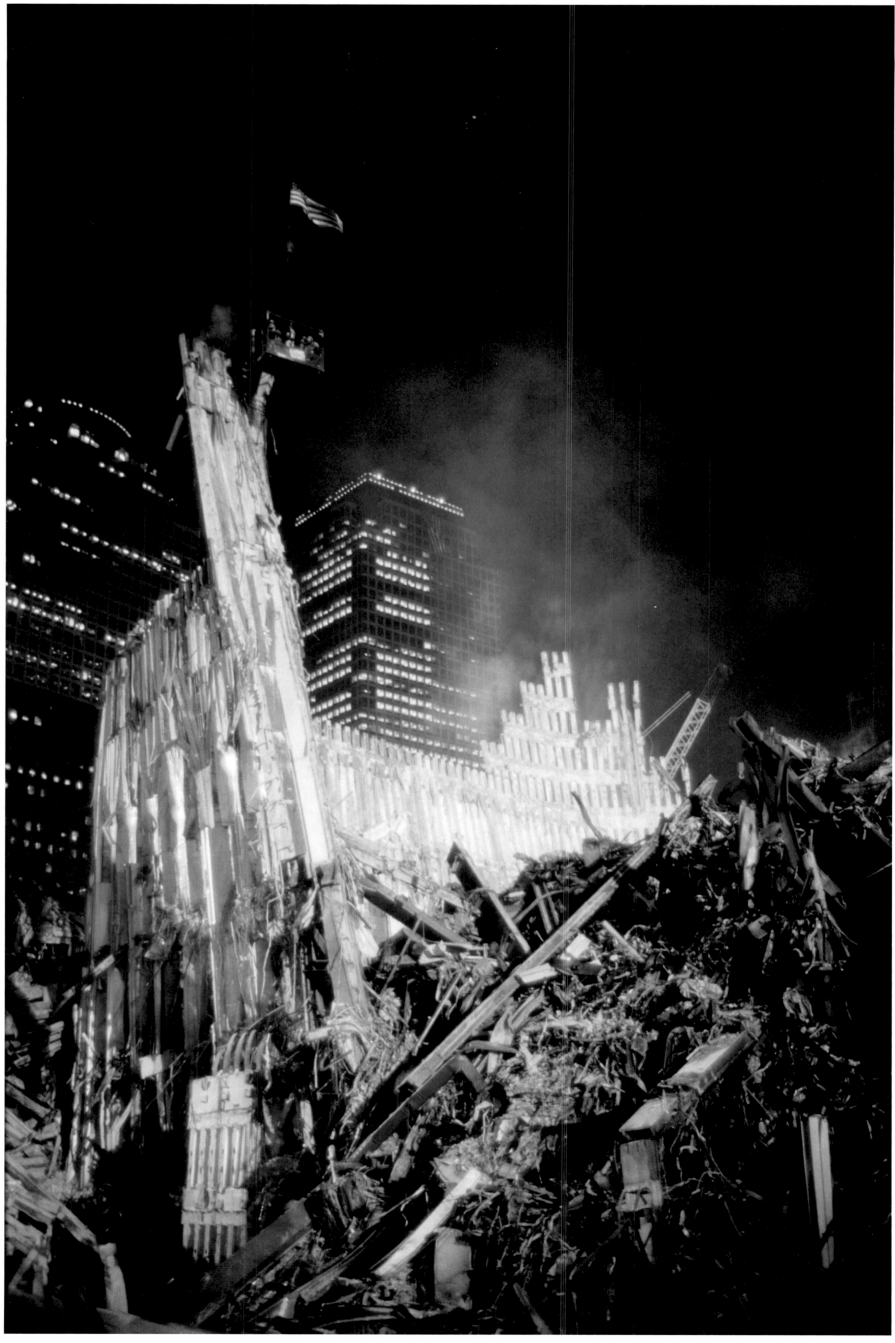

Ironworkers giving the South Tower a haircut

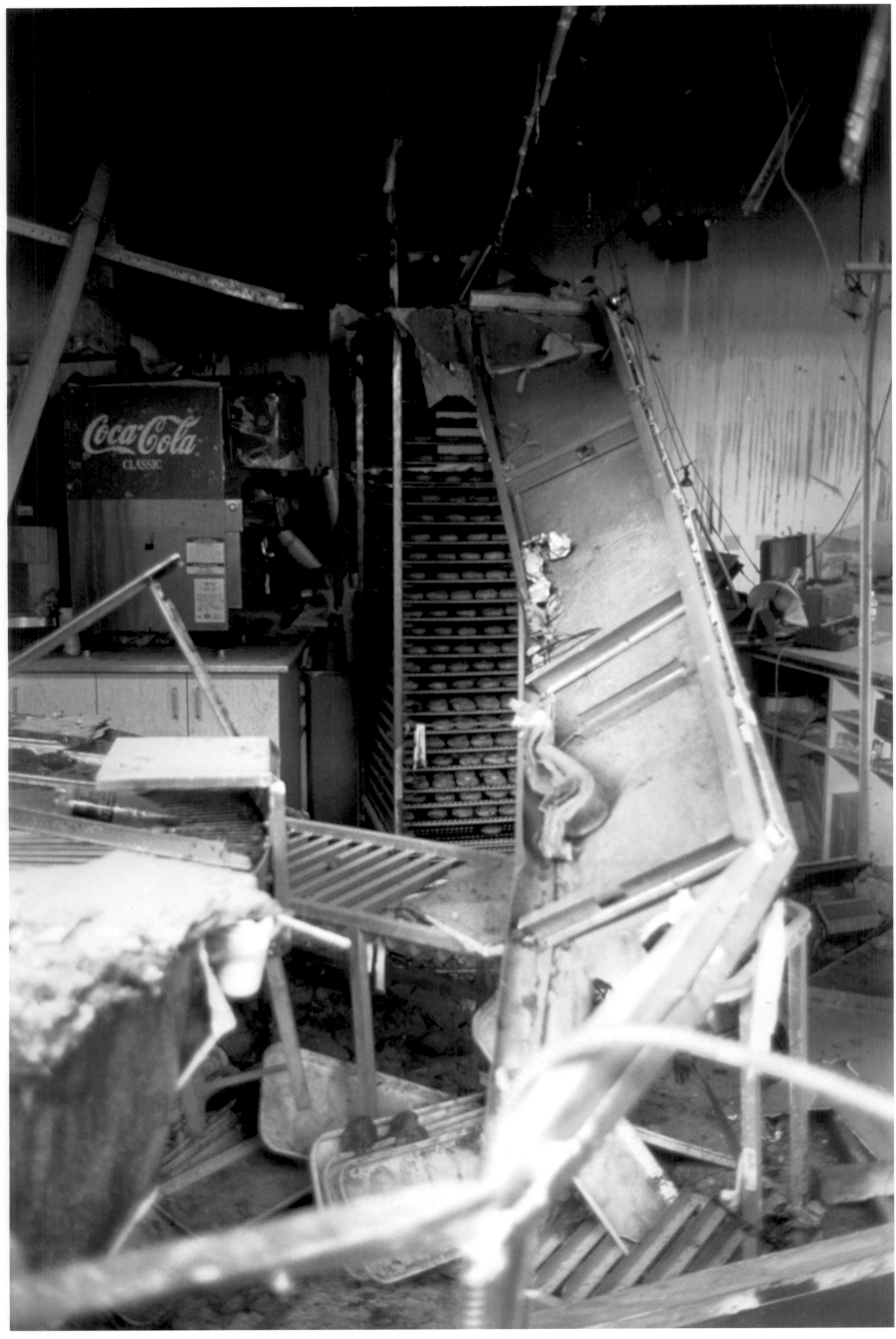

Donut shop in Building 5

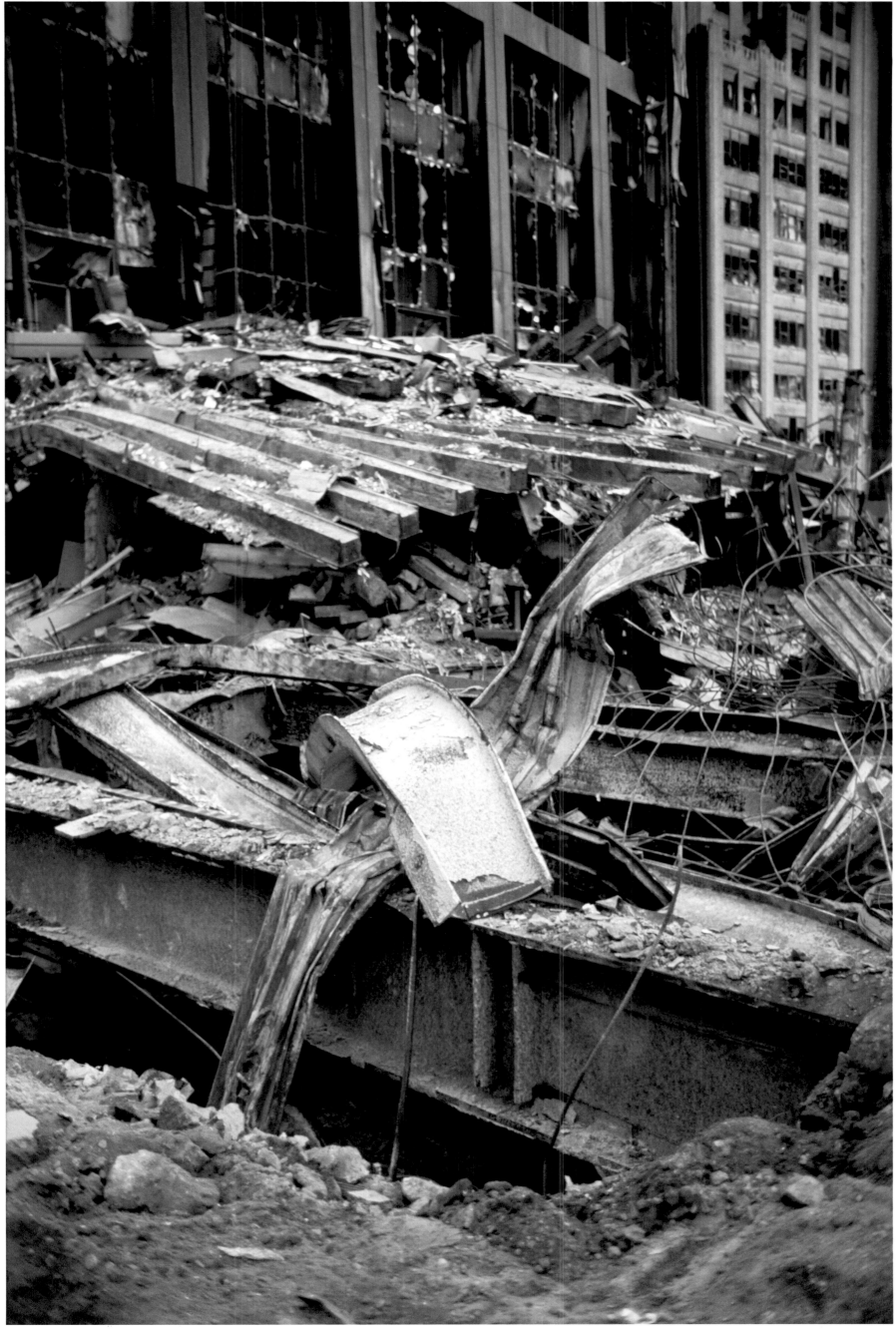

Debris in front of the Bankers Trust Building on Liberty Street

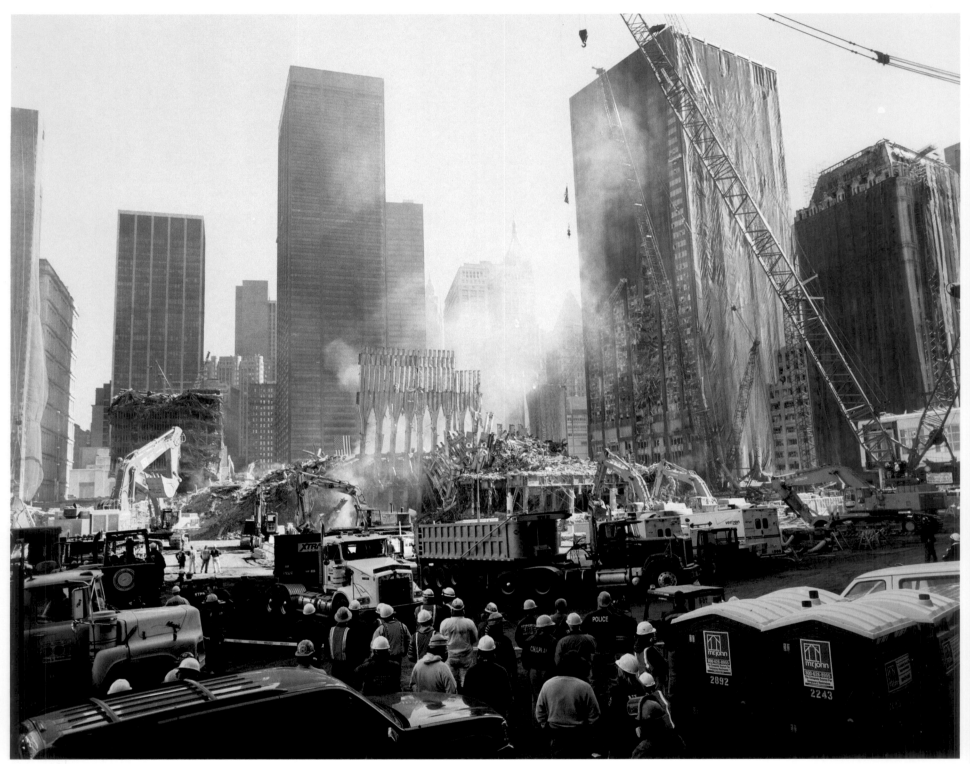

Workers watching as two grapplers attempt to pull down the South Tower shroud

10.18

It was a clear afternoon—warm in the sunlight, cool in the shadows—and this test of strength between two manmade objects drew a small crowd at the site. The attempt to pull down the South Tower's shroud smacked a little of horses pulling timber at a county fair, and there was a festive excitement coursing all along West Street. The wall st ll stood about eight stories tall, and it was anchored in bedrock six stories below ground. The grapplers had tried to pull it down once before, but they had failed. Now that more debris had been removed from along its base, they wanted to give it another shot.

Two of the biggest grapplers stood at the ready, like giant horses, about eighty yards away. Each held in its bucket an iron bar with thick steel cable wound around it; the other end of the cable was tied to the top of the shroud. At the signal, the grapplers simultaneously raised their arms and began backing away and forcing their buckets down, as if they were pawing at the air. The crowd watched expectantly, hoping to see the wall give way and share in that sense of triumph. But instead there was a pistol-like crack—almost a sonic twang—as the cables snapped and the grapplers reared back and up on their treads.

Still people lingered, happy to pause for a moment in their work and take in the scene. Again the crew secured the lines to the wall, and the grapplers repeated their maneuvers. Once more, however, the volley of snapping cables echoed across the pile, and the shroud remained standing. Slowly, the fair-like atmosphere drained away as we returned to our various labors.

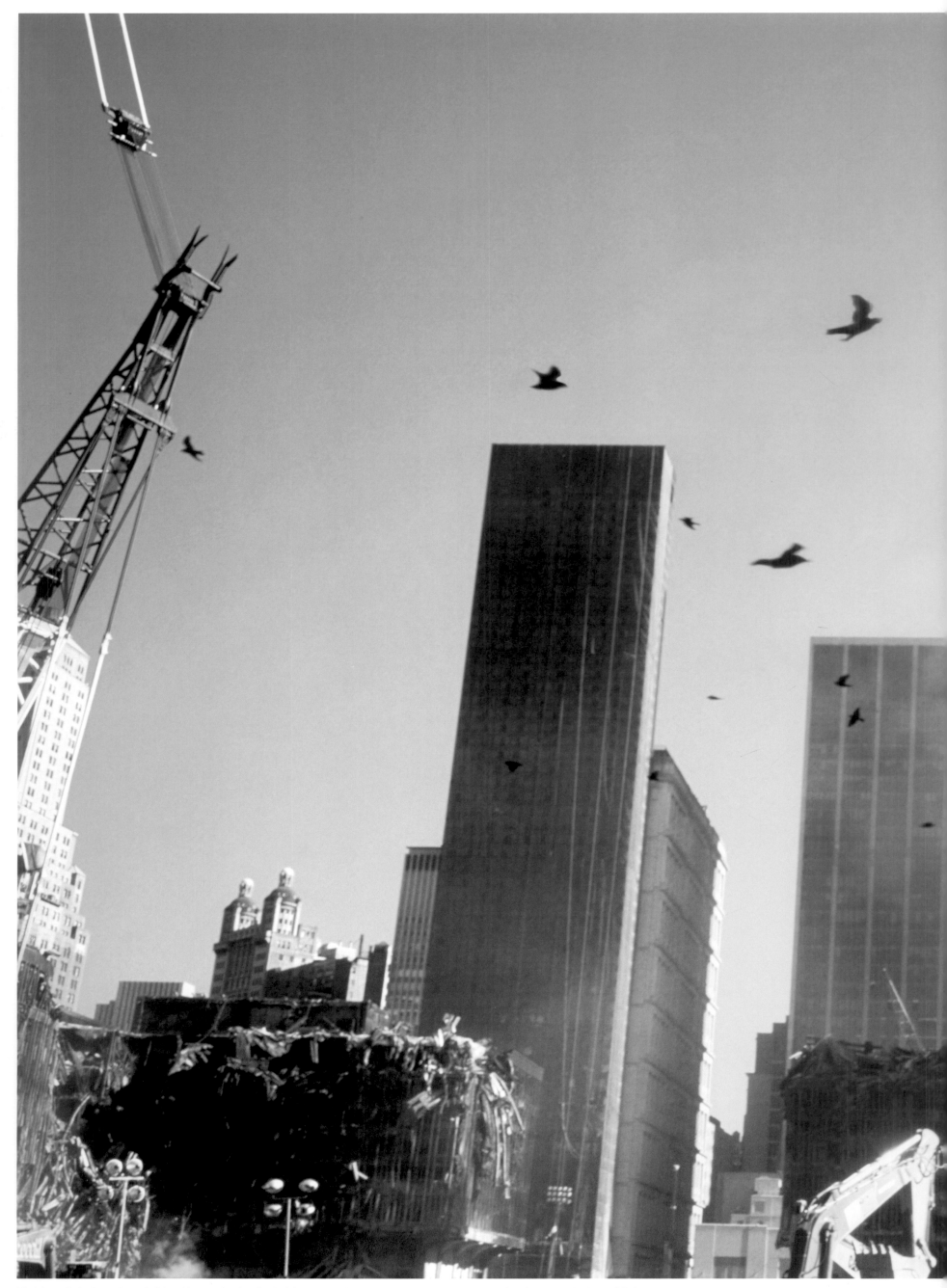

I don't know whether it was the crack of the cables snapping that disturbed them, or pure chance that they were passing overhead, but for a few minutes the sky was full of birds wheeling through the sunlight and smoke, their calls and whistles bringing a touch of nature, momentarily, back into the zone.

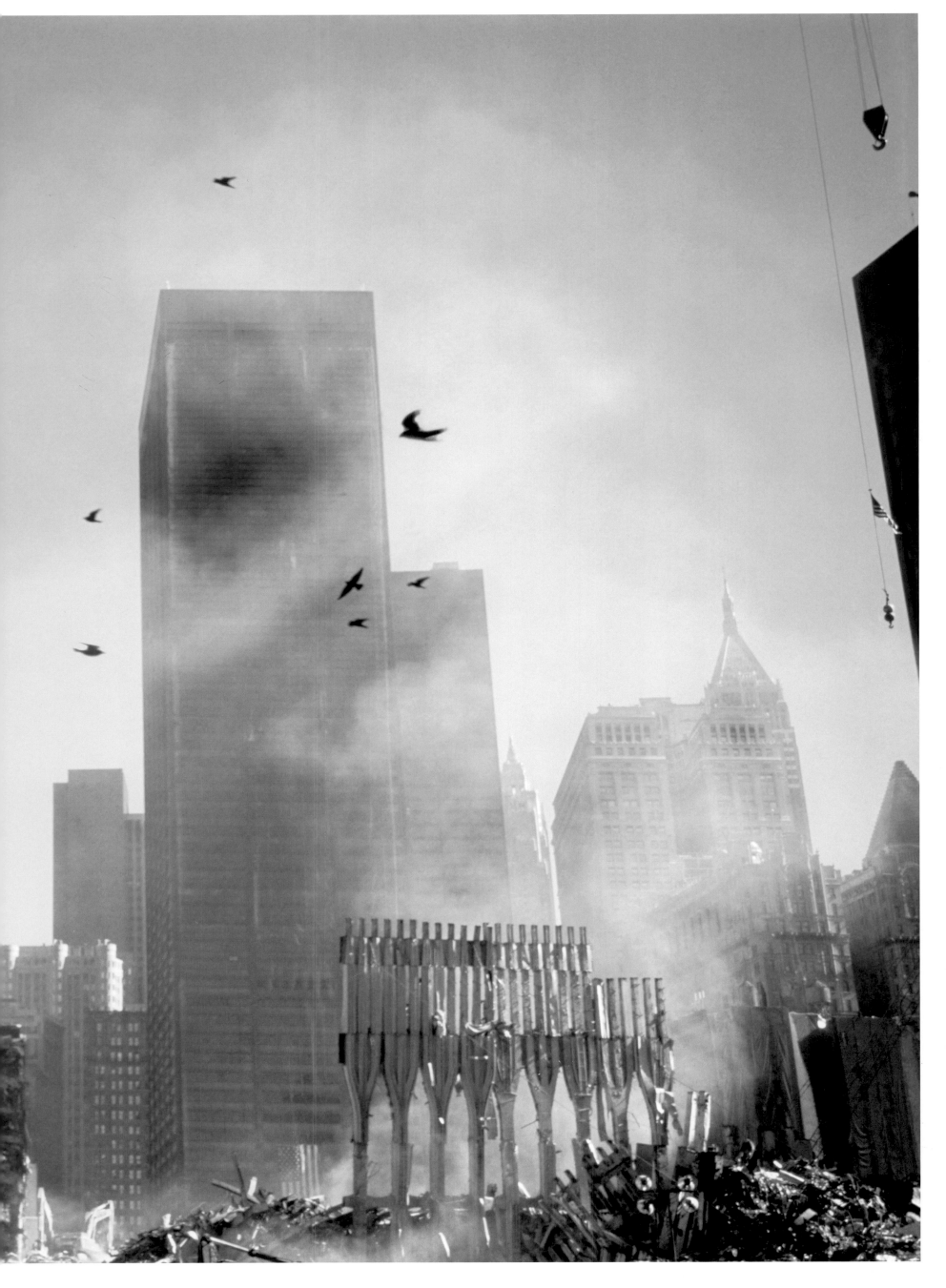

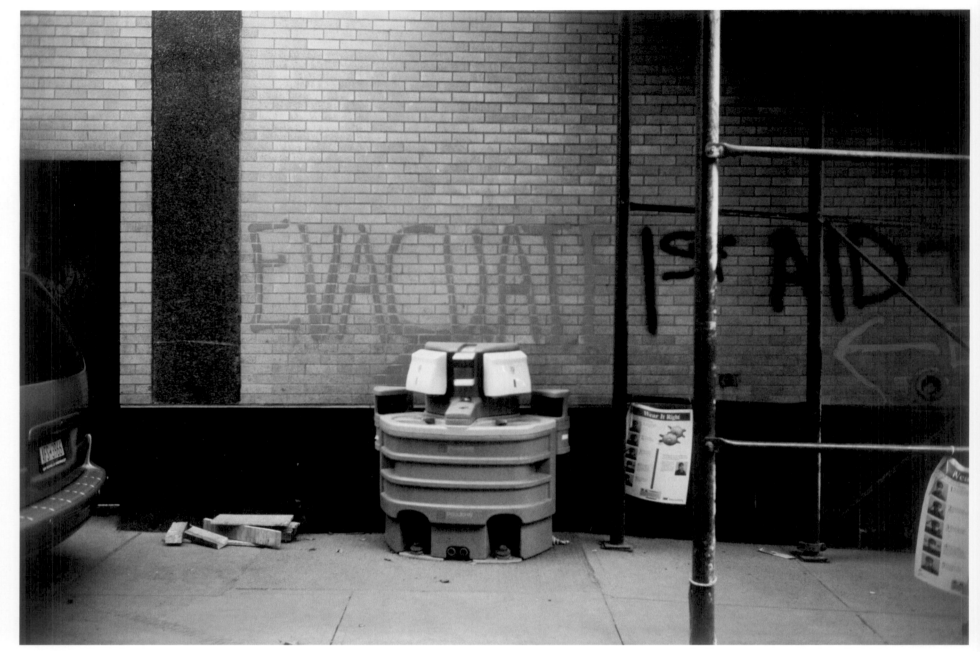

Spray-painted signage on Cedar Street

10.21

New Yorkers are used to graffiti. Often it is badly drawn and noisily cursive, a defacement of public space calling for attention but empty of content. All around the pile, however, urgent and powerful writing was scrawled on the walls, crying out with meaning. "TRIAGE" it shouted. "MORGUE" it pointed. "EVACUATE" it screamed in day-glo orange. And in the dust on windows and marble façades it whispered or lamented: "Pray," "Missing," "Have hope," "Where's Frank?" These fragile notes—written in the dust of the towers and exposed to the wind and rain—survived for months in the midst of so much else that had been destroyed.

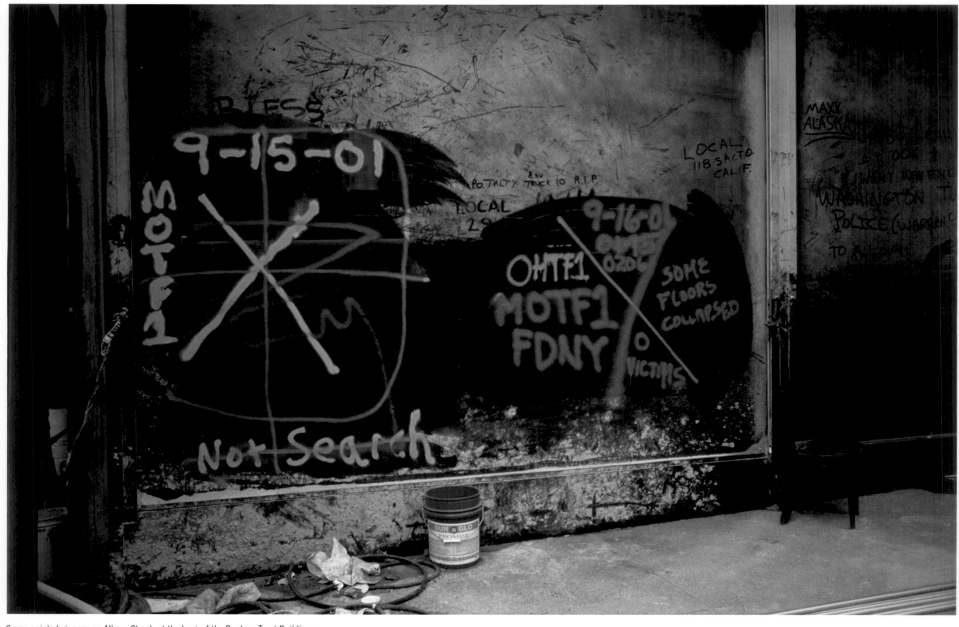

Spray-painted signage on Albany Street, at the back of the Bankers Trust Building

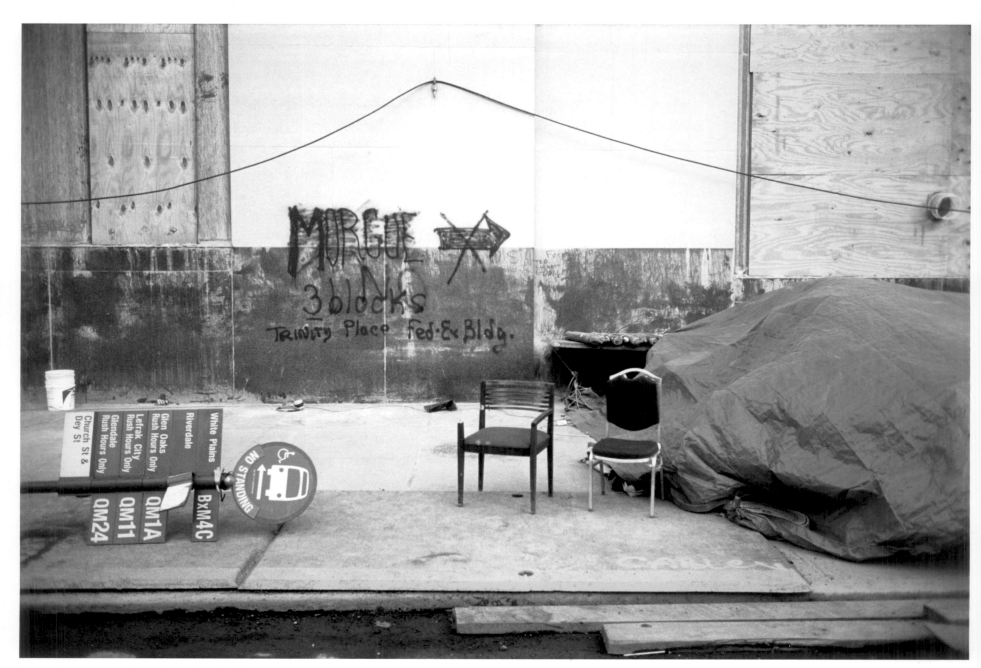

Spray-painted signage on the front of Century 21 on Church Street

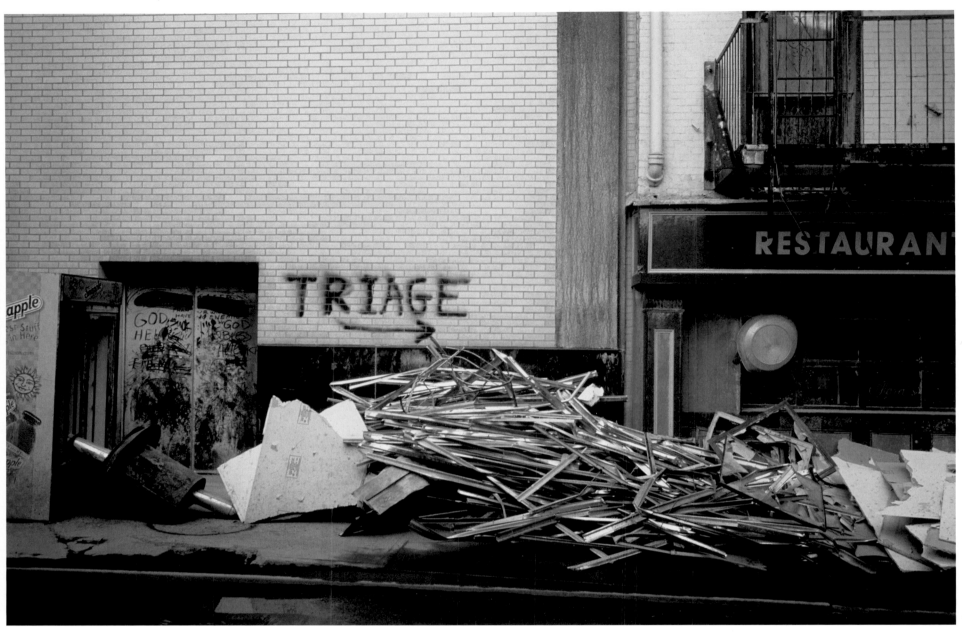

Spray-painted signage on Cedar Street

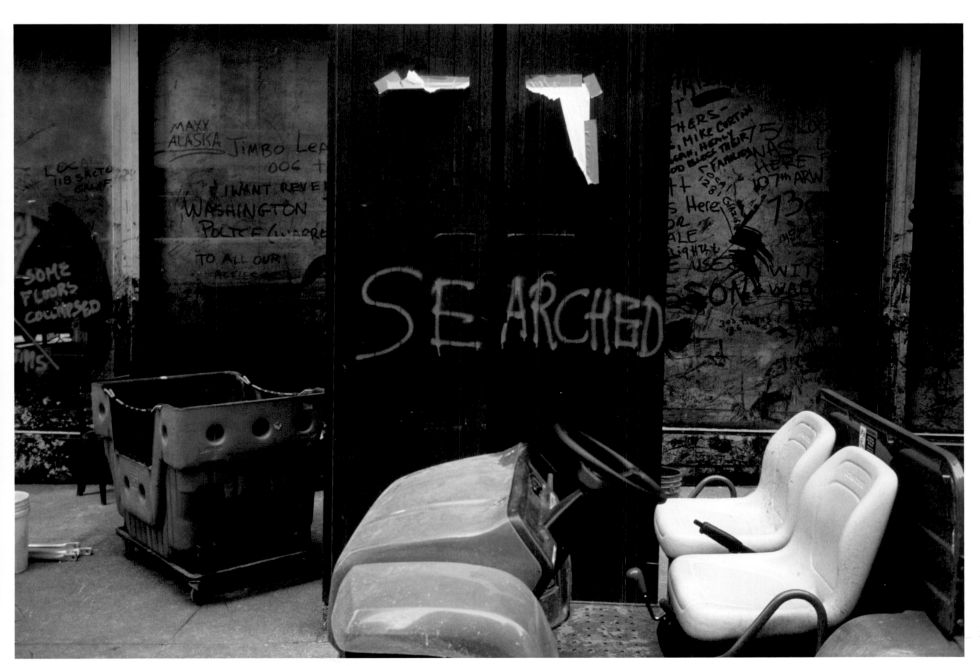

Spray-painted signage on Albany Street

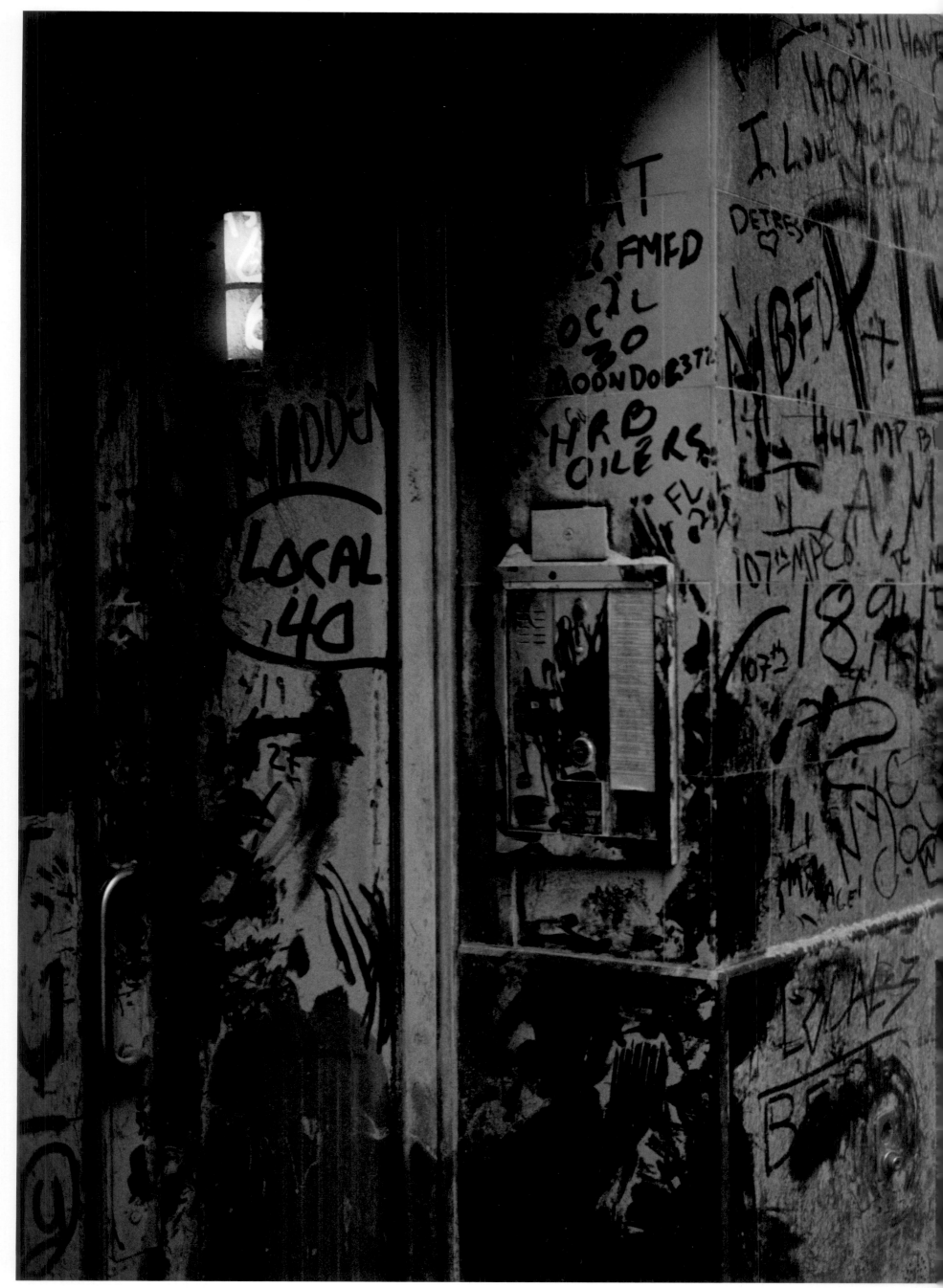

Writing in the dust on Cedar Street

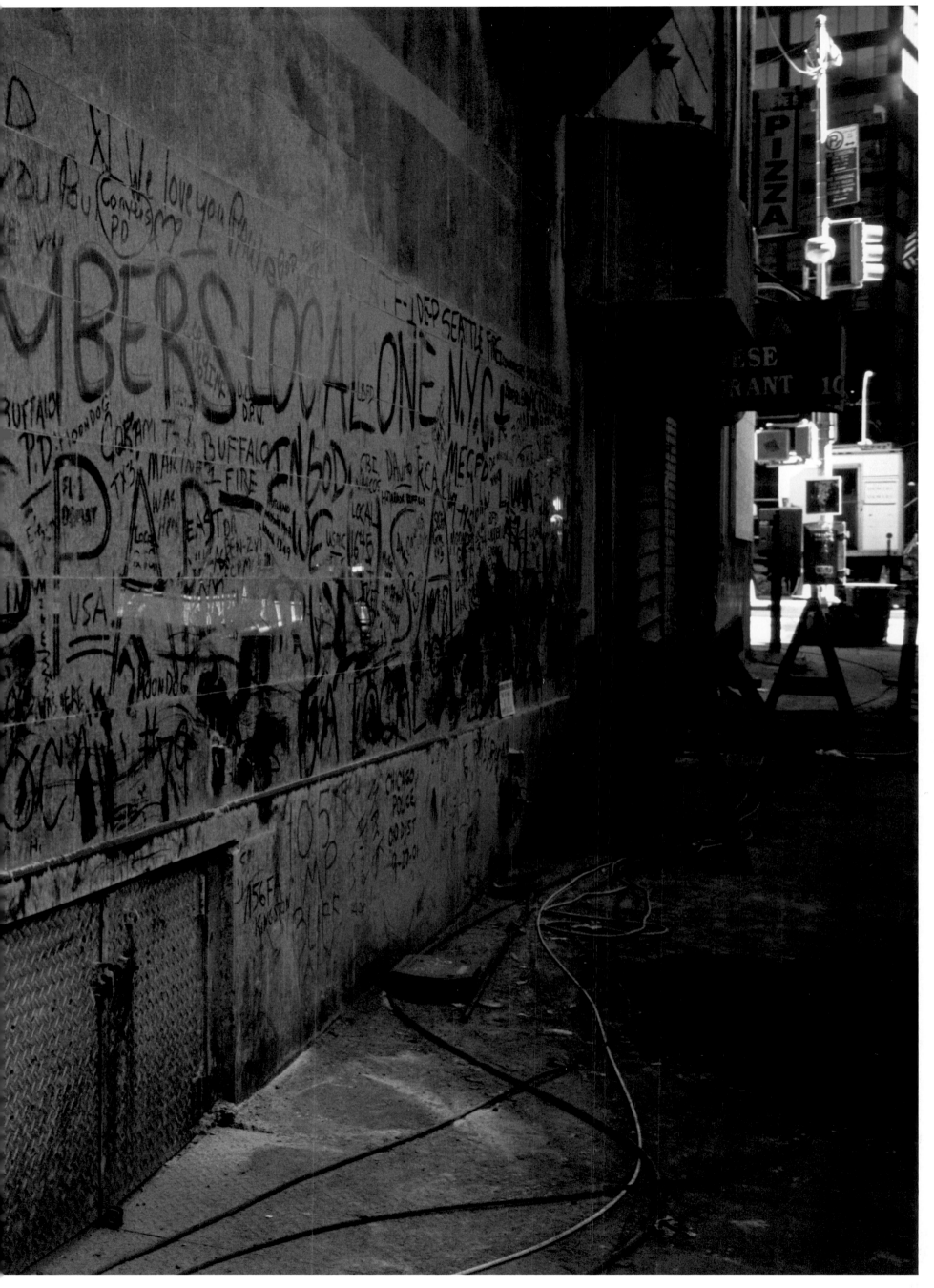

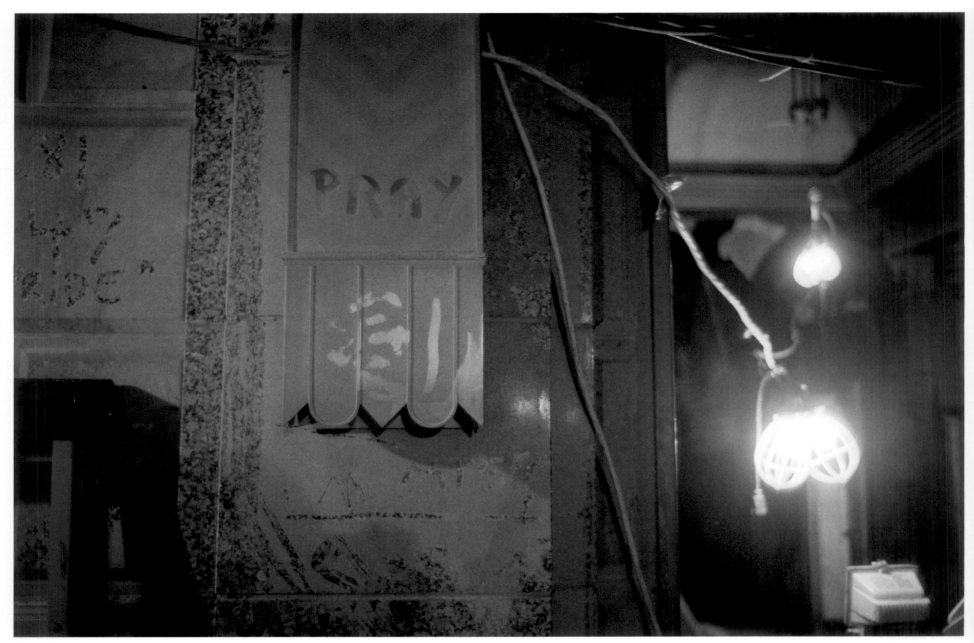

Writing in the dust in the lobby of 90 West Street

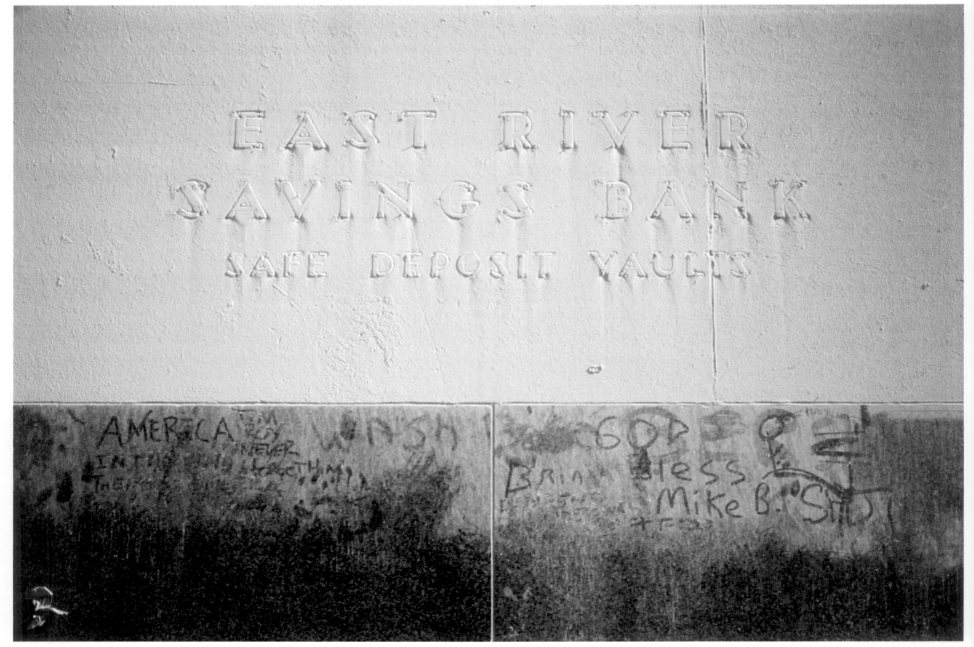

Writing in the dust on Church Street

Signage on Church Street

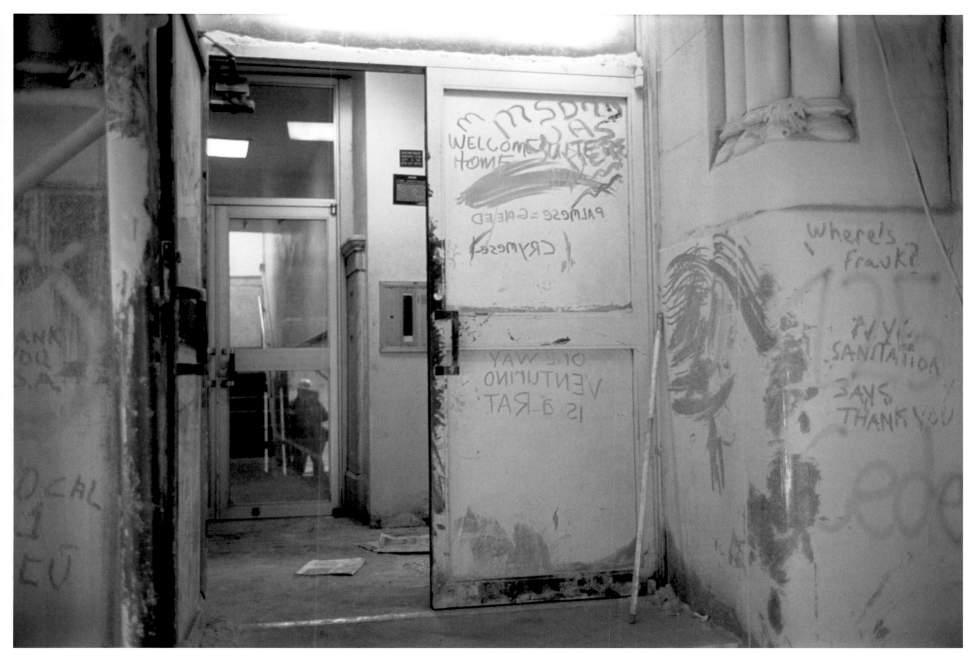

Writing in the dust in a lobby on Cedar Street: "Venturino is a rat"

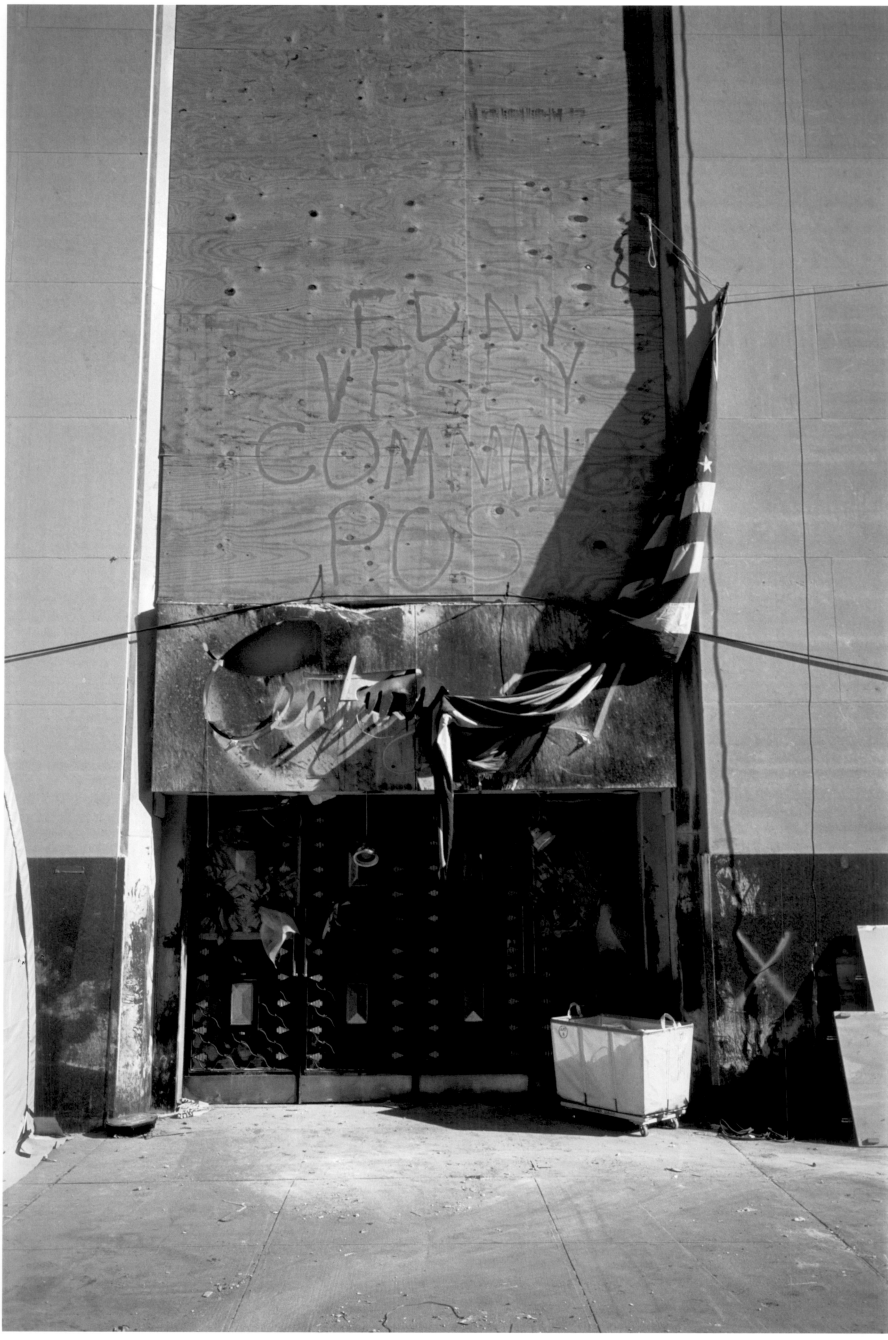

Century 21 on Church Street

Boarded-up stores on Cedar Street

10.21 I didn't expect to see Osama Bin Laden on Washington Street, but there he was, riddled with bullet holes. Precinct 1 of the NYPD has a substation there, near Rector Street, and someone had placed this image—retrieved from a shooting range—in the window.

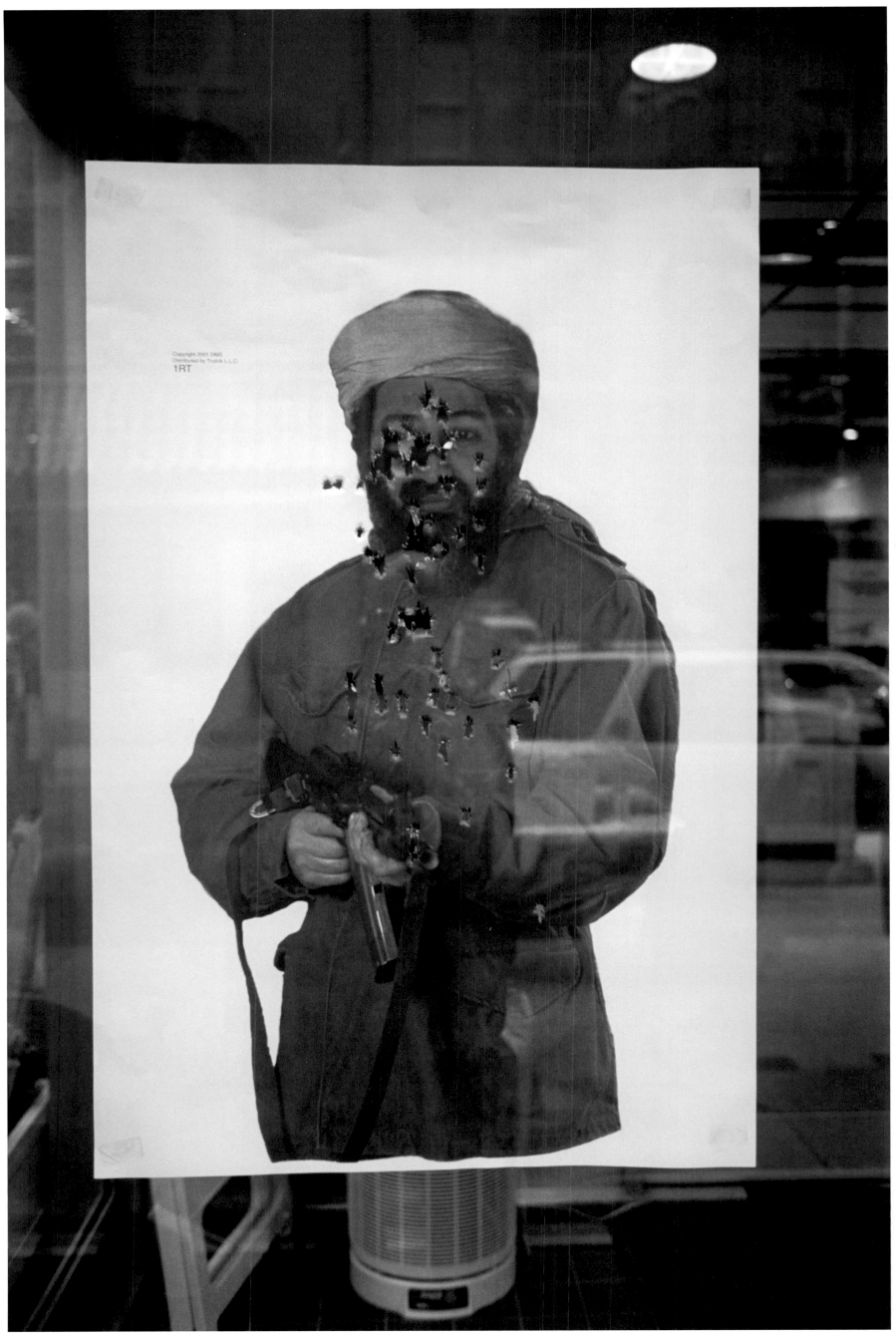

Shooting-range target in a window on Washington Street

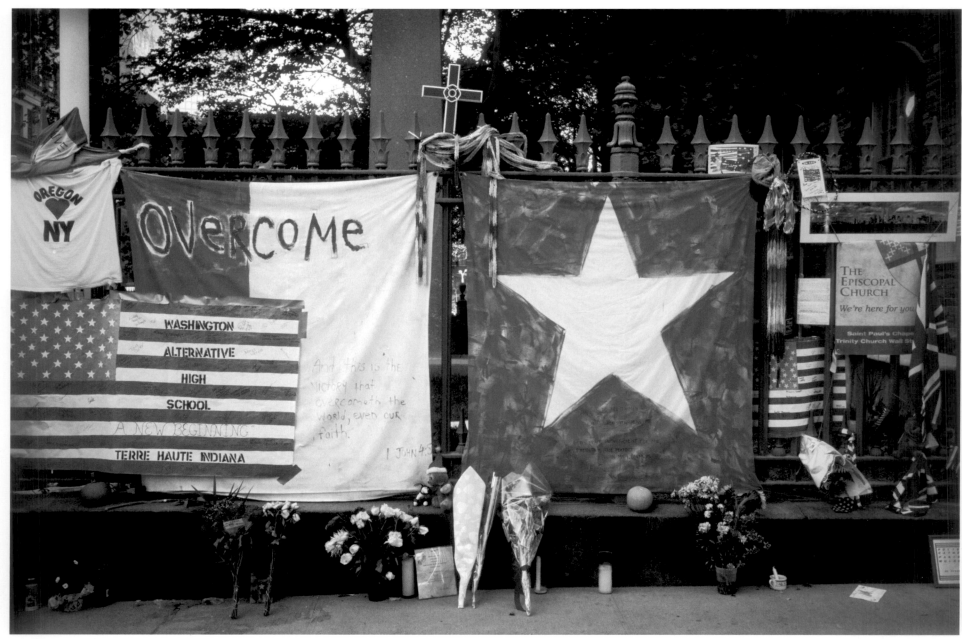

Handmade banners on the fence of St. Paul's Chapel

Officer Athanasiou had stopped me earlier in the day and asked me to leave the zone; after Lieutenant Torre from the Arson and Explosion Squad tore into him, however, he became more helpful. Walking around the site together, we happened upon this memorial, which included photographs of his fallen comrades, and he told me his story.

While he and his partner were helping people find their way out of the towers on that morning, they were joined by a female police officer. When the first building started to fall, the three of them ran through the streets just ahead of the dust cloud, but they became separated as the cloud overtook them. For a few moments, Officer Athanasiou could hear the other two on his radio, lost in the dust and calling out for help. Then they were gone. As he looked at his partner's photograph, he was overcome by tears.

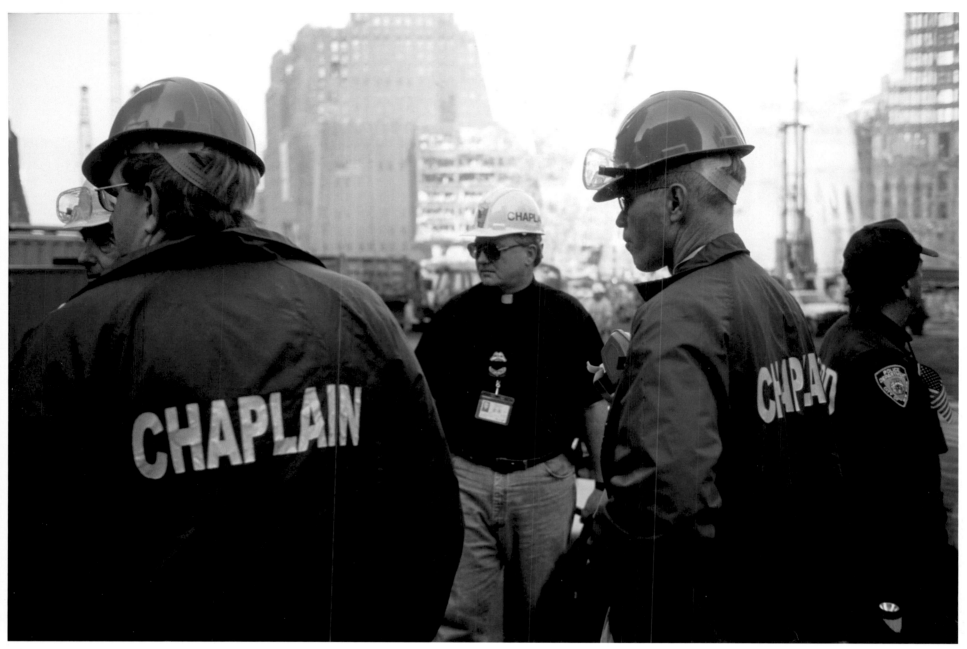

Chaplains on West Street

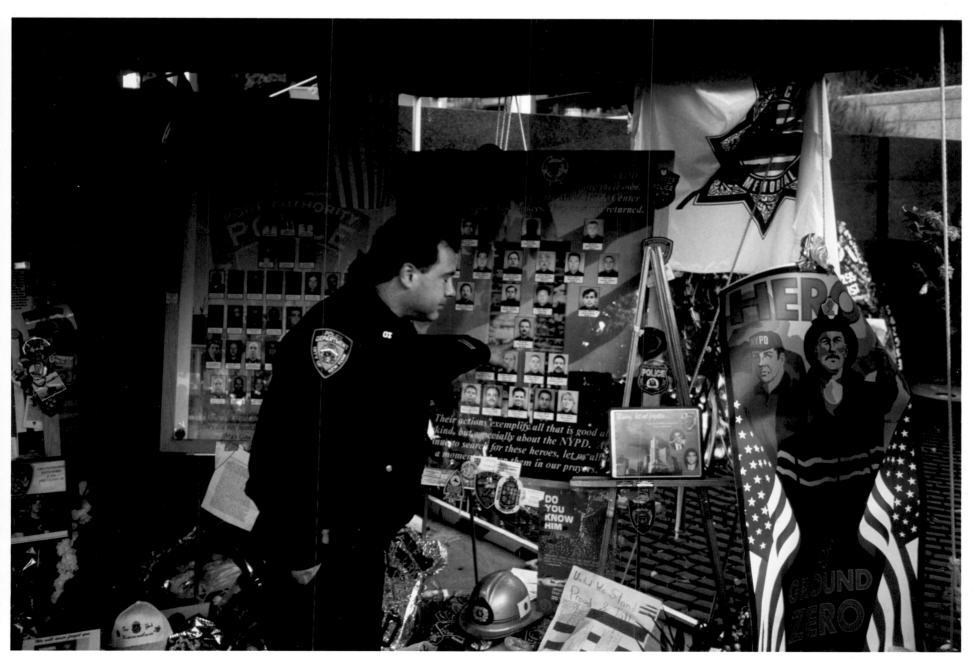

Police Officer George Athanasiou points to a picture of his lost partner at a temporary memorial behind the Winter Garden.

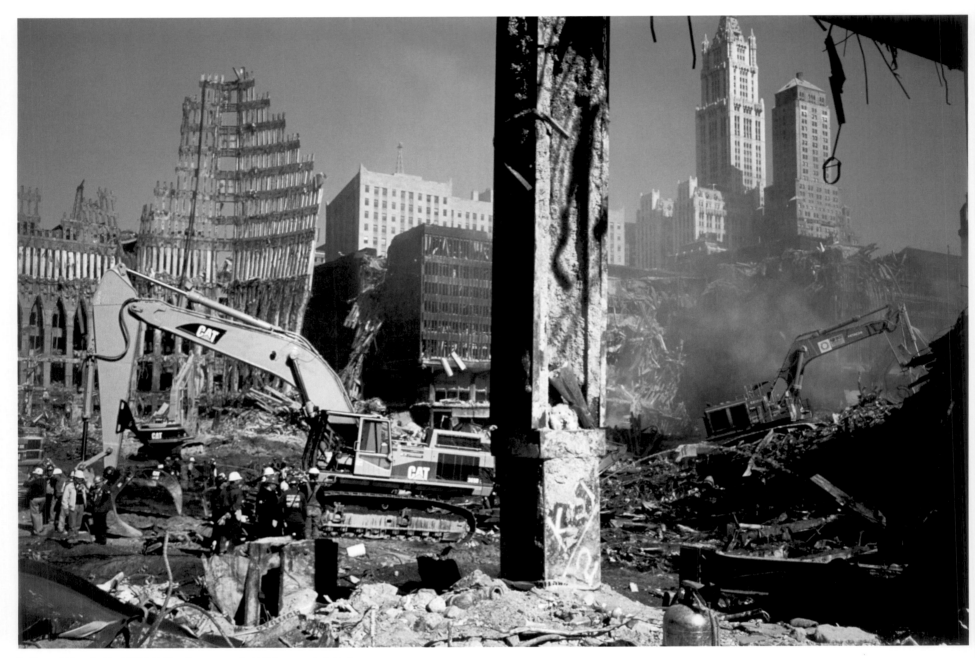

Looking north from the Marriott Hotel lobby, where someone had left flowers and a teddy bear

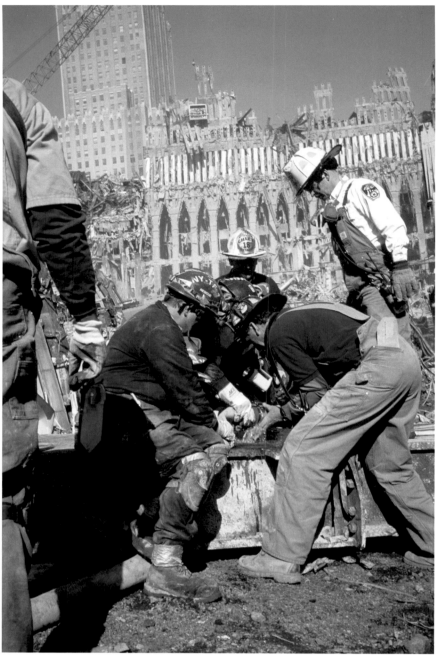

Firemen grapple with a hose coupling

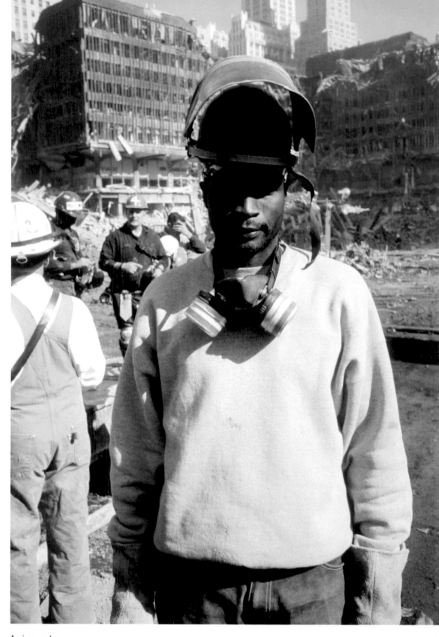

An ironworker

An ironworker on Liberty Street

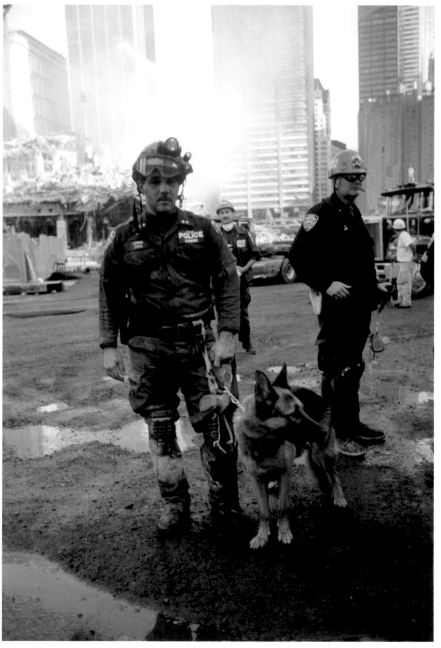

An officer and dog from the NYPD K-9 Unit

There wasn't much to see from Broadway, one block east of the eastern edge of the site, but every day people would congregate there anyway, to silently stare through the slivers of side streets at the smoke and dust rising from the pile. It wasn't just morbid curiosity that brought them downtown; thousands of people—not only New Yorkers—needed to see Ground Zero for themselves to fully comprehend the dimensions of what had taken place there.

I felt that the authorities should have regularly offered the public a Sunday pilgrimage past one of the site's borders, so that visitors could come to terms with their feelings and their grief. But administrations often fail to think in human terms, and this one was no different.

FOLLOWING PAGES: The collision of historical events is often surprising. The best food available at Ground Zero—certainly the best chili!—was served in the very church in which George Washington was inaugurated. St. Paul's Chapel, which had been converted into one of the culinary outposts at the site, was supplied by Eli Zabar's E.A.T. on the Upper East Side, and every day a wealth of delicious sandwiches, soups, breads, rolls, and sweets would arrive from uptown. I ate all over the site, but most often, when my legs started to give out and my stomach began to rumble, I headed over the pile toward St. Paul's.

You showed your pass, mounted the steps, and entered a little oasis staffed by friendly volunteers. Inside the church, you could rest on one of the pews, get a massage, or simply sit quietly in the near-dark of this centuries-old sanctuary and be with your thoughts.

An honor guard saluting the remains of a fireman on Vesey Street

Crowds trying to see the pile from the corner of Broadway and Fulton

Handmade banners on the fence of St. Paul's Chapel

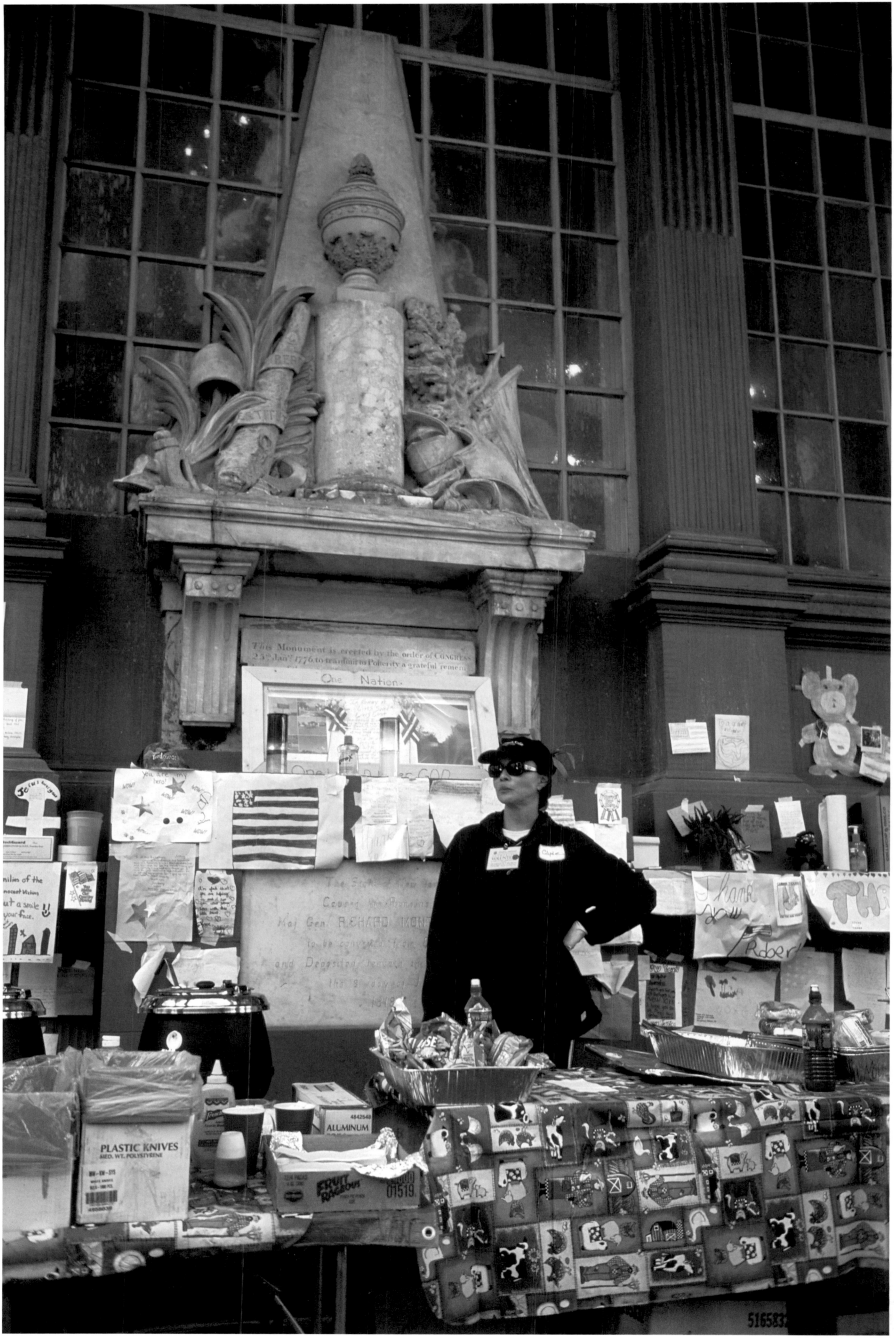

A volunteer behind a lunch table at St. Paul's Chapel

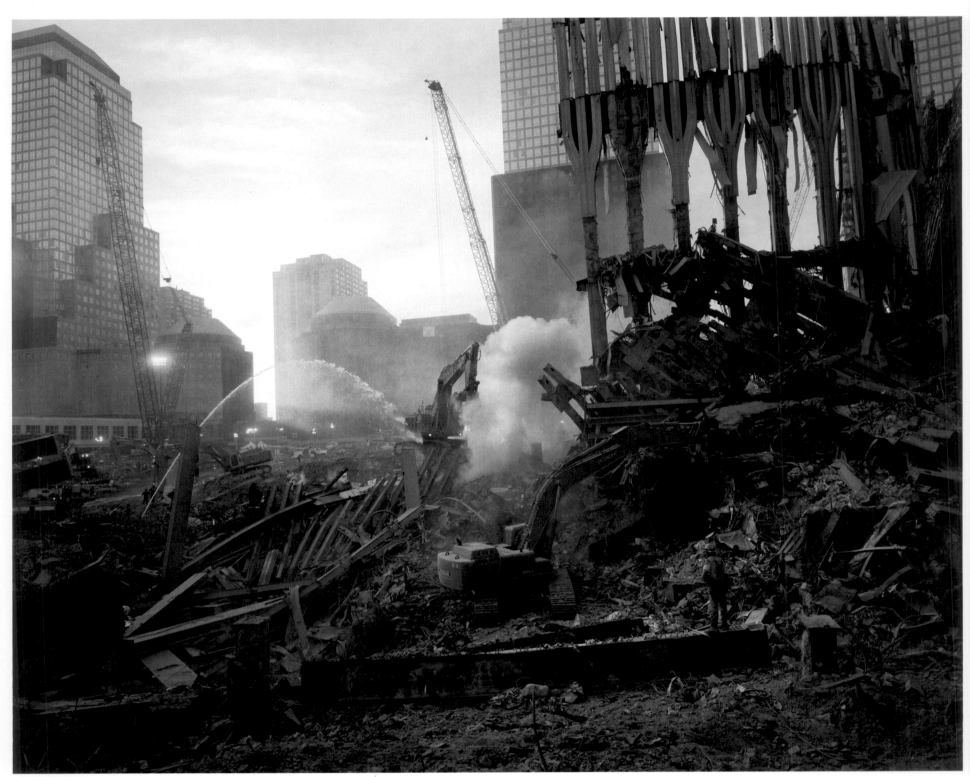

Inside the pile, looking west

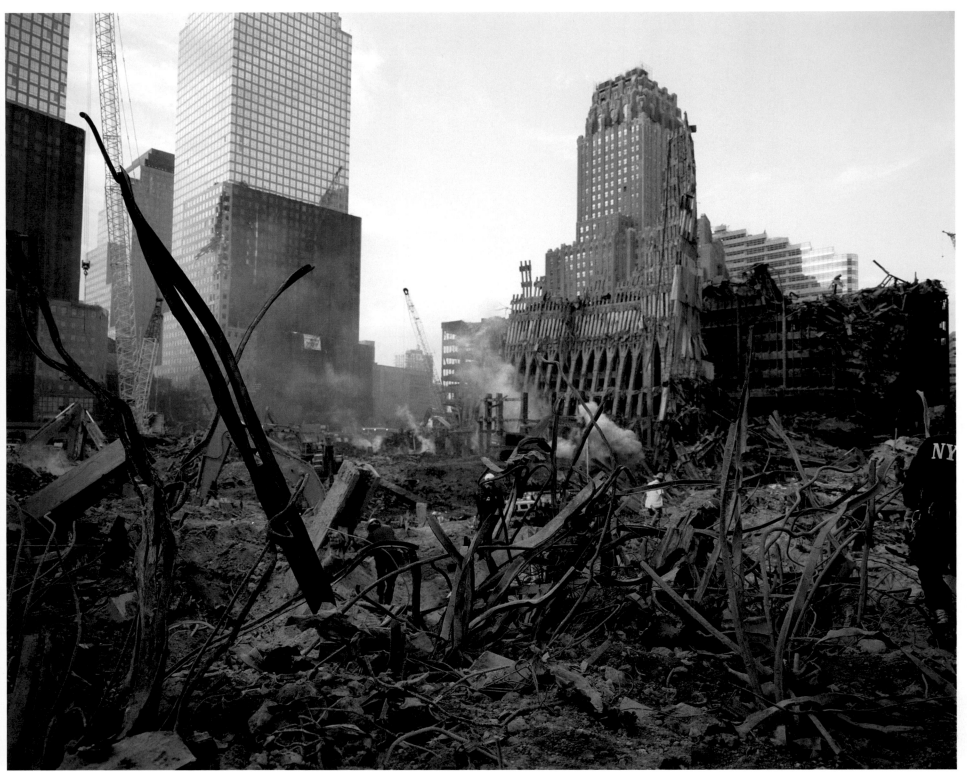

Inside the pile, looking northwest

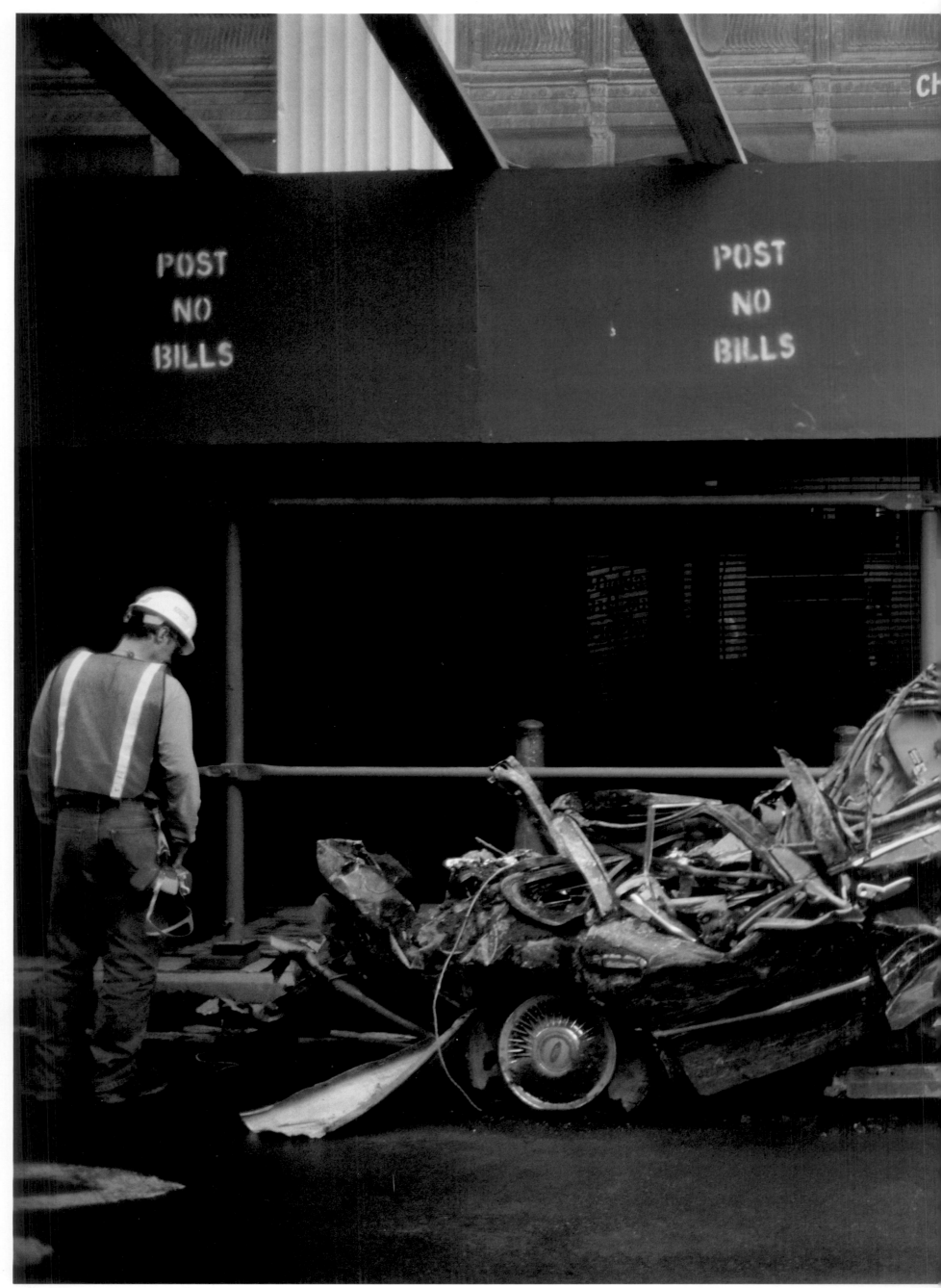

A car found in the wreckage on Church Street

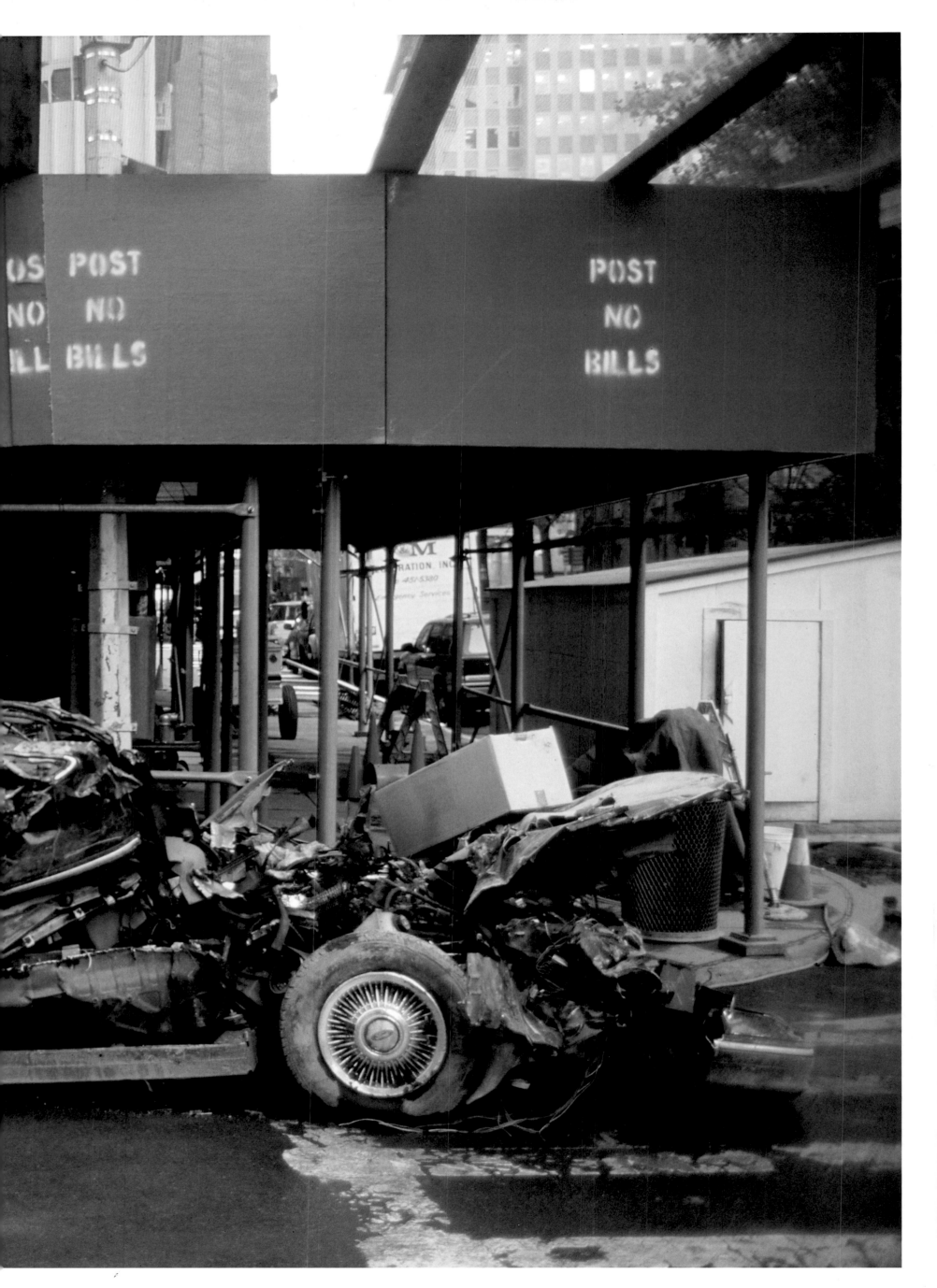

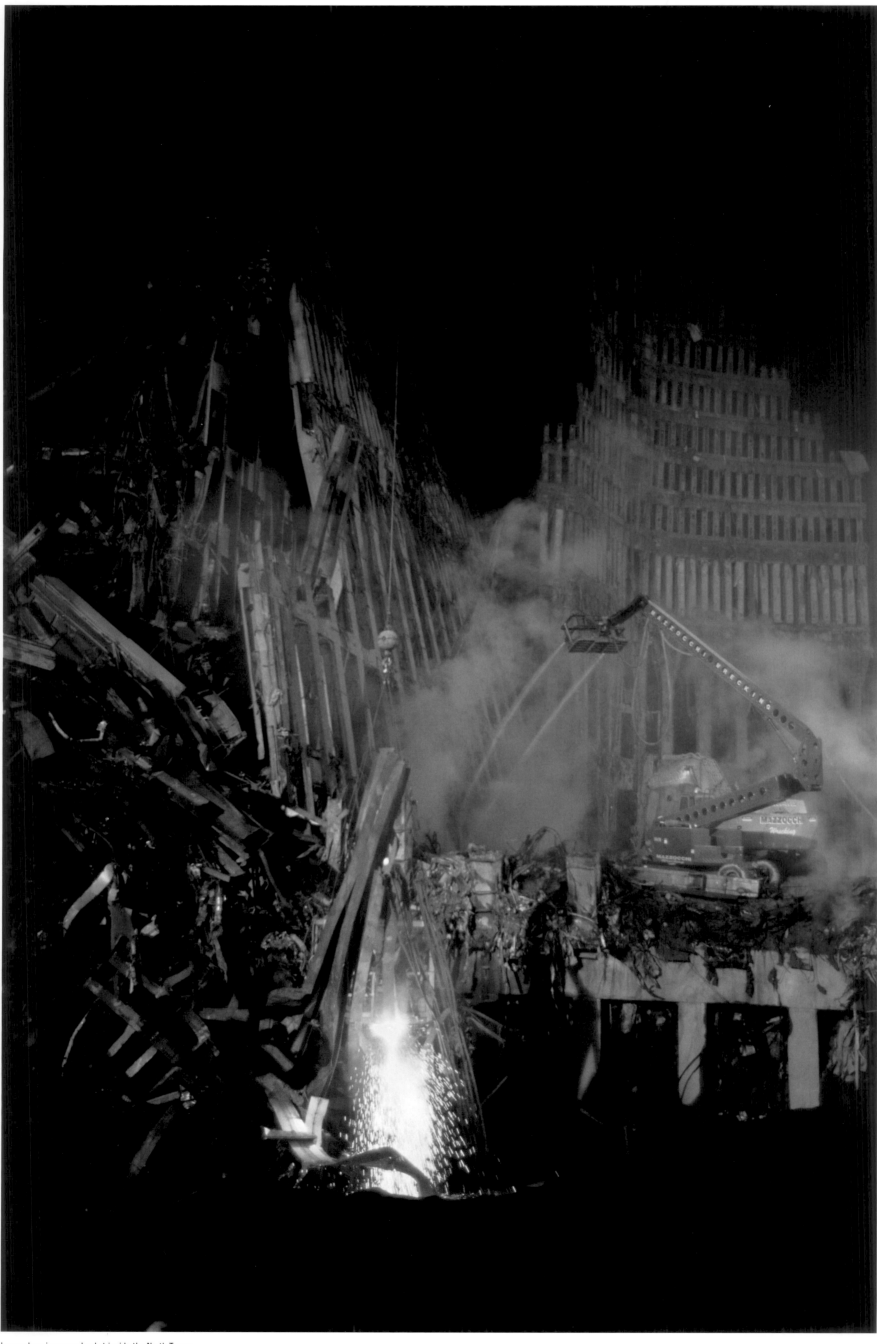

Ironworkers in a man basket inside the North Tower

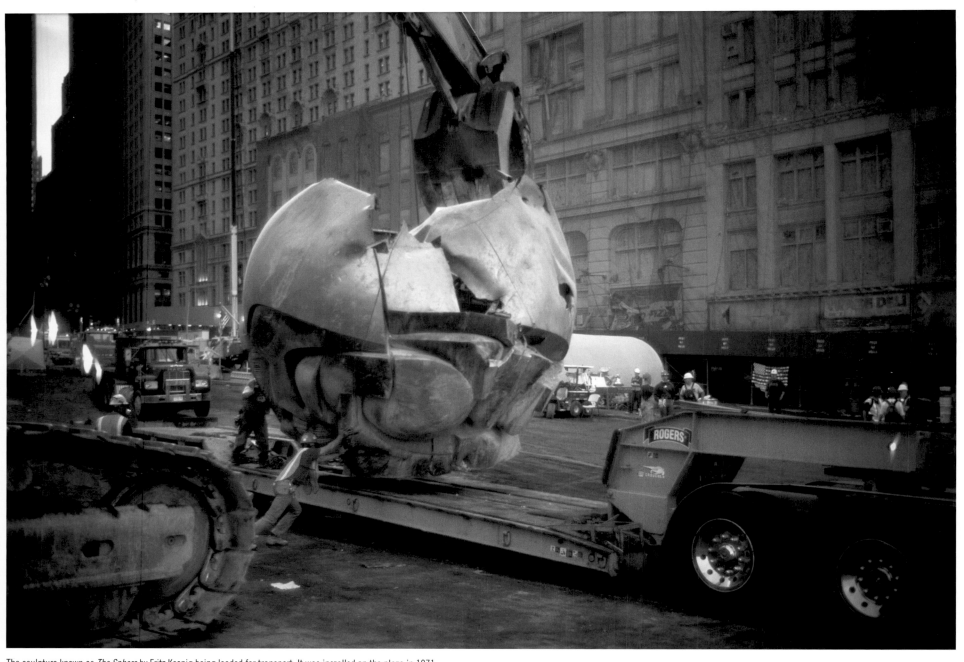

The sculpture known as *The Sphere* by Fritz Koenig being loaded for transport. It was installed on the plaza in 1971 and has now been relocated to Battery Park.

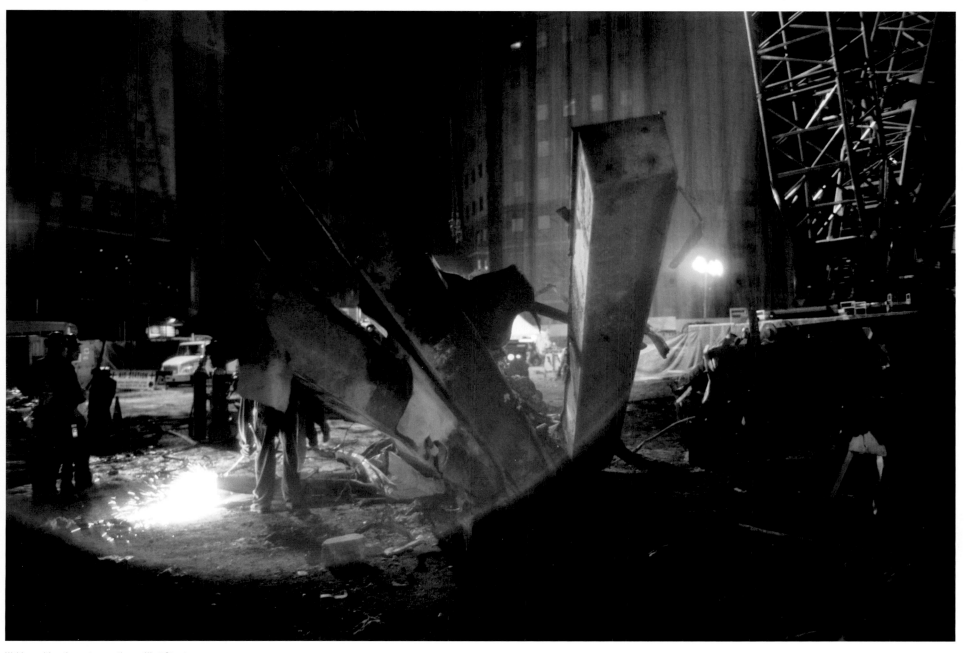

Welders with a three-story section on West Street

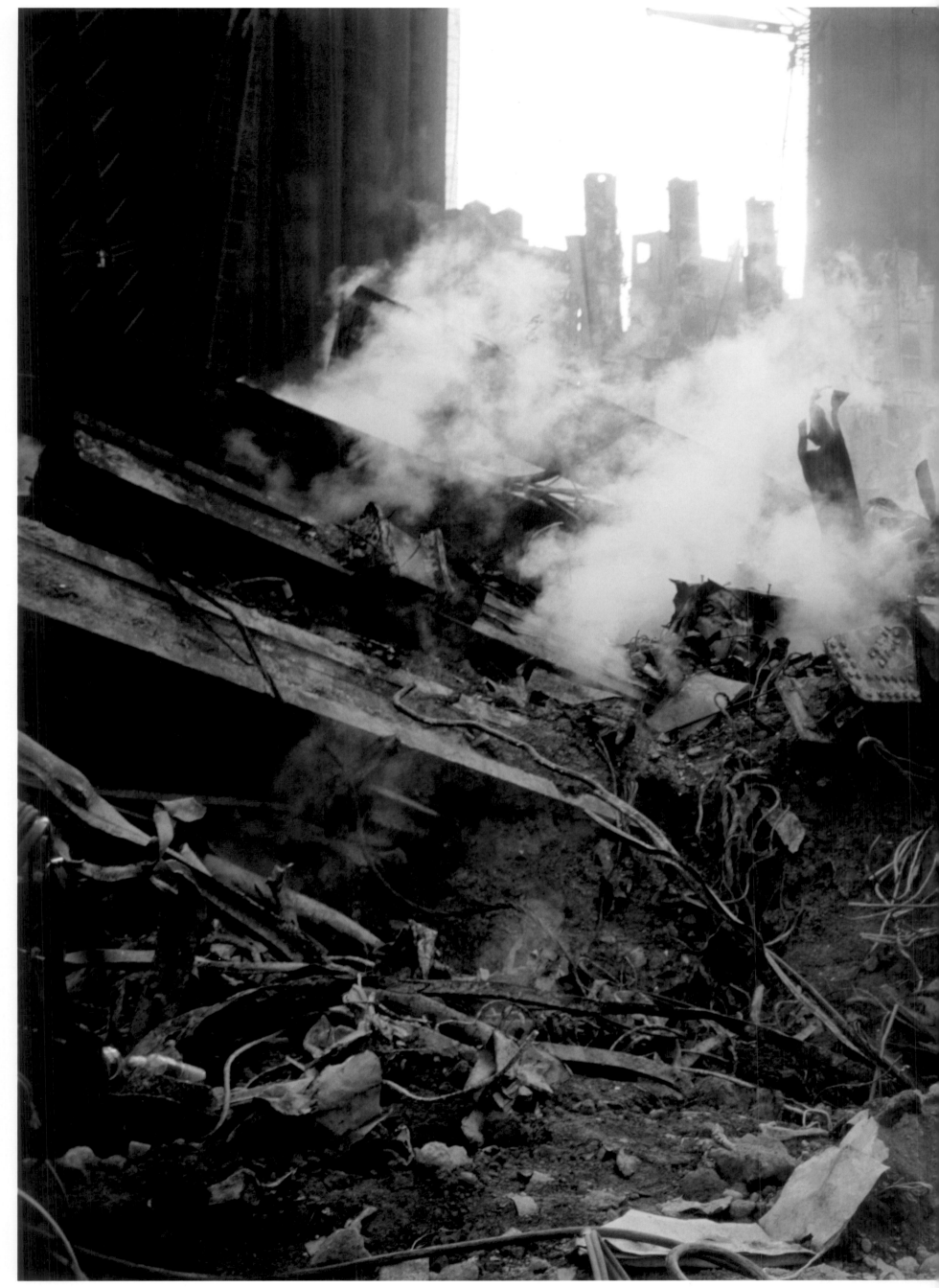

Core columns in the middle of the South Tower

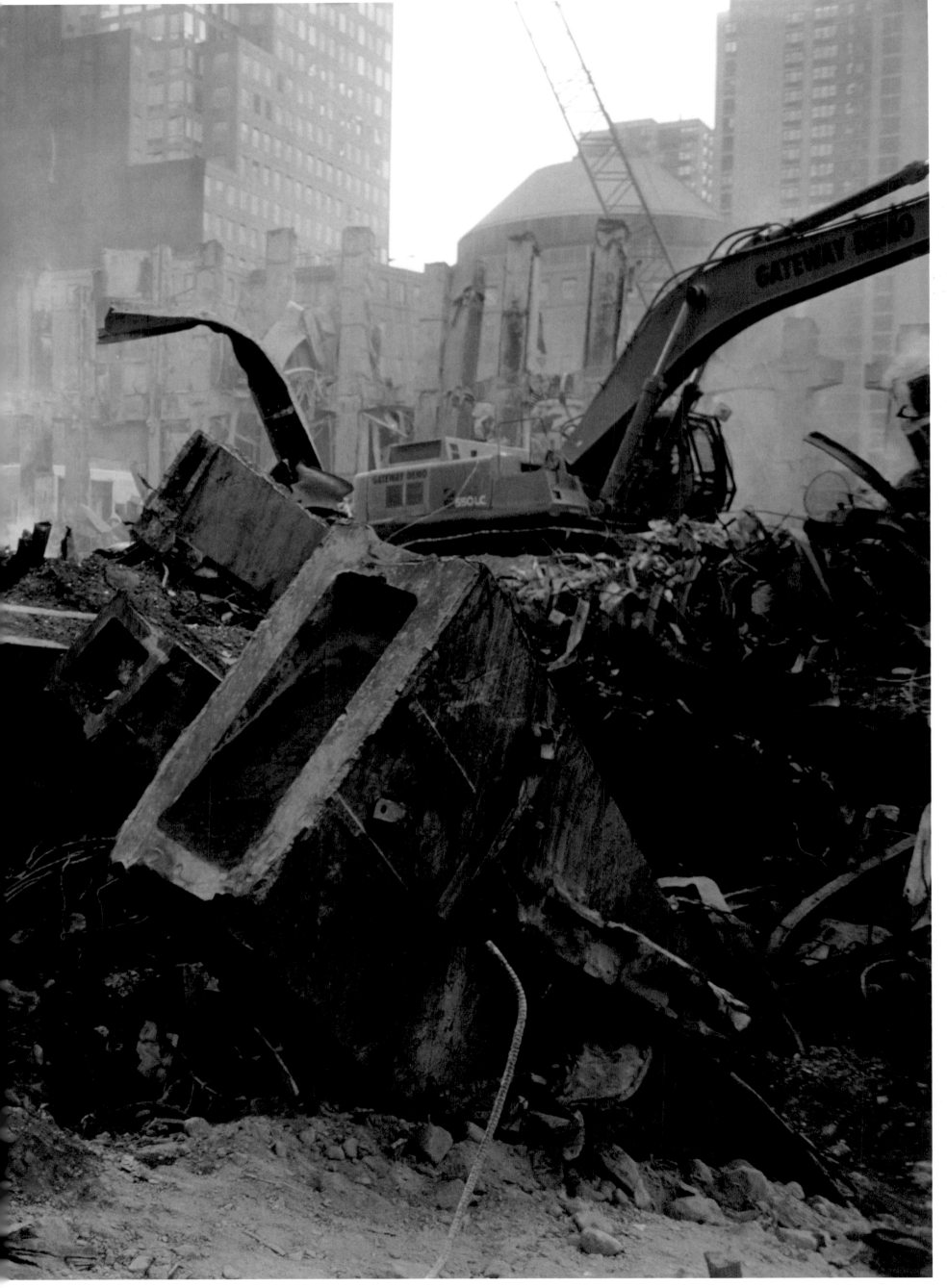

10.24

By late October the shrouds had taken on the presence of ruined cathedrals—particularly the North Tower's shroud, which was one of the only things that had been left untouched on the site. A handful of us were standing up the hill from this shroud that evening as the shifts changed, when into the momentary lull floated the heart-piercing sound of a single trumpet. We turned toward the sound and there, down the hill from us, was a lone civilian playing *Taps*. We stood in silence as the familiar notes soared out of the natural amphitheater that the site had become and into the twilight.

The trumpeter turned out to be a Frenchman. He was a Broadway musician who'd managed to convince a cop on the perimeter to bring him in so that he could offer his gift.

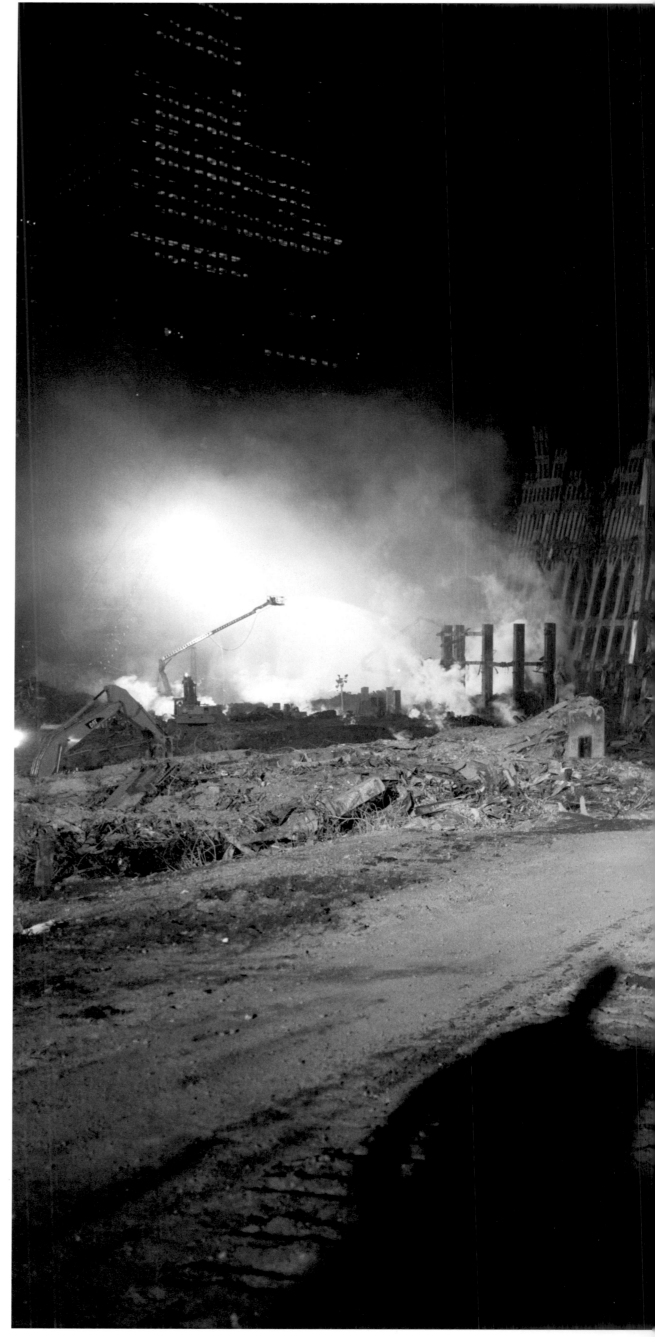

Dusk, a trumpeter plays *Taps*

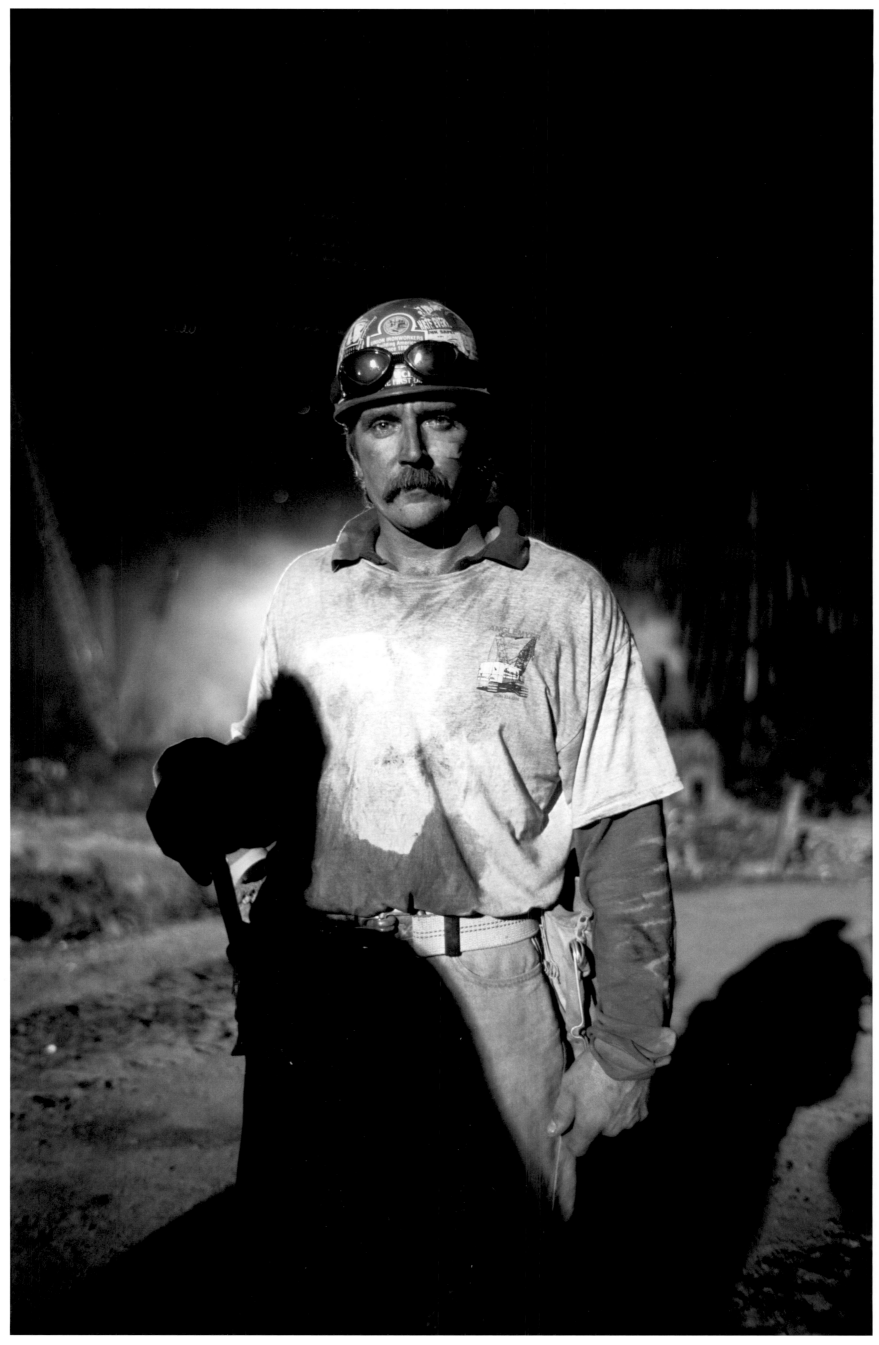

A welder wounded by an explosion of buried ammunition in the Customs Building

A truck driver and her rig

A truck with a hand-painted hood, a proud owner's personal contribution to the clean-up effort

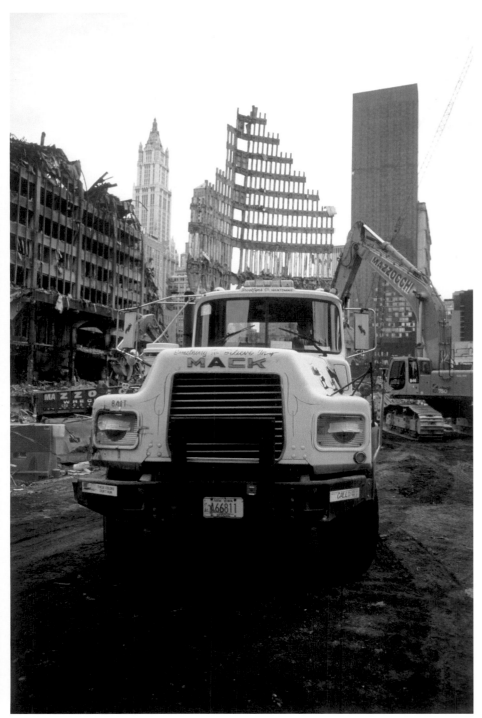

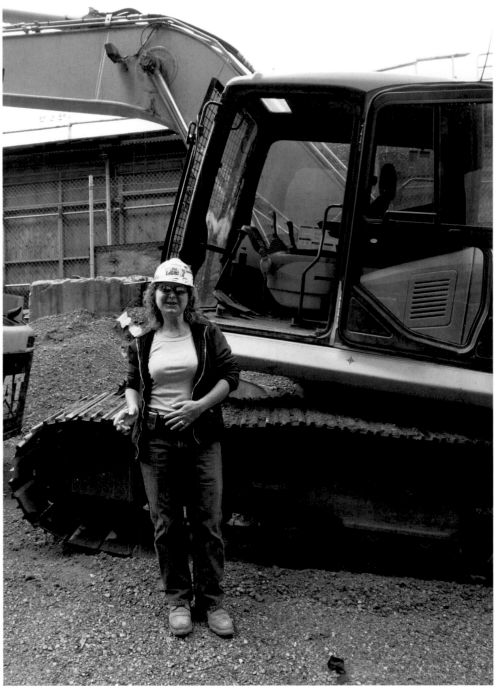

A truck with "Something To Believe In" written on the hood

Pia Hofmann in front of a grappler

Women were rarely seen doing heavy or mechanical work on the site, but of course there were exceptions. The woman shown opposite, whom I only saw once, was driving one of the largest dump trucks in the zone. Another was Pia Hofmann (above), who was licensed to operate the biggest cranes and handle the grapplers; she was the only female member of the International Union of Operating Engineers. Pia became legendary in the zone because she was the catalyst for altering the most important ritual at Ground Zero: the handling of the dead.

Whenever remains of members of the uniformed services were found, they were always covered with a flag and taken out of the site flanked by an honor guard. This was because the police and fire services were conceived on a military model, and this formal response to death is part of their code. But the remains of civilians were put in red medical bags, so the question "Flag or bag?" came into common use to differentiate civilians from men and women in uniform. Some of the workers were bothered by this.

One day, while Pia was on a grappler, she uncovered the body of a woman. But when she heard the spotter call out for a bag, she objected, arguing that this woman deserved the same treatment that those in the services received. To ensure that her point would be taken seriously, she then lowered the claw of her machine around the body, refusing to lift it until her request had been satisfied. From that day forward, all civilians were given a flag and an honor-guard procession out of the site.

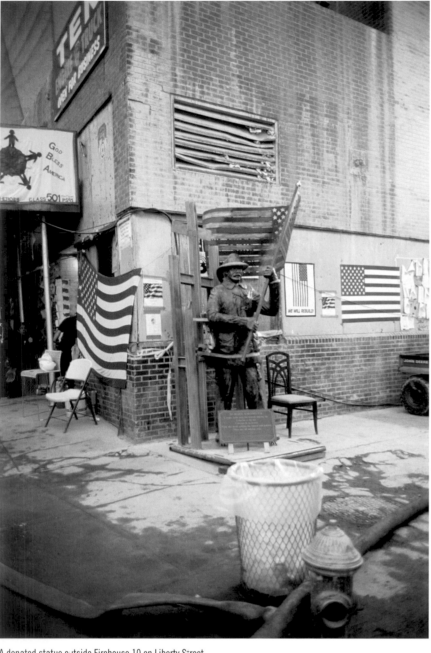

A donated statue outside Firehouse 10 on Liberty Street

A chair on Church Street, near The Millenium Hotel

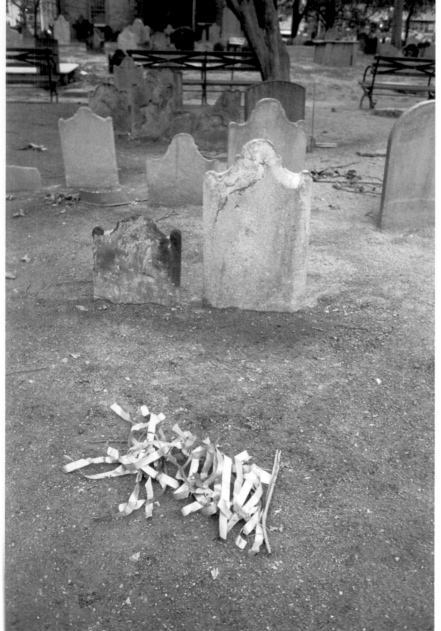

St. Paul's Cemetery, gravestones and an aluminum blind

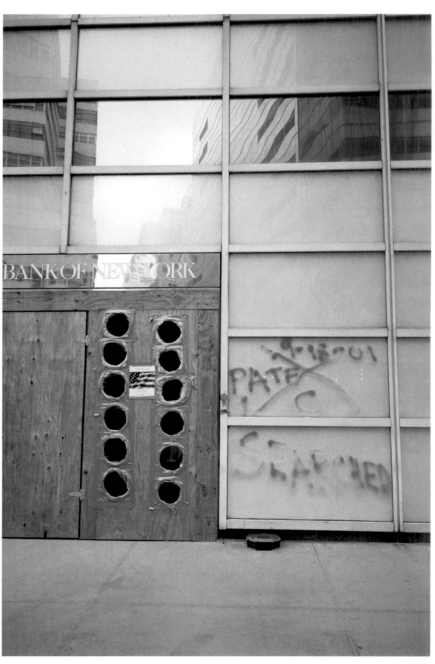

A boarded-up doorway at the Bank of New York on Barclay Street

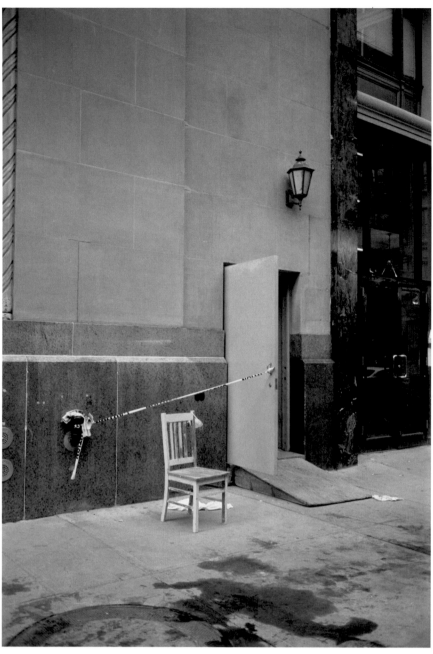

A chair on Washington Street

A chair and cable spool behind the Bankers Trust Building on Albany Street

A rat trap in front of Building 5 on Church Street

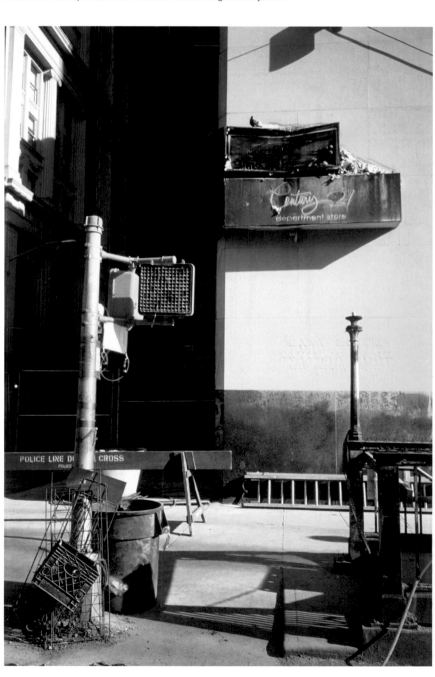

The corner of Church and Dey

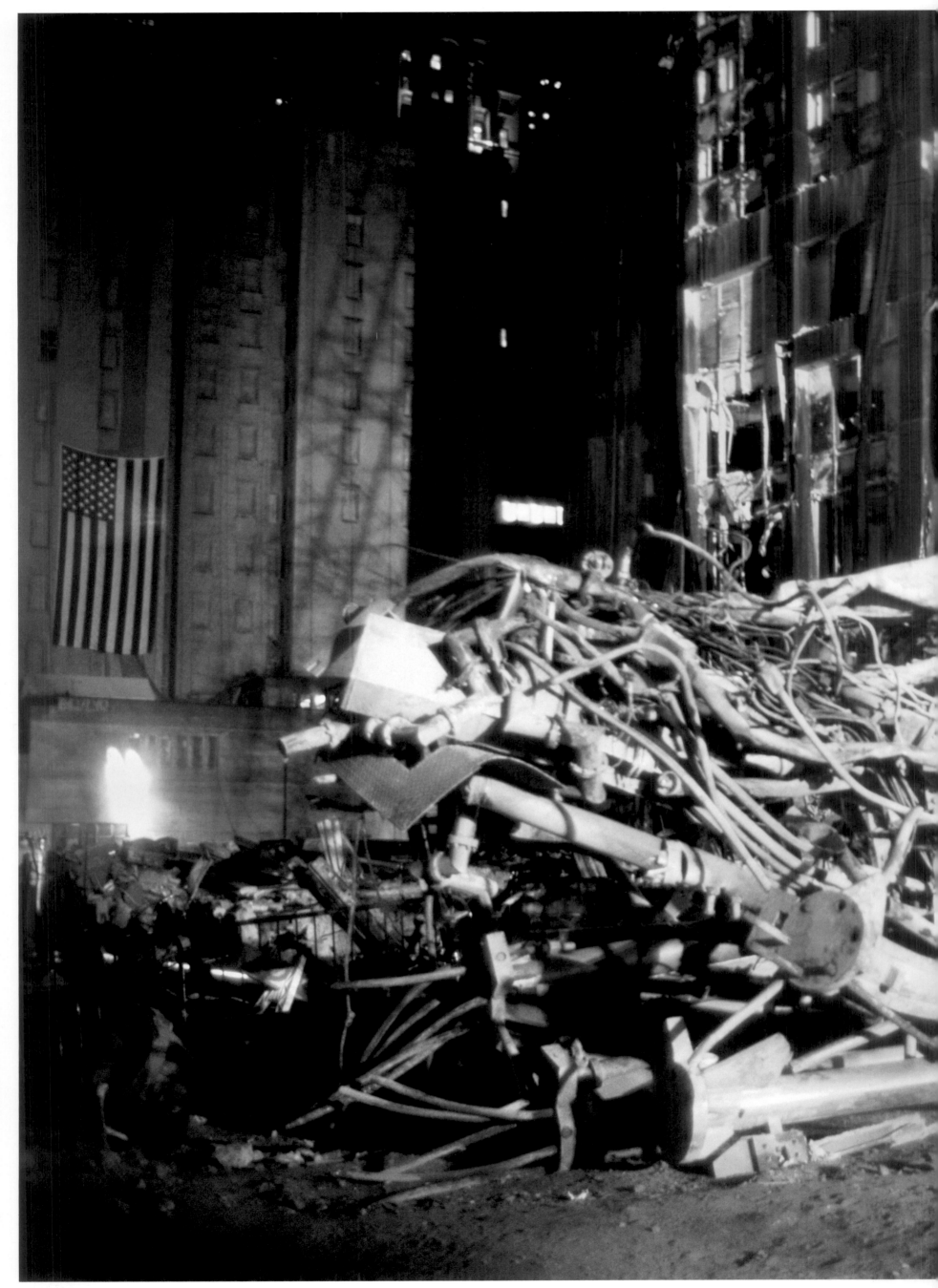

The antenna from the North Tower on Liberty Street

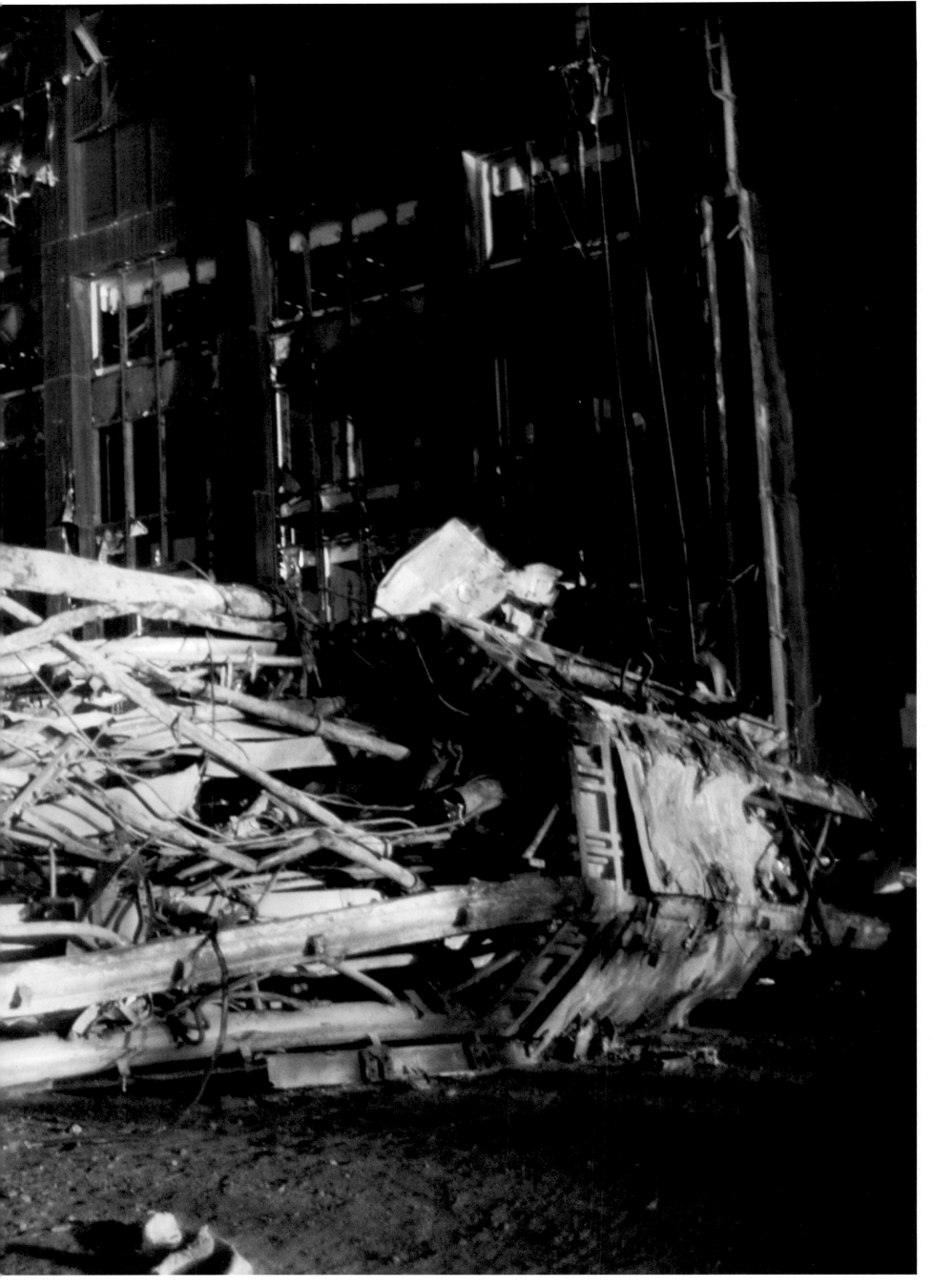

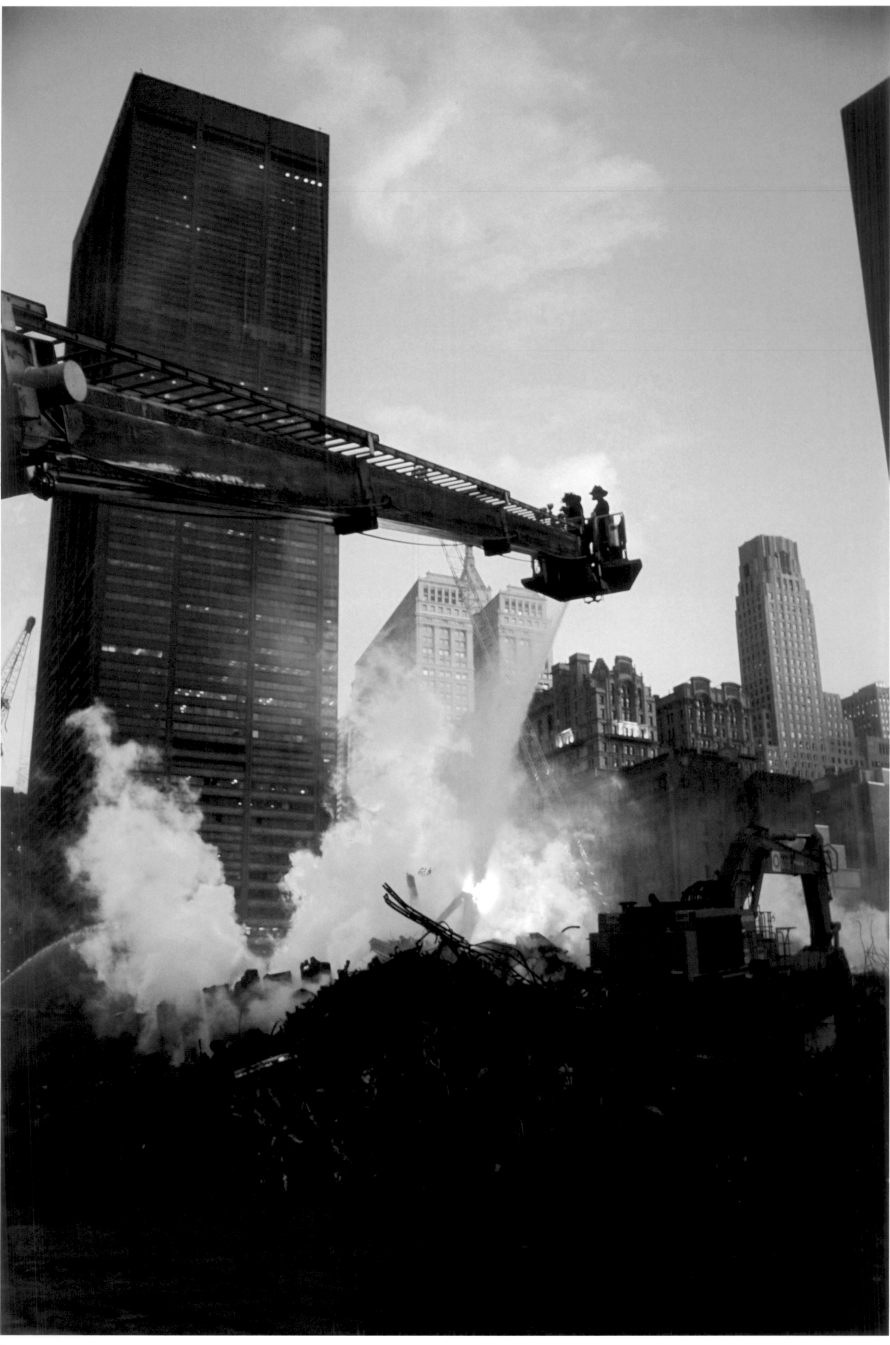

Firemen spraying the pile

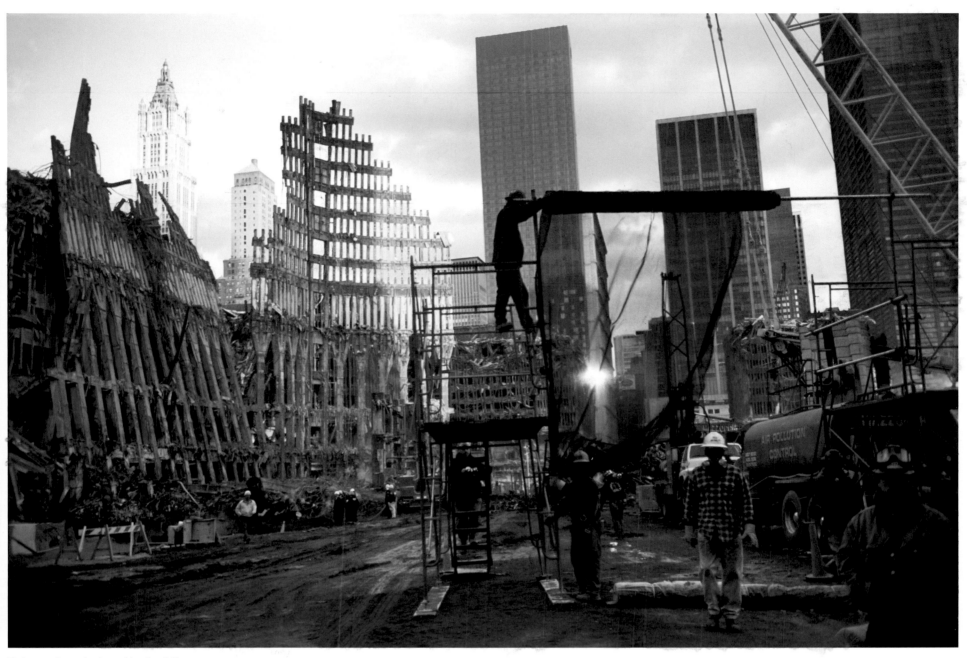

Workers erecting a cleaning and burning station

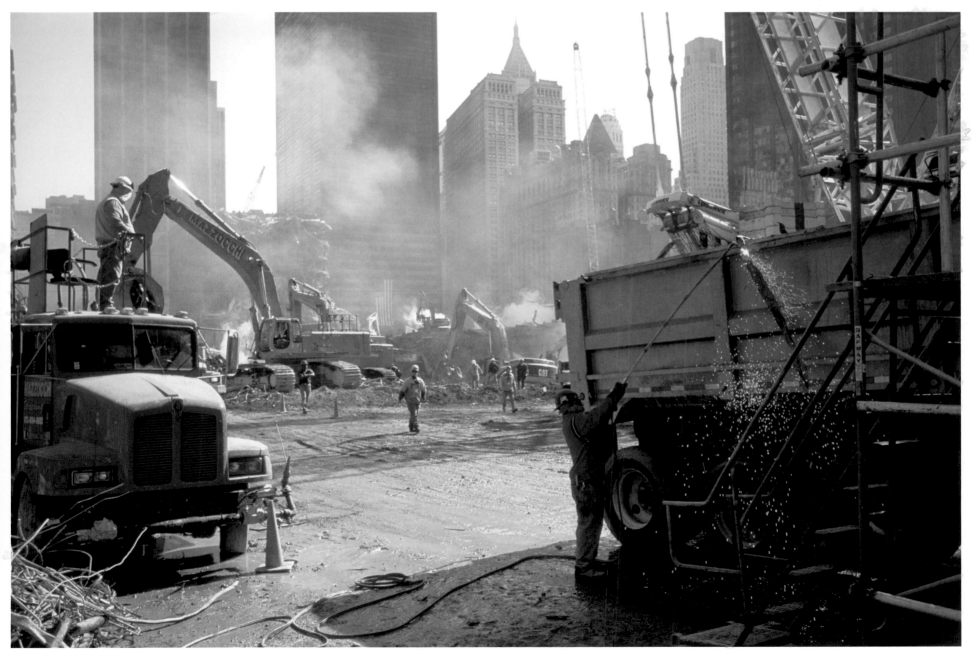

A worker trimming steel hanging over the edge of a truck

PREVIOUS PAGE: By the end of October, seven hundred thousand pounds of debris had been removed from the zone and a new road into the valley between the towers had been cleared from West Street. This road, along with the Tully Road constructed at the southeast end, gave more trucks access to the center of the pile. As shown on the previous page, a cleaning and burning station was being set up to allow welders to stand on scaffolding and trim off any steel hanging over the edge of the trucks. Nothing was allowed to stick out, because cable and rebar, bouncing and waving around as the trucks jolted over the rubble, could take off a man's head in an easy swipe.

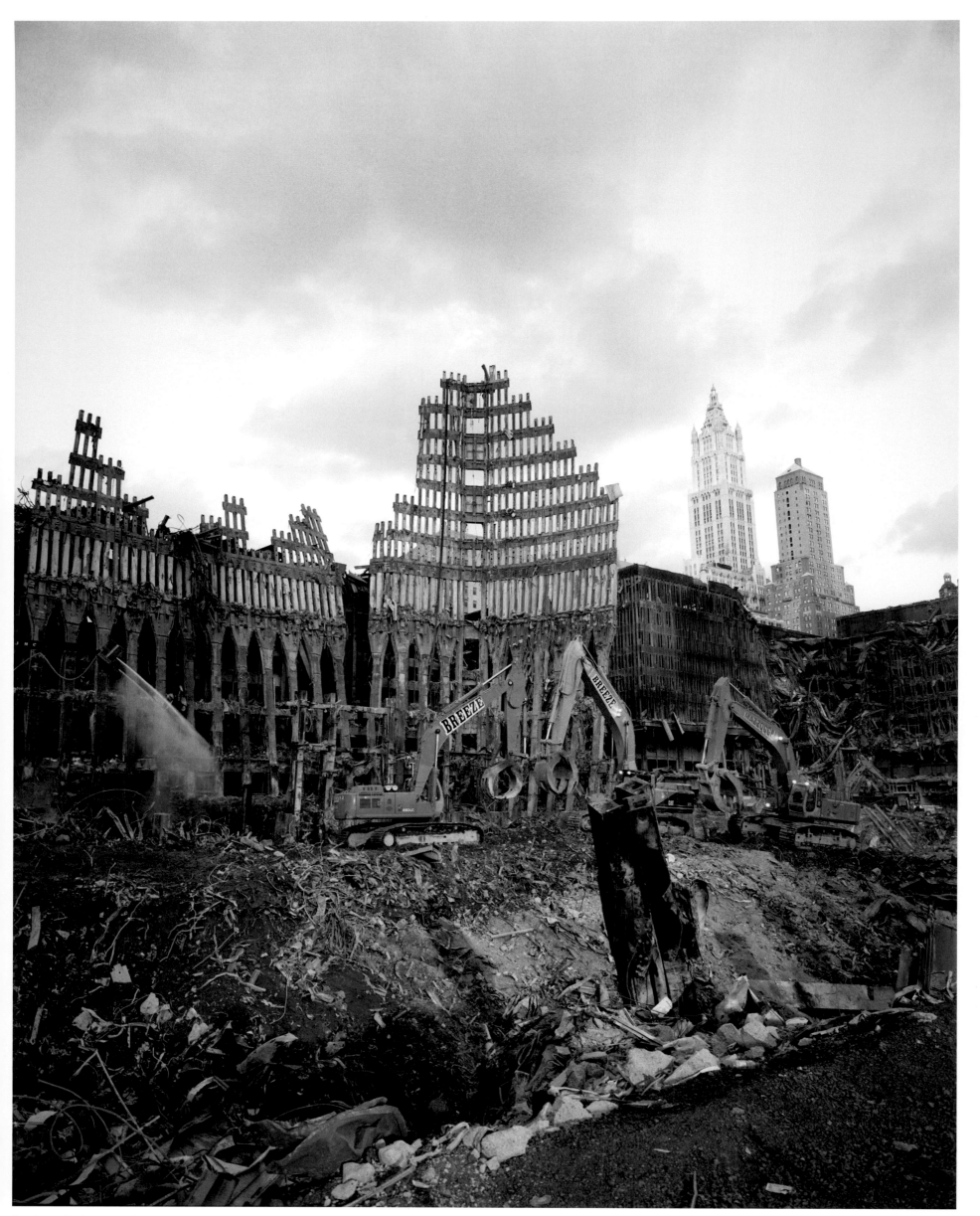

Grapplers working in the lobby of the North Tower

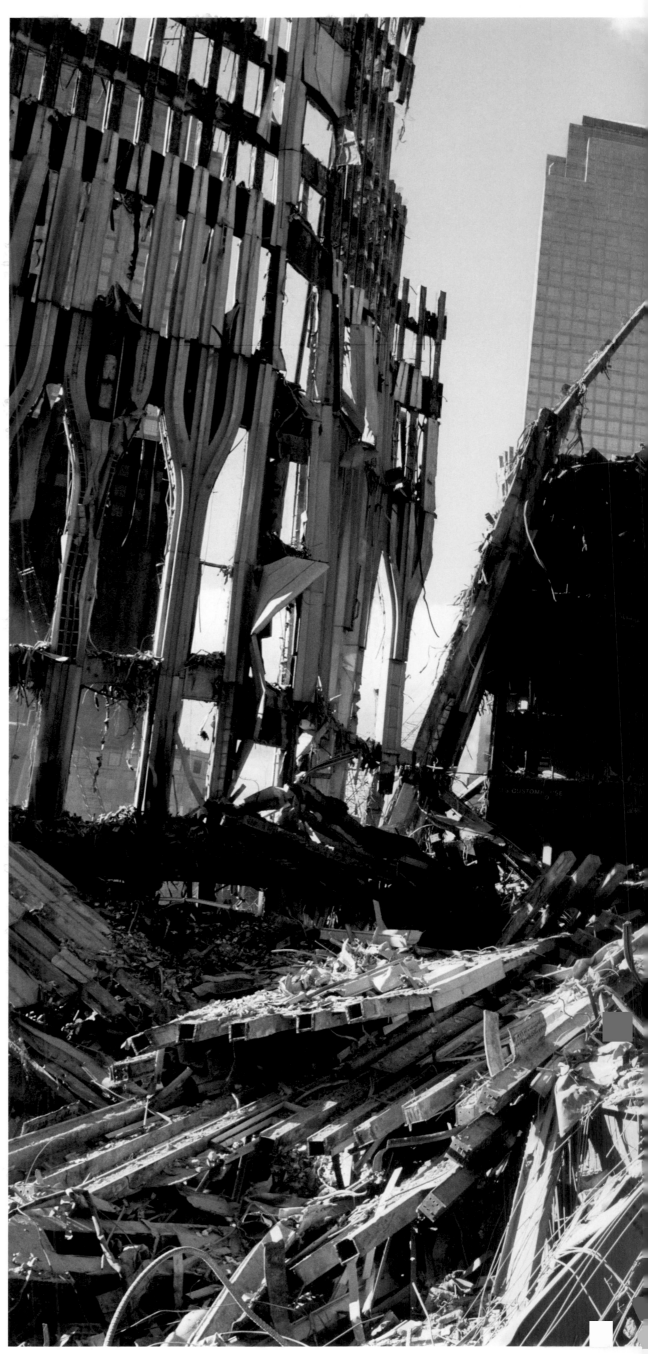

Inside Building 5, looking west

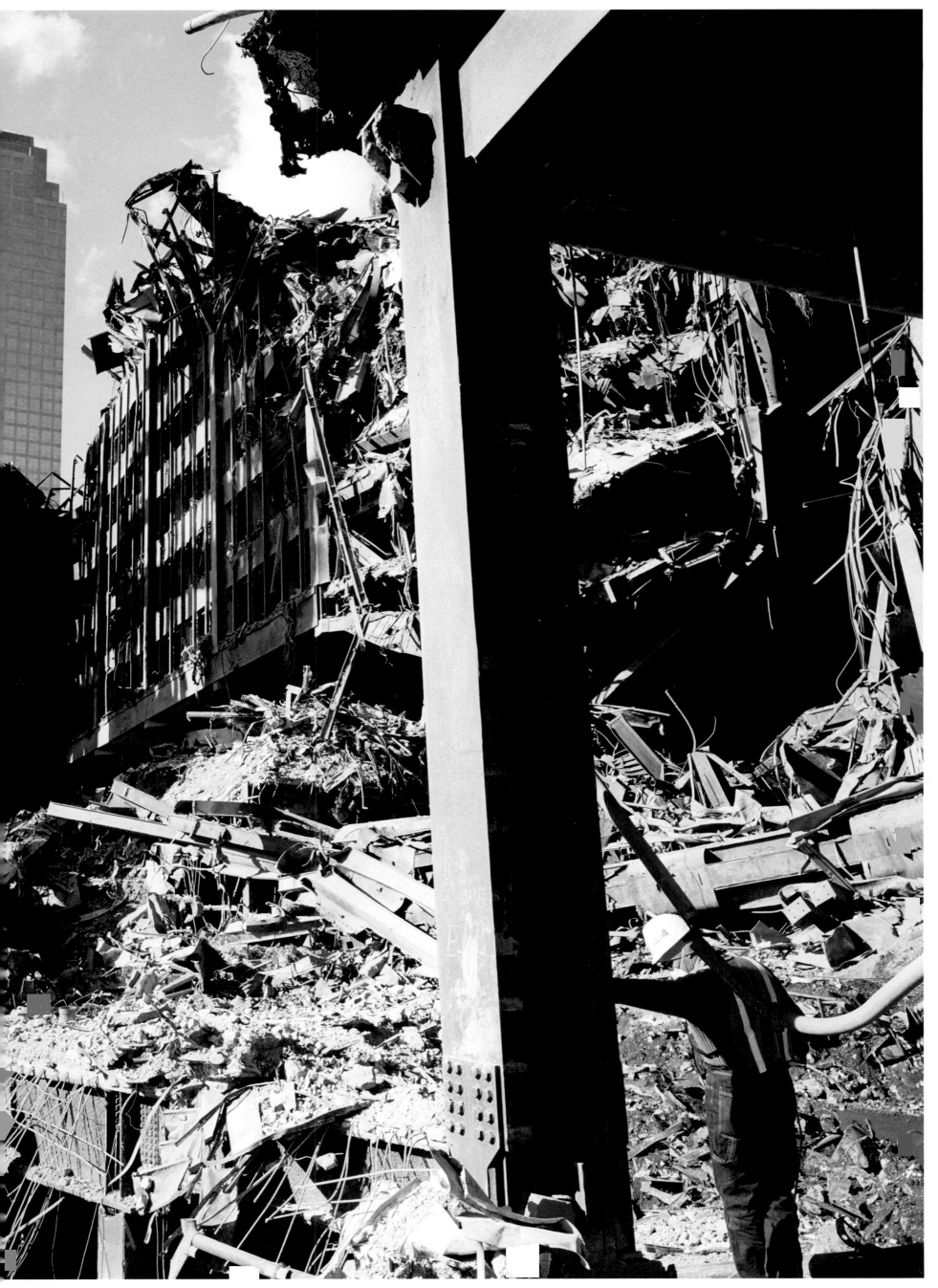

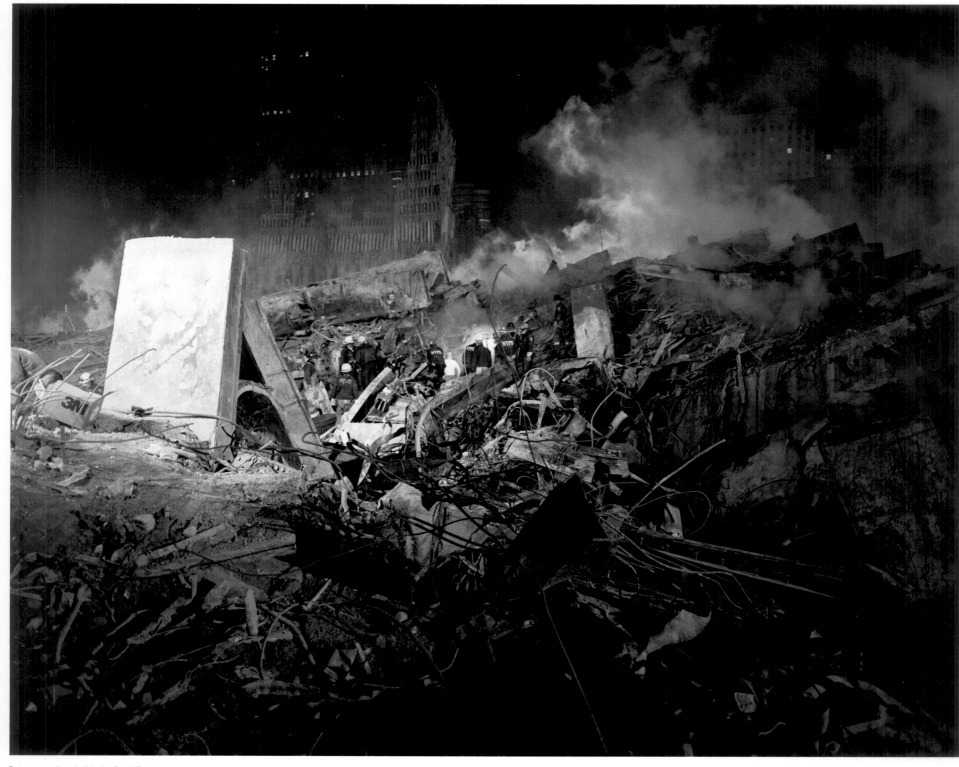

Recovery workers inside the South Tower

Just after ten o'clock one night, I saw more than a dozen firemen running up a hill leading to the center of the South Tower; the way they were racing heedlessly through all the dangerous standing steel made me follow them. When I reached the top of the hill I saw at least fifty men were gathered around the glowing light in the center, under the massive fallen core columns. It had the epic feel of Rembrandt's *Night Watch*—majestic, chaotic-looking, yet with an underlying order that arises out of tremendous purpose.

I worked my way in close enough to hear someone say, "We've found five more, in a stairwell." Then someone else said, "They're in their bunker coats, and intact," and then, "This stairwell is from the North Tower!"

Shock ran through the field of men: the North Tower was at least a hundred yards away. I could sense the mental calculations going on around me in the awful silence that followed, each of us trying to imagine the stairwell hurtling through the air, crashing into the debris of the South Tower, and being buried by whatever else fell on top of it. For a moment, time stopped for us, too. But then, as if with a collective intake of breath, everyone sprang into action again: new firemen arrived to investigate, directions were shouted, and men started to cart away the debris by hand.

Suddenly a fireman came up to me—shaken, I'm sure, by the recent discovery—and began to rage against my presence there, saying that I wasn't a fireman, that I had no right, that I had to leave the scene immediately. He pushed me back up the hill and then returned to the center. I saw a chief a few yards away, a man about my age. I walked over, explained what had happened, and made my case: "Listen, Chief, this is a historic moment, and I'm the only one here with the means to record it." Together we looked down on the scene below. Then, taking my elbow in his big paw of a hand, he walked me down to the light and bellowed, "This man stays! He's here for us."

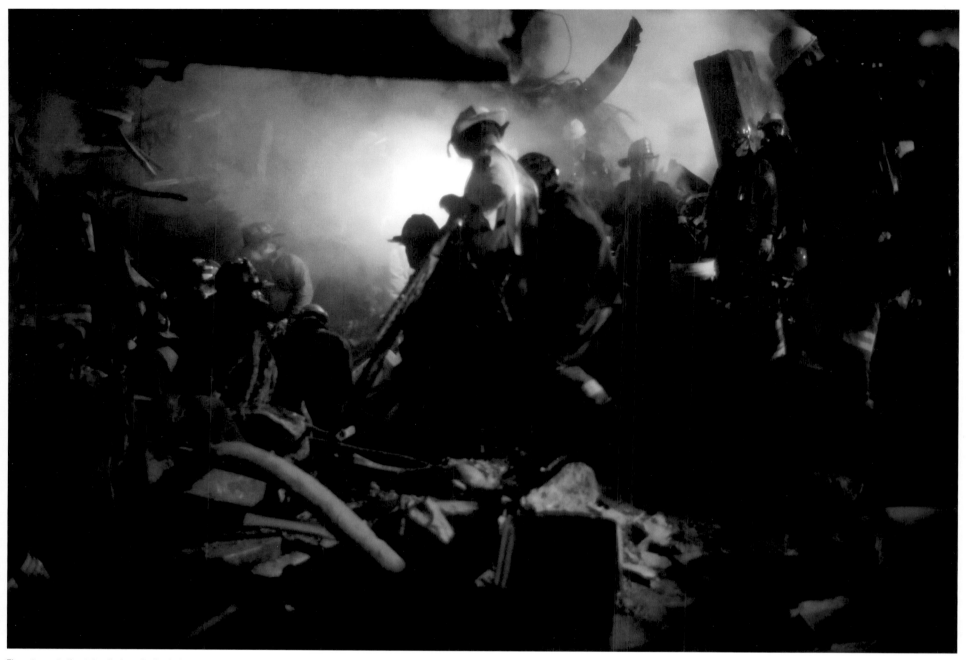

The entrance to the stairwell where the five bodies were found

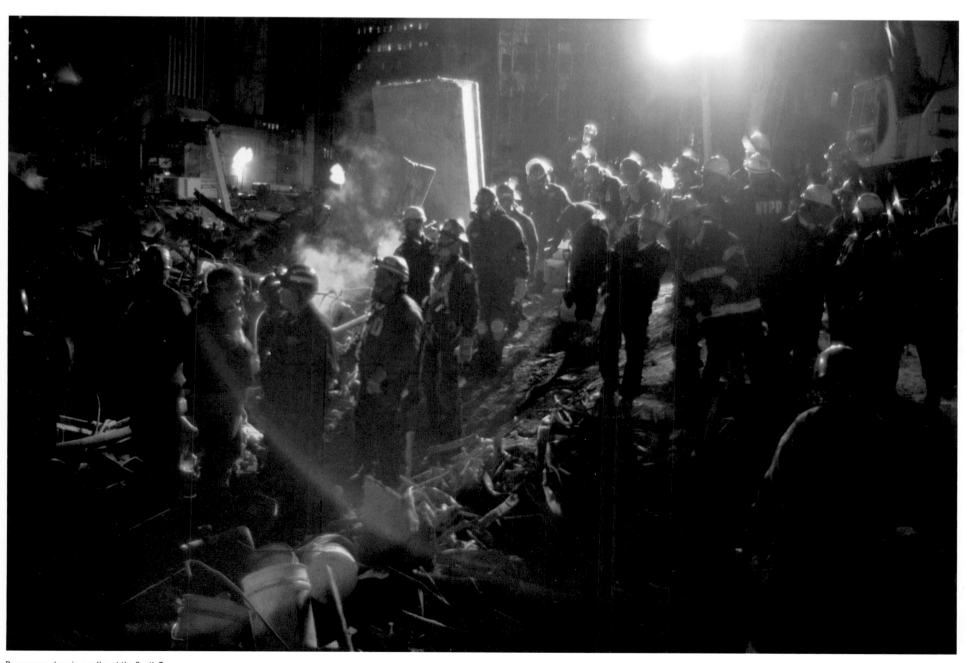

Recovery workers in a valley at the South Tower

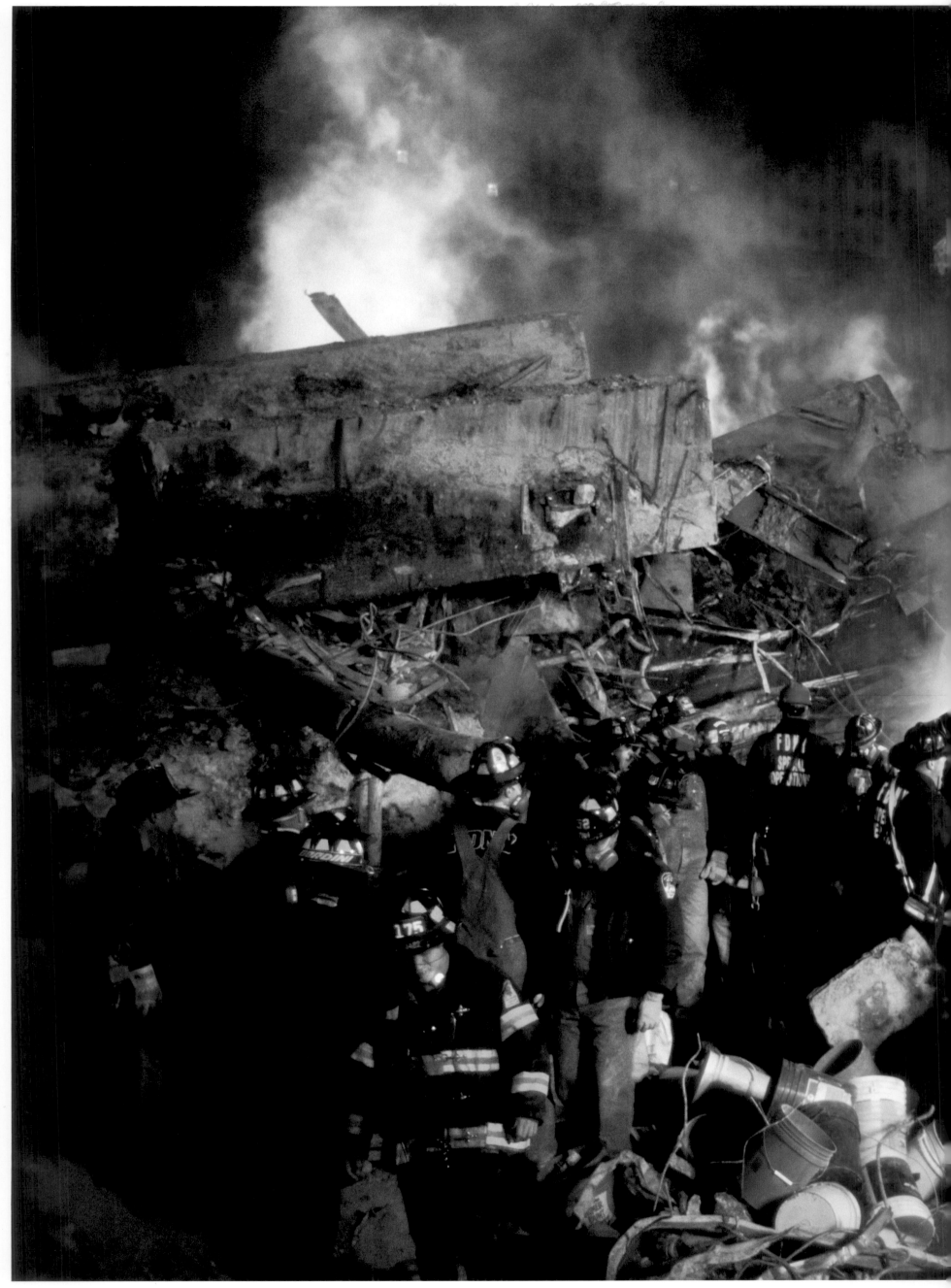

Five more found

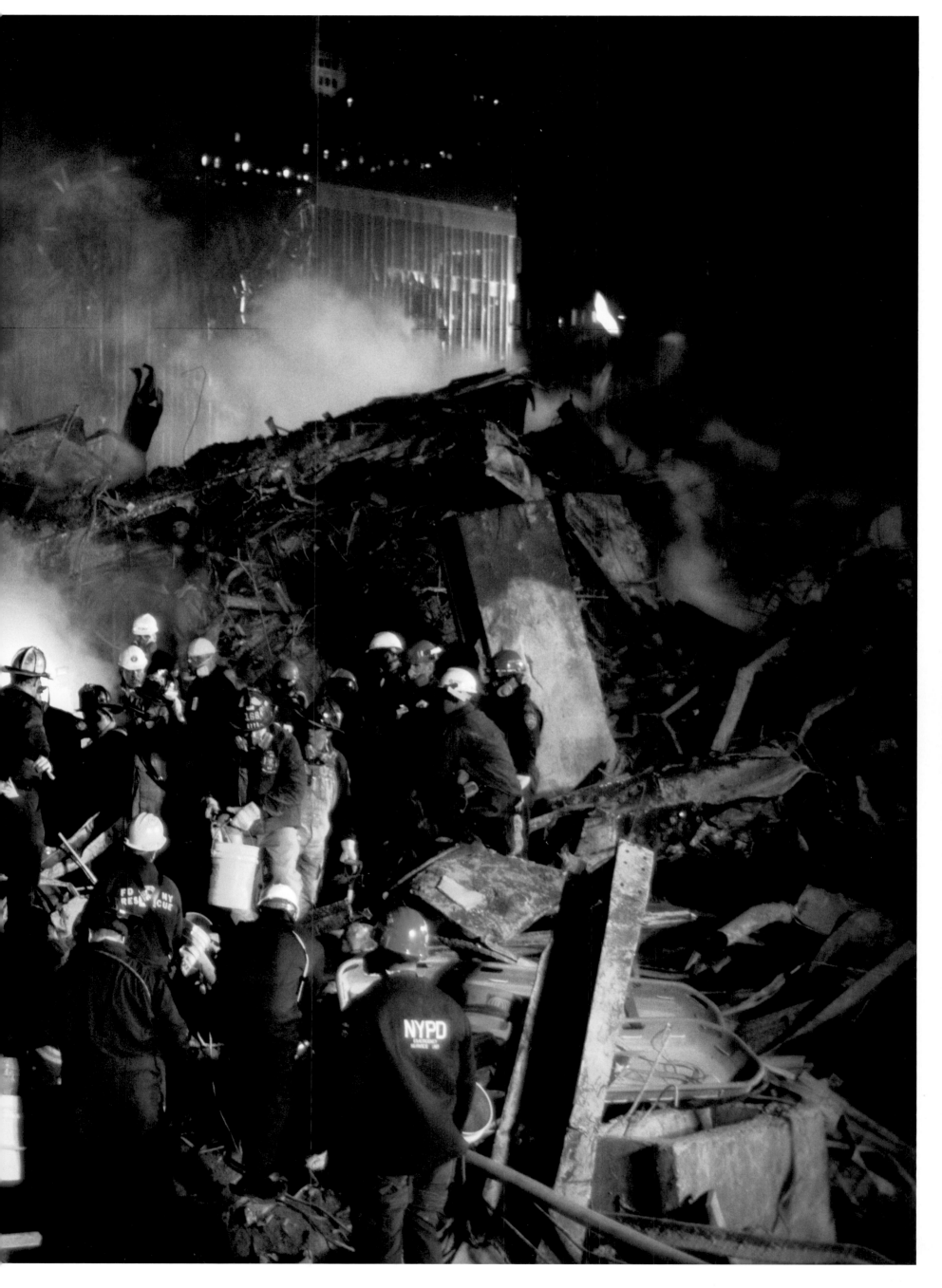

10.28

On the last Sunday in October, Mayor Giuliani opened the site to seven thousand family members for a memorial service held on Church Street. Thousands of folding chairs had been set up in front of a stage backed by two giant screens, and there were barriers to keep people out of the rubble. On the east side of Church Street, scaffolding had also been erected for the hundreds of journalists who were getting their first close-up look at one edge of the pile.

It was a sunny, cold day. Smoke and dust were suspended in the air, veiling the site. There was an empty, weary feeling coming from the gathering. The pain, still fresh, now mixed with resignation on the faces and in the posture of the thousands seated there. Many people held up photographs of the missing and the dead. Representatives of all faiths spoke and opera singers, calling forth the grief that song can release, wove a strand of hope and left us opened to it. No politicians addressed the audience.

After the service, the crowds dispersed north and south along Church Street. I noticed a woman move toward a barrier and say something to a fireman on the other side. Then she handed him a bouquet and a photograph. First he looked attentively at the photograph, as if he were being introduced. Then he looked up again at the woman—really looked at her—before walking the sixty feet to a pile of earth and debris at the base of Building 4 and carefully putting the flowers and the picture on the pile. Following the woman's lead, more people then lined up to give mementos to the six or so firemen gathered there.

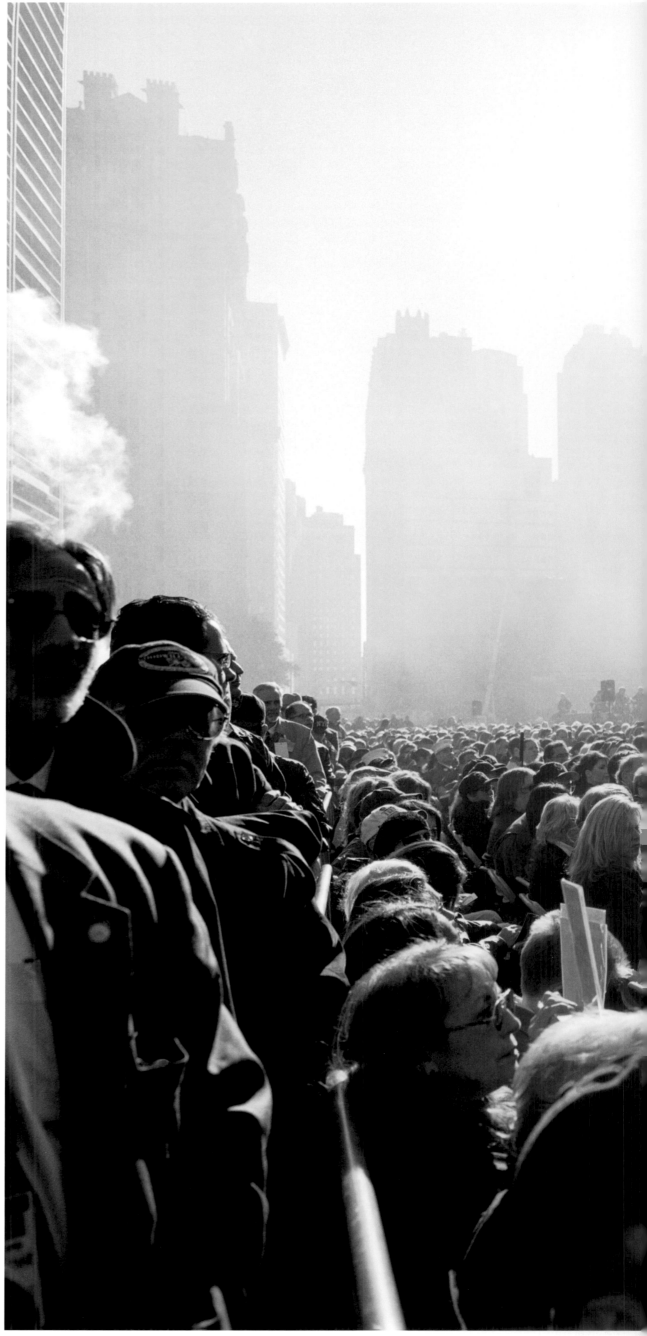

Seven thousand family members attend the memorial service on Church Street

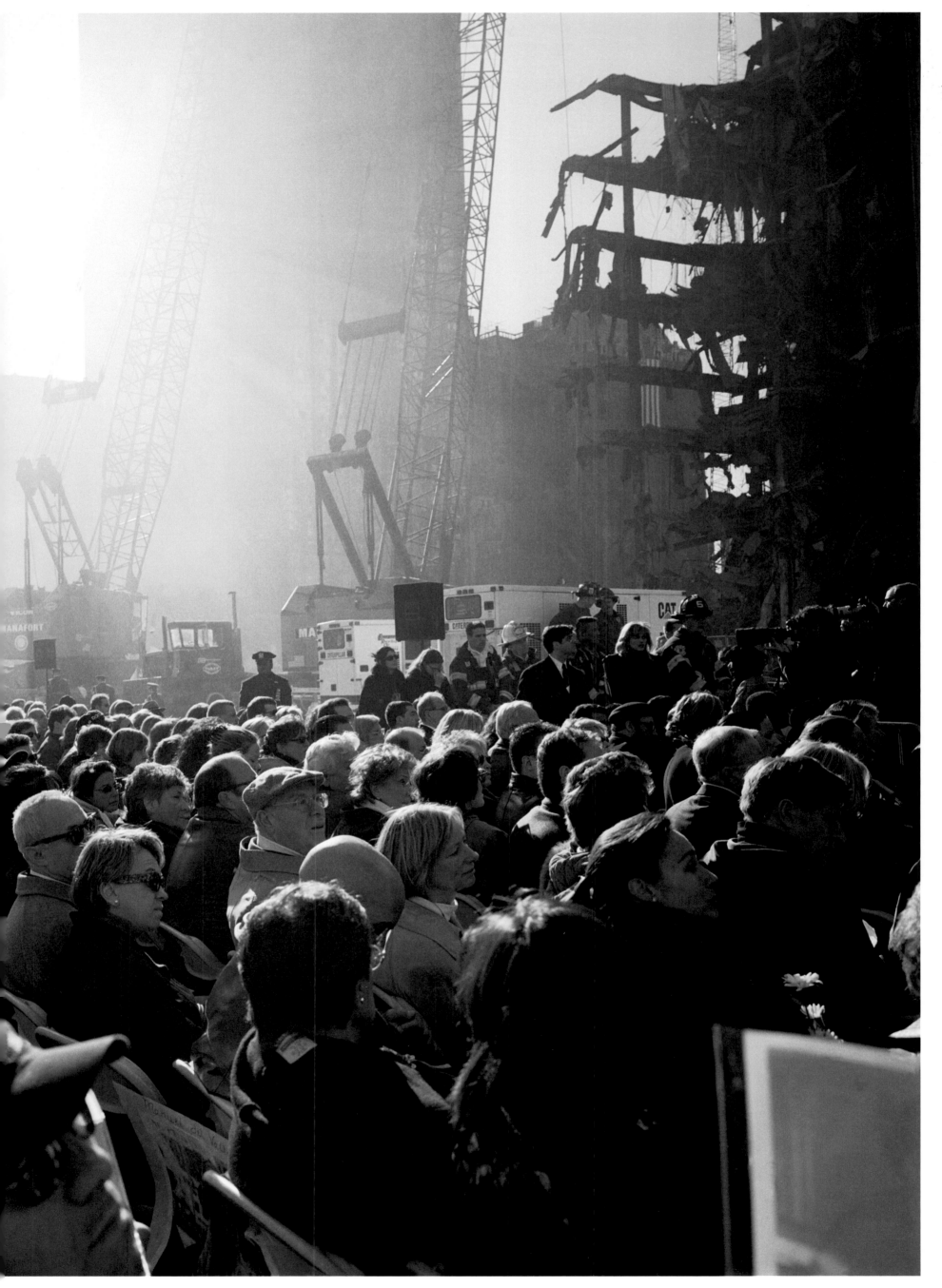

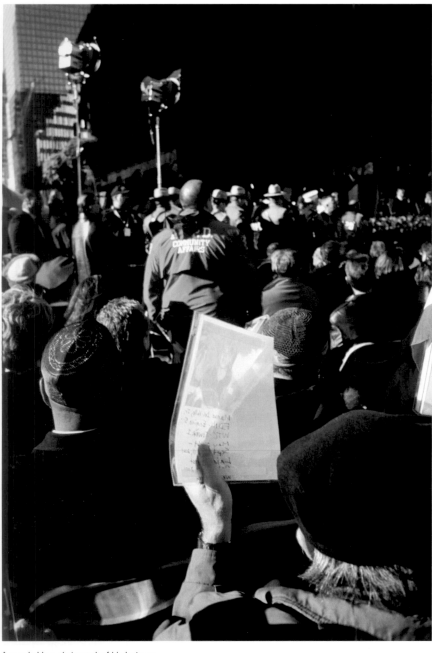

A man holds a photograph of his lost son

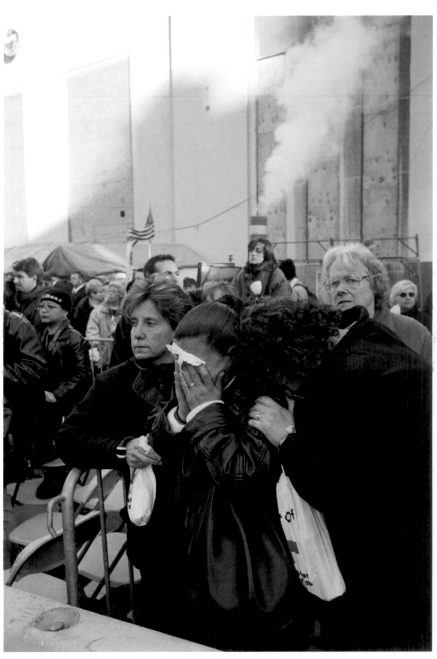

Family members grieving

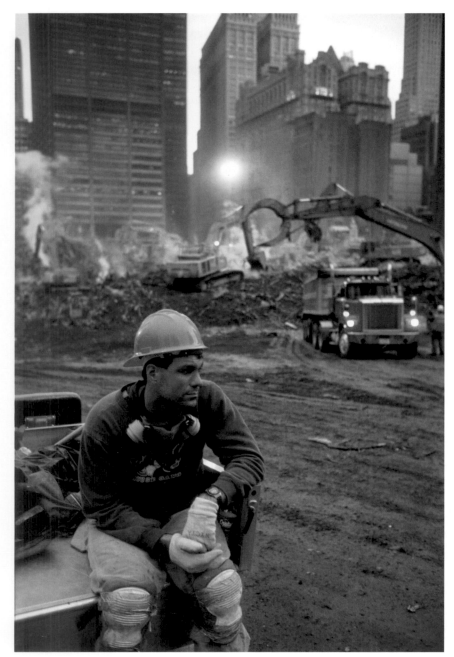

A recovery worker on the back of a mule

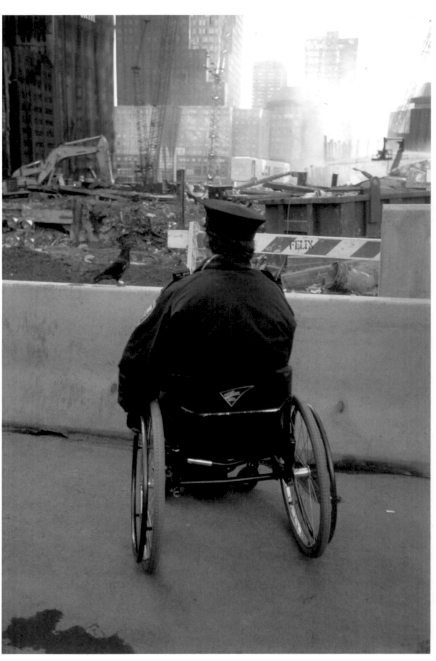

An injured fireman returns to Ground Zero

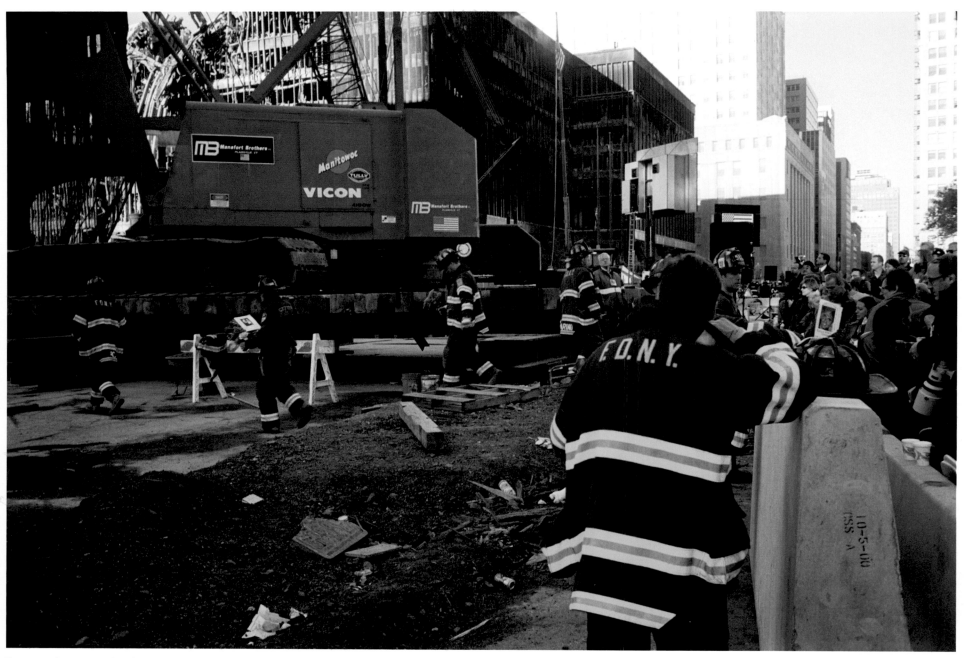

Firemen carrying mementos from family members to the pile

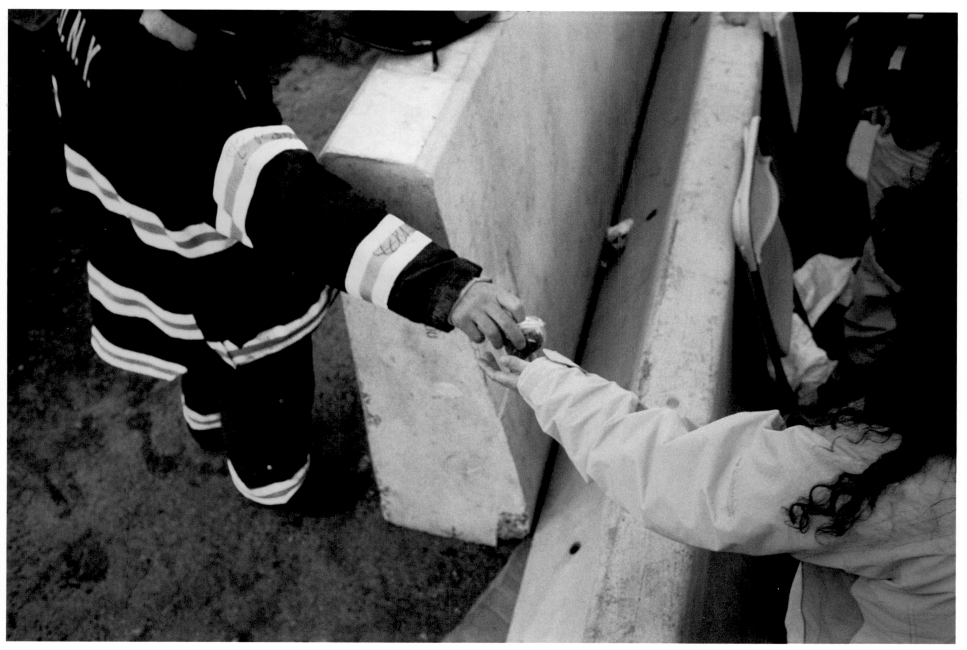

A fireman hands a stone from the pile to a family member

In a sense, all New York City's firefighters had been in mourning at the site for weeks. Perhaps that's why they executed this ritual with such compassion—approaching the pile with measured steps, carrying their burdens lightly, and then caringly laying them to the earth. I was walking back and forth taking pictures of this impromptu procession when two men—a priest and a rabbi— called me over and gave me a picture to put on the pile. "I'll bring it to one of the firemen," I assured them. "No," one of them replied, "we want you to put it on the pile for us."

Within seconds I had been transformed from a dispassionate observer to a member of the procession. I looked at the picture in my hand and there was a young man looking back at me. I felt completely overwhelmed. And yet the firefighters had been doing this for weeks. What right did I have to refuse? I moved toward the pile, blinded by my own tears. I don't remember how long it took to get there or where I put the picture. I only know that I knelt down, because much later I noticed that there was mud on the knee of my pants.

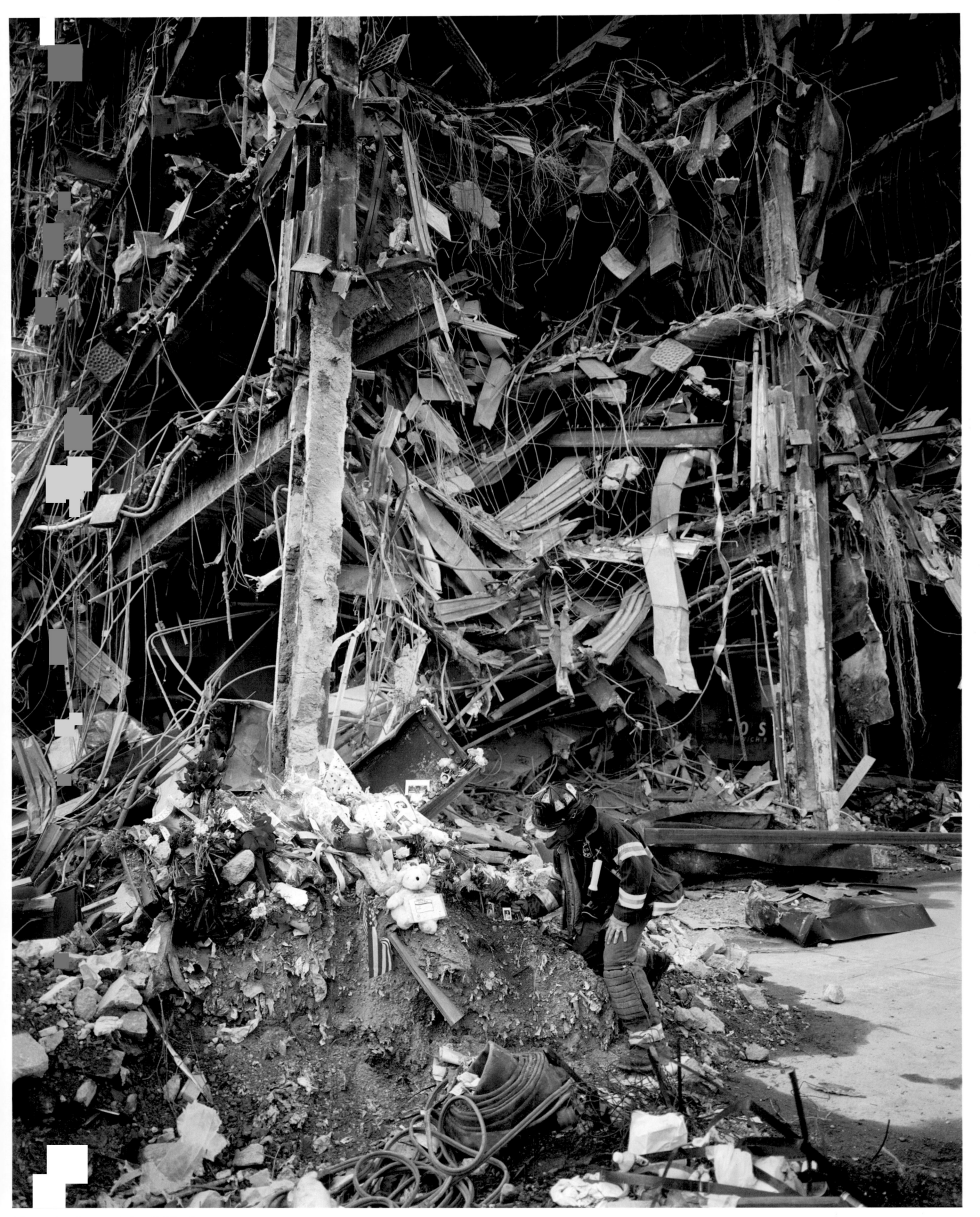

A fireman places flowers at the foot of Building 4

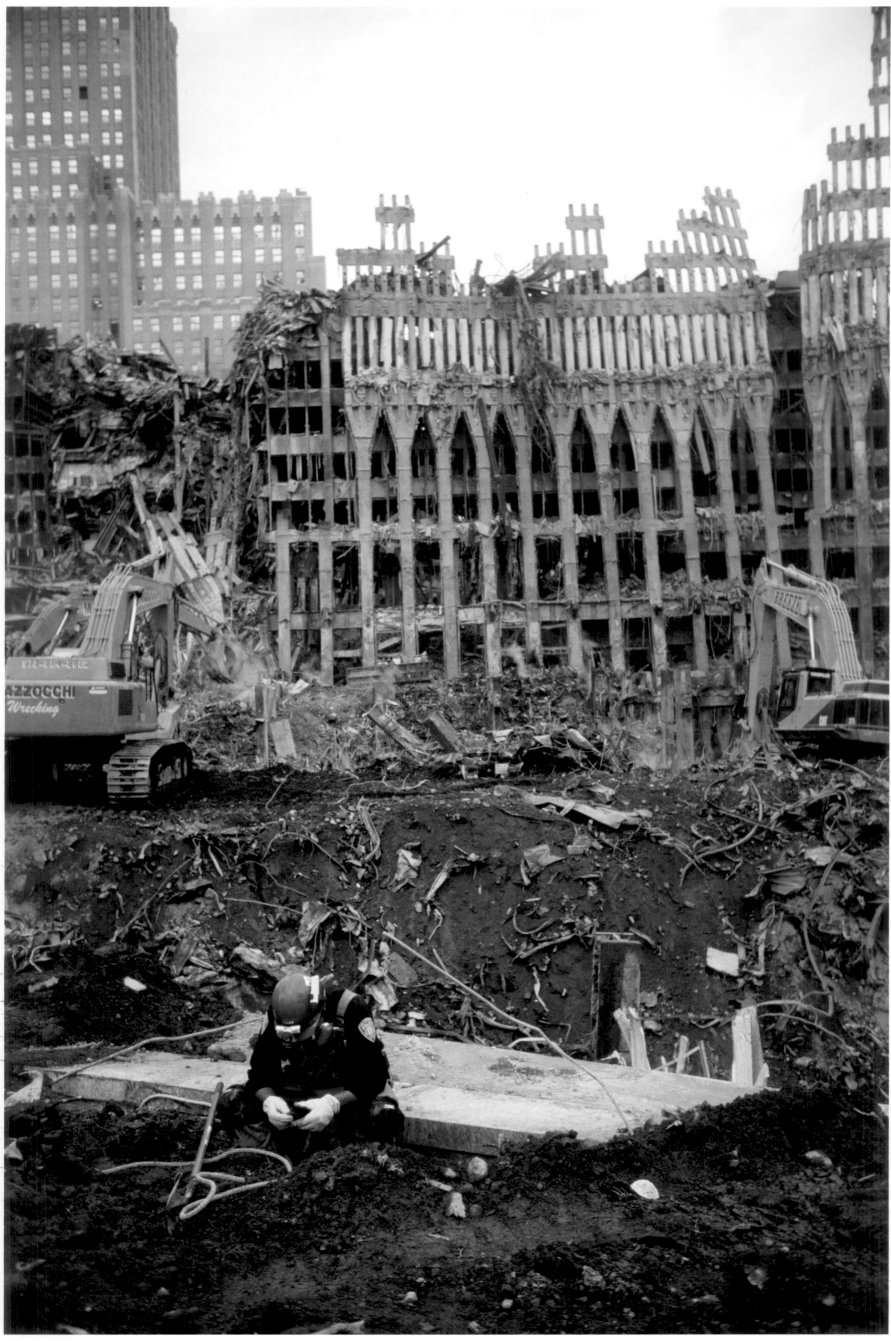

A recovery worker studying a find

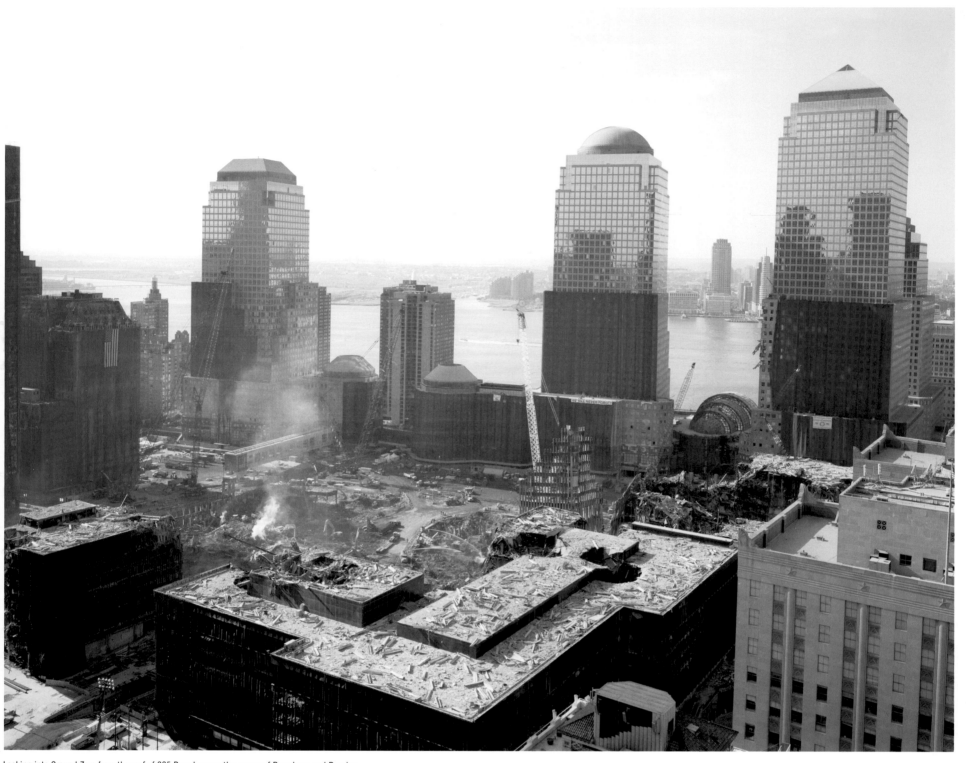

Looking into Ground Zero from the roof of 225 Broadway on the corner of Broadway and Barclay

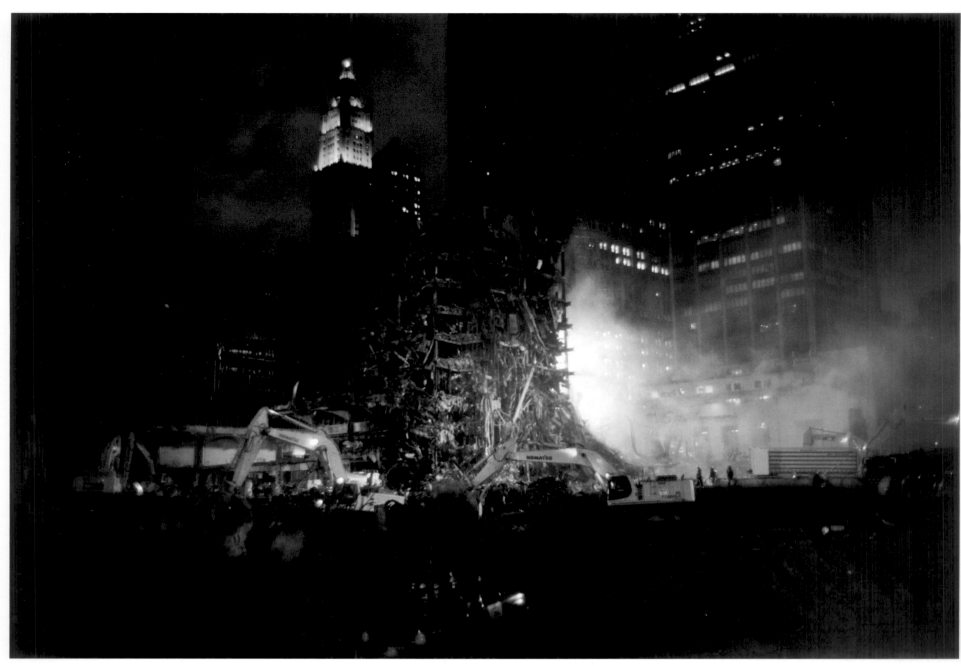

Twilight looking toward Building 4 and the Woolworth Building

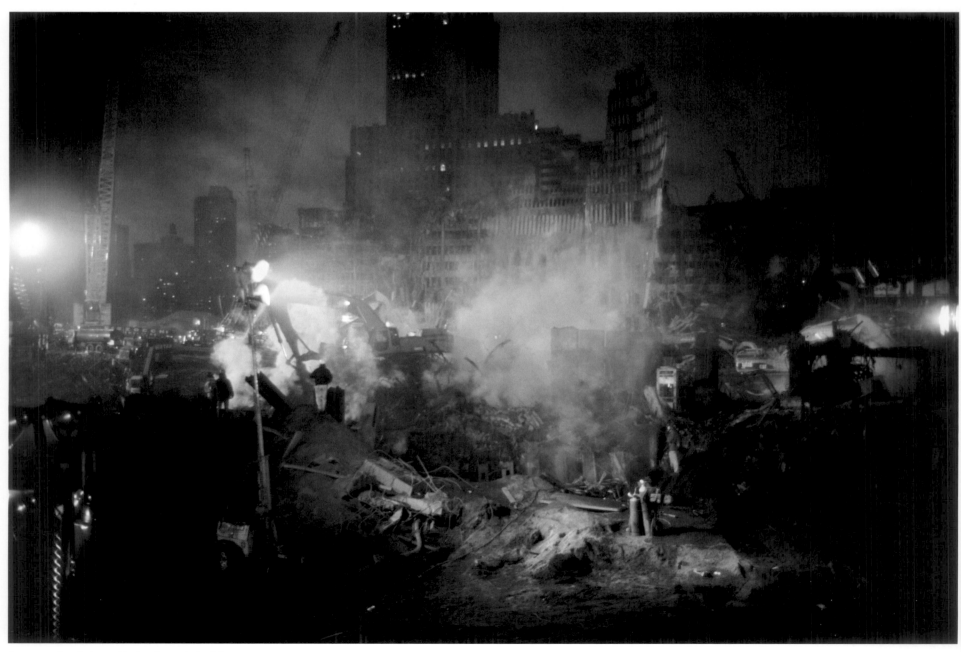

Green gas and smoke from welders' torches at the South Tower

11.05

The wrecking ball was banned in New York City sometime in the 1970s. It was too dangerous a method for destroying buildings so close to the crowded streets of Manhattan. As the superintendent of the site, Charlie Vitchers, explained, "Rivets could fly out of beams like bullets." Nevertheless, it was decided to take down Buildings 4, 5, and the Customs Building as quickly as possible—rumor had it that the DDC wanted them down before Mayor Giuliani left office—so the wrecking ball was the tool of choice. At Ground Zero, however, instead of using the conventional ball, they used a six-thousand-pound piece of a core column. Then, after the burners had gone in and weakened the structure, they smashed Building 4 down with this battering ram.

The Tully Road into the valley

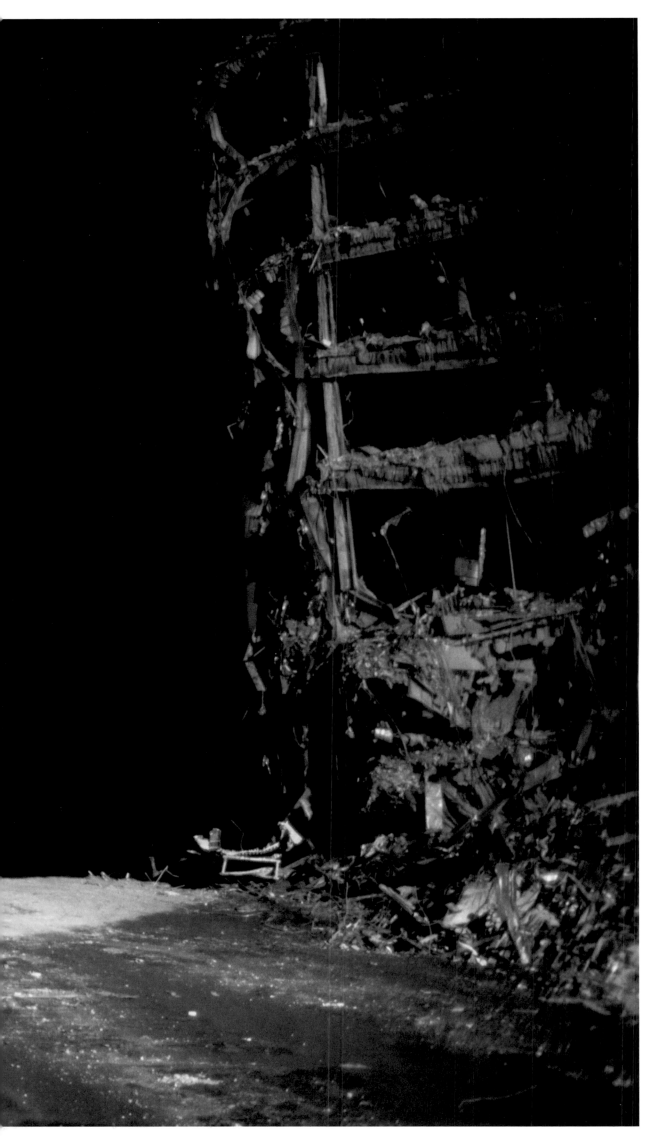

Walking up the hill around midnight, I entered this space—floodlit, expectant, hushed. Behind me, the site was seething with activity; here it was an empty stage, waiting for the actors to enter. Either way, the zone was a place invested with enormous significance: all actions seemed larger than life here.

It was long past time to go home. I'd been on the pile since ten-thirty in the morning, and I was exhausted. I crossed the stage and headed north, where I began my two-mile walk through the no man's land of lower Broadway to the West Village. With twenty-five pounds of equipment on my shoulder, it felt like an impossible distance.

For almost everyone working at Ground Zero, the outside world seemed to get a little further away every day. The pile exerted an almost magnetic pull, and most of us couldn't wait to get back to it. Each of us felt that we were a small part of something huge and important, and how often does that happen? To submit to such an enormous enterprise was grueling, but it was also transforming. For many of us, it was leaving the zone, rather then returning to it, that became the ordeal. Sometimes, though, fellow New Yorkers made the transition a bit easier.

That night, by the time I reached the slight rise at City Hall, I felt as if I could not take another step. Then behind me, out of the stillness, I heard a metallic "ding." A guy on a bicycle rickshaw pulled up beside me and told me to get in—a mind-reading angel! And he spoke with such authority and generosity that I did exactly that. "I could see how beat you were from two blocks away," he said. "Where do you want to go?" I asked him to take me up to Canal Street, where I could get a cab. He told me he ferried people out of the zone as a way of doing his part—another player on the pickup team at Ground Zero.

On Canal Street, life felt almost back to normal; the sidewalks and streets had all the usual hustle and go of New York at night. I hailed a cab and—still high from my rescue by rickshaw—I recounted my experience to the driver. As he pulled up in front of my building, he said, "No charge, man, you're doing good work." How about that! The city had carried me home.

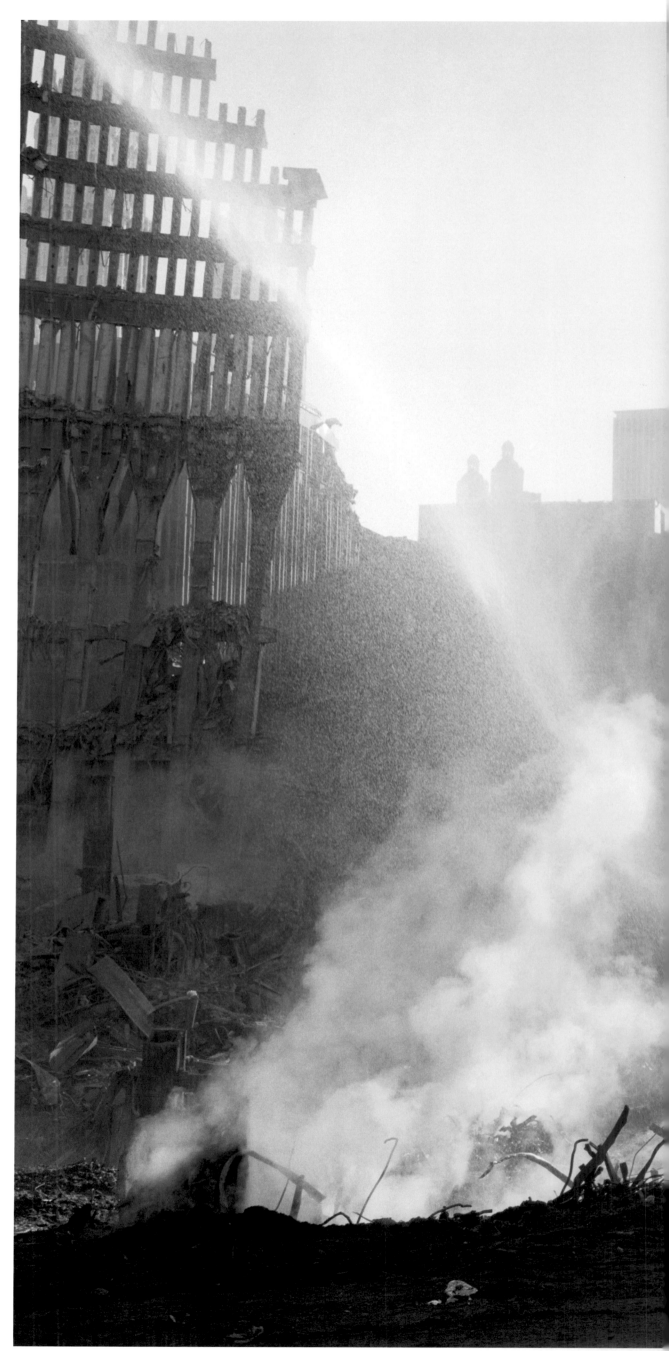

Grapplers and spray in the valley

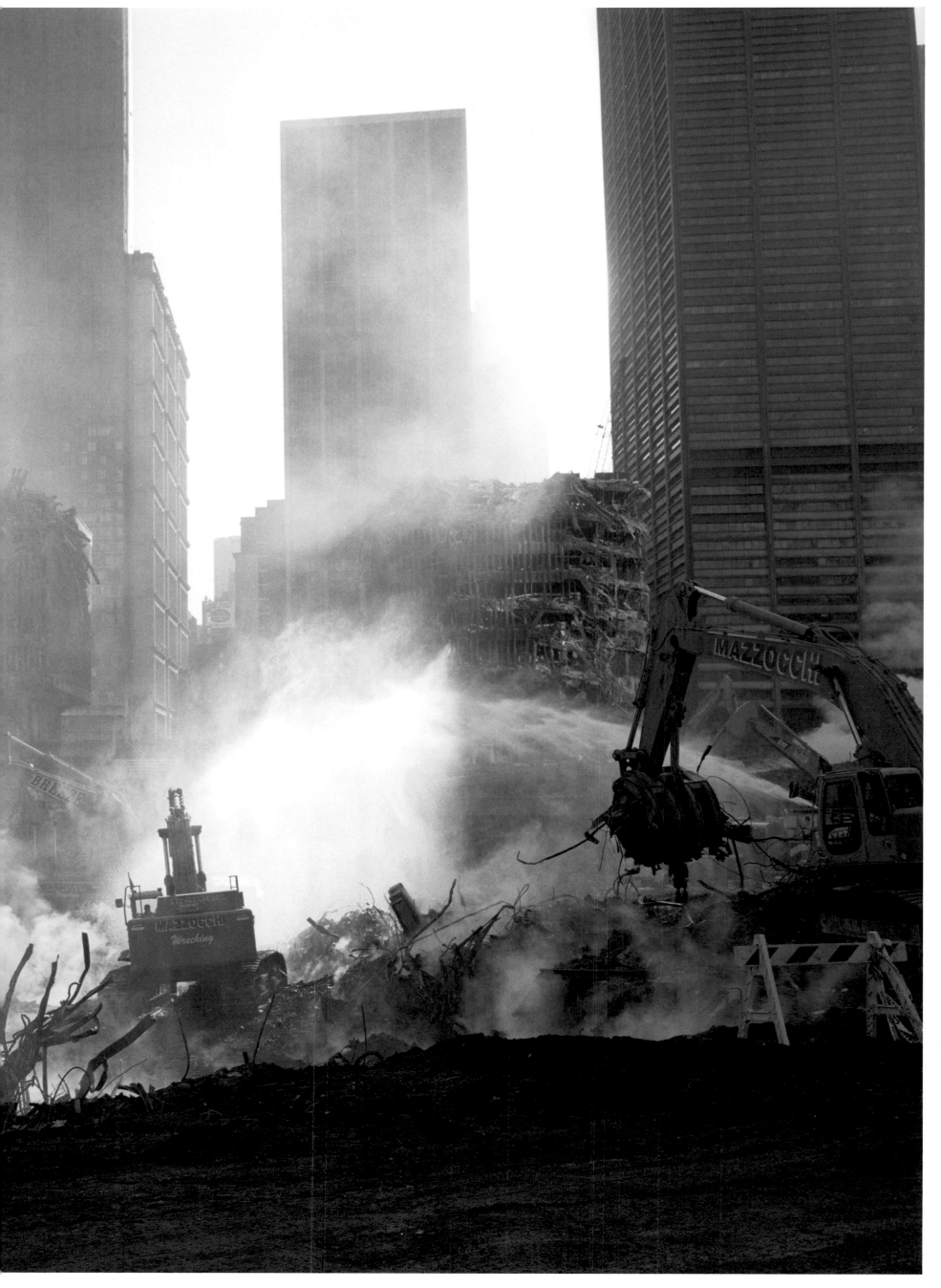

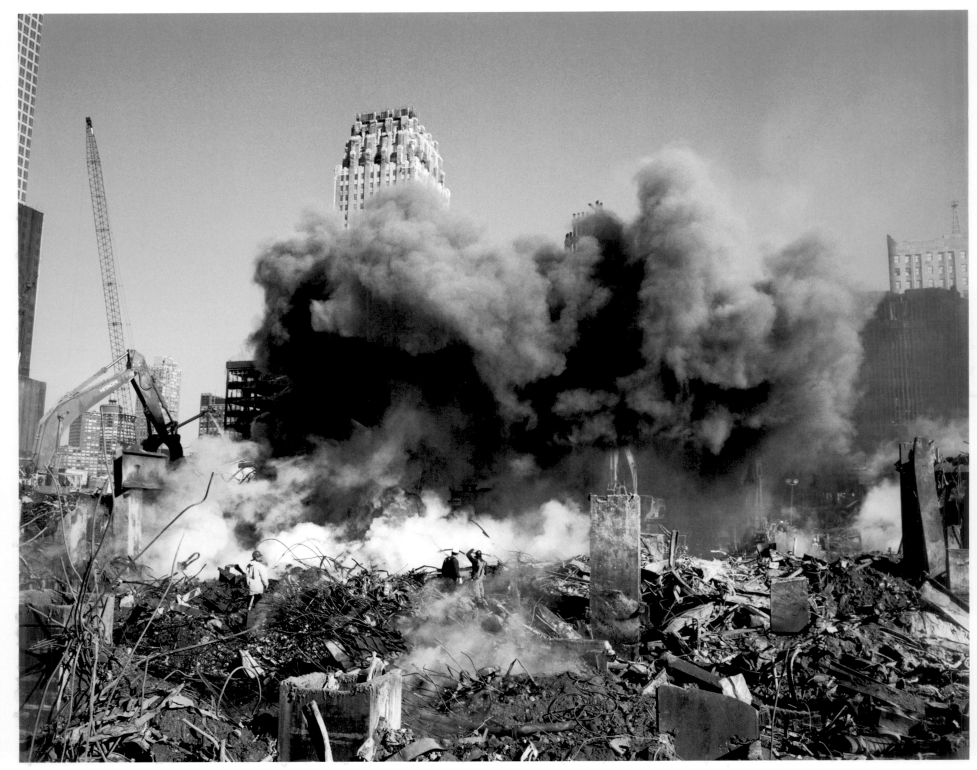

Smoke and ash explode from the pile when steel is pulled out and oxygen races in

11.08 As long as the fires raged below ground, every stick pulled out by a grappler allowed a gust of oxygen down into the hole, which would be followed by an explosion of smoke and ash. We were all covered with ash during the day. Here the rising cloud, changing almost instantly from black to white, passes in front of a glinting tower and makes a scrim of smoke through which beams of light shower down, pouring a bit of the heavens onto the pile.

One afternoon, when I was late coming downtown, I was greeted excitedly by several members of the Arson and Explosion Squad as I walked onto the pile. "Oh, Joel, you missed an amazing sight today," one of them exclaimed. "We were on our knees, digging in the smoke, when all of a sudden we were surrounded by Monarch butterflies—swarms of them flitting around us, tapping on our helmets in the smoke. One of the guys stood up and said, 'Souls.'"

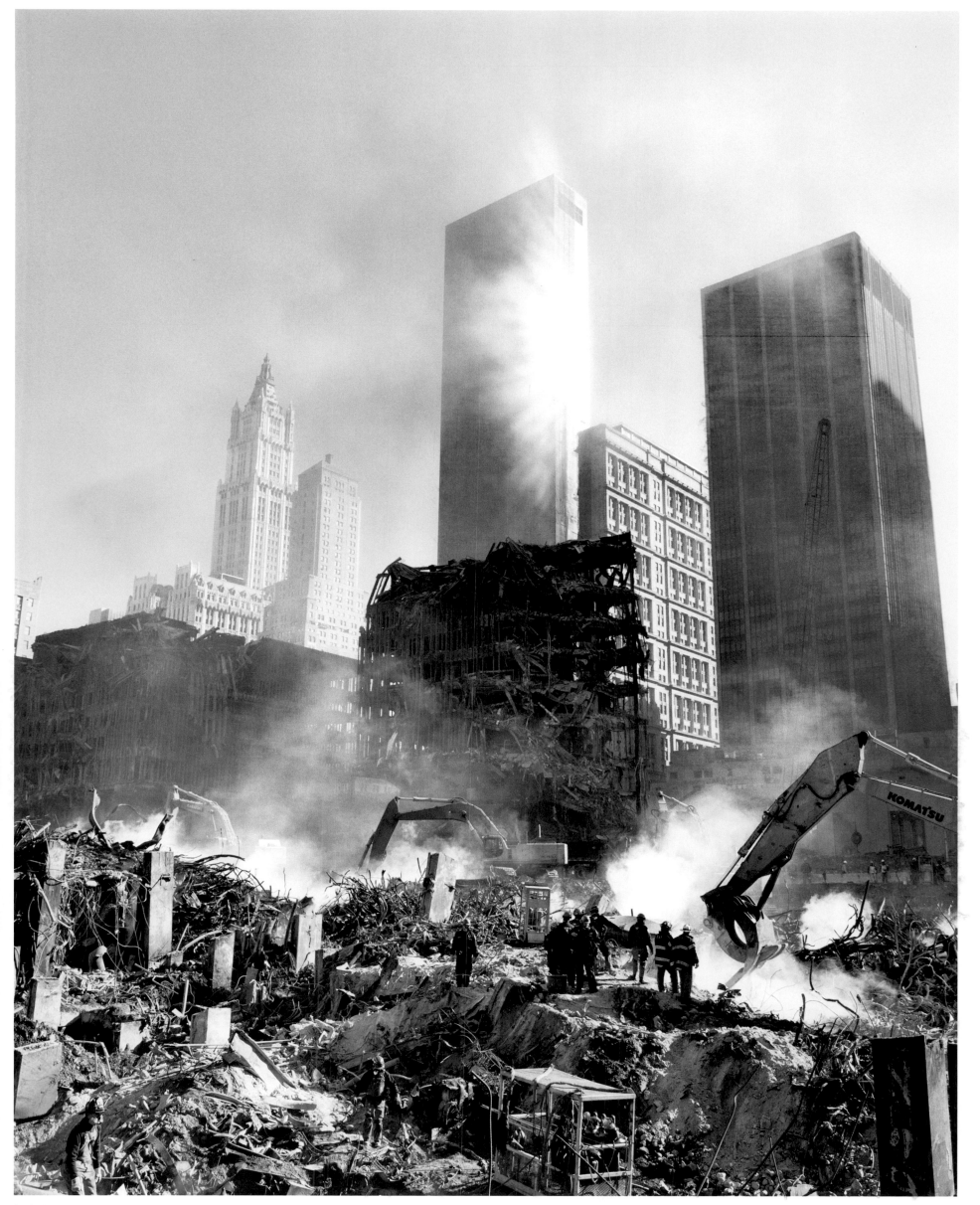

Smoke rising in sunlight

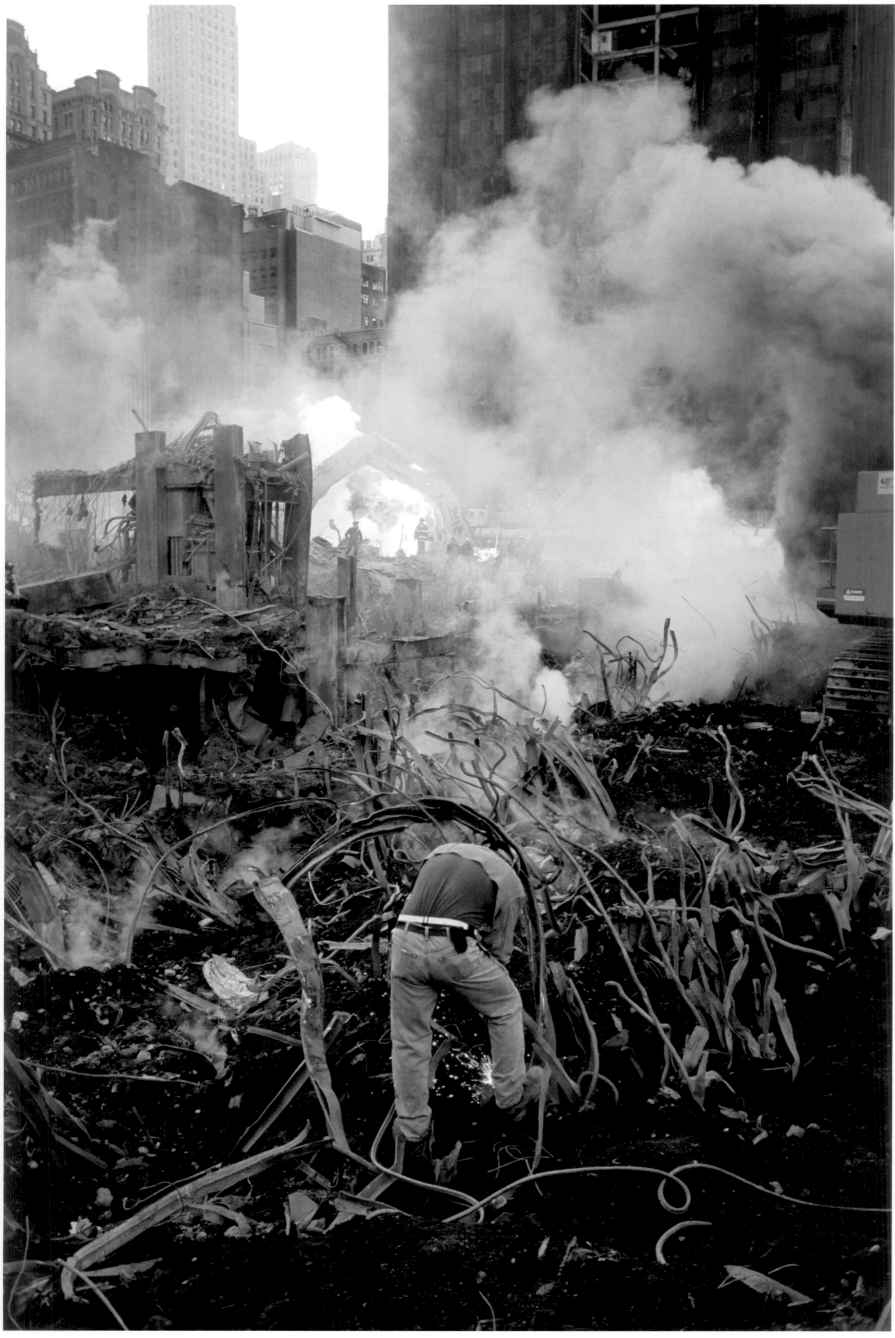

A burner at work clearing standing steel

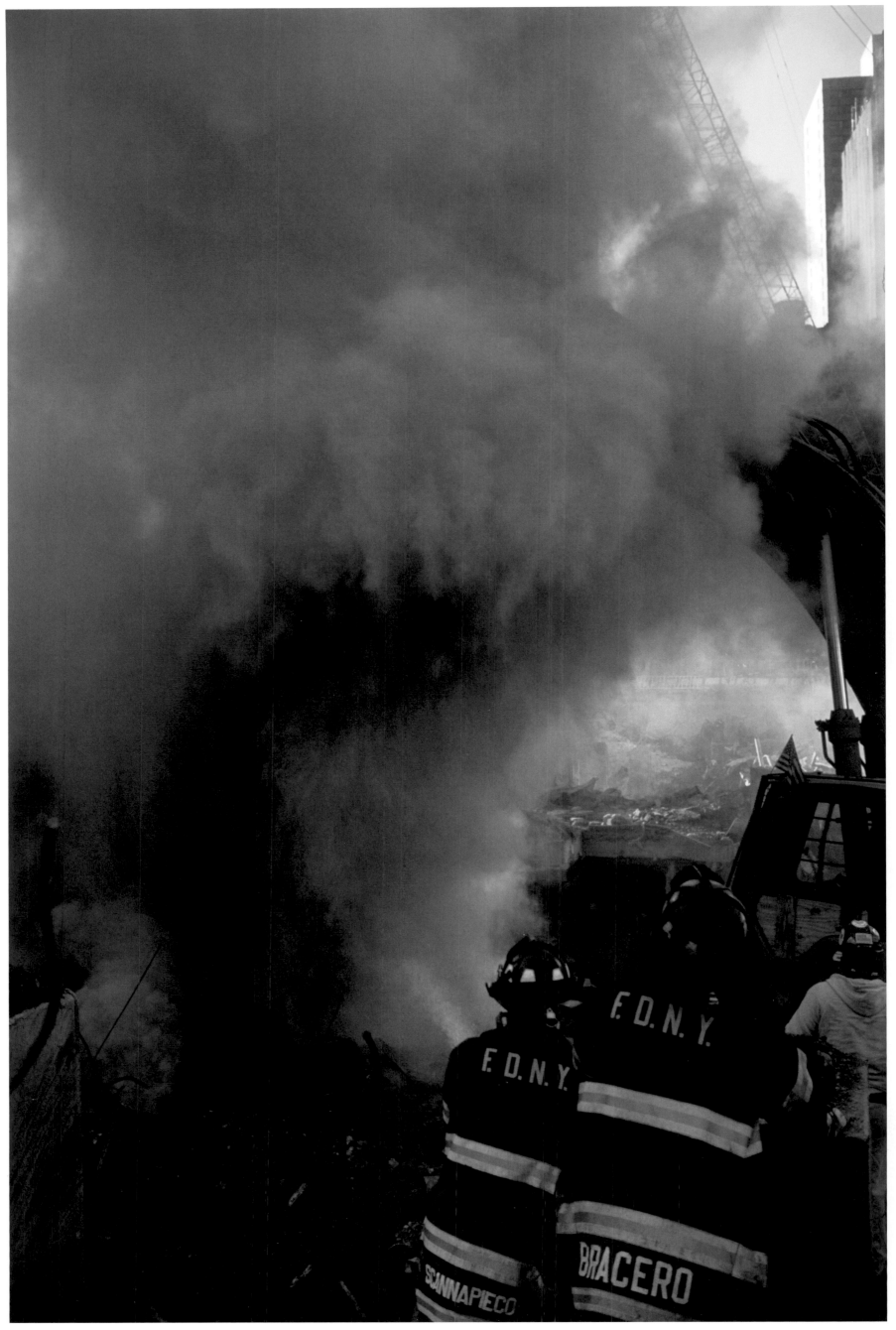

An explosion of dust and ash over spotters

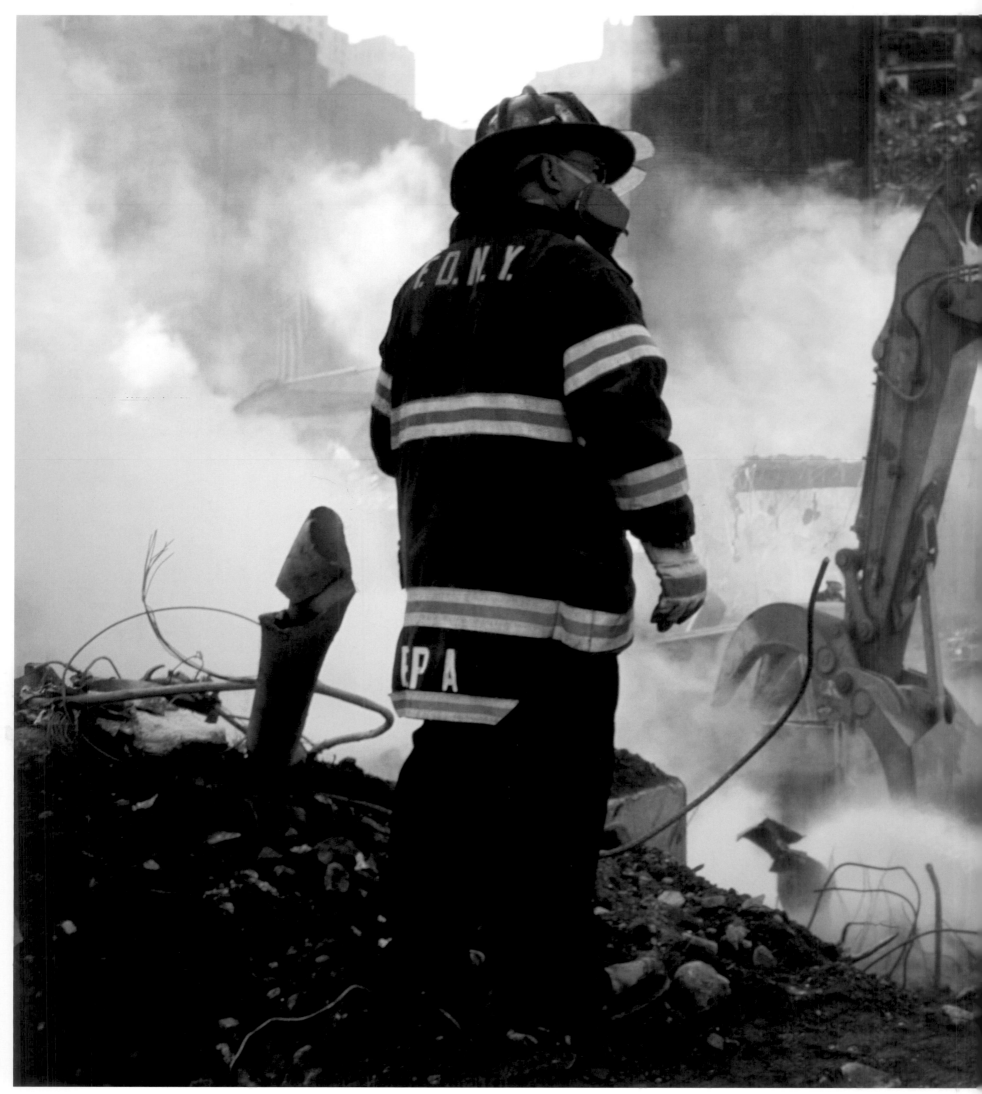

Spotters in the South Tower

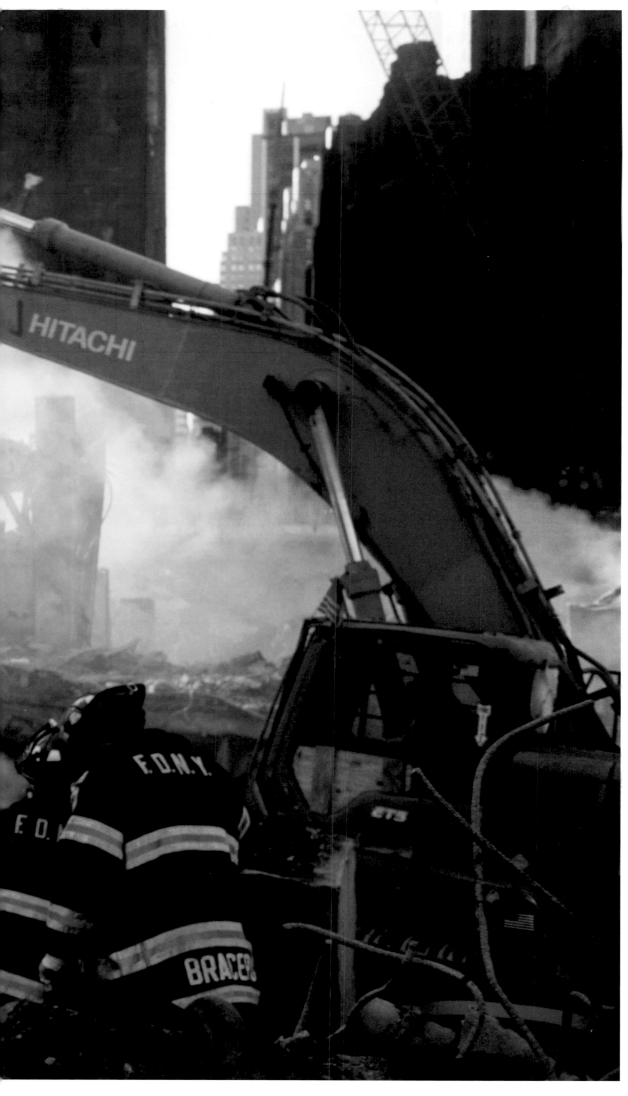

Spotting was dangerous. The pile was an unstable network of hard matter and voids, and disturbing it in one place could easily cause a collapse in another. There were also unexpected explosions of ash and debris. Add the stress of standing for eight to ten hours in the smoke and noise, so close to the brute force of a moving grappler, and you can understand why tempers were sometimes short and fights broke out between operators and spotters. It was often impossible to be heard over the roar of the machines; sometimes, when the spotter wanted the driver to stop but couldn't get his attention, he would throw a rock or a piece of steel at the cab of the grappler in frustration. The pressure of working so close to death often brought people to their limits.

On November 1, in an effort to accelerate the clean-up effort and reduce the overtime cost to the city, Mayor Giuliani decided that only twenty-four men from each of the uniformed services would be allowed to do recovery work on the pile. On November 2, the firemen staged a protest, arguing that the dead deserved better treatment than this. The police, who have a longstanding rivalry with the Fire Department, were there to enforce the Mayor's edict. It was like tinder and flint; a fight broke out during the protest, and a dozen firemen were arrested. Peter Gorman, president of the Uniformed Fire Officers' Association, said that the Mayor's decision had made the recovery work "a scoop-and-dump operation," and that it was upsetting to the mourning families. Their concern was that unexamined debris would go directly to the landfill at Fresh Kills, Staten Island, and be thrown into the huge sorting hoppers, known as "grizzlies," and that crucial forensic evidence would be lost. One fireman, Bob McGuire, whose nephew was among those lost in the rubble, said, "I don't want him to end up in a dumpster." Ultimately, a compromise was reached, and seventy-five firemen were allowed to work the recovery on the pile.

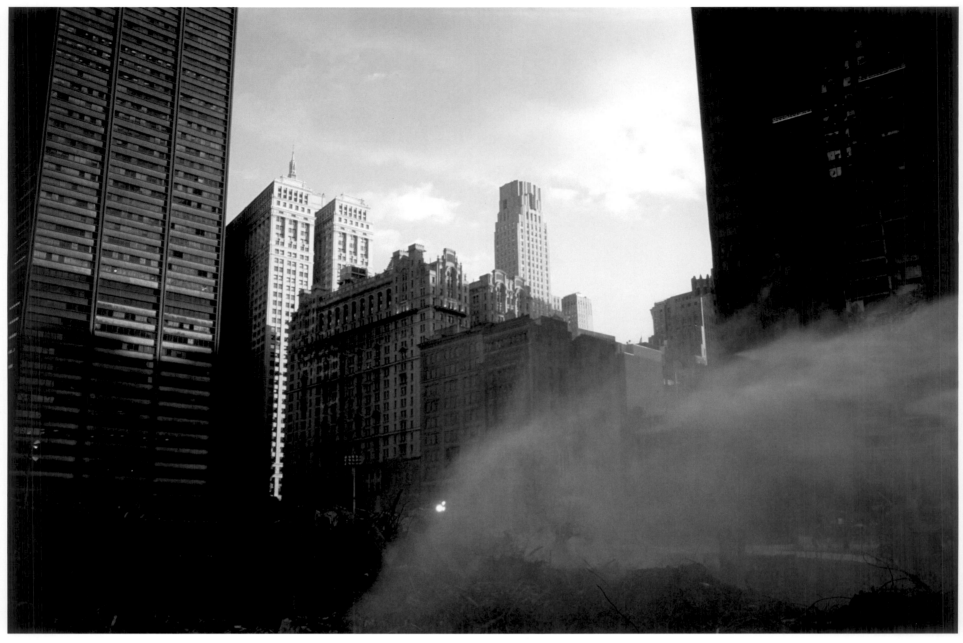

A veil of spray across the pile

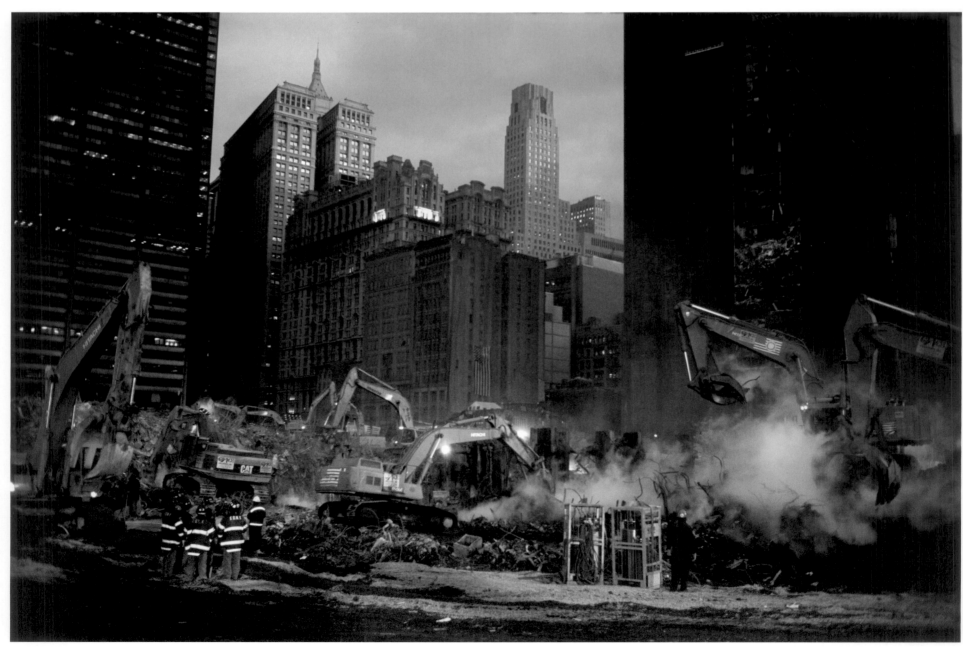

Ten grapplers daisy-chaining at dusk

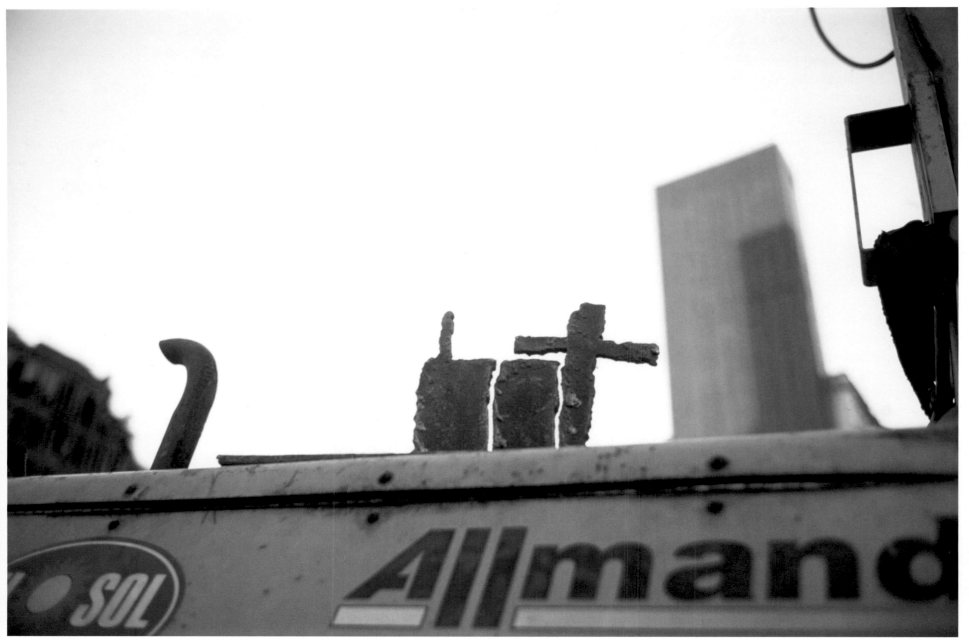

A welder's doodle

I was standing with a friend watching the work when I noticed an oddly shaped piece of steel in the rubble. I picked up a ten-pound piece of I-beam and saw that the Twin Towers—antenna included—and a cross had been burned away from the rest of the beam. Like a whittled bit of wood, or a piece of Outsider Art, this had been made by a welder killing time, a doodle scrawled in steel. I had never seen anything like it before, but over the coming months these creations became a little cottage industry, a way of making mementos to give away: crosses, crescents, Jewish stars, and other designs burned out of the towers' refuse.

It's hard to come to terms with the awful beauty of a place like this. After all, the site—thick with grief and death—was dangerous, noisy, dirty, poisonous, and costly almost beyond measure. And yet the demolition at Ground Zero was also a spectacle with a cast of thousands, lit by a master lighter and played out on a stage of immense proportions. As I stood there on the November evening (shown opposite, bottom), watching the light play and fade on the buildings as the dinosaurs beneath them danced their mad to-and-fro, it all looked wondrous.

FOLLOWING PAGE: As the pile diminished, new perspectives on the landscape around it became visible. The Woolworth Building, a glazed-brick tower built in 1913, came to symbolize the sanity and stability of an earlier time. Its graceful proportions, capped by the castellated tower, were freshly displayed by the daily changes in the light: silky gray when backlit by the morning sun; ghostly silver in fog or haze; brilliant white and edgy in the hard, southern light of fall; golden in late afternoon; cotton-candy pink at sunset; and magical at night, when its green spire could be seen from the depths of the pile. For me it became a beacon, my reference point on my tours around Ground Zero.

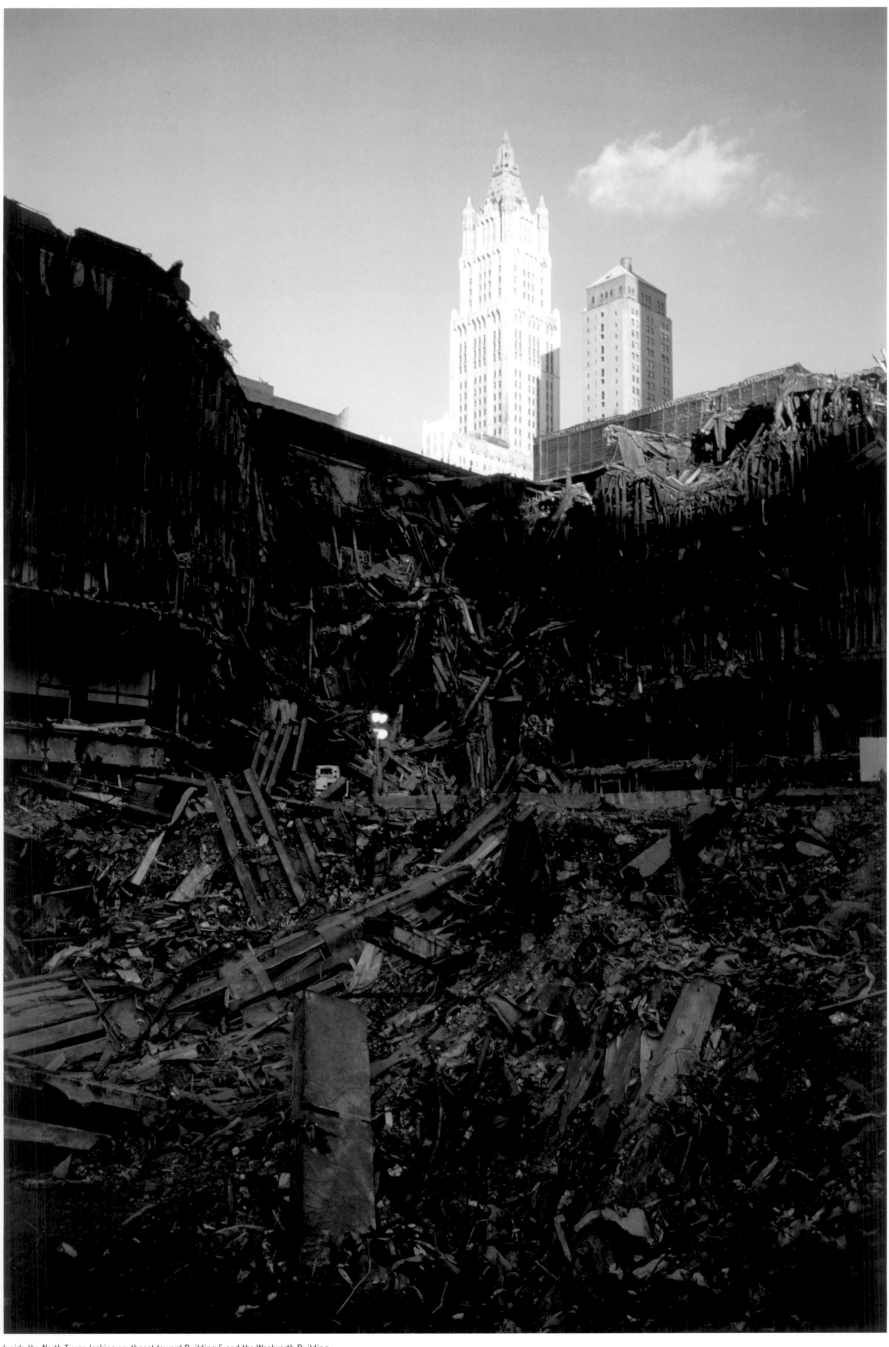

Inside the North Tower, looking southeast toward Building 5 and the Woolworth Building

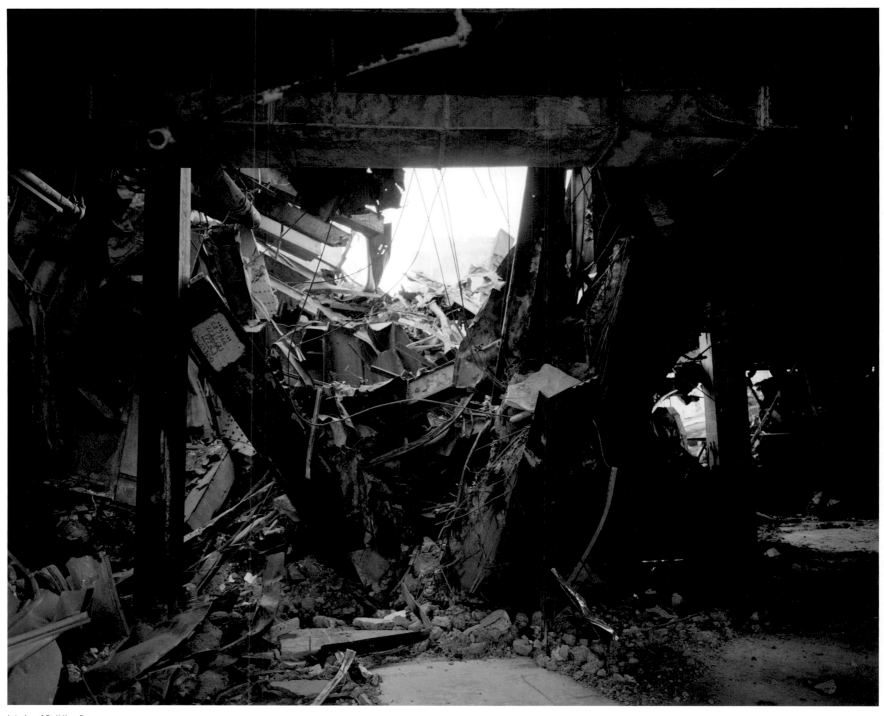

Interior of Building 5

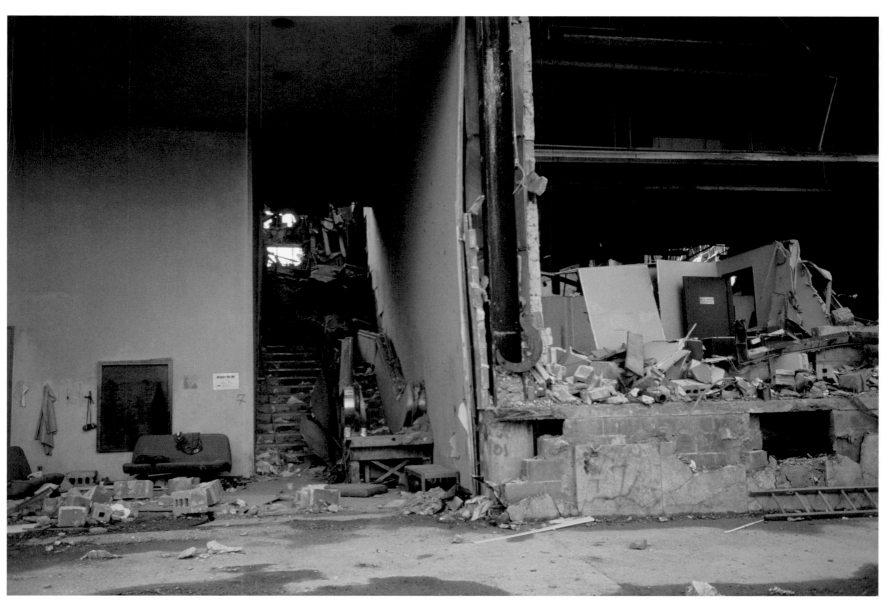

A stairway in Building 5

11.12

Inside the pile, the visual partner to the Woolworth Building was the shroud of the North Tower. In its own way, it presented an image of undeniable emotion—wrecked yet monumental, soon to be dismantled but enduring. It is etched in my mind, whether silhouetted by sunlight through its latticework, or black under cloudy skies, or incandescent in the swirling vapors illuminating the night on the pile.

For most of us down there, the shroud became the first thing we looked for when arriving at the site, especially if we had been away for any period of time. It was viewed not just as an iconic image, but also as an indicator of how the work was progressing. The more visible it became, the more we understood how fast the pile was vanishing.

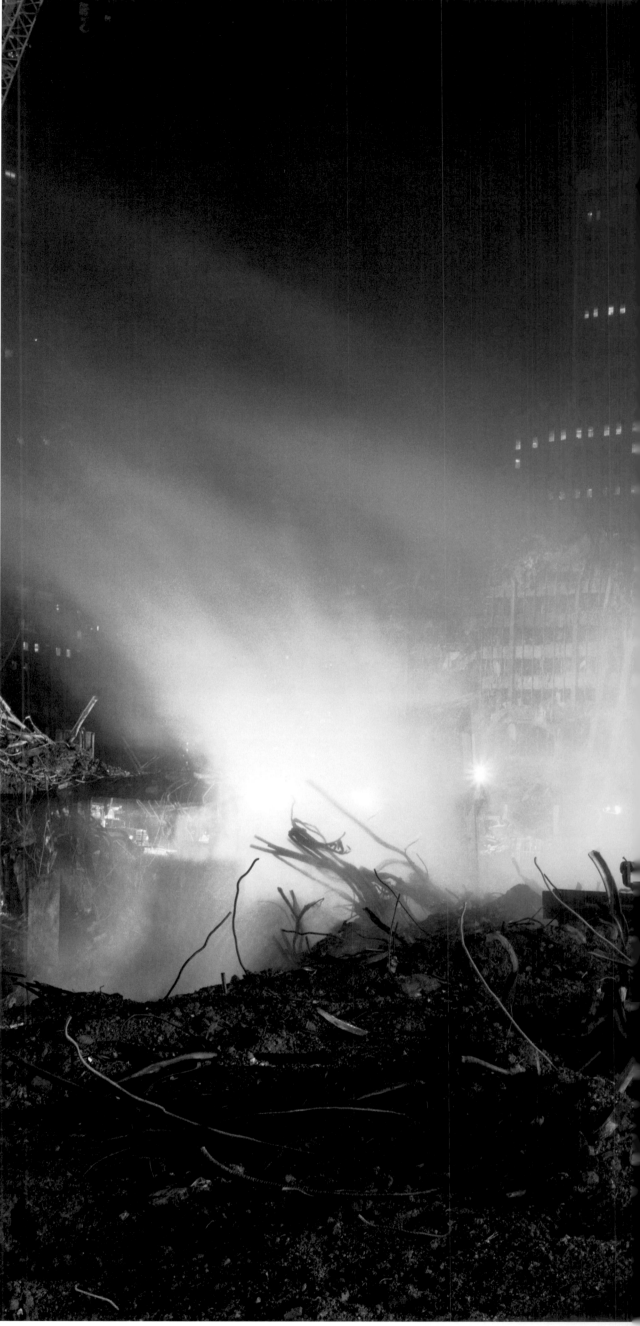

The North Tower shroud in smoke and spray

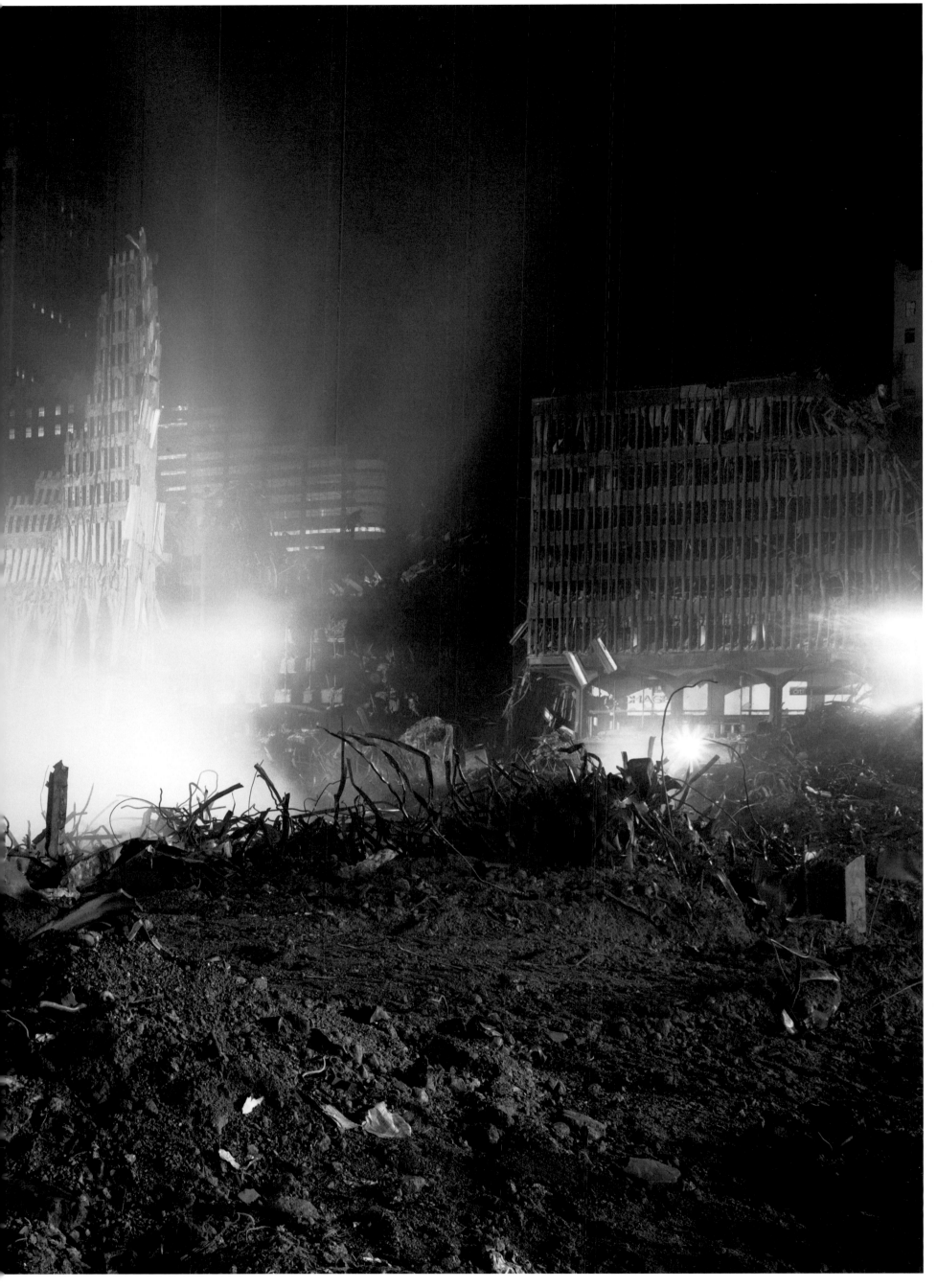

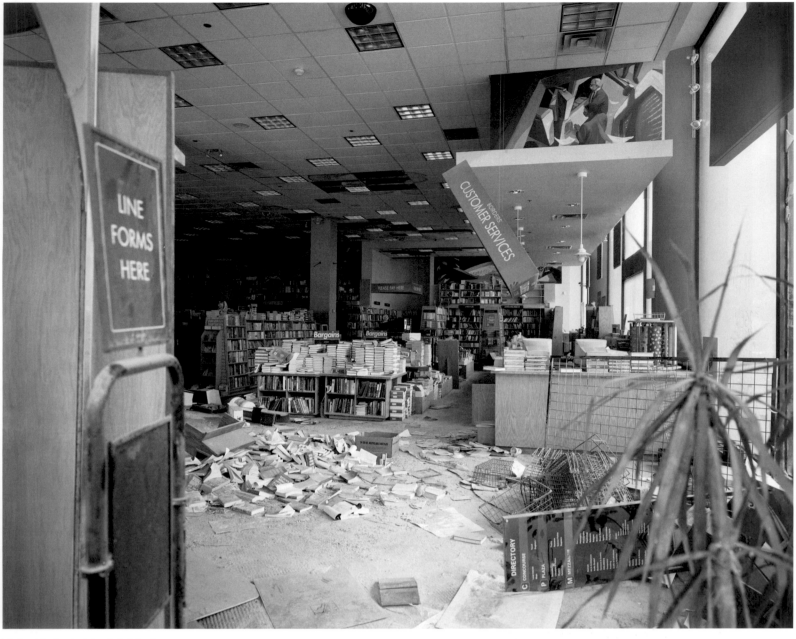

Interior of Borders bookstore in Building 5

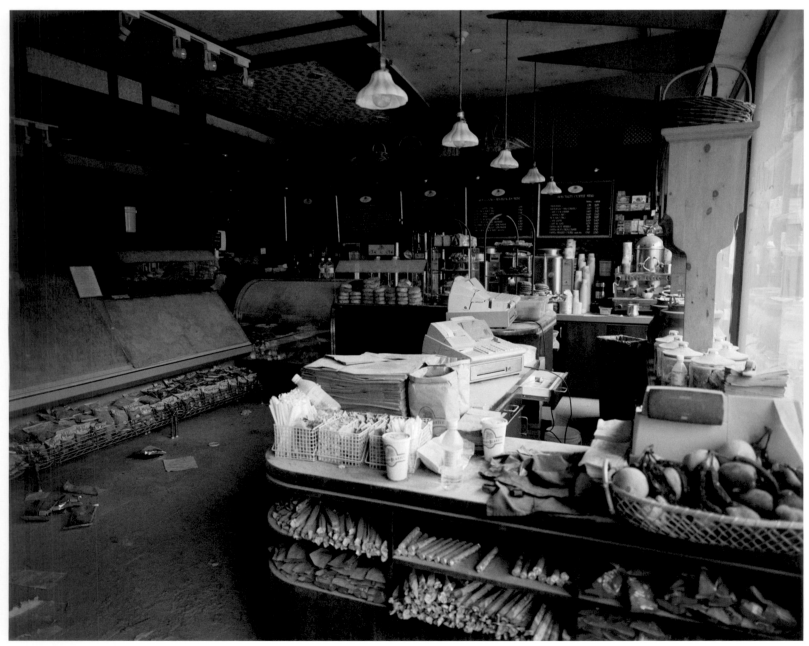

Interior of the Devon and Blakely deli in Building 5

Window of Borders bookstore, Building 5

11.15

It was two months after the event and the deli (shown opposite) stood as a culinary time capsule of the appetites of New Yorkers. It had been early in the day when the towers were hit, so the counters and cases were fully stocked, the bagels in all their varieties neatly stacked, the cookies and fruit alluringly arrayed near the cash register. In the refrigerated glass cases, cheeses and cold cuts, salads and chicken wings, cakes and pies still waited for hungry office workers to come down for a coffee break. Except for the bananas gone black as licorice, and the dust covering every surface, you might think everything on display was still edible.

Suddenly, an edge of discomfort intruded on my musings as I picked up on scratching sounds in the dimness, little snickers and twitches indicated that this feast, although abandoned by humans, was still being enjoyed by the rats. I slipped out the door and back onto Vesey Street to continue my work.

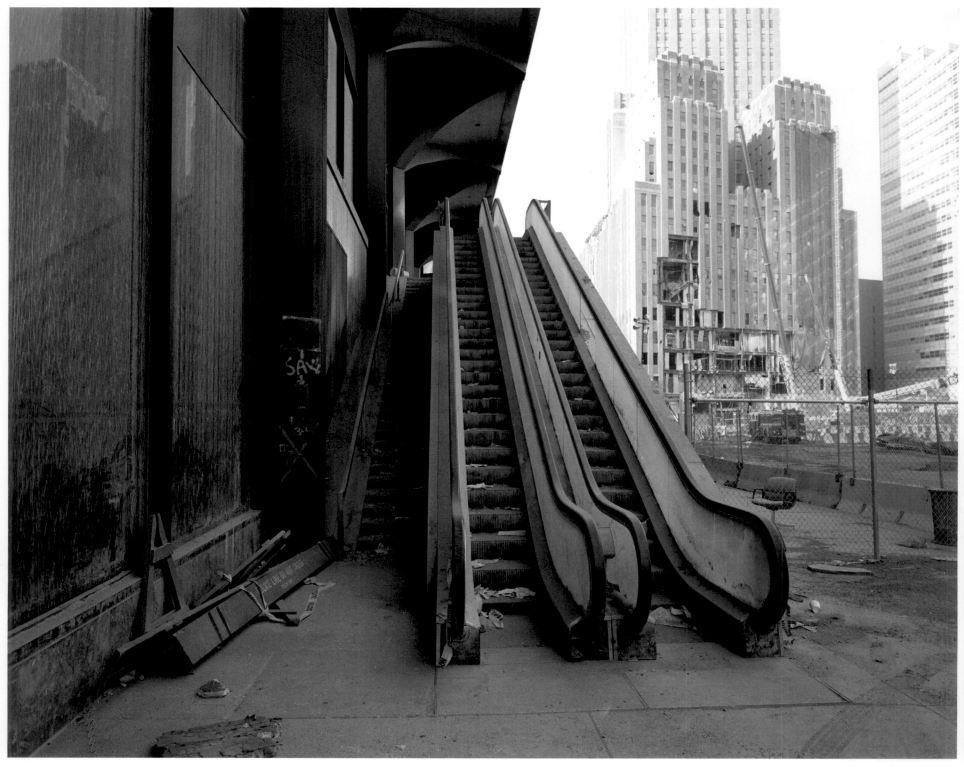

Escalators to the mezzanine level of Building 5

A pair of dead escalators scattered with ash and papers rose to the mezzanine level of Building 5. At the top I saw huge, plate-glass windows smashed open. Climbing through one of them, I found myself standing in what was once a pre-school daycare center. Strewn about the room, as if blown by a sudden gust of wind, were a dozen cribs heaped up with toys and blankets, bolsters and tables. My first reaction was, "Who would dare do something like this?" In fact, the destruction in the room was insignificant when compared to the chaos throughout the site, but it struck home in a powerful way because of the innocence of the objects: the lunchboxes, the little coats and backpacks still hanging on their pegs. All around the room were signs of unfinished play, clay figurines and drawings, games of cops and ambulances on their way to rescue people who needed help. And here and there, stamped in the dust, I saw footprints—inspectors, most likely, checking the premises—which looked as unearthly as footprints on the moon.

A window in the daycare center in Building 5

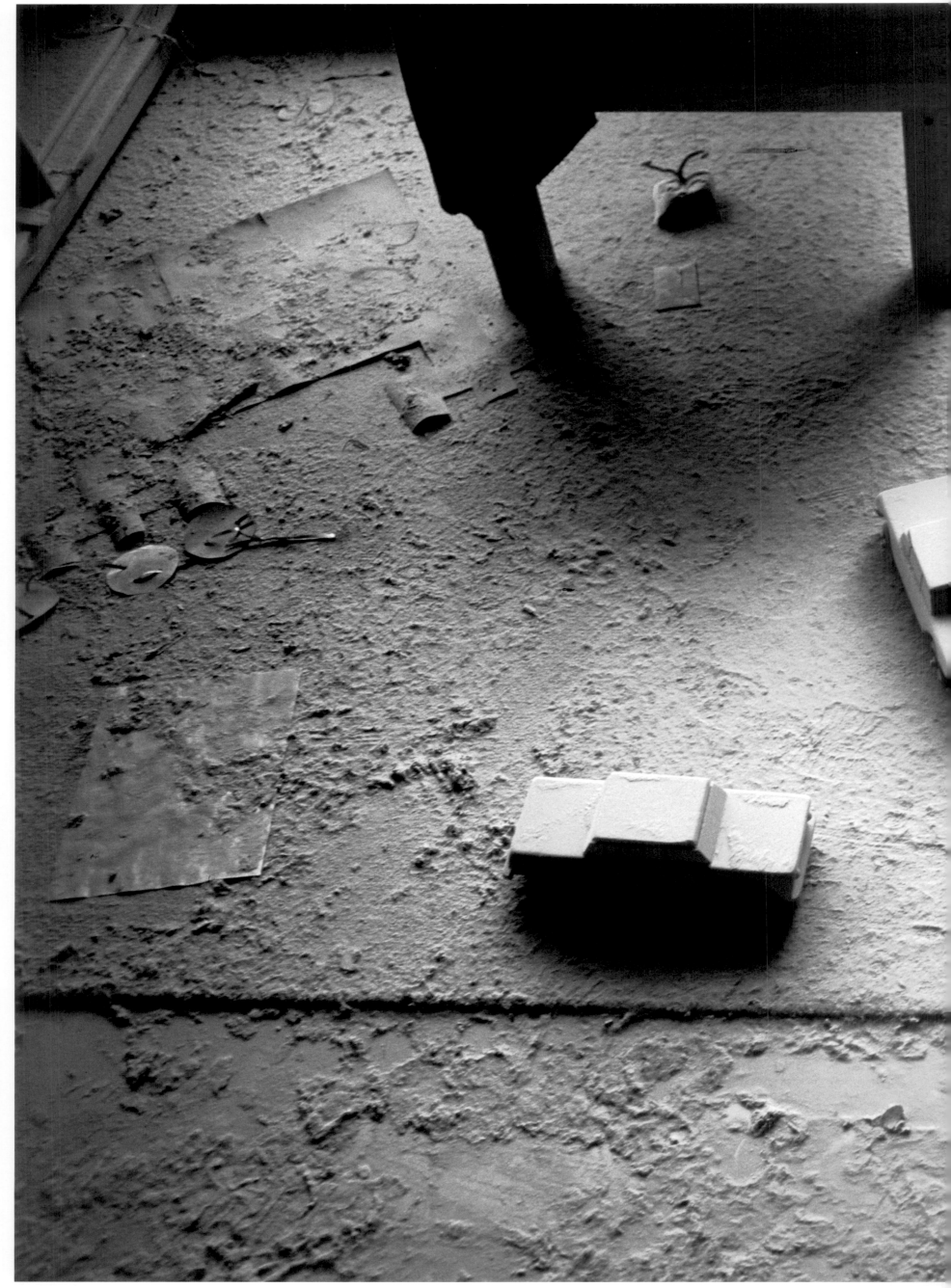

Abandoned toys on the floor of the daycare center

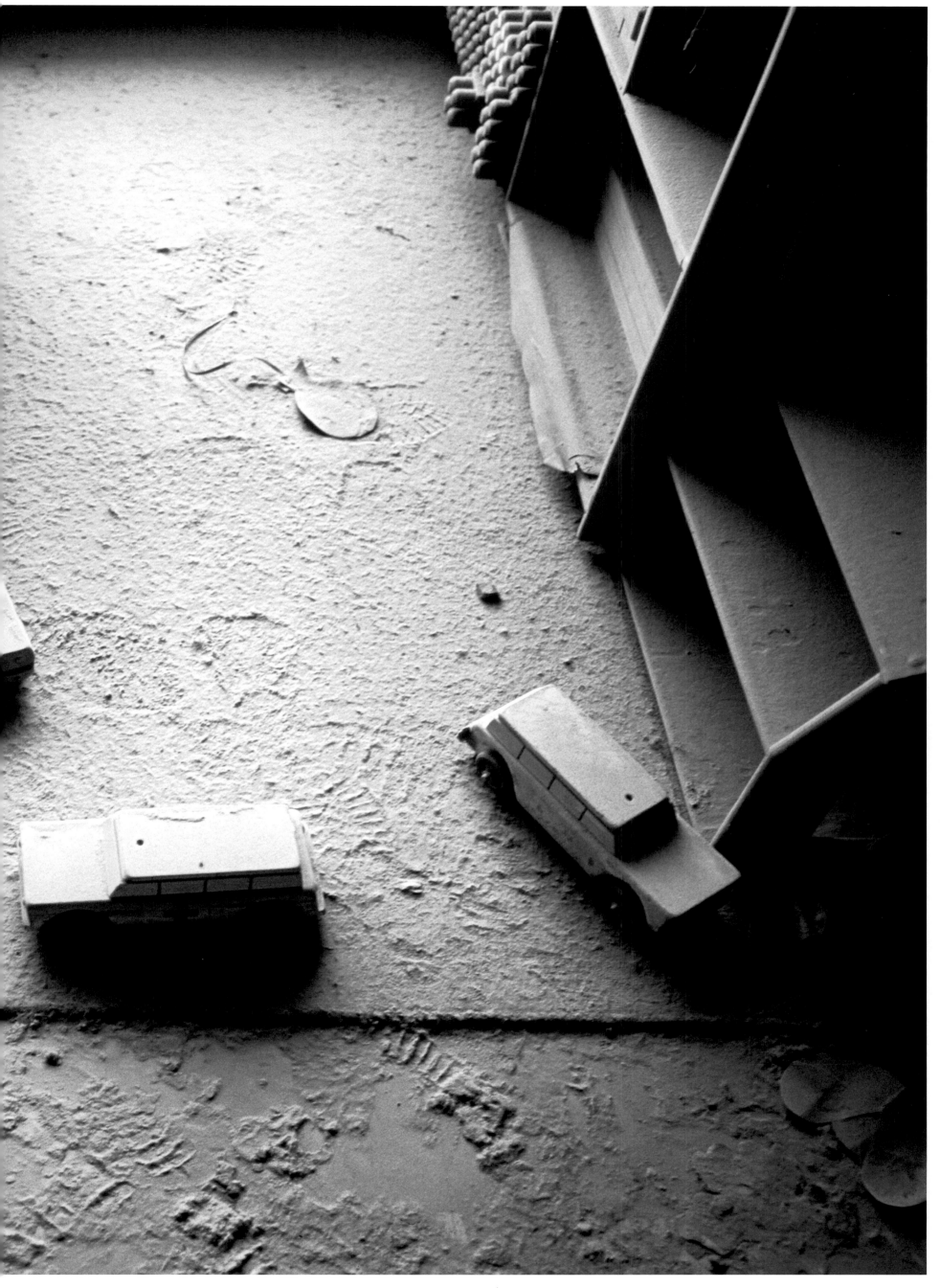

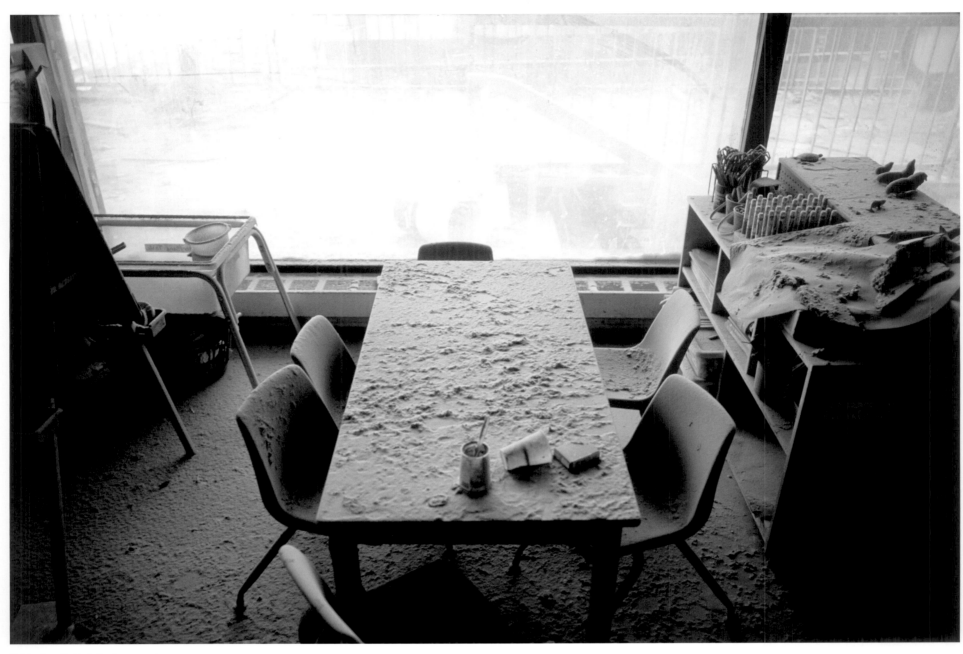

Children's worktable in the daycare center

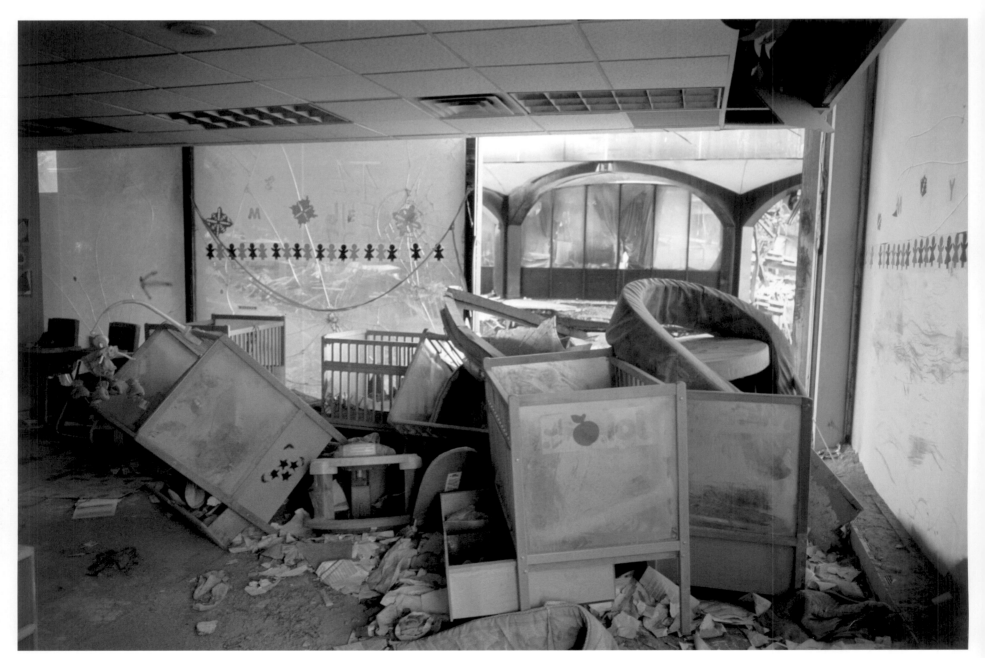

Interior of the caycare center

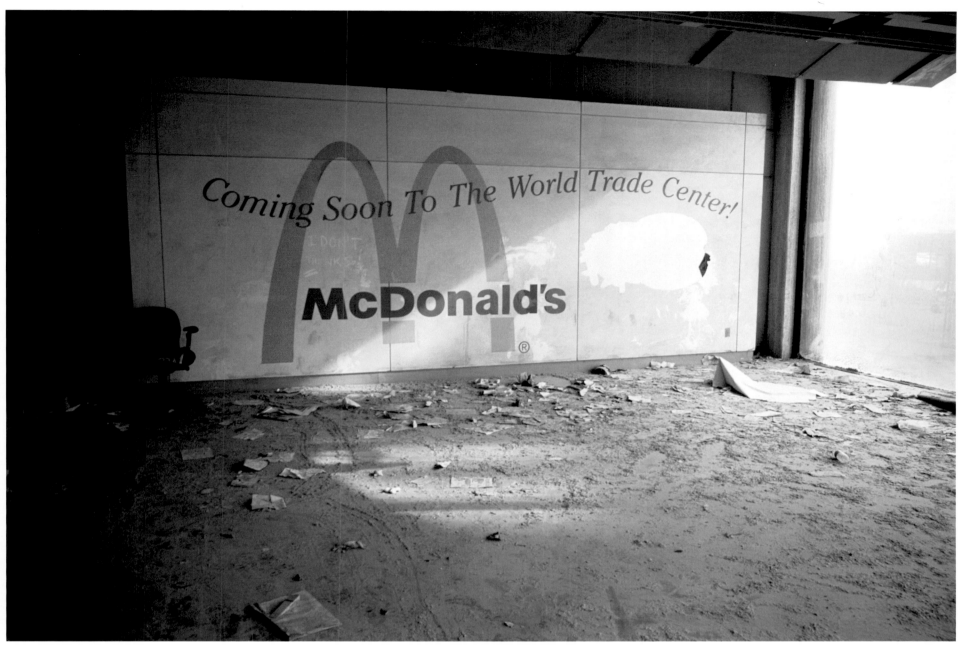

An entrance to the mall below Building 5

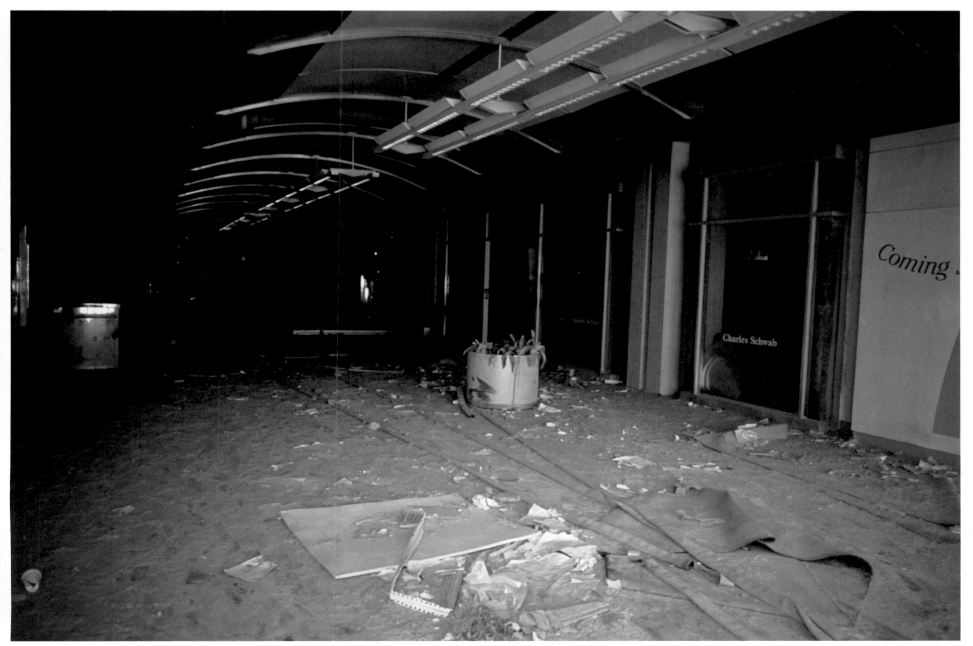

A walkway to the underground mall in Building 5

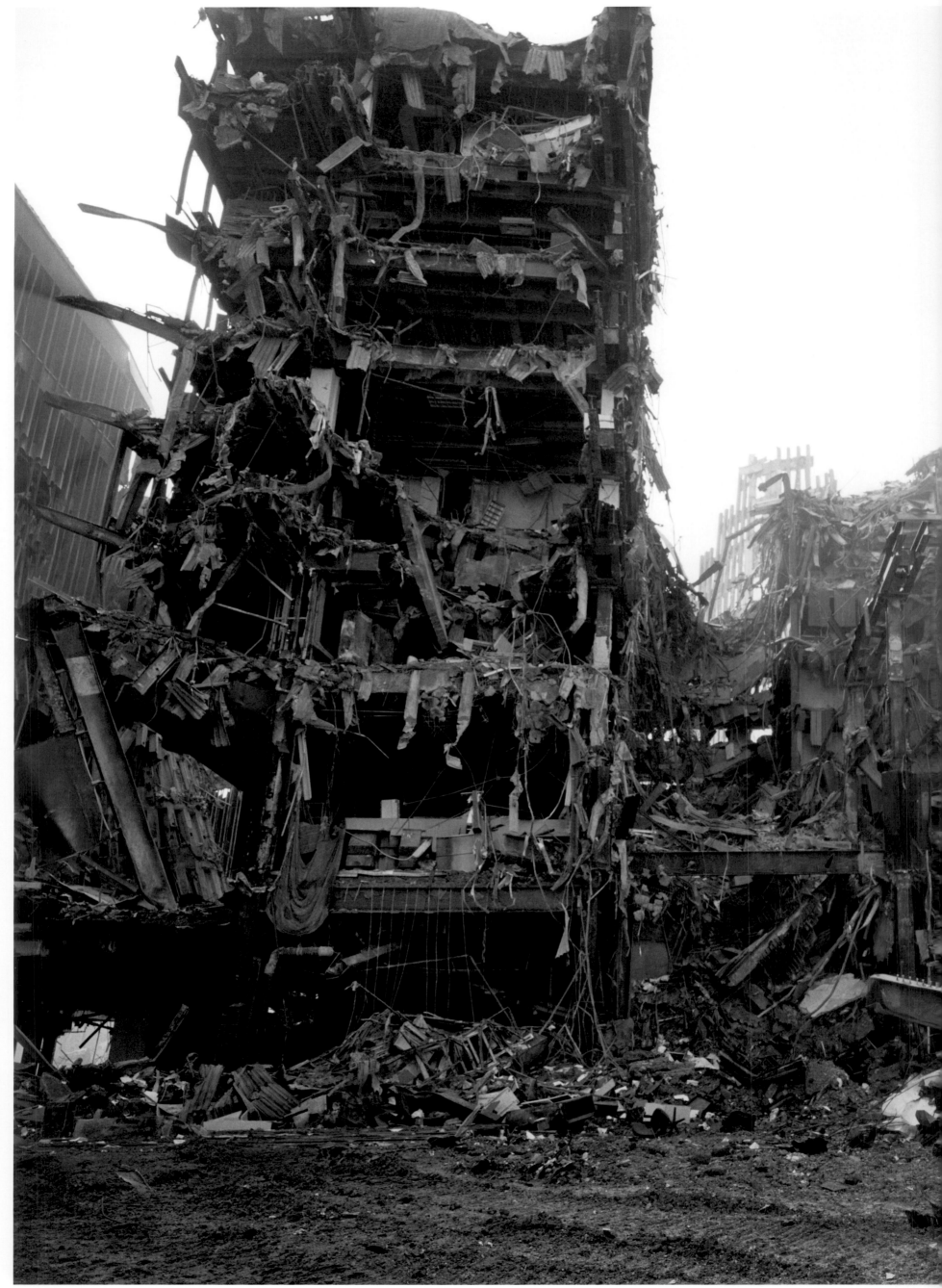

The remains of the Customs Building

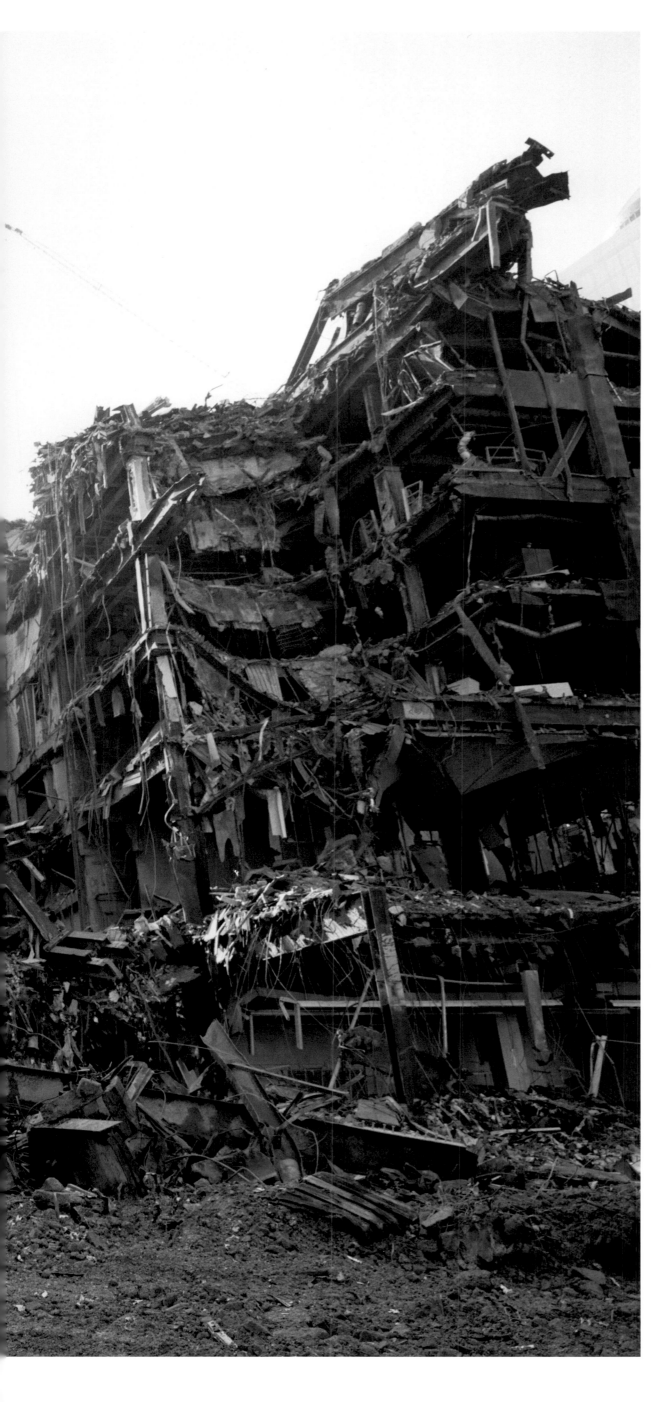

FOLLOWING PAGE: Rest and relaxation rooms began appearing around the site. This one was in the Marriott World Financial Center Hotel on West Street. A ballroom was outfitted with Barcaloungers, televisions, and computers so that workers could get some rest and send emails home—since some of them didn't leave the zone for days at a stretch.

It was quiet in there, and always seemed empty when you first walked in, but a once-around-the-room would reveal that every lounger had a sleeper in it. The services for the workers were generous, although getting into the buildings themselves was almost as difficult as getting into the site. Security was fierce, but once inside the food was plentiful and tasty, and fresh clothing and equipment were there for the asking. There were other, more intimate, services as well: counseling and therapy, podiatry and massage for all those aching bodies. The comfort of the place and the kindness of the volunteers sometimes made it difficult to leave.

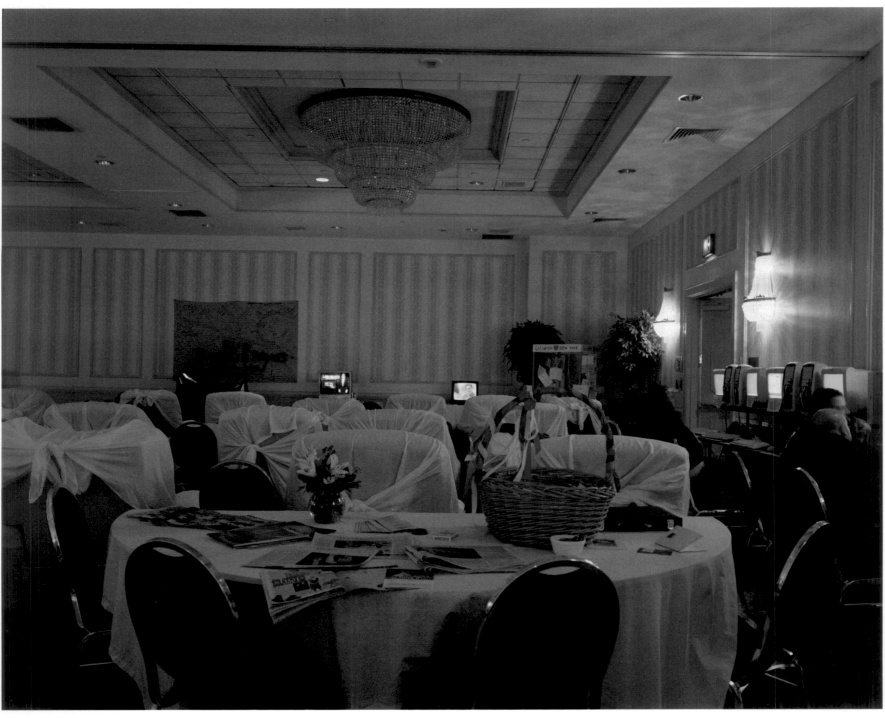

An R&R room at the Marriott World Financial Center Hotel

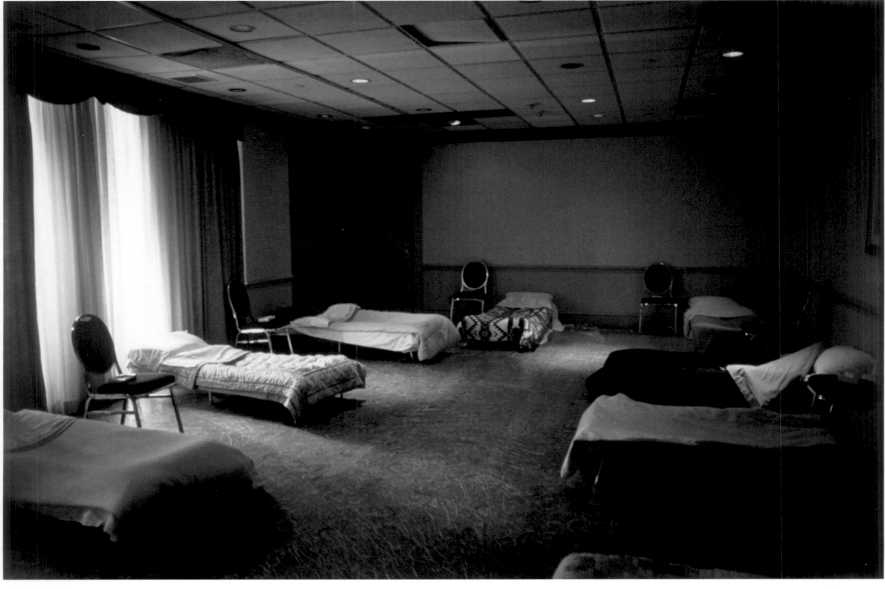

Beds set up in a conference room at the Marriott World Financial Center Hotel

A parking meter on Barclay Street

I often wondered, as I walked along Barclay Street, what it was that did this to the parking meters. There were at least eight of them, all leaning over the sidewalk at a thirty-degree angle, their bodies charred and their plastic faces melted away.

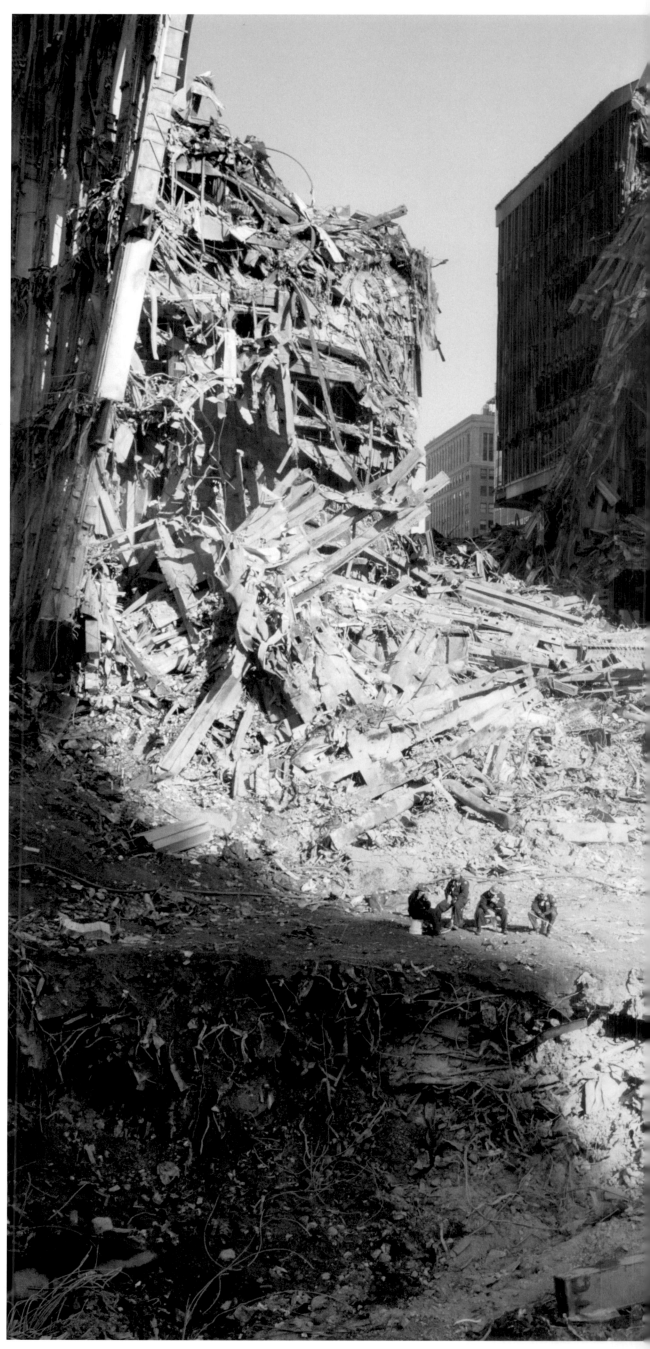

The valley between the North Tower and Building 5

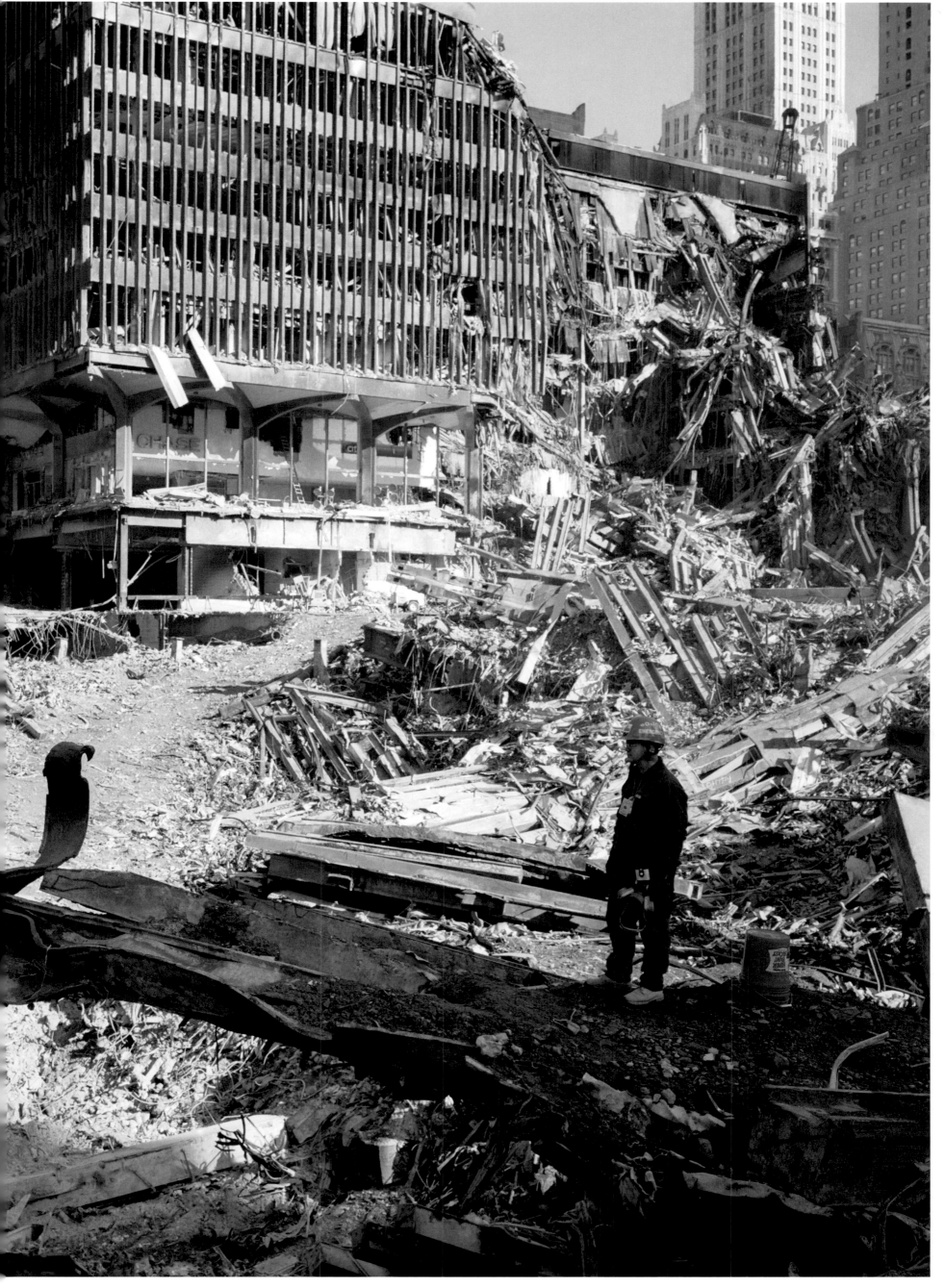

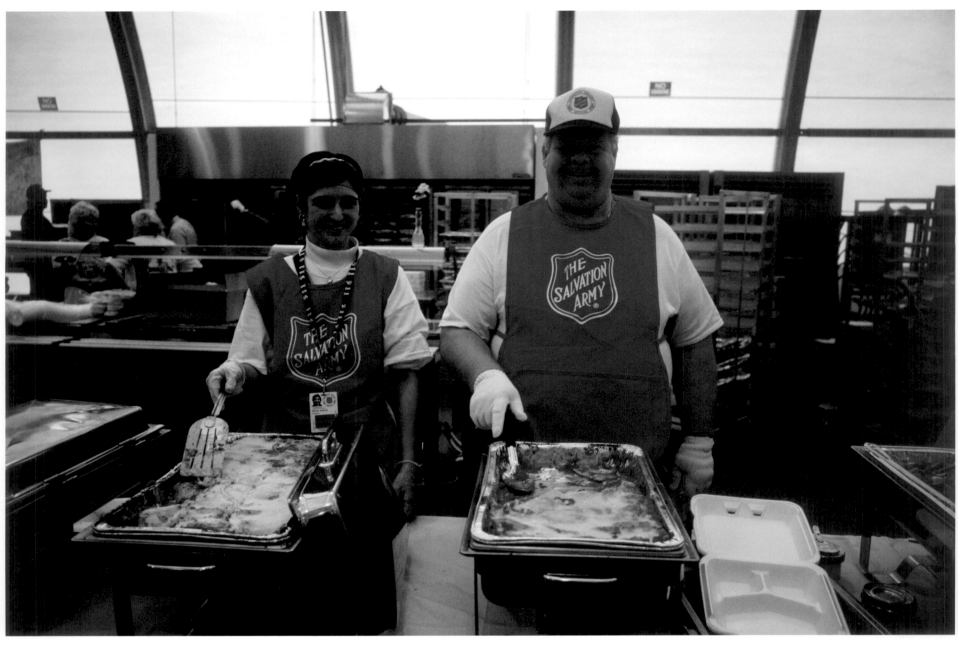

Volunteers serving lasagna in the Taj Mahal

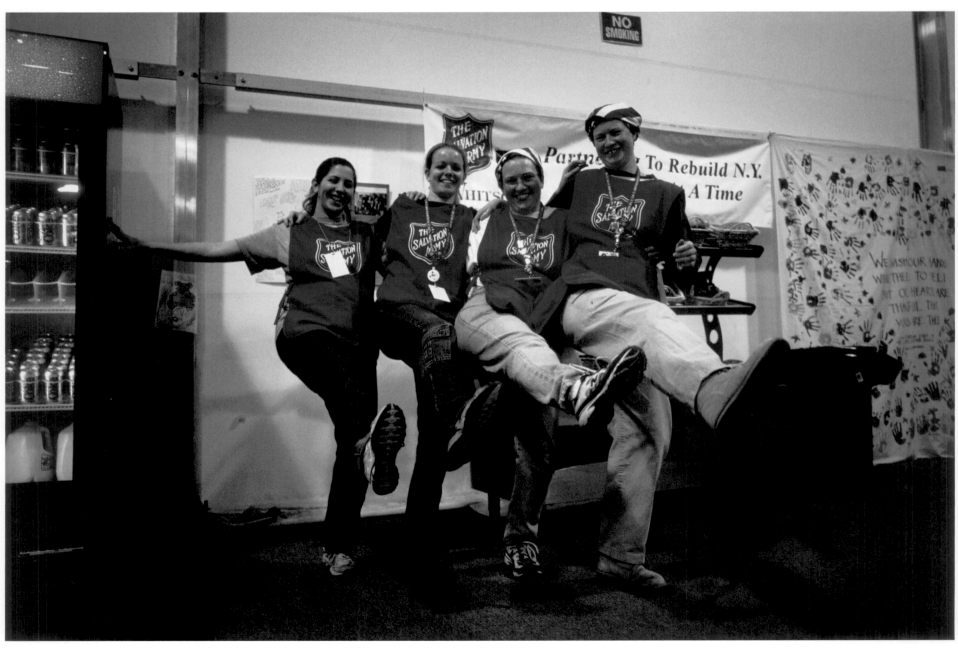

Salvation Army volunteers dancing in the Taj Mahal

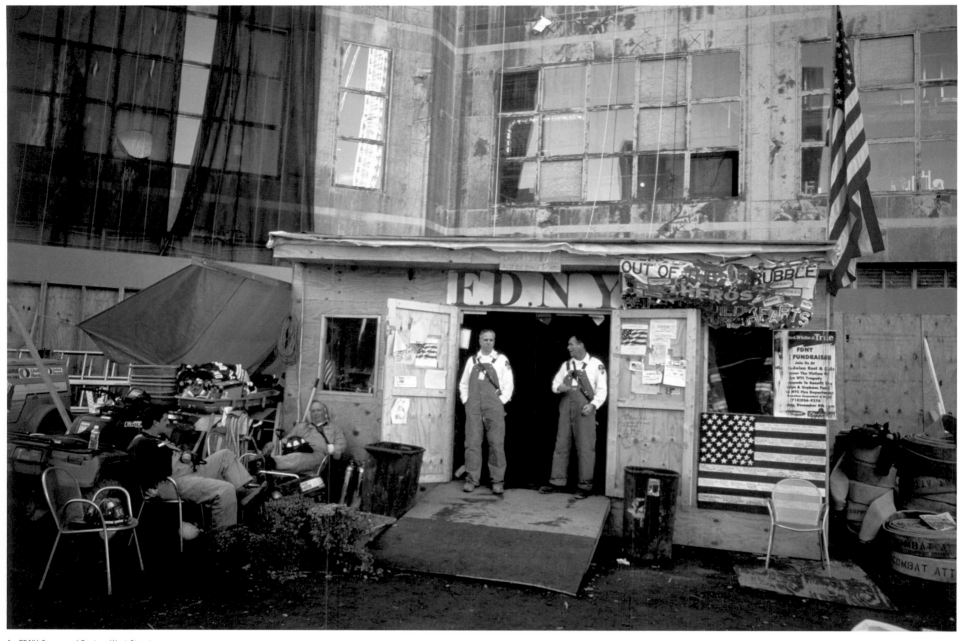

An FDNY Command Post on West Street

Interior of the FDNY Command Post on West Street

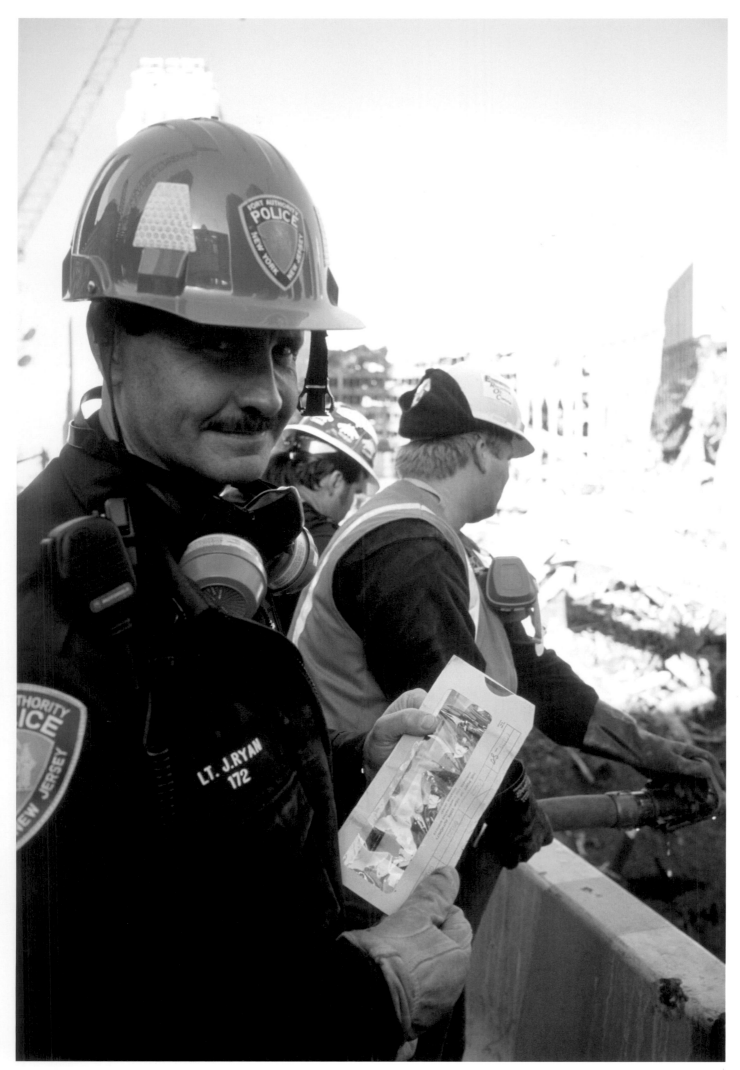

Lieutenant John Ryan with his Police Academy graduation photograph

12.03

I was down in the valley at the north end of the pile, watching as a grappler reached into a compressed section of debris. When the claw swiveled around, hundreds of envelopes filled with photographs fluttered to the ground. I picked a few up and saw right away that they were part of the Port Authority photographic archive. Calling a stop to the work, I ran up the hill to find Lieutenant John Ryan of the Port Authority Police Department, who was the officer in charge. He grabbed some men and some plastic bags and went down to see for himself. When he left, I looked at what I was holding. It was a torn 8x10-inch negative from 1929, of the construction of the George Washington Bridge, with a zeppelin flying over the Jersey side of the Hudson River. Some time later in the day, Lieutenant Ryan caught up with me and thanked me for the heads-up on the archive. Then he grinned, holding out an envelope: "Look what I found!" It was his Police Academy graduation photo. His needle in the haystack.

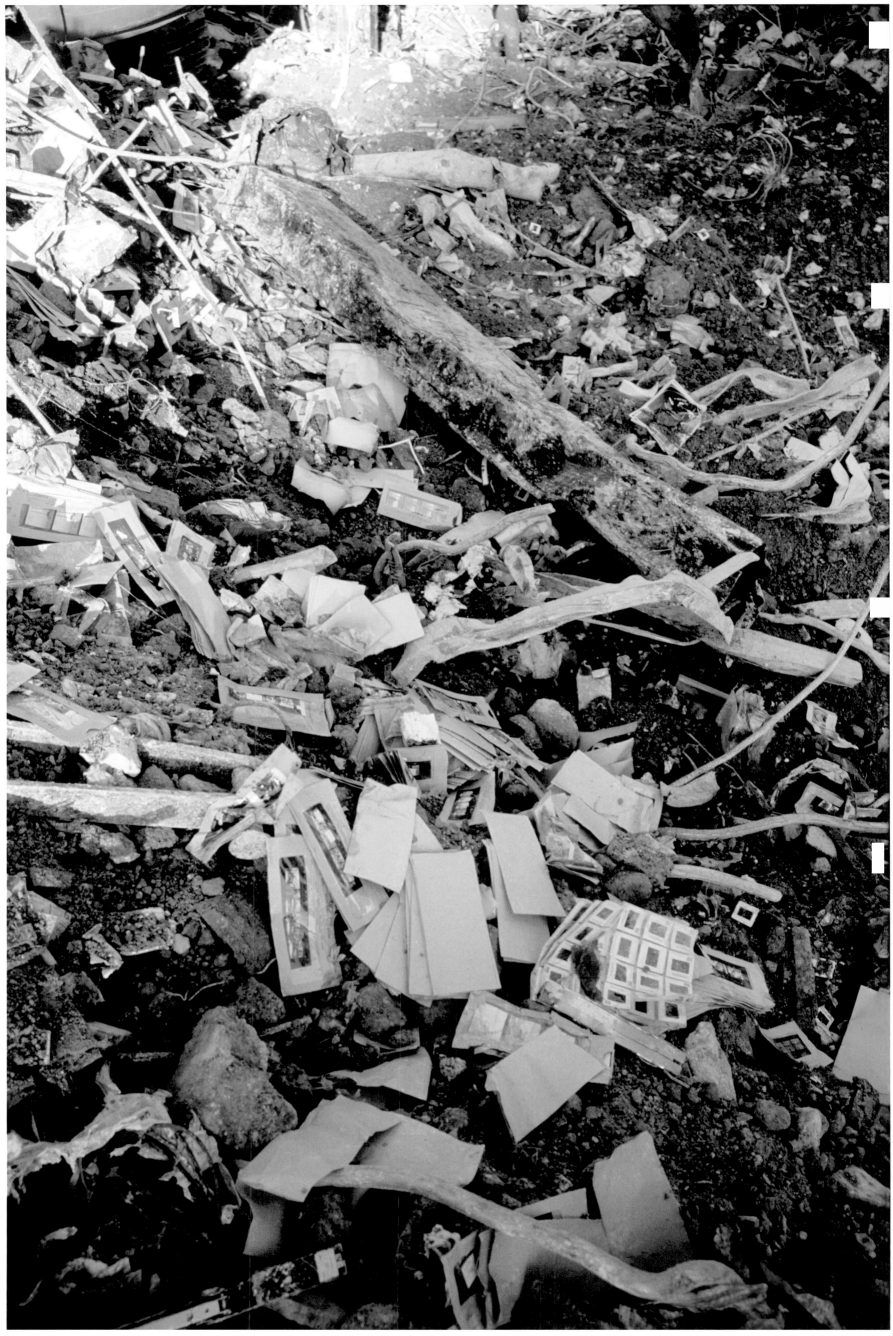

Photographs from the Port Authority photographic archive

An opening to the subway line beneath Church Street

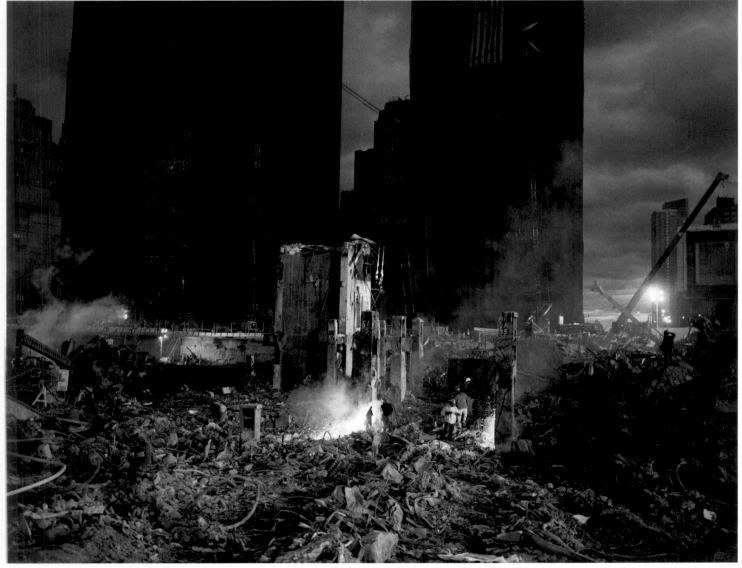

Dusk, welders working where the Marriott Hotel once stood

The burning went on twenty-four hours a day, big sticks and little ones, it didn't matter—the steel had to be burned to make it manageable, moveable. Onto the trucks! Out of here! Down to the next level! The ceaseless repetition and discipline of it all was astounding to see—the infernal fountains of sparks, the gaseous green smoke of the torches, the eerie light flickering into the night, or against the ebb of day, the tiny figures silhouetted against the progressively diminishing pile.

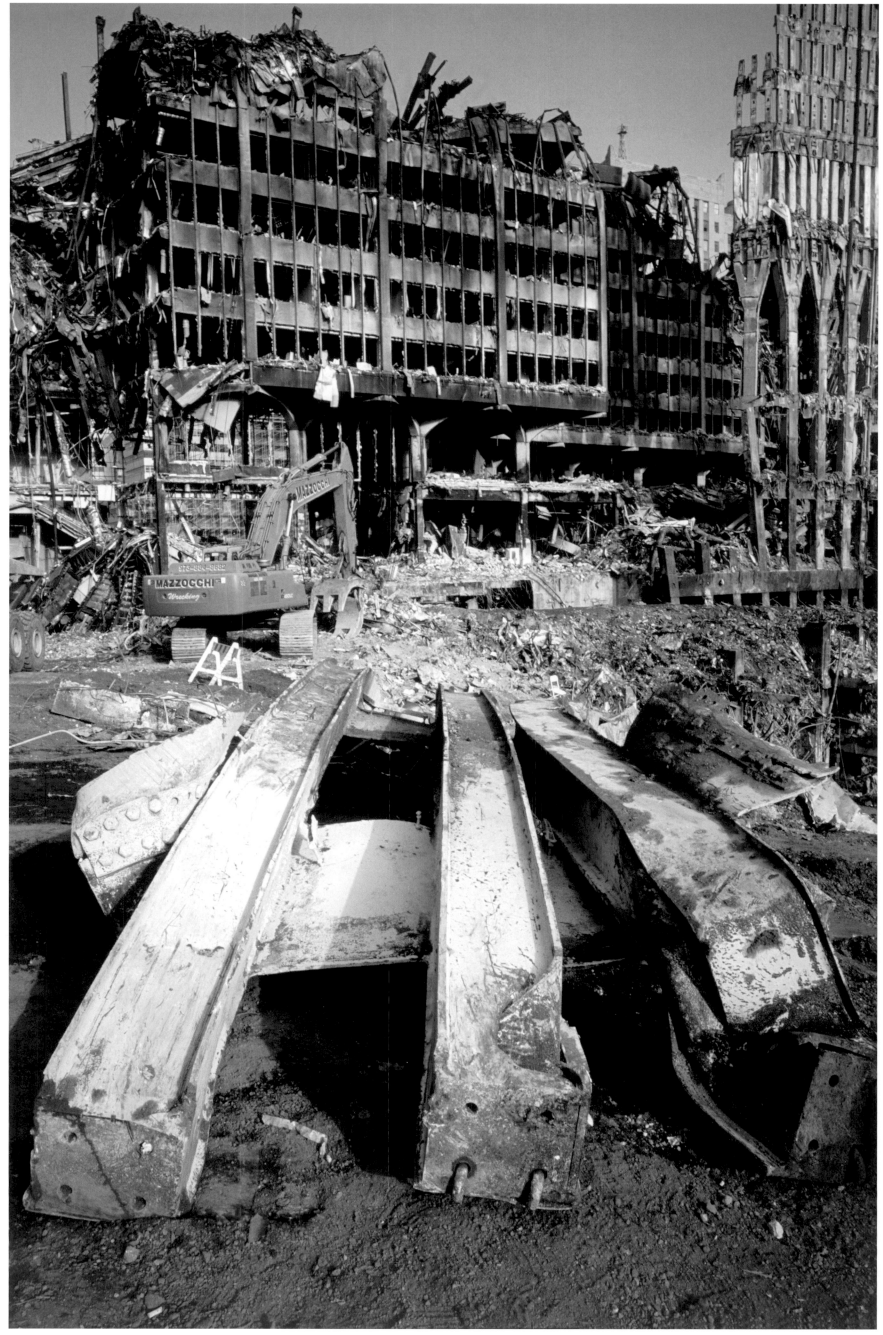

A three-story module of columns and spandrels

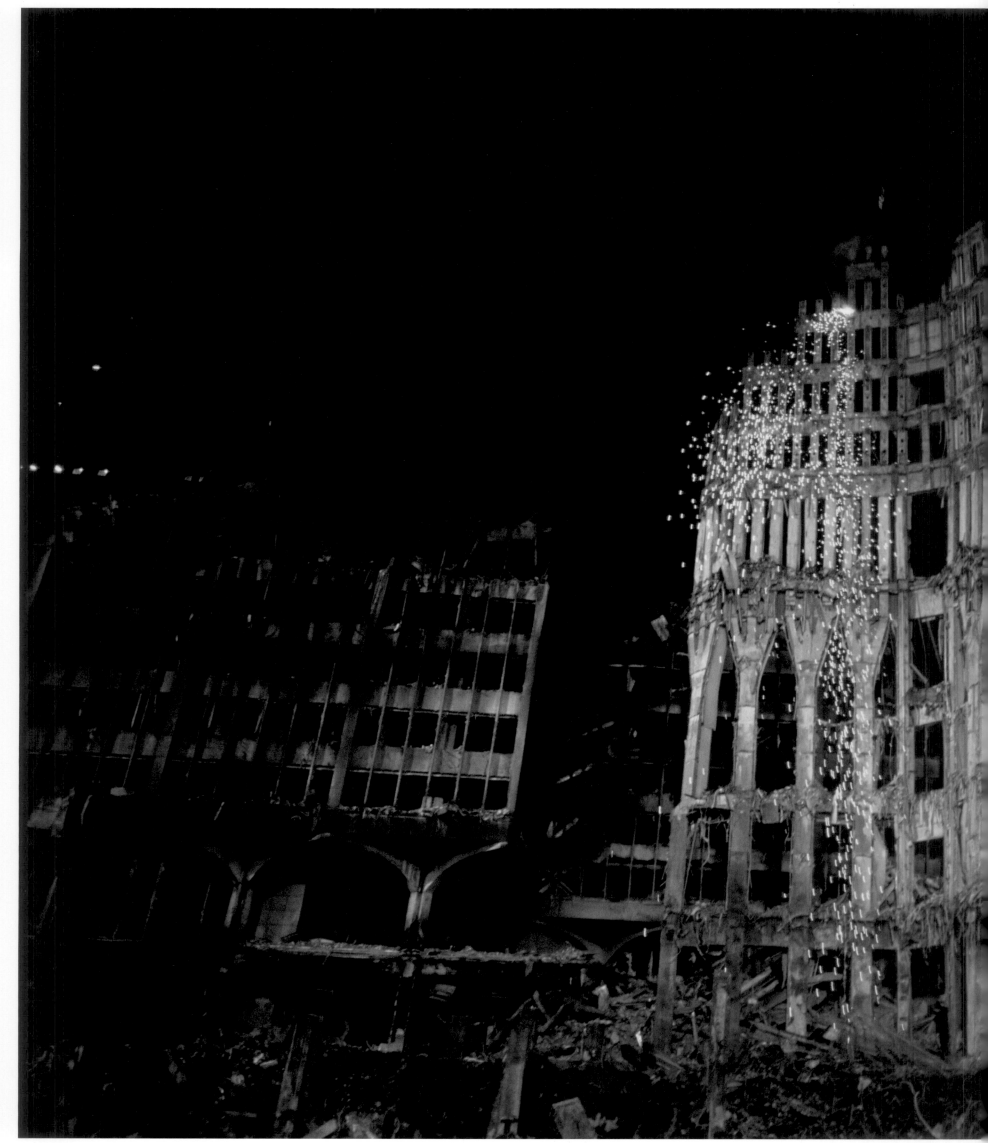

The beginning of the demolition of the North Tower shroud

12.07

The man basket swung into position, its flag drooping, and a few minutes later a cascade of sparks splashed and bounced down the inside of the wall. The North Tower shroud was coming down. This tragic—but now also beautiful—icon was finally disappearing before our eyes, stick by stick. The sentiment around the pile had been to find a way to keep this as the ultimate memorial to the dead, and it was easy to see why. It was the thing itself. It didn't need to be designed by a team of architects or planners; it said everything that needed to be said far more profoundly and eloquently than any stand-in for it ever could. But that was not how it would play out. Sometimes the answer is right there, staring us in the face, and time and again we turn away.

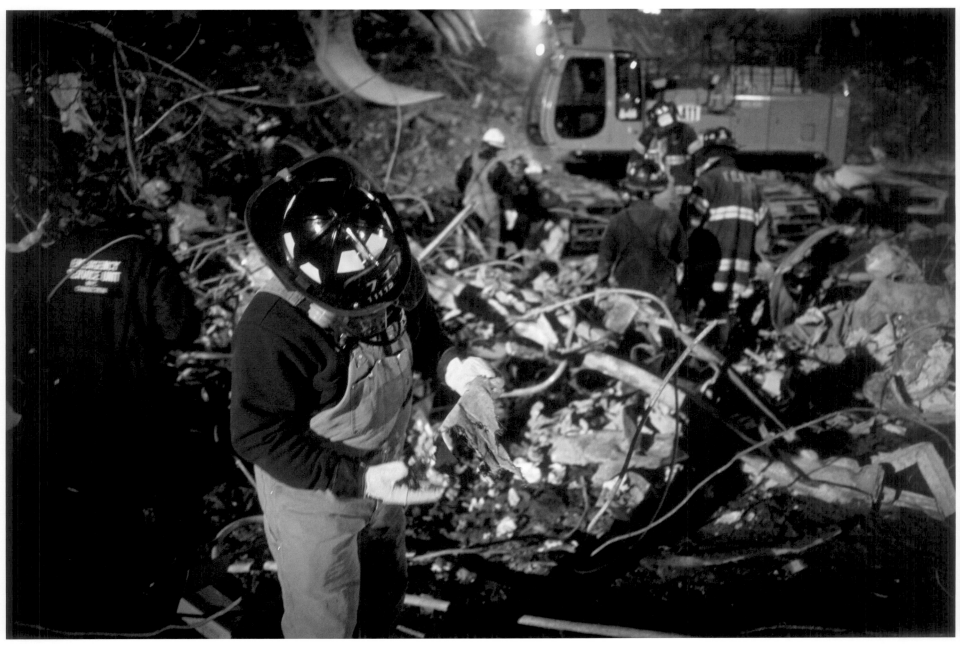
A fireman examining a piece of clothing

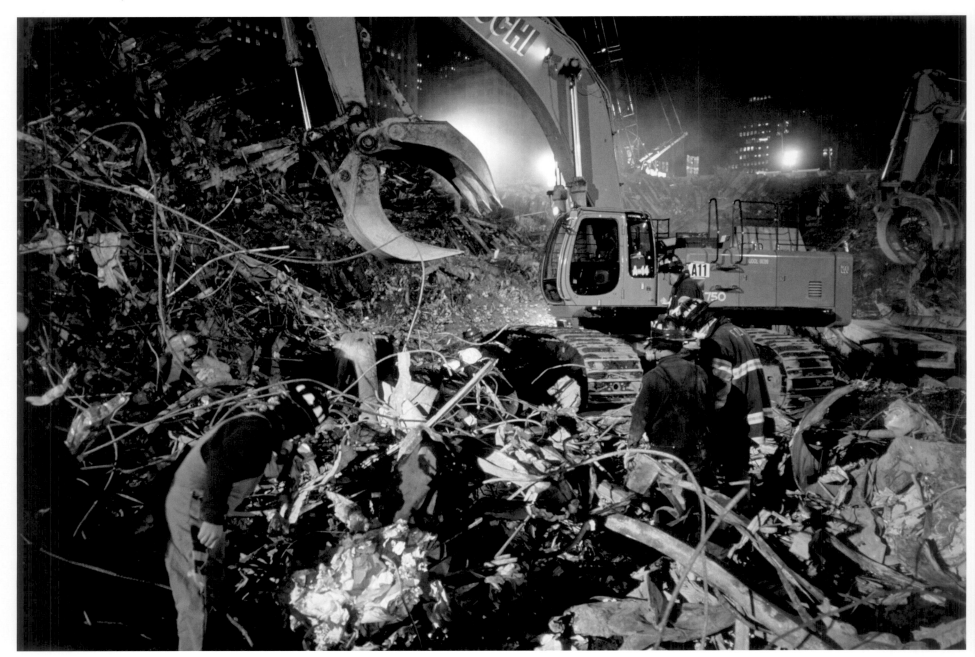
Firemen searching through the debris dropped by a grappler

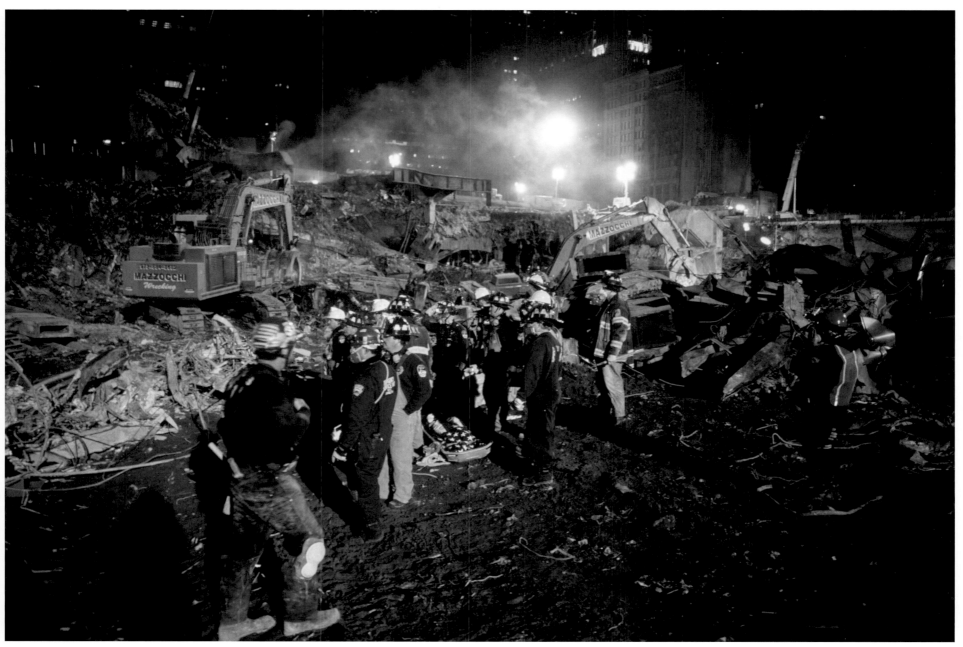

Firemen in the valley with recovered remains in a flag-draped Stokes basket

Some things are visible everywhere yet not really seen. So it was with the Stokes baskets—small, orange, sled-like plastic stretchers with cutout handholds all around the edges. These containers were used by the recovery teams to transport remains from the site. On this night, a greater number of recoveries than usual were made below the North Tower. The firemen were deep into the thicket of tumbled steel, moving through it like men wading into the surf, pushing their bodies against the waves and coming up out of the steel carrying tattered fabrics, or a shoe, and then announcing a discovery of human remains. At these moments, the firemen would always cluster together, carefully clearing the spot of debris. Then a Stokes basket and a folded flag would arrive, and the body would be laid in the basket and draped with the flag. In the image above, the Stokes basket lying on the ground is waiting for an honor guard to gather, to walk it out of the pile.

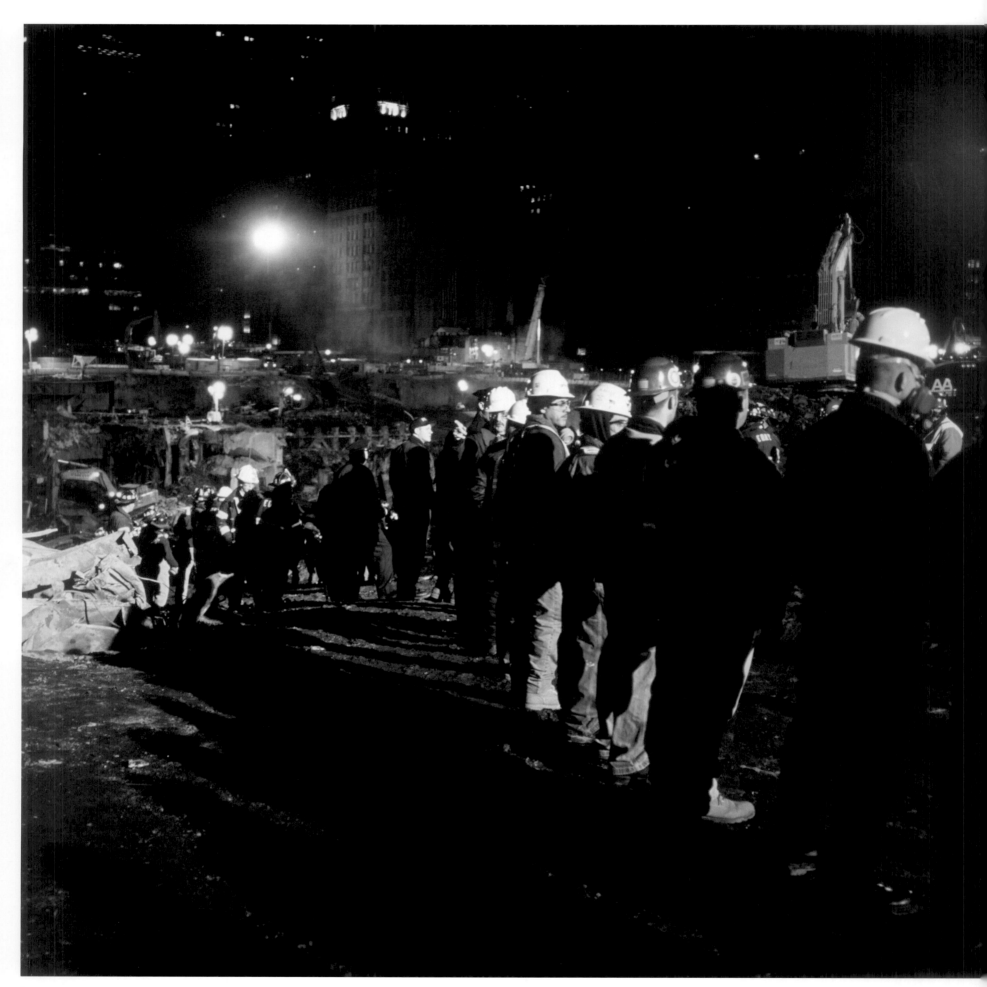

An honor guard forms as firemen bring up recovered remains.

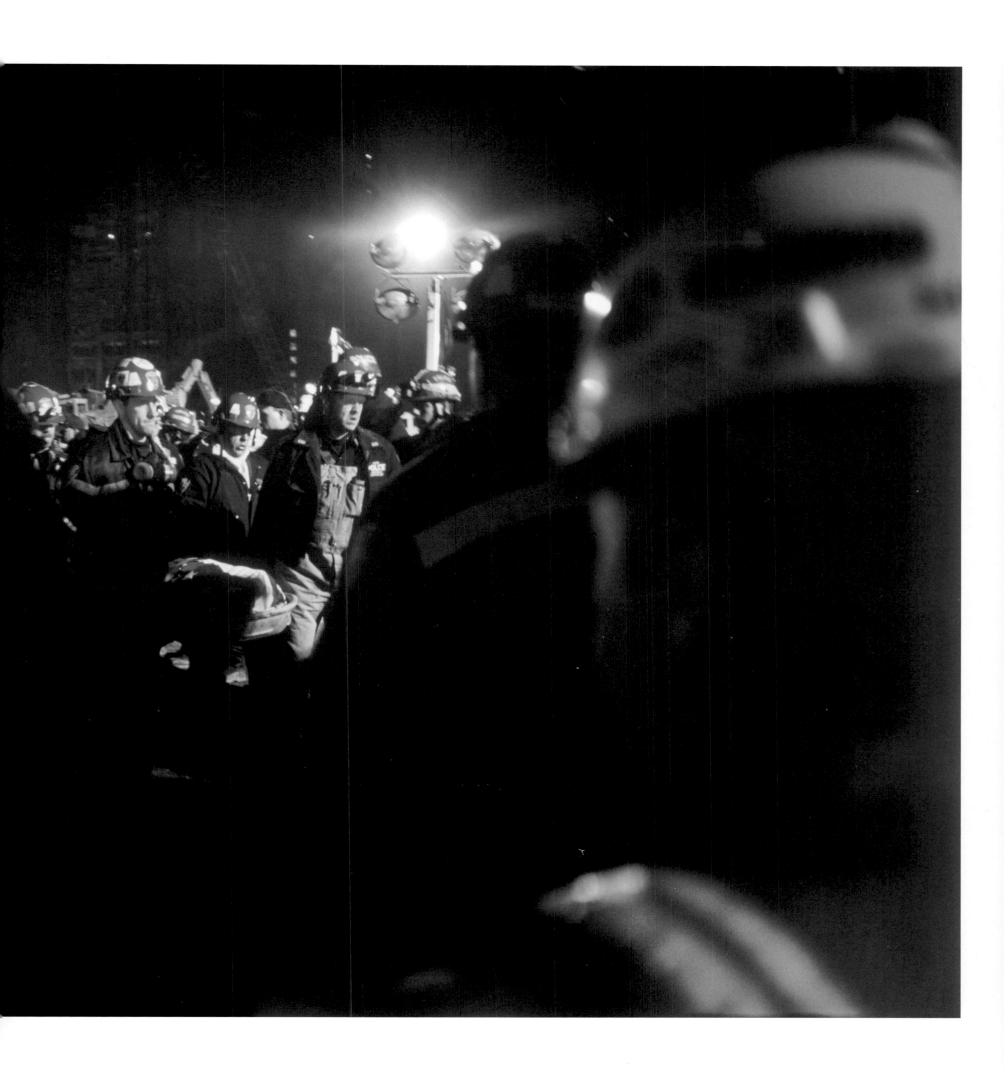

Who knows how many times the honor-guard ritual was performed at Ground Zero? More than nineteen thousand body parts were recovered there. Work would stop in the immediate area of the recovery, everyone would line up along the road, and members of the uniformed services—or, increasingly as time went on, the workers themselves—would carry the flag-draped remains to a waiting ambulance. It was always a genuine, solemn moment, not done for public display but as the fulfillment of the duty that those assembled were there to perform: to recover the dead.

WINTER

Fresh Kills landfill was both the repository and the catalog of everything being removed from Ground Zero—except, of course, the human remains, which went to the morgue. The "grizzlies" at Fresh Kills disgorged an assortment of found objects that had only one thing in common: they had survived. On any given day the still-life would look different, depending on where the rubble was coming from. Badges, bullets, beepers. Guns, signs, cellphones. Watches, eyeglasses, wallets. All the small stuff of everyday life that made it through, from the fragile to the most durable, finally found its way here, to a table in Staten Island.

Fresh Kills landfill with cars from Ground Zero

Crushed cars collected at Fresh Kills

Wrecked cars

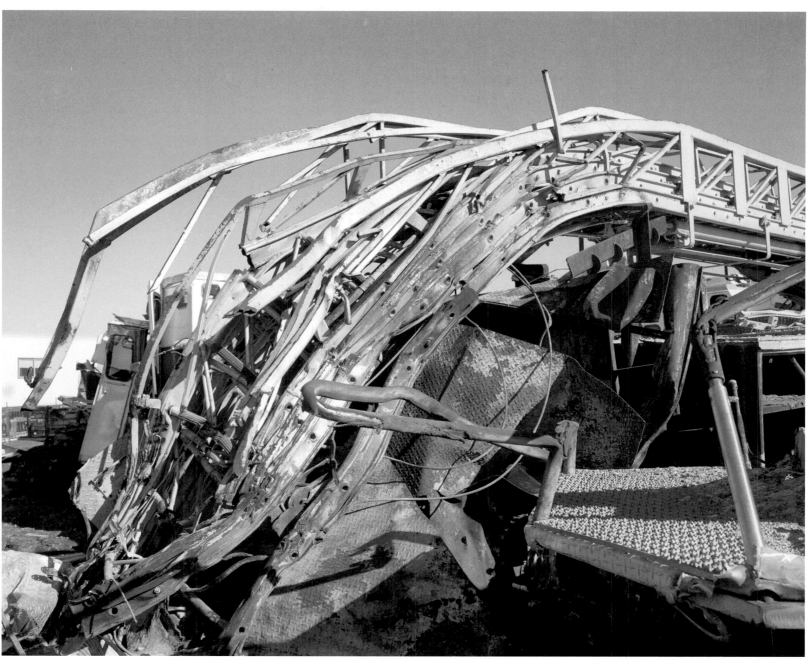

The crushed ladder of a fire truck

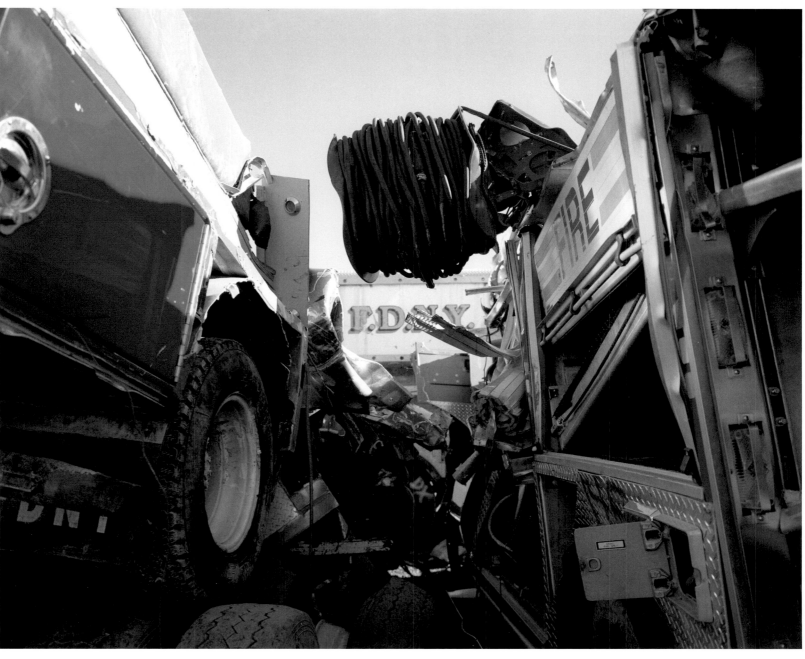

Fire trucks at Fresh Kills

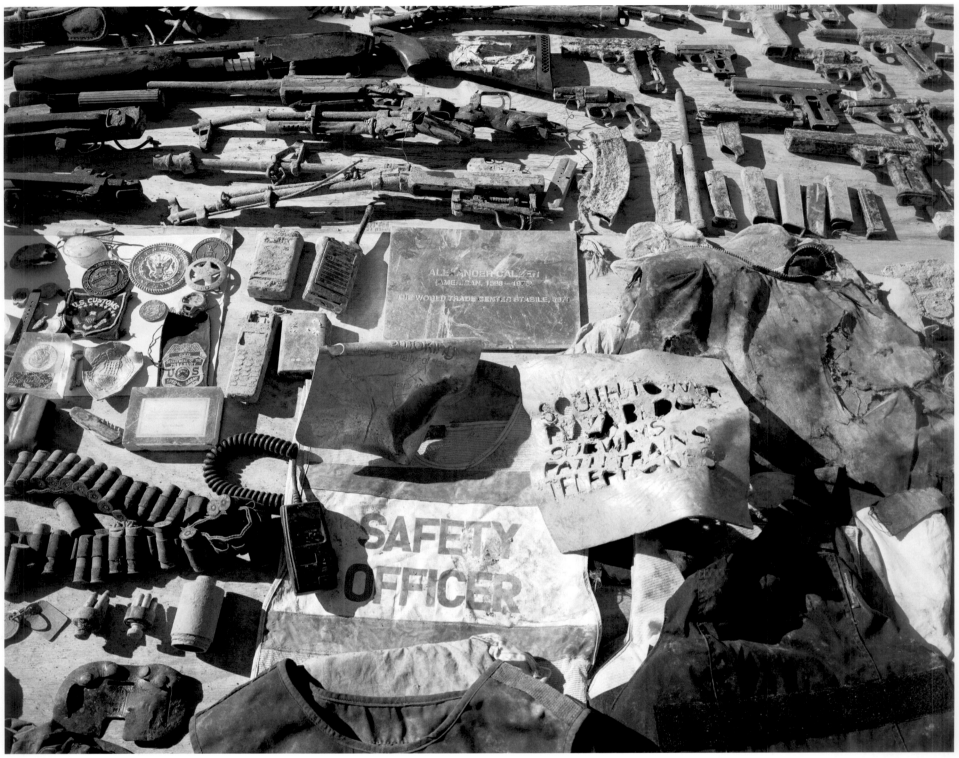

Objects found in the sifted debris

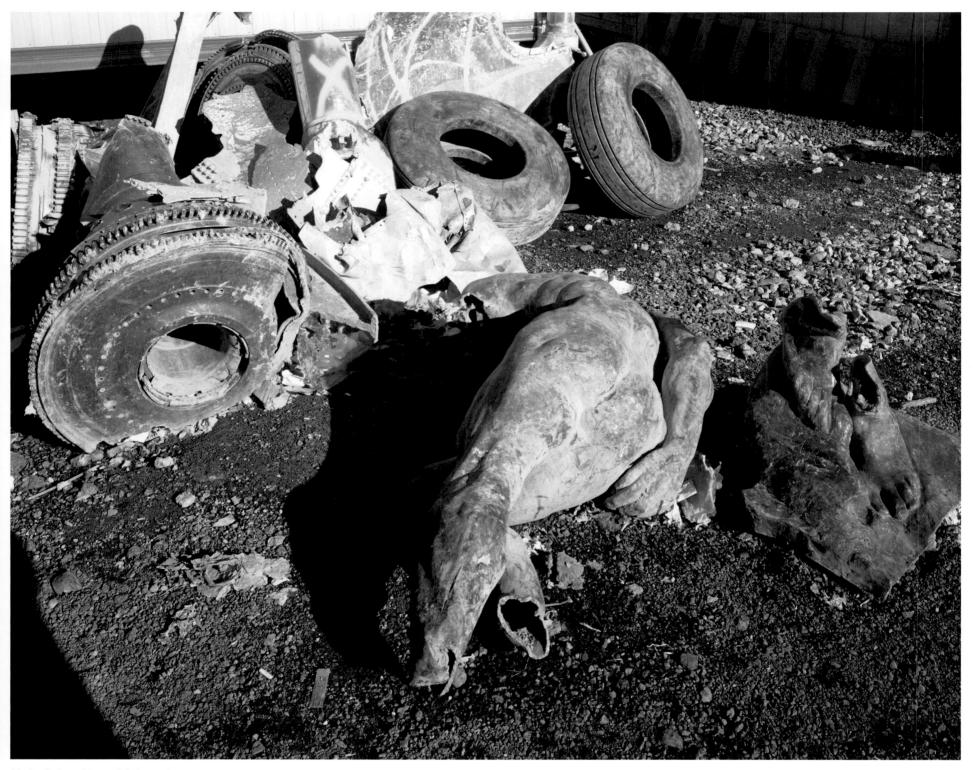

A broken Rodin sculpture and airplane parts

Most of the time, one could see the thinking behind the organizational scheme at Fresh Kills—fire trucks went with fire trucks, cars and vans were stacked together, steel and cables had their resting places—but why the broken sculpture of *Adam* by Rodin, for example, came to rest near the fuselage and wheels of the American Airlines plane remains a mystery.

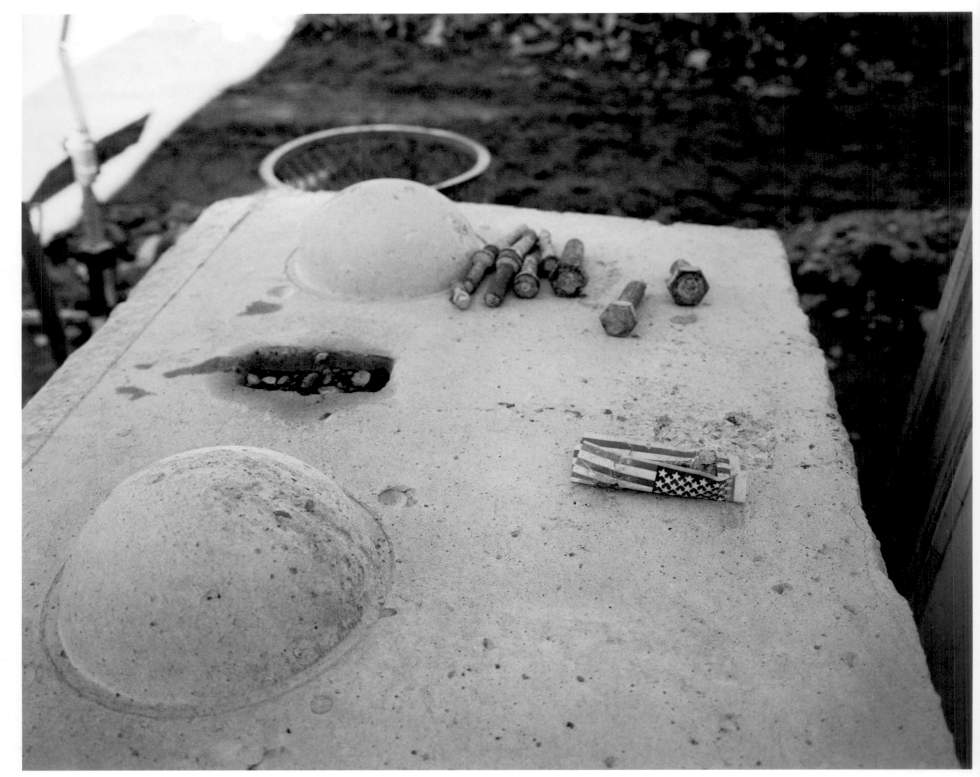

Still-life at Fresh Kills

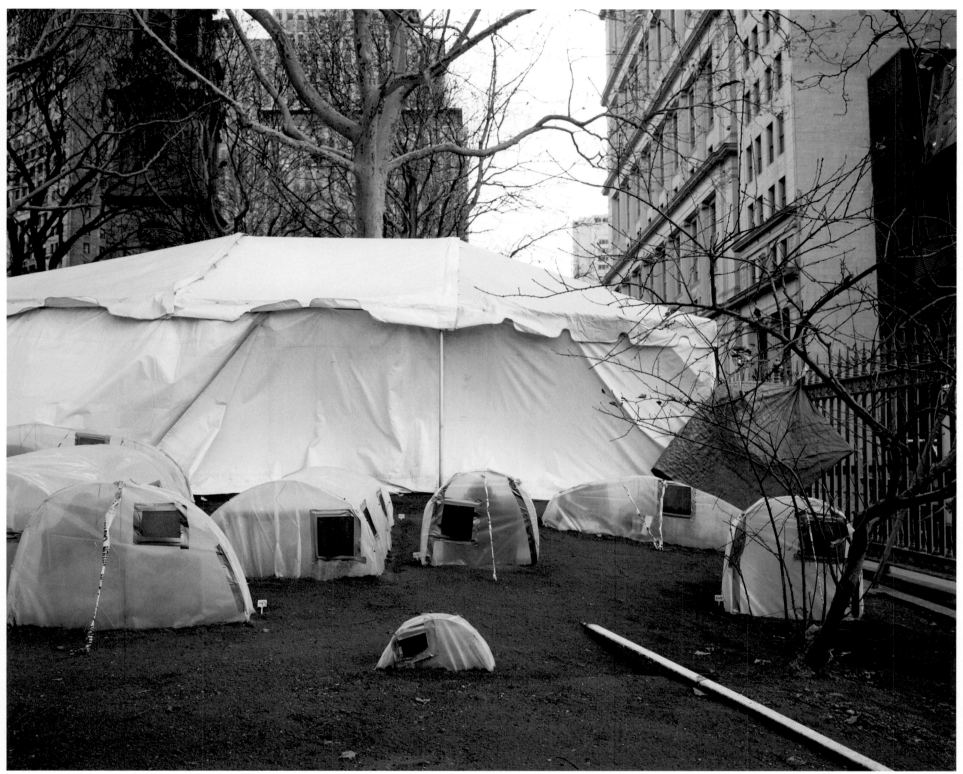

Covered headstones in St. Paul's Cemetery

I can't look at this photograph without remembering how fast things moved in the clean-up of lower Manhattan, and how I felt that I needed to be everywhere at the same time, and, of course, couldn't be. Walking by St. Paul's Cemetery one evening back in October, I had seen that it was covered a foot deep in papers, ash, and debris. Looking through the fence, I'd thought to myself, "I must come back here tomorrow and photograph this." I spent most of the next day on the other side of the pile, and when I finally got back to St. Paul's the entire cemetery had been cleaned up.

Here, four months later, eighteenth-century headstones had been covered in plastic tents to protect them from the corrosive substances that were in the air around Ground Zero.

FOLLOWING PAGE: Sixteen acres divided into square feet is more square feet than I know how to calculate. And not just square feet on a flat plane, but cubed—from the top of the pile down to the bedrock seventy feet below. The bottom photograph shows the daily attack on those square feet. Men (and it was mostly men) on their hands and knees with a trowel or hand rake and a homemade sifter, turning everything over, examining it, smelling it, and finally sieving it—preserving anything of possible significance before moving on to the next square foot.

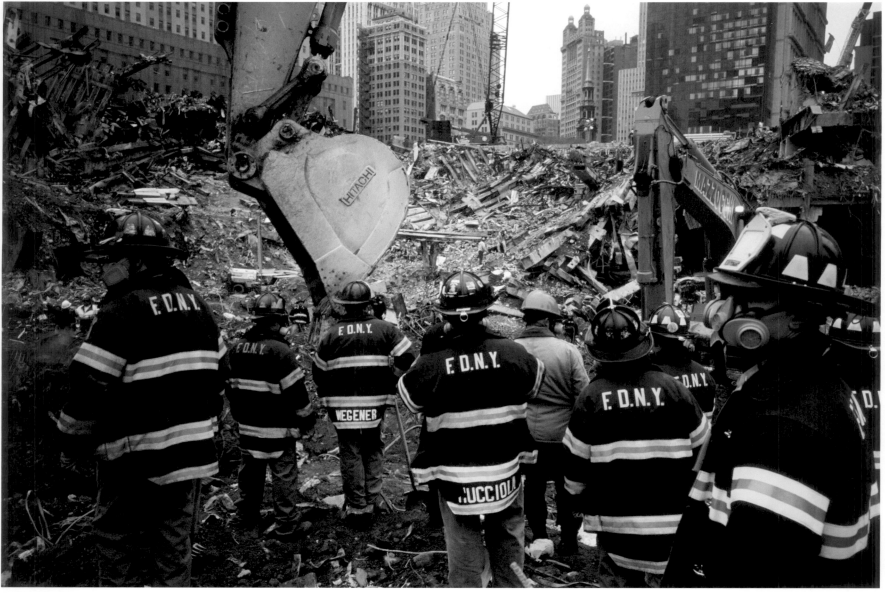

Firemen preparing to enter the valley

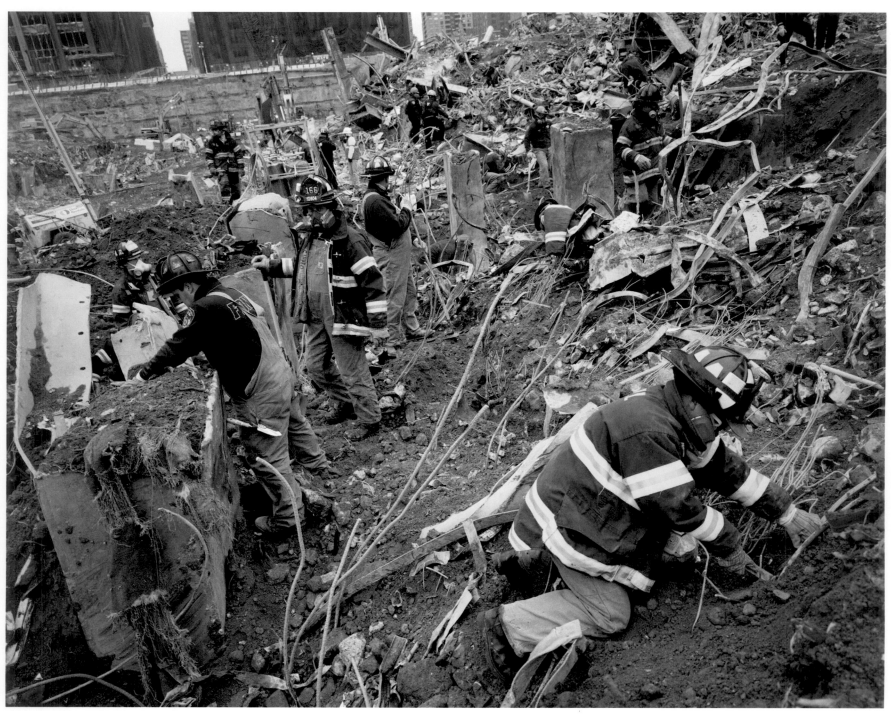

Firemen searching and sifting for remains inside the North Tower

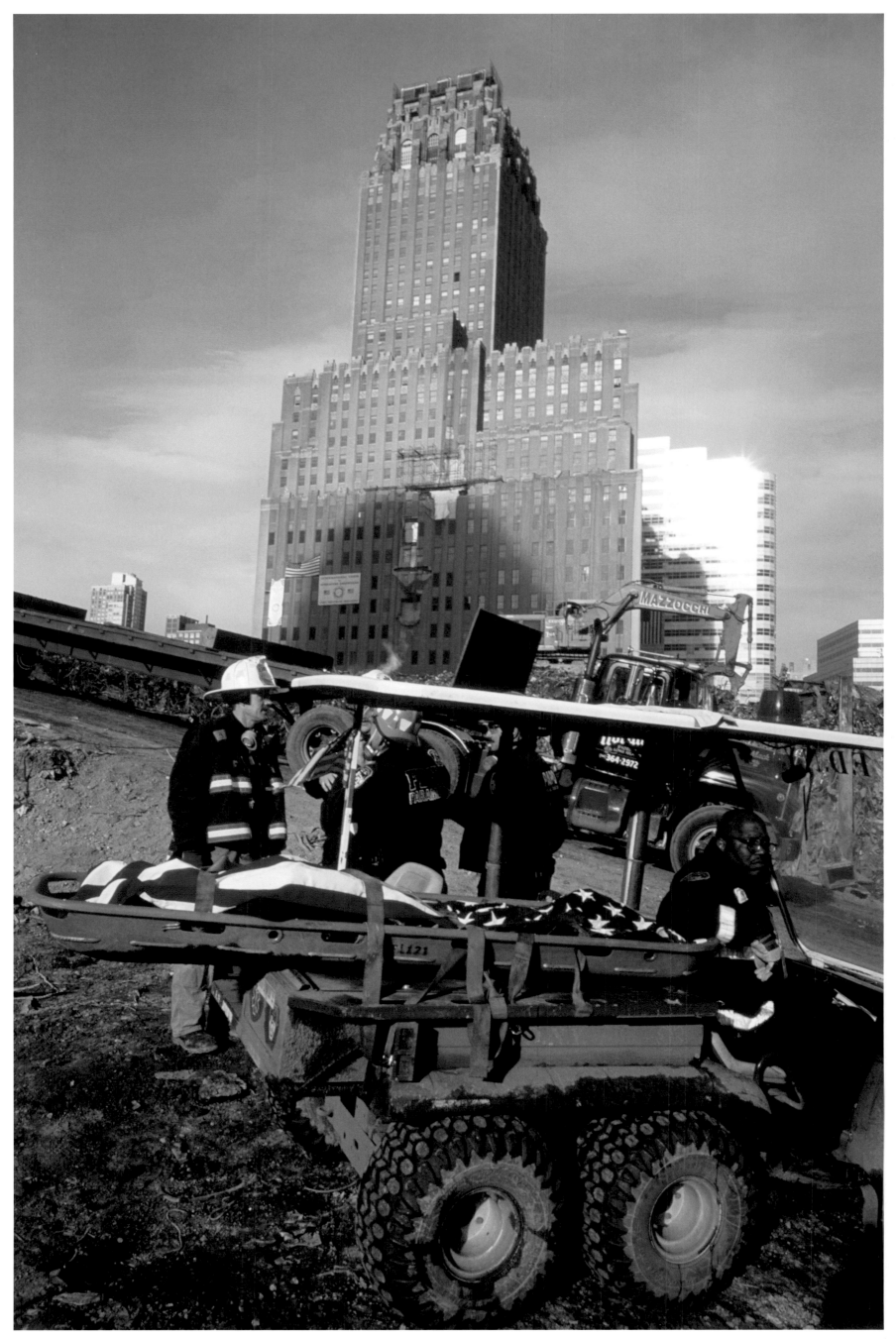

A flag-draped Stokes basket on the back of a mule

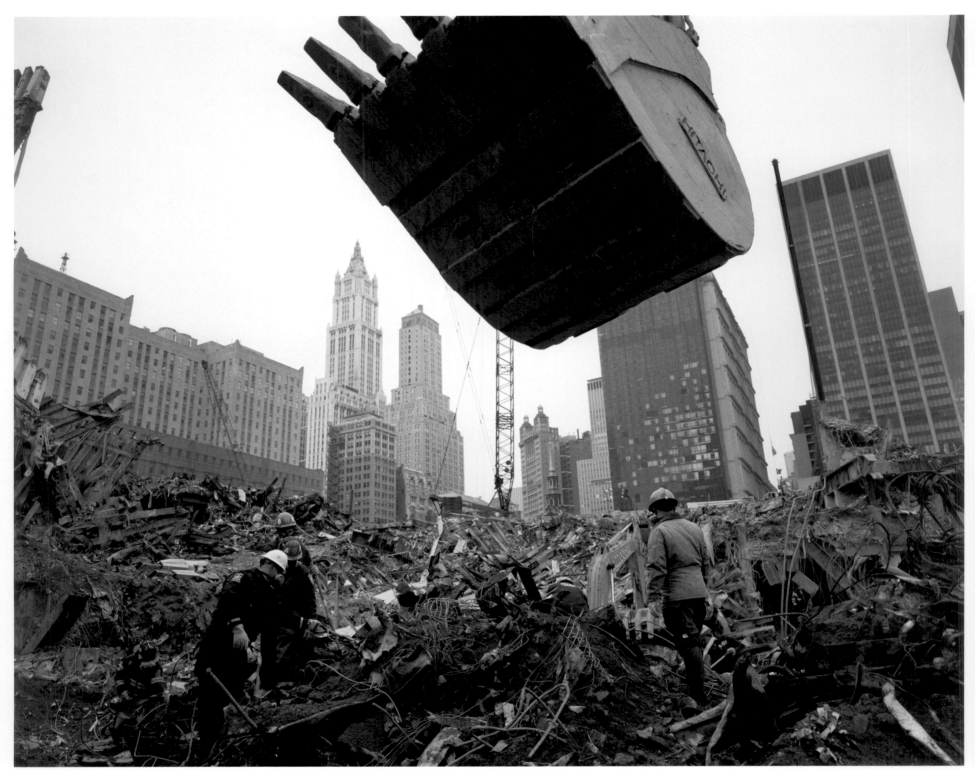

Underneath a grappler, looking east

12.23

The Tully Road wound its way up out of the southeast corner of the pile and onto Liberty Street. It was a temporary road, made of asphalt millings and dirt piled on top of compressed debris—a road that they would ultimately have to take apart to get to the bodies that they knew lay buried beneath. In the meantime, any remains recovered in that quadrant were carried out of the site over the Tully Road.

One of the engineers, looking at the debris-filled space between these columns under the Tully Road, estimated that it contained at least twenty stories of compressed matter. One could see the corrugated-steel floors were every four inches or so; that's nearly two hundred feet of building in ten feet of space. It was here that someone spotted a fireman's bunker coat in the debris, and realized there might be others in there with him. The problem was that the Tully Road provided critical access to the site, and digging below it would certainly destabilize the road above. On the other hand, no one wanted to wait another month to free the body from the pile. Eventually, compassion prevailed; the engineers turned a blind eye, holes were dug into the side, beams were wedged in to shore up the debris above, and two firemen's bodies were recovered.

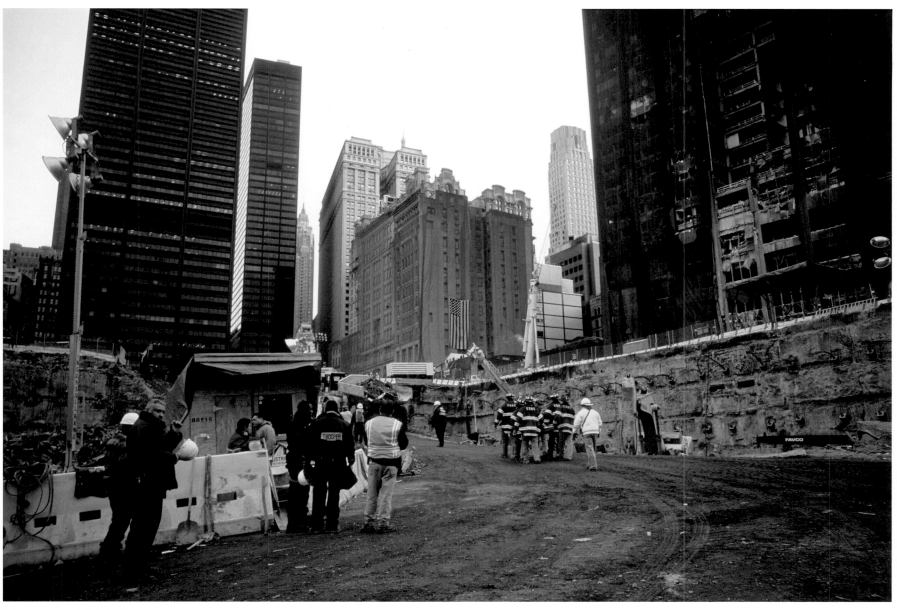

An honor guard on the Tully Road

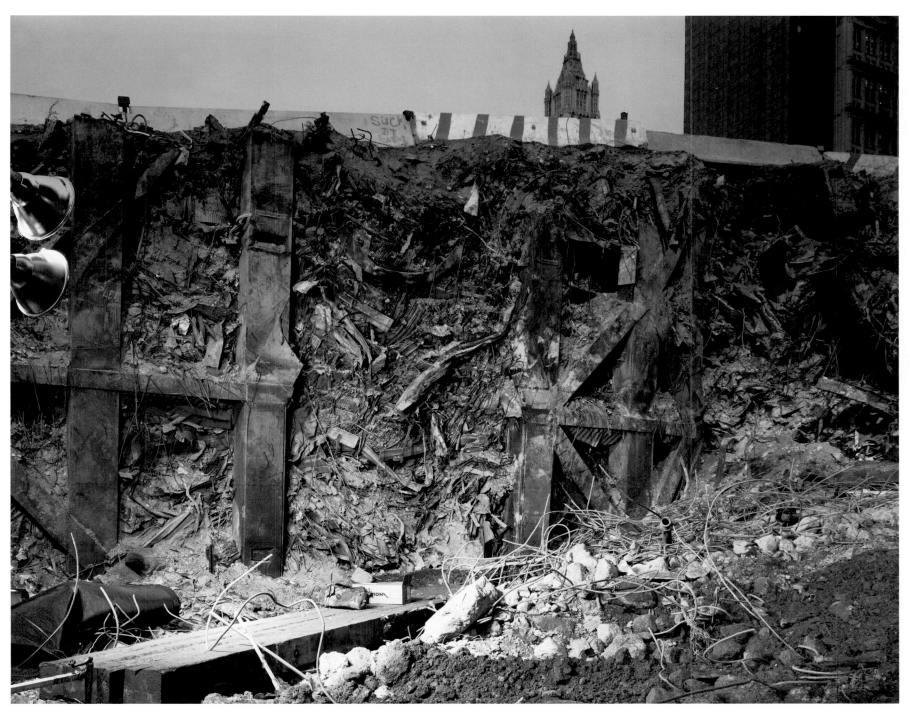

Compressed debris of the North Tower supporting the Tully Road

The expression "My desk is a mess" was true in every sense of the word in the offices I prowled through in the Bankers Trust Building. All around the serious business of work, now never to be completed, were the playful *tchochkes* of office life. There were still Smurf heads on pencils—I thought those had died out in the 1980s! Not to mention funny coffee mugs, plaques, signs, and posters exhorting us to foolish endeavors. Lottery tickets, scratched and useless, lay next to fortunes from Chinese cookies, letter-openers of ridiculous shapes and proportions, and office trophies in gilded plastic. It was a little bit like a crazy museum of office life in the twenty-first century, and in that regard the viewer could not be blamed for feeling incredulous that the people who worked in these cluttered spaces actually got anything done. Perhaps it was the sweetness of the snapshots that gave the inhabitants of these places their individuality. Family and pet photographs were everywhere, along with sailboats and cars (loved ones in their own "escapist" way, I guess). There were also party pictures of birthdays, awards dinners, weddings, and other gatherings showing drunken or costumed moments, which—no matter how embarrassing—people still kept on their desks for pleasure.

I was fairly deep inside the building when I heard a long creaking sound, and the wind moaning slowly in several tones. The creaking reminded me of a wooden ship groaning as the sea rolled it on the waves. I then realized that the whole building—which had already lost a huge part of its façade—was in motion. Hundreds of thousands of steel connections were imperceptibly rubbing against each other, and their tiny squeals carried throughout the sixty stories in a rising crescendo of friction. It was then, in my rooted stillness, that I noticed that all the hanging wiring and rebar and dangling ceiling panels were shuddering. Time to get the hell out of there!

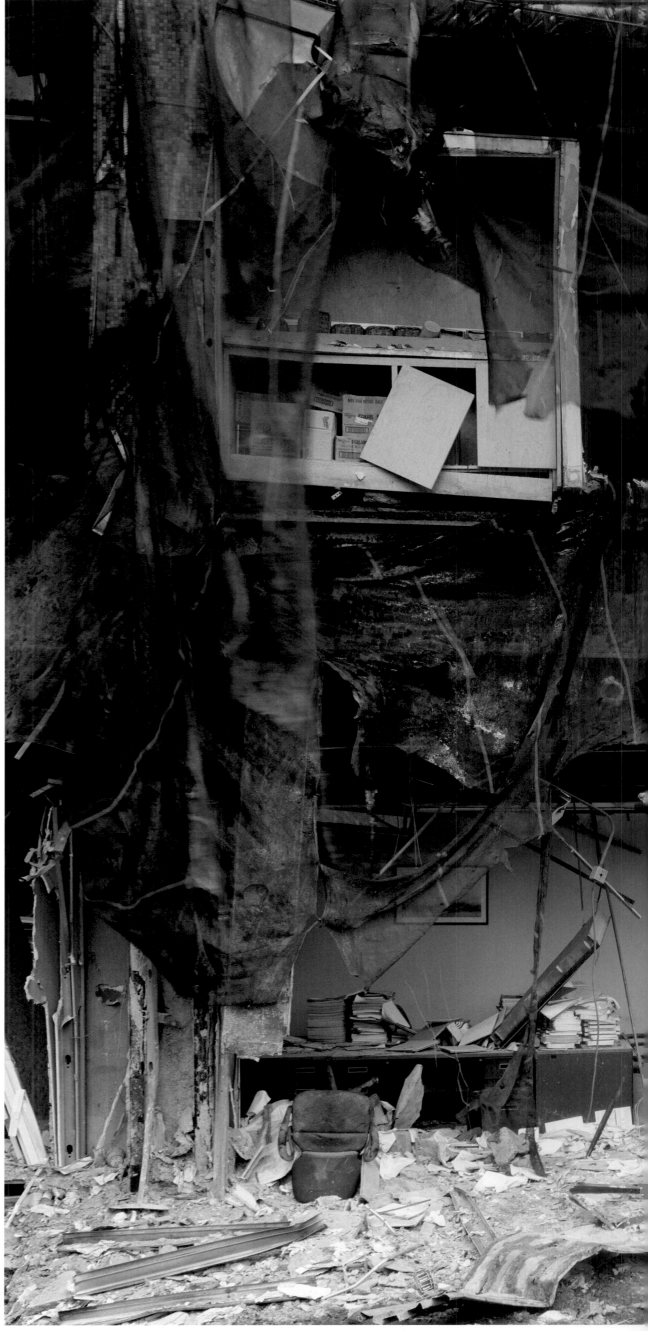

Exposed offices in the lower floors of the Bankers Trust Building

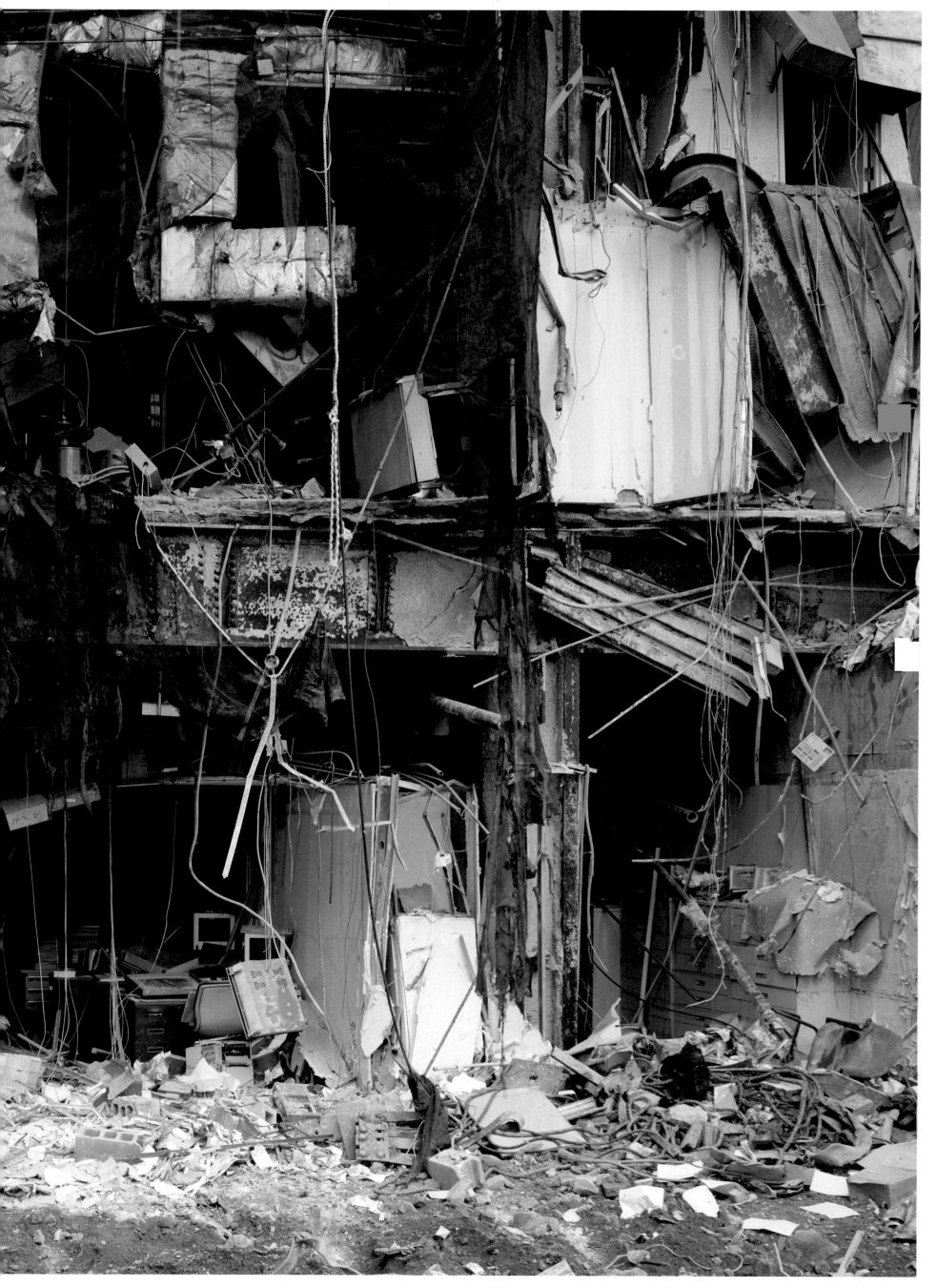

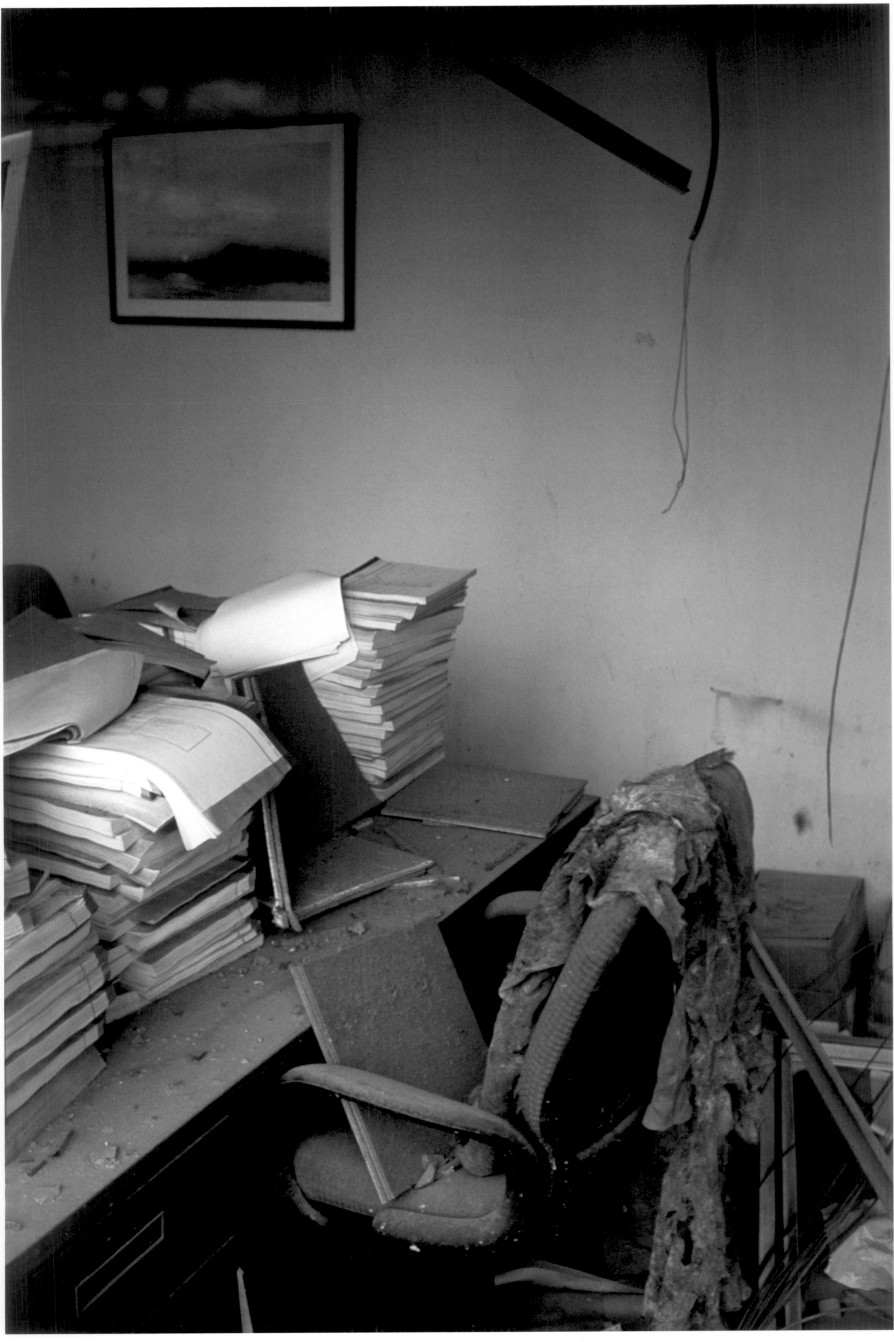

An office in the Bankers Trust Building

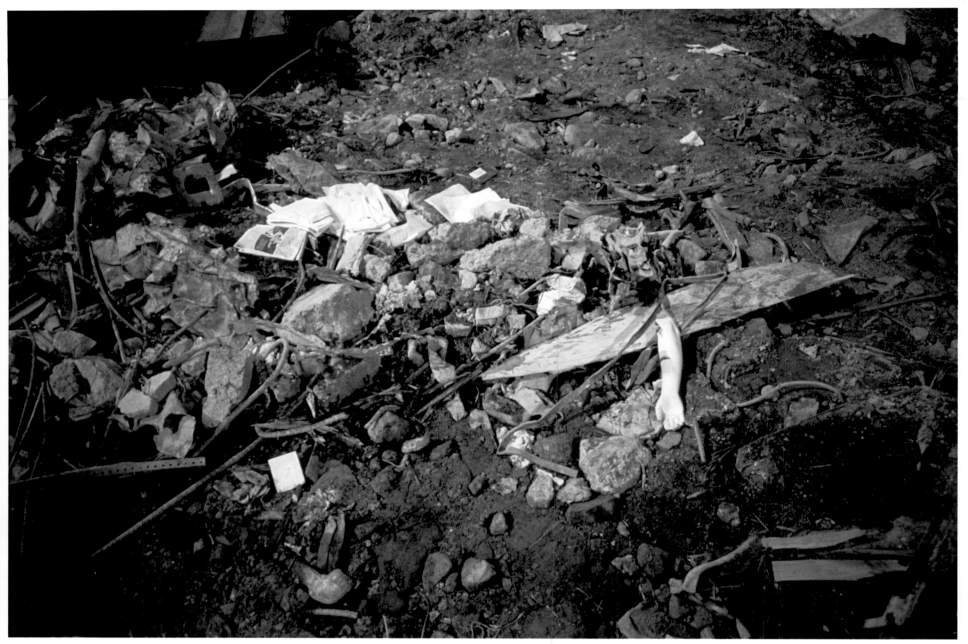

Papers, a mannequin arm, and rubble inside the South Tower

Rubble in an office in the Bankers Trust Building

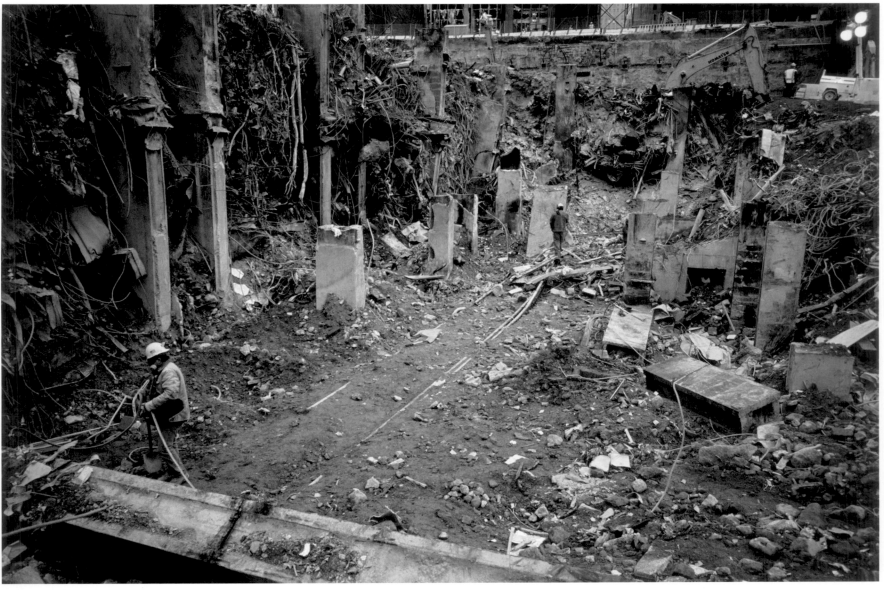

Workers and exposed PATH train tracks underneath the South Tower

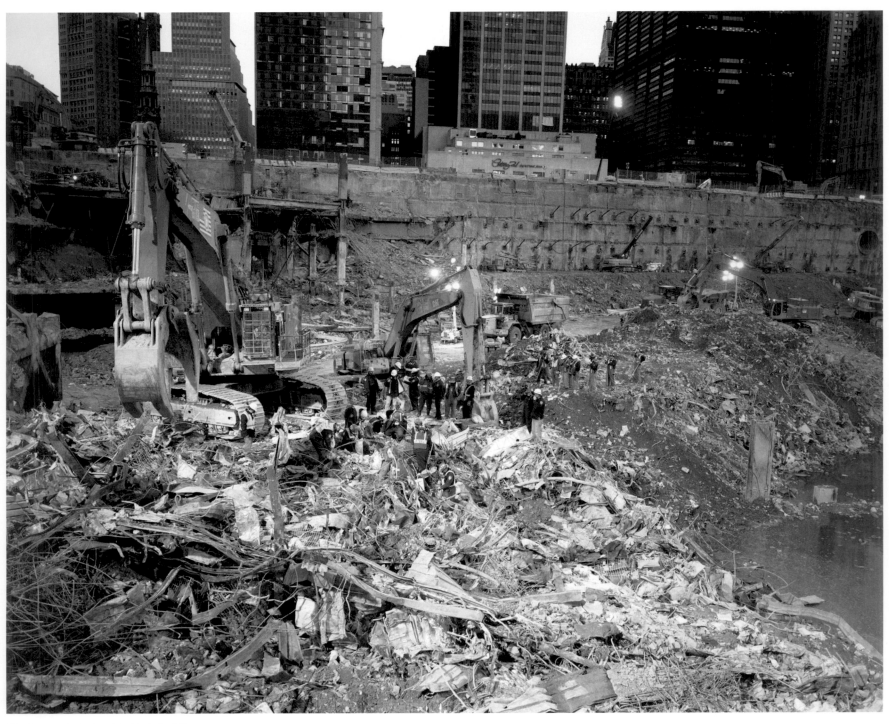

The discovery of a bank vault inside the North Tower

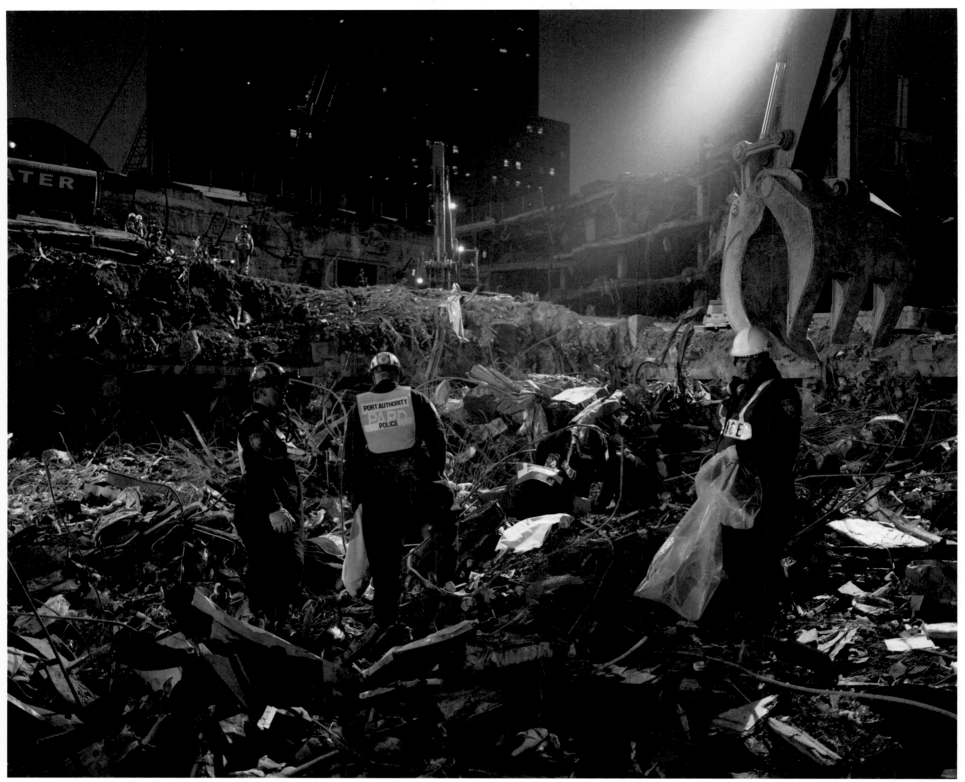

Port Authority police searching through the bank vault

02.08

FOLLOWING PAGES: These guys may look a little like Keystone Cops from the silent-movie days, but in this case they really have got the goods—eleven million dollars in cash! When I came across them one evening, they were lying on the ground and reaching into a destroyed bank vault that had fallen from a bank's offices in the North Tower. Shining their flashlights into the dark, they were groping around, pulling out fistfuls of money—yen and lira, pounds and dollars—and stuffing it into gunnysacks. Many of them had cigars, "tough-guy" style, stuck in their mouths. (So many men chewed big stogies on the site that I often wondered if someone had come across a smoke shop underground and "liberated" them.)

When the men were done, they stood for their portrait (minus the cigars): ten guys and eleven million dollars. Then they piled it on one of the mules with a little box on the back and trundled off into the night. As they drove away, I saw one of the bags fall off the mule.

By this time, I had already mortgaged my house and taken out a business loan in order to document the work at Ground Zero. I was still waiting for support from the Museum of the City of New York, which was long on promises but short on delivery. I was now five months into the work and I was getting desperate. In that brief instant, standing in the dark, two words flashed through my mind: "My funding!" But then I let out my New York taxi whistle, which stopped them instantly, and one of them came running back to save me from a life of crime.

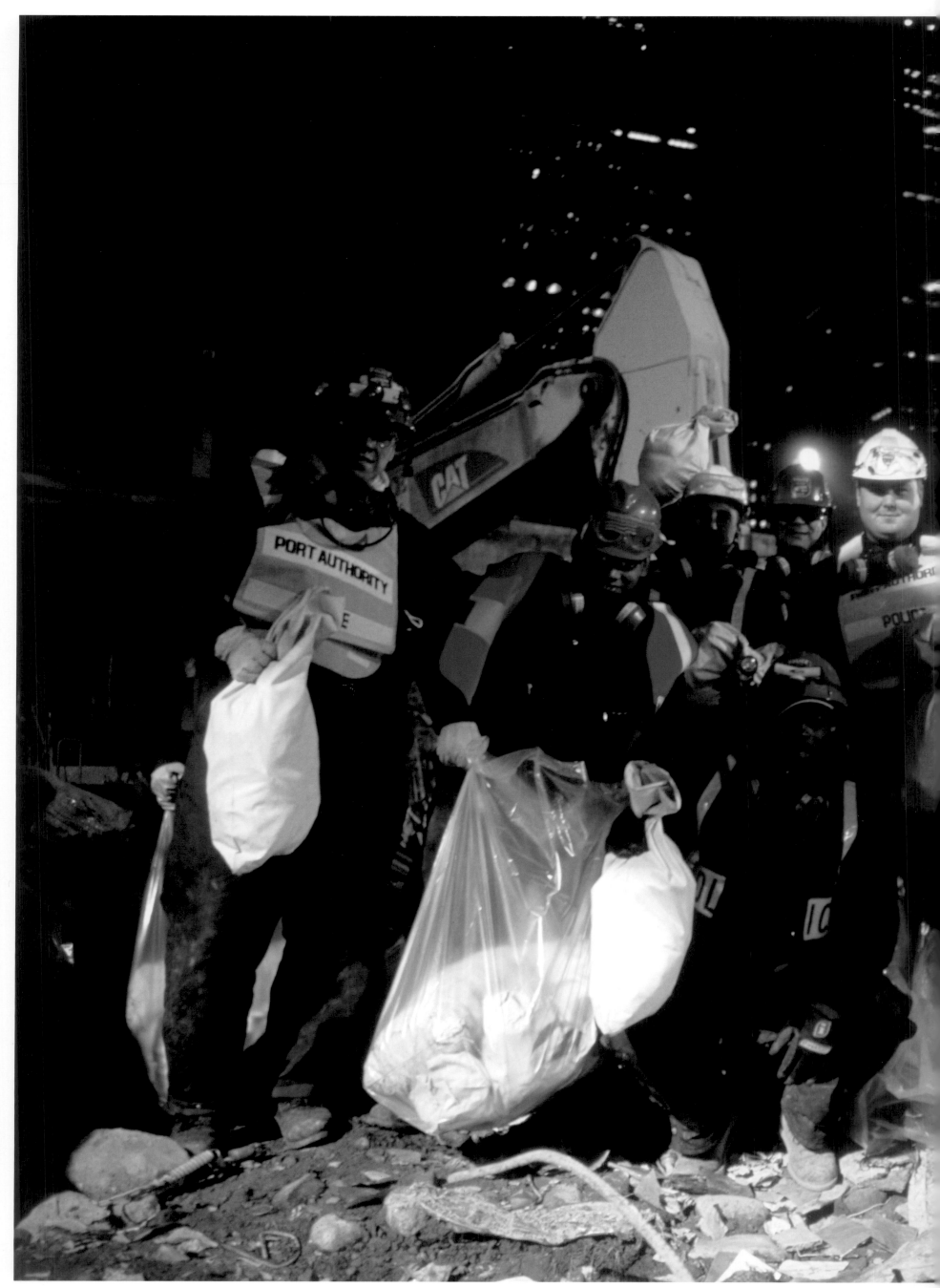

The night they found eleven million dollars

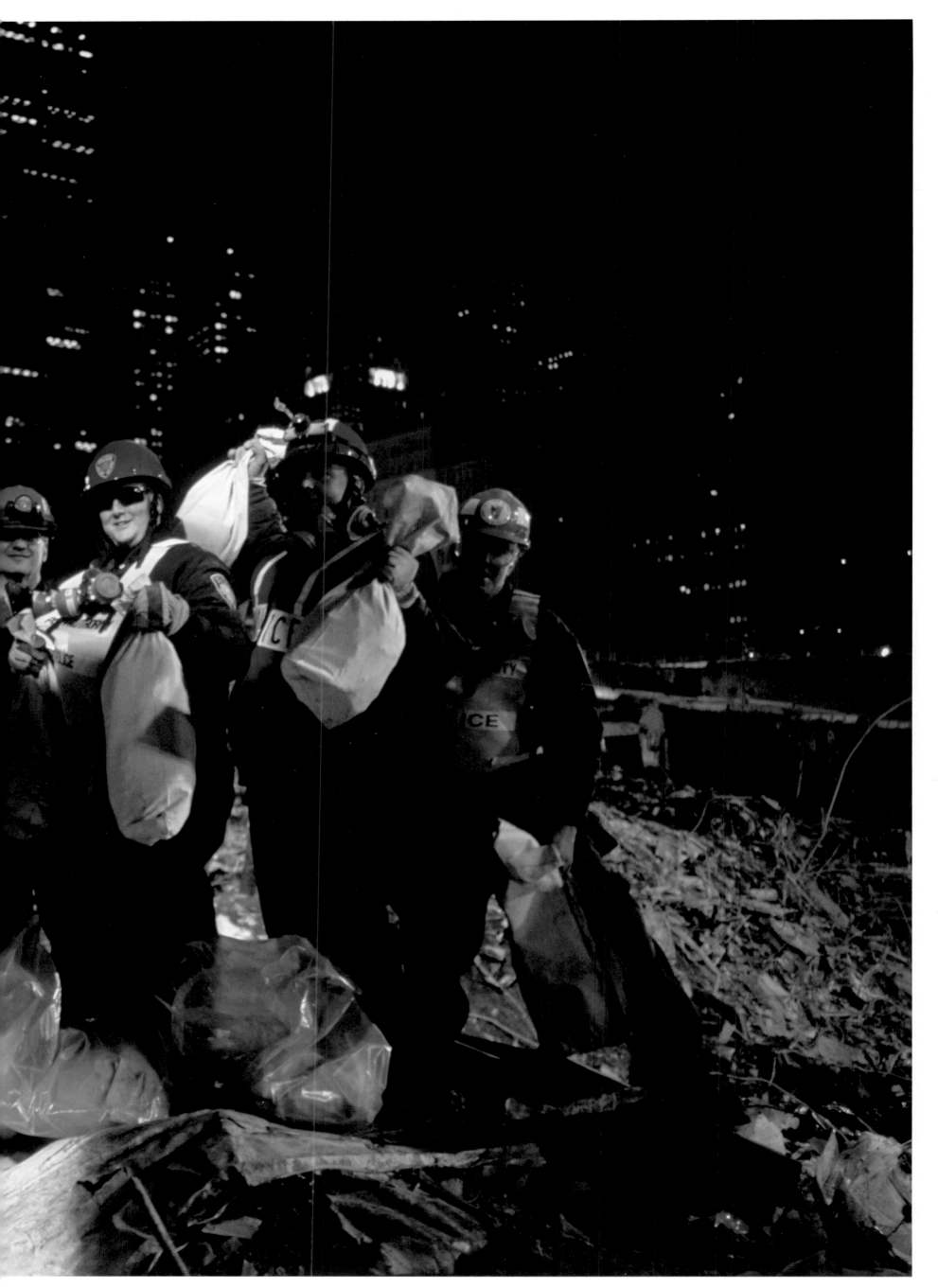

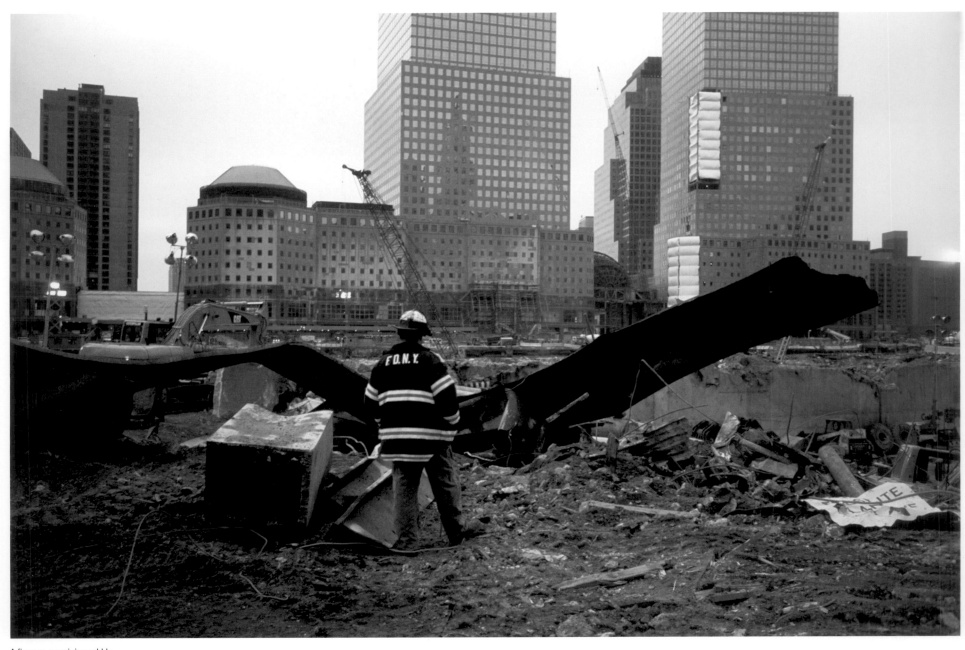

A fireman examining rubble

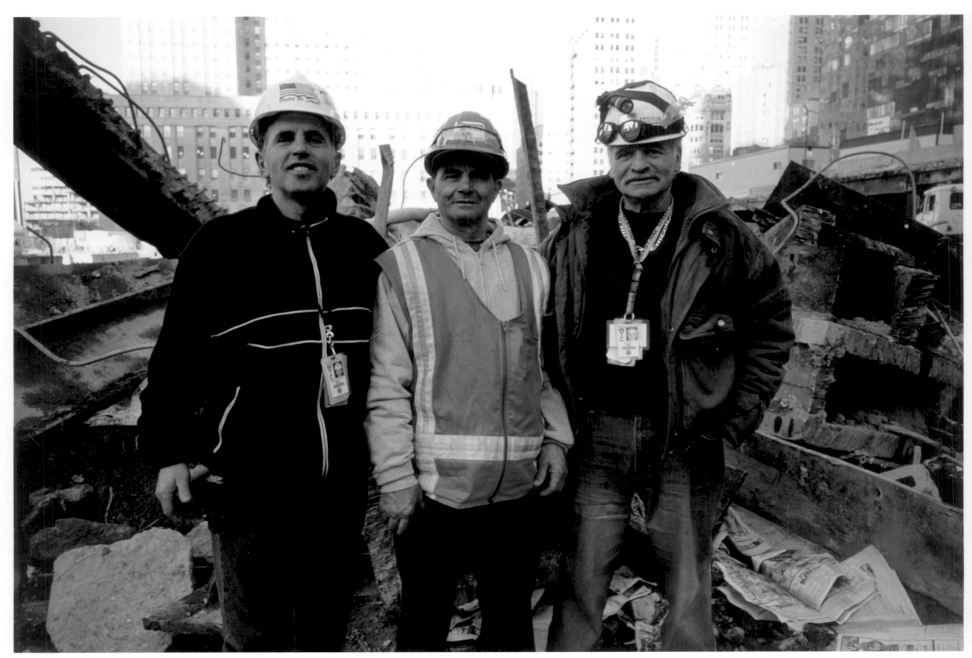

Construction workers

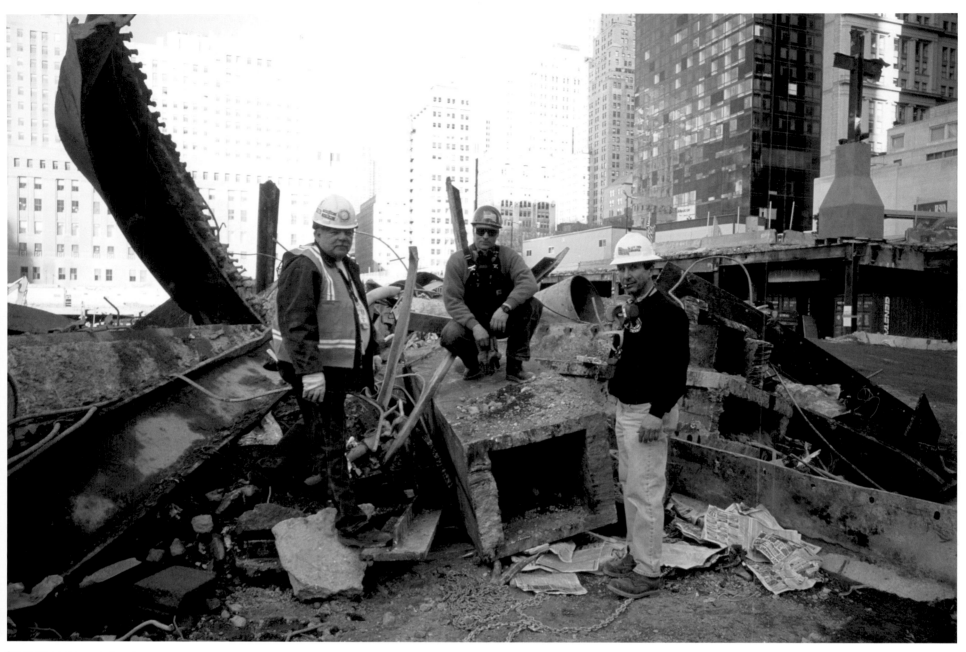

Construction workers and a box column

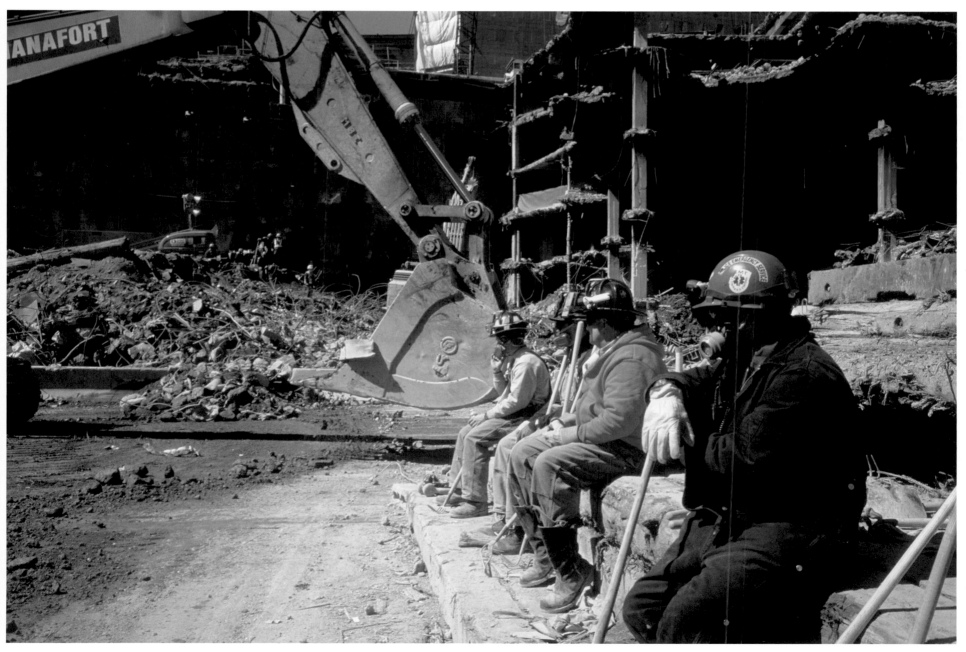

Workers waiting for a grappler to lay a new raking field

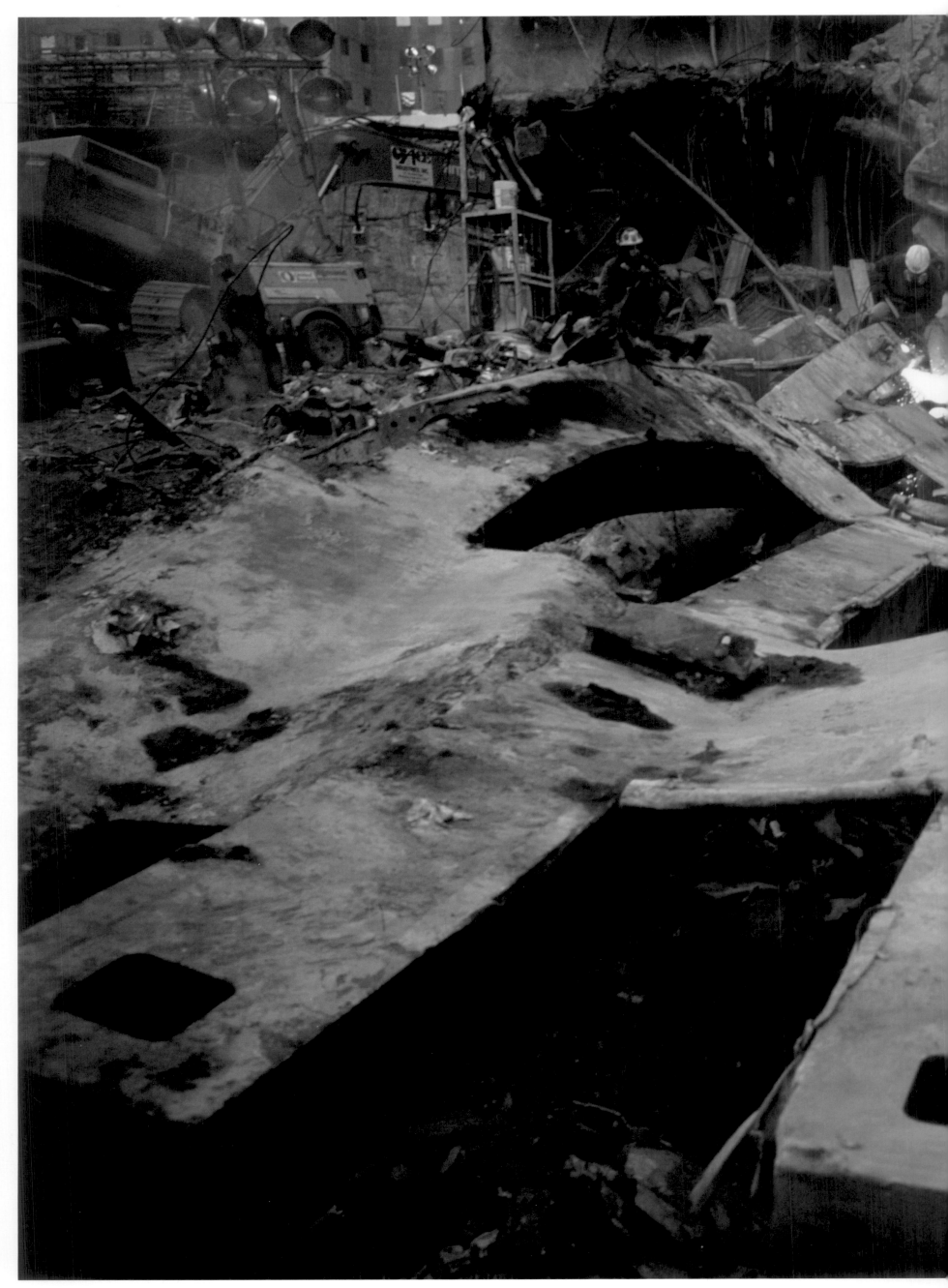

Welders working on a three-column section of the South Tower at dusk

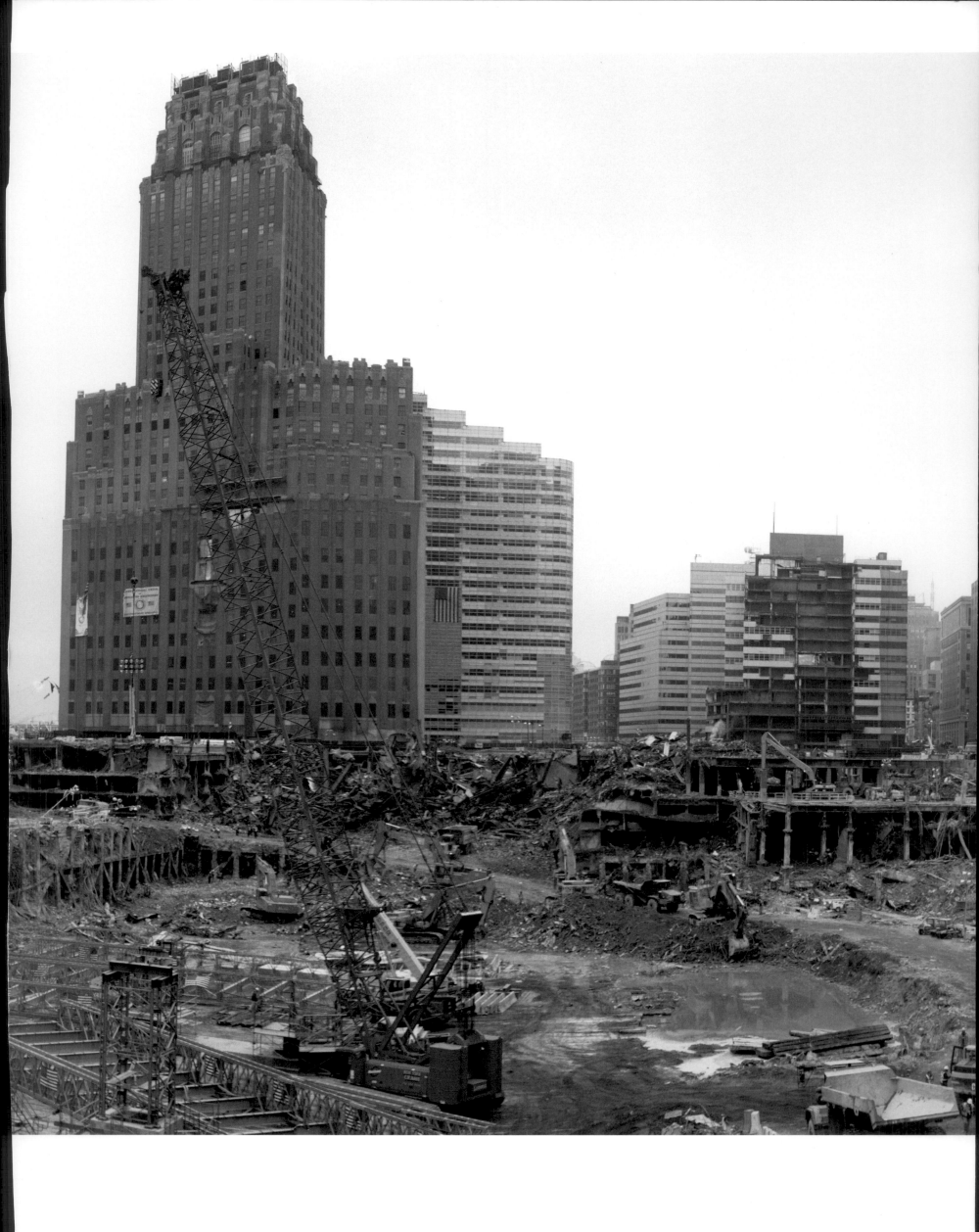

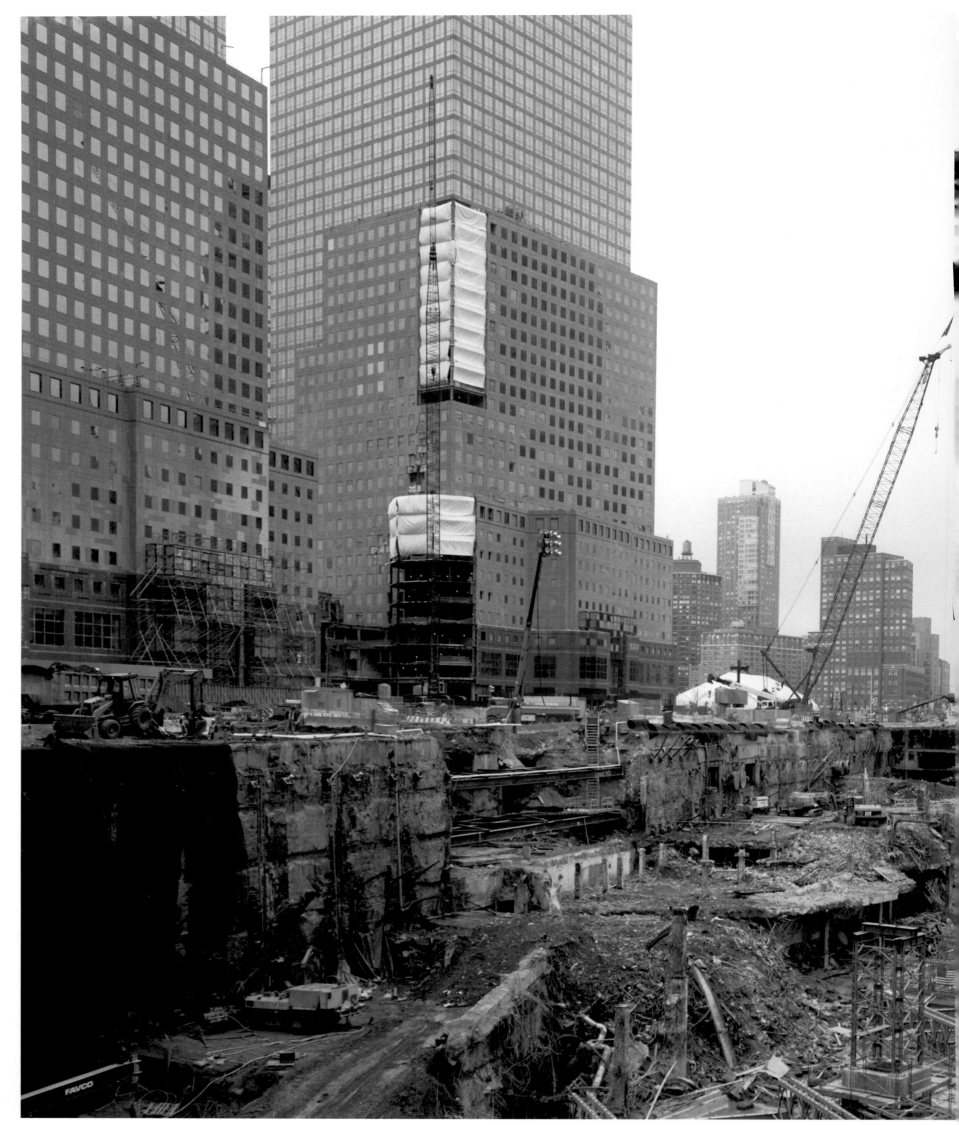

Assembled panorama of the site, looking north

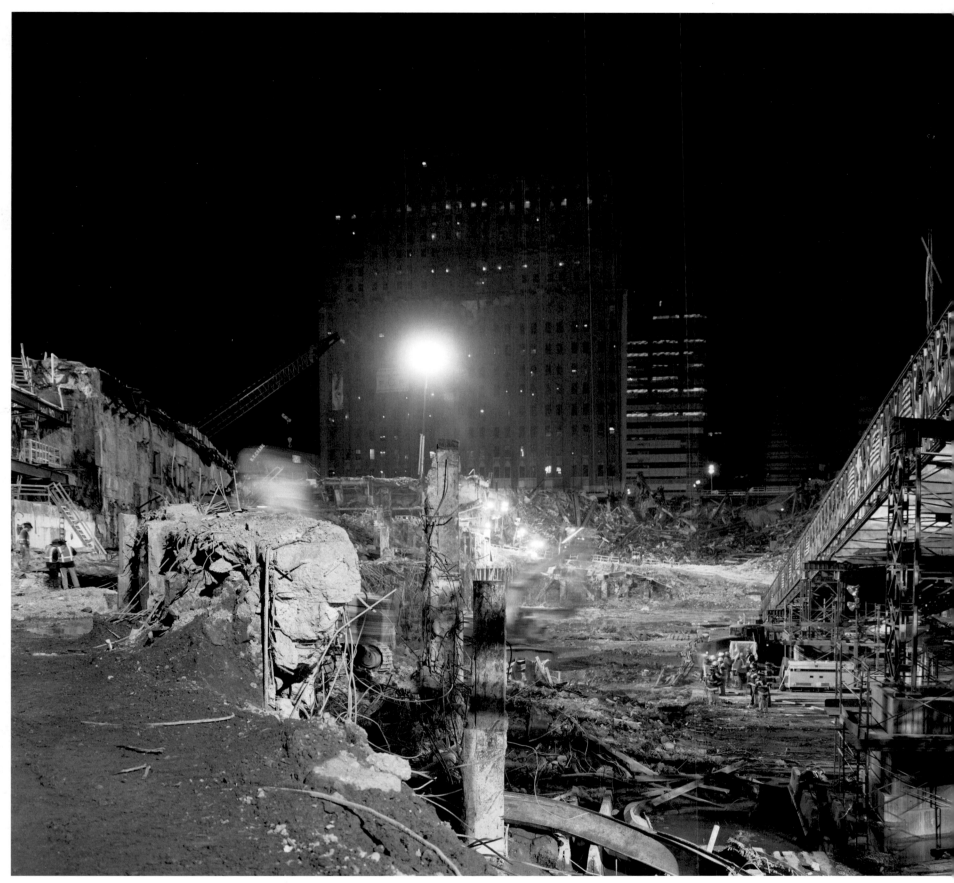

Before the Tully Road could come down, a temporary bridge from Liberty Street into the center of the site had to be erected.
The workers were excited to be building something new. This, after all, was what they had been trained for.

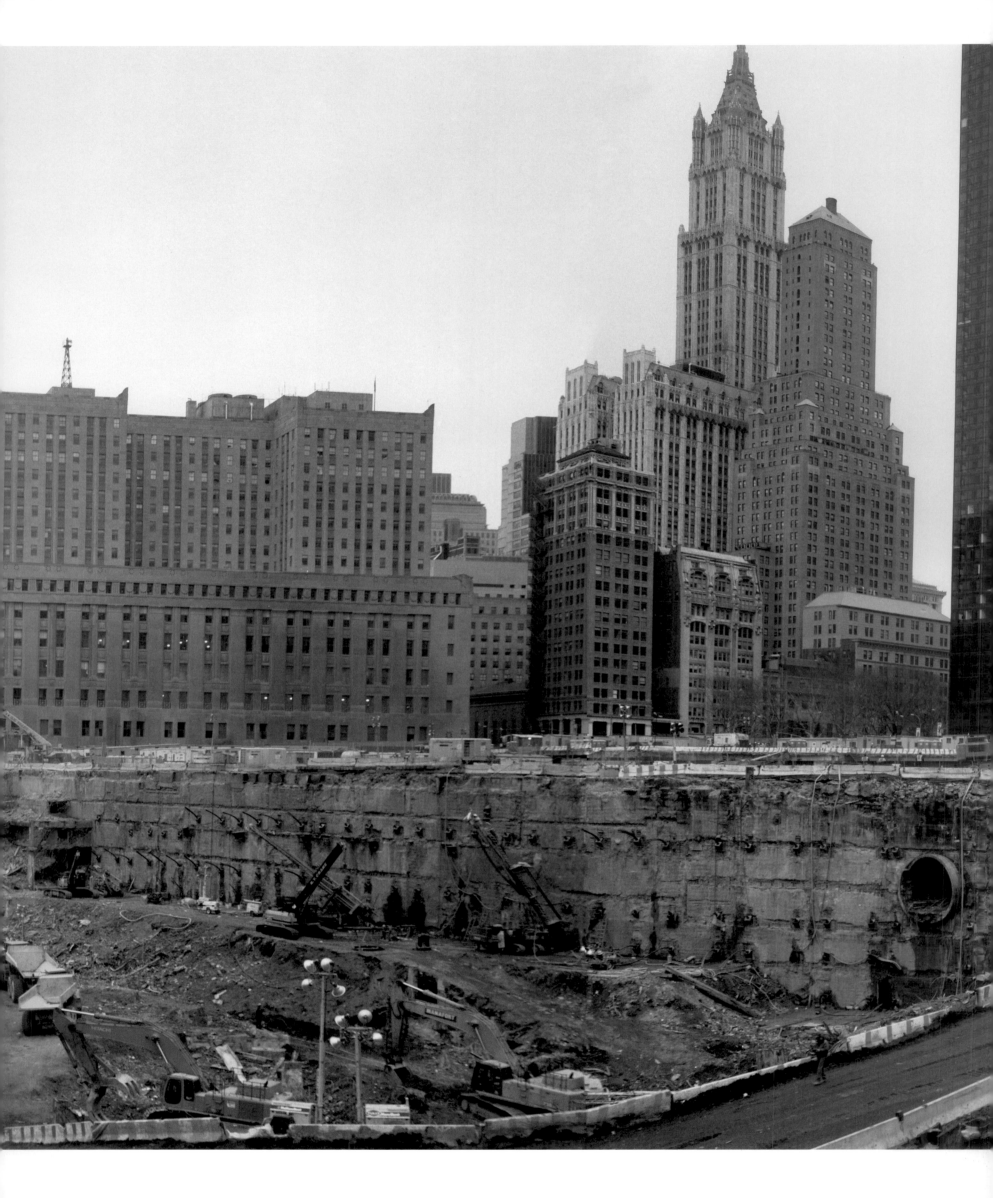

Almost six months after September 11th, and the pile was now a pit that in some places reached down to bedrock. Here and there, one could see pools of water where seepage from the river had made its way in. Few New Yorkers realized that there had been sump pumps in the South Tower that had run twenty-four hours a day ever since the building was constructed.

In the lower left corner of this image, the steel supports and sections of the prefabricated Acrow bridge are in position. Further north are the exposed garage levels of the Customs Building. The white object in the distance is the Taj Mahal dining tent. In the center, grapplers are removing debris from the lowest, wettest point and are preparing a flat field to be covered by timbering to create a stable base for more cranes, grapplers, and trucks. On the right side is the Tully Road, which winds down into the center and runs past the PATH train station. The management of the site's four quadrants was now under the direction of Superintendent Charlie Vitchers. Charlie had been there from day one, but his company, Bovis, was now overseeing the entire site. By this time, nearly one million tons of debris had been removed.

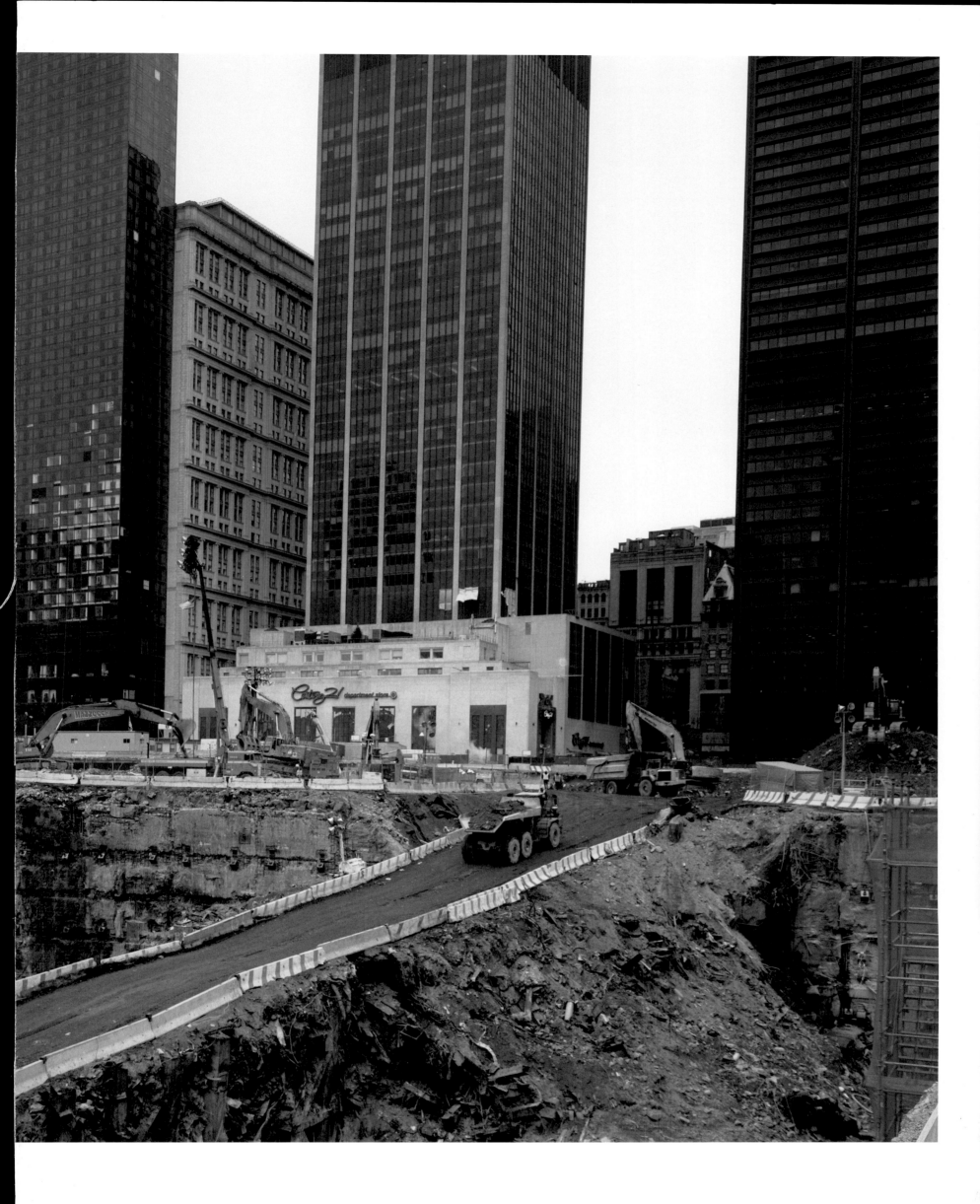

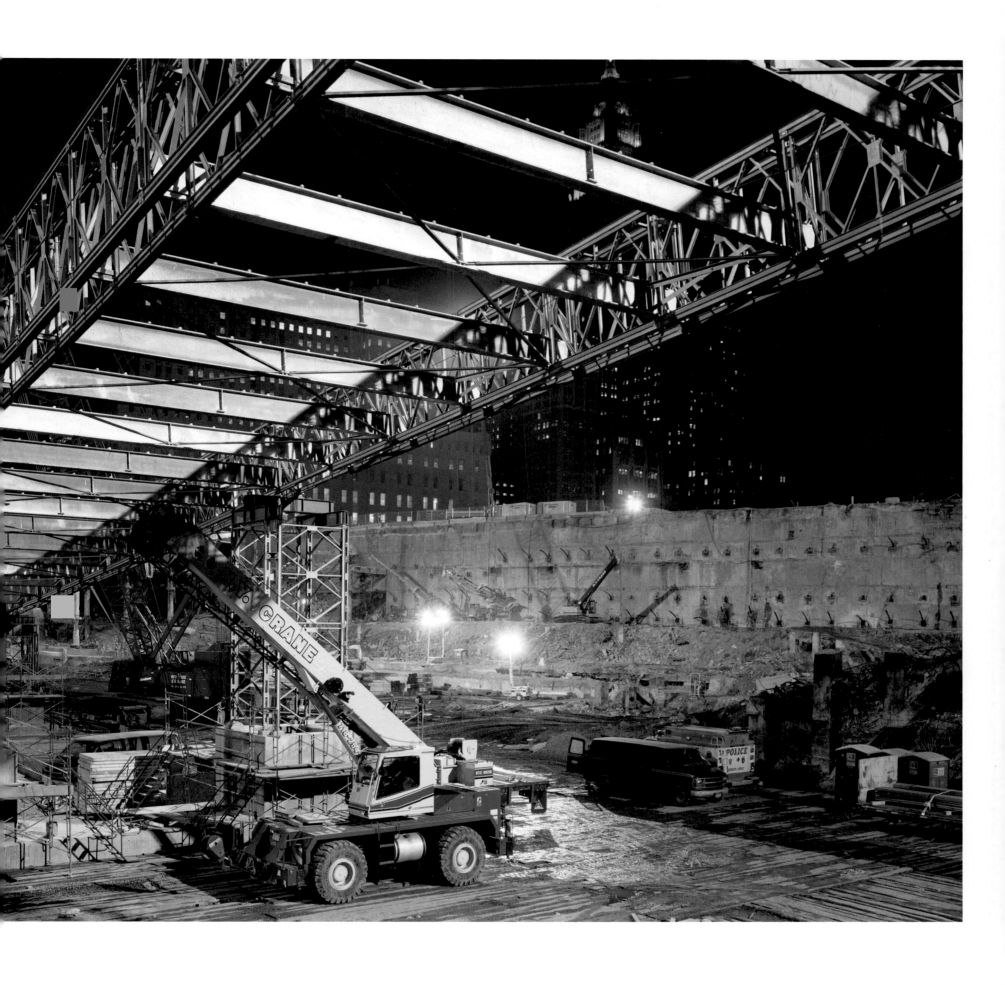

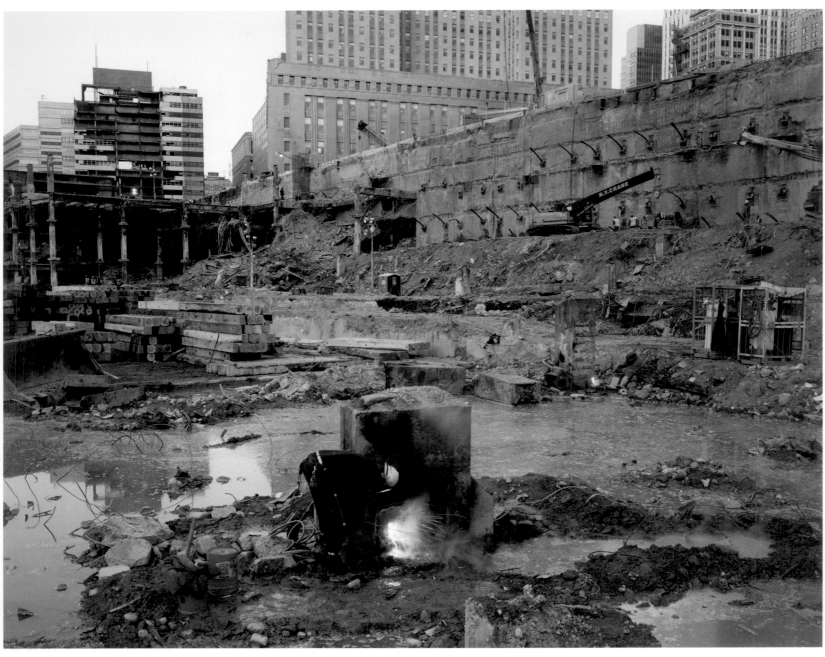

A burner taking down a box column at bedrock

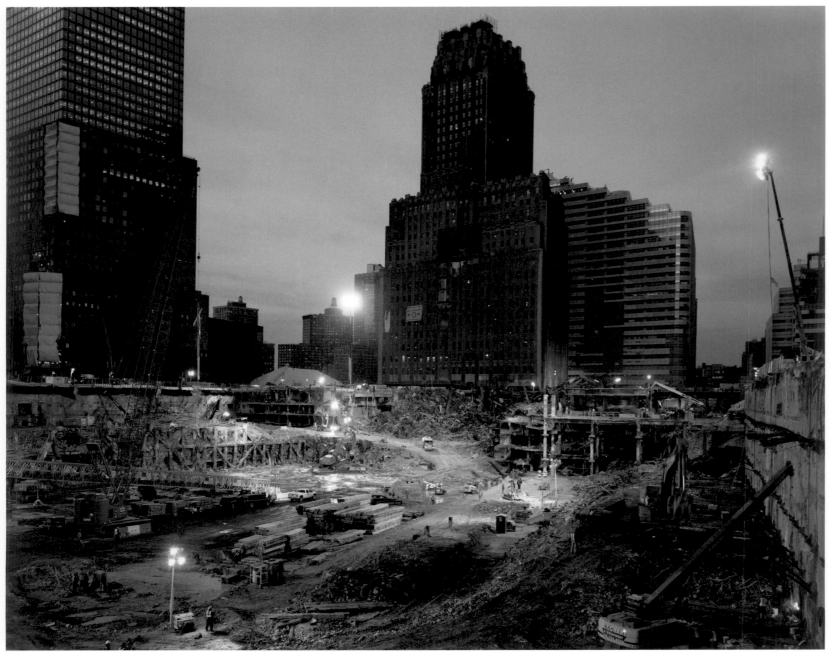

The site looking northwest, with stacked timber to make a stable base for machinery over the muddy bedrock

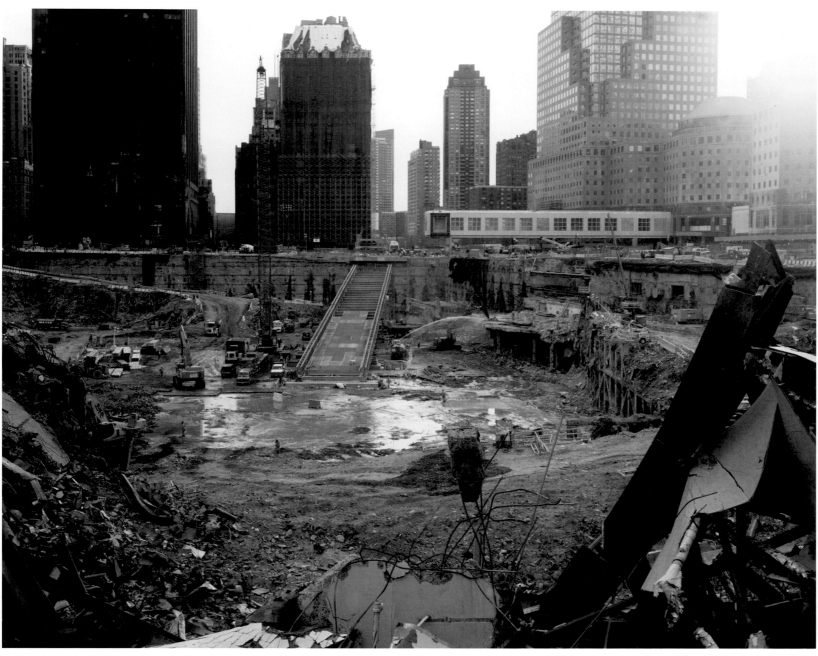

The bridge from the north end of the site, with a pool of water from the river

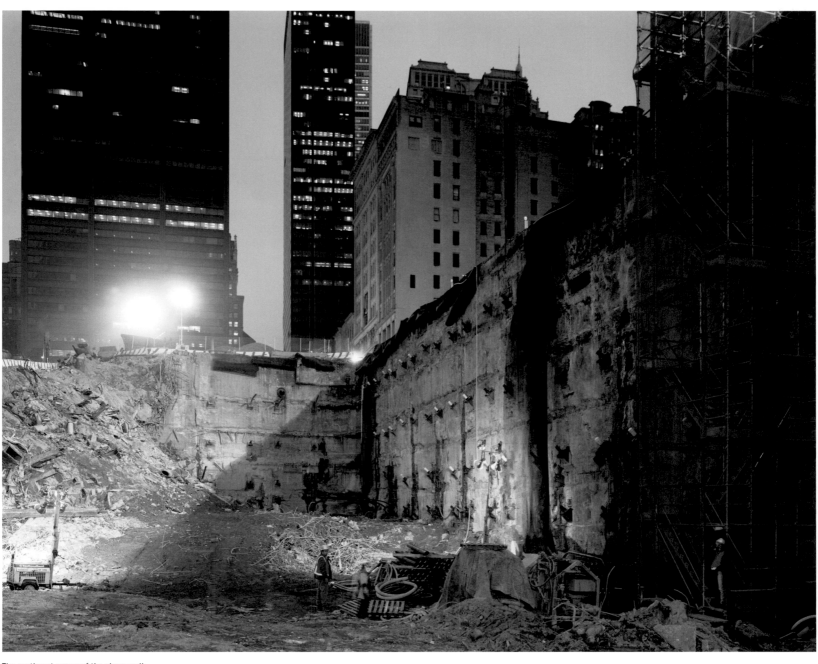

The southeast corner of the slurry wall

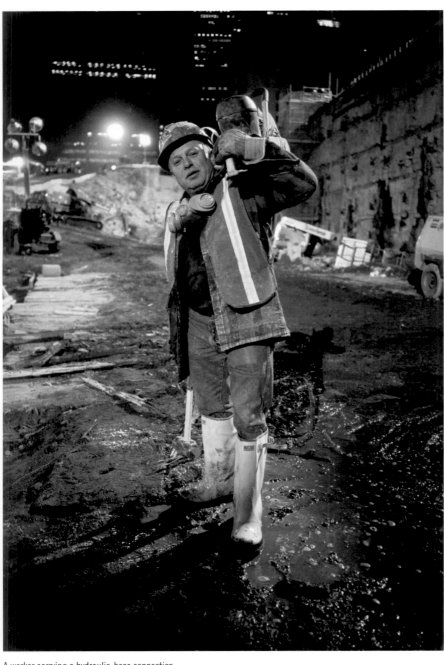

A worker carrying a hydraulic-hose connection

A safety inspector

A volunteer in front of the Taj Mahal

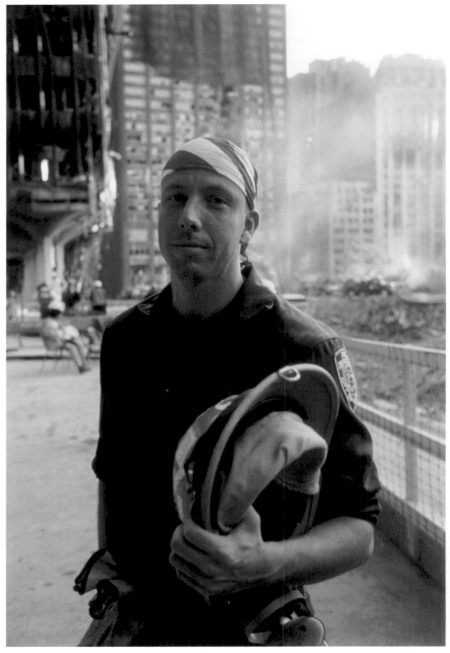

Detective John Ahearn

A Salvation Army volunteer in the Taj Mahal

A worker carrying a hydraulic hose

A Red Cross volunteer with a collection of pins

Retired fireman Lee Ielpi; the body of his son was recovered on the site in December.

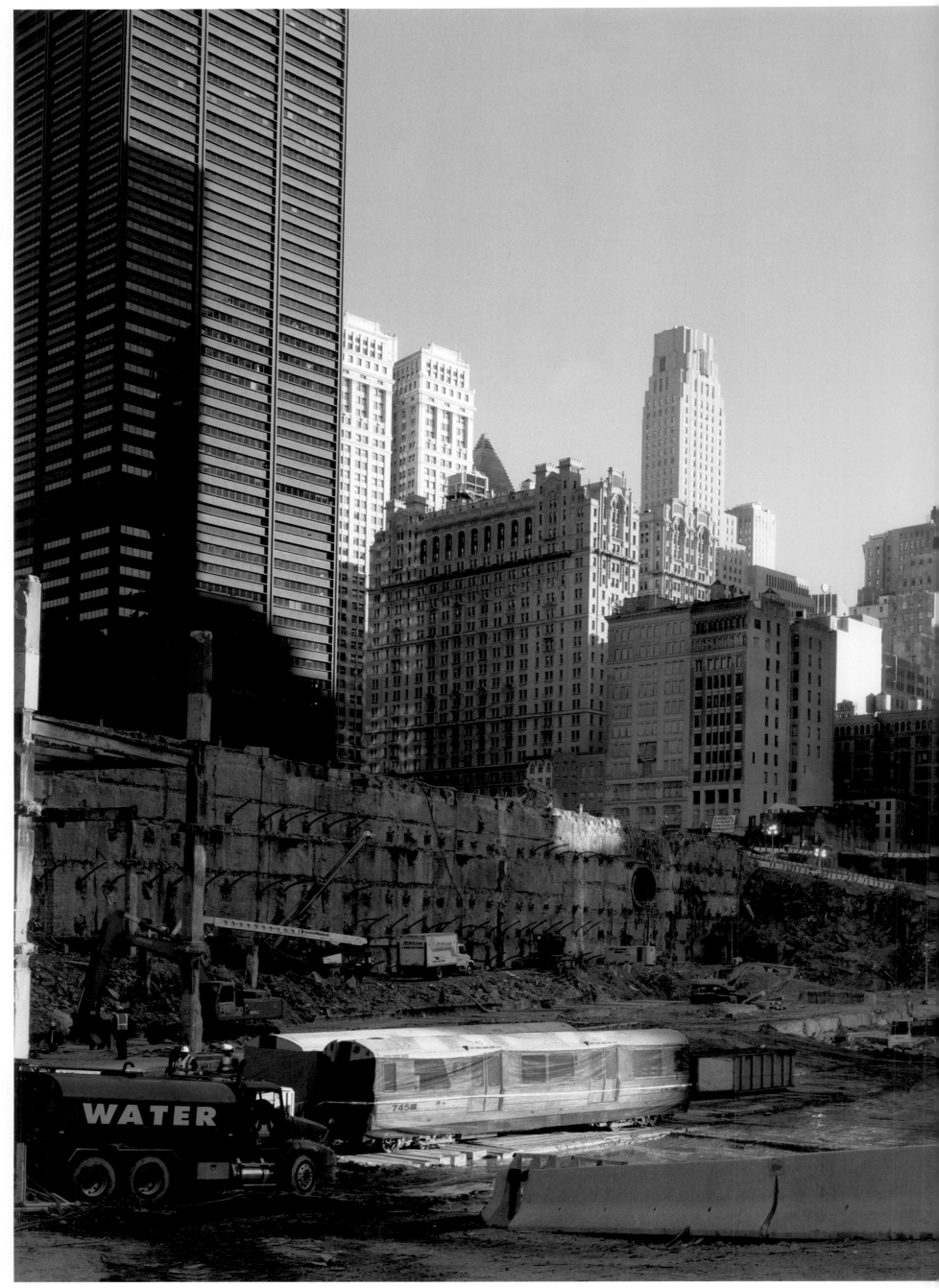

The Ghost Train

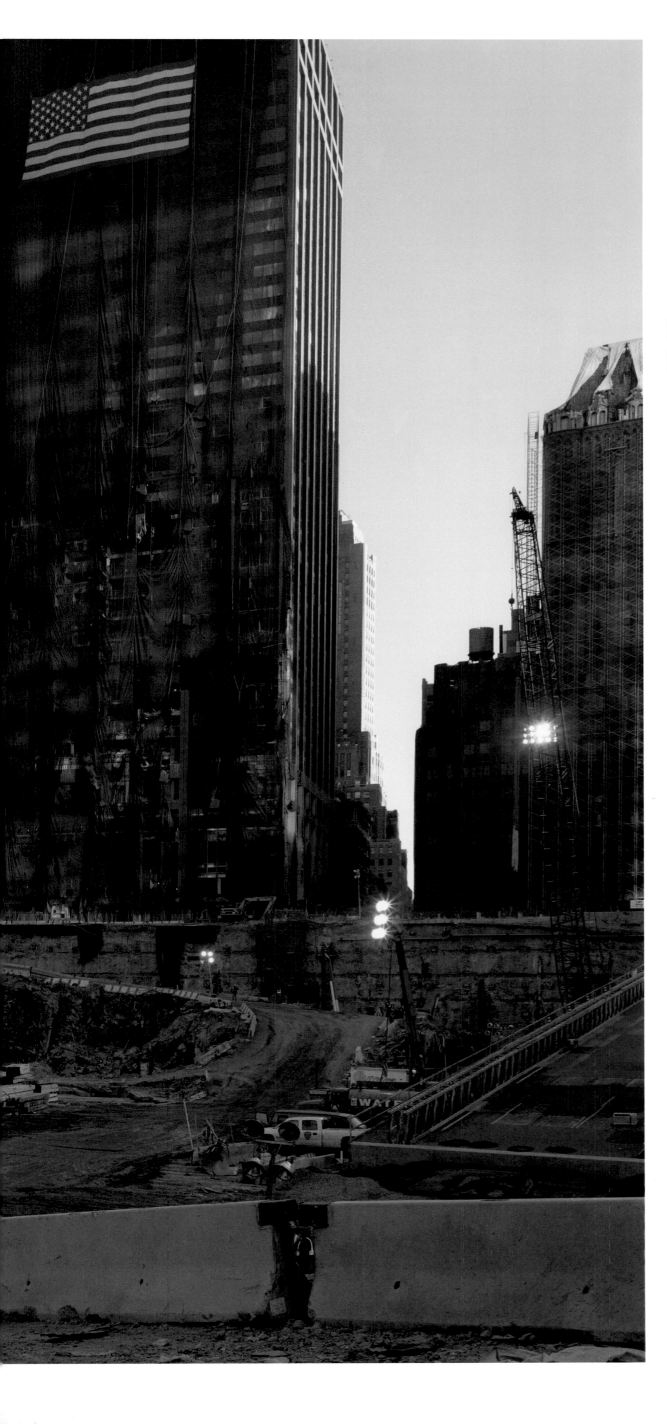

02.23

The last train in the PATH station has finally been brought out into the light. Shrouded in black, it was called the "Ghost Train"—a solemn reminder of the day of the attack. An empty train, it had remained in the station for six months.

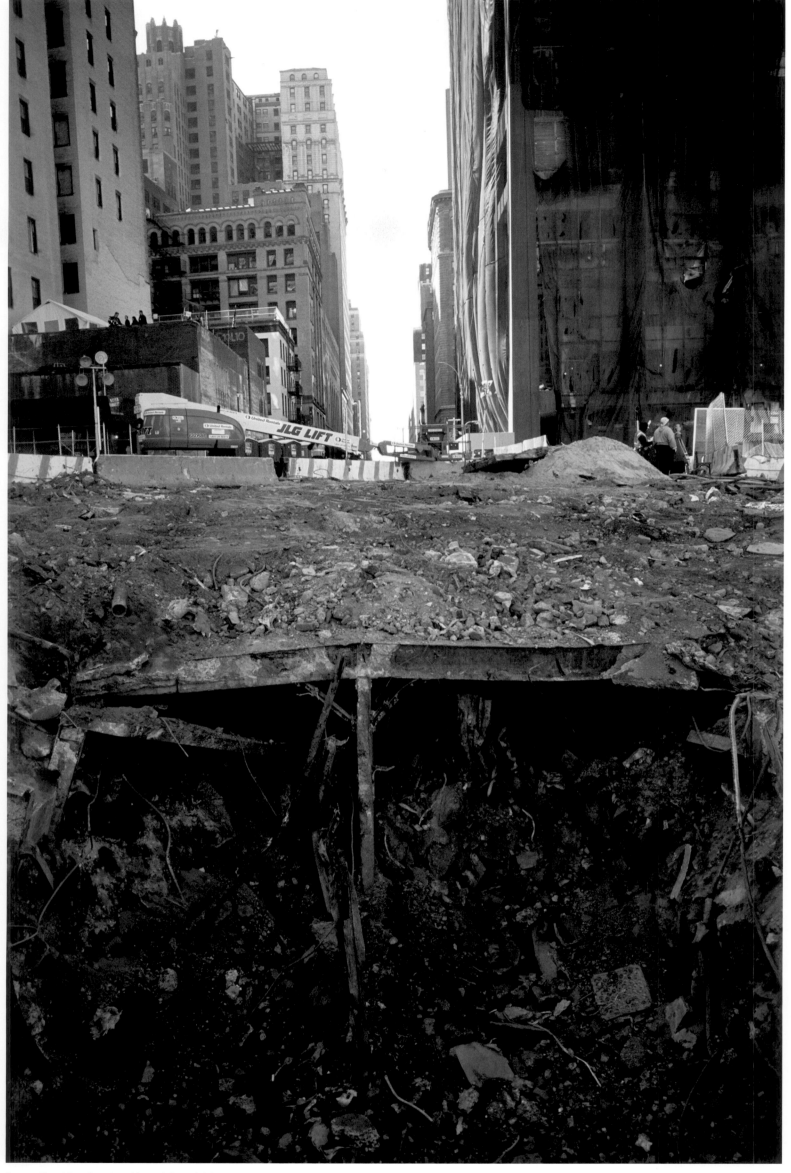

Cross section of the subway tunnel beneath Greenwich Street

The subway tunnel running under Greenwich Street had over five hundred feet of collapsed sections in two locations. And although the subway system in that part of lower Manhattan is a complex tangle of lines running close to one another, the engineers thought that the tunnel could be repaired fairly quickly.

When the subways were originally built in the early twentieth century, the method used was called "cut and cover." Trenches were dug in the relatively soft soil, framed out with steel arches known as "bents," and boxed in by concrete and brick. Everything was then covered over with about seven feet of earth, which also carried the water, sewer, and utility lines. Seeing the tunnels in this cross section reminded me how delicate the balance between the city's infrastructure and the daily life we take for granted here really is.

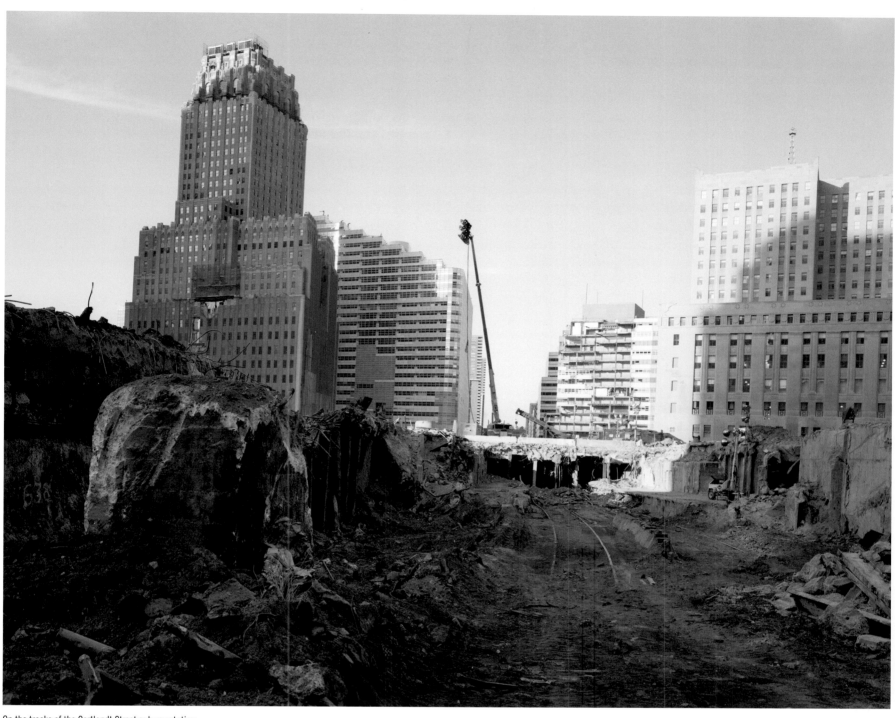

On the tracks of the Cortlandt Street subway station

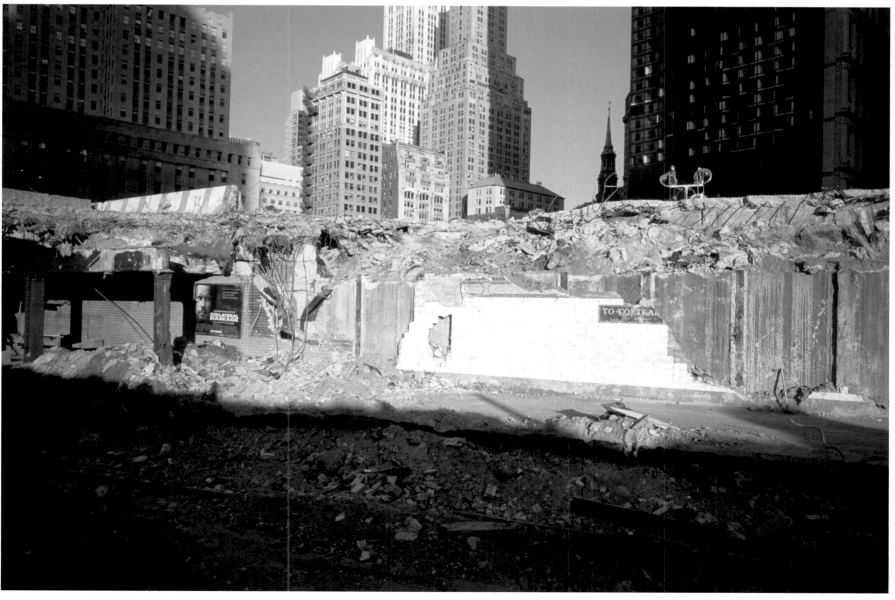

Looking northeast from the Cortlandt Street subway station

SPRING

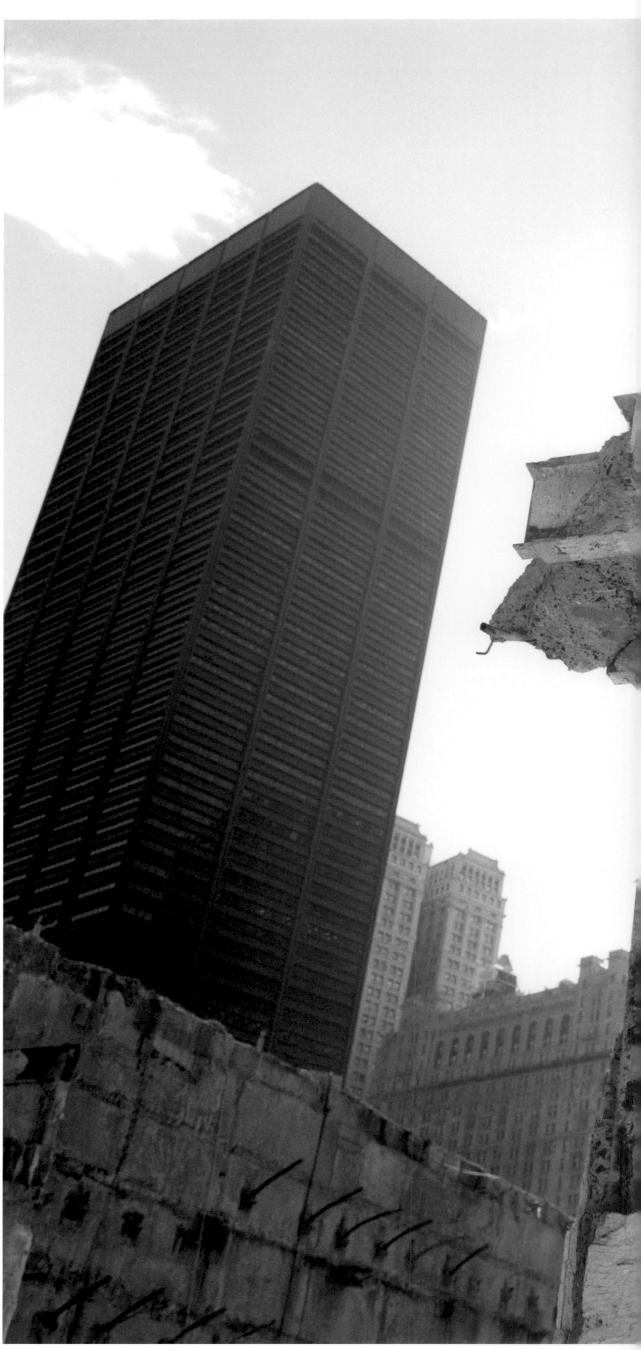

A column from the PATH train station

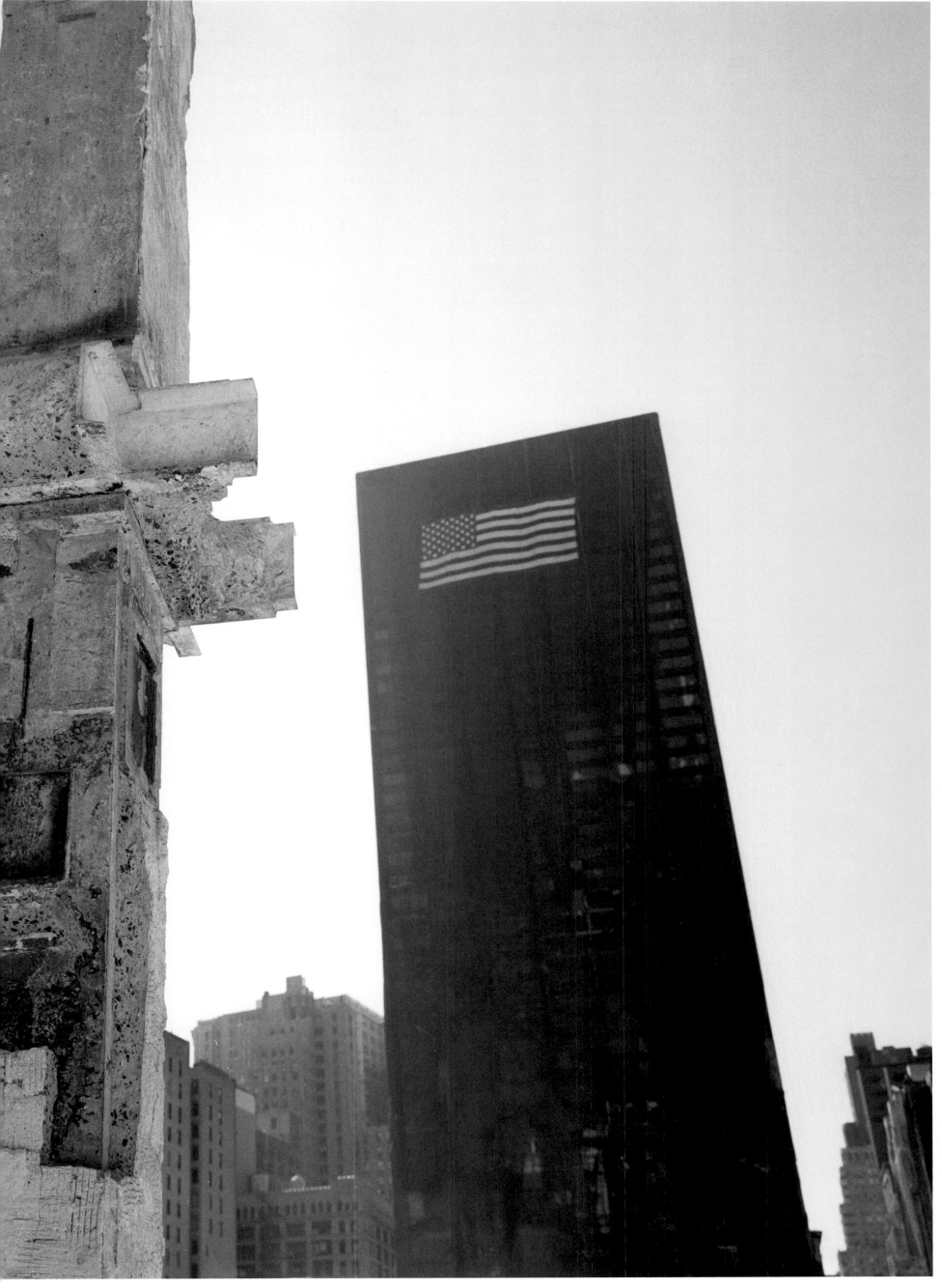

A cinderblock with a fragment of a femur

Raking through the debris was tedious, repetitive work. At the same time, it required careful and discriminating observation, which in itself was exhausting. Coated in the tower dust—which constant watering had turned into gray mud—concrete shards, stones, and human bones all began to look alike. Ralph Geidel, a fireman who was searching for the remains of his brother, earned the nickname "The Raven" because he found more bones than anyone else on the site. "Maybe it's just the way they roll under the rake," he said, "but I can tell right away when it's bone."

Here part of a femur, or thighbone, has been set aside; it is waiting to be "tagged and bagged" by the Global Positioning System team. They would take a reading of the exact location of the find, so that when a DNA match is made, the victim's family will know where their loved one was found.

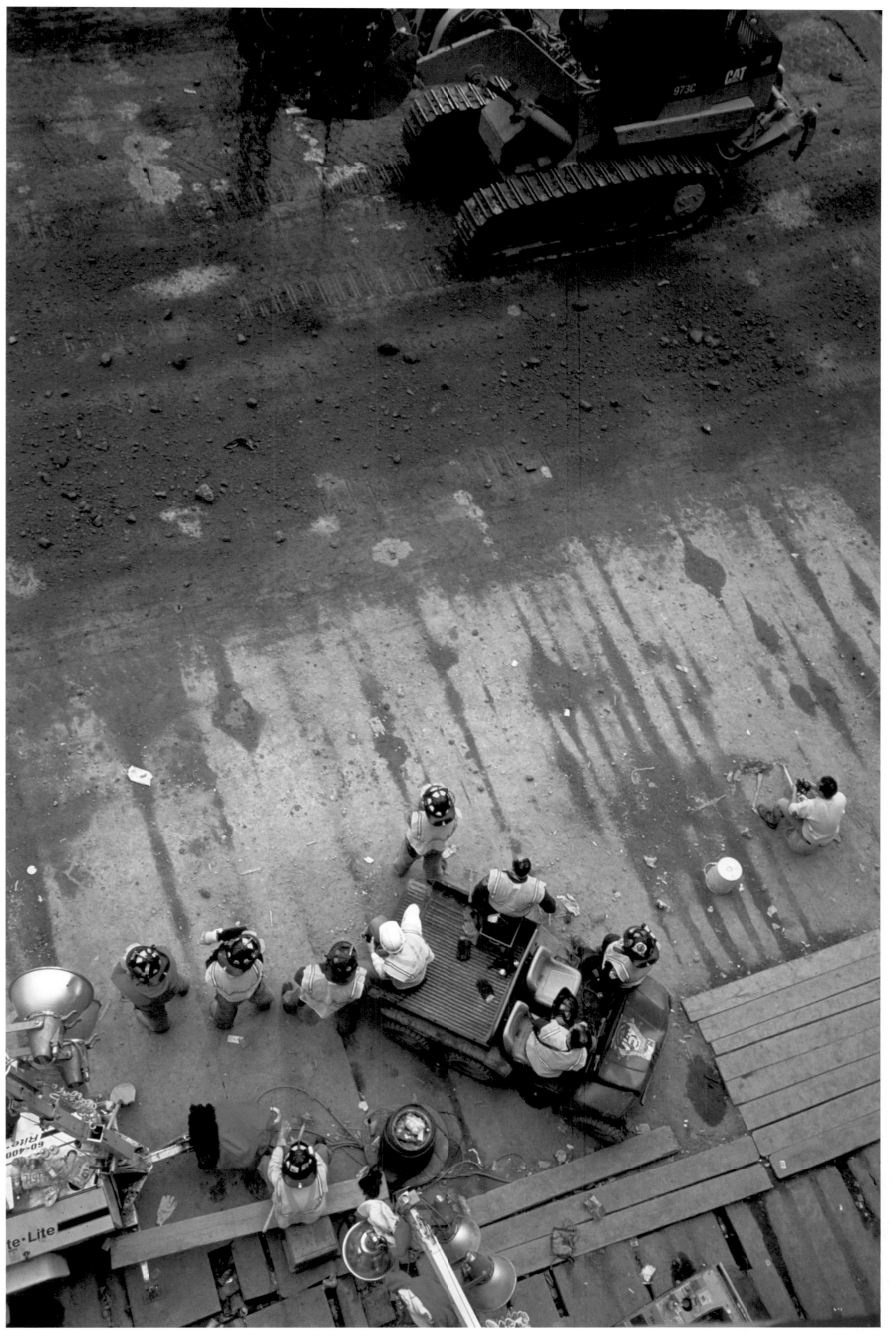

Firemen waiting for a Caterpillar to spread a raking field

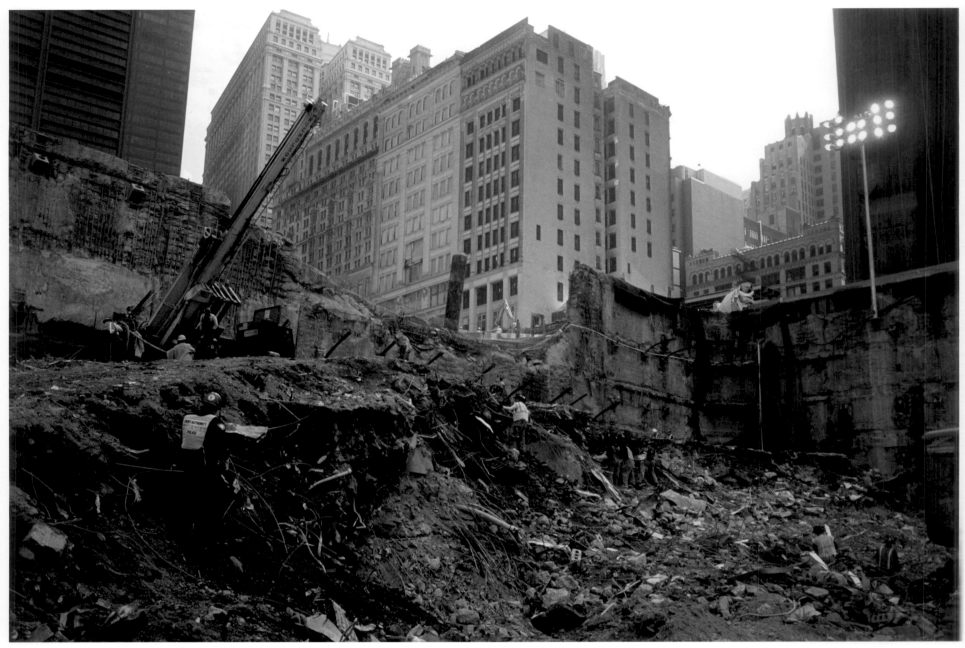

Workers digging where the Tully Road once stood

For seven months, the area known as the Tully Road, the last area of the South Tower, lay untouched beneath the feet, wheels, and treads of everything that went over it; now it had come down. Firemen were poring over it day and night in the hopes of recovering the remains that they knew must be there.

One afternoon, while I was working in that area, the fireman in the center of the photograph above called out to me and came walking down the pile holding something. "Here," he said, handing me a triangular piece of steel to which a bible had been fused in the intense heat. "You should have this." The bible had been shredded, burned, soaked in water, rolled in dirt, and buried. Now it had been recovered, and handed off on yet another journey. The page was open to Matthew 5:38 "An eye for an eye ..."

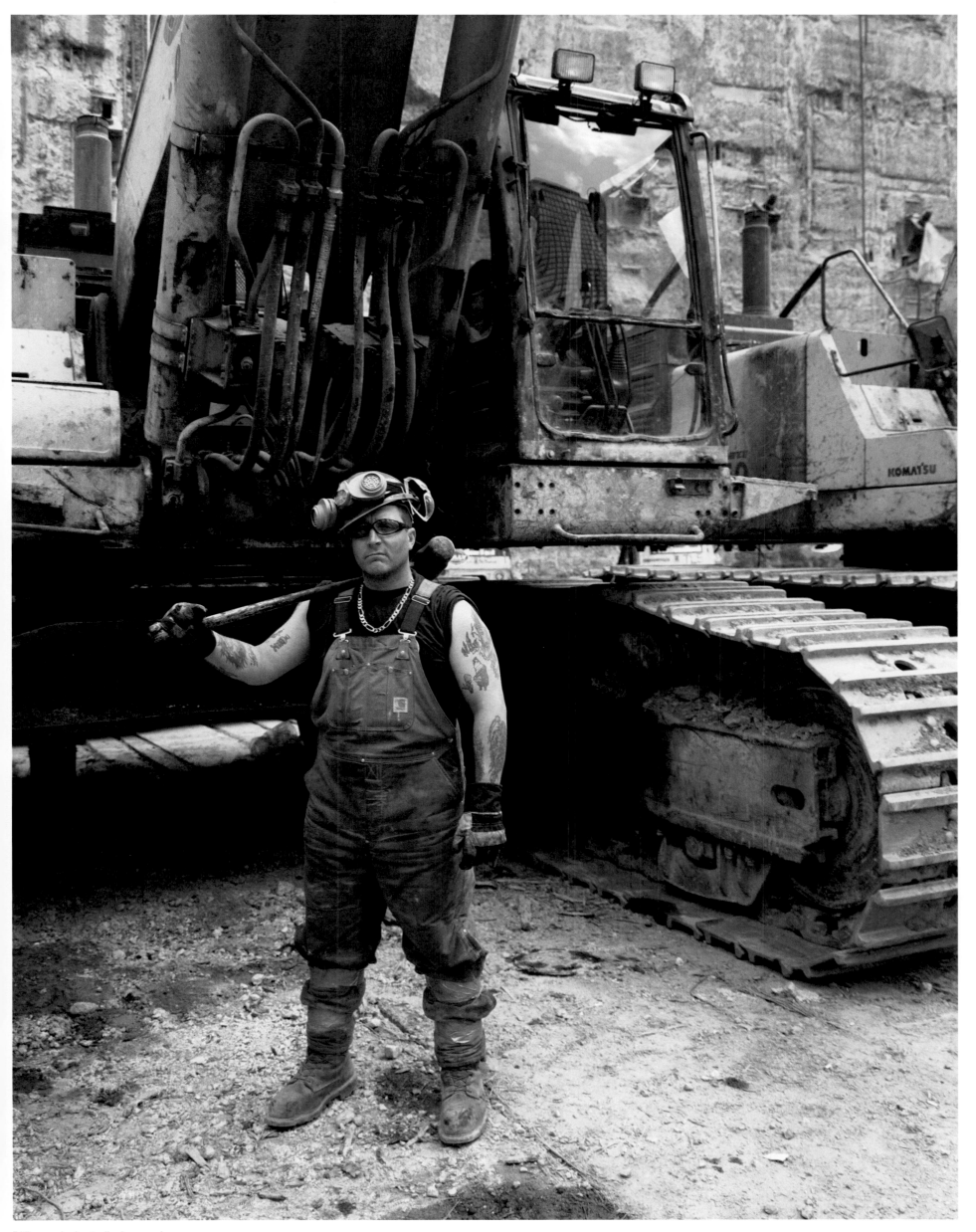

Eddie, a mechanic, standing by a grappler

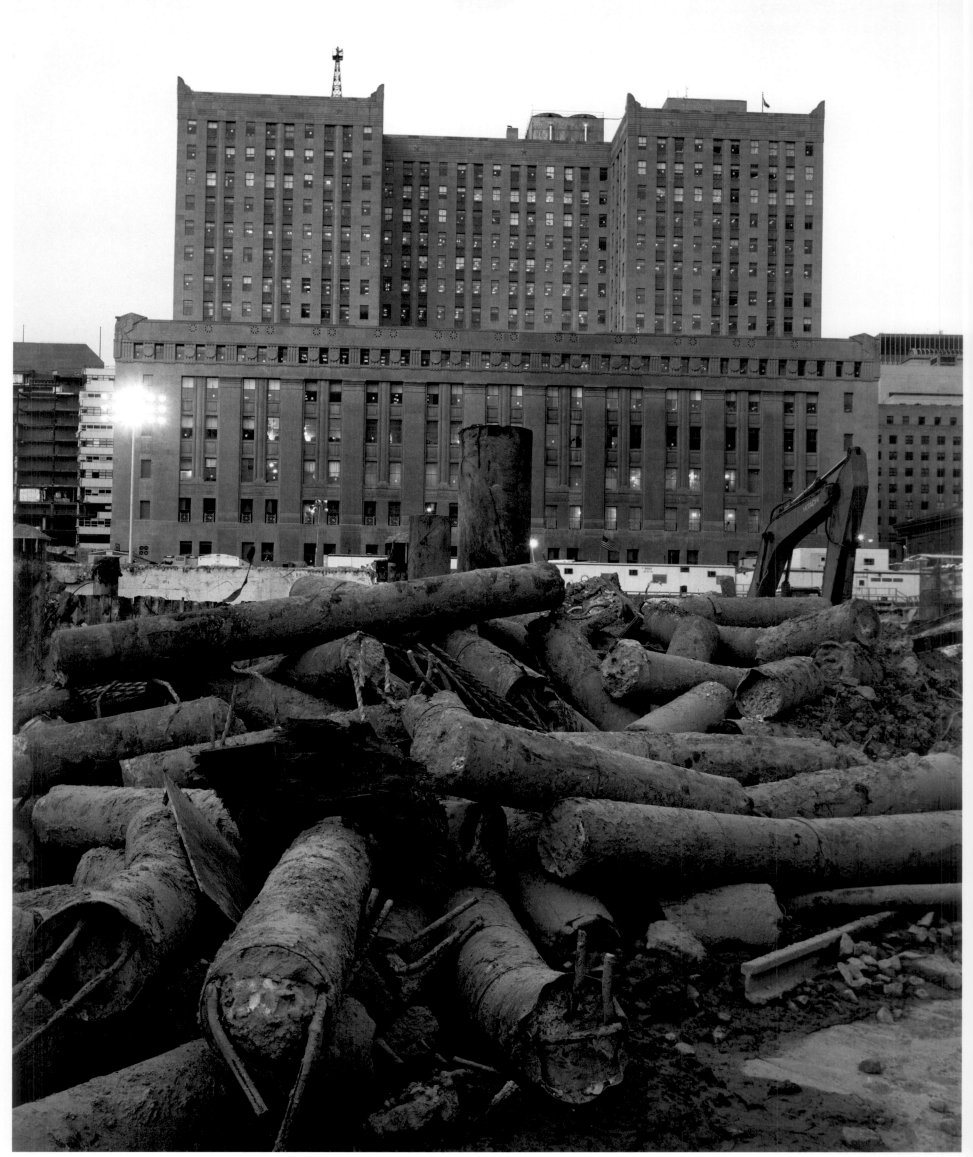

Columns from the original subway line, with the Federal Building in the background

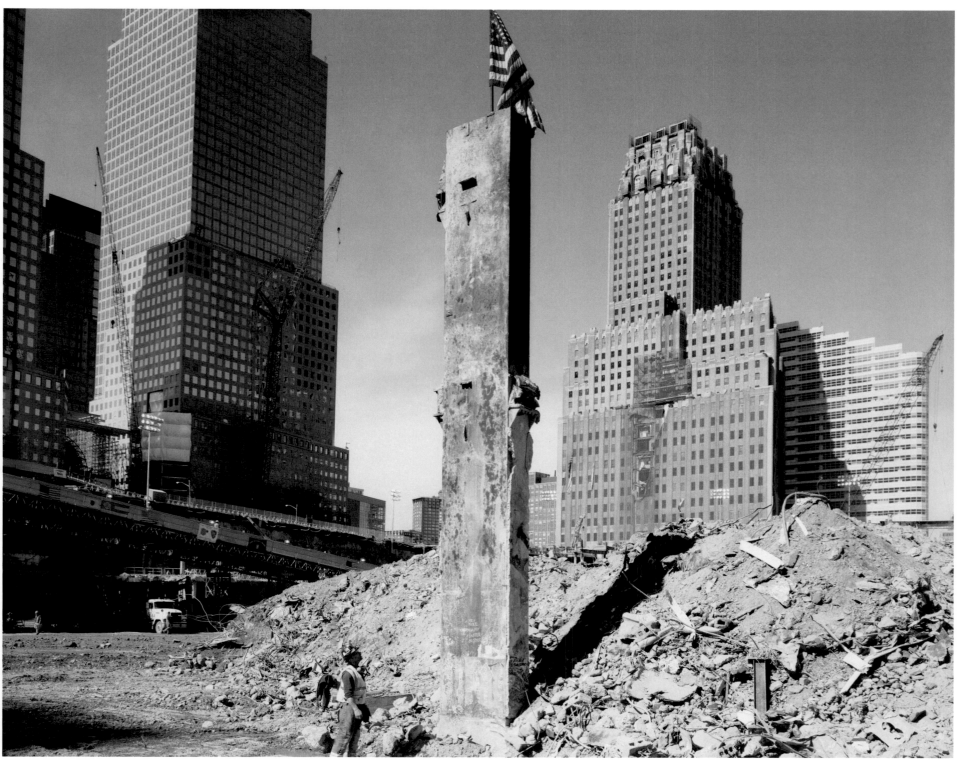

The last column

I don't know whose suggestion it was, but I know it came from a worker, emerging from the emotional experience that life or the pile produced: How about we save one column and make it the last "body" out of the site? The idea traveled around the zone, and column 1001B, from the South Tower, was chosen. There it stood, naked at first but progressively written upon and covered with photographs and mementos as the weeks passed, becoming a gathering place for impromptu ceremonies and photo ops, services and single mourners. Like a sundial in the spring light, its long shadow marked the passing of the day; soon it would mark the passing of the entire chapter of this time.

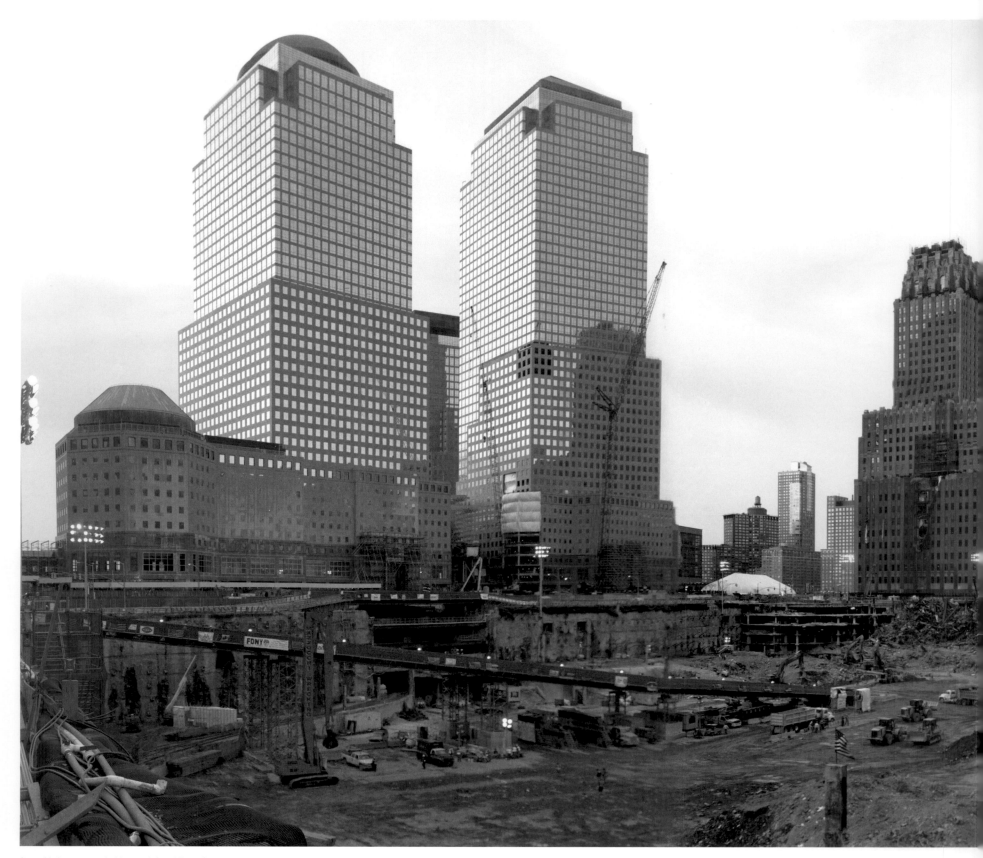

Assembled panorama, looking north from Liberty Street

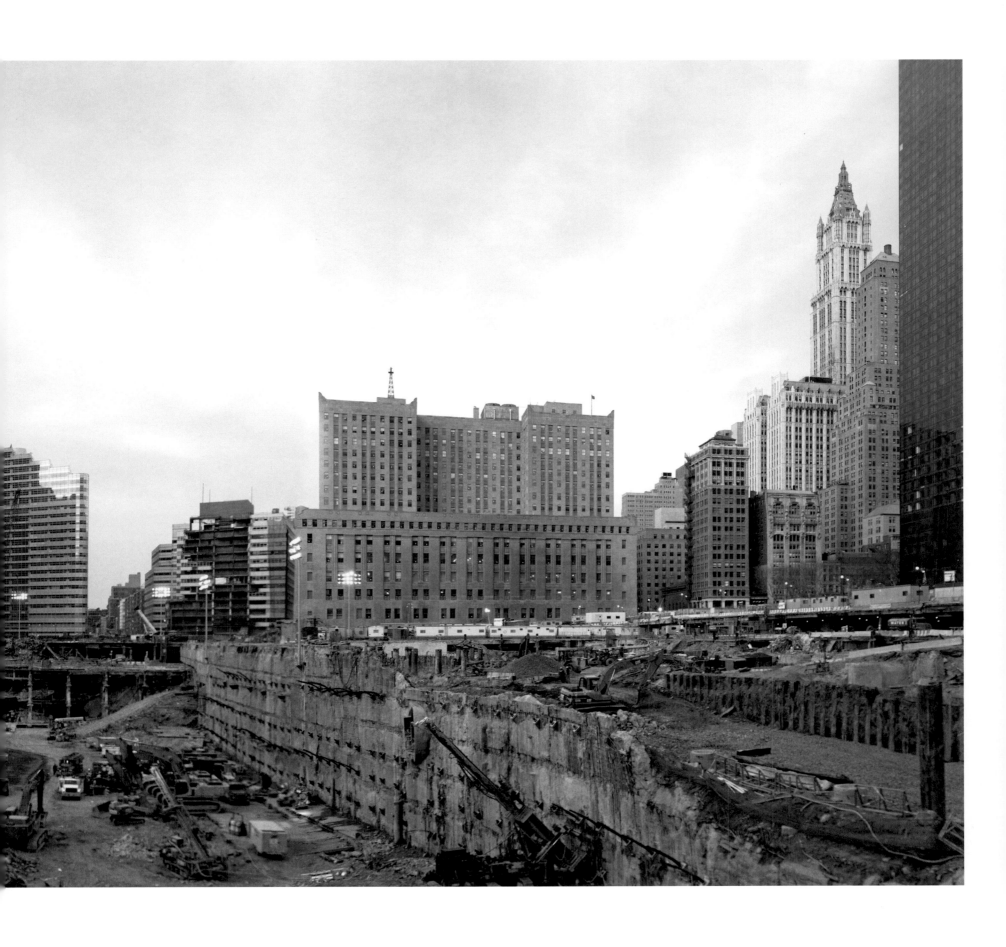

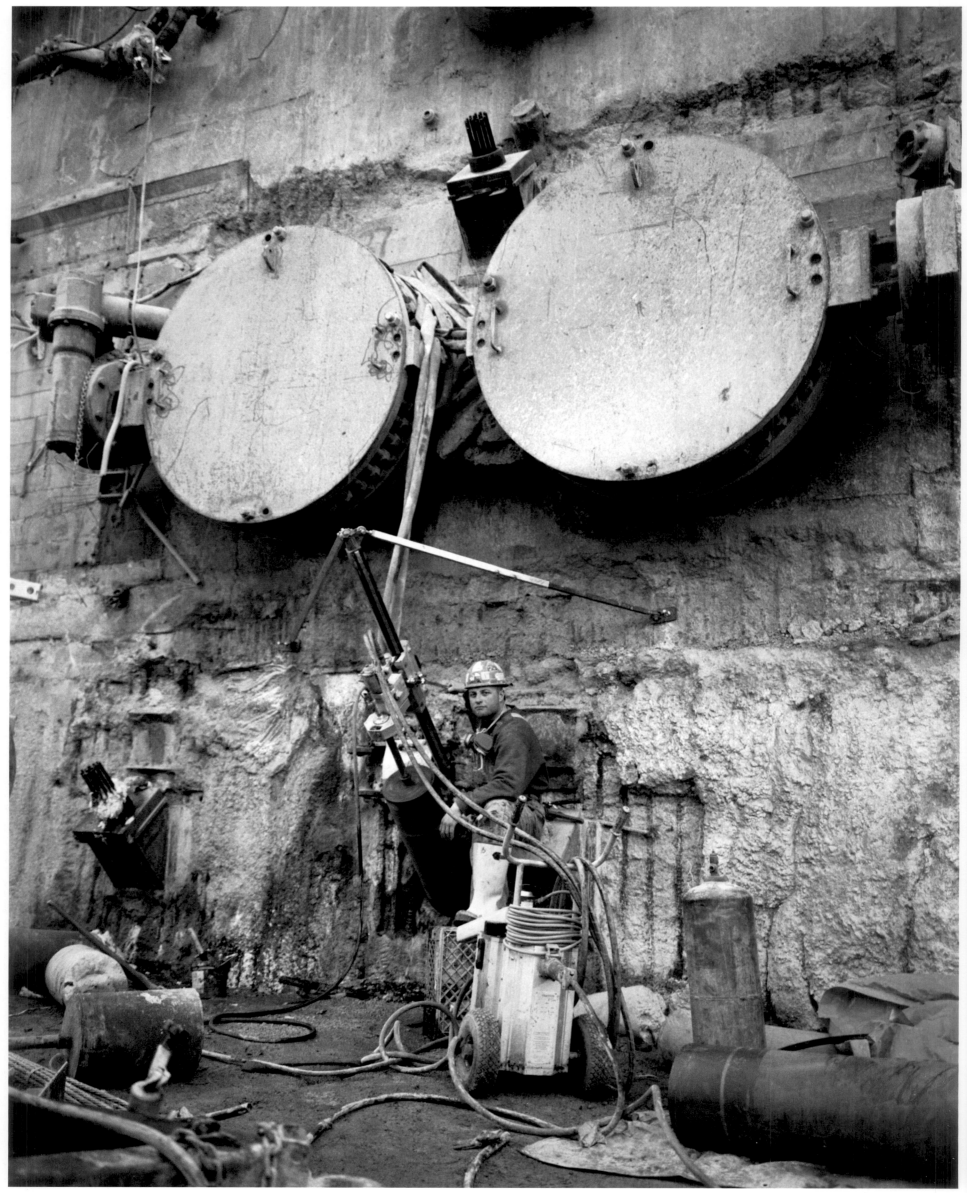

A worker drilling a tieback hole beneath water gates in the west slurry wall

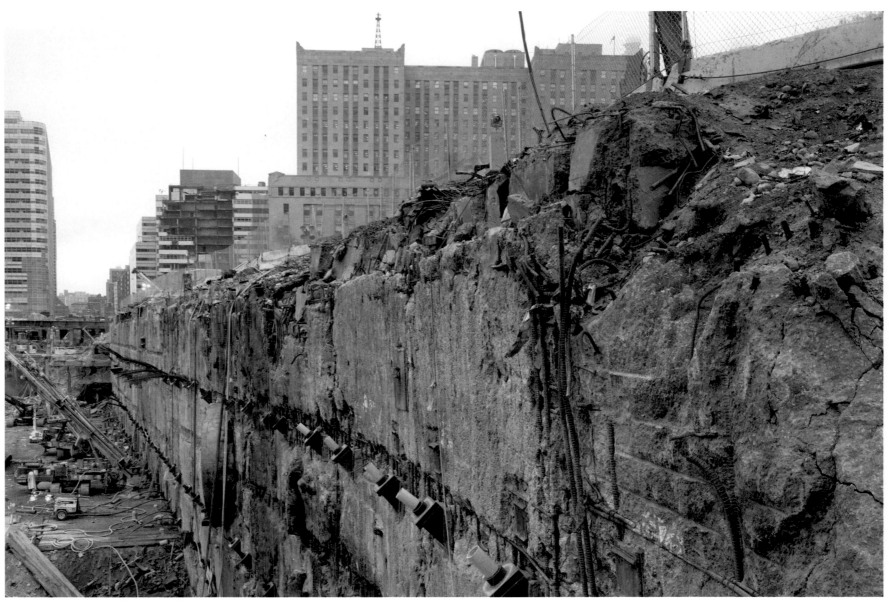

The east slurry wall

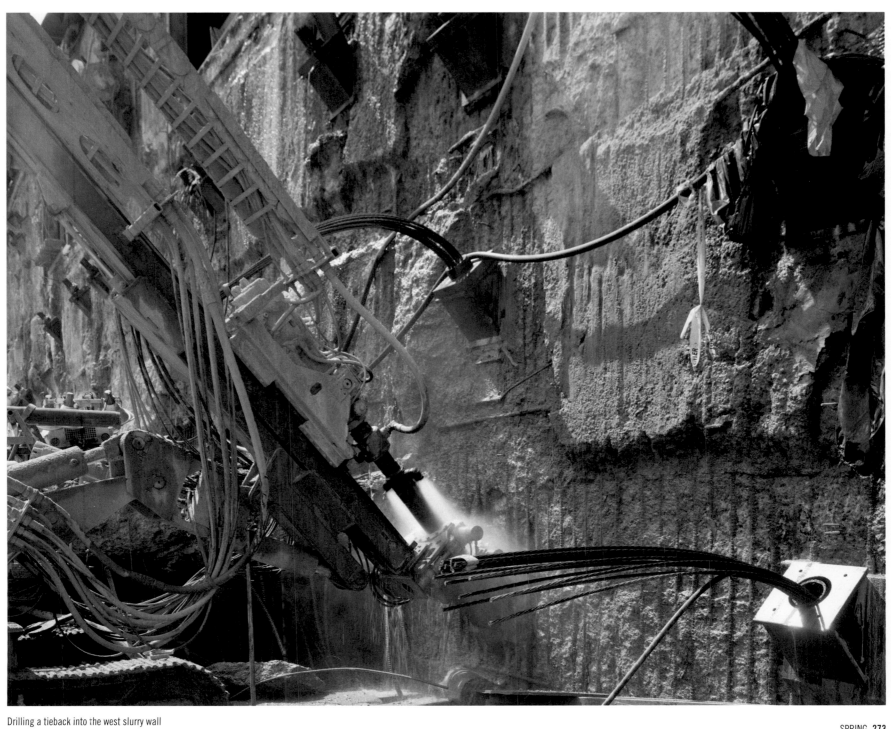

Drilling a tieback into the west slurry wall

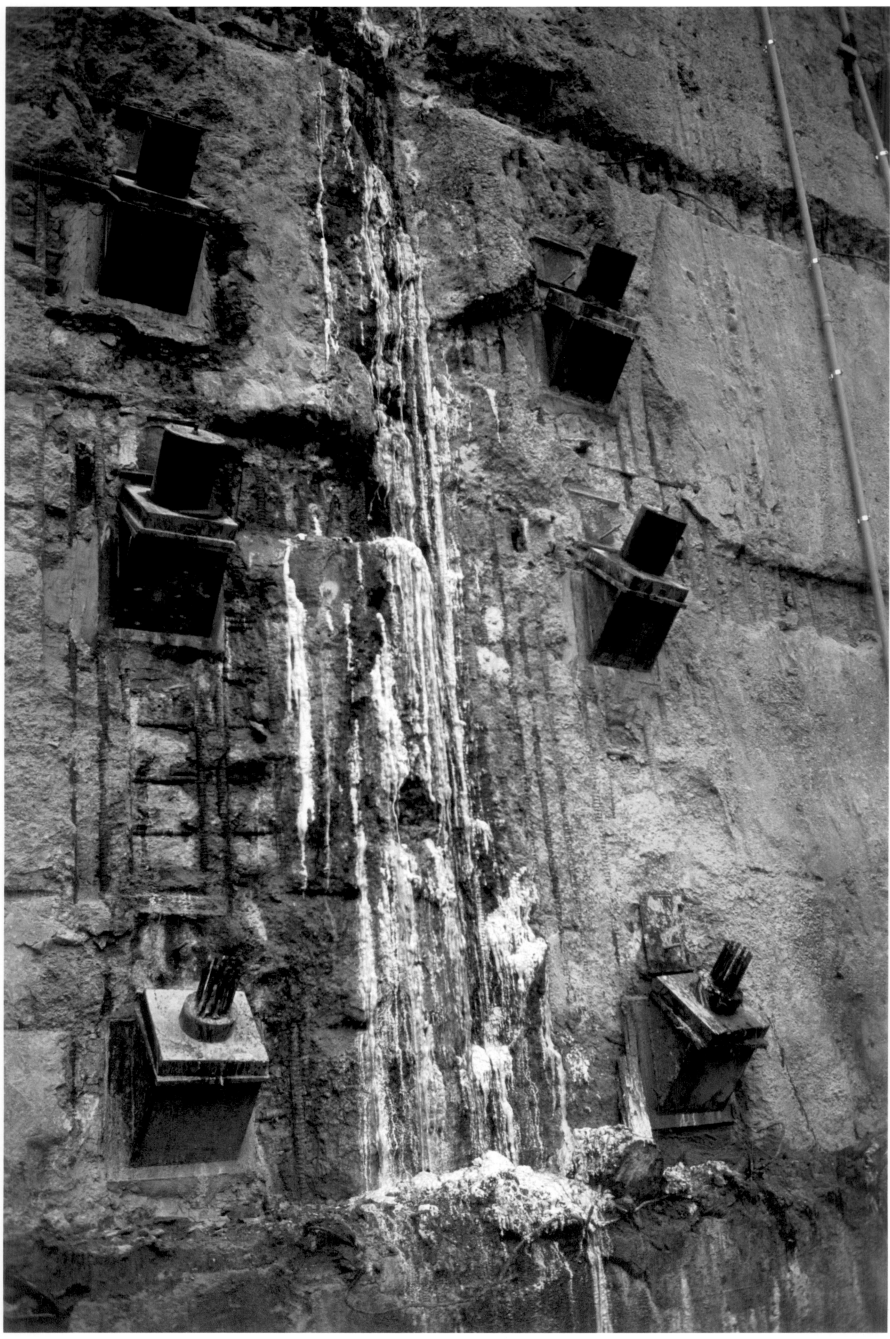

Chemical stains from leaks in the west slurry wall

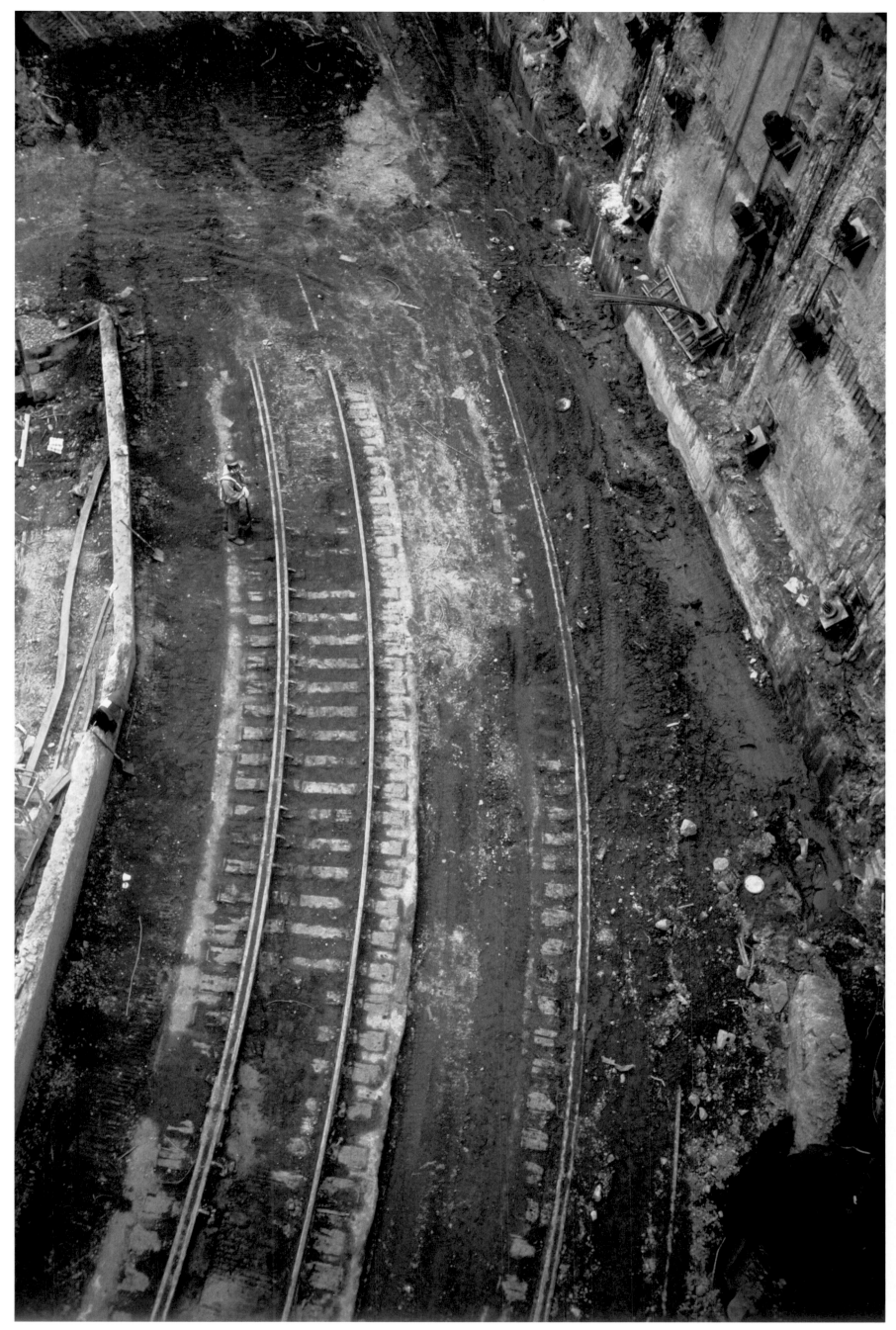

PATH train tracks along the south slurry wall

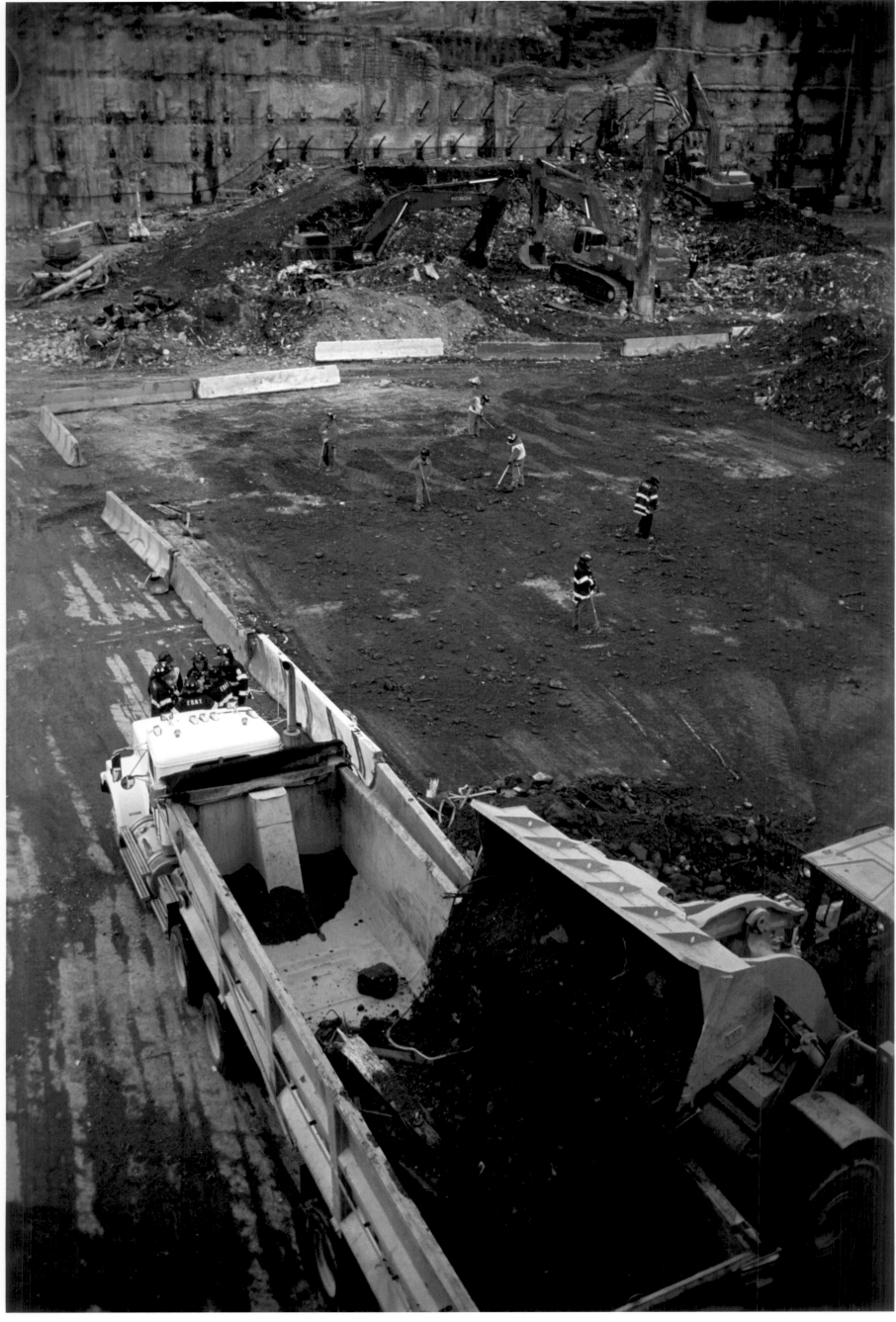

Sifted debris being removed from a raking field at the southeast end of the site

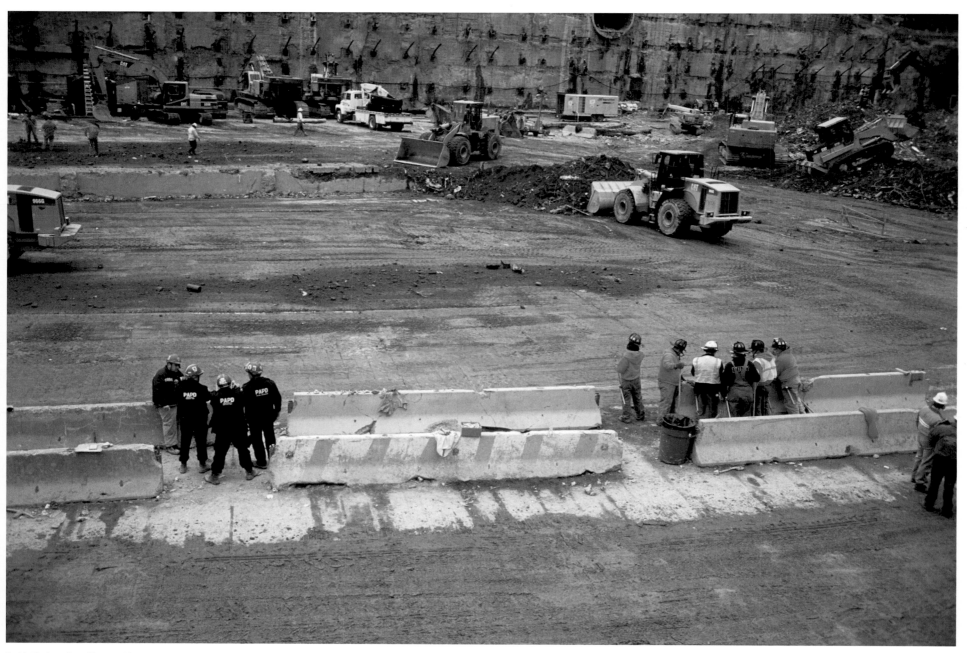

Port Authority police officers and firemen standing apart at a raking field

During the early days, the firemen, having lost the greatest number of men of all the services, were perceived to have the moral authority on the site; it seemed natural to all of us that they took the lead in the search for human remains. As the weeks passed, however, this power imbalance naturally produced tensions between the uniformed services. Then, when Mayor Giuliani reduced the numbers of recovery workers in early November, these tensions flared up, and the conflict served to make the rivalries more volatile. Here, seven months after the event, I was reminded again how deep the division was.

05.01

The site was nearly empty. The slurry wall was visible all the way around. The last column stood fully exposed, the PATH train tracks were now visible, and the raking fields were clearly laid out, easily handling the steady stream of debris from the few active areas of the site. Beyond the eastern edge of the slurry wall, toward Church Street, the subway was being rebuilt and the clean-up continued in the southernmost part. The northern end, toward Vesey Street, a warren of equipment yards and trailers, was the center of operations for the management of the site.

An aura of peace had settled over the place as everyone knew that the work was soon drawing to a close. With that knowledge came a feeling of nostalgia. Perhaps the emptiness brought it out. At times it seemed striking that two million tons of debris had disappeared—and, with it, the reason for us being there. People talked about the early days: the pile, the excitement of the group effort, the coming together. That was the big thing, of course—how we had come together. Those who felt driven by a need to help had found their way in and become part of a community.

In the beginning, when seen from afar, workers in the zone had looked like a colony of ants busily scouring a hill and cleansing it. Now, however, people were no longer diminished by the mountain of debris; they were singular, specific, their individuality clearly defined. There seemed to be more time now to stop and visit with one another—even as our time was running out. More time for me to make portraits, listen to stories, and talk about the future. In the early days, no one talked about the future; the present had been so enormous.

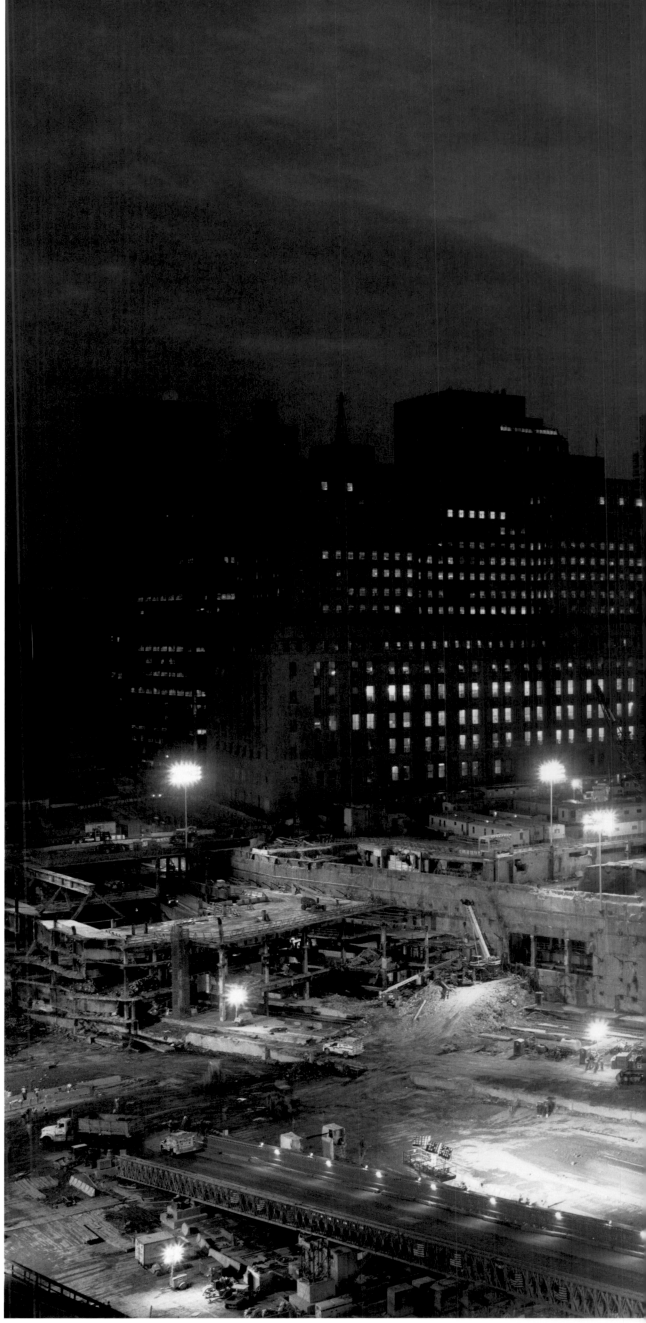

The site at dusk, seen from the World Financial Center

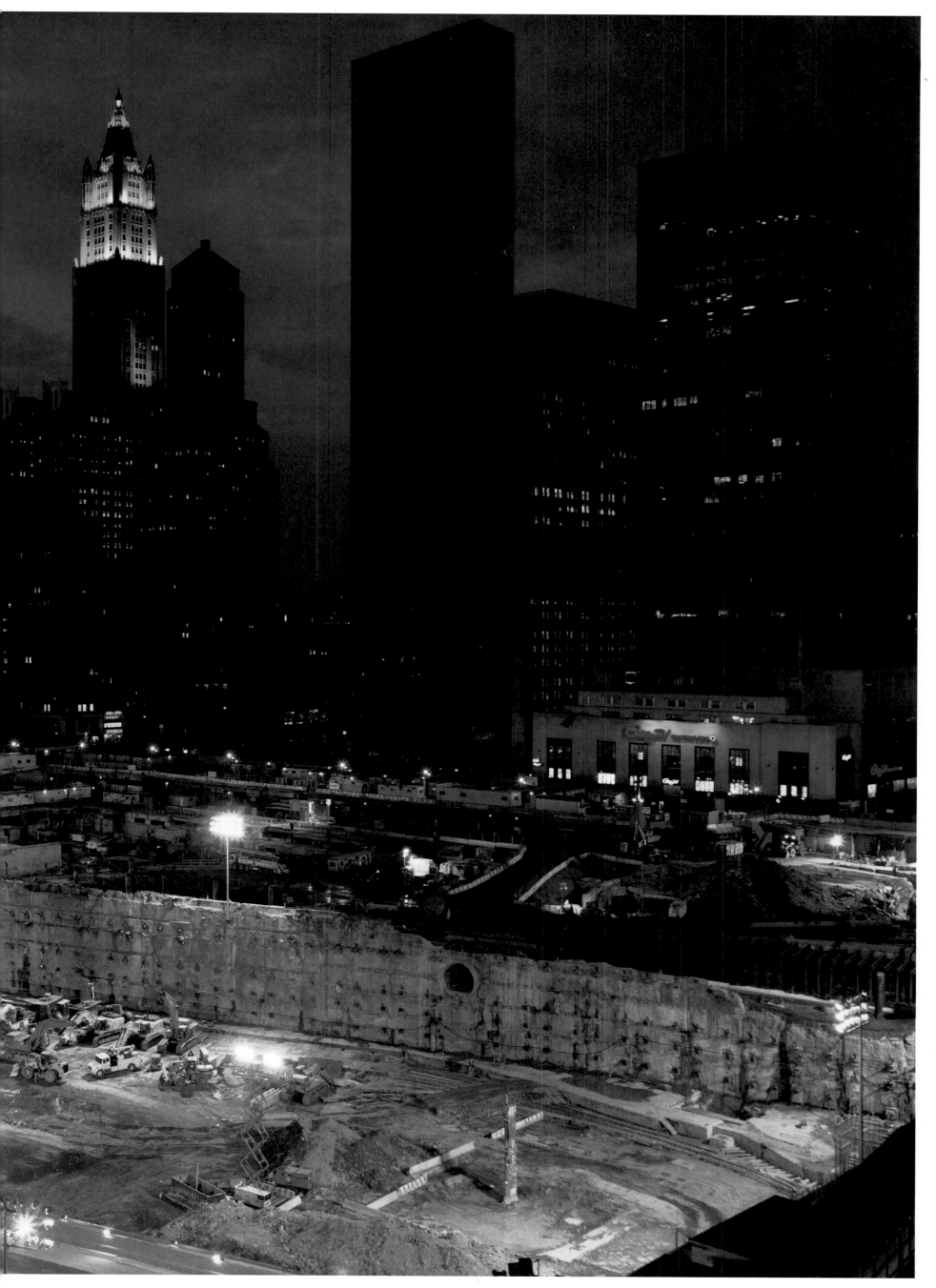

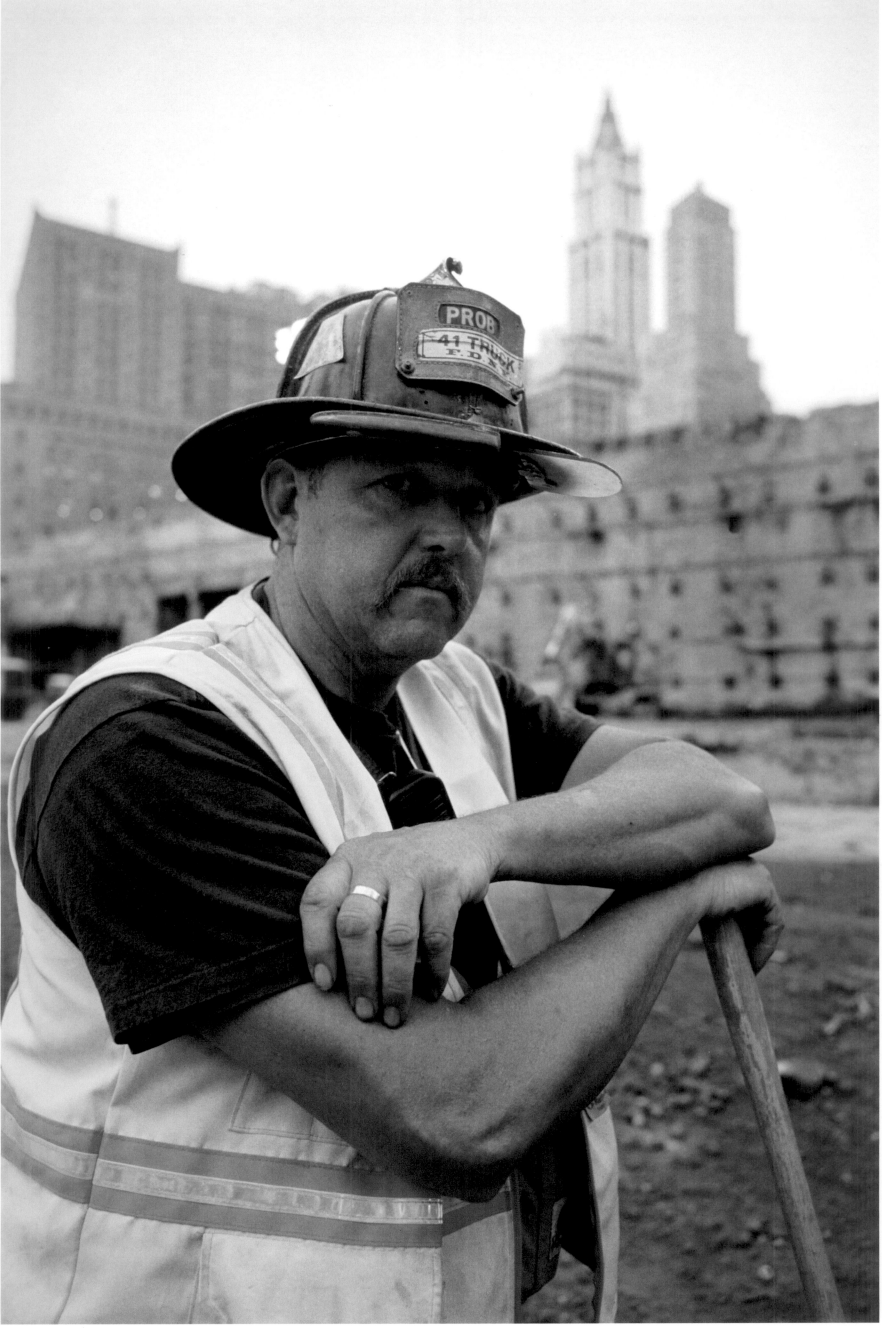

Toolie O'Toole, standing in a raking field

A raking field

The bulldozer had finished spreading a thin layer of rubble over the raking field just as the shift changed at five o'clock. The field lay undisturbed. I stood at its southern end and just took it in—nondescript bits of concrete and dirt, sticks and metal shards. Could I make a photograph of this? Would it mean anything? As I looked at the upside-down image on the ground-glass back of my view camera, I saw a pair of feet enter the top of the frame and steadily grow into the full figure of a man who stooped to pick up a fallen rake lying there. Then he crossed the field, dragging the rake over the rubble. I watched him as he made his way out of the frame. When I left the camera and caught up with him, he introduced himself as Toolie O'Toole and told me he was on his way home, having raked all day. I asked him why he'd stopped to pick up the rake when his day was over, but he just gave an easy shrug in reply, as if to say: "Just a reflex," or "Can't help myself." I mentioned to him how affecting I now found it to observe the act of raking—how that simple, seemingly ancient and eternal gesture, performed by so many people for so many months, had become emblematic of the work on the site for me. He nodded as I spoke. "That's us," he said. "We're gardeners in the garden of the dead."

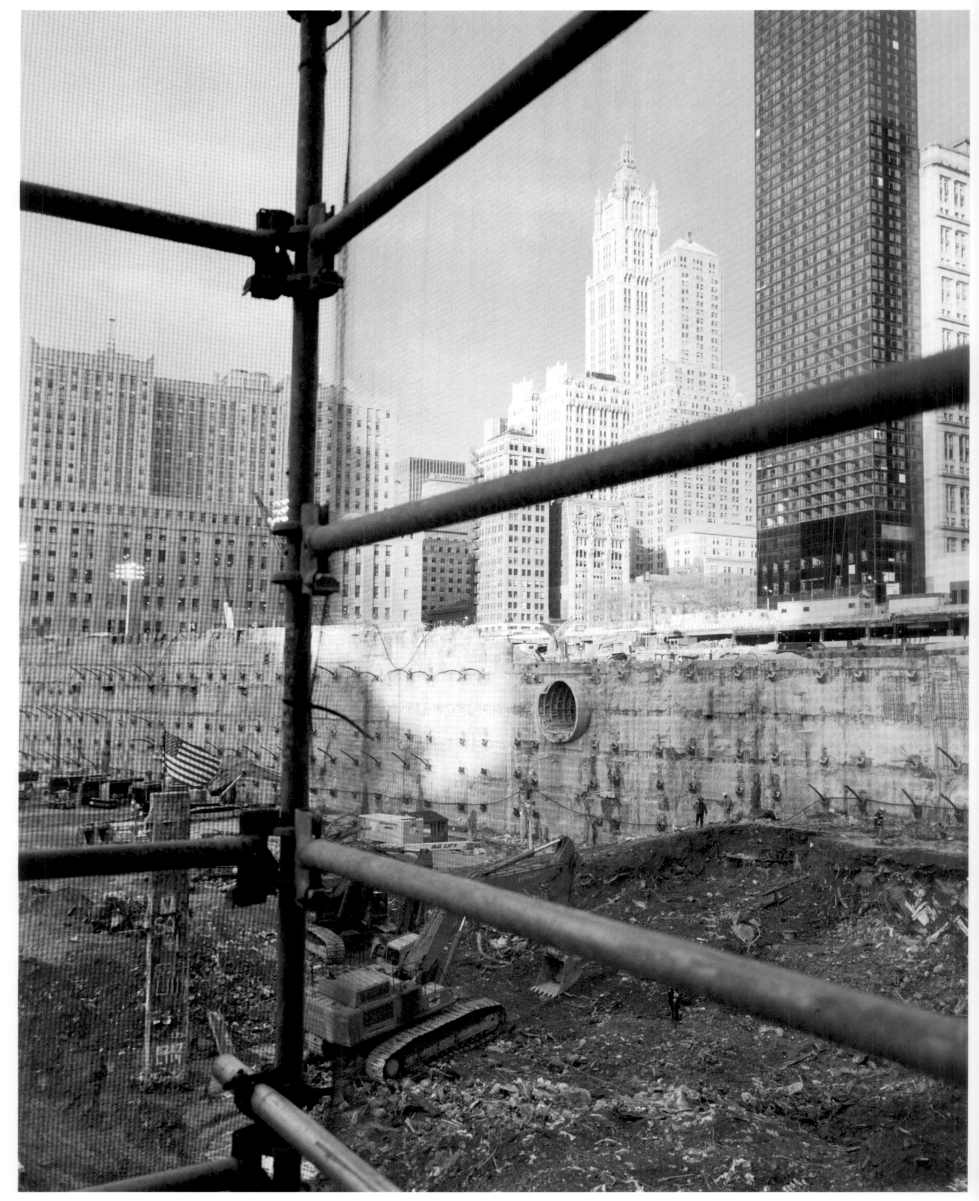

Looking northeast from inside a temporary stairwell

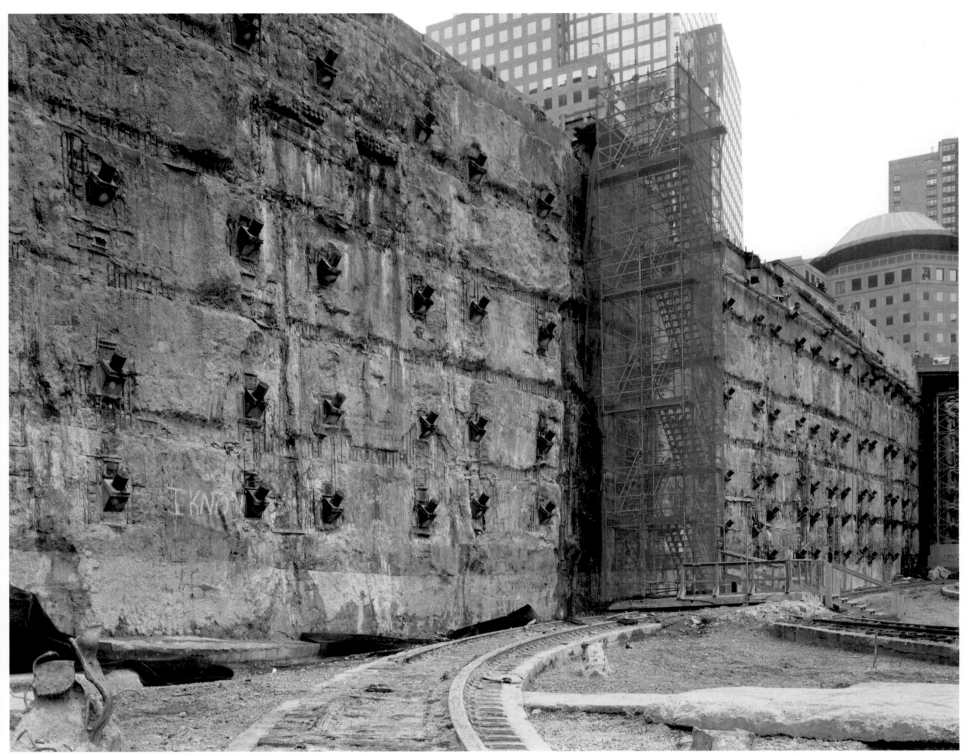

The south slurry wall and PATH train tracks

I walked and photographed every inch of Ground Zero over and over again as it was transformed from a huge pile into a vast, empty pit. Among the revelations emerging from the site was an altered sense of scale: human scale, city scale, and—not least—nature's scale and its fractured and fitful relationship to architecture.

In the early months, I assumed that nothing could be more moving than the towering ruins of the buildings themselves, but their removal ultimately revealed the power of empty space. The bathtub was the inanimate hero of the disaster. One of the great engineering marvels of the world, it not only withstood the incalculable force of the collapse but also managed—under the assault—not to give way and let the Hudson River flood Lower Manhattan. Walking down into it revealed a power similar to that of standing at the pyramids. Every day I spent down there, I felt the majesty of those walls, with the city behind them soaring into the sky above. The space seemed to breathe, as manmade and natural wonders do, drawing us toward awe and contemplation.

This was a totally new space for the city to have in its midst—a truly sacred space, purified by loss, below sea level yet open to the sky. Walking down into the pit reminded me of visiting Maya Lin's Vietnam Veterans Memorial in Washington, DC. As we descend below ground, the names mount up and we walk among the spirits of the dead; at the same time, we are out in the open and feel uplifted by that experience. Of course, the bathtub was never meant to be seen, buried as it was behind garages, stations, malls, and service areas. But after all that had been stripped away by catastrophe, its massive walls still stood—our Parthenon, our Stonehenge. That spring, it felt to me like a new kind of public space—commemorative yet liberating—where human scale had its appropriate dimension.

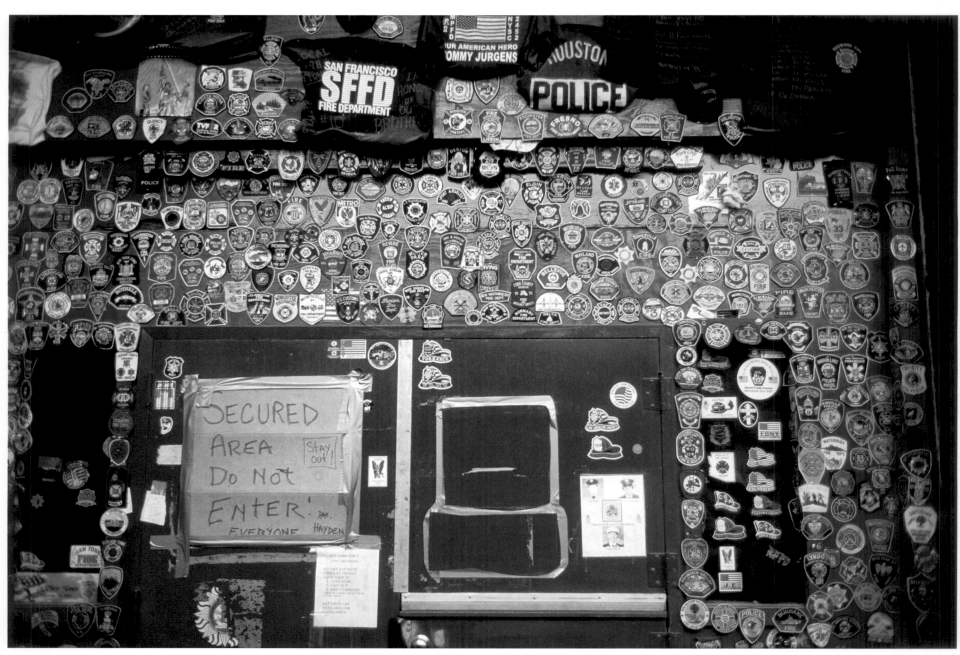

Collection of patches on Firehouse 10

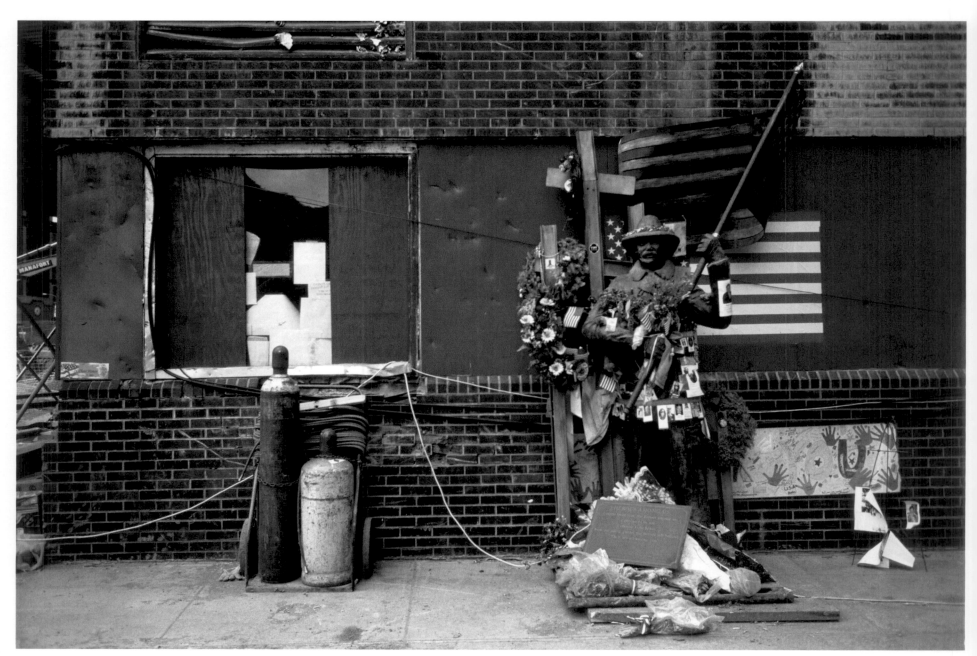

The donated statue outside Firehouse 10 on Liberty Street, now adorned with flowers and mementos

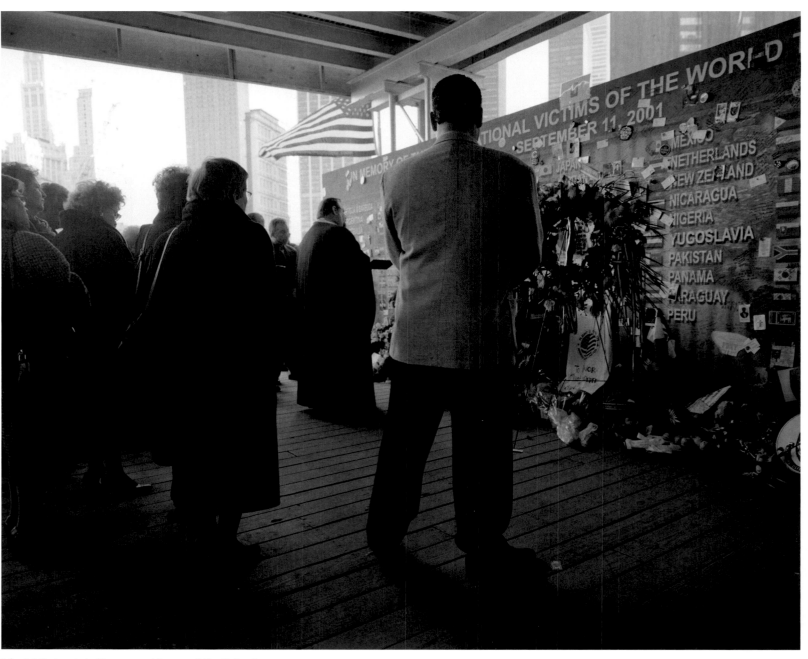

A Greek Orthodox priest with mourners at the memorial inside the site

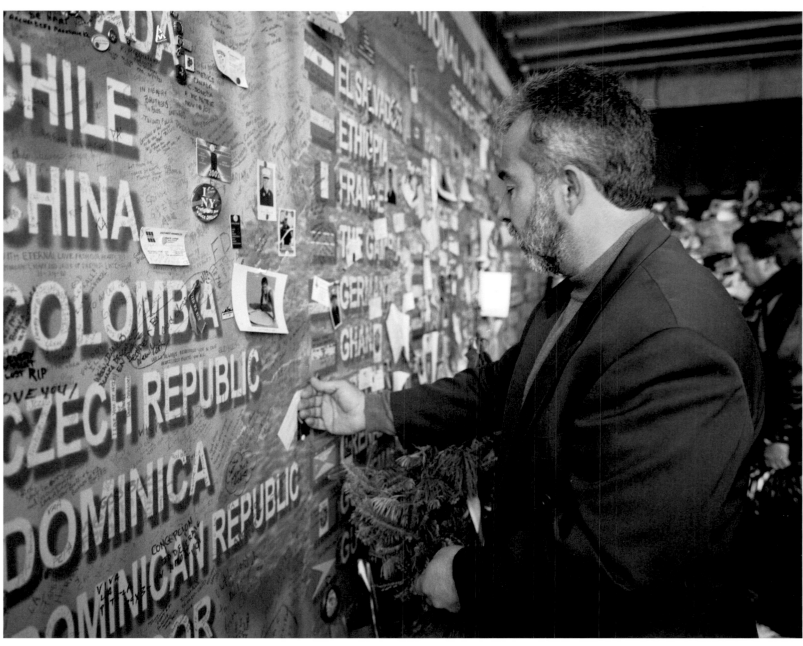

A wall near the South Bridge representing all the nations that lost citizens on September 11th. This man
placed a small photograph of his relative there, and, weeping, gently brushed it goodbye.

The back of the Bankers Trust Building on Albany Street

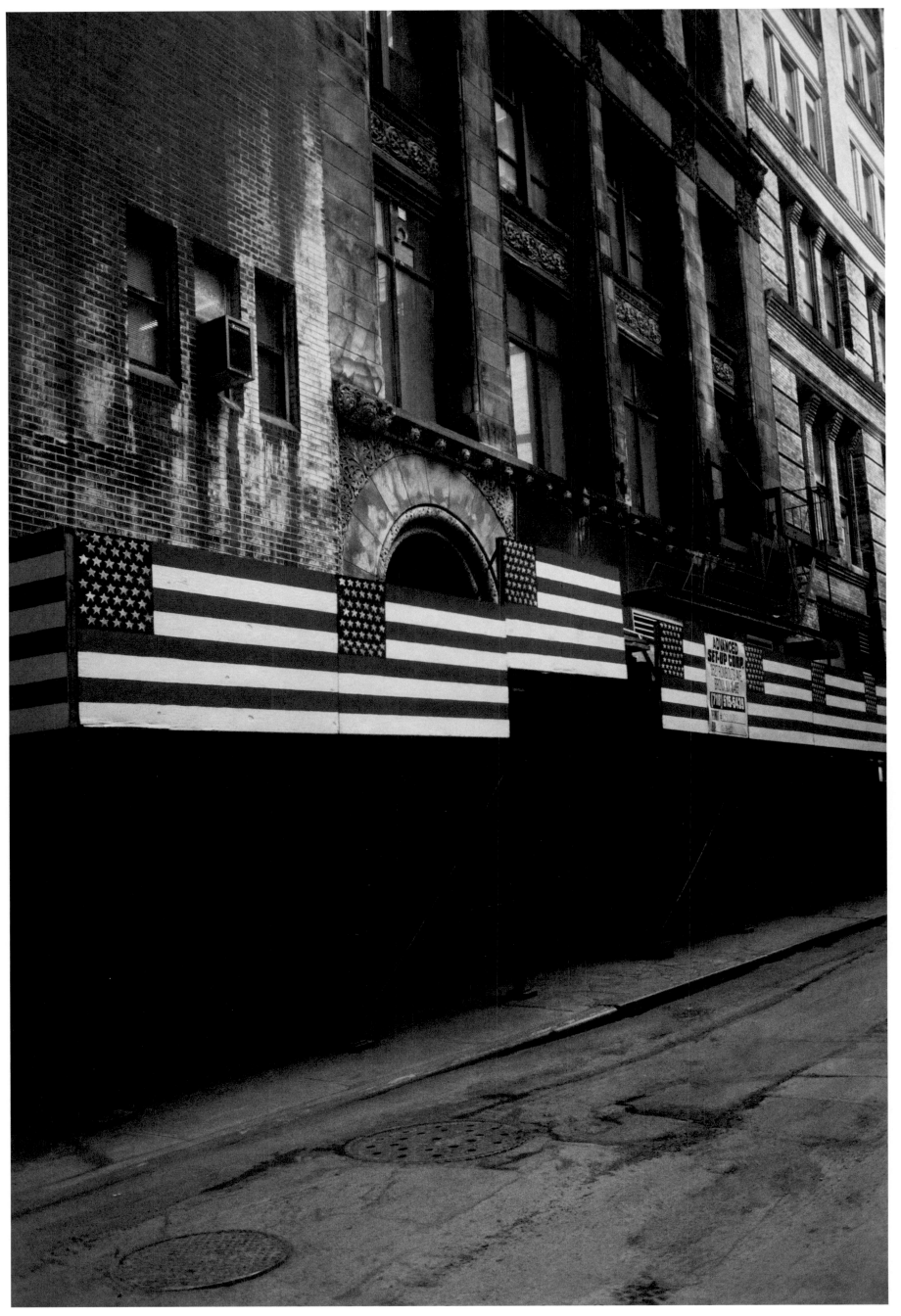

Flags painted on scaffolding along Cedar Street

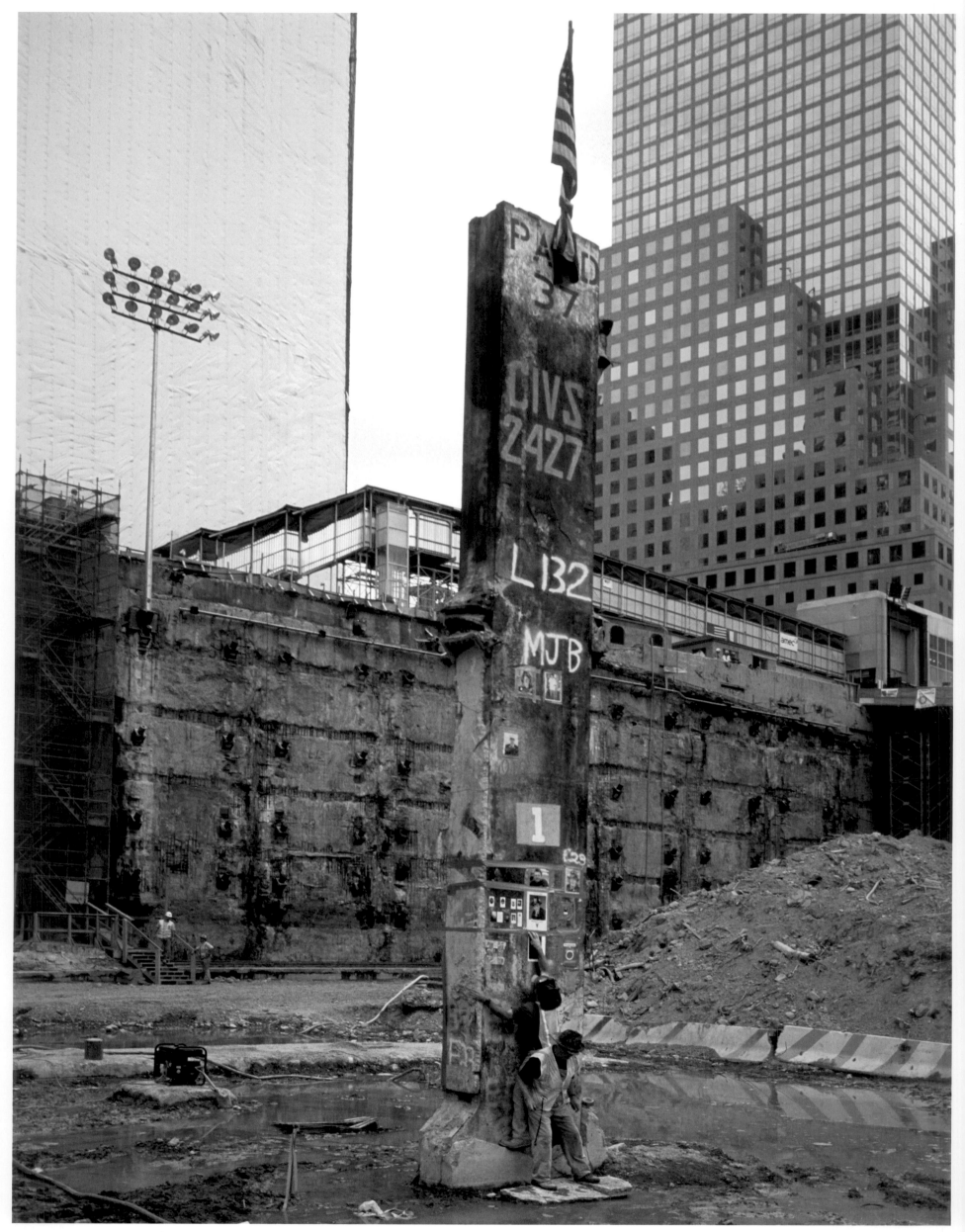

Paul and Ralph Geidel, father and son, putting a photograph of Ralph's missing brother, Gary, on the last column

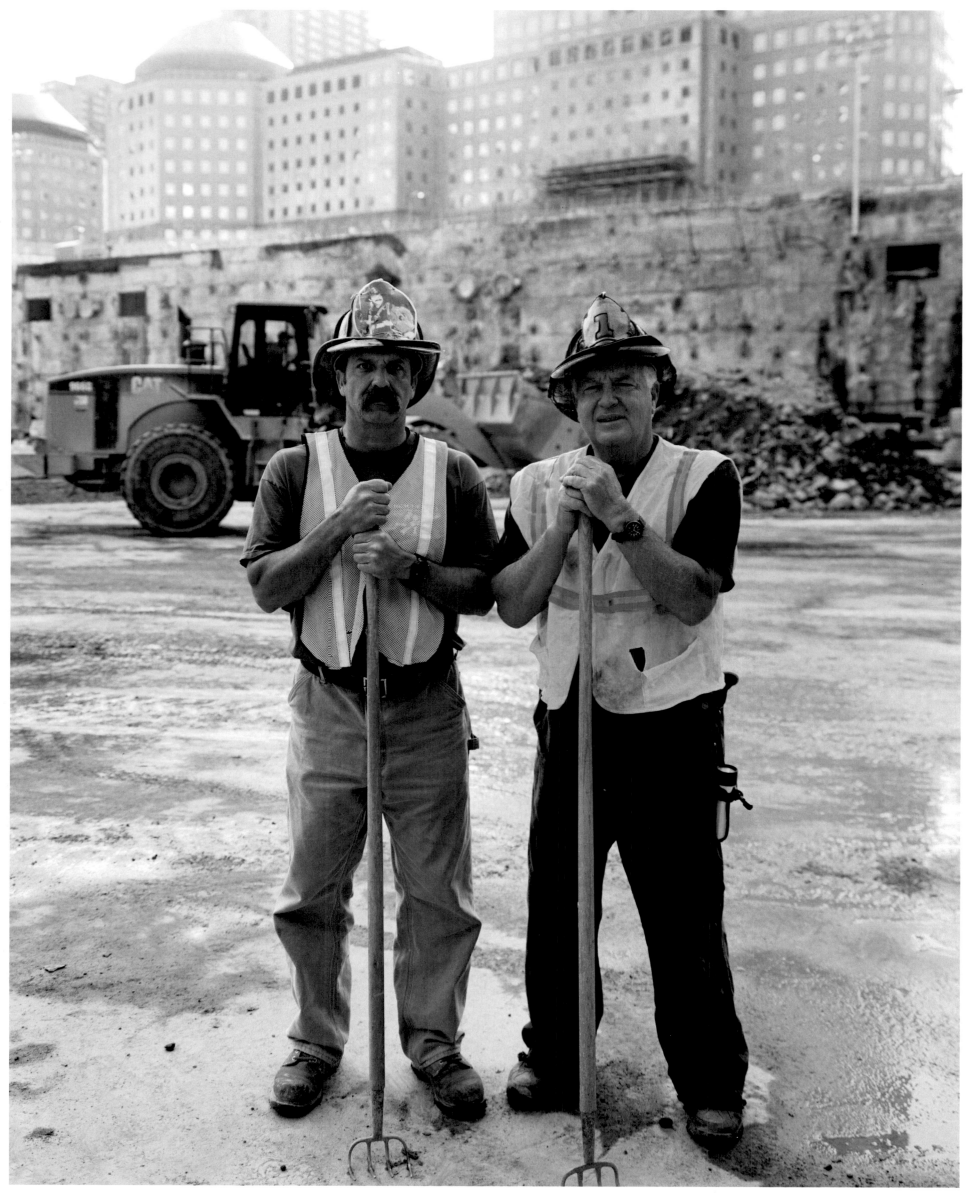

Ralph and Paul Geidel waiting for a fresh raking field

I was easily a hundred yards away when I saw two figures joined together at the base of the last column. Shouldering my big camera, I humped my equipment as fast as I could around the puddles and over the mounds of dirt, and got there quickly enough to capture what was happening: two men were struggling to ga n a purchase on the column's sheer face. The older one squatted with his back to the steel while the younger, a photograph in his outstretched hand, was pressed against the column, half-sitting on the other man's back. Slowly the man pushed out of the squat and lifted the other high enough up on the column for him to tape the photograph ten feet above the ground.

When they ceased their labors, I went to meet them and hear their story. Paul Geidel and his son Ralph (The Raven) had attached the photograph of Gary, Ralph's lost brother, to the column. For eight months they had been part of the recovery crew working the site.

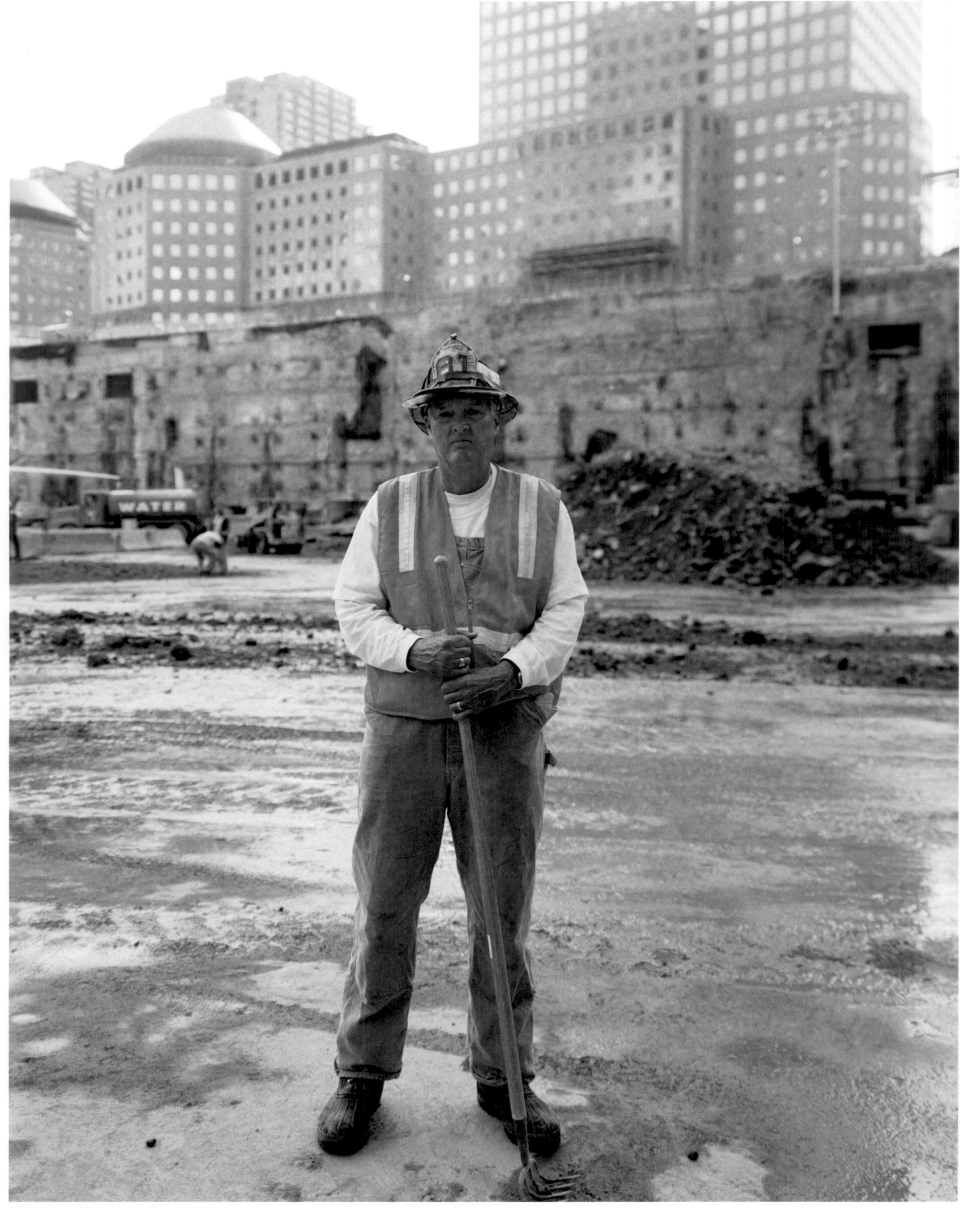

Retired Lieutenant George Reilly, a worker on the raking fields, searching for his missing son

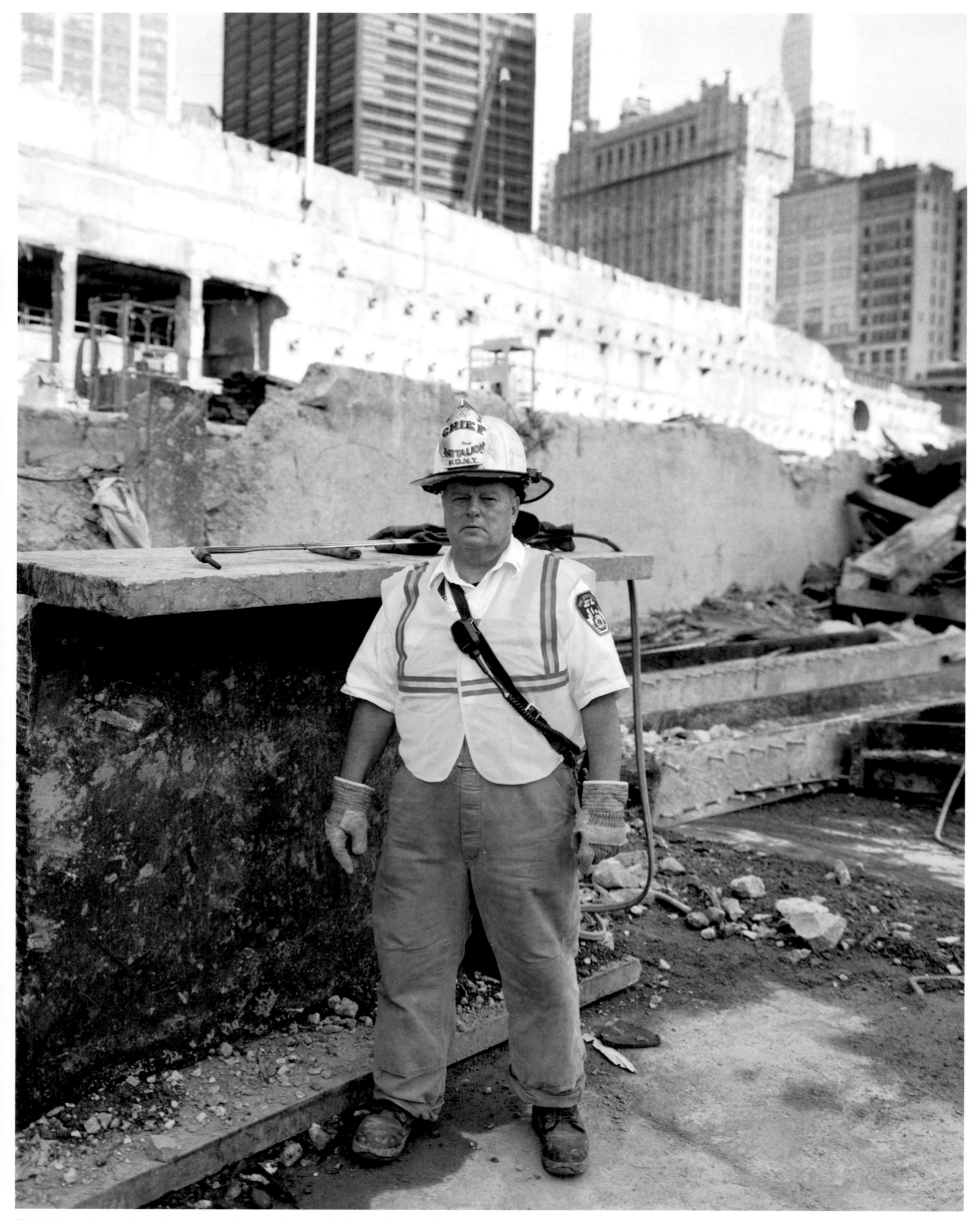

FDNY Chief Howard Carlson said to me, "I'm worried about these guys. They've worked so hard on this and now it's almost over, and they're going to feel the loneliness when they're on their own. I worry that they'll turn to drink."

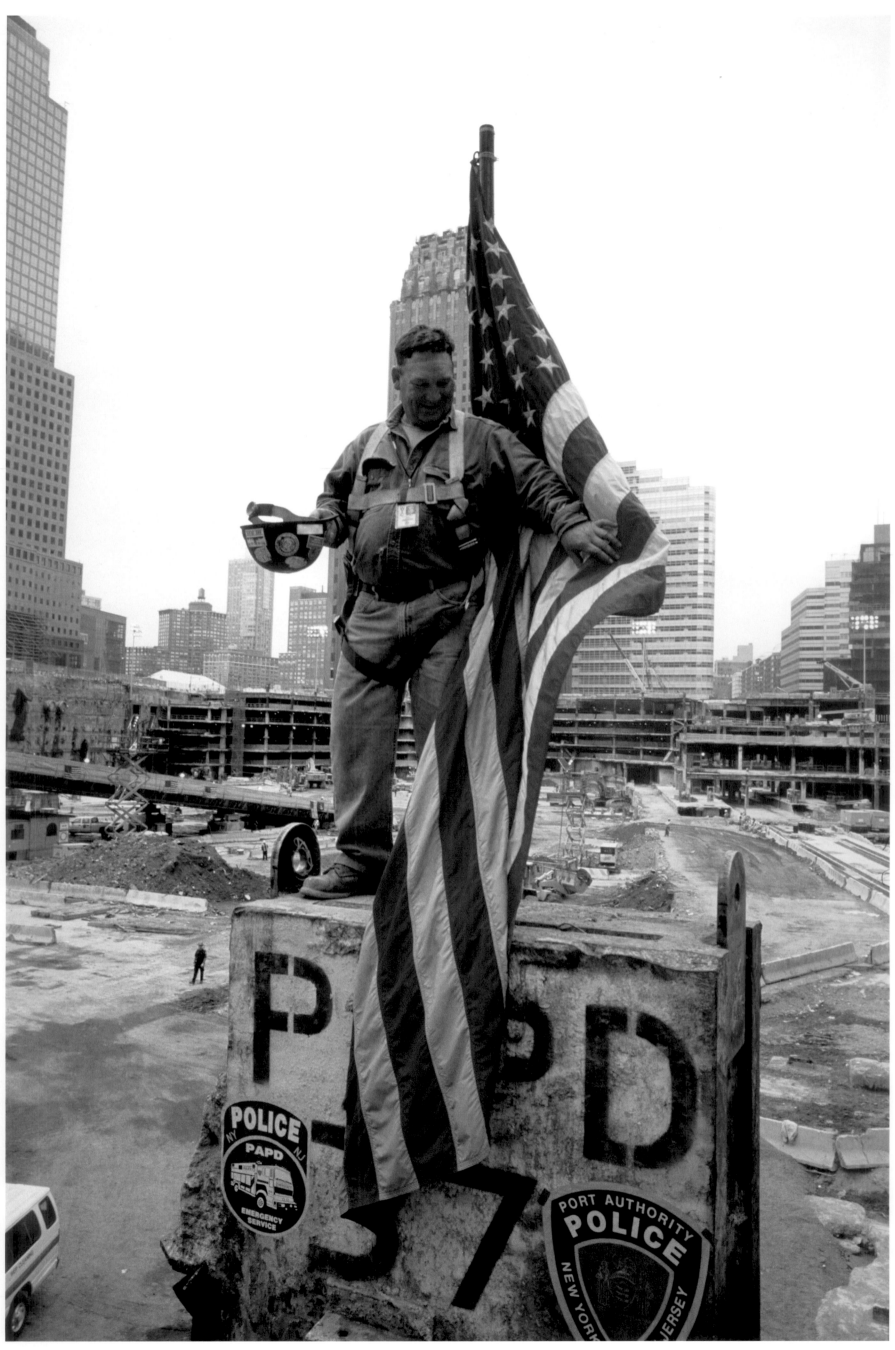

Willie Quinlan, an ironworker, on top of the last column

When I asked her about herself she offered, charmingly, that she was Ivonne Sanchez, Miss September in the Emergency Medical Services calendar

An ironworker

A security worker

A fireman on a raking field

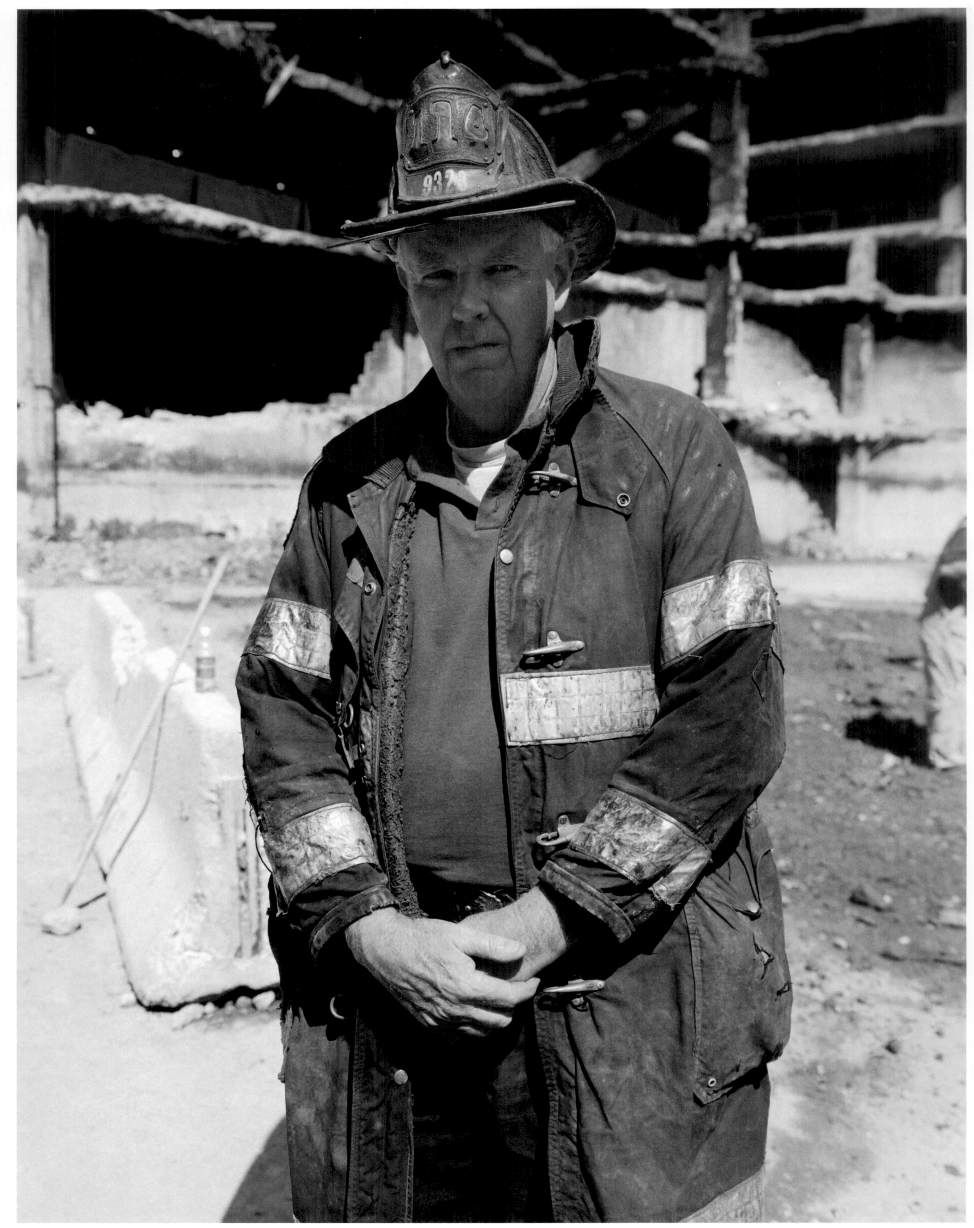

Retired Lieutenant Baudon Malmbeck, resting near a raking field

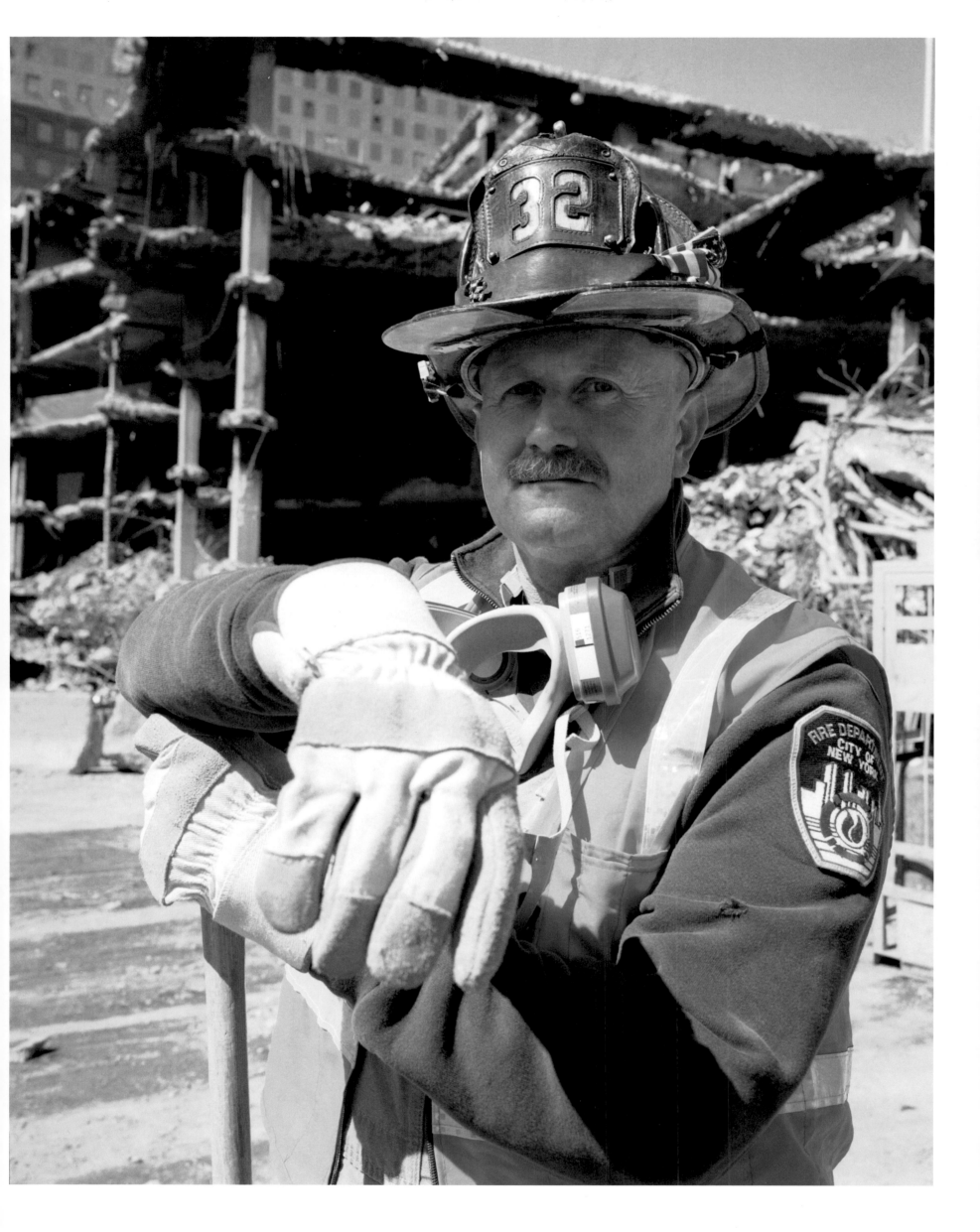

A fireman in a raking field

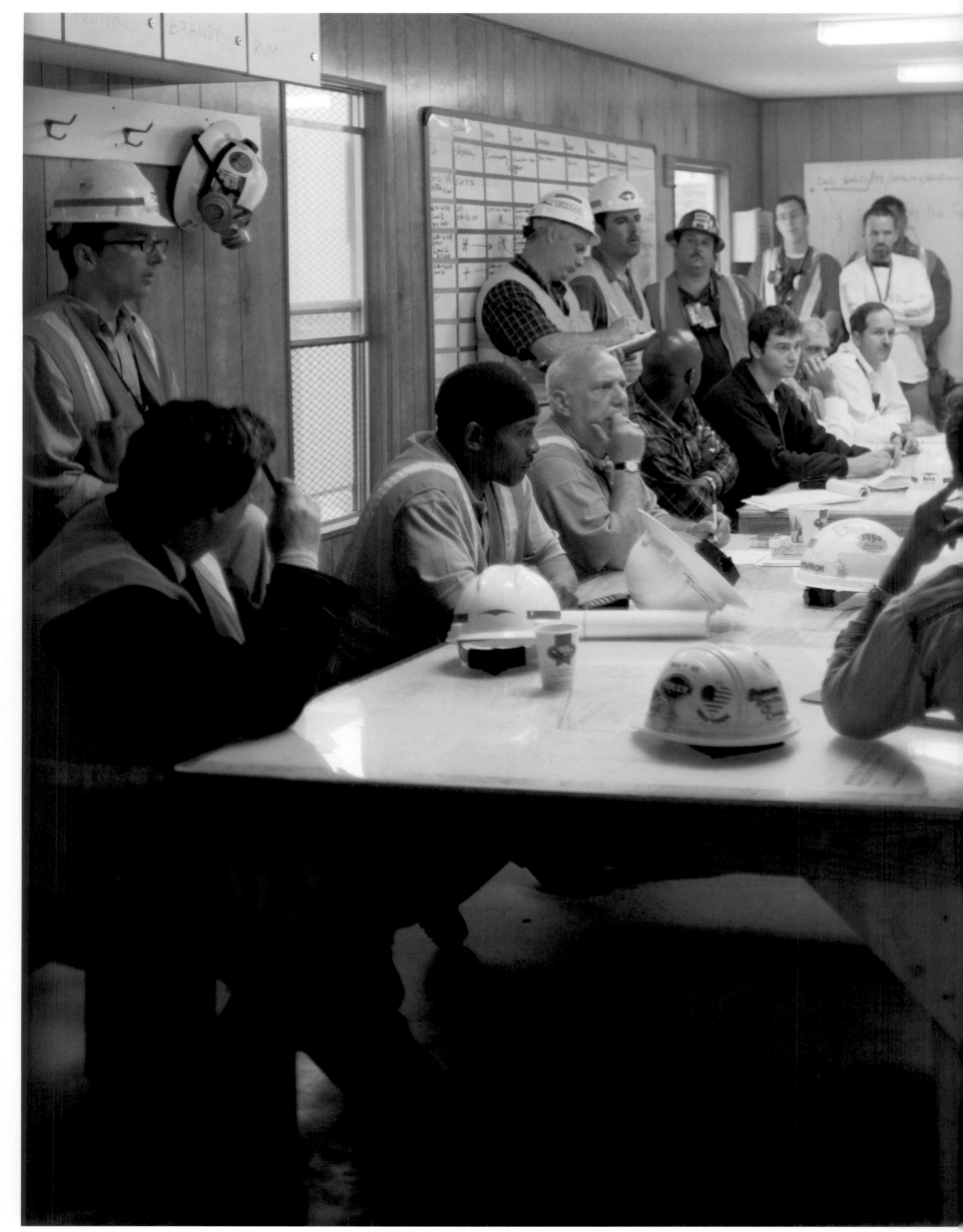

Charlie Vitchers and the trades

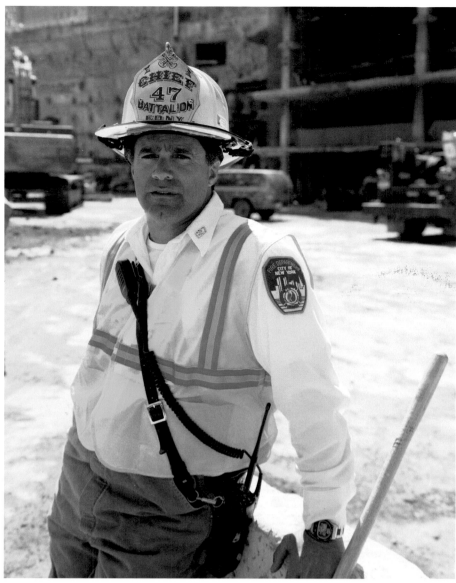

Chief Tom Jordan, resting

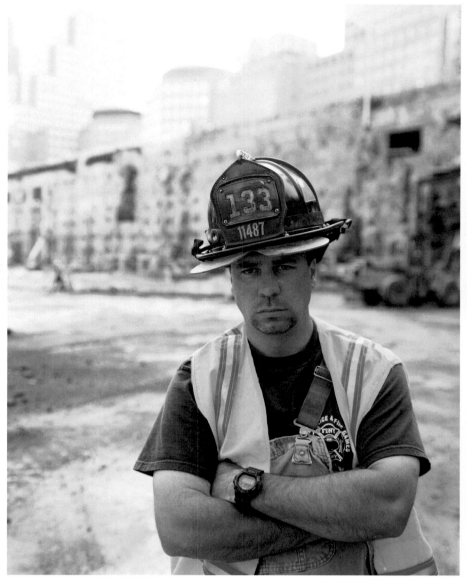

Christopher Burack, near a raking field

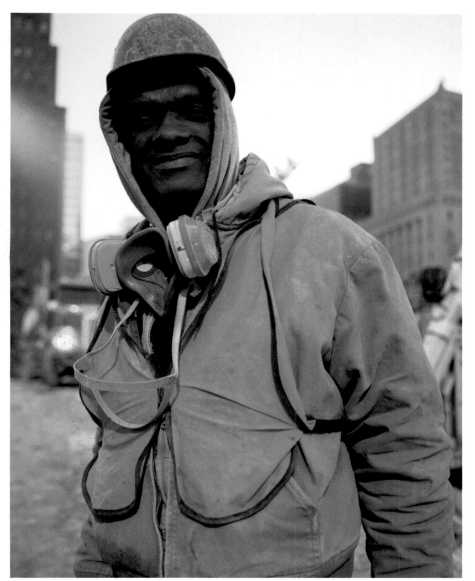

A construction worker

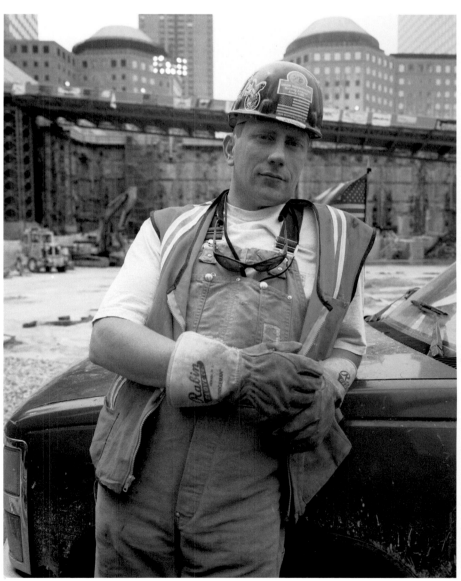

An ironworker resting

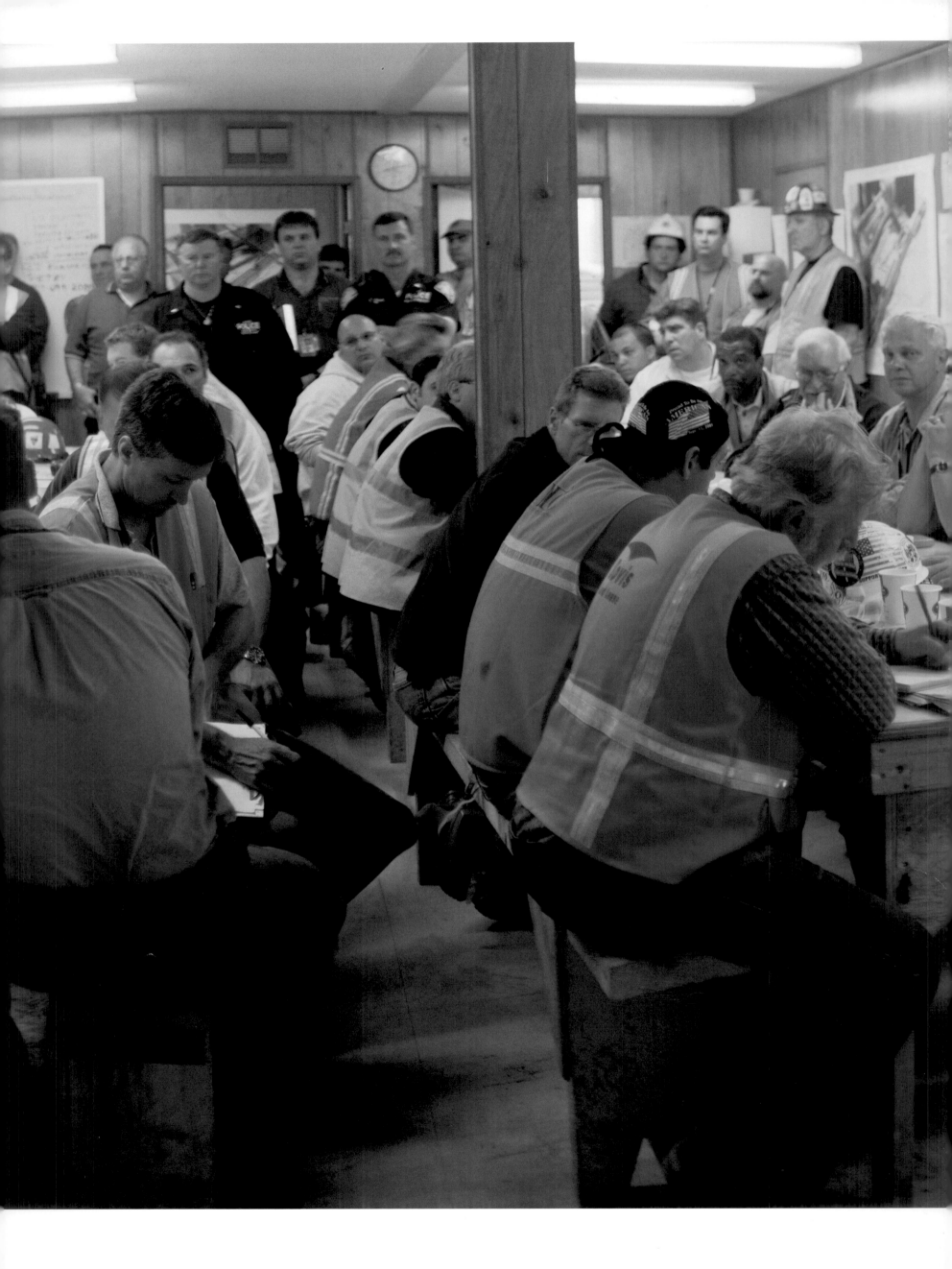

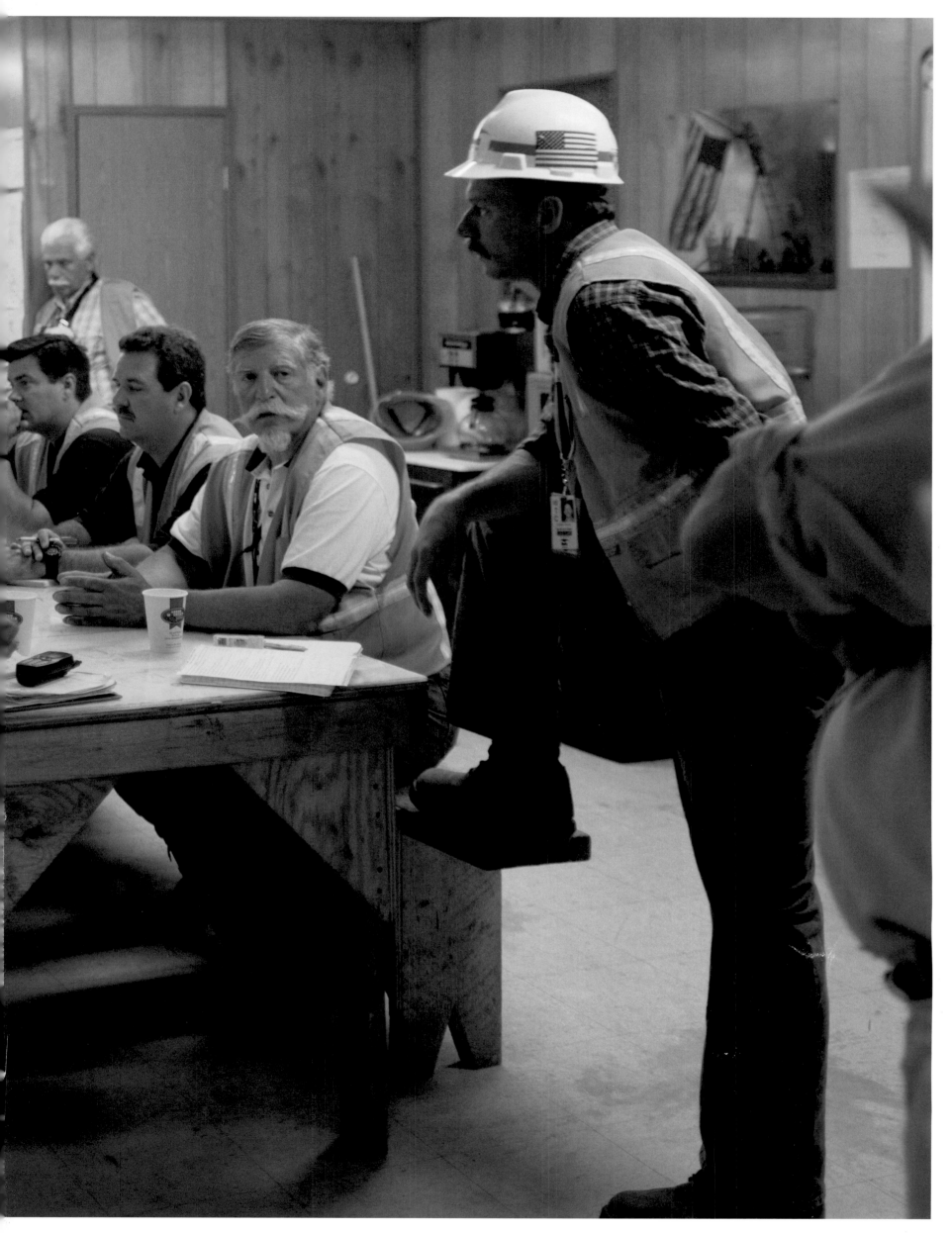

When I first attended this twice-daily meeting, I had the strong impression that I had seen this all before: a gathering of men wearing the distinctive clothing of a special Order. Dutch painting, I thought, groups of men with ruffs of lace around their necks, sitting in austere chambers, and debating some issue of social or commercial importance. The Synod, I thought, elders in day-glo nylon vests gathered in a double-wide, fluorescent-lit trailer, listening to Charlie Vitchers define the procedures for the day as he considers the needs and concerns of the knowledgeable men gathered there. The men whom he addressed were known as the "trades," a team of thirty to forty supervisors, each responsible for the various trades (ironworkers, operating engineers, carpenters, dock builders, electricians) carried out on site.

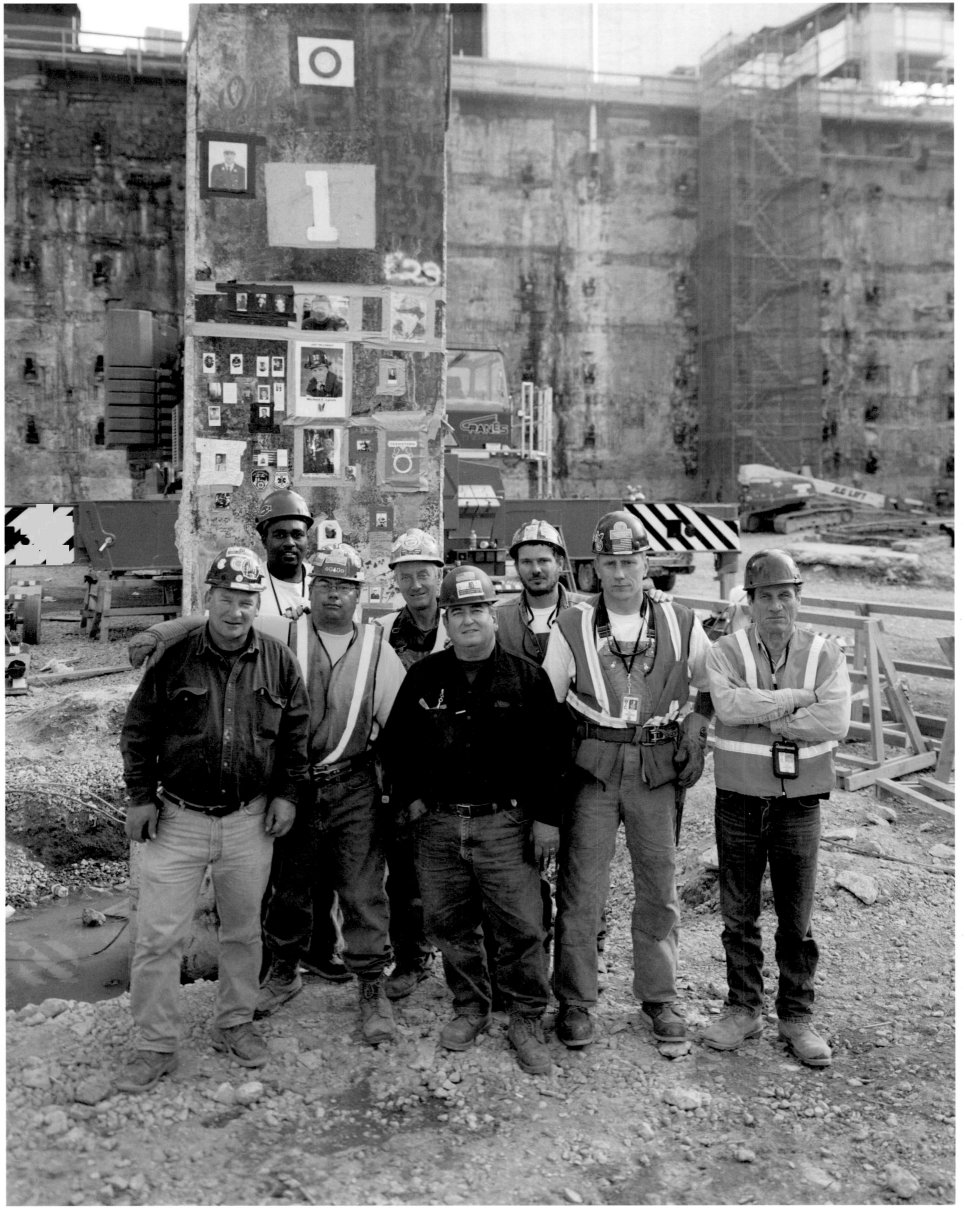

Ironworkers in front of the last column

Men who handle heavy tools and machinery have a different relationship to the ground than the rest of us. They stand differently. Usually these guys are working in a shower of sparks, wearing black-windowed helmets and big mitts, intently peering at a single furiously burning point of light. Dangerous forces are always at play, whether they're high up on a tower or, as at Ground Zero, two stories below ground in a crazy tangle of steel. No wonder their stance is so deliberate and sure: like steady hands and the ability to stay focused, it's a survival skill.

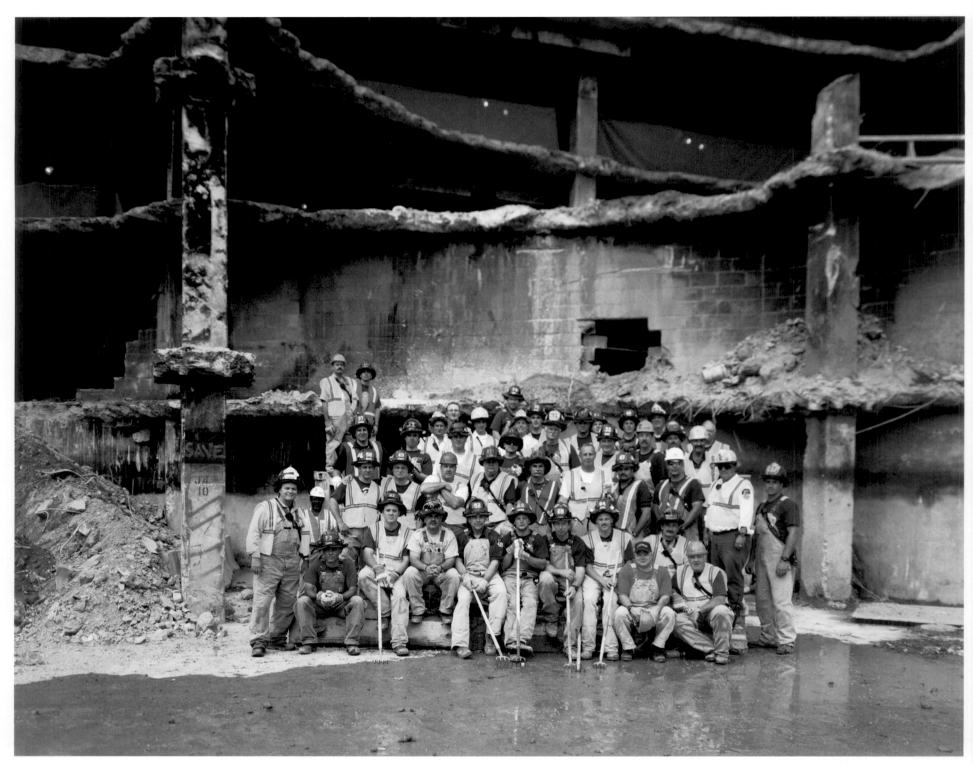

Group portrait of the raking teams

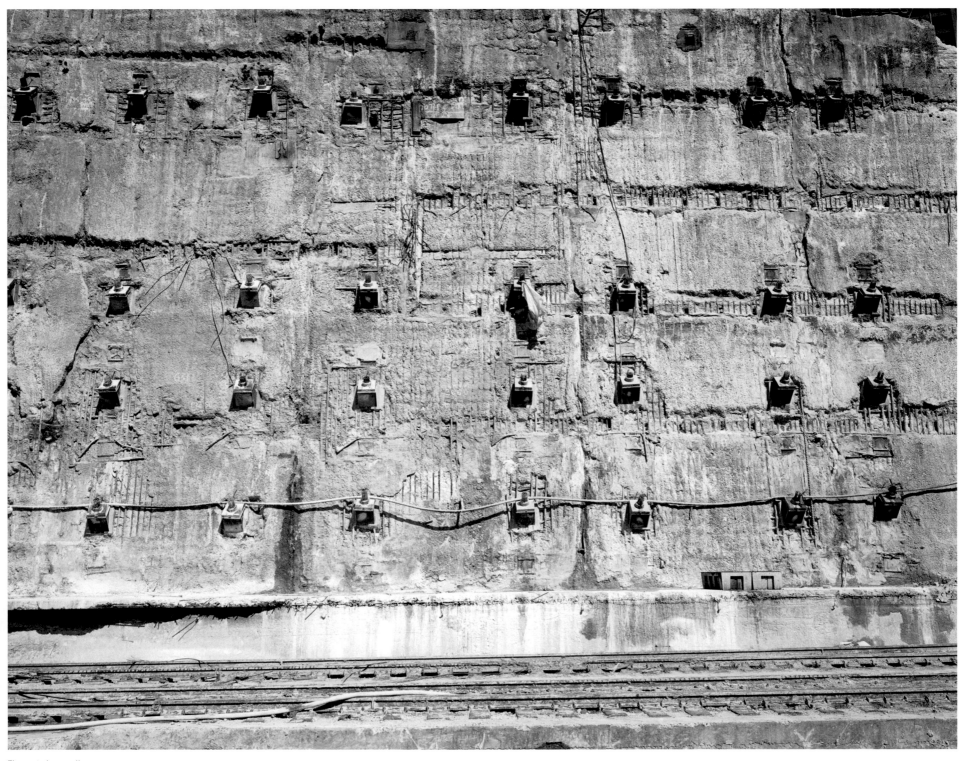

The east slurry wall

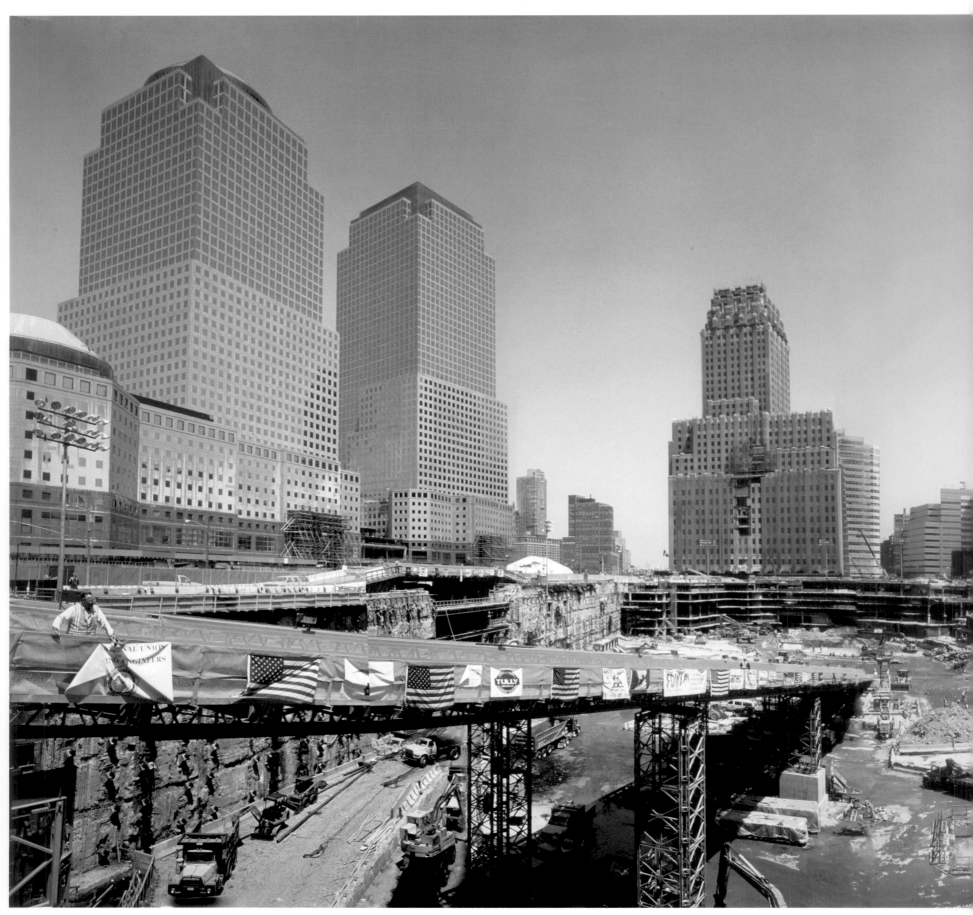

Assembled panorama of the site, looking north

Seward Johnson's sculpture, *Double Check*, became one of the most familiar images from the day of the tragedy, as the figure was photographed, methodically going about his business, covered in a blizzard of paper and ash.

An elevator pit, between the South Tower and the Marriott Hotel

The tunnels under the Hudson were partially flooded and the entrance barricaded

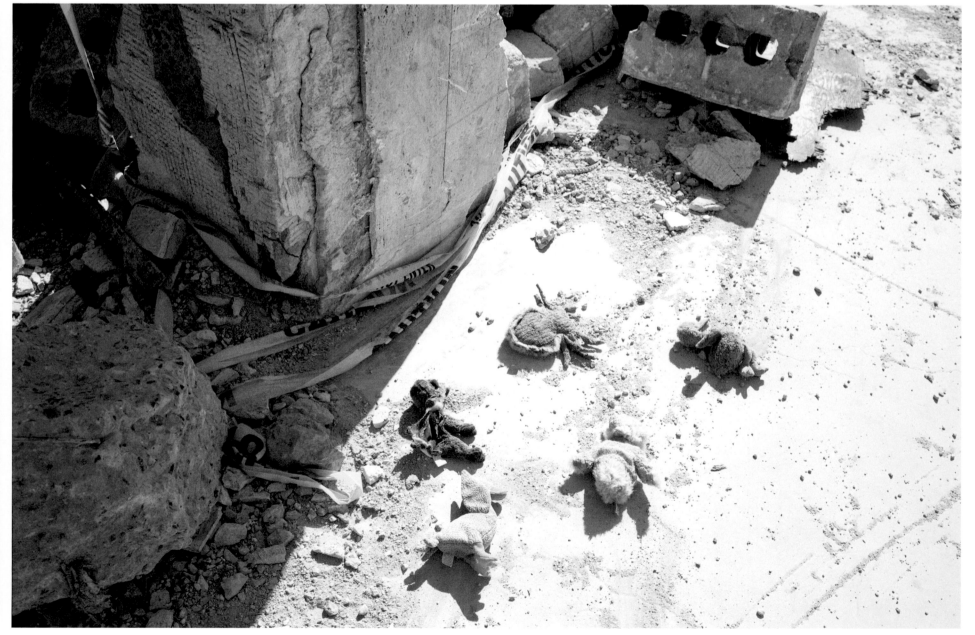

Stuffed toys in the PATH train station

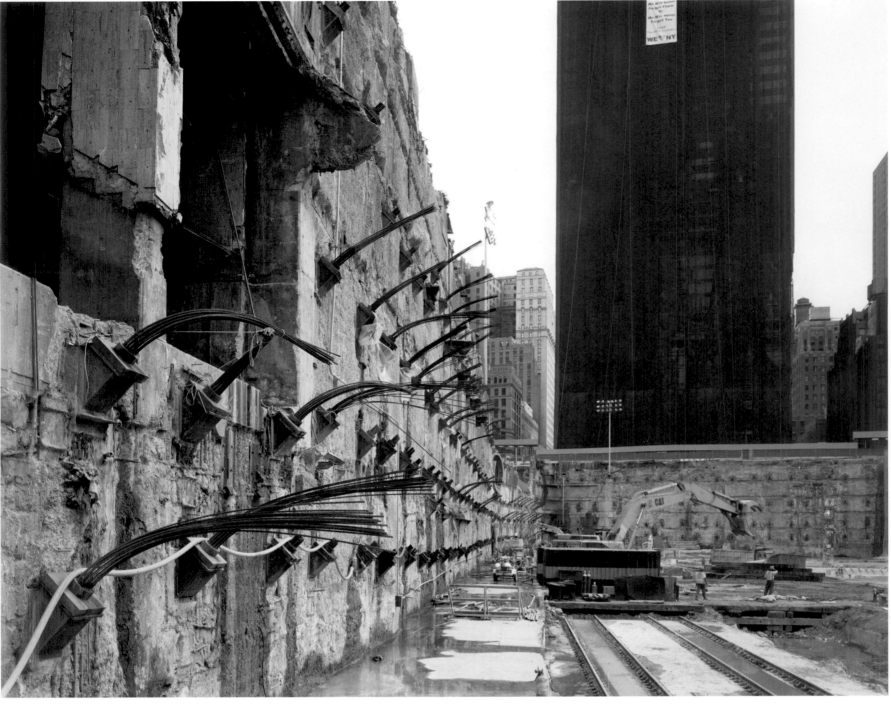

The east slurry wall, looking south

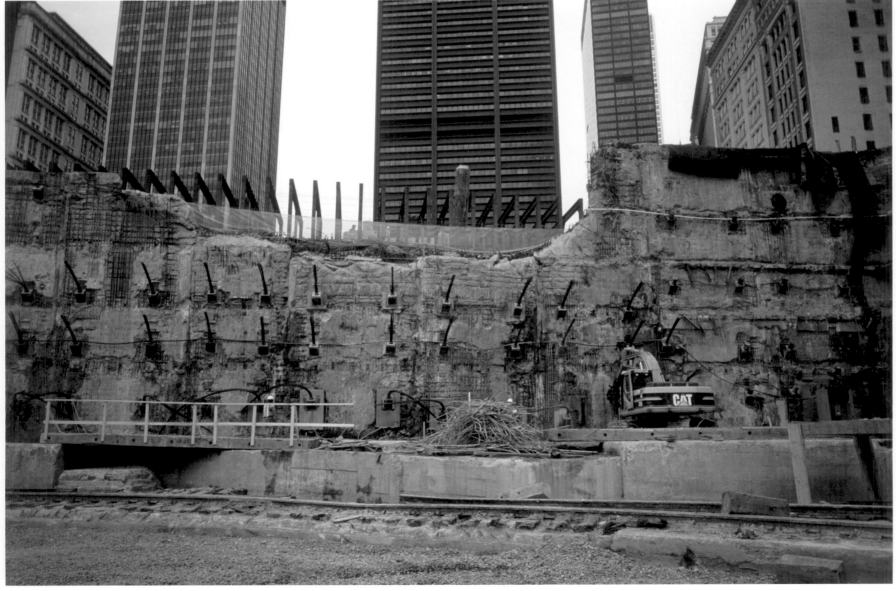

The east slurry wall and repairs to the Cortlandt Street subway station

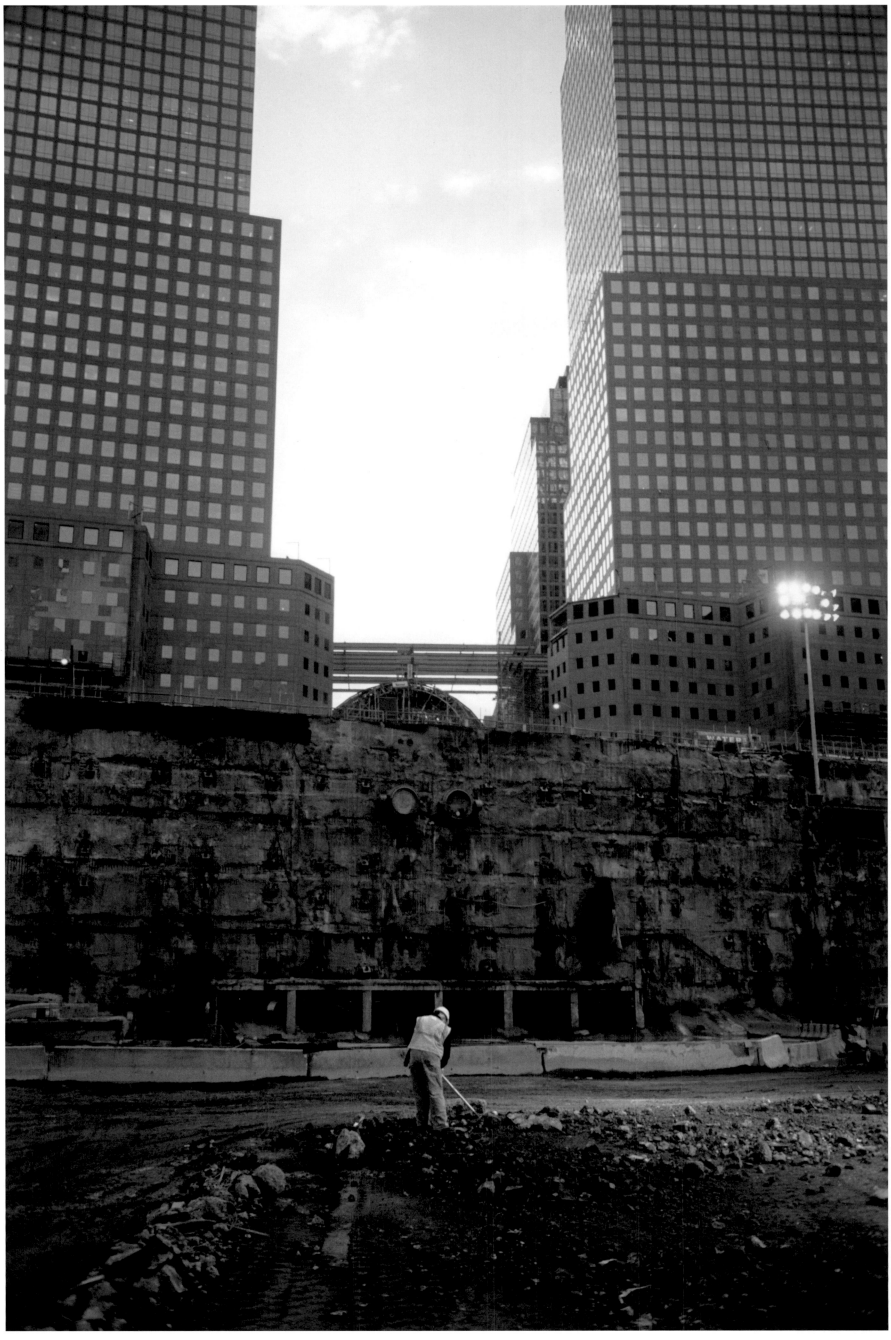

A lone worker raking near the west slurry wall; seventy-two-inch water mains are visible in the wall.

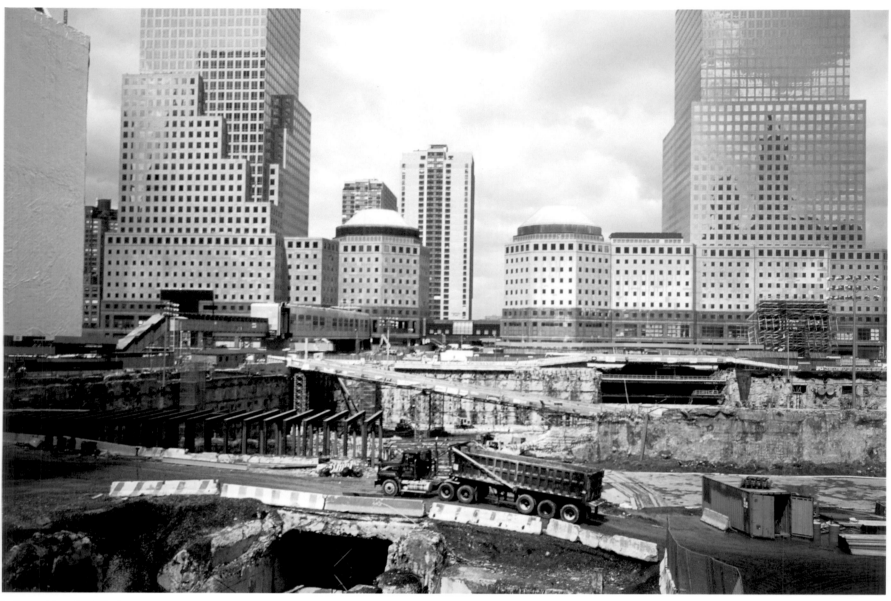

Looking west from Church Street

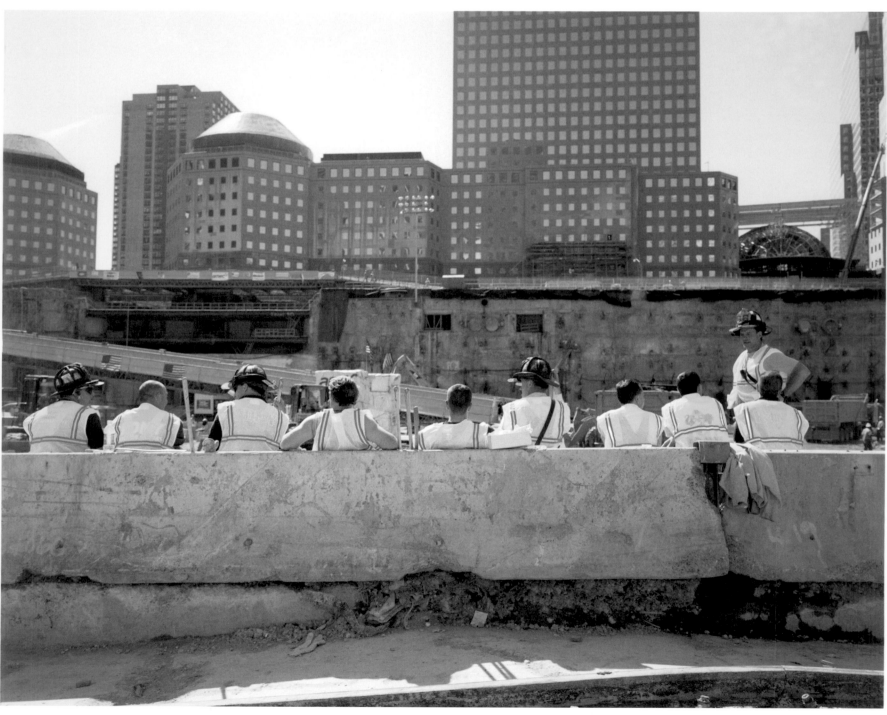

Rakers resting

05.16

The light was a New York light, hard and beautiful in advance of an early summer storm that was on its way. The World Financial Center's windows had been repaired, and the buildings (shown opposite) looked oddly fake now, like models of themselves—a backdrop for the stage set spread out in front of them. The steel bracing for the subway tunnels is still fully exposed. Soon it will disappear seven feet below street level again, and we'll only know it's there when we hear the faint rumble of the train through the gratings at our feet.

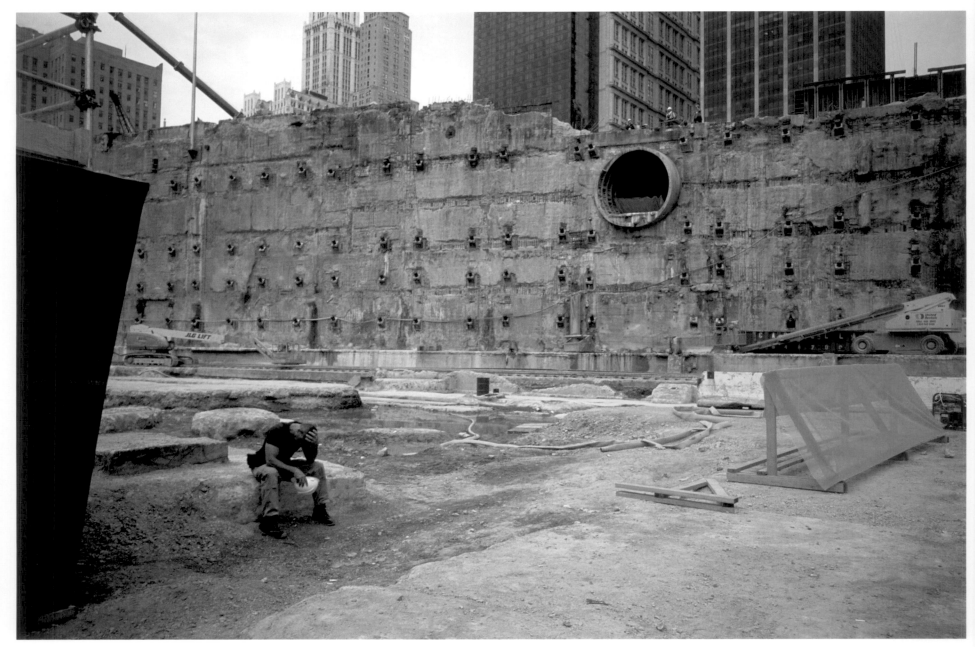

A worker resting near the east slurry wall

It was only a metal ramp into the site but it had an austere beauty beyond its functon With its skirts blowing in a May breeze in clean afternoon sunlight, it rcse into the eerie stillness of the city.

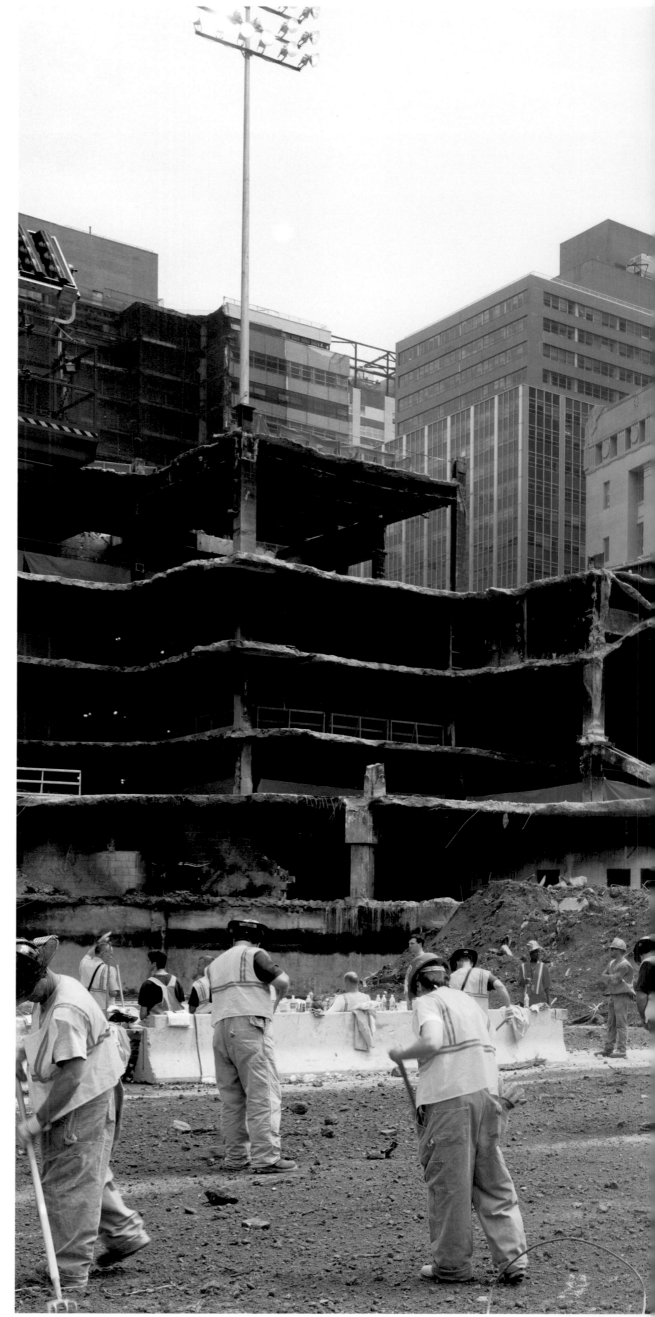

05.28

This is it! The last day of work on the site. Here the workers are raking through the debris one final time. I find myself thinking of Millet's *Gleaners*, and I wonder why it is that so many of these late images stimulate connections to the art of the past. Is it that things are simpler now, and therefore more clearly seen? Or am I holding on to these images, fixing them in my mind by referencing works of the past to establish continuity? Is it wrong not to simply let them be what they are, people picking over the fields?

Gardeners in the garden of the dead

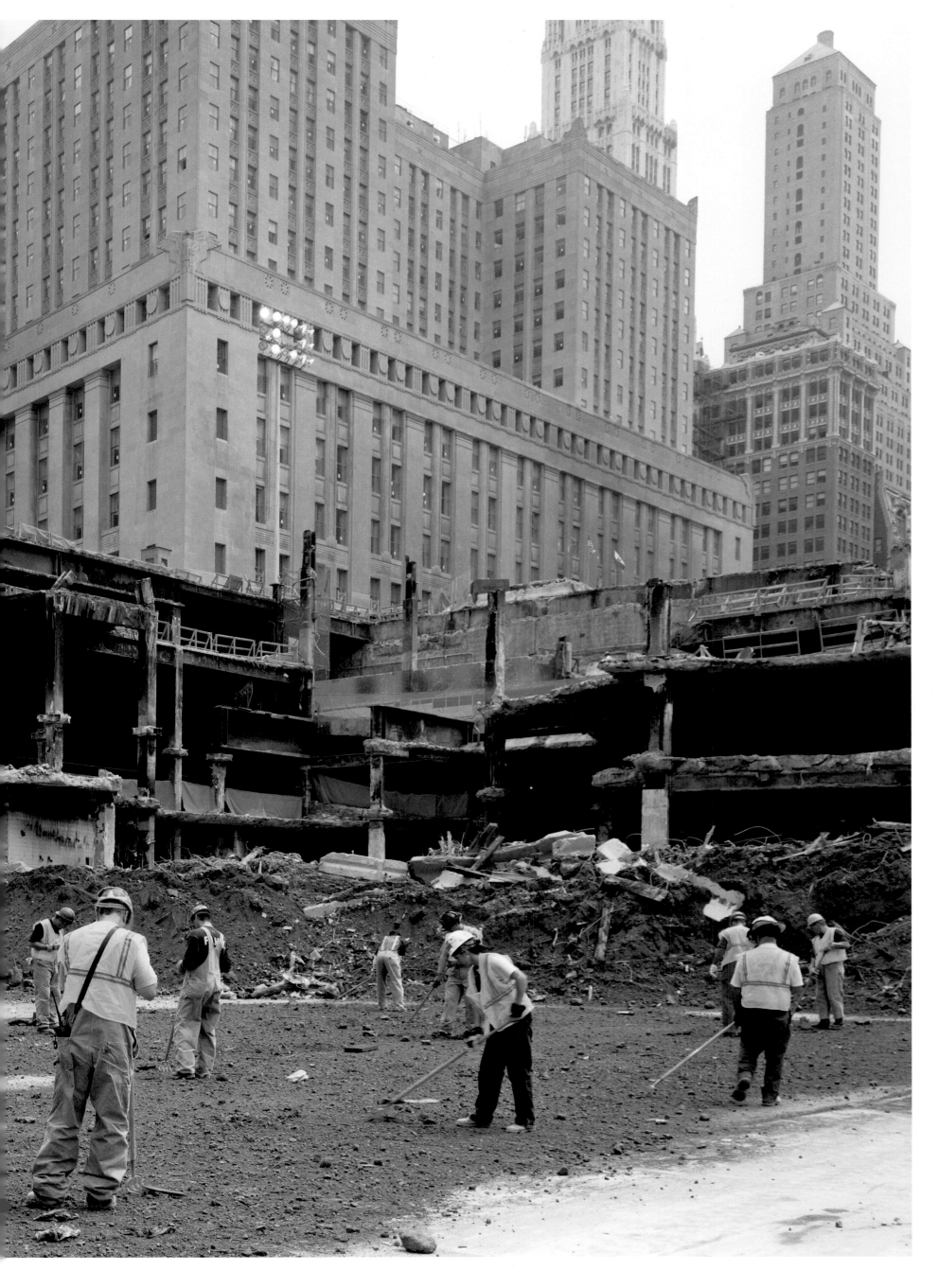

Rubble in a raking field

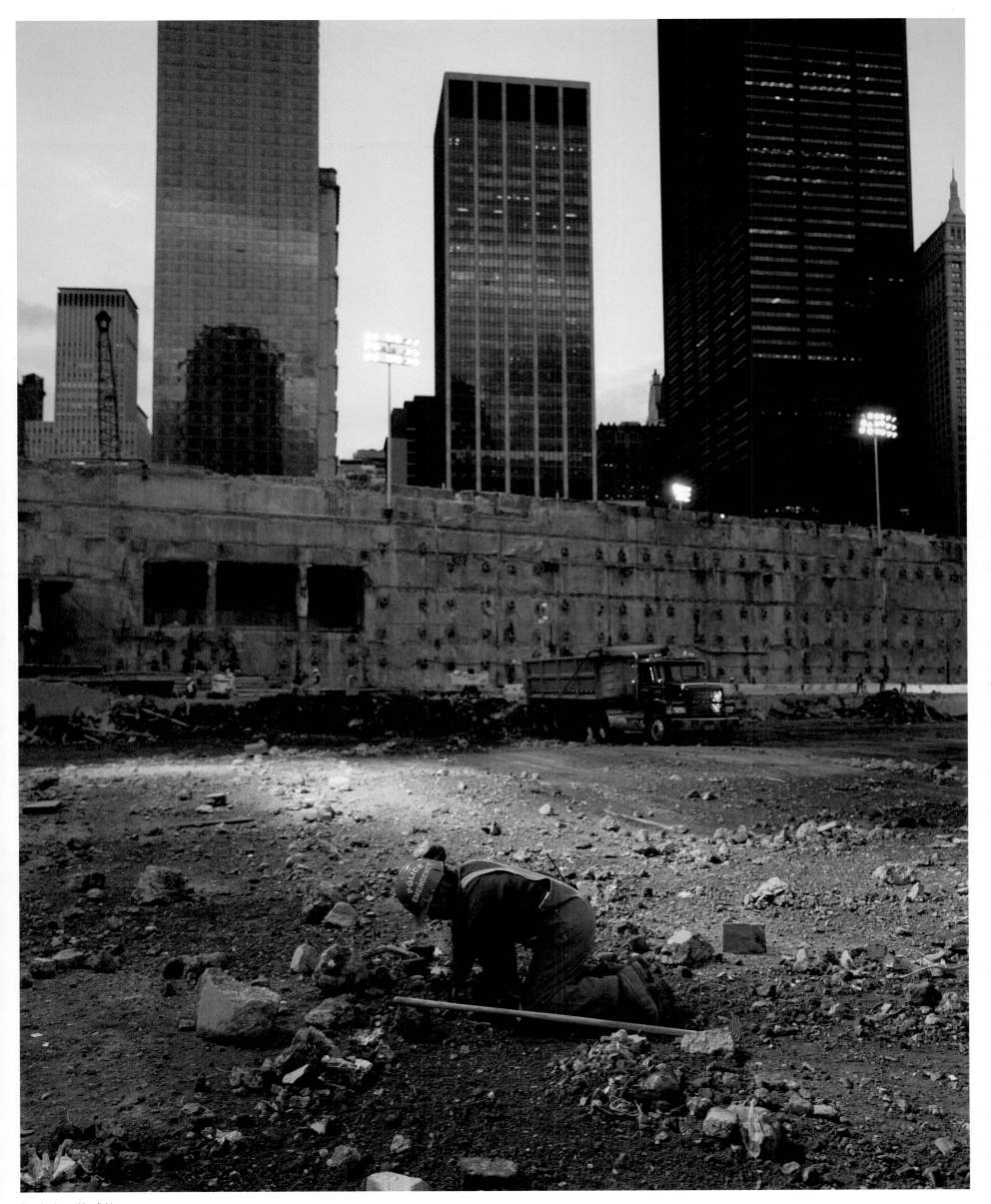

A worker in a raking field

The shift has ended. But one man, on his hands and knees in the fading light, still turns over debris, looking for things that he'll recognize only if he does it this way—bit by bit, lost in the moment, devoted to the task.

One day, Fuji asked if I'd like to ride over the site in their blimp. Looking down on Ground Zero, the space seemed so small; had it really been eight months almost to the day since I first stepped inside the barriers? This tiny patch of Manhattan had become my life; my community was there, I awoke every day with a sense of urgency to get back to it so I wouldn't miss anything.

By 2001, I'd been making photographs for forty years. Inevitably, I'd grown familiar with the way I saw my work and the issues I thought seriously about, and many of my responses had become routine. But 9.11 had awakened in me a profound need to give something back to my native city, and what I had to give was a record of what all the other people around me were doing in response to the tragedy. Bearing witness week after week reminded me why I'd become a photographer to begin with—those first years when I'd burned with the desire to be out every day with my camera to see what the world had to offer. It was that same feeling of desire that drove me now, and it made me feel young again.

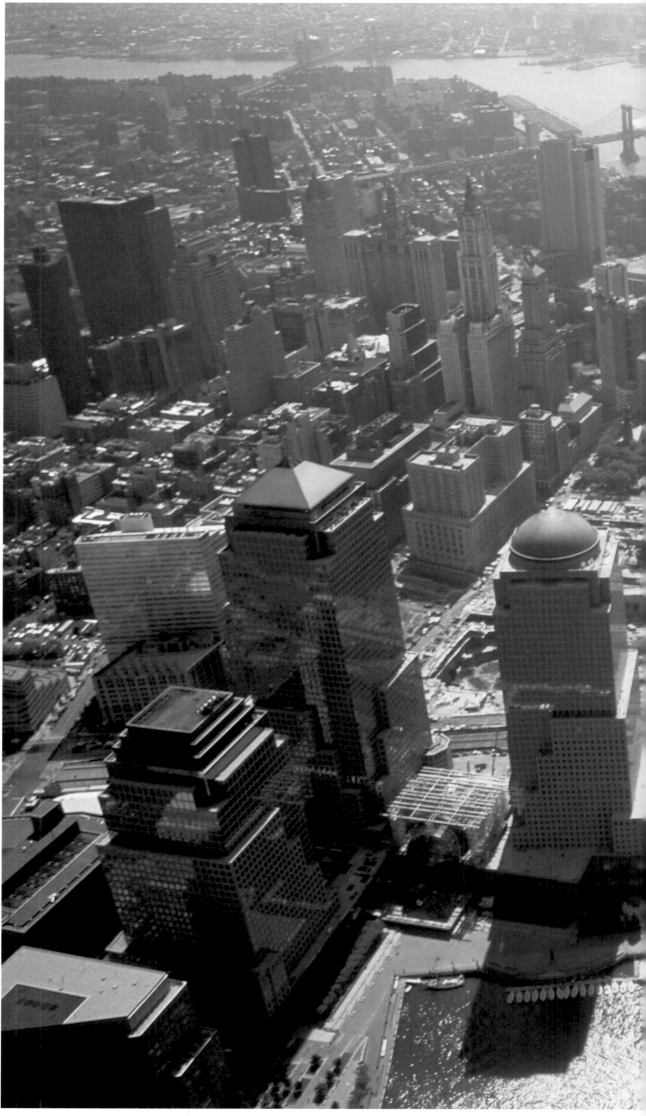

An aerial view of the site from the Fuji blimp

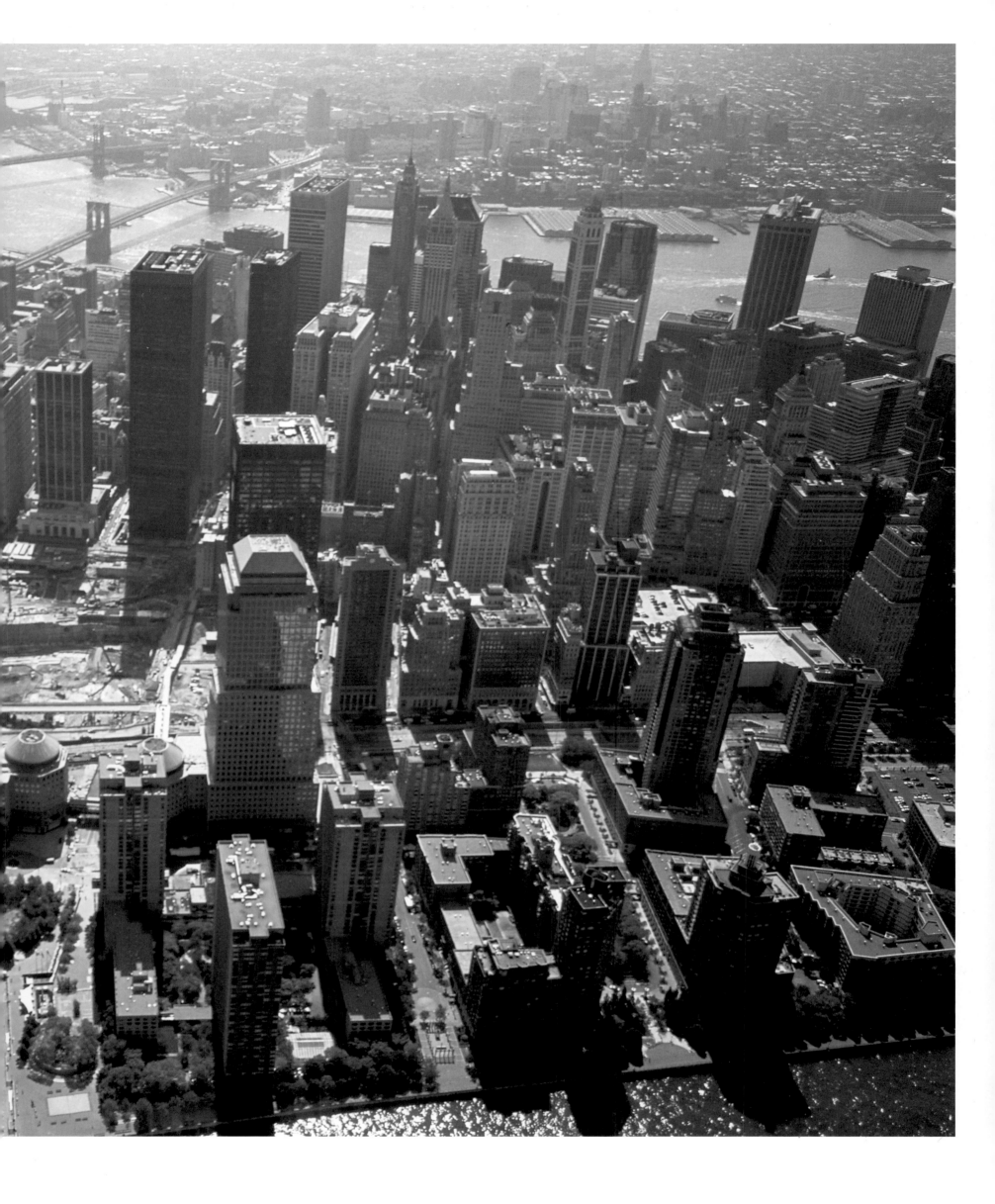

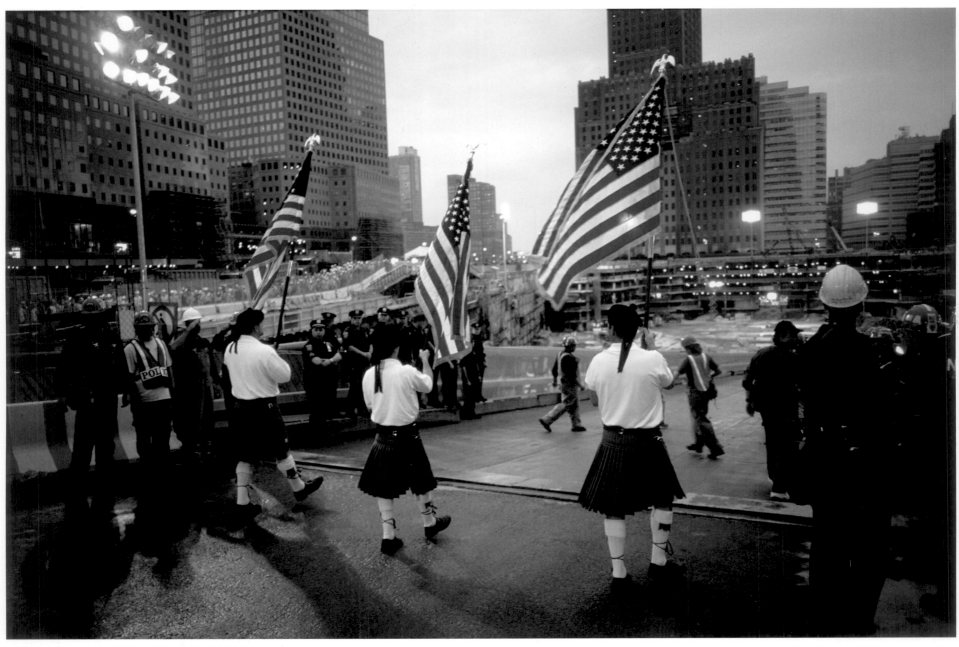

Flag-bearers leading the pipers down the ramp for the closing ceremony

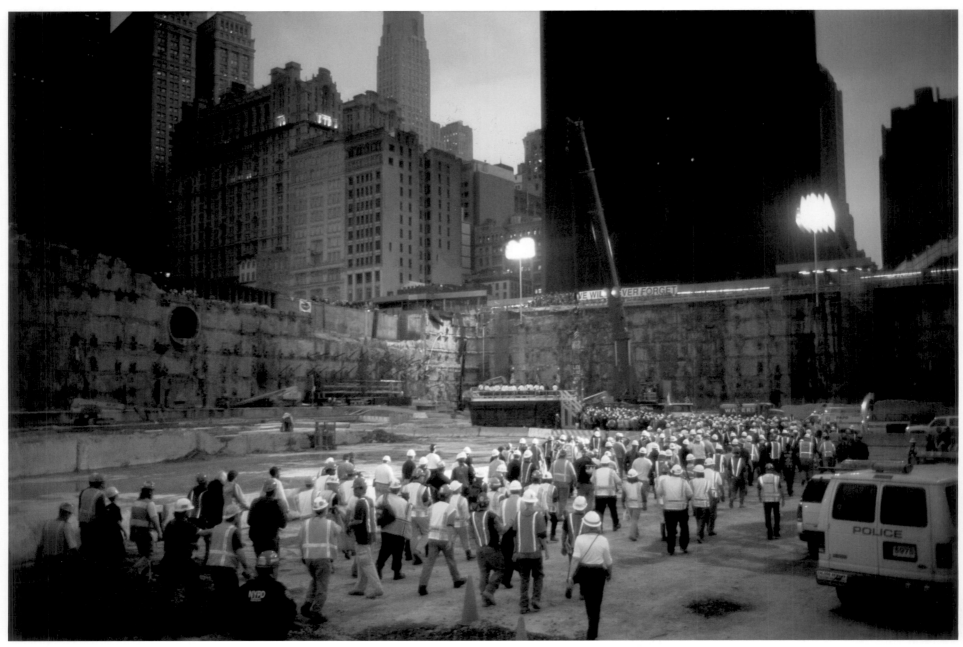

Workers walking toward the last column

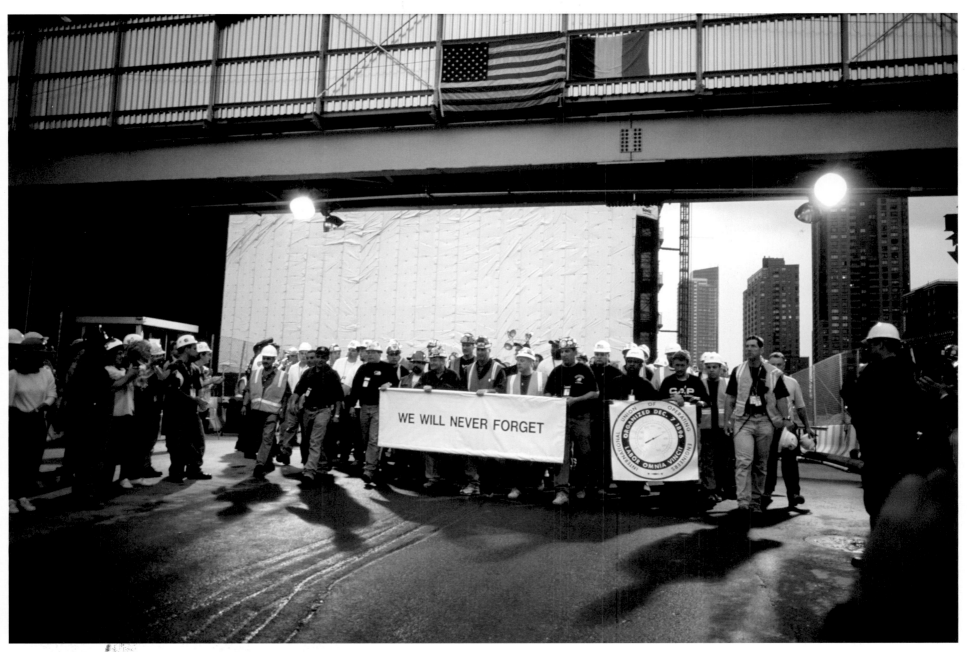

Workers marching into the site for the closing ceremony

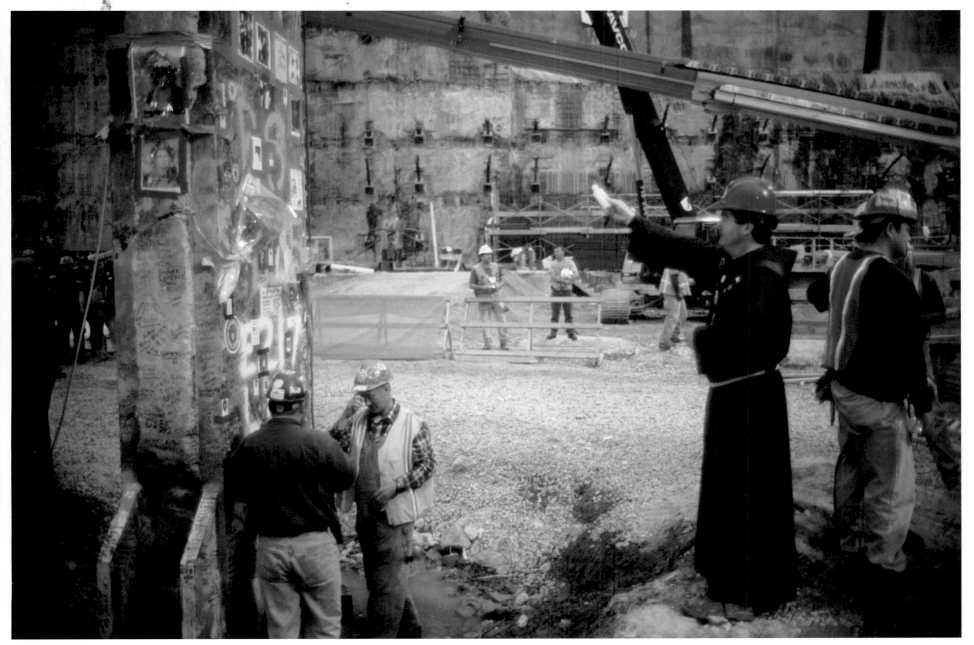

The last column being blessed

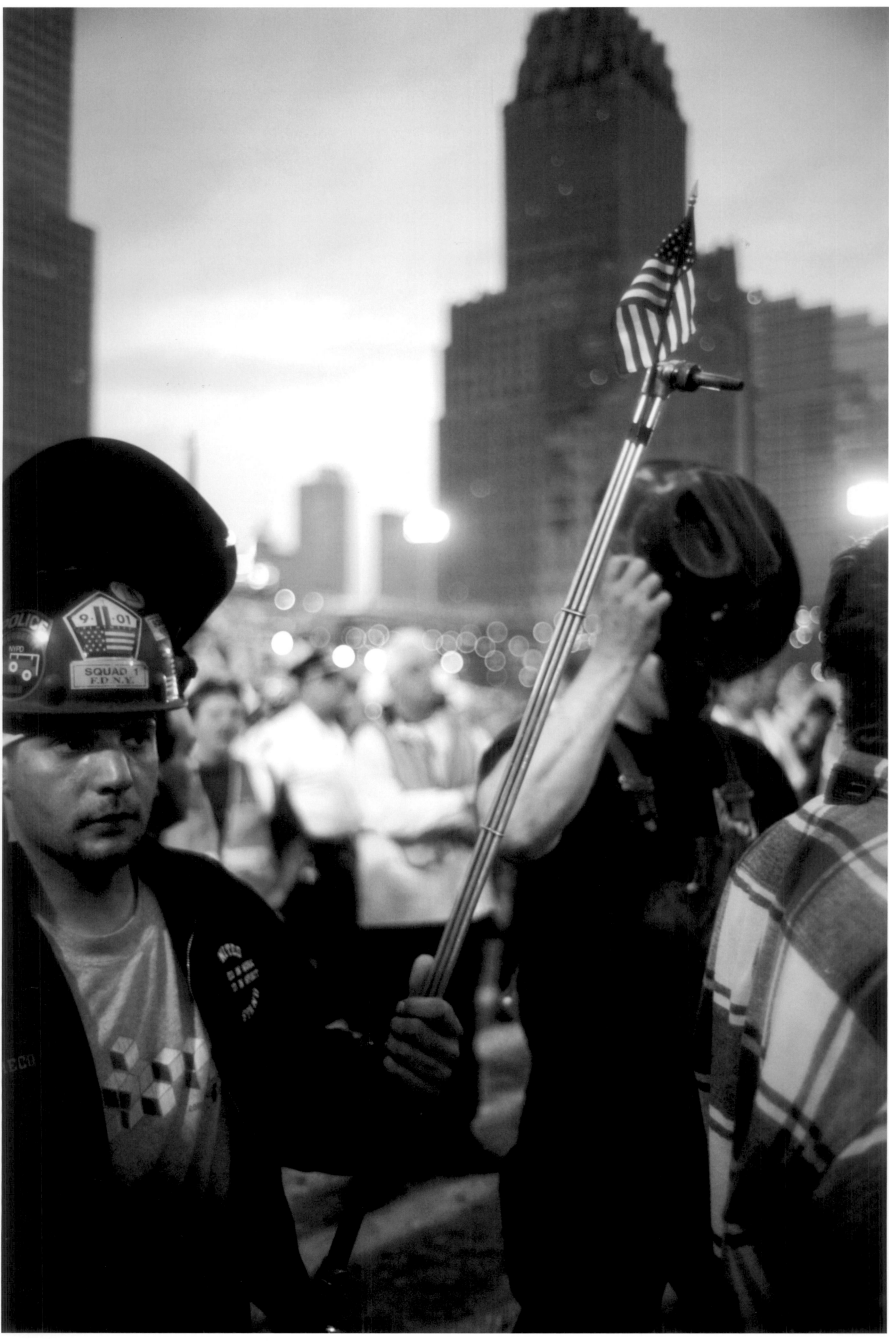

A welder standing with his torch and the Stars and Stripes

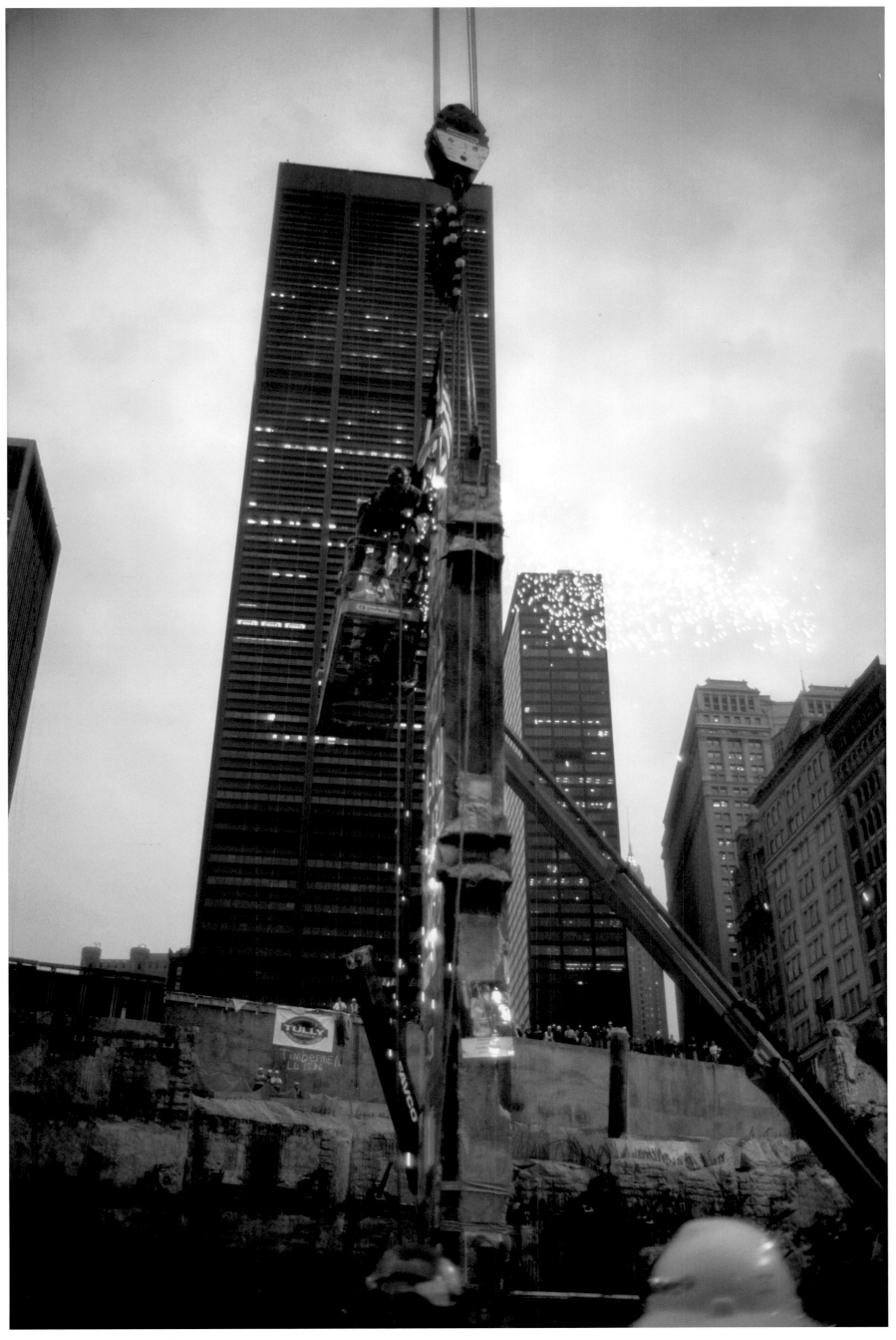

A welder cutting down the flagpole on the last column

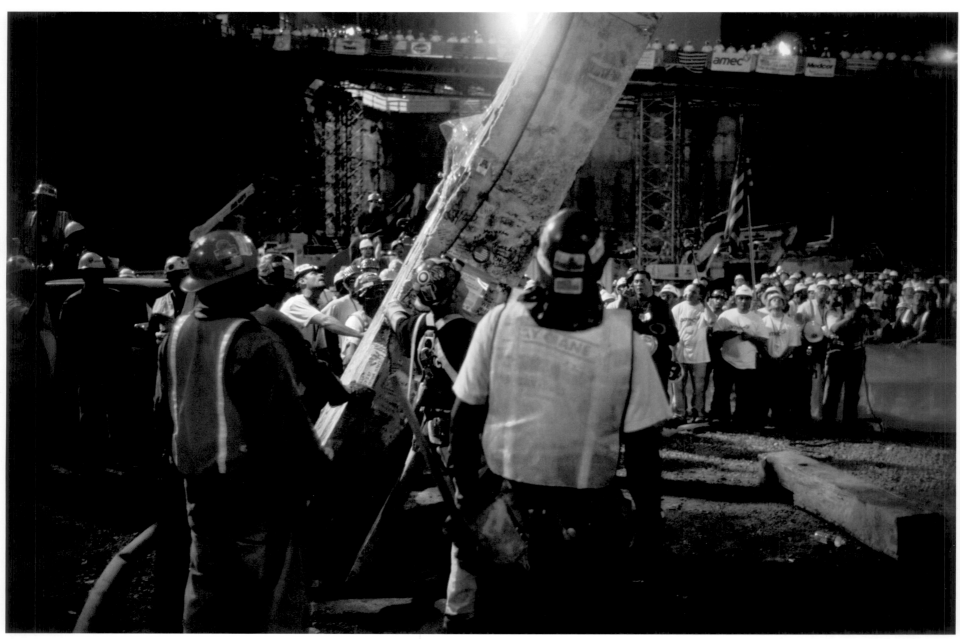

Tilting the last column forward

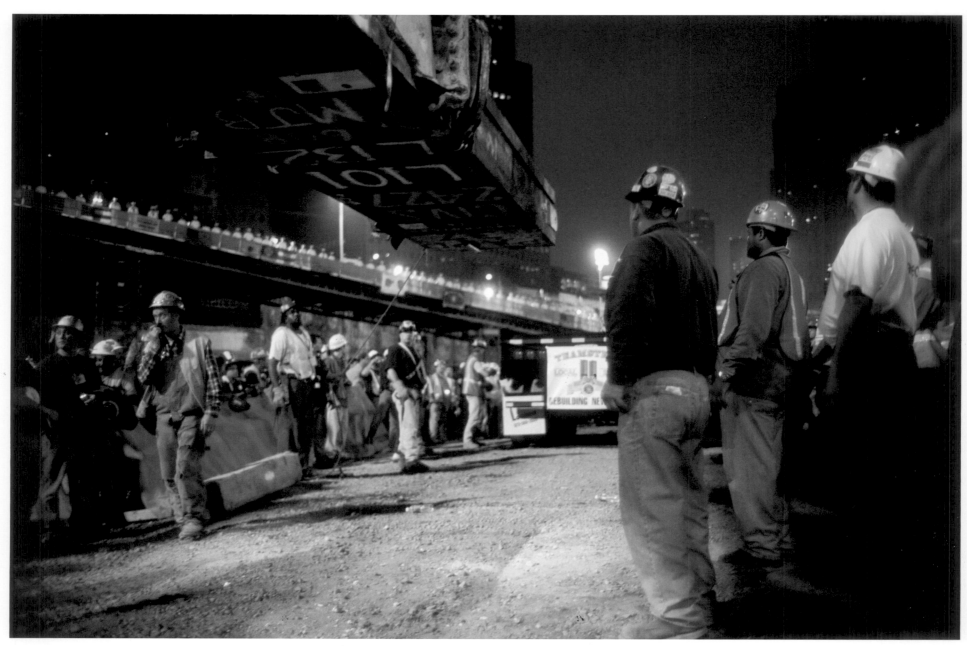

The last column suspended

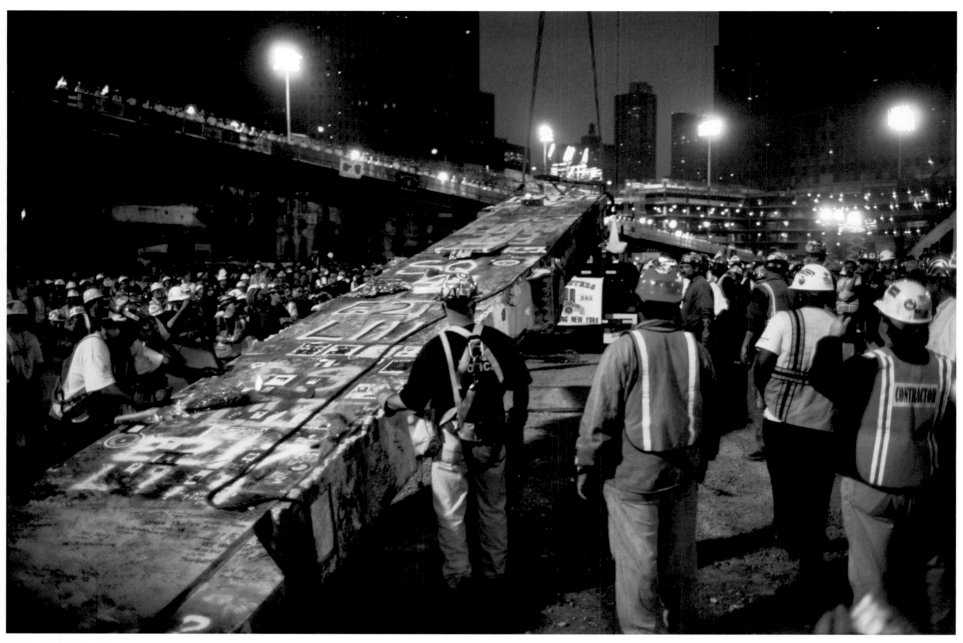

Bringing the last column down

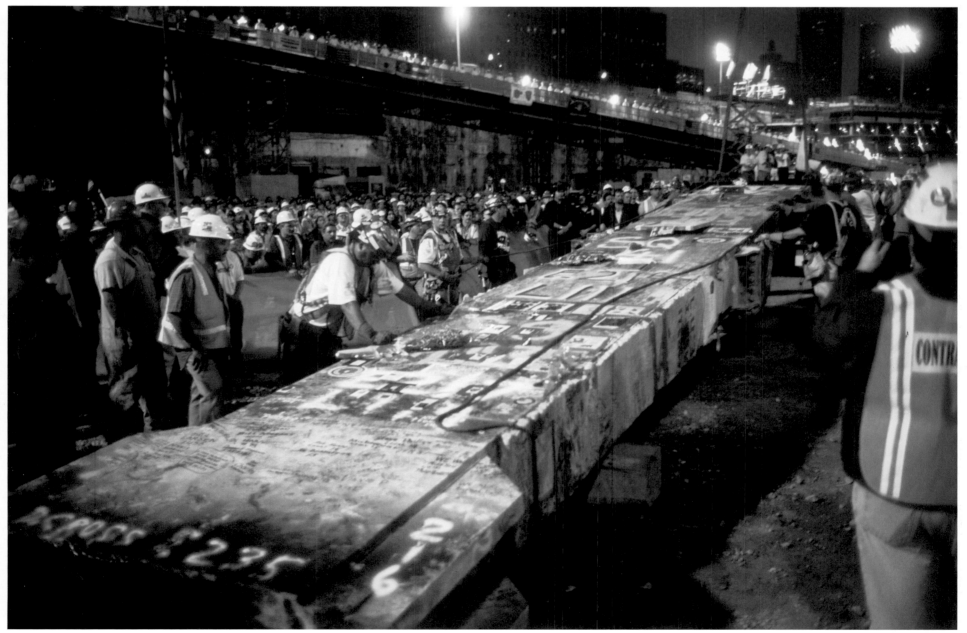

The last column on the ground

05.28

On that last night, the construction workers came by the hundreds—men and women who were still assigned to the site, and those who had once worked there and moved on. This was their time, their closing ceremony. They wore hard hats and day-glo vests, scarred work boots and union tee shirts; some carried their tools, others carried signs showing their solidarity. There was something almost medieval about the evening's odd but uplifting pageantry, the clusters of men from different guilds marching down the ramp: ironworkers, teamsters, operating engineers. They walked with arms around shoulders, or hands in overall pockets, buddies and loners, a steady stream of them parading toward the last column on this mild spring evening. Gracing the passageway down to the site were sailors from the *Iwo Jima*, on shore in New York for their annual Fleet Week celebration. They stood crisply at attention in their dress whites, a beautiful contrast to the rugged gear of the army of construction workers.

Down at the south end, the last column was the gathering place; nearby was a platform built hurriedly that afternoon for the ceremony. The energy near the column intensified as the workers crowded around it, some signing their names, others posting photographs. A Benedictine monk appeared and sprinkled holy water on the base. A cherry picker lifted a welder to the top of the column, so that he could burn through the steel rod that held the flag and bring it down to be formally folded for the presentation.

Normally it would take several hours to cut through a column of this scale—sixty tons and four stories high—so the ironworkers had made all the substantial cuts a few days beforehand, leaving only a few inches at the corners to hold it in place. Now, while a crane held the column securely, they cut it free. I was fortunate to be standing at its base, and as it floated loose I watched it sail over my head like a massive obelisk. Many hands steadied it in the air as it hung six feet above and parallel to the ground. When it was lowered, the workers swarmed around it to sign their names. Then a flatbed trailer (called the "Black Virgin," because it had never been used) was backed into place and the column was gently lifted onto the chocks on the trailer bed.

And then an astonishing thing happened. Perhaps a dozen workers leaped on the trailer to "dress" the column. First they wrapped it in black nylon, tenderly folding and tucking the cloth in around the edges. Then they draped it with an enormous American flag. The final touch was to place on top of that a massive floral wreath.

A fireman tolled the bell for the dead, and a few brief remarks were made. Then the truck, surrounded by the workers, moved to the north end of the site. There the column would wait until the morning of May 30, when, accompanied by the cry of bagpipes, it would follow the firemen and policemen out of the pit—the last procession to leave Ground Zero.

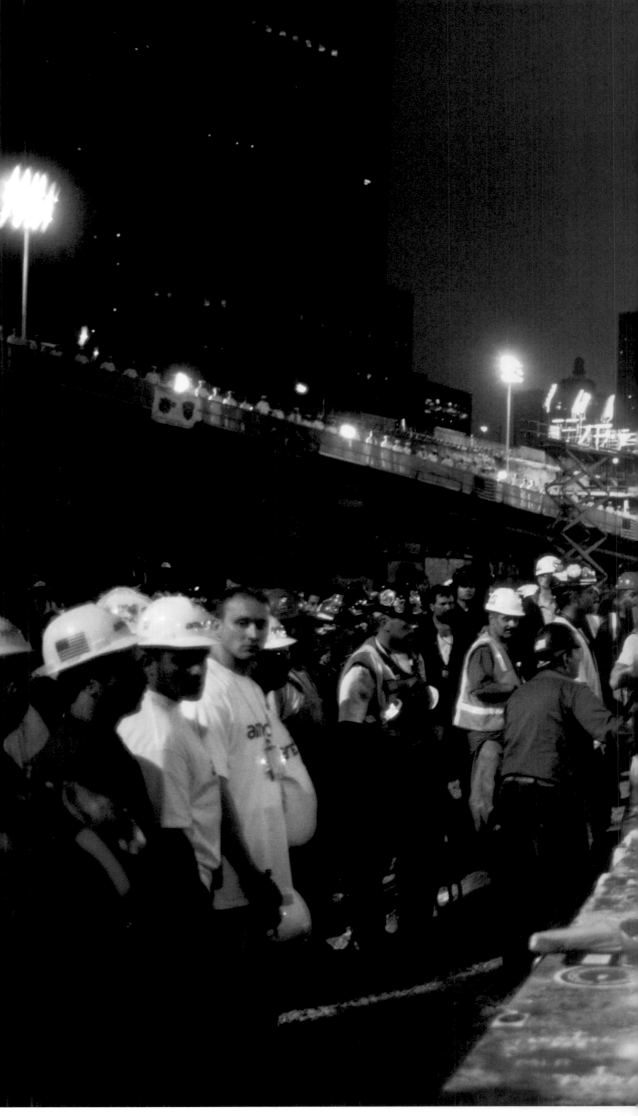

Signing the last column

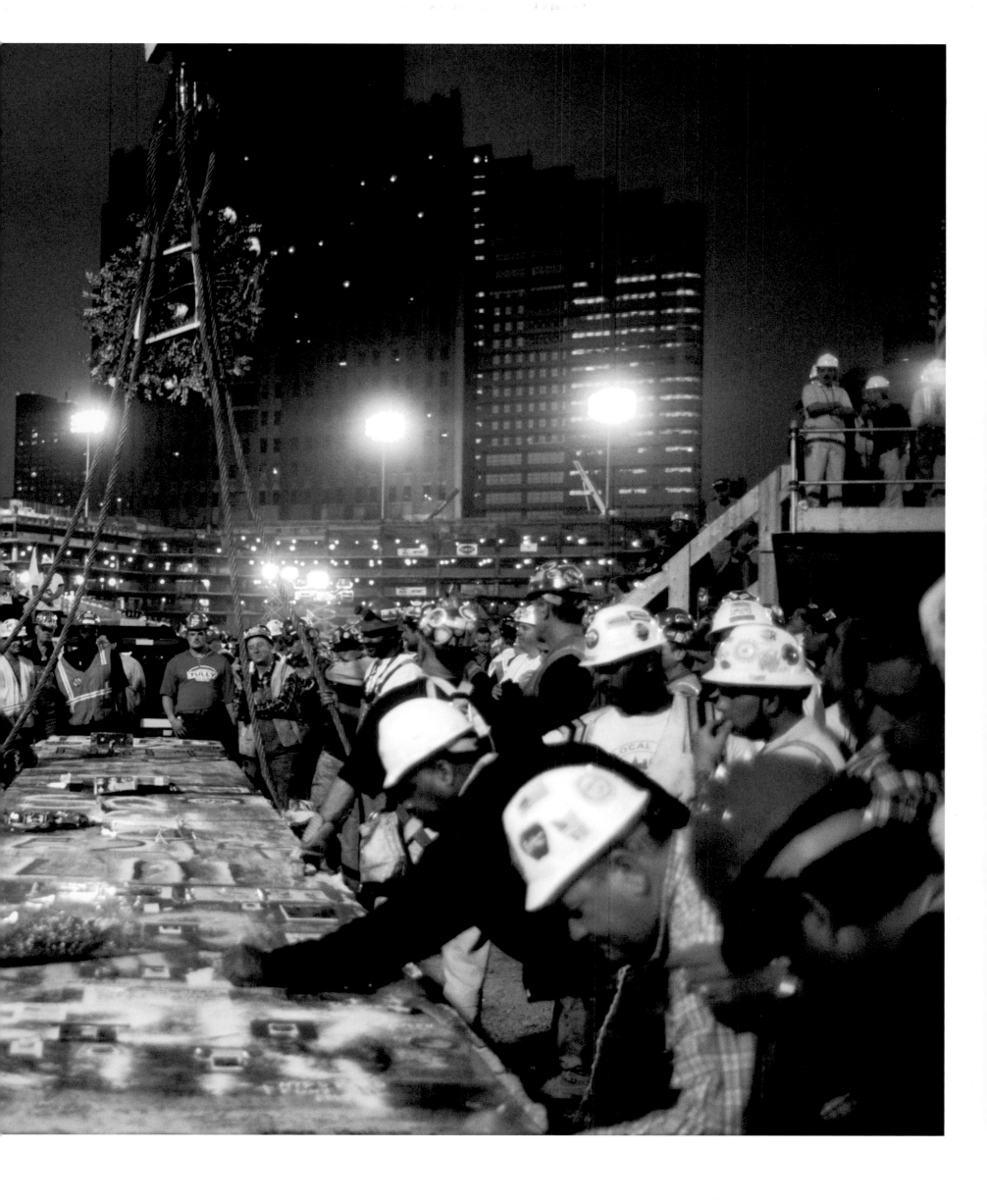

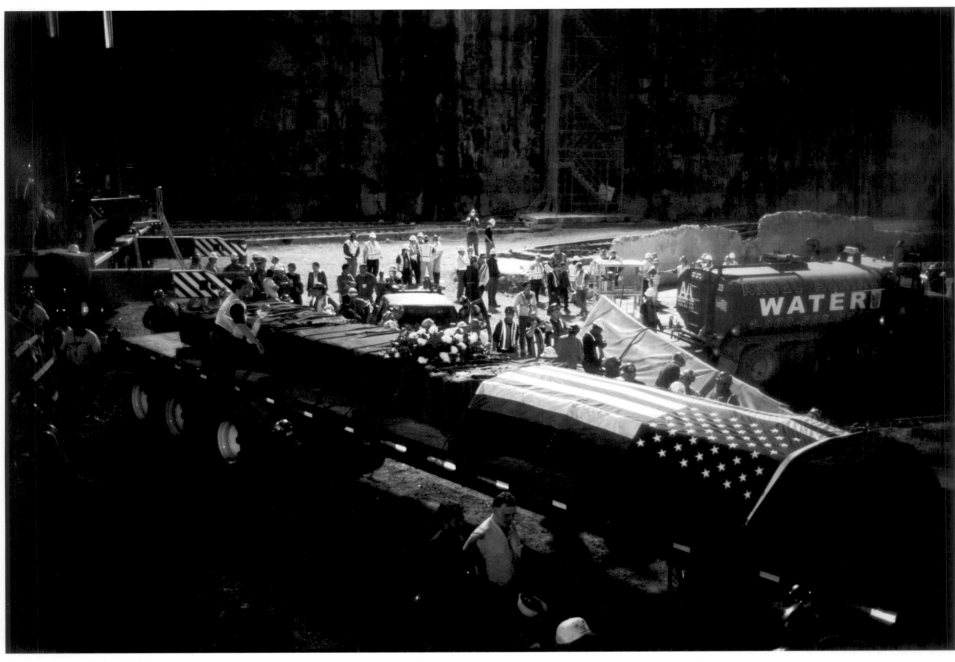

The last column on its way to the north end of the site

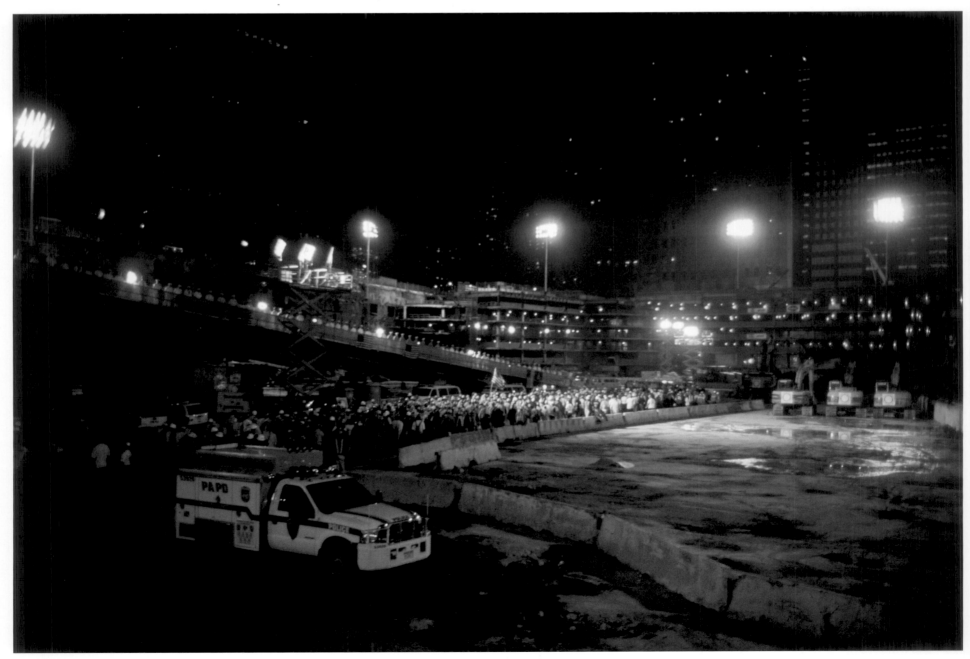

Workers marching with the last column

Sailors from the USS *Iwo Jima*

05.30 The last column leaving Ground Zero

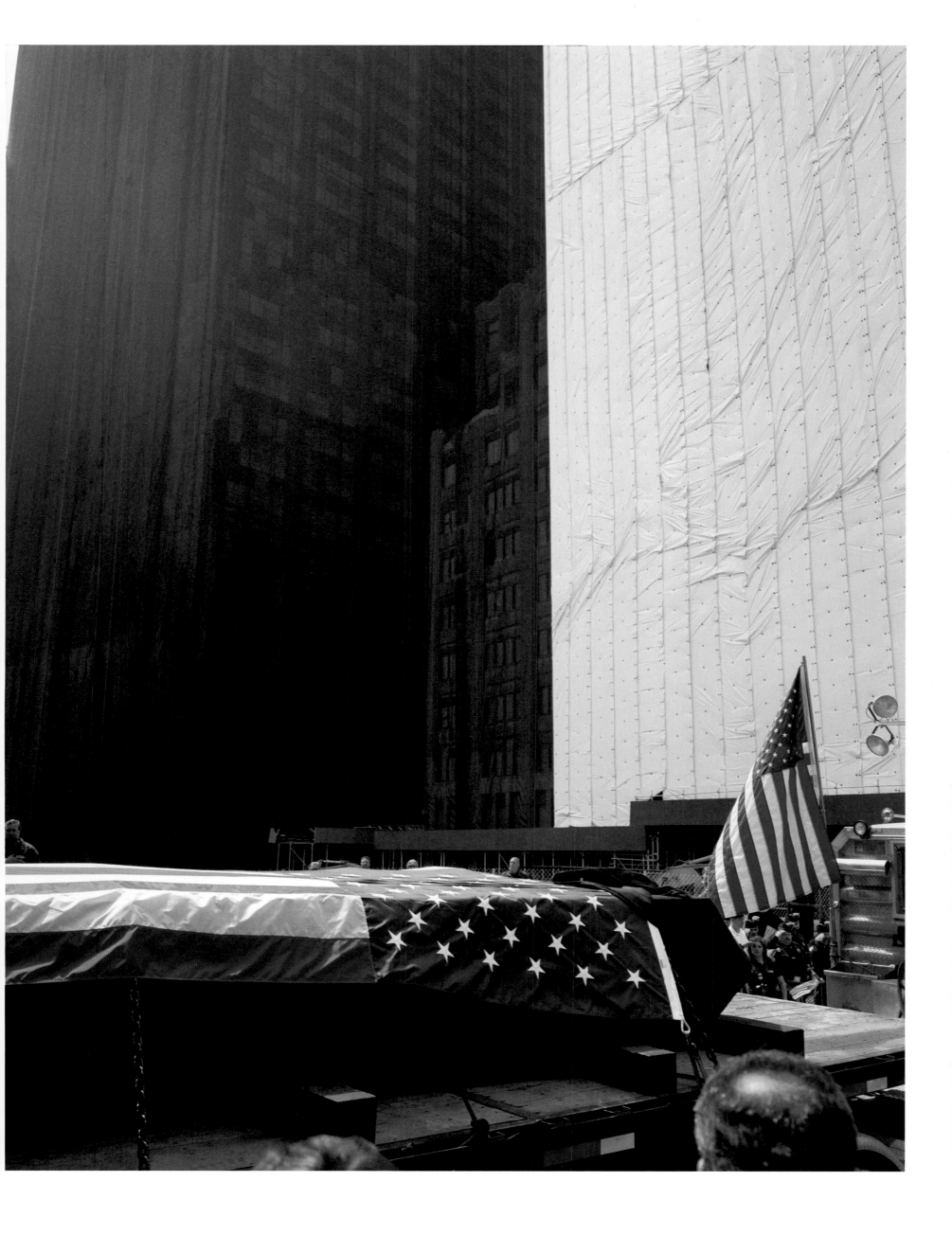

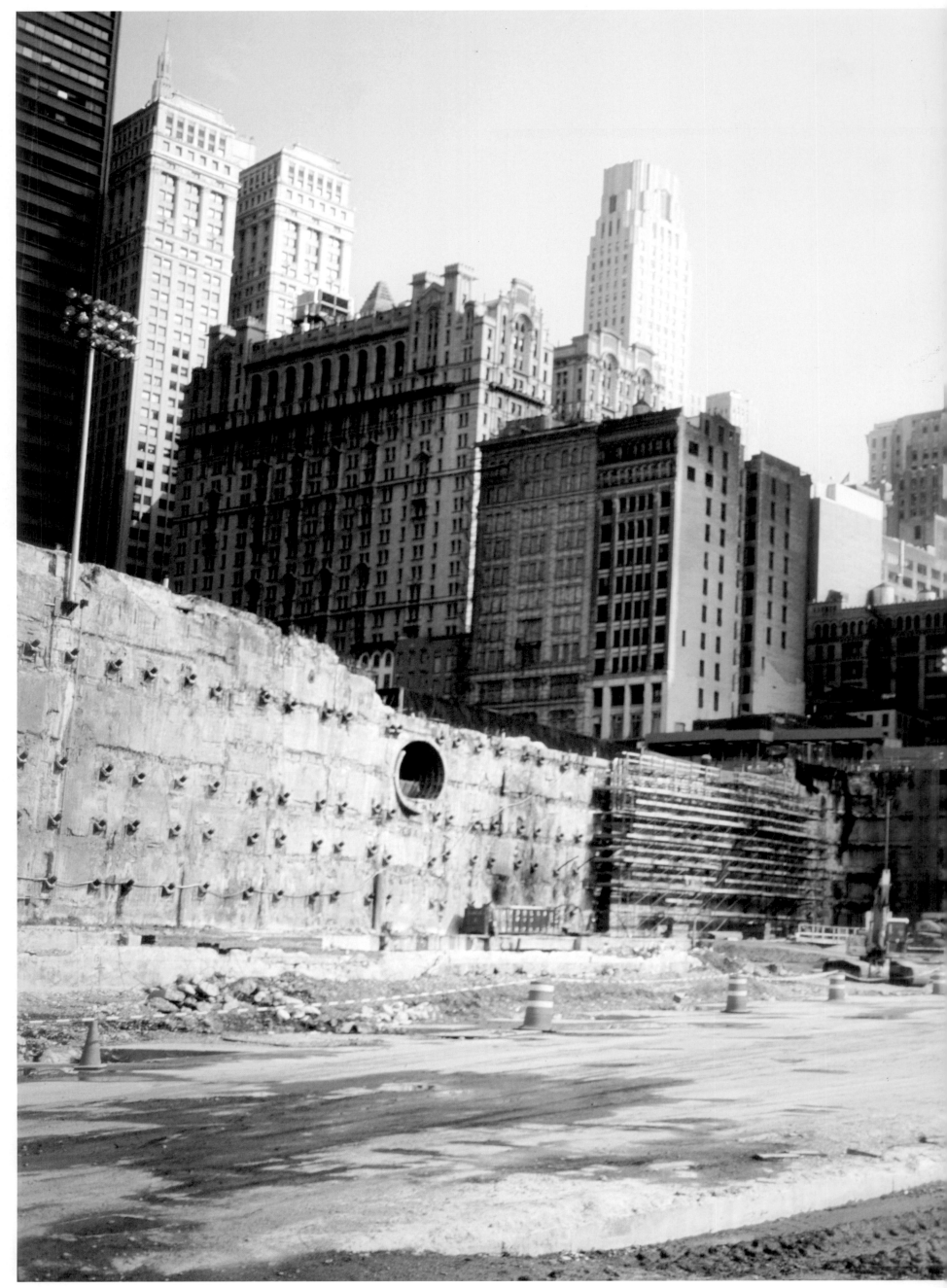

Looking southeast across the empty site

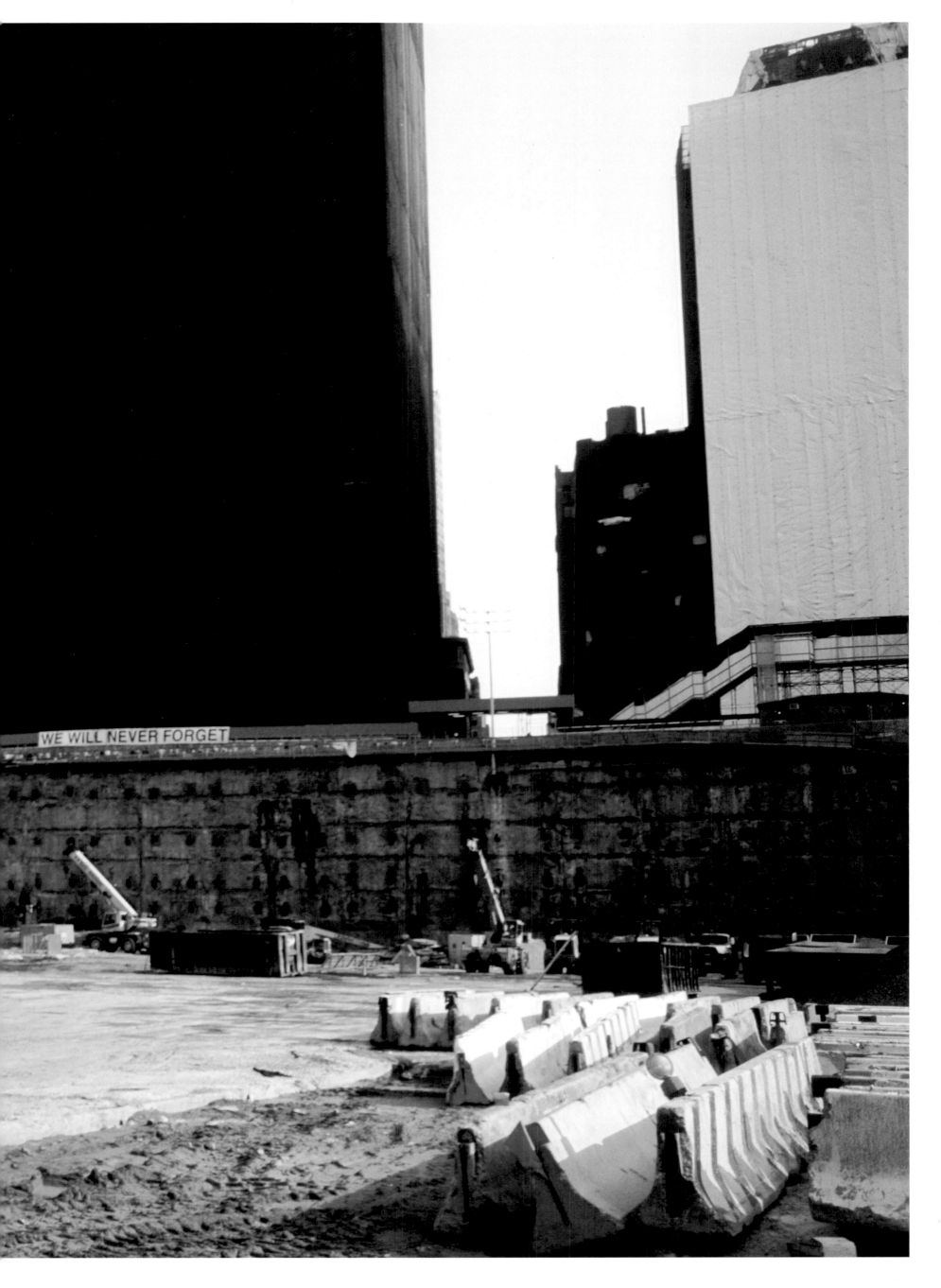

06.21

It seemed fitting to go back into the site on the longest day of the year—a day not unlike 9.11, except that the promise of summer was in the air. The familiar territory within the bathtub walls was unnaturally quiet as I descended, now empty of the nearly two million pounds of debris that had so recently fallen there. It was a slow, meditative walk, filled with images that randomly flashed across my mind. I felt as if an enormous transparent library soared above me, through which I could see, distributed throughout its layered levels, the eight-thousand-plus images that I'd made— first as I walked on my early rounds over the hills of rubble, and later spiraling down and around the site throughout the successive months of its removal.

I crossed over the PATH train tracks near where the last column had stood. As I stopped for a moment to look at a weathered scrap of newspaper, yellowed and decaying in the light, my eye caught a touch of unexpected color at my feet. There, in the shadow of a railroad tie, some tender shoots of grass were making their way up through the rubble. For thirty-five years, this patch of dirt must have lain there in the dark, beneath the rolling wheels and pounding of the trains, and now, with a little sun, some rain, and the cycle of day and night and season, back to life it came. If the earth has such resilience, then we, who stand on the grass in the sunlight, are truly blessed.

Grass growing among the leftover debris on the PATH train tracks

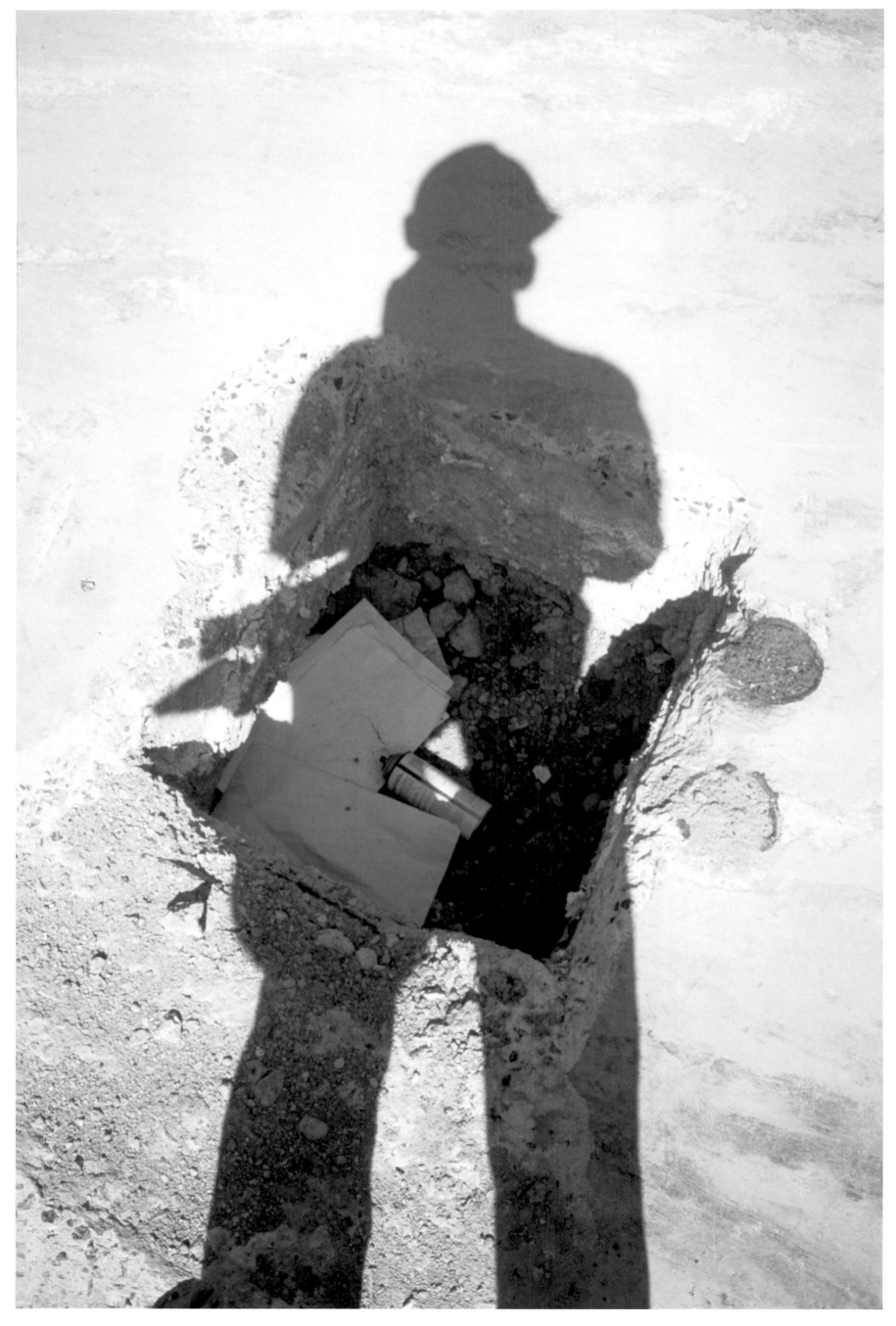

PLAN OF THE SITE AND INDEXES

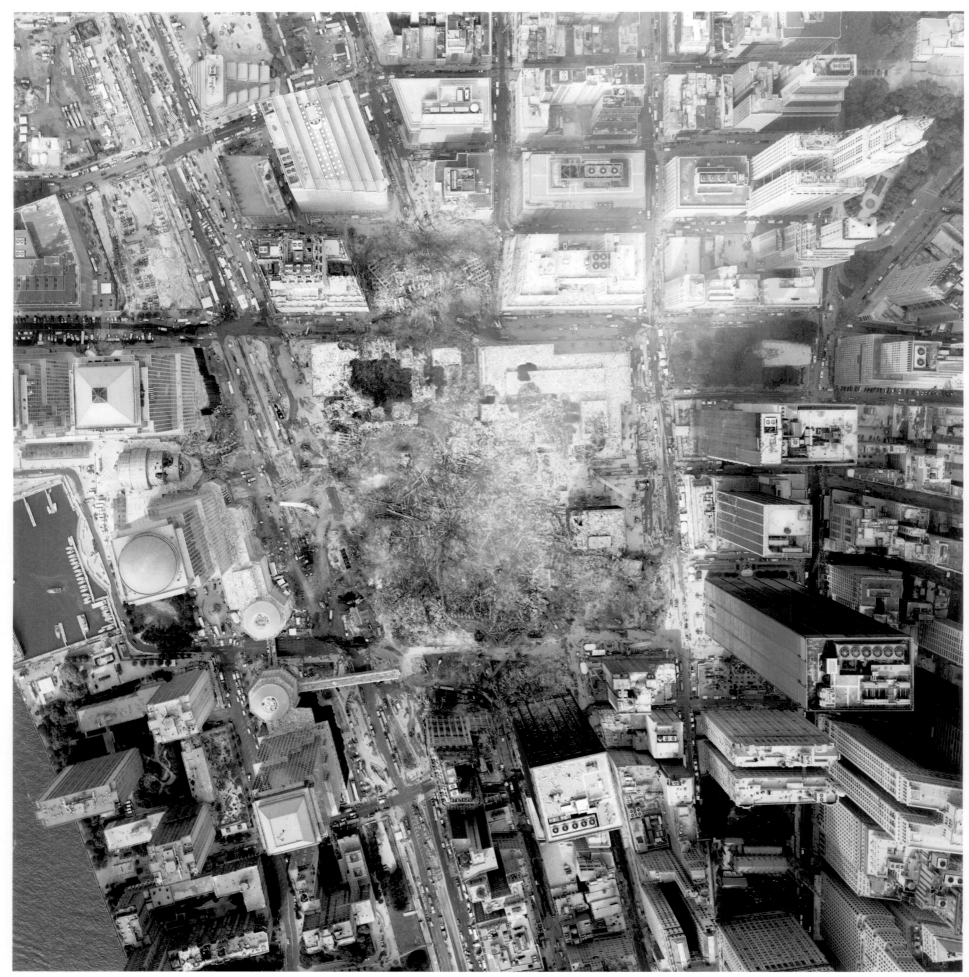

NOAA Aerial view of the site

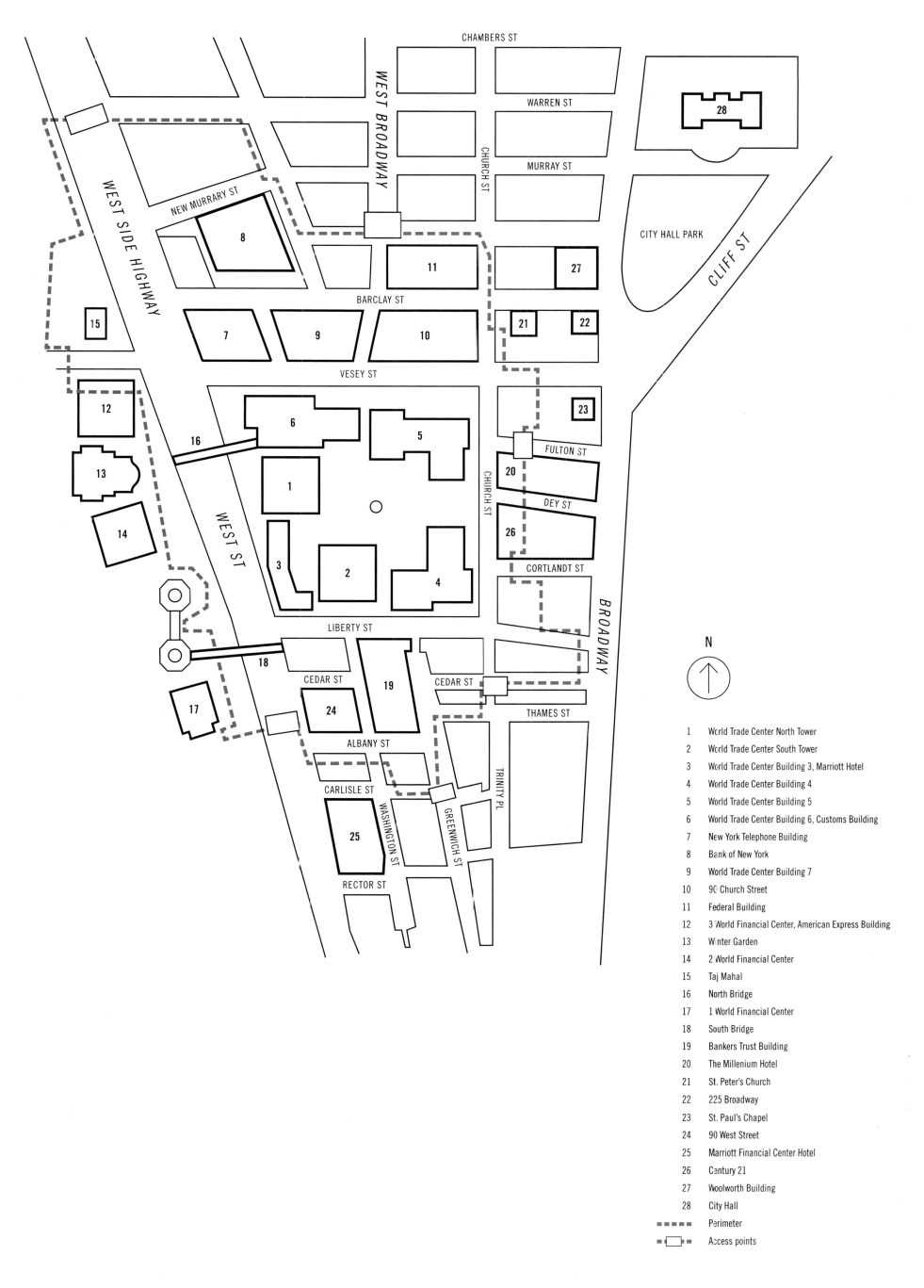

CHAMBERS ST

WEST BROADWAY

WARREN ST

CHURCH ST

MURRAY ST

28

CITY HALL PARK

CLIFF ST

NEW MURRARY ST

8

15

WEST SIDE HIGHWAY

27

11

BARCLAY ST

21 22

7 9 10

VESEY ST

23

12

6

5

16

FULTON ST

13

CHURCH ST

20

DEY ST

1

14

26

3 2 4

CORTLANDT ST

WEST ST

LIBERTY ST

18

CEDAR ST

19

CEDAR ST

THAMES ST

24

17

ALBANY ST

TRINITY PL

BROADWAY

GREENWICH ST

CARLISLE ST

25

WASHINGTON ST

RECTOR ST

N

↑

1	World Trade Center North Tower
2	World Trade Center South Tower
3	World Trade Center Building 3, Marriott Hotel
4	World Trade Center Building 4
5	World Trade Center Building 5
6	World Trade Center Building 6, Customs Building
7	New York Telephone Building
8	Bank of New York
9	World Trade Center Building 7
10	90 Church Street
11	Federal Building
12	3 World Financial Center, American Express Building
13	Winter Garden
14	2 World Financial Center
15	Taj Mahal
16	North Bridge
17	1 World Financial Center
18	South Bridge
19	Bankers Trust Building
20	The Millenium Hotel
21	St. Peter's Church
22	225 Broadway
23	St. Paul's Chapel
24	90 West Street
25	Marriott Financial Center Hotel
26	Century 21
27	Woolworth Building
28	City Hall
▪▪▪▪▪	Perimeter
▪◻▪	Access points

343

GENERAL INDEX

INDEX OF PHOTOGRAPHS

TIMELINE

09.23
24–5, 29, 40–1, 42–3, 44–5, 52–3, 54 (top), 79 (third row, left), 342

09.25
33 (top), 35–8, 39, 47 (bottom), 48–9, 50 (bottom), 50 (top), 54 (bottom), 56–7

09.26
19–22, 27, 32, 33 (bottom), 46, 47 (top), 51, 55, 72, 73

09.27
30–1

10.05
58–9, 60–1, 62, 63, 64 (bottom), 64 (top), 65, 66, 67 (bottom), 67 (top), 68–9, 70–1, 74, 75, 78 (right), 79 (third row, right), 97 (top)

10.07
76–7, 78 (left), 79 (first row, left), 79 (first row, right), 79 (second row, right), 80, 81, 82 (right), 83, 86–7, 88, 89 (bottom), 89 (top), 90–1, 92, 93, 94, 95, 100, 108 (top), 109, 118 (bottom), 150 (top, right), 174–5

10.09
96 (bottom), 101, 103 (top), 106, 107

10.11
82 (left), 85, 96 (top), 97 (bottom), 98–9, 102 (bottom), 102 (top), 103 (bottom), 104–5, 110, 151 (bottom, left), 252 (bottom, right)

10.18
112, 114–15

10.20
79 (second row, left), 108 (bottom), 118 (top), 119 (bottom), 119 (top), 120–1, 122 (bottom), 123 (bottom), 123 (top), 125, 128, 133 (bottom), 134 (top, left), 134 (top, right), 151 (top, right), 155 (bottom)

10.21
116, 122 (top), 124, 127, 129 (bottom), 130, 131 (top, left), 131 (top, right), 133 (top), 134 (bottom, left), 134 (bottom, right), 135, 138–9, 151 (bottom, right), 151 (top, left)

10.24
111, 129 (top), 131 (bottom, right), 136, 137, 141 (bottom), 141 (top), 142–3, 144–5, 147, 148 (bottom), 150 (top, left)

10.25
140

10.26
150 (bottom, right), 152–3, 154, 155 (top), 157, 160, 161 (bottom), 161 (top), 162–3

10.27
150 (bottom, left), 158–9, 208 (top)

10.28
164–5, 166 (bottom, right), 166 (top, left), 166 (top, right), 167 (bottom), 167 (top), 169

10.30
131 (bottom, left), 136 (bottom, left), 170, 171

11.05
172 (bottom), 172 (top), 184 (bottom), 208 (bottom)

11.08
176–7, 178, 179, 180, 181, 182–3, 187 (top)

11.11
253 (bottom, right)

11.12
184 (top), 185, 186, 187 (bottom), 188–9

11.15
190 (bottom), 190 (top), 191, 192, 193, 194–5, 196 (bottom), 196 (top), 197 (bottom), 197 (top), 198–9, 253 (bottom, left)

11.21
201

11.26
79 (fourth row, left), 200 (bottom), 200 (top), 202–3, 205 (top)

11.29
205 (bottom)

12.03
206, 207

12.05
79 (fourth row, right), 148 (top), 209

12.06
149 (left), 204 (top), 252 (bottom, left)

12.07
210–11, 212 (bottom), 212 (top), 213, 214–15

12.12
226 (bottom), 226 (top), 228

12.23
227, 229 (top), 234 (top), 252 (top, right)

01.25
218–19, 220 (bottom), 220 (top), 221 (bottom), 221 (top), 222, 223 224

01.26
225

01.27
285 (top), 285 (bottom)

02.08
204 (bottom), 233 (top), 234 (bottom), 235, 236–7, 272, 302 (bottom, left)

02.10
230–1, 232, 233 (bottom), 243–6, 273 (top)

02.15
229 (bottom), 238 (top), 248–9, 251 (bottom), 251 (top)

02.16
238 (bottom), 239 (top), 250 (bottom), 250 (top), 252 (top, left), 253 (top, right), 257 (bottom), 257 (top)

02.23
254–5, 256

02.24
240–1

03.28
239 (bottom), 260–1, 262, 297, 309 (bottom)

03.30
253 (top, left), 263, 264, 265, 267, 268, 269, 270–1, 273 (bottom)

04.06
274, 276, 282, 284 (bottom), 286, 287

04.08
275, 277, 294

05.01
278–9

05.07
280, 281, 283, 288, 293 (left), 293 (right), 310 (bottom), 310 (top)

05.11
284 (top)

05.16
295 (bottom, left), 305, 308 (bottom), 312 (bottom), 312 (top), 339

05.20
295 (bottom, right), 309 (top), 311, 315, 319

05.24
306–7, 320–1

05.25
289, 290, 291, 296, 298–300, 302 (top, left), 302 (top, right), 303, 318

05.26
292, 295 (top, left), 308 (top)

05.27
302 (bottom, right), 304

05.28
295 (top, right), 314, 316–17, 322 (bottom), 322 (top), 323 (bottom), 323 (top), 324, 325, 326 (bottom), 326 (top), 327 (bottom), 327 (top), 328–9, 330 (bottom), 330 (top), 331

05.30
333

06.21
334–5, 337

ACKNOWLEDGMENTS

This project began on an impulse, but it benefited along the way from the positive energy of friends—and strangers who became friends—which kept the momentum strong during that difficult period in all our lives.

Immediately upon hearing of my plan, Vivian Ubell, David Sumberg, and Carol Green generously helped me begin. Later, Linda Collins and the Morris and Alma Schapiro Foundation came to the project to help fund the exhibition prepared in conjunction with the Museum of the City of New York. In 2002, Marilyn Donini and Diane Eidman at Altria and Roberta Boccardo and Livio Vanghetti at Philip Morris Italia helped underwrite the representation of the work in the US Pavilion at the Venice Biennale. Thanks must also go to Pat Harrison and Brian Sexton at the State Department, Bureau of Educational and Cultural Affairs, for supporting the work early on and sending it on its four-year journey around the world. Special thanks to Robert Macdonald and Sarah Henry at the Museum of the City of New York, who originally endorsed my presence inside Ground Zero. And also to Adrian Benepe, Commissioner for Parks and Recreation, who gave me my first entry pass for the "forbidden city."

The work, and the archive from which it comes, could not have been made without the technical support of corporations and individuals who immediately understood the scope of the project. All the film was generously arranged for by Brandon Remler of Fuji Photo Film USA. Leica Camera, Inc. and Mamiya America Corporation gave equipment to the project; Jeff Hirsch at Fotocare was the conduit for much of this assistance. Heidelberg Americas Inc., Fuji Photo Film USA, and Creo all donated scanners to produce the archive. Adobe donated much-appreciated software. Special thanks to Baldev Duggal, Jay Tanen, and Glenn Rabbach of Duggal Visual Solutions, NY, whose involvement from design to production helped create all the exhibitions. And also to Scott Hagendorf and his team of printers, Philip Heying and Jorge Ochoa at LTI New York, for their relentless efforts and great skill.

None of the work outside the zone could have been done without my staff, who were incredibly supportive of me and the project over the entire year it took to make the archive, and who continued to be so even as the project took on new dimensions. Many thanks to my studio director and project manager Ember Rilleau, my talented archive manager Jon Smith and my archivists John Saponara, Melissa Piechucki, Lauren Knighton, Rachel Stinson, and Micah Pastore. Thanks also to Susan Jerkins for her efforts to record my early impressions of Ground Zero.

Finally, there are the men of the NYPD Arson and Explosion Squad, and in particular Detective Amadeo Pulley and Lieutenant Mark Torre, who not only protected me and helped me to remain in the zone during the most crucial period of the work, but also provided me with the means to stay on and finish the project after they left the site. I can only hope that they now feel I was worth all that trouble!

I am grateful to David Remnick of *The New Yorker* for his early support and willingness to publish a selection of the photographs, and to Terry Gross of *Fresh Air* on National Public Radio for her consistent interest in the project, and also to Robert Krulwich for his sensitive documentary on ABC's *Nightline.* I am particularly grateful to Jon Snow of *Channel 4 News*, London, whose broadcast of our visit to the site influenced the decision of Richard Schlagman, publisher at Phaidon, to publish this work.

No book is made by the artist alone. In this instance the sensitive editing help I received from Alice Truax enabled the stories to find their voice and come together as a whole. At Phaidon, I would like to thank Amanda Renshaw, editorial director, whose exquisite understanding of photographs and how they work contributed enormously to the life of this book, and also Jane Ace, who shepherded the work and kept us on schedule. In addition, many thanks to Paul McGuinness and Fran Johnson in production, Tracey Smith and Samantha Woods in editorial, Fernando Gutiérrez at Pentagram, and Robert Hennessey, for his subtle refinements to the images.

And to my wife Maggie Barrett, who watched me disappear into the pile every day and was there to soothe, encourage, and advise me when I emerged again, I offer my deepest love and gratitude: I could not have stayed the course without you.

Joel Meyerowitz
New York City
2006

Phaidon Press Inc.
180 Varick Street
New York, NY 10014

Phaidon Press Limited
Regent's Wharf
All Saints Street
London N1 9PA

www.phaidon.com

First published 2006
© 2006 Phaidon Press Limited
Photographs © Joel Meyerowitz

ISBN-13 978 0 7148 4655 2
ISBN-10 0 7148 4655 4

A CIP catalogue record for this book is available
from the British Library

Designed by Fernando Gutiérrez / Pentagram
Printed in Italy